THE PELIC. UNIVERSITY OF WESTMI:

Founding Editor: Nikolaus P

Joint Editors: Peter Lasko and Judy Nairn

John White

ART AND ARCHITECTURE IN ITALY: 1250–1400

John White was born in 1924. After a course at Trinity College Oxford he served for four years as a pilot with the R.A.F. and then studied at the Courtauld Institute of Art. Subsequently he held a junior research fellowship at the Warburg Institute for two years and then taught from 1952 to 1959 at the Courtauld, first as a Lecturer and later as a Reader. From 1959 to 1966 Pilkington Professor of the History of Art and Director of the Whitworth Art Gallery, University of Manchester, and from 1966 to 1971 Professor of the History of Art and Chairman of the Department of Johns Hopkins University, Baltimore, he is now the Durning-Lawrence Professor of the History of Art and Vice Provost of University College, London. His other publications include articles in learned journals, largely on the Italian fourteenth and fifteenth centuries, *The Birth and Rebirth of Pictorial Space* (1957), *Duccio* (1979), *Studies in Late Medieval Italian Art* (1984), and *Studies in Renaissance Art* (1983).

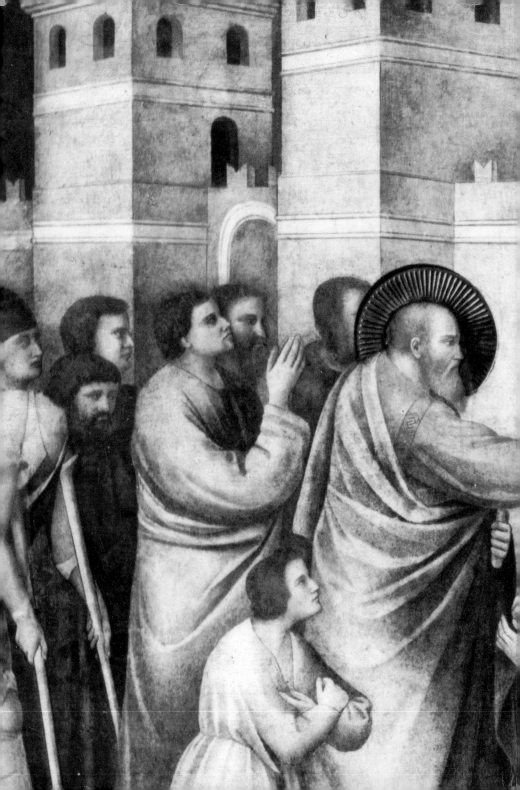

John White

Art and Architecture in Italy 1250 to 1400

Penguin Books

Penguin Books Ltd, Harmondsworth, Middlesex, England
Viking Penguin Inc., 40 West 23rd Street, New York, New York 10010, U.S.A.
Penguin Books Australia Ltd, Ringwood, Victoria, Australia
Penguin Books Canada Limited, 2801 John Street, Markham, Ontario, Canada L3R 1B4
Penguin Books (N.Z.) Ltd, 182–190 Wairau Road, Auckland 10, New Zealand

First published 1966
Second (integrated) edition 1987
Copyright © John White, 1966, 1987

Library of Congress Catalog card number (hardback): 86–62812

ISBN (hardback) 0 14 0560.28 9
ISBN (paperback) 0 14 0561.28 5

Typeset in Monophoto Ehrhardt
and printed in Great Britain by Butler & Tanner Ltd, Frome and London

Designed by Gerald Cinamon

CONTENTS

PART FOUR

ARCHITECTURE: 1300–1350

PART FIVE

PAINTING: 1300–1350

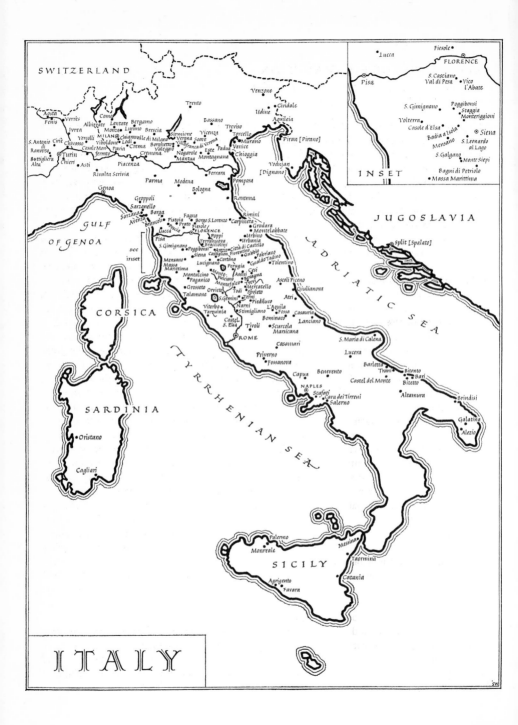

SWITZERLAND

Venzone

Trento

Bassano

Udine • *Cividale*

Aquileia

Treviso

Como *Bergamo*

Agosta • *Verrès* *Albizzare* *Lentate* *Brescia*

Fenis *Ivrea* *Monza* *Lurano*

Vercelli MILANO *Chiaravalle di Milano*

S. Antonio *Ciriè* *Viboldone* *Lodi*

di *Chivasso* *Casale Mon-* *Pavia* *Crema*

Ranverso *ferrato*

Buttigliera *Turin* *Cremona*

Alta *Chieri* • *Asti*

Piacenza

Rivalta Scrivia

Genoa

GULF

OF GENOA

Groppoli

Sarzanello

Sarzana *Barga*

Avenza *Brancoli* *Pistoia* *Fagna*

Lucca *Vicopisano* *Prato* *Borgo S. Lorenzo*

Pisa *Fiesole*

S. Gimignano *FLORENCE*

Poggibonsi *Bracciolini*

see *Mensano* *Siena* *Castiglion*

inset *Massa* *Cortona*

Marittima

Lucignano *Perugia*

Montalcino *Monte-* *Assisi*

Paganico *pulciano* *Montefalco*

Grosseto *Orvieto* *Todi*

Talamone *S. Gemini*

Viterbo

Tarquinia *Narni* *Stimigliano*

Castel. *L'Aquila*

S. Elia *Tivoli* *Fossa*

ROME *Scurcola*

Marsicana

Casamari

CORSICA

Priverno

Fossanova

Capua

Benevento

NAPLES

Scafati

Cava dei Tirreni

Salerno

SARDINIA

Oristano

Cagliari

TYRRHENIAN SEA

Palermo

Monreale

SICILY

Agrigento

Favara

Messina

Taormina

Catania

Trento

Vicenza

Verona *Soave*

Sirmione

Borghetto

Franca di Verona *Padua*

Nogarole *Montagnana* *Murano*

Mantua *Este* *Venice*

Chioggia

Vedujan [Dignano]

Parma

Modena

Bologna

Ferrara

Pomposa

Ravenna

Rimini

Carpineta

Gradara

Montelabbate

Urbino

Terranuova *Urbania*

Poppi *Fiorentino*

Arezzo *Gubbio*

Città di Castello *Fabriano*

Gualdo Tadino

Tolentino

Gesi

Bevagna *Ascoli Piceno*

Trevi *Giulianova*

Mercatello

Spoleto *Atri*

Terni

Piediluco

Casauria

Bominaco *Lanciano*

S. Maria di Calena

Lucera

Barletta *Trani* *Bitonto*

Castel del Monte *Bari*

Bitetto

Altamura

Brindisi

Galatina

Alezio

ADRIATIC SEA

JUGOSLAVIA

Split [Spalato]

INSET

Lucca *Fiesole*

FLORENCE

Pisa *S. Casciano* *Vico*

Val di Pesa *l'Abate*

S. Gimignano *Poggibonsi*

Staggia

Volterra *Monteriggioni*

Casole d'Elsa *Badia a Isola* *Siena*

Mensano *S. Leonardo*

al Lago

S. Galgano *Monte Siepi*

Bagni di Petriolo

Massa Marittima

ITALY

PREFACE TO THE FIRST EDITION

The period covered by this book has long been the object of intensive study. Many of the greatest names in art history have contributed, or are still contributing, to an unending stream of books and articles. These range from magisterial surveys of the entire field to complex investigations of the most minute details. At every level, therefore, my debt of gratitude is quite impossible to repay. Neither the notes, which have been kept to what seems to me to be the essential minimum, nor the select bibliography, which is merely a pointer to some of the more important sources of information, can, by the very nature of things, be more than a token of what I owe to writers, many of whom have not been named.

The general shape of the book, built for the most part round biographies of the major artists, has been conditioned by my belief that this traditional format remains the most appropriate for the period in which, for the first time, artistic personalities as such are well enough documented to become appreciable in any quantity or detail. The division into architecture, sculpture, and painting, though undesirable in principle, particularly in relation to a time when the arts were notable more for their unity than for their separation, seemed to be necessary in the interests of clarity. There appeared to be no need, however, to insist on the often unfortunate modern distinctions between major and minor or fine and applied arts, and the latter are treated without segregation at such points as seemed to be appropriate for various reasons. The internal chronological divisions at 1300 and 1350 are as arbitrary as the opening and closing dates of the book as a whole. I felt that some subdivision was desirable in order to avoid such extremes as having to discuss the architecture or sculpture of 1400 before the painting of 1250. Any alternative dividing lines seemed to be neither more convenient nor less misleading. None of the three compartments so created are rigidly respected, and the varying sequences in which painting and sculpture are considered reflect my estimate of their changing inter-relationships.

The limitations of space arising from the nature of the series as a whole meant that any attempt to achieve an even coverage of the field would have reduced the text to a mere string of names. The outcome is therefore a compromise. Without, I hope, ignoring the need for a reasonable survey, I have concentrated heavily on those artists and works of art or architecture which seemed to me, for one reason or another, to be the most important. This means that many fine artists and many considerable works, some of them possibly more beautiful or more significant in certain respects than those which are discussed, have had to be left out. I have, on the other hand, included many passages on works which could not, unfortunately, find a place within a strictly limited list of illustrations. I did this partly in the interests of a reasonable historical coverage within the guiding lines already mentioned; partly because such passages seemed to me to be essential to an understanding of the works which could be illustrated; and partly because I believe the final test of what I have written to lie in its success or failure in terms of increased understanding and enjoyment in front of the works themselves.

Particularly in the earlier sections of the book I have tried, wherever I have felt able to deal with artists or with works of art or architecture at some length, to approach the various topics in a way which demonstrates the essential workings of art-historical method as I understand it. Words such as 'seems' are deliberately used throughout to indicate degrees of probability or uncertainty, especially where detailed argument

could not be included. Finally, on matters such as dating, attribution, and the like, I have tried as far as possible to make those things which seem, in the light of present knowledge, to be so well established that they can, for all practical purposes, be treated as certain, stand out clearly from the surrounding structure of less secure hypothesis. One of the least desirable aspects of the intense interest in this particular field in recent years has been the extent to which, in certain quarters, hypothesis has been raised upon hypothesis, until the often tiny basis of reasonable certainty has been buried under a mountain of attractive but insecure assumption. By a natural process of conditioning the latter is then often treated as the firm foundation of known fact which it is not. I have therefore done my best, however unsuccessfully at times, to cut down to bed-rock in these respects and to allow the nature of the speculative super-structure to remain visible from the foundations upwards. It is in this context that I have reduced the references to Vasari to a minimum; and this perhaps requires some explanation. When dealing with a period which lay to some extent outside the range of his remarkable expertise, what he says, however fruitful in suggesting avenues for research, can only be accepted on the basis of outside evidence. When he can be checked, he seems to be wrong at least as often as he is right. In such circumstances the tendency to quote Vasari as an authority whenever his opinion happens to coincide with one's own has little to recommend it.

Among the many people who have helped me, I owe especial thanks to Dr Margaret Whinney and to Professor Johannes Wilde for their advice and encouragement in the early stages of the work, when they read a number of chapters in typescript. I am also extremely grateful to Dr Howard Saalman for his generosity in allowing me to read much of his unpublished material. Professor George Zar-necki has come to my aid time and again. Apart from his advice on art-historical matters, I cannot begin to say how indebted I am to Professor Nikolaus Pevsner for his kindness and under-standing and for his endless patience. I owe a great deal to Mrs Joan Allgrove, Professor Sir Anthony Blunt, Dr Eve Borsook, Professor Hugo Buchthal, Mrs Diana Donald, Mr Julian Gardener, Professor Louis Grodecki, Dr George Henderson, Dr Peter Kidson, Mr Andrew Martindale, Dr Peter Murray, Miss Stella Mary Pearce, Mr John Pope-Hennessy, Dr Nicolai Rubinstein, Professor Charles Seymour, Jr, Dr John Shearman, Dr Kathleen Speight, and Dr Max White. I am also grateful for all that I have learnt over the years in the course of innumerable arguments and dis-cussions with undergraduates and graduates who have worked with me.

But for Miss Pauline Newton, whose speed and efficiency were as remarkable as her help-fulness was constant, I think the typescript would not be finished yet. I would also like to thank Mrs Judy Nairn, Mrs Helen Wightwick, and Mr Donald Bell-Scott for so greatly easing the path to actual publication. It goes without saying that I have been given assistance of every kind by members of staff at the University of Manchester and at the Courtauld and Warburg Institutes in the University of London, as well as by the owners of collections, by librarians, by gallery and museum officials, and by civic and ecclesiastical authorities in Italy and else-where.

I am grateful to the Central Research Fund of the University of London for a grant towards the cost of photographs at the very beginning of the preliminary research. In photographic matters generally I have been greatly helped by Mrs Anne Dunkerley. Thanks for permission to reproduce individual photographs are due also to those copyright owners mentioned separately in the List of Illustrations.

PREFACE TO THE SECOND EDITION

In preparing this second edition after so many years, I decided at the start that I would still wish to retain the form and flavour and the fundamental purposes of the original. Where little has been changed, it may reflect the fact that little new work has been done. In other cases, much of value may have been achieved, but of a detailed kind which does not seem to me to have greatly altered the broad pattern. Sometimes, minimal or minor alterations are a recognition that, in tackling a period in which such a vast proportion of the original production has been lost and in which so much of what remains is both undated and unsigned and otherwise undocumented, the necessary work of dating and attribution has continued, far too often, to result in seemingly unending wars in which contestants battle back and forth to little purpose in an unchanged landscape rendered even more confusing by the smoke of conflict and the steadily accumulating literary debris. In many areas, indeed, the mass of publication far outweighs the actual advance in knowledge and in understanding that results.

In other ways, much progress has been made. New processes of conservation, in revealing long-lost beauties, have, at the same time, led to greater understanding of the physical reality of works of art and of the workshop processes and structures which conditioned their creation. Long overdue attention has increasingly been paid to the archaeological foundations of every aspect of the history of late medieval art. The patterns of thought and patronage, and the economic, social, and political structures and motivations, which provide the context for production in the arts, have been the focus of renewed concern. Where all or any of these factors seem to have resulted in substantial change or have thrown up new prob-lems, yet to be resolved, these are, as far as possible, reflected in the text or in the notes. I have also, naturally, tried to excise mistakes and to incorporate new factual knowledge in relation to the necessarily restricted range of topics covered in the first edition. The bibliography has also been updated, but I have, as a matter both of principle and of personal distaste, con-tinued to refrain from the insertion of pontifical, one-line reviews.

As a result of my own research on Duccio during the years that have intervened between the two editions, I have come to see the relation-ship between the early Sienese and Florentine schools of painting, and of both of them to the sculpture of the period, in a rather different light. The extent to which the great Tuscan artists were, between them, evolving a new and common visual language, albeit spoken with distinctive dialect inflections and often used to say quite different things, has been increasingly borne in on me. As a result, I have taken Duccio out of his position as the final artist in the section dealing with painting up to $c.$ 1300 and placed him immediately before Giotto as the first of that great line of painters who, between them, made the first half of the fourteenth cen-tury a turning point in the history of European art.

In struggling with the often awkward process of revision, I have accumulated further debts of gratitude to many of those who helped me in the initial enterprise, and most particularly to Professor Julian Gardner, Professor Andrew Martindale, and Professor Nicolai Rubinstein. In addition, Professor Enzo Carli, Dottore Alberto Cornice, Signor Paolo Mora, Professor Angiola Maria Romanini, Professor Franklin Toker, Dottore Giovanni Urbano, Signorina Sabina Vedovello, Dr Valerie Wainwright, and

Signor Bruno Zanardi are among the innumerable friends and colleagues who have helped me. I am lucky to have found in Professor Peter Lasko a second editor no less patient than the first, and I am doubly lucky that Mrs Judy Nairn has continued to convert what can turn out to be a rocky and uncertain road into a smooth and easy path to publication. I also owe a great deal to Mrs Fenella Wood for the transcription of the manuscript.

Finally, I am grateful also for the help which I have had from the Faculty of Arts Travelling Fund in University College London in financing many trips to undertake research, to look again at long-familiar sights, and to explore new territories.

Art and Architecture in Italy
1250 to 1400

ARCHITECTURE

1250–1300

INTRODUCTION

The late thirteenth and early fourteenth centuries in Italy are a time of vigorous growth and ceaseless architectural experiment and adventure. New forms are constantly evolved to meet the new needs of a multiform society in the throes of economic and social revolution. In religious architecture it is marked by the continued expansion of the Dominican and Franciscan orders, and by the pouring of the new wealth of the towns into a series of ever grander schemes for the expression of God's glory and their own magnificence. This growing civic pride, this sense of unity, or the desire for it, despite the bitter factions and the rending struggles for internal and external power, was accompanied by the accumulation of great individual and communal wealth. It led to the creation of a secular architecture that has no parallel elsewhere in Europe. Not only do the buildings of the day provide the essential physical environment for the visual arts from which they are inseparable; they also play a vital role in the establishment of a new vocabulary of form. The latter still embraces all the arts, but adds a fresh complexity and richness to their fundamental unity. The period is characterized by the emergence of the individual artistic personality and the germination of the modern concepts of the artist and the architect, yet the idea of specialization in the arts was barely in its infancy. The major and the minor arts were not distinguished from each other. Mason and sculptor, architect and mason, were not yet separated. All of them were craftsmen first and foremost. Often a single man habitually combined two or more of the now distinct roles of sculptor or goldsmith, architect or painter. Even where he did not, fame in the visual or applied arts was, as common practice, taken to qualify a man completely for the direction of the most important architectural commissions. In such a world there is no justifying any underestimation of the role of architecture.

However much they may be masterpieces in their own right, the buildings of this period have always occupied a rather unhappy position in the history of art. They are the victims of invidious comparisons with the Northern Gothic architecture to which many of them are in part stylistically affiliated; with the native Italian Romanesque tradition that precedes them and with the Renaissance that follows; and above all with the visual arts by which they are embellished and completed. It is therefore all the more important that their contribution to the cultural history of the period and to the subsequent development of Italian architecture should be seen for what it is, and for what it was in its own day, as far as that is possible.

In social and in economic terms the thirteenth-century building boom in Italy is a phenomenon which far outstrips in its importance anything occurring in the visual arts in that or in succeeding centuries. The direct

investment of money and manpower and the economic and social spin-off were of quite a different order.

In the mid thirteenth century there were three main sources of architectural inspiration. The first was the varied, omnipresent, and still living, native Romanesque tradition. This contributed to almost every major achievement of the next fifty years and to much that was done throughout the succeeding century. The second was French Gothic architecture. This was often experienced directly or through German inter-mediaries and was embodied, largely by French architects, in the great Cistercian monasteries built in Lombardy and South Central Italy during the preceding seventy-five years. The third source was the small but increasingly influential body of work in which the elements of Northern Gothic art were beginning to be adapted in a specifically Italian manner to Italian taste and needs. By far the most significant of these seminal early-thirteenth-century achievements was the construction of the double church of S. Francesco at Assisi.

THE ARCHITECTURE OF THE FRANCISCAN

AND DOMINICAN EXPANSION IN ITALY

The mendicant churches offer a telling introduction to the study of late medieval Italian architecture. Certain more or less constant architectural demands, arising out of a consistently applied religious programme, provide a unifying theme without disguising the regional variety that remained a feature of Italian life and art. The newly formed orders were, moreover, expanding across the whole of Europe, and since they were the most consistent and persistent Italian champions of Gothic forms, a number of the salient characteristics of Italian Gothic architecture can be seen in their wider, European context.

ASSISI

Although S. Domenico at Bologna was founded slightly earlier, it is to S. Francesco at Assisi that site, architectural form, and subsequent decorative completion have given a unique aesthetic and historical importance [1 and 2]. The

1. Assisi, S. Francesco, founded 1228, consecrated 1253

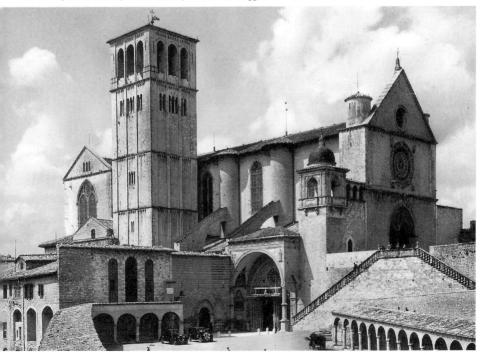

2 and 3. Assisi, S. Francesco,
founded 1228, consecrated 1253,
plans of upper and lower churches* (*below*)
and interior of upper church (*opposite*)

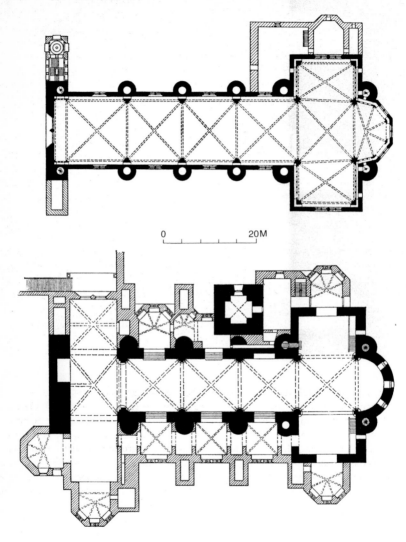

0 20M

* Unless otherwise indicated, all plans and elevations (but
not the diagrams of fresco cycles) are reproduced at the scale
of 1:800.

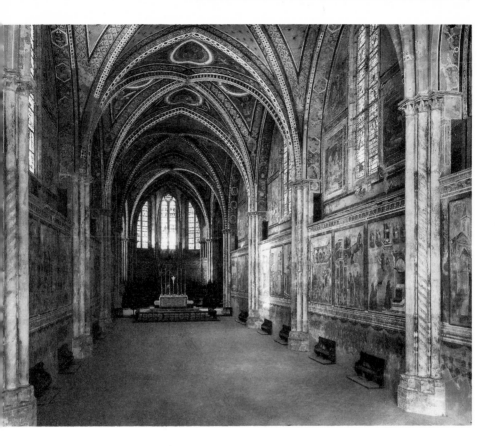

church was founded in 1228, the year of St Francis's canonization and two years after his death. Although it was only consecrated in 1253, it was probably substantially complete by 1239.[1] It is a double church like the Sainte Chapelle in Paris, which it antedates, and the upper building, rather than the crypt-like lower structure, has the major architectural significance. Although it provides a pattern for only a relatively small group of buildings,[2] many of the fundamental characteristics of Italian Gothic architecture are already established in it. Its plan is simple, and the unadorned Latin-cross form and aisleless nave closely resemble those of its possible prototype, the late-twelfth-century cathedral of Angers.[3]

There is extreme volumetric clarity, and in the nave the overriding sense of a single unified space is unimpaired by its articulation into bays [3]. It is a preacher's church, and nothing interrupts the congregation's view or breaks the steady architectural flow towards the altar and the pulpit. Breadth and airiness are combined with a firm sense of architectural mass. Balance is the keynote. Every vertical acceleration is held by a horizontal of equivalent power, and each strong horizontal broken by a vertical. The outcome of the interplay of members is both an enhancement and an exact expression of the actual architectural volume and its major axes.

There is a clear structural logic, and no attempt is made to use hidden engineering or

external elements to create an internal sense of weightlessness by means of thin and soaring members. Such buttressing as is needed is supplied by massive, semi-cylindrical forms, and the spectacular mechanics of the flying buttress are eschewed. The aesthetics of the Roman and the Romanesque remain the foundation of the finest creations of Italian Gothic architecture. The wall and its solidity, not its destruction or negation, are the basis of the final architectural achievement. The vitality of this feeling for the wall in its simplest form, flat, solid, and predominantly rectilinear, is obvious in S. Francesco, whether internally or in the plane geometry of its façade. The area occupied by windows is comparatively small except in the choir, which therefore draws the eye by its increase in luminosity. Coolness, and yet sufficient, even light, and a clear field for the fresco painter, are the outcome. The feeling for plane surfaces extends not only into the five-sided apse but into architectural details. The clustered columns, of Burgundian inspiration, are the only rounded elements, and all the heavy ribs of the square, cross-vaulted bays are firm, five-sided prisms that reiterate the basic form and volume of the apse. The lack of any distinction between diagonal and transverse elements emphasizes that in every aspect of design, from large to small, the effect depends on the relationship and repetition of a few simple and easily distinguished forms, accompanied by a minimum of sculptural detail. In this simplicity and in its contrast to the architectural complexities of the great contemporary cathedrals of the Île de France, Assisi has much that is, in principle, common to the Gothic of innumerable churches, small and not so small, that were to be built throughout Europe in the late thirteenth and in the fourteenth centuries. Nevertheless, the traditions controlling the embodiment of these principles are such that its position both in time and space could never be mistaken.

The Burgundian connexions grow still clearer in the sister church of S. Chiara, also at Assisi, and seemingly built between 1257 and 1265, when it was consecrated. The plan derives from S. Francesco, but the encircling wall-passage, marked by a much heavier cornice, instead of running behind the columns well below the capitals, is at the level of the springing of the arches. The clustered columns have been shrunk against the wall, their elements reduced from five to three. They have no connexion with the longitudinal arches of vaults that now appear to sit like flattish caps upon the high walls of a wide, rectangular room. Walls, yet more bare and more unbroken, and much smaller windows, are the salient features of this nave. Its close resemblance to that of St Gildard at Nevers, of c. 1245,[4] underlines how seldom the individual elements of Italian Gothic architecture have no precedent or parallel elsewhere in Europe. On entering the building the tendency to spatial unification is paradoxically stressed by the near-invisibility of the transept openings. It only gradually becomes apparent that the church is not a simple hall and the apse a mere continuation of the nave.

Externally, the limited interest in verticality is shown by a façade which, like that of S. Francesco [1], and like the campaniles of both churches, derives almost unaltered from the Umbrian Romanesque tradition. Here again the high rectangle of the flat screen is horizontally divided by cornices. A first low rectangle contains the doors and damps down any resultant vertical thrust. A second frames the spatially neutral main rose and is crowned by a free-standing pediment with a smaller oculus. The slope of the pediment is now less steep, and the greater width of the façade in relation to its height is accentuated by wide horizontal bands of pink and white stone. The fact that in Italy buttresses seldom fly is almost caricatured by the massive arches, much more wall than arch, and vice-like in effect, which were soon added to secure the structure.

S. FRANCESCO AT BOLOGNA

Any danger of thinking that there was ever a 'mendicant architecture' as such is dispelled by

moving from Assisi to Bologna. Founded in 1236, consecrated in 1250, four years before part of the tribune fell, killing a certain Brother Andrea, 'maestro della ghiexia', and seemingly substantially completed by the early sixties, S. Francesco is a brick construction typical of the Lombard and Emilian plain. It hides behind a massive screen-façade in the Romanesque tradition of Parma, Piacenza, and Pavia. The pointed openings and the relative emphasis on height instead of width hardly prepare one for the strength of the Northern Gothic influences in the main body. The plan, with its ambulatory and nine separate radiating chapels, is less remi-

niscent of the continuously roofed Cistercian radial systems of Clairvaux and Pontigny than of their common sources in the Île de France [4].[5] Externally the formal build-up of the choir reflects the transformation of French forms upon Emilian soil [5]. Rectangular chapels with rectangular buttresses are linked by flat connecting walls. The massive flying buttresses, again rectangular in plan and section, press against the flat pilasters that define the angles of the faceted choir. The heavy forms pile up and then seem suddenly truncated, since there is no visible pitched roof to give a final concentration to the vertical movement.

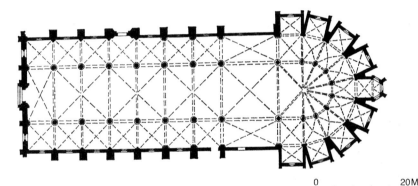

4 and 5. Bologna, S. Francesco, founded 1236, consecrated 1250, plan and choir

0 20M

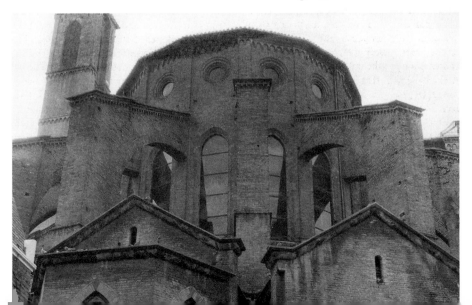

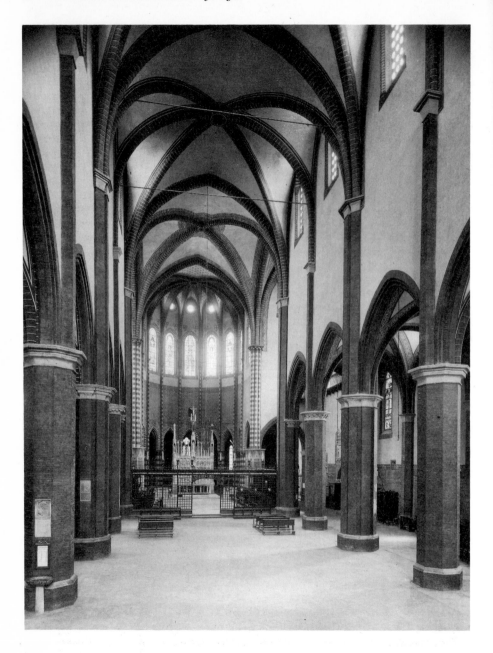

6. Bologna, S. Francesco, founded 1236, consecrated 1250

Internally there is nothing specifically Franciscan in the sexpartite vaults of the nave and in the low flanking aisles [6]. The emphasis on line and plane is thoroughly Italian, on the other hand. The nave piers alternate between plain octagons and octagons composed of clusters, not of columns, but of pilasters. The vaults, with their bold, almost square, prismatic ribs, are supported by applied pilasters set out singly or in groups of three. The planar forms give way to rounded elements only in the columns of the choir, and everywhere the brick of the supporting system makes a lively linear contrast to the wide white surfaces of wall and vault. The relative flatness of the vaults themselves becomes particularly obvious in the choir, which seems, as in the external view, to come to a sudden stop immediately above the oculi. This further stresses the width and flatness of a polygon in which the arches, walls, and windows blend into continuous horizontal strips no less emphatic than the verticals of their individual members. The whole effect is one of calm and rationality and simple colour contrast. Clear definition and distinction of 'supporting' and 'supported' parts, and a sharp-edged clarity of formal detail; the retention of the structural elements of Gothic architecture and a positive exploitation of their necessary resolution into the simple forms traditionally best suited to a brick construction; such seem to be the basic qualities of a church that set the pattern in Bologna for two hundred years and more.

S. MARIA NOVELLA IN FLORENCE

The supreme and earliest surviving complete example of the adaptation of the vaulted, aisled basilican design to mendicant needs, and of a thoroughgoing exploration of the rhythmic possibilities of the Gothic idiom, is that of S. Maria Novella, the principal Dominican church in Florence, founded by 1246 [7 and 8]. The choir and transepts seem to have been started by 1279, and work appears to have continued on the nave, without substantial subsequent change of plan, until its virtual completion in the early fourteenth century. The short-headed, cruciform plan with its straight-ended choir, four flanking chapels, and square or near-square bays for crossing and transepts combines features of such North Italian Cistercian foundations as Rivalta Scrivia with others characteristic of the South-Central Cistercian tradition, headed by Fossanova, and subsequently modified in S. Galgano near Siena. In the nave a similar blending is observable in the rapid expansion towards the North Italian square bays, which are, however, set in the

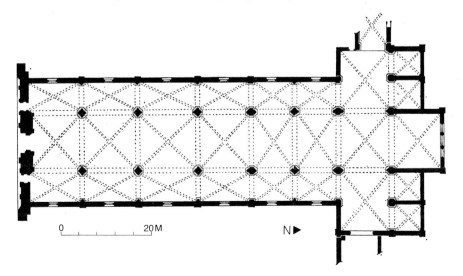

0 20M N▶

South-Central, one-to-one relationship with those of the aisles. Alternatively, the whole plan may be regarded as a grafting of certain Cistercian features on to that of S. Francesco at Assisi. This stresses the vital fact that the novelty of the completed three-dimensional design is Italian mendicant rather than transplanted French Cistercian in its origins.

In structural terms, the slimness of the supports, combined with the bay-shapes, gives unprecedented airiness and spatial unity to the design. The breadth and moderate height of the nave, and the unusually wide openings into the relatively narrow aisles, break down the separation of the subsidiary spaces common to all Cistercian churches. The height of the aisles is consequently over two-thirds that of the nave, and recalls the proportions of such vaulted Romanesque buildings as S. Eustorgio in Milan, not to mention a number of unvaulted Tuscan Romanesque buildings such as the Pieve at Arezzo. Now, however, for the first time in Italian Gothic art, light has been combined with lightness and free movement. Although the hierarchy of the spatial subdivisions is maintained, there is an unusual rhythmic interpenetration of the entire volume of the nave. In comparison, the nave of S. Francesco at Bologna assumes the air of a rhythmically patterned, rectangular volume.

Until the recent campaign of restoration in S. Maria Novella, the continuity of movement in the architectural structure itself was accentuated by the picking out, against the white walls, of all the ribs and arches and their slender supporting members in the cool grey-green of Tuscan *pietra serena*. Given the smoothness of all these elements and the lack of sharply pointed forms, the effect was to ensure that movement was combined with calm in a swift-flowing stillness. This Brunelleschian quality essentially derived from Vasari's cleaning-up campaign of 1565–72, which likewise largely cleared away the colourful profusion of memorials and frescoes on each wall of the Franciscan church of S. Croce.[6] What Brunelleschi actually saw, and what can still be seen in part,

was very different and demonstrates how much the final effect of Italian Gothic architecture could be, and in great part actually was, transformed by painted decoration.

Originally, only the vertical supports were plain and all the ribs and arches carried a bold zebra patterning, derived from Tuscan Romanesque and here acquiring special Dominican significance. The smooth shafts would have borne a canopy of colour. The saints and angels, which in part survive in the ten niches which originally decorated the flat soffits of the transverse arches of the nave, break up the flow of architectural form. The voids thus notionally created in the solid volumes of the arches drain them of their architectural significance. On the other hand, the dazzle of the abstract patterning would have caught the eye and drawn attention upwards from the frescoed narratives on the walls below towards another world, vibrant with meaning, setting off the colouristic riches of what were then seen as the veritable vaults of heaven.

However much it may have been transformed by decorative means, the sense of calm and quiet inherent in the architectural forms themselves is epitomized in the clear, closely grouped forms of the triple east window, which replaces the much looser patterns of Cistercian end-walls and which, since it is set in a contrasting frame of relative obscurity beyond the light-accentuated crossing, contributes to a final concentration on the altar.[7] The same end is subtly furthered by the diminishing length of the nave-bays as the crossing is approached. This speeds up the natural perspective diminution, adding to the sense of space in an already lengthy nave. Whether this is a deliberate refinement or the sensitively managed outcome of a change of plan begun in the third bay from the crossing, the aesthetic point would have been more obvious when the original placing of the monks' choir in the bays before the crossing, preceded, as it was, by a massive, arched and vaulted, two-storey *ponte* or *tramezzo*, carrying the rood screen, partially obscured the now uninterrupted vista.[8] The numerous subsequent

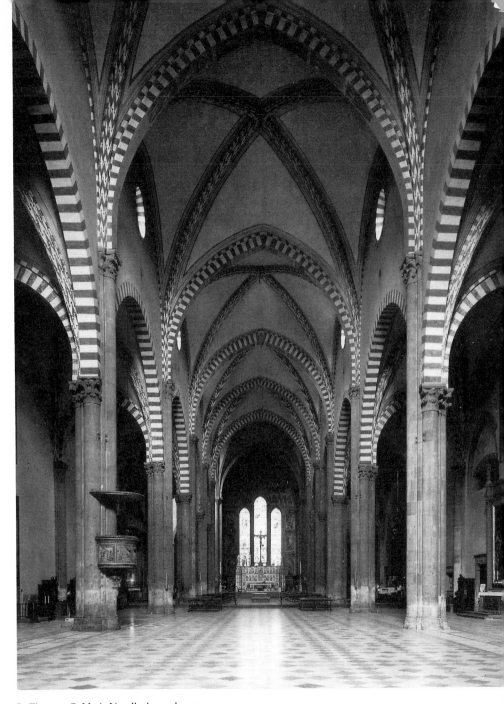

8. Florence, S. Maria Novella, begun by 1279

examples of equivalent subtlety of mind and eye show that such problems should not be too easily dismissed. These very years are marked by growing interest in the appearances and metamorphoses of real space. It is part and parcel of an ever-increasing determination to transform the two-dimensional world of wall- and panel-painting into a seemingly three-dimensional reality. The sensitivity to architectural space that could characterize a man who was a leading explorer of sculptural form is seen by turning to the one surviving and substantially unaltered architectural masterpiece that is generally attributed to Arnolfo di Cambio.

ARNOLFO DI CAMBIO
AND S. CROCE IN FLORENCE

The history of the rival, Franciscan church of S. Croce, half-embedded, like S. Maria Novella, in its system of cloisters and monastic buildings, typifies that of many of the great mendicant constructions. The rapid geographical expansion of the new orders was accompanied by dramatic growth within the individual cells of the body corporate, and often, as in the case of S. Maria Novella in 1221, the story began with the transfer of an existing church. Here, however, the setting up of a small house by St Francis himself in 1211–12 was followed by the building of a church first mentioned in 1225. This was already apparently being enlarged, or possibly replaced, by 1252, and an even finer edifice was being planned by as early as 1285. Apart from Florentine tradition, the belief that Arnolfo di Cambio designed the new building, founded in 1294/5, depends on two things. The first is a tenuous stylistic relationship to the little that can hypothetically be reconstructed of the original project for the new Florentine Duomo, of which he is documented as being capomaestro in 1300. The second consists of such links as may justifiably be forged between his architecture and his sculpture. By the probable date of his death in 1302 it is likely that the chapels flanking the choir of S. Croce had been completed. The first southern aisle-bay was finished by 1318 and the third northern by 1326, but although the nave was not completed until the end of the century, there were no important subsequent variations in a design conspicuous for clarity and balance in a complex whole adapted to the special purposes of the Franciscan order, and for space and calm, combined with Gothic lightness, unity, and movement [9].

S. Croce is one of the largest and most richly decorated mendicant churches in Italy.[9] The violent opposition aroused by its building in an order already deeply riven by the long controversy over the interpretation of the extreme rule of poverty, laid down by a saint who had not even wished his followers to build themselves permanent dwellings of any kind, is not surprising. The battle was intensified by the fact that two of the most important writers of the Spirituals or Strict Observants, Pietro Olivi and Ubertino da Casale, who in 1310 castigated its excessive luxury as the mark of anti-Christ, were living in the monastery while the church was being built. It is typical of the paradox and the tension, indeed the dualism, present not merely in the Franciscan order but also in Florentine society as a whole during this period of the birth of capitalism, that S. Croce was also the favoured church of the great banking families of the Bardi, Alberti, Peruzzi, and Baroncelli.

The plan, like that of S. Maria Novella, is modified Burgundian-Cistercian, this time with ten, not four, chapels flanking the choir, and a five-sided apse in the Assisan manner [10]. A major factor in the design is the open-trussed wooden roof that runs, unbroken, down the nave to the entrance-wall of the choir. Favoured in Early Christian Rome and in Ravenna, such roofs were common throughout the peninsula in Romanesque times and they were especially popular in Central Italy, where the tradition was wholeheartedly embraced by the mendicants. The similar roofing of the aisles is supported by transverse pointed arches, marking bays which are less long and narrow than

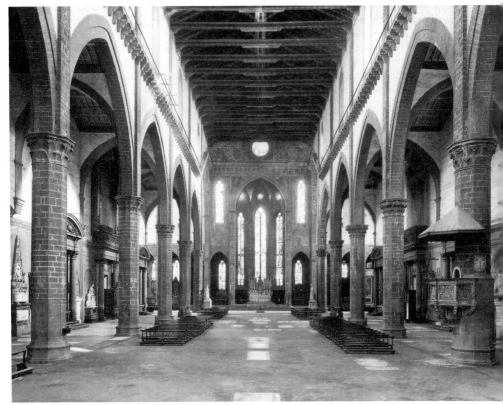

9. Arnolfo di Cambio(?): Florence, S. Croce, founded 1294/5

in S. Maria Novella. The nave arcading is still wide, however, and the stopping effect of the transverse arches, together with the pools of shadow that collect in the upper volumes of each bay, encourages a movement into the long, unbroken free space of a nave in which great width is lightened by an even greater height. This lightness is accentuated by the slimness of the nave supports and by the thinness of an overburden pierced by simple windows and articulated by extremely flat and narrow pilasters. Despite the extensive area of these upper walls, the outcome is a quality almost of weightlessness.

Awareness of the evenly illumined volume of the nave as a positive entity, not merely as an interspace that separates surrounding solids, is ensured in many ways. Its great length is measured, but not interrupted, by the nave arcading. Its width is stressed by the repeated transverse accents of the roof, in which the seemingly close setting of the trusses forms a resilient, spatially dynamic net, 'closing' the ceiling and suggesting the existence of a cubic volume without actually shutting down the lid. The nature of this volume is still further emphasized by the rectangularity and flatness of the wall that frames the entrance to the choir.

This rectangularity is as much asserted by the shape and disposition of its major openings in relation to its boundaries and to each other as by the boundaries themselves. The cubic quality of the architectural space is finally established by the continuity of the lateral walls above the heightened arches of the transepts, and by that of the gallery, which rises over these same arches in the course of its unbroken travel round the four walls of the nave.

As one moves towards the choir, the same wide openings that allow the free expansion of the volume of the nave into the aisles assist the heightened arches of the crossing in establishing

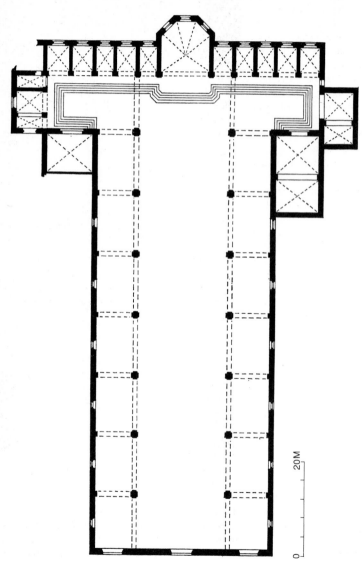

10. Arnolfo di Cambio(?): Florence, S. Croce, founded 1294/5

20M

0

the visual unity of the whole space. Diagonal views are opened up that quickly take in the whole area of the transepts. The heightened crossing-arches also accentuate the slimness of the last free-standing piers, so that the lateral spaces do not seem to be cut off. Lastly, the unity of the T-shaped volume is pressed home by the way in which the carefully framed end-wall of the nave stretches, unbroken by the slightest change of plane, past the pilasters of the crossing arches to the end of either transept. Indeed, the openings of the main and flanking chapels play a lateral variation on the nave arcades and crossing arches in such a way as to create a species of internal façade. It carries with it the associations of free, outdoor space and adds to the impression of internal grandeur and of airy spaciousness.

As in S. Maria Novella, a two-storey vaulted *tramezzo* half a bay deep immediately preceded the friars' choir, which occupied the last two bays of the nave and effectively divided the church into three distinct areas reserved respectively for the priests, the friars and male faithful, and the laity in general.[10] A possibly Sienese drawing, seemingly executed by 1332 and identified as being for a Baroncelli chapel occupying one bay of the *tramezzo*, is especially significant in the history of European art as one of the earliest architectural measured drawings to have survived [11]. The braccio scale is set out on the left, and the eight-braccio width of the bay is clearly indicated on the base line.

This substantial interruption of the nave, removed, together with the colourful confusion of memorials and frescoes on the walls and piers, in Giorgio Vasari's cleaning-up campaign of 1566, would formerly have partly obscured the architectural unity which he laid bare. This does not mean that Arnolfo himself was uncon-cerned with the kind of spatial effects which were discussed earlier. The partial blocking of the nave would have been offset to some extent by the visual acceleration caused by the doub-ling of the upper windows in the two bays concerned. In concert with the leaping rhythm of the crossing arches and the rising of the

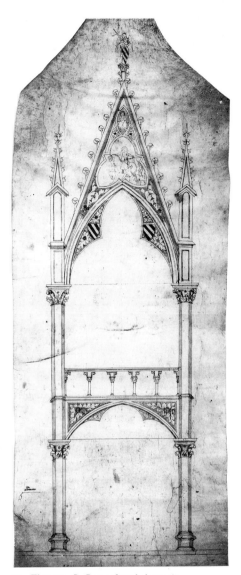

11. Florence, S. Croce, founded 1294/5, drawing for *tramezzo* chapel

gallery, which seems to add speed even to the quick-fire repetition of the roof-beams, this cre-ates a counter-balance for the lateral expansion of the nave space. It speeds the movement to

the choir-wall and towards the apse that opens out within it and absorbs and concentrates the shock.

The clarity and crispness of the whole design is ultimately based upon economy and sensitivity of detail. Most striking is Arnolfo's feeling for the smallest change of plane throughout a building in which planar surfaces are a dominant structural feature. Apart from the few simple rings upon the faceted octagonal columns, there is not a rounded rib or moulding or a round, columnar form in the whole building. Prismatic columns, heirs to a long Tuscan Romanesque tradition, lead to the flat soffits of the arches. A single delicate change of plane from arch to overburden bridges the step from soffit to pilaster. Each such change carries its own sharp, linear definition. Line and plane are all. Nowhere, except of course in the main arch-forms, are there the soft transitions and blurred boundaries which are implicit in the curve. Such clarity of rectilinear definition is the necessary first step from the looser medieval systems of proportion to the precise and detailed modular relationships of the Renaissance. Nevertheless, if the final balance of the building is largely dependent on the rectangle and cube, and on the interplay of verticals and horizontals, the openings of the arches and the windows show Arnolfo's feeling for the slimness and vertical sweep of Gothic forms. There is no blunting or distortion of the Gothic structural elements which reach their climax in the slim shapes of the apse, and yet the emphasis is not, as in so many Northern Gothic buildings, on the lines of force that form dynamic boundaries for the space enclosed. To a remarkable extent the stress is not upon the cage or box by which space is articulated or shut in. The building seems not so much to enclose as to define a space. The form and disposition of the simple planes and prisms of the church are so devised that they seem to reflect attention rather than absorb it. As in Arnolfo's sculpture and in many of the finest works of art, the solid thing itself, though it controls every reaction and no part of it is inessential, is strangely self-effacing.

It draws the onlooker into those worlds beyond the range of words, where what is inexpressible becomes reality and the intangible defined by solid stuff.

THE WOODEN-ROOFED HALL CHURCH AND ITS DEVELOPMENT

The power of the reforming orders, and the seeds of spiritual decline, are visible in the relatively splendid buildings that have so far been discussed. The popular austerity and humble zeal which helped to put that power in their hands are nowhere better enshrined than in the innumerable lesser churches which sprang up alongside those of the Austin Friars and the Servites, and the other smaller but expanding orders, in almost every town and city in the land. They followed the tradition of the Romanesque country churches of which the tiny, living-room-sized buildings that St Francis knew and loved were the extreme example. The simplicity of the latter could be, and very often was, preserved. Extremes of smallness, on the other hand, would have been self-defeating in buildings primarily designed to house the growing urban masses untouched by existing parish organization.

A typical example of the mendicant church as it developed after the death of the founding saints is S. Francesco at Cortona, in which is buried that same Brother Elias who, as General of the Order, had been the driving force behind the controversial grandeurs of S. Francesco at Assisi. The rough-stone church, begun in the second quarter of the century and later modified, is basically a rectangle measuring some 145 by 50 feet (44 by 15·50 m.). It is lit by simple lancets down one side and covered by a wooden, truss-supported roof. A flight of two steps, followed by a further one, is the prelude to the only element of complication, namely the three simple pointed arches in the end-wall. The latter open into a cross-vaulted, rectangular main chapel, which extends a few feet beyond the otherwise unbroken rectangle of the ground-plan, and into two similar flanking

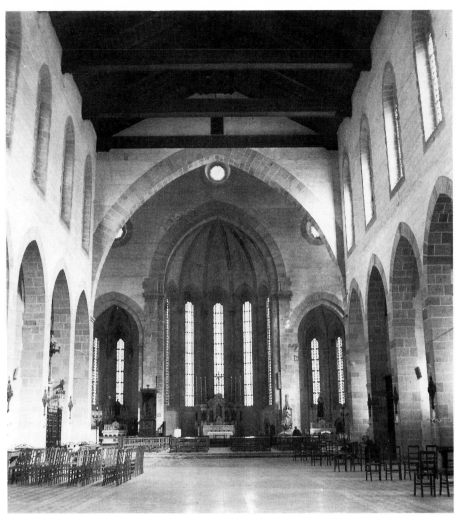

12 and 13. Messina, S. Francesco, founded 1254

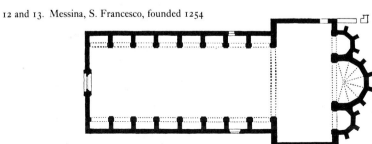

chapels that do not. Sculptured capitals, and ribs of the simplest, near-square profile completed the architectural decoration. Similar churches, sometimes on an even simpler plan, entirely without vaulting or with only a single altar-chapel, and sometimes with an added architectural grace-note of some kind,[11] were built in brick or local stone all over Italy in the succeeding hundred years.

In all such churches spatial unity is clearly not the outcome of aesthetic urge but of economy and practical simplicity; of the new relationship of priest and laity; and above all of the need to preach. The frequency with which the lack of structural complexity produces bell-like clarity in the acoustics is among their most striking attributes. There are none of the confusing reverberations commonly found in vaulted Gothic churches. No raising of the voice or straining of the ear is needed to distinguish every spoken syllable from one end of these often vast enclosures to the other. It is, moreover, clear that extreme simplicity upon the grandest scale does have its own aesthetic. The great, bare barns of Tuscany, in particular, are not easily forgotten, and their quality is often scarcely altered by the added complication of a cruciform plan.

The almost wholly reconstructed S. Francesco at Messina, founded in 1254, is among the most remarkable of such early cruciform designs [12 and 13]. It marks the dawn of a new era for an order which, because of its close ties with the papacy, had faced considerable hostility in the Hohenstaufen Sicily and Southern Italy of the first half of the century. A wooden-roofed nave of moderate height in relation to its width, and high, but only slightly projecting transepts, create block-forms reminiscent of Apulian Romanesque architecture. The interesting feature of the nave is that eight chapels flank it on either side. They are far too shallow to disturb the spatial unity, and their undecorated, pointed arches give the appearance of internal buttressing. This idea, occurring in the late twelfth century in the Cistercian foundation of Silvanès, was taken up by the

mendicants, beginning with S. Catarina in Barcelona, and became common during the thirteenth century in Catalonia and in Southern France.[12] Another notable feature of S. Francesco is the way in which the pointed arch before the crossing is both an immediate monumentalization of the motif of the flanking chapels of the nave and a cunningly calculated frame for the three polygonal choir chapels and their framing oculi. Since the flanking pair of chapels are the same height and width as those in the nave, and since the choir opening is intermediate in size between these and the crossing arch, the latter may also be seen, in spatial terms, as the beginning of a forward movement, followed by concentration on the altar and by contraction and return. Alternatively, if the nave forms are regarded first, it is the culmination of a sweeping forward movement, concentrating on the altar and followed by formal growth and a short return in space. These are only the most elementary of the linkages between the simple, basic forms. They do, however, show that in buildings of such plainness as the wooden-roofed hall churches the final architectural effect is often founded on the most delicate subtleties of relationship. An arch that frames or does not frame what lies beyond – a simple harmony of proportion or the lack of it – and the sense of freedom and simplicity strikes home or leaves the mind as blank and empty as the unarticulated space itself.

Flanking chapels next appear in the wooden-roofed nave of S. Lorenzo at Naples, which seems to have been added after 1289, as a result of a change of plan, to a magnificent choir erected between c. 1270 and c. 1284. Despite the fine French detailing, the combination of a nave and transepts on a plan reflecting S. Francesco at Messina, and a choir with ambulatory and flanking chapels in the manner of Royaumont (1229–35) and Valmagne (1257 ff.), is not completely happy.[13]

Curiously enough, the even more extreme transition from an original Romanesque main body to a late-thirteenth- or early-fourteenth-

century Gothic choir with five radiating chapels, seen in the Duomo at Barletta, is to some extent more memorable because more strange. The four narrow bays of a Romanesque nave that seems almost as high as it is long are connected to the wide forms of the new choir by two more bays which open out diagonally. The narrowness and verticality of a virtually unmodulated space give way to one which is in its own way no less severe and solid and wall-weighted, though the stress is now on faceted complexity, on spatial penetration, and on lateral extension. When seen from choir to nave, it seems as if a rounded polygon is being drawn into a rectangle. Flow and compression take the place of contrast and expansion, and much the same is true externally, as the undulations of the ambulatory chapels swell beyond the sidewalls of the nave.

The standard cruciform plans of Central Italy, formed by adding transepts to the simpler system, involving only a choir and flankng chapels, are exemplified by the churches of S. Domenico at Pistoia and Pescia in Tuscany and at Spoleto in Umbria.[14] In S. Domenico at Pistoia, seemingly begun in the late thirteenth century, the trussed roof runs uninterrupted to the choir, and the existence of the transept chapels is barely appreciable from the nave. At Pescia, and in S. Francesco at Pistoia, started in 1294, the crossing and the transepts, like the chapels, are vaulted. It is only in the context of such unpretentious buildings that the architectural subtlety of a man such as Arnolfo, and the positive aesthetic qualities of his achievement of spatial unity within a complex whole, can be appreciated to the full. The supreme examples of the type, and those most often said to have affected his design for S. Croce, namely S. Francesco and S. Domenico at Siena, seem in fact to be dependent fourteenth-century creations. As often in the history of art, a feeling for the importance of the humblest traditions of the local arts and crafts to the development even of the greatest innovators of the day must be accompanied by awareness that the progress is not necessarily from simplicity

to sophistication. The impression that it is so may arise quite simply from the greater use that great men make of what they borrow, and in borrowing, transform.

Important pseudo-basilican variants of these two main groups of wooden-roofed hall churches are represented by S. Francesco at Gubbio and S. Domenico at Orvieto. The former now has largely eighteenth-century vaulting, but its slender octagonal columns seem originally to have supported a simple arcading and plain wall on which was set an open-trussed roof such as can now be seen in the bay preceding the main, five-sided apse and its flanking apsidal chapels. The pitched roof, probably slightly stepped down over the aisles, must have stressed the height of the nave and resulted in a compromise between an aisled hall church and the standard basilican high-nave and low-aisle design of Central Italian Romanesque architecture. The Pieve at Mensano is a simple Romanesque hall church, and at Gubbio the Romanesque heritage is plainly visible in the compact block of an exterior to which the windows and the repeated verticals of slim pilasters lend a certain air of Gothic grace [14]. As later in the much more complex S. Croce in Florence, there is a sharpness and an all-pervading sense of quality and even of sophistication in the detail of a basically simple structure which, though unfinished in 1292, was seemingly well under way as early as 1259.[15]

S. Domenico at Orvieto, of which only the choir and transepts of the building consecrated in 1264 are now left standing, represents a far more grandiose original conception.[16] The straight-ended choir with its four flanking chapels seems to be a precursor of the plan of S. Maria Novella. It is a reminder that many of the best known thirteenth-century architectural forms may well have been established in lost buildings put up many years before those which now seem to be the earliest. The nave of S. Domenico was evidently a foretaste of the kind of architectural adventurousness that achieved maturity in the cathedral. In a cruciform building some 270 feet (82 m.) in length, a nave of

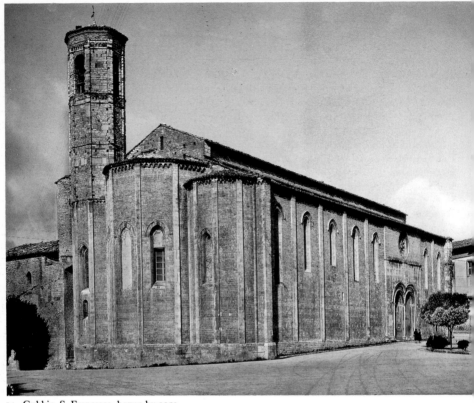

14. Gubbio, S. Francesco, begun by 1259

57 feet (17·40 m.) was flanked by aisles which were only 7 feet (2·10 m.) wide and at least 60 feet (19 m.) high. The thinness of the wall and of the nave piers of striped travertine and basalt presupposes a wooden roof for the nave at least, although the transepts may have been vaulted like the chapels. Beneath this roof the nave arcading must have acted almost as the outworks or advance guard of the enclosing wall, creating a spatially resilient border to the unimpeded volume of the nave. If, as is likely, altars were soon built along the side-walls, any possibility of treating the aisles as flanking passages would have disappeared, and a series of unenclosed, vestigial chapels would have been created. Such an unusual design is particularly

interesting thirty years before the seemingly original invention of the absidioles that give a three-dimensional, altar-enclosing flexion to the solid side-walls of the Duomo.

S. FORTUNATO AT TODI

The final decade of the thirteenth century was a period of unusual architectural activity all over Central Italy. The riches accumulated during the economic expansion of the major towns in the preceding forty years were beginning to pour into ever larger building projects, and the Franciscan church of S. Fortunato at Todi is among the most important and most interesting of these enterprises.

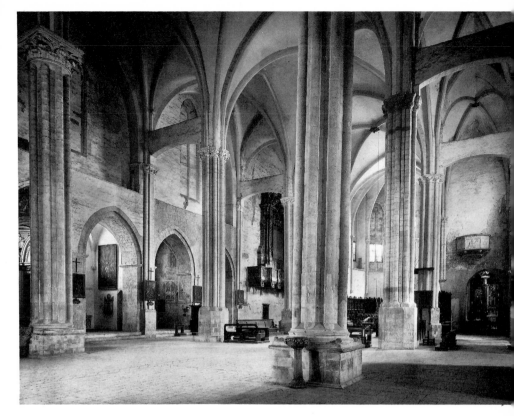

15 and 16. Todi, S. Fortunato, begun 1292

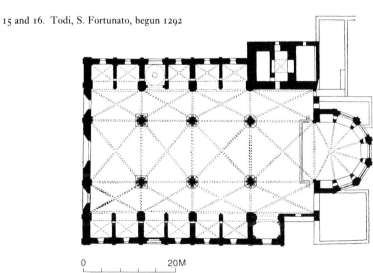

0 20M

The foundation stone was laid in 1292 by Bishop Nicola, whose two predecessors were Franciscans. The destruction of the old church and the building of the new were well advanced by 1298, and the eastern half appears to have been largely complete by 1328. The western half, together with the lower part of the unfinished façade, was only erected during the first half of the fifteenth century. Although the dividing line between the two campaigns is clearly visible, the chapels flanking the two western bays were founded before the interruption, and the few modifications in the detail of the design do not affect its unity.

Externally the building squats like a huge hangar on the hill. The introductory flights of steps seem only to accentuate the mass of the broad rectangle of the façade. A single, low, pitched roof stresses its unity, its Brobdingnagian scale, and its close kinship to the wooden-roofed barn churches of Tuscany and Umbria. Nevertheless, its great breadth in relation to its length hints at a different internal structure [15 and 16]. The expectation is not disappointed, for the massive shell conceals the airy complex of a vaulted Gothic hall in which the aisles are flanked by rows of chapels and the four bays culminate in a seven-sided apse. The South Italian connexions of this hitherto rare Cistercian transposition of the chapel system adopted in S. Croce in Florence were discussed in relation to S. Francesco at Messina and S. Lorenzo in Naples (p. 36 above). The motive for the proliferation of small chapels in both systems was seemingly the need to accommodate more and more daily masses as the Franciscan order became increasingly clerical.

Apart from satisfying particular Franciscan needs, the architectural solutions of S. Fortunato also reflect the strong Umbrian Romanesque traditions of the vaulted hall church. Then again, the rib-forms and side-wall and passage treatment recall S. Francesco at Assisi with its Angevin ancestry, and the design of certain doorways can be matched at Fossanova. Nevertheless, the main source of inspiration seems to be a building that may well be the work of an Angevin architect – namely the late-twelfth-century choir of Poitiers Cathedral. The essential difference is that, whereas the nave and aisles at Poitiers are of equal width, at Todi the nave is twice as wide as the aisles. The length and breadth of the four central bays ensure their thorough domination of the aisles.[17] The resultant visual and spatial unity, combined with the slimness of the clustered columns, soaring lotus-like from their high bases, is so complete that the pulpit could be placed high up in the centre of the end-wall of the right-hand aisle!

This very practical and non-theoretical recognition of the extent to which an omni-directional space has been created, despite the dominance of the nave and the major accent of the choir, leads to a recognition of the way in which wide, simple openings to six chapels upon either flank encourage and give constant focus and significance to lateral and to diagonal views and movements. Before the upper windows were blocked, light must have flooded evenly throughout the building. The inherent contrast between the airiness and emptiness of the contained, articulated space and the surrounding areas of plain wall must always have been strong, but added emphasis would have been thrown upon the vaulting with its even height and great simplicity of form. Herein lies the second major deviation from the Poitevin prototype with its heavily stressed longitudinal and transverse arches. Just as each main pier at Todi is encircled by eight indistinguishable colonnettes, so all the ribbing of the vaults is uniform in shape and in dimension. A single plain prismatic form in the Assisan manner serves impartially for longitudinal, diagonal and transverse elements. The visual excitement engendered by these simple, frond-like forms as they strain almost vertically upwards, continuing the column-form for several feet before beginning to fan out, is only marred by the too obvious fact that such audacity flies in the face of structural reality. Only the massive masonry cross-ties stop the central vaults and piers from

bursting outwards. Detailed accommodations in design reveal, moreover, that these lumpish elements were evidently planned, as well as being necessary, from the first.

A carefree and at times uncomprehending attitude to Gothic structure is one recurring feature of Italian architecture. But, whether in architecture, sculpture, or painting, the determination to give actuality to dreams half-sensed, to step beyond the bounds of safe traditions and sure knowledge and accept the consequences, is another. It is this intensity of vision and desire, this urgency in the achievement of a goal, regardless of the incidental inconsistencies and even failures which ensue, that underlies so many of the great achievements both in this and in succeeding periods.

The positive aspect of the architectural audacities of S. Fortunato is accentuated by the possibility that there is some intentional element in the numerous departures from the rectangular and the level.[18] Particularly in the earlier sections these at times produce dramatic effects of accelerated foreshortening. Most remarkable of all, however, is the internal engineering of the massive campanile, which is first mentioned in 1328 and follows the pattern of that of S. Francesco at Assisi. The interaction of the segmental arches carrying the wide stairs up through the hollow square in three flights to each side; the transformation of the supporting corner masses into free-standing, square piers set within the main square of the tower; the final barrel, seated upon longitudinal segmental arches; all of them contribute to an interplay of void and solid, of arrest and movement, straight and curved, that shows with what sure touch the Umbrian Romanesque traditions of structural engineering could be continued and transformed under the impact of new attitudes to architectural space.

S. ANTONIO AT PADUA
AND S. LORENZO AT VICENZA

A final, grandiose illustration of the variety of form embraced by the major building projects of the expanding religious orders, and of the way in which conflicting architectural streams could blend or fail to blend in thirteenth-century Italy, is seen in the Santo at Padua.

St Anthony died in 1231, and despite Ezzelino's conquest of the city in 1237 and his subsequent ferocious tyranny, a new church, replacing a small earlier building, seems to have been begun by the end of the decade. Although the surviving documentary and structural evidence is sparse, it has been strongly argued that this was not the present, domed building, but a simple structure which was itself enlarged in the period between 1258 and 1263, when St Anthony's body was translated to it. If so, it was only in the subsequent period, from which the project for an ambulatory and radiating chapels, completed at least by 1290, almost certainly stems, that the even more radical decision to transform the existing church into a domical structure was taken.[19] In any case, the work was substantially completed by c. 1307–10, only for the east end to be largely rebuilt with a much heightened ambulatory after severe lightning damage in 1394.

Externally the multiplicity of domes recalls St Mark's, but a St Mark's no longer calm and squat in its main bulk and delicate in its lace-like detail [17]. Simplicity and mass and sturdy rectilinearity characterize the forms that build up to spectacularly crowded cupolas upon tall, vertically accented drums. The massive screen façade, the octagonal towers, and much of the brickwork detailing derive directly from the Lombard Romanesque, but the repetition of the pointed arches and the general complexity of the articulation add their own distinctive flavour. In plan [18] the extension of the centralized formula of St Mark's by the addition of a further dome at one end of the main axis, creating obvious similarities with the longitudinal, domed churches of Aquitaine, such as those at Périgueux, Souillac, and Cahors, is overshadowed by a completely different system of support and aisle arrangement, and by the incorporation of a choir and ambulatory and a ring of radiating chapels, all of which were

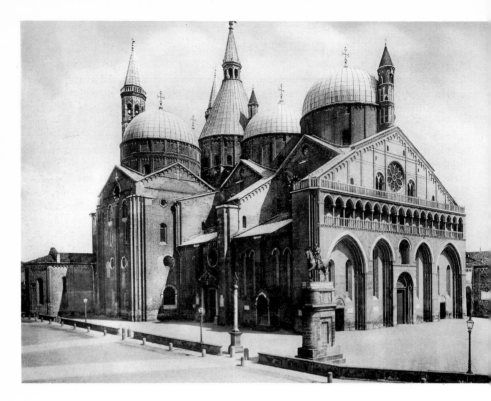

17 and 18. Padua, S. Antonio, by 1290, later modified

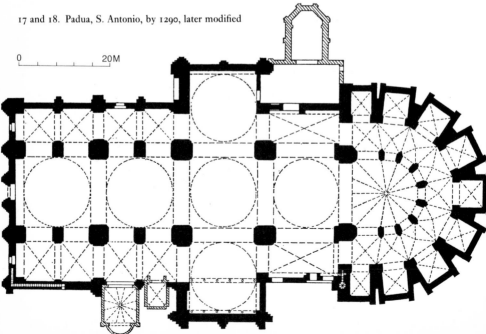

0 20M

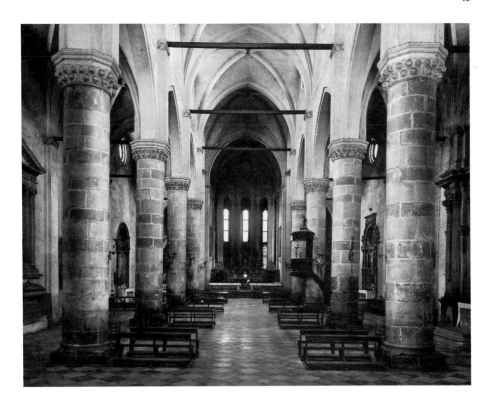

19 and 20. Vicenza, S. Lorenzo, after 1281/2(?)

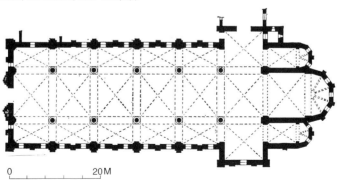

0 20 M

rebuilt after the destruction of the previous east end by lightning in 1394. These create an outline reminiscent of S. Francesco at Bologna and its French forerunners. A very different outcome is, however, ensured by the sheer mass of the ill-lit, virtually unembellished masonry and by the vast scale of the spaces that have been enclosed. Since all the major arches are round-headed and applied columnar forms are confined to the region of the ambulatory, it is only in the aisles that Gothic elements gain the upper hand. Gothic, Byzantine, Romanesque: here the stylistic categories seem to be no more than the identifying labels of gigantic forces locked in ponderous, sometimes awe-inspiring, not infrequently ungainly, battle. The outcome of the unending conflict is a building that is like no other in the land.

Far less imposing, and far more important for the subsequent history of Venetian architecture in particular, is the Franciscan church of S. Lorenzo in near-by Vicenza [20].[20] It was probably built in the years following 1281–2, and the quiet Lombard forms of S. Corona at Vicenza, begun c. 1260, supply the immediate prototype for the interior [19]. Less accentuated

bases; foliate capitals replacing cushion forms and making a far easier transition from the smooth cylinders of the stone columns to the more delicate pilaster forms above them; and finally, the more steeply pointed longitudinal and lateral arches, all add grace to the calm forms earlier seen in S. Corona. The outcome is a pleasantly proportioned and still restful nave in which the concentration on the altar is undisturbed by the sense of spaciousness to either side. The wooden tie-beams are an integral feature of the design, as also is the relative drama of a transept which extends beyond the aisles and runs the full height of the nave.

Externally, the most notable feature is the Lombard screen-façade with its graceful, stone-faced blind arcading into which a massive sculptured portal was subsequently inserted. The brick and terracotta detailing completes a network of relationships that spreads not only through the Veneto but throughout the Lombard and Emilian plain.[21] Nevertheless, despite the linkages of detail, none of the relevant late-thirteenth-century parallels can rival S. Lorenzo at Vicenza in its quiet harmonies.

THE GOTHIC CATHEDRALS: SIENA, ORVIETO, FLORENCE

The relative importance of the mendicant orders in the religious as well as in the architectural life of the times is stressed by the fact that so few other churches of any consequence remain to be considered. This does not mean that the inseparably intermingled civic and religious life of every town and city no longer tended to revolve around the duomo or cathedral. The enormous building programmes of the Early Christian, Byzantine, and Romanesque periods had already provided most Italian towns with magnificent main churches. It was therefore only under the impact of some extraordinary religious event, such as the Miracle of the Holy Corporal at Orvieto, or as a direct result of phenomenal economic growth, as at Siena and Florence, that new cathedrals were begun. Individually, the cathedrals of these three towns are, for differing reasons, unsurpassed in Italy. As an interacting group, they form a major triad in the harmony of Italian Gothic architecture.

THE DUOMO AT SIENA

Siena Cathedral [133 B] is particularly interesting in the present historical context, since its building and reconstruction span the whole of the period from 1250 to 1400 in a way that intimately reflects the waxing and waning of civic power and ambition. Furthermore, its sculptured pulpit and façade, its stained-glass oculus and its altarpiece, connect it to the central development of Tuscan sculpture and painting [21]. Finally, the associated documents and drawings establish it, together with the cathedrals of Orvieto and Milan, as one of the most important sources of information on medieval European architectural procedure.

The date of founding is uncertain, but work is documented c. 1226 and 1247 and the vault-ing of the choir and of part of the nave aisles was under way in 1260, whilst the bronze ball on the dome was paid for in 1264. Despite the Tuscan Romanesque banded marbling, the new building possibly had much in common with Notre Dame la Grande in Poitiers, since the nave may have been covered by an arch-supported barrel-vault which sprang from just above the crown of the existing arches into the cross-vaulted aisles.[1] Undoubtedly there was a sweeping progress to the great hexagonal crossing. Then, as now, the latter reached almost to the full width of the aisles, drawing the space together till, on close approach, the complex vistas into the once shallow transepts caught the eye [133 B]. The structural and documentary evidence seems to show that the original transepts were two bays wide and only one bay deep, and that a straight-ended choir, with central vaulting which was even lower than that of the nave, extended for only two bays beyond the crossing. Indeed, a document of 1287 refers to the great round window as being 'above the altar of S. Maria'.[2] The way in which the dome must once have dominated a substantially centralized eastern end, spinning attention off into the secondary spaces and as surely gathering it in again, can still be sensed in the existing building. The feelings aroused by the complicated distortion of bay units, the impression of spatial interpenetration and of unity in complexity, are summed up in the volumetric complications of the dome itself, as the irregular, basic hexagon of its plan is turned by squinches into a dodecagon that melts into a circle. In spite of the nearness of S. Galgano with its straight-ended choir, and despite the constant stream of architectural administrators which the monastery supplied, the inspiration for the new cathedral lies less in Cistercian

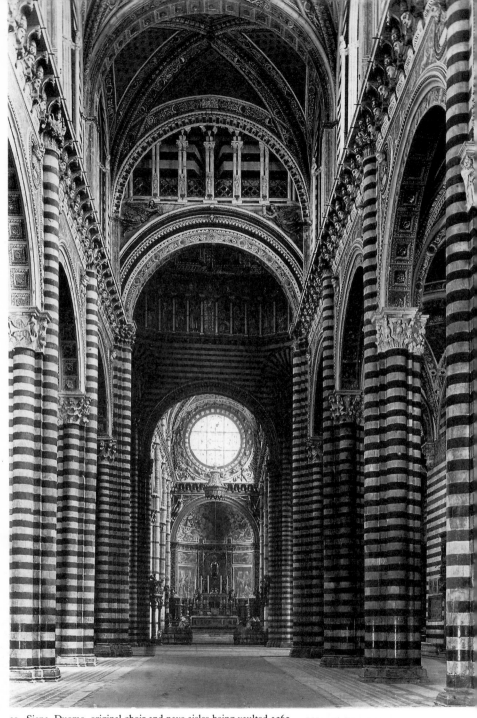

21. Siena, Duomo, original choir and nave aisles being vaulted 1260

Gothic architecture than in the Romanesque cathedrals of Pisa and, as regards the massive cornice which was once immediately below the springing of the barrel-vault, of Bari and Barletta, and in the Duomo at Ruvo, which is also in Apulia.[3] Such influences were combined with that of Poitou in an adventurous and influential extension of the Romanesque vocabulary of form, and Gothic detailing was scarcely hinted at except in the windows and in the arcading of the drum. Such buildings as the Duomo at Grosseto, reconstructed between 1294 and 1302,[4] on the remains of an older structure, by Sozzo di Pace Rustichini of Siena, likewise testify to the continuing liveliness of

the Romanesque tradition in Tuscany as well as in the Abruzzi and in the remoter areas of Southern Italy.

THE DUOMO AT ORVIETO

The original design of Orvieto Cathedral must without doubt be numbered among the greatest masterpieces created anywhere in Italy during the period of transition from Late Romanesque to Gothic architecture [23]. The existing choir was begun only in the late 1320s, and the extension of the transepts to create the present cruciform plan came even later. In the original structure, founded in 1290, the transepts were

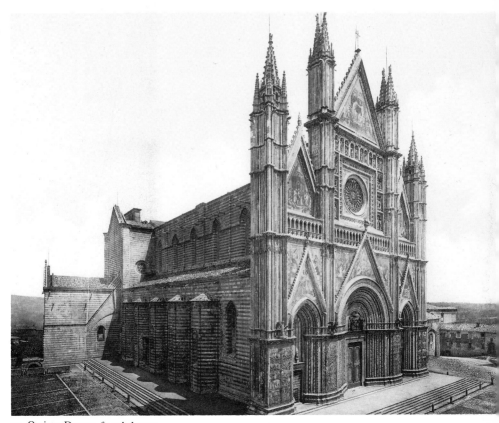

22. Orvieto, Duomo, founded 1290

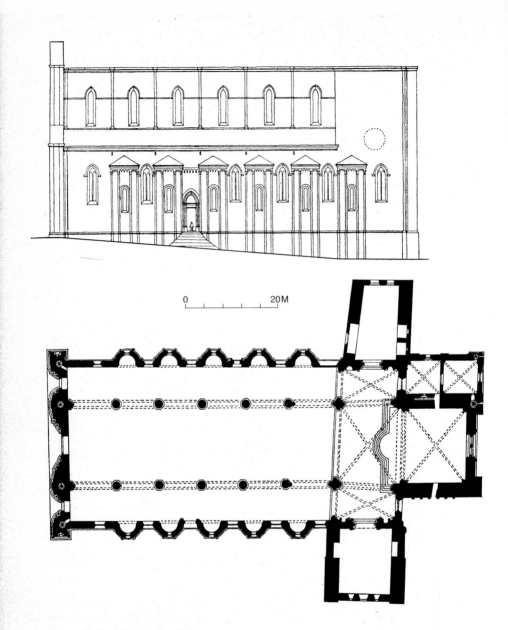

0 20M

23 and 24. Orvieto, Duomo, founded 1290,
diagram of original flank and existing plan (*above*)
and interior (*opposite*)

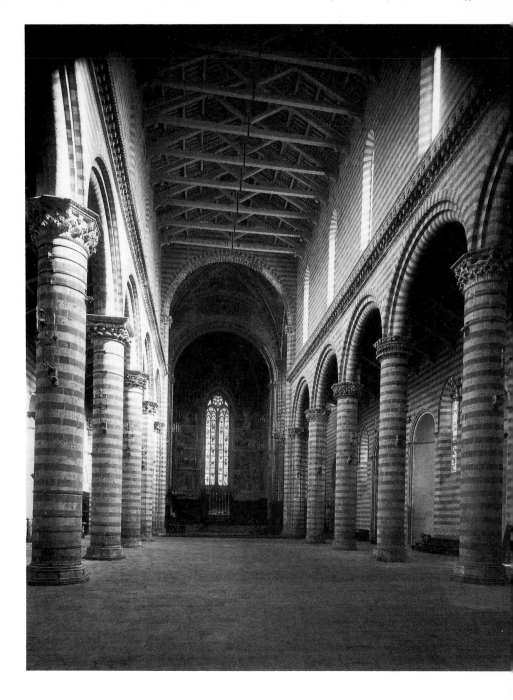

contained within the basic rectangle of the plan. The choir preceded the crossing, and behind the altar a single great apse, flanked by pointed windows, gathered up the waves of lesser apses rippling down each flank [22]. Even now the quality of movement is accentuated by the regularly varied rhythm created by the apse and window asymmetrically offset in each aisle-bay. When these forms are related to the arches of the nave and to the massive cylinders of their supporting columns, they generate an ever-changing sequence of visual counter-rhythms. Indeed, in walking down the nave, each column, almost six feet in diameter, is so sited as to overlap the beginning of the corresponding apse. The column being closer to the eye, the apparent diameters of the two forms almost coincide, so that the convex curve runs smoothly on into its concave counterpart. This laterally extended, wave-like quality has its vertical component in the rise and fall of these same apses and their alternating lancets. Up and down, and in and out, pointed and rounded, planar, convex, and concave: these interweaving rhythms are all tied together and accentuated by the unbroken moulding which runs through and round the apse-forms at the level of the springing, and continues up and over the pointed windows. The result is that the sequence of soft, rounded curves in space and sharp, steep curves upon the plane is visually inescapable.

In the nave the omnipresent, streaming motion of striped travertine and basalt stonework gathers force in the horizontal accent of the gallery [24]. The latter is surmounted by an absolutely planar upper wall pierced only by the lancet windows. These are similar to the ones below, but now sit soberly above the crown of the nave arches. By such means the implication of a bay-form is extended upwards into the unbroken upper volume, dominated by the regular staccato of the transverse trusses of the roof, yet is never categorically imposed upon it.

The alternation of the plainest round and pointed openings; the subtlety with which the sense of movement permeates and yet does not disturb the harmony of the simple, static volumes; the balanced sensitivity to mass and space, transform what might have been no more than another essay in attenuated, Late Transitional Romanesque into a major work of art. The comprehensive unity of the original design reveals, moreover, an unusual relationship between internal and external structure. The rhythmic repetition of asymmetrically balanced units, which so subtly varies and enlivens the architectural vistas of the interior, also results in a closely connected but quite different set of external rhythms [22 and 23]. At the lower levels the apse forms, rather than the flanking lancets, take the eye. They are therefore immediately related to the windows in the upper wall, which are the other dominant articulating features. The outcome, since there is no vertical coincidence between the lower apses and the upper windows, is another major asymmetrical relationship. If, on the other hand, the upper and the lower storeys are considered independently, still further balances and contrasts rapidly become apparent. It is now the flat clerestory that provides the stabilizing, regular bay-beat, while an unbroken cornice rises over every window. On the lower wall, no bay divisions interrupt the rippling flow of apse and lancet which, since it was once continued on the end wall of the transepts, established an unusually close bond between the flanks and the apse-dominated eastern end. The sense of nave and transepts carved out of a single block can only have been comparable to that created by such masterpieces of Apulian Romanesque as Trani or Bitonto or S. Nicola at Bari. On the other hand, the volumetric richness added by the substitution of flanking semicylinders for the South Italian arch-forms, and the complex, syncopated rhythm created by the interaction of the aisle and clerestory walls are quite unprecedented.

If the flanking chapels are, indeed, externally a transmutation of the rounded buttresses of S. Francesco at Assisi, or, in their internal form, an echo of the niche and wall construction of the so-called Temple of Mars at Todi, it is in

either case a classic illustration of the way in which the creative mind releases the potential hidden in the patterns of the past. Since the church was set within an open square, its visual and volumetric subtleties were apparent from the first. The very closest attention must therefore be paid to the regular curvatures, concave to the centre, that have been created by the way in which the nave walls have been seated upon columns that themselves are ranged in mathematically accurate straight lines.[5] Particularly when the whole ground-plan is skewed, it is extremely difficult to distinguish the intended from the accidental. Nevertheless, a long tradition lies behind such deviations from a hypothetical norm. Irregularities and refinements are undoubtedly seen side by side in the Greek temples, and the truth of the matter may well be that men who were often unable to make things absolutely straight and regular, were simultaneously aware that deviations are enlivening and that perfect rectilinearity can be as sterile and as deadening in a building as a whole as in a single moulding.

If some of the subtleties of relationship undoubtedly apparent in the earlier building have been lost; if the rippling lateral apses now contrast not only with the upper wall but with the planar, rectilinear closure of the choir; and if the original balance between continuity and contrast is upset, there are, as at Siena, certain gains. There is an increase in the already dramatic sense of space and structural grandeur, and a new and most impressive climax in the simple sweep of the great window of the choir.

ARNOLFO DI CAMBIO
AND S. MARIA DEL FIORE
AND THE BADIA IN FLORENCE

The economic and political surge which powered the project for a new cathedral in Siena is dwarfed by the expansion that led, half a century later, to the planning of the new Duomo in Florence. The death of the Emperor Frederick II, the gaining of independence, and the establishment of the Primo Popolo,

which was in power from 1250–60, mark a turning-point in Florentine history. The popular uprising which re-established Guelph power in the city led to the creation of the office of Capitano del Popolo to set beside that of the Podestà. The latter was the solitary, and usually foreign, chief executive and magistrate combined. He was elected, normally for a year, in order to control the bitter internal feuds which would otherwise have destroyed the community. The powers of the Podestà were further limited by the appointment of the twelve Anziani, two from each sesto of the city, to oversee its government and provide an element of democratic control. The new administration rapidly embarked upon a boldly expansionist policy in which the economic element was if anything more important than the military. Already in the thirties, the city had begun a revolution in the chaotic medieval currency by illegally minting a silver soldo (solidus). This was valued at twelve of the silver pennies (denarii) of which the fluctuating base metallic content had become a source of increasing commercial difficulty. In 1252 they completed the process by minting the fiorino d'oro. This was valued at twenty soldi or one lira (libra) and became, because of its jealously guarded purity, the stable though constantly appreciating basis of European finance.[6] During the years of Ghibelline domination (1260–7) following the disastrous battle of Montaperti in 1260, the emerging Florentine merchant class had become the papal bankers. Since the Papacy was forced to fight with money for lack of armies of its own, the Florentine banking network spread across the greater part of Europe at the same time as the city itself was becoming an ever more important centre for the wool trade which, apart from usury, was by now the greatest source of monetary wealth.

The period of Angevin dominion (1267–82), marked by increasing commercial ties not only with Charles of Anjou's South Italian kingdom but with the papacy and with France, was one of constant and explosive growth. When the Sicilian Vespers of 1282 brought Charles's rule

to an end, it is no surprise to find that Florence was quickly taken over by the new commercial powers, to become, as they were, Guelph by choice and interest. Already in 1251 the seven Merchant or Greater Guilds had become military as well as commercial associations. It was they who now, together with five of the Lesser Guilds, established the government of the Priors, which consisted of six representatives who were chosen from among their own body, and the Podestà was now subordinate to them. The new government, which was in effect a kind of democratic oligarchy on a wider but none the less severely restricted base, accelerated the already rapid process by which the powers of the old feudal landed nobility were curtailed. Those who had not already been impoverished or absorbed into the new commercial structure were subjected to severe legal restrictions. The latter found their clearest expression in the famous Ordinances of Justice of 1293. Their promulgation represents a further, definitive stage in the transfer of power from land-based military and agricultural groupings to an urban civilization founded on commerce and on capital. It was a period of political expansion, of far-reaching economic revolution, and of rapid social change. The accompanying surge in wealth and population underlay the crescendo of building activity which reached its peak in the 1290s.

A scheme for the renovation of the old cathedral of S. Reparata had already been considered in 1285, and after being set in motion in 1293 had quickly proved to be unworkable. By 1294 'renewal' was being discussed. In February 1296 it was already possible to speak of a 'work of the greatest splendour', and the foundation stone was laid on 8 September, according to an inscription, probably of 1368. In April 1300 Arnolfo di Cambio is referred to as the capomaestro and there is mention of a 'magnificent and visible beginning', but possibly by as early as March 1302 Arnolfo was dead. The extent to which this great ecclesiastical project was a truly civic affair is made clear by Villani. He explains that, apart from liberal indulgences and pardons, the building was financed by a subsidy of four denarii in the lira (a 60th part) from the city treasury and by a poll tax of two soldi on every male inhabitant.[7]

The fame both of Arnolfo and of the existing building, completed long after his death with many intervening changes in plan, is such that it has been accepted for some time that his design was fundamentally a smaller version of the present structure.[8] A careful re-examination of what may or may not be the remains of Arnolfo's project embedded in the lower part of the flanks of the first and second bays from the entrance of the existing building has, however, led to the modification and elaboration of an earlier hypothesis that, instead of a vaulted nave and aisle design of the type eventually adopted, but of rather different proportions, there was a system involving simple wooden roofs. This appears to be confirmed by recent excavations which, however, also seem to show that the east end was indeed planned, like the existing structure, as a triconch, centred on an octagonal crossing which was almost certainly to be covered by a cupola. This would therefore have related Arnolfo's scheme to the great northern tradition reflected in the trefoil designs of St Mary in Capitol and Holy Apostles in Cologne.[9] Already in 1293 the Guild of the Calimala had provided funds for new marble piers for the nearby baptistery. Arnolfo himself may have carried out the work, and it is the Romanesque marble cladding of this building, rather than the more ornate marbling of the façade of S. Miniato, which seemingly set the pattern for the outside of the new cathedral. The plan was based on the rectilinear severity and planar simplicity of a high socle,[10] and it seems that the entire architectural design was founded upon the subtlest differentiation of closely related planes. This sensitivity to the flat surface, involving changes of plane of less than an inch in the marbling of the socle, is perhaps the closest link with S. Croce.[11]

The stylistic connexions between the Duomo and the Benedictine church of the Badia are hardly more specific. According to Villani the

building was begun in 1284,[12] and the high altar was consecrated in 1310. It was built on an extremely restricted site and was wooden-roofed except for the choir and its two flanking chapels. The choir façade is now the only orig-inal part of the building that can readily be seen, and the austerity and restraint of the design are such that it is only through long contemplation that its qualities reveal themselves [25]. The entire effect depends on the subtle relationship

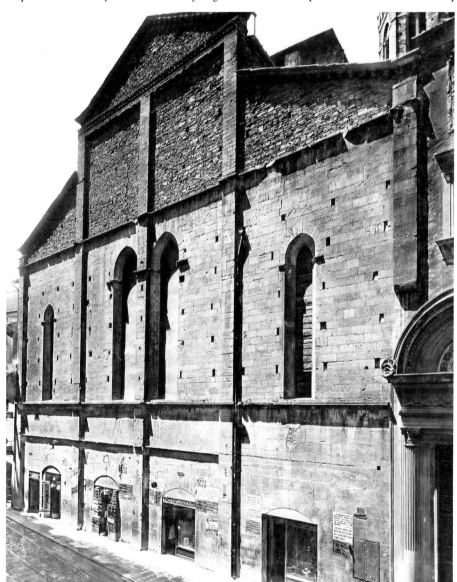

25. Arnolfo di Cambio(?): Florence, Badia, begun 1284

between three basic architectural elements reduced to their simplest terms. This trinity is the flat, undecorated wall, the virtually unadorned openings of the windows, and the simple, flat pilasters and plain cornices. At the lowest level the four evenly spaced segmentally arched openings for shops, which are common in Tuscan palace architecture, draw attention slightly inwards from the wings.[13] Above is the carefully demarcated zone that signifies the level of the floor of the choir. In separating the commercial and ecclesiastical elements, it provides a firm base for the latter. Next, the central emphasis is further strengthened by the two main lancets, closely grouped about the central pilaster, although the placing of the outer pair of windows in the middle of their respective fields gives these their due importance. Indeed, the whole façade is so designed that a subtle, all-pervading three-four rhythm is created out of the conflicting demands of the tripartite ecclesiastical interior and the quadripartite commercial substructure. It is purely and simply through their delicacy of relationship that the severe, rectilinear network of cornices and flat pilasters and the spatial movements of pilasters, walls, and windows blend in grace and grandeur. There is a similar subtlety of interplay between the slopes that link the crowns of the windows and those of the main pediments and of the flanking roofs. They are united in a harmony too fine to countenance the use of parallels, just as the main rectangular compartments all defy analyses depending on division by whole numbers.

The existence and the importance of these relationships which, as has been seen, are later exploited in very similar form and with equally remarkable results in S. Croce can easily be confirmed by looking at the Romanesque churches of Umbria, such as the Duomo and S. Pietro at Assisi or S. Pietro at Spoleto, which appear to provide the forerunners of this disciplined, planar design. In all of them the relationship of rectangle to rectangle, and more especially of the door and window openings to the framing elements, seems casual and even

haphazard in comparison. The fundamentally close relationship between the Florentine Badia and S. Croce, and their association with Arnolfo di Cambio, make it significant that it was in Umbria that the known activities of Arnolfo the sculptor were concentrated during the preceding years. In 1277–81, before his journey to Orvieto, he was working in Perugia, with Assisi in full view only a few miles down the valley.

THE CHOIR OF THE DUOMO AT MASSA MARITTIMA

If the logical basis for the reconstruction of Arnolfo's artistic personality is often elusive, only the most profound illogic can support the continued attribution of the choir of Massa Marittima Cathedral to Giovanni Pisano in the face of the carved inscription in the church.[14] Despite its careful mutilation, it declares that the work was begun in 1287 by a certain 'J.... us Pisanus'. This cannot possibly have been Giovanni Pisano the sculptor, since no Latin or Italian corruptions of his Christian name end in 'us'. The Pisan character of the carefully harmonized columnar additions to the upper part of the Romanesque façade, which includes an atlas closely reminiscent of Giovanni's manner towards the turn of the century, do, however, suggest that the unknown artist had connexions with the flourishing atelier headed first by Nicola and subsequently by his son.

The heights which could be reached by Pisan architects are shown by the Camposanto, the cemetery of Pisa, started in 1277 by Giovanni di Simone [26].[15] The elegance and delicacy of its arcading represent the ultimate sophistication of the Pisan Romanesque. Giovanni's sensitivity in the use of the traditional marble striping and in the play of light and line in the round-headed arches and in their supporting piers is witnessed by the way in which his simple seeming framework could assimilate the delicate Gothic traceries inserted in the fifteenth century. No less remarkable is the sense of interval and proportion that allows the sixty-two arches and six closely similar entrances of

26. Giovanni di Simone: Pisa, Camposanto, begun 1277

this unbroken rectangle to blend into a work of art in which restraint and discipline are combined with lightness; gravity with grace.

The polygonal choir of Massa Marittima, which a second inscription probably indicates as being finished in 1304 and which reveals some slight external connexions with Giovanni Pisano's façade for Siena Cathedral, is certainly the work of an unusually sensitive architect [27]. The three-bay extension is so organized as to create a smooth transition from a fully Romanesque nave to a clearly Gothic choir. The simplicity, severity, and weight of the latter are such that in spite of the change of idiom, no conflict is aroused. The mass and grandeur of the piers at the beginning of the added section,

27. Massa Marittima, Duomo, choir, begun 1287

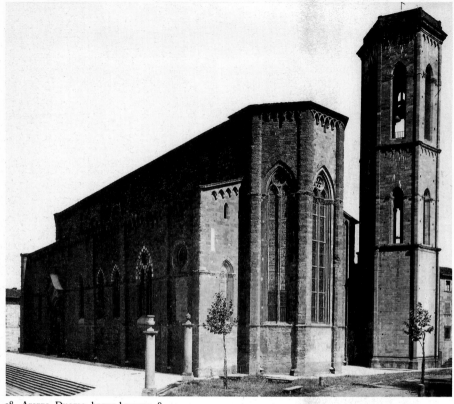

28. Arezzo, Duomo, begun by 1277–8

the classicism of the capitals that succeed the superb Romanesque series in the nave, and the round-headed arcades and vaulting that precede the pointed arches of the choir, all make their contribution to the final harmony. Upper and lower cornices provide a clear articulation of the walls, but the most telling detail is the treatment of the windows, in which pointed caps that harmonize with the vaulting dominate, and yet do not destroy the effect of the Romanesque round-headed lights. The steady movement towards an increasing, but always carefully restrained, Gothicism seems to indicate an attitude that differs from the normal medieval approach to architectural additions in which the new and old could be set side by side with no attempt to smooth away stylistic contrasts by a gradual transition. It is perhaps a symptom of new attitudes in Tuscany. These were to lead in the next fifty years to a new interest in town planning. Instinctive taste begins to be replaced by a conscious concern for the visual harmony of whole streets and squares.

THE DUOMO AT AREZZO

The unbroken block-form of the Duomo at Arezzo, isolated with its octagonal campanile on its high, stepped podium, maintains the reticent tradition of so many of the Central Italian Romanesque buildings and of the mendicant churches that followed in their wake [28]. The

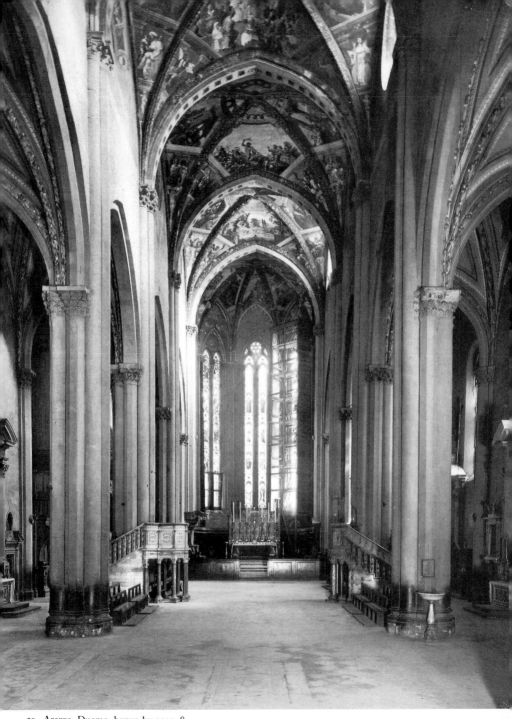

29. Arezzo, Duomo, begun by 1277–8

vertical sweep of the interior of this most Gothic of late-thirteenth-century Italian cathedrals is only hinted at by the exterior. The lack of buttressing, apart from an intermittent series of pilasters that are wholly insignificant as supports, ensures that there shall be no outward indication of the details of internal structure [29]. As is the case in so much of Italian Gothic architecture, the basic volumes of the building provide their own support. No tremor of the energies and tensions that vibrate within disturbs the outer surface of the architectural prism.

The new church was planned in 1275-6 and begun by 1277-8. By 1288-9 the apse and first bays were in use and the pattern set for the remainder of the building, which was slowly carried forward during the next two hundred and fifty years and completed in the nineteenth century. The height and span of the nave arcading, combined with the length and narrowness of the aisle bays, recall the nave of S. Maria Novella in Florence. On the other hand the five-eighths division of the extremely shallow polygonal choir relates it to the Duomo at Massa Marittima of a few years later, as well as to the mendicant churches of Trevi and Montefalco, which probably derive from the early-thirteenth-century Cistercian building of S. Martino al Cimino. The lack of transepts, and the great relative increase in height in a nave that is two and three-quarter times as high as it is wide, also contribute to an outcome which differs greatly from that in the Florentine Dominican church. The almost square plan of the nave bays in itself assists in speeding the eye towards the altar through the substantially unified volume of the building. The movement is accelerated by the vertical dominance of the nave, which culminates in the slender windows of the light-filled apse. The fact that the emphasis upon the vertical axis actually plays a major part in drawing the eye towards the sanctuary allies the building to the classic achievements of Northern Gothic architecture. The smallness of the lateral windows, which so accentuates the attraction of the apse, the emphasis upon bare wall, and all the architectural details, no less obviously combine into a form found nowhere outside Central Italy.

CIVIC BUILDINGS

The continuity of Italian late medieval architectural development is as obvious in the major public buildings of the period as it is in the great cathedrals. The conceptions underlying the Romanesque cathedral group of Pisa and the complex of Duomo, baptistery, and campanile in the course of redevelopment in Florence are clearly related. The thread that links the late-twelfth- and early-thirteenth-century public buildings of the lively North Italian communes to the new palaces of the Podestà, of the Capitano del Popolo, and of the Priors, is no less evident. In civil as in ecclesiastical architecture, the transition from the Romanesque into the Gothic is a gradual process, and the later style owes much of its distinctive flavour to this continuity of vision. It is as much a symbol of stability and order in a turbulent, changing world as an embodiment of new ideas and new ideals.

The new buildings are not merely the architectural reflection of physical and economic growth and of the increasing independence and ambition of the towns: they epitomize the developing complexity of urban organization and administration. They also mirror the growing concern with the practical ordering of life on this earth in a world still permeated and largely dominated by the other-worldly. The new economic, spiritual, and practical relationships are often expressed by the actual physical juxtaposition of the civic and religious centres in the main squares of the towns. The virtually intact survival of a few such squares and groups of buildings is a reminder that the final work of art with which the art historian must somehow come to grips is certainly no less than the ever-changing complex of the medieval town, seen as a whole within the expanding and contracting circle of its walls.

ORVIETO

Nowhere in Italy does the most characteristic development of mid-thirteenth-century administration, the creation of the office of Capitano del Popolo, achieve more splendid architectural illustration than in Orvieto. Again, as in the case of Florence, then allied to Orvieto, the powers of the Popolo, representing the guilds and the bourgeoisie, had been consolidated by the imperial crisis of 1250, and the Palazzo del Capitano, built in the local honey-golden tufa, probably dates from the immediately succeeding years.[1] The pattern is that of the earlier communal meeting places of Bergamo (by 1199), Como (1215), and Milan (1228–33). The building is essentially a single great hall, supported on the massive arches and transverse barrel-vaults of an originally open, ground-floor loggia [30]. The latter forms a link between two squares in the manner of its North Italian prototypes. The closing of the arcades, the addition of a second chamber and a bell tower, and above all of a grand external stair and balcony, appear to have taken place in the final quarter of the thirteenth century. A similar, but less architecturally ambitious, stair and balcony adds interest to the even more uncompromising block of the Palazzo dei Papi, and a corresponding feeling for the isolated volume of a building is again revealed in the new Duomo.

The outstanding feature of the Palazzo del Capitano is the way in which the asymmetrical setting of the balcony and the bold diagonals of the stair ramps give the main block of the building added architectural richness. The repeated rhythms of the stepped supporting arches provide an exciting middle term between the simple openings of the voids beneath and the linear

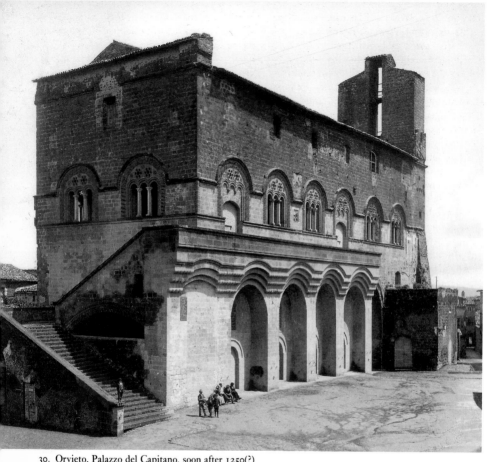

30. Orvieto, Palazzo del Capitano, soon after 1250(?)

decoration that reduces the severity of the upper surfaces and links the windows which were copied, later in the century, in the Palazzo Vescovile and the Palazzo dei Papi. The stairs and balcony at Orvieto also symbolize the citizens' new ease of entry to the Council Hall itself, as well as to the open loggias and squares beneath. This, the first great period of Italian civic architecture since Antiquity, was a time in which society was still beset by every kind of feud and faction. It was also notable for a new fluidity of movement both between the warring groups themselves and vertically through the social strata, which, by now, were subject to recurrent metamorphosis and upheaval. It is symptomatic that although the fortress character of earlier town architecture is still reflected in much of the new civic construction, it is the great external stairway, and no longer merely the internal stair enclosed within a building or a courtyard, that is one of the most characteristic and architecturally vital features of the age.

Externally the Palazzo del Capitano is almost entirely Romanesque in detail, elaborating

forms found in the neighbouring Benedictine abbey of SS. Severo e Martirio, which was transferred to the Premonstratensians in 1220 and then considerably enlarged.[2] Internally four pointed arches, corbelled from the walls, support the wooden, pitched roof and, in conjunction with the evenly spaced windows, articulate the Council Chamber.[3] As with the external detail, similar forms recur in the Palazzo Vescovile and in the Palazzo dei Papi. Nevertheless, the importance of the system is by no means to be measured by its repetition in a couple of dependent Orvietan palaces. The finest achievements of Italian Gothic architecture are often associated with the simplest forms, and it is this extremely elementary type of roof support that characterizes some of the most impressive of the late-thirteenth- and early-fourteenth-century halls and hall churches both in Umbria and elsewhere in Central and Northern Italy.

The direct source of this distinctive feature does not appear to lie in the scattered series of Romanesque and Early Gothic churches in which it occurs: in few of these do the diaphragm arches appear as rhythmically repeated forms, and when they do they tend to be associated with a nave and aisle design like that in the Badiazza at Messina, in S. Maria Maggiore at Lanciano, and in the Duomo at Atri. It seems, instead, to derive from the Cistercian refectories and infirmaries of Fossanova and Casamari. These, in their turn, are related to the late-twelfth-century Catalan dormitory of Santes Creus (1190–1225). The latter leads on to a similar room at Poblet and to a long line of thirteenth-century diaphragm-arched hall churches in Catalonia and southern France. The evolution of the form as a simple solution to the problem of roof support, and one which allows full use of the available area at ground level, is to be seen at Fossanova, where the five arches are carried on truncated pilasters corbelled out a few feet from the floor. The airier proportions of the Palazzo del Capitano at Orvieto, and the corbelling of a reduced number of arches many feet above the ground,

produce a distinctive sense of space. The contrast with certain other Umbrian examples of this system could hardly be more extreme. In the remarkable refectory of the Friary of S. Fortunato at Todi no less than thirteen segmental brick diaphragm arches have been set at three-yard intervals. The long, low room is dominated by their powerful, close-ribbed appearance and the play of light and shade within the deep recesses must have been extremely dramatic before the latter were filled in with a series of ill-fitting vaults. Another kind of contrast is presented by such buildings as the Palazzo Comunale at Tarquinia. Set on its road-spanning archway, with its massive blind arcading haphazardly related to linked windows in a distant parody of French usage, it is but one reminder out of many of how easily local ambition could outdistance local skill.

THE PALACE OF THE POPES AT VITERBO

The close stylistic links between the Palace of the Popes at Viterbo and the Palazzo del Capitano at Orvieto can scarcely be fortuitous. Nearness to Rome and strong political ties with the papacy made up for what Viterbo lacked of Orvieto's natural impregnability, and the city was among the most important seats of the Curia in the later thirteenth century. An inscription over the main doorway of the palace gives the date 1266. This was a year in which the French Pope Clement IV (1265–8) visited Orvieto, where his predecessor had spent two-thirds of his equally short pontificate. The adjoining loggia is dated 1267, and it was from Viterbo in 1268, the year of his own death, that Clement watched Conradin and his army marching southwards to defeat at Tagliacozzo.

Except that the rough grey of the local peperino replaces the warm Orvietan tufa, the outside of the palace [31], with its continuous cornice linking and overrunning the round-headed windows and main door alike, closely resembles that of the Palazzo del Popolo at Orvieto. Abundant traces of red and blue reveal, however, that the architectural and heraldic

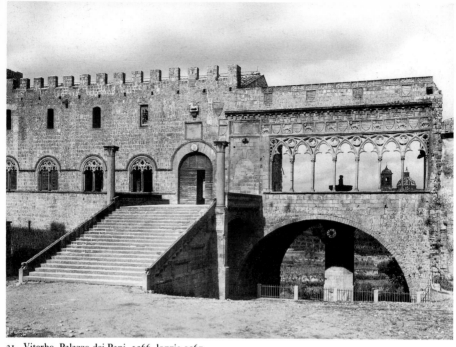

31. Viterbo, Palazzo dei Papi, 1266, loggia 1267

detail were once highly coloured. In the loggia, which must originally have been roofed over and arcaded on the valley side as well,[4] the interlacing of traceried, round arches, echoing on a larger scale those of the windows of the main hall, gives rise to pointed, Gothic forms. The heraldic sculpture, the tracery itself, and the slim twin columns that support it, lend a certain gaiety to a building that is otherwise conceived in terms of mass and powerful architectural engineering. Great arched buttresses pin the structure to the hillside and the massive octagonal column of a well-shaft pierces upwards through the huge, five-arched and bridge-like barrel-vault on which the loggia stands. The shoulder of this same vault takes the thrust of the almost rounded arch that carries on its back the spacious entrance platform. From the latter, wide and shallow steps cascade into the square. Crisp cornices, and rectilinear

panelling such as is common in Umbria and the Marches, decorate the balustrades and show the forms to which the rough, volcanic peperino is most apt. The very similar, and increasingly complicated, traceries of the thirteenth- and fourteenth-century cloister of S. Maria della Verità show that the stiff and somewhat clumsy carving of the detail of the loggia is largely due to the unsuitability of the local stone for the delicate openwork on which the Viterbese stone carvers set their hearts. The clear-cut delicacy of the simple marble detailing of the near-by cloister of S. Maria in Gradi underlines both the limitations of the medium and their skill in overcoming them.

The extent to which the detailed treatment of the steps and the bold spatial play of arches, intersecting at right angles, represent the distillation of a century-old tradition can be seen by walking through the Romanesque quarter of

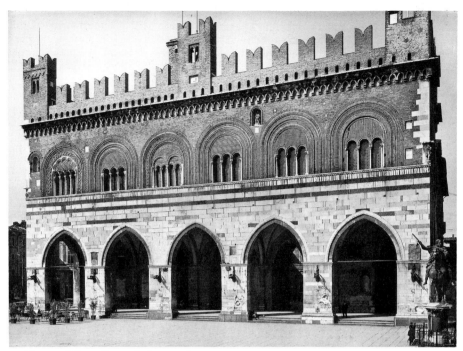

32. Piacenza, Palazzo Comunale, begun 1280

S. Pellegrino. Almost identical forms, adapted to the scale of private houses, are also to be seen in a number of fourteenth- and fifteenth-century buildings. The stairs and balcony, boldly suspended on a flattened half-arch, that give light and shade, movement and architectural interest to the probably fourteenth-century façade of the Casa del Vico are the most striking of these witnesses to the gradual erosion of the fortress concept. The austere grandeur of such additions to the Romanesque town walls as the tower gate of S. Biele, dating from 1270, are, however, a reminder that the arts of military engineering were by no means dead or even dying in a turbulent late medieval world.

THE PALAZZO COMUNALE AT PIACENZA

The final flowering of the Lombard Arengario or Broletto is achieved in the unfinished Palazzo Comunale of Piacenza on the Emilian border [32]. The building was begun in 1280 at the order of Alberto Scotto, the long-time ruler of the town, and its construction was entrusted to four local architects. Inscriptions indicate the progress of the work in 1281 and 1282, and the projected building would undoubtedly have enclosed a central courtyard. It would therefore have resembled the heavily manhandled Palazzo del Comune at Cremona of 1206 after the latter's enlargement towards the middle of the century. The sophistication of the new building at Piacenza is shown by comparing it with the all-brick Arengario at Monza. The latter was built between 1250 and 1293 and incorporates only the most tentative modifications of the Romanesque traditions represented by the Palazzo della Ragione at Milan. The mid-thirteenth-century Palazzo di Cittanova at Cremona belongs to the same line of

development. The heavy, pointed arches of its loggia form a covered way in the manner taken up with greater self-assurance in the more-or-less contemporary Palazzo Comunale at Bologna. The architectural severity of the latter, with the heavy symmetry of its wide window openings repeating the forms of the arcades below, is thrown into relief by a comparison with the Loggia dei Militi, built in Cremona in 1292 [33]. The height of the two arches of the loggia and the rich terracotta decoration of the

three upper windows, which are closely related to those in the northern transept of the cathedral, built in 1288, give the façade a feeling of comparative lightness, if not grace, and this is accentuated by the almost tower-like proportions of the whole.

The interesting two-to-three grouping of the openings in the Loggia dei Militi reflects a taste for such relationships which had already found more complicated expression in the five arches and six windows of the main façade of the

33. Cremona, Loggia dei Militi, 1292

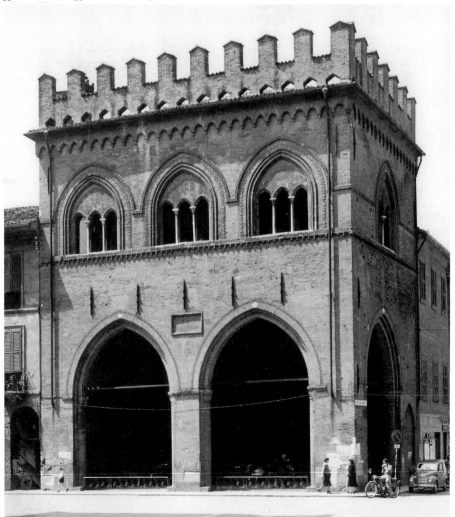

Palazzo Comunale at Piacenza. There, within a structure largely dependent for effect on its proportions, the grey-white and pink marbling of the lower storey is set off against the rich red of the brick and terracotta of the upper half. Six simple pointed arches lead into an open loggia two bays deep. Their severity of form is set against the relatively intricate detail and predominantly rounded shapes of the upper windows and against the busy Ghibelline battlements of the roof. The hardness and smoothness of the broad stone surfaces, the velvety quality of the brick, and the intricate texturing of the terracotta lunettes and surrounds of the windows gain a maximum intensity of impact from their mutual relationship, though this may once have been considerably modified by external fresco paintings. The loggia is imposing in its height and scale. The complex internal spaces and outward vistas that it creates, and the sense of flow between the riches of architecturally articulated space and the wide sunlit areas of the piazza that surrounds it on three sides, and of the courtyard glimpsed upon the fourth, provide a striking contrast to the undifferentiated vastness of the space enclosed beneath the wooden trussed roofs of the council hall and anteroom above. That all these textural, colouristic, formal, structural, and spatial contrasts should be maintained at such a pitch of mutual enrichment within a building that, at first glance, is endowed with so compact a unity, is a revelation of what could be done with the simplest architectural elements by men whose minds were permeated by a great tradition.

THE BARGELLO IN FLORENCE

A second major group of civic buildings, far more closely allied to the medieval fortress, is represented by the Bargello in Florence [34]. In their struggles with the surrounding feudal lords and with each other; in the very process of destroying castle after castle and of casting down the towers that had made stone forests, far more fierce than any modern asphalt jungle,

out of every town, the Communes had themselves acquired the aspect of expanding castles. Already in twelfth-century Florence the first circle of the Roman wall had been enclosed within a second which, although it reached across the Arno, was itself engulfed by the mid thirteenth century. Even within the walls internal feuds did not die down with the destruction of the private fortresses and tower houses. The first thought of each government, however 'popular', was still directed to its physical defence against opposing factions. Indeed, the more revolutionary the form of a new constitution, the more its promulgators might feel obliged to cling to the more conservative of architectural forms: and so it was in Florence with the Primo Popolo.

The Bargello was begun about 1255 as the Palace of the Capitano del Popolo, who had previously made do with a rented private house.[5] Then, after the disastrous defeat by the Sienese at Montaperti in 1260 and the reversion to the older and less democratic governmental system, it became the Palace of the Podestà. The architectural model for the building seems to have been the block-like, towered fortress of the Palazzo dei Priori in the newly subjugated hill town of Volterra. This, the oldest surviving Communal palace in Tuscany, had been begun in 1208, and the lower part at least was completed in 1257. The similarity to the even more severe three-storey block of the later Bargello, which, with its string cornices and Gothic *bifore*, originally stretched from the pre-existing corner tower to the Piazza S. Firenze, must have been quite striking. The internal division into a series of great halls, often occupying virtually an entire floor and connected to a few smaller ante-chambers, is typical of all this class of buildings. Typical also was their tendency to grow not only vertically (the upper storey of the Bargello was substantially modified in the fourteenth century) but also horizontally to enclose internal courtyards.

The Palazzo Nuovo del Podestà at S. Gimignano, its cortile lined by a rustically ambitious stair and balcony poised on inter-

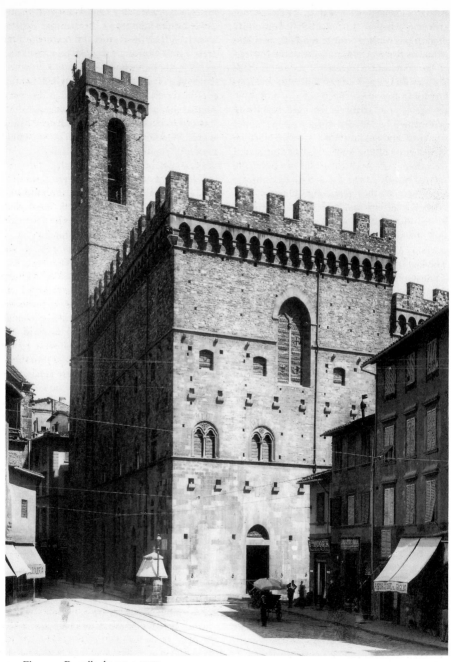

34. Florence, Bargello, begun *c.* 1255

secting arches, was begun *c.* 1288–9 and enlarged in 1323. It shows the emergence of the same type of building in a town that still possesses many of its thirteenth-century towers and town houses. At Massa Marittima, indeed, the Palazzo Comunale is actually formed by the union of three tower-like sections dating from the early thirteenth to the mid fourteenth centuries.

The reciprocity in terms of architecture, as of social ambition, which ensured that as fast as the feudal classes either lost their powers or joined the newly powerful, the rising bourgeois should take on the noble trappings of the social order which they were so busily destroying, is well illustrated by the Palazzo Pretorio at Poppi. It was begun *c.* 1274 by Conte Simone di Battifolle and later became the castle of the Conti Guidi. The original structure on the right, with its single row of first-floor *bifore*, was, like the Florentine Bargello, a severe, rectangular three-storey block which, also like the Bargello, was subsequently extended to enclose a courtyard. It is, however, in the Palazzo Vecchio at Florence [136], which will be considered later, that the Volterran palace has its most magnificent progeny.

THE PALACES OF TODI AND PERUGIA

Between the Lombard and Emilian pattern followed at Orvieto and the Tuscan fortress type of the Bargello, there stands a varied series of civic palaces in which a more or less open and extensive ground-floor loggia forms the basis for a building of at least three storeys, often furnished with a fine external staircase, yet in many cases still retaining the clear marks of castle ancestry.

At Todi the substantially thirteenth-century cathedral and three civic palaces, grouped about a single square, have all in varying degrees survived the vicissitudes of centuries of constant use. The much restored Palazzo del Popolo [35], begun in 1213, heightened by one storey in 1228–33, and completed by 1267, immediately reveals a general connexion

with such buildings as the late-twelfth- and early-thirteenth-century Broletto at Brescia. Although the colour and the texture of the grey-white stone of Todi provides a maximum contrast to the mellow Bolognese brickwork, the wide distribution and closely comparable parallel development of the type is illustrated by the Palace of Re Enzo in Bologna, which was built about 1246 in close relationship to an earlier group of buildings. The kinship is particularly noticeable in the scale of the arches of the loggia. In either case vistas open out from one square to another through the angle of the building. The subsequently linked, and also highly restored, Palazzo del Capitano at Todi seems to date from the 1290s, when it might have been thought that the founding of S. Fortunato would have demanded all the architectural energies of so small a town [35].

The wider but still rounded arches and more massive piers of the ground-level loggia are boldly contrasted with the Gothic *trifore* above. The use of diaphragm arches in the council chamber links the internal structure with the abbey of S. Fortunato [15] and with a long line of important fourteenth-century Umbrian constructions. It is, however, not so much in the detail or the general structure of the individual buildings as in their subtle grouping that the supreme achievement of the medieval architects of Todi lies. Confronted in the earlier building by a tall, slim block and by the two-three-one-three rhythmic symmetry of the arches and the windows, opening with severe and timid grace into the great blank areas of wall, the later architect of the Palazzo del Capitano reacted with an intuitive, almost certainly unconscious, sensitivity that sums up the highest qualities of late medieval architectural craftsmen. Any heaviness that might result from the setting back of a wider, lower block is counteracted by the broader openings of the loggia and by the increased delicacy of the windows. The lightness and extent of the latter is magnified at first-floor level by pierced relieving arches and a running zigzag of connected gables. On the second floor a similar function is performed by

a continuous moulding in the Orvietan manner which arouses formal echoes of the openings of the ground-floor logge of both buildings. The more developed feeling for the horizontal articulation of a façade by cornices that give firm anchorage to the window openings, accentuates the quality of floating, strip-like application in the windows of the older structure. Yet, in the very act of attempting a more organic relationship between the parts and the whole, the later architect confirms the sensitive understanding of the earlier building revealed in his balancing of masses. Time and again, as one walks round the palaces and observes the seemingly haphazard changes of level which distinguish each and every comparable element in the two buildings, the laws of natural perspective recombine these elements into harmonious contrapuntal groupings. This phenomenon is demonstrated in illustration 35, in which the lower cornice of the Palazzo del Capitano seems to coincide exactly with the line of window bases in the Palazzo del Popolo, and the asymmetry of door and windows in the central zone acquires a positive quality within a system of dynamic balance. The latter attains its climax in the broad flow and the daring spatial intersections of a stairway in which mass and movement have been monumentally combined.

Each new departure in the arts is in some ways an implicit criticism of what went before. Here, in the cautious terms of some forgotten architect in an Umbrian hill town, is instinctive criticism at its most constructive.[6] It underlines what must be obvious at every level and at every

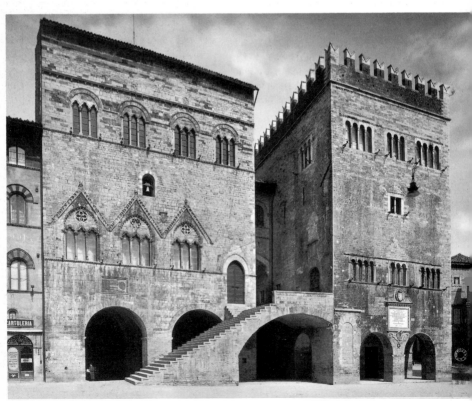

35. Todi, Palazzo del Capitano, 1290s(?), and Palazzo del Popolo, begun 1213, heightened 1228–33, completed by 1267

turn in Italy: the persistence of the architectural idiom of the Romanesque within the gradually evolving styles of a new age.

Late-thirteenth-century variations on the theme include such very different buildings as the Palazzo Pretorio at Prato (before 1284), with its important fourteenth-century additions that include the outside stairway, or the Palazzo dei Consoli at Bevagna in Umbria, where the massive piers and pointed arches of the loggia, and the simple *bifore* and broad external stair, form part of an unspoilt twelfth- and thirteenth-century piazza.[7] At Genoa the wide arched loggia of the brick Palazzo di S. Giorgio, which, with its Gothic detail, dates from *c.* 1260, would almost form a covered street but for the steps that flow down into it. Indeed, in the Palazzo Lamba-Doria [36], which was given by the Genoese Commune to the victor of the naval battle of Curzola, fought against the Venetians in 1298, the ground-floor loggia with its fine polygonal columns recalls the Bolognese arcades, although the outflow of the main stairs indicates its private nature. The four storeys of the striped white marble and black stone façade are clearly defined by intervening cornices and are enlivened by the pointed *quadrifore* which repeat the shapes and rhythms of the arcade beneath. Originally this palace, the forms of which are elaborated in the roughly contemporary Palazzo Vecchio del Comune, must have been distinguished by a discipline, a symmetry, and a calculated, if repetitive, rhythm unsurpassed elsewhere in Italy at such a date. It has been shorn of any obviously defensive character and is, of all the Early Gothic private palaces of Italy, among the earliest and farthest on the road towards a truly civil architecture.

The most overwhelmingly palatial of the substantially thirteenth-century Central Italian civic palaces is, however, the Palazzo dei Priori at Perugia [37]. The main body, consisting of the first ten bays of the long side and the first three of the short, was substantially built between 1293 and 1297 by Giacomo di Servadio and Giovanello di Benvenuto, two otherwise unknown Perugians.[8] The first impression is of

enormous mass enlivened by a filigree of windows. The additions of 1333–53 upon the short flank and of 1429–43 upon the long only accentuate the qualities that must always have been apparent when the view was not confined

36. Genoa, Palazzo Lamba-Doria, soon after 1298

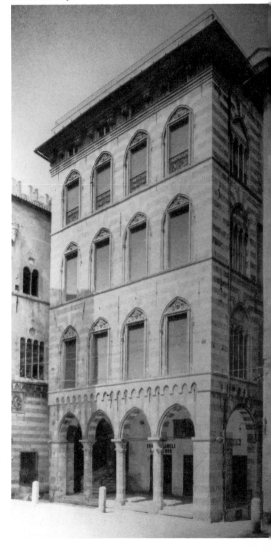

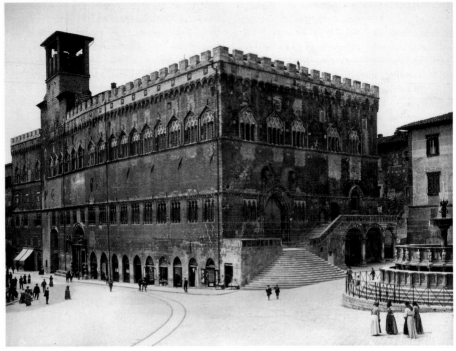

37. Giacomo di Servadio and Giovanello di Benvenuto:
Perugia, Palazzo dei Priori, 1293–7 and later

to what was then the relatively tall and narrow north face of the building. The latter would have lacked the fan-shape of the present steps, and also the arched fourteenth-century balcony that adds so greatly to the sense of architectural movement. Despite the more straightforward steps, the original, symmetrical façade must always have been dominated by the pointed trefoil of the entrance door. This would be large even for a cathedral, and such grandeur is unprecedented in relation to a civic building. It marks a further stage in social evolution and gainsays the implications of the reconstructed battlements above. The sense of mass obtained in three-quarter views is not entirely due to the actual scale or to the general proportions, though these are impressive enough. It is enhanced by the repetition of large numbers of identical openings which, despite the forms of their individual members, are united to establish horizontal accents widely separated by unbroken areas of masonry. The feeling of weight and horizontality in what is actually an extremely tall building is finally intensified by the fact that the lower cornice runs above the lower windows, while the succeeding cornice joins the bases of the upper windows. This gives unusual clarity and definition to the unbroken mass of grey stone pressing down between them. Internally, the wide expanse of the great hall is given similar weight by the heavy, rectangular section of the eight closely spaced round diaphragm arches that support the equally extensive upper chamber.

Considered as a whole, the size and symmetry of the original structure, its regular

repetition of identical units and its clarity of definition, mark it out as typical of the new age. The size and frequency as well as the form and delicate detailing of the windows reflect the ambitions of new classes struggling to give reality to a changing vision of the social order. Those of the upper storey, in particular, constitute a master-stroke which makes the related, possibly derivative, and certainly more fully Gothic forms of the Palazzo del Capitano at Todi seem both thin and hesitant by comparison; for in the very act of giving a distinctive, picture-framing emphasis to each individual triple window opening they create a rippling architectural continuity that is unique.

SCULPTURE

1250–1300

INTRODUCTION

Late-thirteenth-century Italian sculpture is dominated by the achievements of three men. The first is Nicola Pisano; the second Arnolfo di Cambio, who worked with him for a time; and the third is Nicola's son, Giovanni. The span of their careers marks a momentous stage in the transition from the world of the medieval craftsman to that of the self-conscious modern artist. Whereas in ancient Greece the primacy of sculpture in the evolution of the visual arts is merely probable, in Italy, in the first decades of upheaval that prepare the way for the Renaissance, it is certain. This short period sees the replacement of a flourishing Romanesque by a well-established Gothic sculpture and the acceleration, if not the beginning, of that slower process by which Italian sculpture becomes increasingly independent of architecture. These same three men, by drawing on the Antique past and northern Gothic present, created a sculptural language in which the greater naturalism of the forms became the vehicle for richer and more varied spiritual and psychological experience. It is the vividness of their achievement in the exploration of new representational means, in the establishment of new canons of dramatic narrative, and in expanding the entire range of sculptural expression, that underlies the ensuing pictorial revolution. They were the very men who for the first time bodied out in the enduring forms of art that warm humanity and sense of immediacy which fired the religious fervour of whole populations and filled the ever more ambitious churches that the mendicants were building in their hundreds through the length and breadth of Italy.

NICOLA PISANO

THE PISA PULPIT

The epicentre of the constant tremors that re-shape the landscape of Italian sculpture during the second half of the thirteenth century lies in the unstable soil of Pisa. At first the dominance of the architect is virtually unchallenged and the sculptor's primary task is architectural embellishment. It is possibly significant there-fore that the underlying principles of Italian Romanesque architecture are nowhere more clearly visible than in the great twelfth-century buildings of Pisa Cathedral. Instead of the Northern European pattern of a single building in organic growth from the twin kernel of font and altar to the soaring bell-towers overhead, there is a coordinated group built up of clearly separated parts, of Duomo, campanile, and baptistery, the whole achieving unity in a lucid interplay of simple volumes, pure prismatic forms, set against cone and cylinder and ovoid. Inside the baptistery, itself inspired by the Holy Sepulchre at Jerusalem,[1] the still, mathematical dance of architectural form continues. Within the circular outer wall the conical inner dome stands on a dodecagon, the columns of which are divided into four groups by pillars. In the centre of the radiating pattern of the floor stands the lace-carved octagon of Guido Bigarelli da Como's font of 1246, and to one side of the rectangular enclosure of the altar the contra-puntal rhythm finds its close in the hexagon of the pulpit inscribed 'Nicola Pisanus' and dated 1260 [38]. There is good reason to believe that here the formal dance is deep with meaning as it weaves from the Apostolic twelve, the mul-tiple of the Trinity and the four evangelists or the four corners of the earth, through the eight that is the baptismal symbol of regeneration, resurrection and salvation,[2] to the first perfect number, six, the sign of the 'Old Adam' who prefigures Christ, the second perfect man.

Except for mention in a Lucchese will of 1258, Nicola Pisano is unknown before the apparition of the seemingly fully mature sculp-ture of the baptistery pulpit. His other two surviving documented works are the pulpit in the Duomo at Siena, contracted for in 1265 and completed in 1268, and the Fontana Maggiore in Perugia, finished in 1278. By March 1284 he was evidently dead.[3] Since documents show that his son, Giovanni, was already being employed in a minor capacity on the Siena pulpit, and he later refers to himself as born in Pisa, it seems that Nicola must have been established there by 1250 at the latest. Since Nicola is twice referred to in the Sienese docu-ments as 'de Apulia', instead of the usual 'de Pisis', it seems that he himself was born in the south, and this is confirmed by the apparent knowledge of South Italian sculpture revealed in his own work.

The building of the baptistery pulpit coincides with a moment of triumph for Nicola's adopted city. The naval victories of 1258 by which, with her Venetian allies, Pisa had secured her overseas possessions against the rival Genoese were followed by the decisive land battle of Montaperti, in which the Ghib-ellines of Pisa and Siena overcame the Guelph coalition led by Florence. The triumphs were short-lived, however, and the half-century fol-lowing the death of the Emperor Frederick II in 1250 marks the moment when expansion ceases. It is a period of increasingly desperate commercial and military defence, leading to ultimate defeat. As yet the accumulated riches of the past were still intact. Commercial con-tacts with the East were still unbroken, as were those with the cities of Provence. The battle for

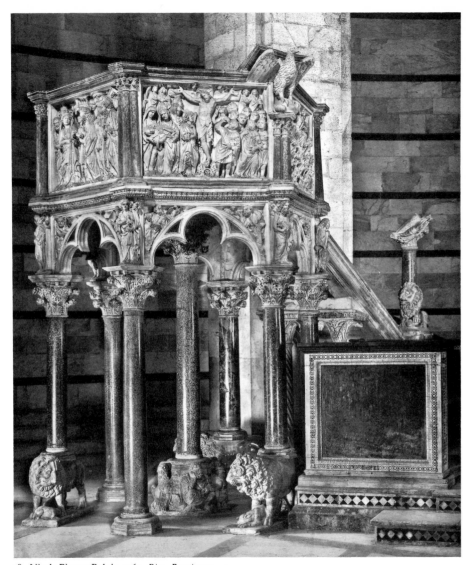

38. Nicola Pisano: Pulpit, 1260. *Pisa, Baptistery*

control of the Via Francigena, down which a constant stream of trade and works of art poured with the pilgrims from the whole of Northern Europe on their way to Rome, had not as yet been lost. As often happens in the life-spans of Italian cities, the climacteric sees a final burgeoning in the realm of art.

The compact polygonal form of Nicola's pulpit, so intimately adapted to its surroundings, is comparatively rare. Austere Byzantine

examples occur in S. Marco in Venice and in near-by Torcello, but in Tuscany there are only the minor polygons at Fagna and Borgo S. Lorenzo. The possibility that monumental Tuscan prototypes still existed in the thirteenth century must not, however, be overlooked, as the surviving pulpits are conservative works confined to minor churches. Nevertheless, the closest existing parallel to Nicola's work is the mid-thirteenth-century hexagonal pulpit at Split (Spalato) on the Dalmatian coast, and a similar pulpit survived until the eighteenth century at Trani on the opposite, Apulian, shore.

As important, and also rare before this date, is the replacement of the simple architrave, favoured in Tuscany, by an archivolt that softens the transition between the supporting columns and the casket, increasing the vertical flow of the design.[4] Indeed, the one specifically Tuscan contribution to the general scheme of Nicola's pulpit is the decoration of its walls with scenes from the Life of Christ instead of with the vegetal forms of the Abruzzi or the dazzling and elaborate geometric inlays of the south.

The finest of the earlier thirteenth-century storiated pulpits is that in Pistoia. It is dated 1250 and signed by a Guido da Como who is possibly, but by no means certainly, the same Guido Bigarelli who signed the font at Pisa four years earlier. Although it does not seem to have been correctly reconstituted and the narrative sequence appears to indicate that some scenes may have been lost, the pulpit represents a landmark in a line of similar structures that stretches right back to the work completed by Guglielmo in 1162 for the Duomo at Pisa and consequently well-known to Nicola Pisano.[5]

Guido's pulpit, with its stylized lions and supporting figure; with its simple architrave and contrasted horizontals and verticals; and above all with its fully Romanesque relief style, characterized by its almost complete respect for the flat surface which it decorates, provides a striking contrast to the full-bodied plastic richness of Nicola's work. The narrative zest that shines through the simple, carefully controlled, symmetrical juxtapositions of these reliefs is embodied in delicately carved, doll-like figures clothed in flat, linear draperies. The fine drill-work; the delight in the flat patterns of the coloured marble inlays; the Lombard-Emilian exploitation of the plain ground of the relief; the subtle alchemy that blends naïvety with sophistication, reflect the culmination of a long development.[6]

The existence of a tradition of the storiated pulpit in Tuscany, while clarifying one aspect of the antecedents of the baptistery pulpit, also serves to stress the start of the revolutionary iconographic expansion which counts as one of the most important facets of Nicola Pisano's achievement. At the angles of the intermediate zone beneath the five reliefs of the *Nativity*, the *Adoration of the Magi*, the *Presentation*, the *Crucifixion*, and the *Last Judgement*, stand six controversial figures which have often been described as Christian virtues. They are almost in the round, and give a new status to the theme within the body of Italian sculpture. Between them, in the spandrels of the arches, are the evangelists and a series of Old Testament kings and prophets, and below them crouch the wild men and the guardian lions. It is the first crisp statement in so condensed and unified a sculptural form of an encyclopedic urge that is intellectually only explicable in terms of the philosophical strivings crystallized in the Summa Theologiae on which St Thomas Aquinas was currently engaged. Artistically it must be seen in the light of the resplendent stone and glass encyclopedias of Chartres and Reims and Amiens, all of them taking shape during the first half of the century. Thematic originality is, moreover, accompanied by remarkable independence in the face of the detailed iconographic sources, and this is particularly clearly shown in the highly unusual Hercules-Fortitude and in the 'virtues' as a whole.[7]

In Italy, as in France, new ideas and new forms are inseparable. The Italo-Byzantine iconographic basis for the angelic figure of Faith, or for the opening scene of the *Nativity*,

is a springboard for a formal revolution [39]. This relief is, properly speaking, not a single scene but a distillation of four separate episodes, the *Annunciation*, the *Nativity*, and the *Annunciation to the Shepherds*, stemming from the gospels and, in certain details, from the apocrypha, and the *Washing of the Christ Child* from a textually speaking unknown source. Each

some feeling of spatial continuity, that the actual multiplicity of the continuous narrative is easily missed.

The massive, reclining figure of the Virgin that recalls, but probably does not directly reflect, Etruscan grave figures serves, by its very scale, to dominate the scene. The immediately juxtaposed repetition of her head in that of

39. Nicola Pisano: Nativity, detail of pulpit, 1260.
Pisa, Baptistery

figure is given that full weight and volume which is one of the outstanding characteristics of Nicola's art. Each incident is told with a dramatic power and selectivity and with a convincing naturalism of gesture and of carefully chosen detail that is new to Tuscan sculpture. Yet Nicola has been at such pains to give formal and dramatic unity to the act to which the separate scenes build up, even attempting, despite the obvious contradictions, to create

the Virgin Annunciate creates a strong central accent which was once completed by the now mutilated figure of the Christ Child. The firm opening vertical, created on the left by the figures of the angel and of St Joseph, was likewise originally balanced by a framing motif that ran down from the now headless shepherds on the right. Where, as in the *Presentation* [41] and the *Crucifixion*, one action fills the entire frame, the high relief of powerful verticals at sides and

40. Nicola Pisano: Adoration of the Magi, detail of pulpit, 1260.
Pisa, Baptistery

centre is accentuated by the intervening troughs of shadow, and the closed and architectonic construction of the scenes takes on an almost diagrammatic clarity.

The firm solidity of the almost architecturally constructed figure design is matched by a lively concern for the decorative qualities of a surface pattern that is likewise based on the repetition of relatively simple forms. The draperies of the axial figures in the *Presentation* fall into almost identical patterns, and the decorative function of such repetitions is even clearer in the *Adoration of the Magi* [40]. As always with Nicola Pisano, the articulation and solidity of the underlying forms is never left in doubt. Nevertheless, the surface pattern established by the iconographically original repetition of the kneeling pose is stressed by

the way in which the sharp pattern of the folds that fall below the waists of these two figures is as far as possible repeated, despite the wholly different pose, in the folds that run up from the lower part of the Virgin's left leg.

So far only general parallels to Nicola's work, and his potential sources of inspiration, have been considered. Here, in the *Adoration*, with its firm closure about the central pyramid of the three kings, Nicola can be seen exploiting his familiarity with a particular surviving work of art. The impassive Roman matron of the *Nativity* who reappears, imperially enthroned, in this relief is one of several direct quotations from the second-century Roman sarcophagus of Hippolytus and Phaedra. This work, like many other historically important Antique remains, is still in

41. Nicola Pisano: Presentation, detail of pulpit, 1260.
Pisa, Baptistery

the Camposanto at Pisa, and served, from the eleventh century, as the tomb of the Countess Beatrice. Comparison of the two seated figures shows that it is mainly the pose, reversed and slightly modified, that has interested Nicola. The proportions have been altered in the direction of those of Tuscan and Lombard Romanesque sculpture, and the features seem to reflect a knowledge of Republican and Early Imperial classical statuary.[8] The relationship between the drapery and the underlying forms is also changed through a dramatic accentuation of the prismatic fold pattern. This raises the whole question of the nature of Nicola's acquaintance with French art, since the system was used fairly extensively at Reims and Amiens shortly before the mid century and is otherwise extremely rare. Equally sweeping trans-

formations are visible if the nudes on the sarcophagus are compared with the naked Hercules of Nicola's *Fortitude*, or if the mighty figure on the right of the *Presentation* is related to its own close prototype in the relief on a Greek marble vase that is likewise now in the Camposanto, but which was, in 1320, to be set up on a lion-supported column outside the Duomo.[9]

The collection of antiquities, the incorporation of classical inscriptions in the stonework of the Duomo, the re-use of antique sarcophagi in innumerable city churches, the literary emphasis on Pisa as a new Rome – all these had been familiar aspects of life in Pisa in the twelfth century, long before Nicola's birth, and were to remain so in the early fourteenth after he was dead and his son Giovanni was

working in the Duomo in a very different style. They provide a context for, not an explanation of, the style of Nicola's pulpit.

The comparisons with surviving antiquities show that the classicism which is one of the outstanding features of the baptistery pulpit has little in common with that deadening devotion to the past that is the mark of the pasticheur. In searching for the motive force that lies behind it, it is important to remember that the techniques required for working directly from nature had still to be developed. The very idea of the life study, with all the formidable problems of abstraction and controlled observation that it entailed, was still in its infancy. Initially the only possible response to a growing urge to represent the actual physical appearance of the natural world more accurately was to turn towards those earlier works of art that appeared to correspond most nearly to the artist's own experience of nature and to satisfy his new needs most completely. This is especially important as the political ambitions of the patron, which dictated the classicizing form of so much of the sculpture produced for Frederick II in the first half of the century, do not explain such an extreme degree of classicism in a Pisan ecclesiastical commission. Nevertheless, the extent and intensity of Nicola's exploitation of the Antique are such that it is difficult to believe that he had not at some time laboured in the imperial Southern Italy of his birth. Despite the direct quotations from Antique art that occur in French medieval sculpture, whether at Reims or, earlier, in Provence, and in spite of constant echoes of Antiquity throughout the history of Italian monumental sculpture from the time of its re-emergence in the early twelfth century, nothing remotely similar occurs outside the limits of the deliberate attempt at a renaissance that Frederick II had personally directed.

How important it is not to indulge in easy over-simplifications when looking for Nicola's stylistic sources, or for those of any great artist for that matter, is easily shown. The seemingly Tuscan Romanesque proportions of the Hercules, so very different from those on the Phaedra sarcophagus, are for example also close to those of a third-century Hercules in almost identical pose on a sarcophagus now in the Thermae Museum in Rome. Then again, the actual carving of the figure on the right of the *Presentation* is, like the head of Simeon, much closer to the style of Trajan's Arch in Benevento than it is to that of the Greek vase from which it derives. What is even more significant is the stroke of genius which enabled Nicola to see, amid the veritable quarry of antiquities by which he was surrounded, that the vase could provide him with a perfect physical analogue for the words which Pseudo-Matthew, one of the most important texts for late medieval artists, took from the liturgy of the feast of Purification: 'Senex puerum portabat, sed puer senem regebat.'[10]

The fact that the imitation of Antique forms was seemingly imposed on South Italian sculptors for clearly defined political ends should not be allowed to detract from an appreciation of the variety and often of the quality of their achievement. The head of the Justitia Imperialis from the Capuan Gate, with its boldly massed forms and simplified planes, remains, for all its mutilation, a compelling work of art.[11] Though Frederick's imperial dream died with him, that small part of it which found embodiment in sculpture did survive, both in the south itself, where it was later seen by the artists flocking to the Angevin court at Naples, and, presumably, in outposts like the castle at Prato, built in the late forties. In so doing it became the inspiration of much that was achieved in Tuscany in the later thirteenth century.

The baptistery pulpit not only marks a new stage in the history of Italian sculpture but reveals within itself a development which seems to show that the reliefs were actually conceived and executed in their narrative sequence. There is a steady increase in the number and in the freedom of action of the figures that is independent of iconographic demands. This is accompanied by a modification of the almost starkly classical figure type of the opening

scenes and its eventual replacement by the French Gothic Christ of the *Last Judgement* beneath which stands the inscription of 1260. In this last scene the extreme quantity of the figures is, of course, partly dictated by the subject, and this leads in its turn to a new type of composition. It is typical of Nicola that in this most French of scenes he should reach back to the Antique relief style of the battle sarcophagi with their even scattering of figures over the whole surface. The decision may well have been affected by the fact that the layer-cake arrangement of the northern reliefs, with single rows of figures standing one above the other upon separate ground-lines, would have made a much more violent contrast with the neighbouring scenes. Nevertheless, in this particular intermixture of French figure types and Antique patterns of relief, created to solve a special problem, there lies the germ of the ideas that were to reach fruition in the next few years.

For all its internal stylistic development, and for all the diversity of sources that are drawn on, the crowning characteristic of Nicola's pulpit is possibly that it both epitomizes and extends the formal application of those very qualities that are fundamental to the group of buildings for which it was designed. The unity of the whole, with its compact, hexagonal form, its increased vertical flow, and its uniformity of sculptural treatment, is evident enough, but the most striking of its many virtues is the architectonic clarity of parts on which the final unity is based. In this it is unique.

Beginning with the details of a single relief such as the *Adoration of the Magi* [40], each head of hair, each beard, is made up out of clearly separable, individual curls, their delicate variations giving life to the essentially repetitive pattern of the whole. The folds do not fall into blended, swinging curves that swell and melt indefinitely. Each is clearly distinguished from its neighbours and is once again built up of clearly separable parts; of one, or two, or three, or more, straight sections. In every scene there is a similar clarity in the figure disposition, with its accentuated repetitions of pose and drapery

pattern, and in the compositional structure. Every relief is carefully distinguished from the marble mouldings of its frame, just as each frame is separated from the neighbouring facets of the hexagon by smooth, clustered columns that emphasize the intervening angle. Finally, the insertion of corner figures [41] at the level of the archivolts asserts the interchangeability of architectural and sculptural functions, at the same time ensuring a clear distinction between the upper, intermediate, and supporting zones within the unity of the whole.

The beauty of the pulpit as it stands must not, however, lead to the assumption that its present appearance represents the artist's true intent. The pulpit was created for a world in which colour played an essential part in all the visual arts, and Nicola did not restrict himself to the deep, stippled red and green marbles of the main columns, to the deep green marble inlays of the cusps, and to the red marble of the clustered columns and relief frames. Fragmentary remains and, in some places, the rough finish, show that strongly patterned vitreous glazes on a gesso foundation formed the background to the figures. This is a French practice that sets off the wholly Italian treatment of the actual relief. Nicola also sometimes uses the black inset pupils common in contemporary Tuscan sculpture, but the very fact that, within a single relief, some of the pupils are treated in this way and others have no markings or insertions of any kind implies that the reliefs were fully coloured. A few perished traces of such colouring seem to have survived, and however peculiar full polychromy in such a context may appear to modern eyes, its use seems to have been the rule and not the exception as far as Italian Romanesque sculpture was concerned. The pulpit stands at the end of a tradition rooted in the thoroughgoing painting of Greek sculpture, which, from the Renaissance onwards, has, like Nicola's reliefs, been so admired for the white purity of its scrubbed marble surfaces. It is, indeed, almost impossible to imagine the transformation that must have been wrought by a rich polychromy envisaged

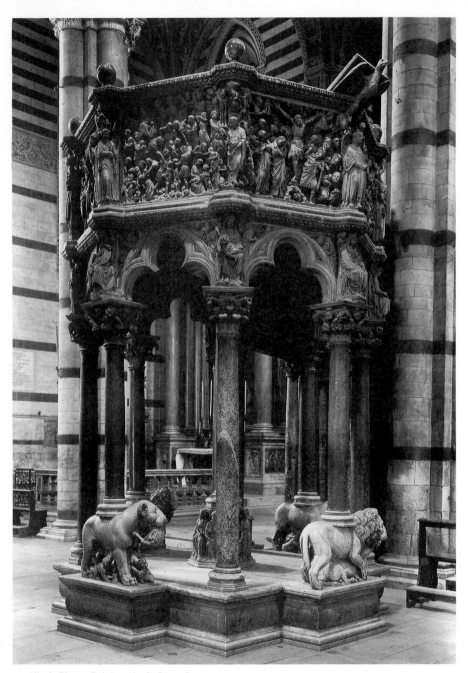

42. Nicola Pisano: Pulpit, 1265–8. *Siena, Duomo*

by the artist himself, and the realization under-
lines the caution that is needed in any attempt
to analyse his aesthetic intentions.

Although there is some evidence of studio
intervention, primarily in the *Last Judgement*,
the carving of the baptistery pulpit seems large-
ly to be due to a single hand, presumably that
of Nicola himself. It is characterized by high
finish and the constant demonstration of an
apparently effortless technical virtuosity, par-
ticularly with the drill, that seems to be partly
derived from the study of Antique remains.

THE SIENA PULPIT

Something of Nicola's full workshop organ-
ization is revealed, some five years later, by the
contract for the Siena pulpit [42], which he
negotiated with Fra Melano, the clerk of works,
who was a monk from S. Galgano. He himself
was to receive eight soldi for each working day,
while his principal assistants, Arnolfo, who had
still not arrived by May 1266, and Lapo, were
to have six. Nicola's young son, Giovanni, if he
worked, as in fact he did, was to have four soldi
paid on his behalf. In a later document a fourth
assistant, Donato, is also mentioned.[12]

The variations in the style and quality of the
work show that the part played by the various
members of the workshop was large and their
independence considerable. Consequently,
various sections have been attributed to one or
other of them on the basis of complex stylistic
comparisons. Although it would be exciting
if the outlines of these sometimes more and
sometimes less convincing stylistic groups
could be clarified, the present haziness is no
mere indication of the idleness of art historians.
Although the emergence of individual artistic
personalities from the cooperative anonymity
of the medieval workshop is one of the unique
and epoch-making characteristics of Italian
thirteenth- and fourteenth-century art, the
modern conception of the autograph work and
of its importance did not as yet exist. The
sculpture on the façade of the Duomo at Orvieto
is a constant reminder of the way in which a
number of artists could cooperate in the various
stages of a single figure, or occupy themselves
with a single aspect of a series of figures sub-
stantially carved by someone else.[13] In such
circumstances an apparent ability to name the
author of each detail of a work as complex as
the pulpit at Siena would be the reverse of
reassuring.

The new pulpit is octagonal, and the other
important departures from the pattern estab-
lished at Pisa are the substitution of figures for
the clustered columns at the angles of the casket
and the use, in all the narrative panels, of a type
of relief that was previously confined to the *Last
Judgement*. Simultaneously the plain mould-
ings, particularly those above the reliefs, have
given way to classical cornices of such com-
plexity that the broken surfaces of these purely
architectural features blend with those of the
narrative scenes. Instead of sculpture clearly set
within an architectural framework, it almost
looks as if a tapestry of figures has been stretch-
ed around the upper octagon. Here sculpture
provides its own articulation, and the whole
could be described impartially as sculptural
architecture or architectonic sculpture.

The increased size of the pulpit, essentially
linked to the greater scale of its surroundings,
and the extended use of figure sculpture go hand
in hand with a greatly enlarged iconographic
programme. The *Massacre of the Innocents* is
added, and the *Last Judgement* now spreads
over two whole panels and their flanking
figures, the intervening angle being filled by
that of Christ. The tapestry-like impression
therefore reflects an actual flowing of the nar-
rative across the architectural framework. At
the base of the central column the figure of
Philosophy now appears, accompanied for the
first time in the history of Italian sculpture by
the seven Liberal Arts.[14] The symbols of the
highest achievements of the mind of man are
thus united with the spiritual qualities, the Vir-
tues, that enable him to attain to the salvation
proffered by the sacred histories.

The tapestry-like quality would have been
significantly intensified by the original colour-

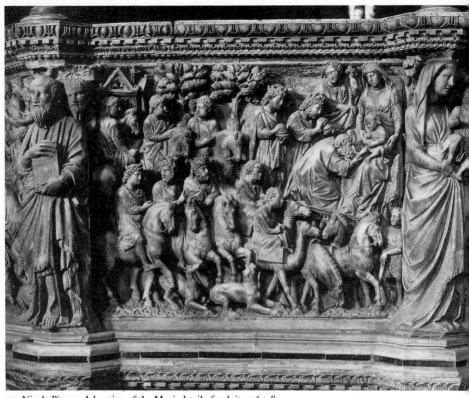

43. Nicola Pisano: Adoration of the Magi, detail of pulpit, 1265–8.
Siena, Duomo

ing of the sculpture, once again combined with richly patterned, glazed backgrounds. Here, however, it seems likely that full polychromy was no longer used and that the colouring of the drapery was confined to the gilding of many of the details, such as hem-lines, and possibly the painting of the drapery linings, where they show, much in the manner subsequently common in French ivories. Whereas at Pisa the carving of decorative fringes was the exception, here it is the rule, and this apparently reflects the change in method indicated by the surviving traces of colour. Despite the great increase in numbers and the decrease in the scale of the figures in the reliefs, continuing the process

evident at Pisa, the interest in high finish and in the virtuoso carving of tiny details is if anything intensified.

A comparison of the *Nativity* or the *Adoration* [43] with the corresponding scenes at Pisa [39 and 40] shows that the reliefs are no longer predominantly held together by the creation of an architectonic compositional structure. Instead, it is the very tension of the unified relief surface established by the closely packed figures that does the work. At Pisa the surface undulates and surges with the subject matter. Here, in spite of the great depth of cutting and undercutting in the narrow interstices, there is an even honeycomb surface. It is the latter that

prevents the multiple narrative of the *Nativity* from falling apart into its separate fragments, although the reclining Virgin is so reduced in relative scale that the central episode no longer dominates and unifies the panel through its sheer mass, but only appears as the first among a group of now quite carefully separated equals.

The new relief style, developed from that of the Antique battle sarcophagus and foreshadowed in the Pisan *Last Judgement*, permits a fresh expansion of descriptive naturalism. Whereas the Pisan *Adoration* typifies an approach in which there is comparatively little distinction between the actual carved depth of the relief and the space that is supposedly represented by it, the two things are practically unrelated in the corresponding scenes at Siena. Although the two episodes of the Journey and of the Adoration of the Magi are here combined, and although the scale of the figures is related to their importance rather than to their spatial position, the discrepancies have become so small that the filling of the entire surface with tiny figures begins to suggest the existence of a steeply inclined but continuous ground plane. Both its continuity and its considerable depth, however modified by the relatively small area of patterned ground that would originally have been visible, are emphasized by the back-turned figure riding inwards and upwards on the extreme left. The new, pictorial form of high relief, which allows not merely representative figures but a cavalcade in its entirety to be shown, is accompanied by an all-pervading liveliness of realistic detail. This interest in the appearance of the particular is such that in parts of the *Last Judgement* the borderline between figure types and individual portraits is on the verge of dissolution.

An increasing desire not merely to symbolize an eternally significant event but to tell a particular human story with as much incidental detail as possible is one aspect of the opening of a new chapter in the history of ideas. Already in the first half of the century Albertus Magnus, who was for a time the master of St Thomas Aquinas, shows again and again in his treatises on plants and animals the special value that he places on personal experience and on personal proof. His determination to deal in detail with particular plants and animals marks the rebirth of descriptive science and, in the case of animals, is accompanied by a first few crude but truly purposive experiments, as when he ascertained for himself that ostriches would not, as was asserted, eat iron, although they would readily accept stones or chopped bone. This constitutes a break with the philosophical tradition of dealing solely with general characteristics, with universals, and of ignoring the peculiarities that are inseparable from the individual. Albertus himself apologized for this departure from the Aristotelian and Platonic practice that he followed faithfully elsewhere. He none the less persisted in his innovations. It is probably at a later date that he declared that 'it is not enough to know in terms of universals, but we seek to know each object according to its own peculiar characteristics, for this is the best and perfect kind of science'. It is the false dawn that precedes the modern age of scientific experiment, and a whole new complex of ideas is codified by Roger Bacon in his discussion of the 'experimental science' which, in its new, independent role, plays such an important part in the Opus Maius. This was the work that he completed in Paris in 1266 while Nicola, in Siena, was beginning to give shape to the pulpit that reflected and in its own way encouraged this same changing attitude to the world of nature.

In Nicola's case the rapidly increasing tempo of his exploitation of the new climate of ideas is inseparable from the completion, in the space of five short years, of an almost dramatic transference from an Antique classical to a fully Gothic ideal of the human figure. Although reflections of Antique art still abound in the new pulpit, the changed attitude may be summarized by comparing the remote, impassive goddess of the Pisan *Nativity* [39] with the majestically human *Madonna and Child* at Siena [44]. Here flesh replaces marble, and the sculptured drapery has become a heavy-hanging,

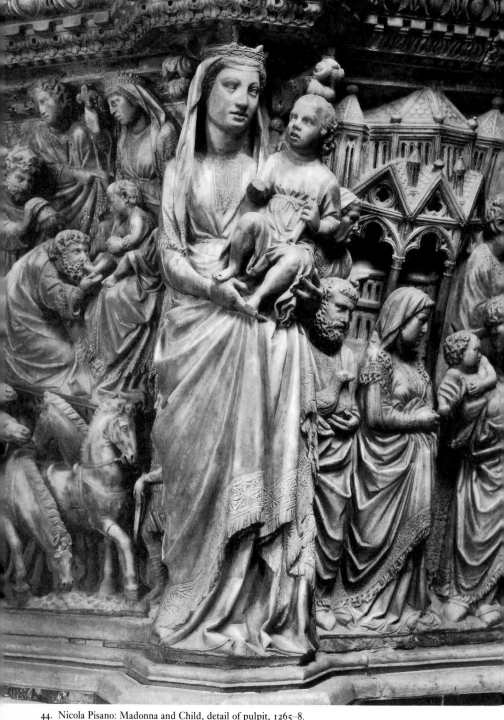

44. Nicola Pisano: Madonna and Child, detail of pulpit, 1265-8.
Siena, Duomo

softly textured cloth. The folds are richer and more deeply cut, yet they reveal the living forms beneath more clearly. Whether here or in the palpitating figure of *Humility*, the patterns of the draperies unfold in space, leading the eye more surely round the body.[15]

The implication in these most complex of the Sienese figures that side as well as frontal views are possible marks a development from the Pisan style, although it is true that the promise is only partly fulfilled. In the seated *Virtues*, on the other hand, in which the block-like form of the lower parts is a continuation of the structure of the capitals below, there are no satisfactory side views as a whole. Below the waist the patterns of the folds upon the separate faces are almost as divorced as if applied to the surfaces of an actual cube. It is, however, symptomatic of a changing attitude that in the *Crucifixion*, which appears to have been largely carved by Nicola himself, the repeated patterns of the folds in the figures of the Virgin and St John retreat diagonally into space, whereas the similar, repetitive complexes at Pisa lie predominantly on the surface.

Whether in these same figures in the *Crucifixion* or in those of the almost free-standing *Virgin and Child* or the *Humility*, the full and firmly articulated body is seen by Nicola as the cage of new emotions which, for all its strength, it is at times unable to contain. The physical and emotional range of this new realism is extended to the full in the fierce tumult of the *Massacre of the Innocents*. The startling powers evoked by the new subject represent no more than the extreme of tendencies that can be seen throughout the pulpit. Neither in spirit nor in technique do there appear to be sufficient grounds for a substantial attribution of the scene to Nicola's teen-age son. Sometimes, as in the angle figure of the Apocalyptic Christ, so reminiscent of the Beau Dieu of Reims and Amiens, the connexions with French art appear to be explicit. Even where no such detailed stylistic parallel is apparent, the whole of this new human realism seems to be intimately linked to the achievements of the French sculp-tors. Unfortunately, the word Gothic all too often conjures up a vision of swaying unreality and charming, weakly articulated figures that is typical only of certain aspects of Late Gothic art. The outstanding characteristics of the classic period of French Gothic sculpture, as it appears between 1220 and 1250 in the side porches at Chartres and in the west portals at Amiens and at Reims, are a simplicity and an accomplished realism in draperies and bodily forms that are expressive of a warmly human spirituality. It is no surprise that at this particular moment the French artists also often build directly on an Antique basis.

If the idea that the driving impulse behind Nicola's artistic borrowings was a desire to bring new realism into sculpture be accepted for a moment, the fundamental reason for his almost dramatic conversion to a new ideal becomes clear. The pagan Antiquity upon which he drew at first, infused as it was with a spirit largely alien to its new surroundings, could only carry a medieval artist, whose whole work was centred on the portrayal of the life of Christ and the embodiment of his doctrines, so far and no farther. French Gothic sculptors, on the other hand, had already succeeded in giving body to a new, intensely human vision of Christian spirituality. With their aid Nicola could give new psychological dimensions to his realism. The swift transition to fresh models is in fact no volte-face, but another aspect of that steady growth in understanding and ambition which is reflected in Nicola's sculpture as a whole and in the Siena pulpit in particular.

The precise nature of Nicola's contact with French Gothic sculpture is not clear. Although such meetings cannot be documented, he may have met French sculptors in the south or travelling through Tuscany. The rapidity with which artists traversed Europe is attested time and again, and he may himself have journeyed into France, though no such travels can be proven. In any case he would undoubtedly have seen French manuscripts and portable works of art of every kind, although, oddly enough, ivories, which might seem to be the

most obvious way of transmitting a knowledge of French sculptural form, would probably not figure on the list at such an early date. It is not always fully appreciated that French ivory-carving to all intents and purposes died out in the twelfth century. The total number of surviving Gothic ivories of all kinds that can reasonably be dated before 1260 is in the neighbourhood of twenty. Even when full allowance has been made for losses, it is therefore evident that ivories were still rare when Nicola was working at Siena. It was only at the turn of the century that the ivory flood which now embellishes almost every large museum began to flow in earnest.

The readiness with which the thirteenth-century artists overcame the barriers interposed by distance is only matched by the ease with which, in the main, they passed unscathed through the political turmoils of the day. With characteristic Italian realism the ecclesiastical and civil authorities seldom allowed political or economic conflicts to impinge on their assessments of artistic worth. While Nicola was marshalling his small company for the Sienese commission, Charles of Anjou's force of thirty thousand men was moving south through Italy. At Benevento, early in 1266, Manfred, Frederick's heir and the new Ghibelline champion, was killed. A bare two and a half years later, the embers of the Hohenstaufen cause were scattered in the rout of Tagliacozzo. Nicola's work was barely finished when Ghibelline Siena was forced to come to terms and bloodily taken over by the party of the Guelphs. Yet, after a period in Pistoia in 1273,[16] the artist from Apulia who made his name in Pisa and Siena started work with his son Giovanni on a monument to the civic pride of the Guelph hill-city of Perugia.

THE PERUGIA FOUNTAIN

Although the hydraulic preliminaries reach back twenty years or more, it seems that the structure of the Fontana Maggiore, once begun, was rapidly completed [45]. In 1277 Bonin-segna, the Venetian hydraulic engineer, was called from his work on the construction of a fountain in the allied Guelph city of Orvieto to replace the original conduit with an aqueduct. His name, alongside those of Nicola and Giovanni, appears with that of the Benedictine Fra Bevignate in the rhymed inscription of 1278 on the lower basin of the fountain. The wording shows that Fra Bevignate, who was to be clerk of works of the cathedral at Orvieto for a time and finally the overseer of public works in Perugia, was the man in charge. Since all procurement would be in his hands, the record of payment for two parchments delivered to him 'causa designandi fontem' does not necessarily militate against the belief that the complex polygonal plan of the fountain, so reminiscent of the pulpits, is the work of Nicola Pisano.

Sited next to the Romanesque Duomo, which had yet to be replaced, and now overlooked by the massive Palazzo dei Priori [37], the fountain shows a sensitivity to architectural scale and composition that is typical of Nicola, though no surviving purely architectural work can reasonably be attributed to him. There is a wide, ground-hugging quality in its slow upward surge. The circling steps lead on through the twenty-five-sided polygon of the lower basin with its fifty architecturally framed low reliefs to the broad, column-supported second basin, the twelve plain concave sides of which are subdivided and articulated by figures. Then, finally, there comes the heavy central bronze column and basin with its caryatid crown. The weightiness of the main forms is offset by the interchanging roles of architectural and sculptural elements, by the delicate pinks and whites of the marble, and by the rich plasticity of the carving that accentuates the spatial palpitations of the main drums. The intricate, off-beat interplay of forms created by the slight displacement of the expected two to one relationship between the polygonal basins reflects the original intention,[17] and the avoidance of exact correspondences encourages the onlooker to travel round the fountain. The point of rest at which a visual symmetry will be

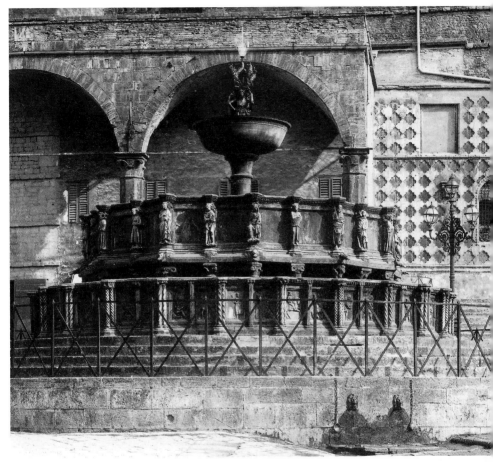

45. Nicola Pisano: Perugia, Fontana Maggiore, finished 1278

established is for ever round the corner, elusive, unattainable. A similar careful lack of correspondence spins the wheels of many of the finest Gothic windows, such as that above the twin doors of the upper church of S. Francesco at Assisi. There the radiating series composed of twelve, fourteen, forty-six, and finally, forty-four members, likewise ensures a constantly shifting relationship of part to part.

Although the idea of water falling from a cupped central shaft into a lower basin is exploited in the late-twelfth-century fountain in the cloister at Monreale,[18] no close prototypes for the Perugian fountain now survive. That inspiration was available in Central Italy seems to be proved by the many-fountained city of Viterbo, to which the Perugian authorities had sent for craftsmen. The angular Fontana Grande is dated 1279, and clearly represents a separate subdivision of the type. Its steps and simple main basin are cruciform in plan and sharp, spiky forms support the lower, lion-mouthed spouts that cluster round the base of the central column. The latter then swells into

a superimposed pair of four-lobed, clover-leaf basins. Like Nicola's fountain at Perugia with its progeny at Narni and Fabriano, the Fontana Grande inspired the whole series of smaller fourteenth-century fountains that embellish the often minuscule piazze of Viterbo.

It is not by visual means alone and for a purely visual purpose that the beholder is encouraged to pursue his orbit round the fountain at Perugia. Here for the reading is a new encyclopedia in marble, apt to its situation as the hub round which the city's life revolves. On the lower basin are the months, Philosophy and the Liberal Arts, the lion of the Guelphs, the gryphon of Perugia, a pair of Roman eagles, and scenes from biblical and Roman history and, not least, from Aesop's fables. Round the upper basin saints, kings, and prophets mingle with personifications of Lake Trasimene, the fishery, and of Chiusi, the granary of Perugia. The personifications of the ecclesiastical and civil aspects both of Rome and of Perugia are accompanied by heroic figures from Perugian history. It is typical of a new age that between Eulistes, founder of Perugia and hero of the turgid Eulistea commissioned some fifteen years later from Bonifacio da Verona, and the figure of Melchisedek, there proudly stand the effigies of Matteo da Correggio and Ermanno da Sassoferrato, respectively the Podestà and Capitano del Popolo of the year 1278, and the first Italian civic dignitaries to take their place in such a company.

This compendium is reminiscent of such works as Vincent of Beauvais's Speculum Majus with its natural, doctrinal, moral, and historical subdivisions. The frankly political element now apparent within the traditional framework is, however, symptomatic of the increase in the prestige of lay and civic organizations that accompanies the expanding power and commercial complexity of the towns. Although the inscription recognizes Rome as 'capud mundi', Perugia herself had recently, like a hundred other similar centres of every size, consolidated her own position as the centre of a universe in little.

For Perugia the third quarter of the thirteenth century was her time of triumph. Securely Guelph in her allegiance, closely associated with the victorious papal policy and yet substantially independent, her dominion over the contado and the surrounding smaller centres was unchallenged. The paving of the piazza and the construction of the aqueduct was accompanied by the determination of measures and the systematization of property and taxes. The growing prosperity was witnessed by the strength of the gold florin, rivalling that of Florence. It was probably in 1276 that the university was founded, to be followed three years later by the laying down of the Civic Statutes and the ensurance of further expansion through the establishment of the wool trade in the persons of the Umiliati recently expelled from Lombardy. Then, in the nineties the Palazzo dei Priori was enlarged [37]. It is this period of military consolidation and of economic, political, and intellectual expansion that Nicola perpetuated in a fountain.

The present extreme weathering of the sculpture was undoubtedly foreseen from the first. The outdoor position and constant exposure to the populace as well as to the water probably dictated the replacement of the intensively worked high relief of the pulpits by figures set in relatively low relief against a plain ground. Although this method was used for the Byzantine cycle of the months on the baptistery at Pisa, here reflected in the month of March, and in Romanesque cycles at Modena, Ferrara, Verona, Parma, and elsewhere, the final effect, in conjunction with the fluid, curvilinear draperies, recalls French practice. The flowing drapery style, somewhat modified in the broad, soft forms associated with the peasant labours of the months, but everywhere expressive of the constant activity of the figures, reaches its maximum complexity in the gentler though no less absorbing occupations of the Liberal Arts. It is an almost unimaginable journey of the mind that separates these supple, rhythmically moving figures from the formal world of the baptistery pulpit. Yet they lie exactly on the

course so clearly plotted at Siena. The knowledge of French prototypes that underlies the growing French flavour of the reliefs is confirmed by the gay May-time cavalier out hunting with his lady-love, and by the accompanying double-headed symbol of the Twins, a usage otherwise known only in French manuscripts. On the other hand the sense of power, characteristic of Italian sculpture in general and of the Pisani in particular, bursts through the softer forms of many of the reliefs and is apparent in a number of the angle figures. The latter betray a similar but more restricted range of drapery style and a corresponding divergence between those that maintain a block-like frontality and others that reveal the increasing awareness of three-quarter views which was already apparent at Siena.

The rhymed inscription shows that Giovanni was by now a fully fledged and independent artist. The words 'boni Johannis est sculptor hujus operis' beneath the pair of eagles even implies that these magnificent birds are his alone. Their vibrant energy is undoubtedly a presage of his later work. Beyond this point the division of labour between father and son is more conjectural, and is further complicated by the probability that many minor craftsmen assisted in the rapid execution of the work. There is no doubt, however, that the bronze group of caryatid figures that melt into one another at the summit of the fountain is both literally and figuratively the crowning achievement of its sculptural decoration. These figures are a technical accomplishment of the highest order, for unlike the column and basin, for which the normal bell-casting methods were used, they, like the lion and gryphon on the Palazzo dei Priori, were cast by the cire-perdue process. Except for the bronze figure of St Peter in the Vatican, this method, favoured for its delicacy by the Romans and Etruscans, was seemingly not used again until the fifteenth century.[19] Rubeus, the craftsman who signed the basin, Rosso, who in 1264 had signed the bronze ball of the cupola at Siena, and the Rubeus who signed the bronze architrave at

Orvieto, probably in the last years of the century, are possibly all the same man, and although his difficulties with the intricate cire-perdue process are shown by the thickness of the metal, Rubeus's efforts were not wasted. These solemn, graceful figures, clothed in a pure, soft-flowing version of the Antique peplos, are in their severe humanity a fitting climax to Nicola Pisano's life-work, for despite conflicting opinions on the matter they were probably substantially designed and modelled by the aged master himself. The Perugian caryatids do, moreover, stress the particular aspect of Nicola's art that underlies the work of Arnolfo di Cambio, the first of his great followers.

THE LUCCA DEPOSITION

Since no further documented or stylistically undisputed, partially autograph sculpture by Nicola survives, there remains, apart from the Arca di S. Domenico, which can most profitably be discussed in connexion with Arnolfo's career, only a single important and problematic complex to be related to the span connecting Pisa to Siena and Perugia.[20] This is the tympanum and architrave in the portico of S. Martino at Lucca, which is the sole surviving monumental composition from Nicola's immediate circle.

The limp figure of the dead Christ in the Deposition is brilliantly adapted to the semicircle of the lunette, and its pathos is emphasized by the contrast with the firm scaffolding of flanking and supporting verticals. The magnificent Romanesque tradition of wooden Deposition groups such as that at Volterra is characteristically enriched and bodied out. Apart from the sudden intrusion, in the figure on the extreme right, of a seemingly Lombard complex of folds that is otherwise unparalleled in Nicola's work, considerations of site, materials, and scale may well have affected the actual manner of the carving. Consequently the possibility that Nicola partly carried out a work that clearly stems, at first or second hand, from

his designs cannot wholly be excluded. Conversely, whenever an unaccustomed heaviness in handling is accompanied, as in this case, by a tendency on the part of some observers to call a work the earliest, and of others to place it among the latest, of an artist's surviving productions, the supposition that it is in fact a derivative work, at least in execution, is always greatly strengthened. In a town with a sculptural tradition as strong as that of Lucca, the presence during the mid thirteenth century of artists of sufficient calibre for such a task, though now unknown by name, occasions no surprise.

If the Lucchese *Deposition* recalls French sculptural achievements, the carving of the façade of Genoa Cathedral, dating from various periods up to the late thirteenth century, is almost wholly ultramontane in character. The same is true of the architectural and sculptural detail of the upper part of the façade of Ferrara Cathedral. Only the screen-form of the latter, with its three equal gables, is fundamentally Italian. Though German intermediaries are possible, the iconography, disposition, and type of relief in the elaborate tabernacle of the Last Judgement are all of them ultimately French in their entirety. Nothing is more revealing of Nicola Pisano's very different aims and achievements than the comparison with this presumably late-thirteenth-century sculpture in Emilia.

ARNOLFO DI CAMBIO

A seemingly straightforward account of much of the career of Arnolfo the sculptor appears in the surviving documents. They show that his salary as plain 'Arnolfo' and Nicola's assistant on the Siena pulpit was fixed as early as September 1265, but that in May 1266 a fine of 100 lire was hanging over Nicola's head if his subordinate did not immediately appear. The latter's arrival was, however, not too long delayed, as payments to him are recorded in 1267 and 1268. Ten years later, in 1277, a request by the Perugians for the release of 'Arnolfo de Florentia' from the service of Charles of Anjou was sent to Rome and quickly granted. This was so that he might work upon a second fountain close to the Fontana Maggiore, on which his former master was probably already employed, and in 1281 several payments to him were recorded. The next landmark is his signature, in S. Domenico at Orvieto, of the tomb of Cardinal de Braye, who is stated to have died in May 1282, although this does not of itself ensure that the monument was actually constructed in that year.[1] No such uncertainty bedevils the inscriptions of 1285 and 1293 establishing that 'Arnolfus' was responsible for the ciboria in the Roman churches of S. Paolo fuori le Mura and S. Cecilia, and these are followed in 1300 by the lost inscription on the tomb of Boniface VIII in the Vatican, in which he was apparently referred to as 'Arnolfus Architectus'.

Beyond this point the problems hidden beneath the placid documentary surface can no longer be ignored. The first is whether, since the documented sculptural complexes reveal a wide range of attack, the various Arnolfos are indeed a single man. The second is whether 'Arnolfo de Florentia' and 'Arnolfus Architectus' can be shown to be none other than the Arnolfo di Cambio of Colle Val d'Elsa who probably designed the Badia and S. Croce in Florence, and who, after a mention in April 1300 as capomaestro of the new cathedral, appears to have died in the period 1302–10.[2] Such questions can only be answered when a clear picture of the stylistic qualities and development of Arnolfo's sculpture has been established. The only reasonable course of action is therefore to begin the search for Arnolfo the sculptor in the first major documented and independent work which has substantially survived, namely the monument to Cardinal de Braye.

THE TOMB OF CARDINAL DE BRAYE

Of the surviving figures of the tomb of Cardinal de Braye, only two headless censing angels are not incorporated in the reconstructed monument [46]. Among those that are, the imprint of genius is perhaps most instantaneously visible in the two small acolytes that hold the curtains of the bier [47 and 48]. The acolyte on the left is poised upon the brink of motion, the lower part of the curtain clinging sheath-like round his thighs, revealing the position of the underlying forms, while the upper border falls away in a wide, deeply cut and shadowed opening. Dramatic emphasis is placed on the emergent volume of the upper part of the body, and no confusion is allowed between the clothing that is worn and the curtain that is held. The prismatic form of the folds and of the upper border of the curtain, the delight in the rich detail of lace and fringe, recall the Siena pulpit. Nevertheless, there is a combination of richness and severity, of easy naturalism and of classical economy, that opens a new chapter in the story of Italian sculpture.

This same confident articulation and sturdy naturalism of proportion mark the rapidly

46. Arnolfo di Cambio: Tomb of Cardinal de Braye, d. 1282.
Orvieto, S. Domenico

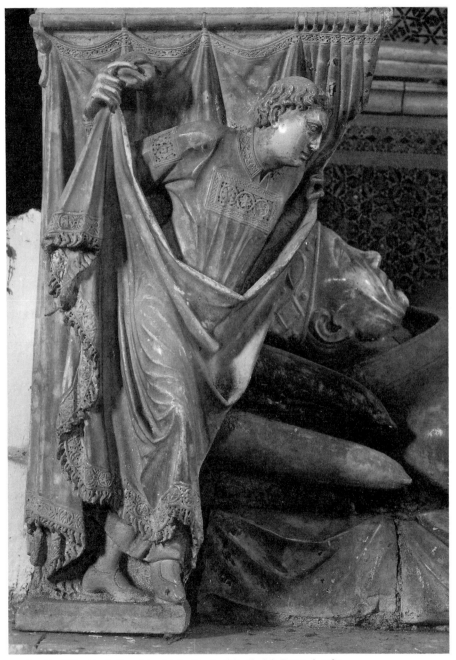

47. Arnolfo di Cambio: Left acolyte, detail of tomb of Cardinal de Braye, d. 1282.
Orvieto, S. Domenico

moving pendant figure in which the complex static volumes of potential motion are resolved and simplified in action. The liquefaction of the folds accelerates the movement of the solid, clearly defined underlying forms. The stiff, crystalline, and columnar folds of the cardinal's robes, the limp heaviness of his gloved and jewelled hand, provide the maximum of contrast in a drama that achieves its climax in the folds of skin drawn tight by death across the bony structure of the face [52]. The pair of acolytes that seemingly introduce a motif wholly new to sepulchral art are often referred to as merely holding the curtains, or as opening them for the benefit of the pious and the curious. In fact they are engaged in a much more solemn and significant ritual. A glance at the swift action of the right-hand figure and at

48. Arnolfo di Cambio: Right acolyte, detail of tomb of Cardinal de Braye, d. 1282. *Orvieto, S. Domenico*

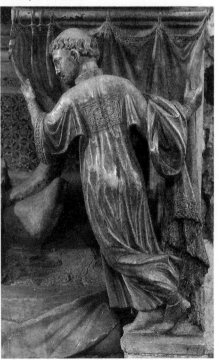

the direction of his movement shows that, having held the curtains open, both are now in the very act of drawing them together, closing before our eyes the final chapter of the dead man's earthly life. Immediately, he reappears upon the left on the next level of the monument, plump-cheeked and wide-eyed, eternally alive and prayerfully expectant of the glory he has earned. Presumably it is St Mark, his name-saint, who presents him to the Virgin, while St Dominic, the founder of the order to which he belonged and in whose church his earthly shell remains, adds intercession from the right. Above, half-smiling and majestic, sits a very empress of heaven with the welcoming Christ Child on her knee.[3]

The direct dependence upon classical sculpture in the figure of the Virgin, the intensified stylization and idealization of fold and feature alike, when compared with the lively naturalism of the earthly realm, appear more probably to reflect the symbolism of the subject matter, the eternal queen of heaven, than to indicate the extensive intervention of assistants, since the same sure sense of volume and of anatomical articulation underlies the ideal forms. The problem is more complicated in parts of the intermediate level, where a certain heaviness of hand does seem to reflect a watering-down of talent. On the other hand, in the figure of St Dominic, the dramatic contrast of void and solid made possible by the monastic cowl is fully exploited. The striking head emerges from the dark tunnel of the drapery in a way that echoes not only the acolyte below but also the earlier use of the same device among the blessed in Nicola's pulpit at Siena. The cramped proportions of these intermediate figures have, moreover, little attributional significance when they may merely represent a necessary adaptation to the demands of the original architectural framework.

Apart from the destruction of the lid or canopy above the effigy, which diminishes the intended interplay of light and shadow, void and solid, the lower half of the de Braye tomb appears to be substantially unaltered, with

traces of the original colour still surviving in the figures, and it seems likely that the whole was set beneath a Gothic canopy of the kind first seen in the tomb of the French pope Clement IV (d. 1268) [49] and reflected in that of Adrian V (d. 1276), which is likewise in S. Fran-

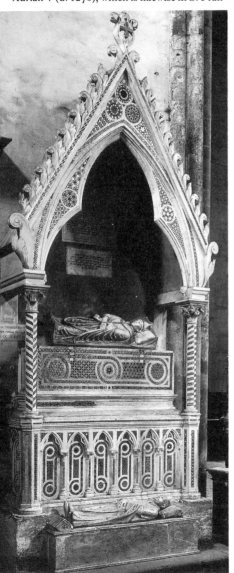

49. Pietro Oderisi: Tomb of Clement IV, 1271–4. *Viterbo, S. Francesco*

cesco at Viterbo.[4] All three tombs are ablaze with closely similar coloured marble and mosaic inlays, and are essentially a development of the type still current in the mid century and exemplified by that of Cardinal Fieschi in S. Lorenzo fuori le Mura in Rome, with its re-used Antique sarcophagus and its dedicatory fresco sheltered beneath a rectangular canopy similar to a Romanesque ciborium. The tomb of Clement IV is shown by documents to have been begun by late 1271 and finished by 1274.[5] A lost inscription stated it to be the work of Pietro Oderisi, who is conceivably identical both with the Odericus who in 1268 signed the inlaid marble floor of the sanctuary in Westminster Abbey, and with the 'Petrus civis Romanus' who signed the now largely dismembered shrine of St Edward the Confessor, probably in 1269. The inlaid marble decoration of these two tombs, brilliant with porphyry, deep speckled green, and red and black, dark blue and white and gold, is known as Cosmati work. Its smooth-running geometric patterns, equally at home on pavement, altar, tomb, and pulpit, were handed down from father to son in a small group of Roman workshops and survived almost unchanged from the early twelfth to the beginning of the fourteenth century.

Pietro Oderisi's combination of Gothic architectural forms and Romanesque decoration by no means represents the sum of his achievement. Gazing at the recumbent effigy of Clement IV [50], its boldly cut and firmly stylized draperies dominated by the magnificent head on which the simple, mitre-like tiara is jammed down to the jug-ears and almost to the jutting brows that overshadow the small, deep-set eyes, it is difficult to realize that this is the earliest surviving Italian example of such a figure. Recumbent effigies in high relief are found in the twelfth century or even earlier in Germany, and German examples may have given added impetus to the rapid development of the form in France in the first half of the thirteenth century, when it takes its place as the natural concomitant of the new urge to realism in the carving of the sculptured portals. On

the other hand, the lack of surviving Italian prototypes does not prove that none existed, for whatever knowledge of northern effigies Pietro

50. Pietro Oderisi:
Head of Clement IV, detail of tomb, 1271–4.
Viterbo, S. Francesco

Oderisi may have acquired if he was indeed but freshly back from a journey overland to England, there is little stylistic trace of it on the tomb of the French pope at Viterbo.

So vivid is the impression of life and character in Pietro's head of Clement IV that it is hard to believe that it is not a portrait likeness. The exhumation of 1885 even showed that pronounced frontal ridges were a feature of the dead man's skull.[6] It is therefore something of a surprise to find that the low forehead and unified sweep of the brow, the deep-socketed form of the eyes and the aquiline nose, the deeply furrowed upper lip, and many of the lesser elements of linear design, are charac-

teristic features of the dramatically stylized heads on painted crucifixes of the period. Indeed, considering the change in medium and purpose, as well as the difference in subject matter, the similarity between the head of Clement IV and that upon the *Crucifix* at S.

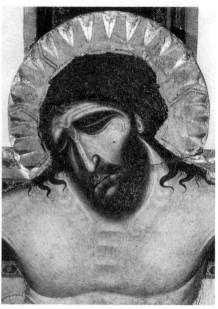

51. Coppo di Marcovaldo(?):
Head of Christ, detail of crucifix, late 1250s(?).
S. Gimignano, Pinacoteca Civica

Gimignano [51], probably painted some ten years earlier by, or in the circle of, Coppo di Marcovaldo, is quite remarkable.

A similar though more extensive modification of a studio pattern in the direction of portraiture appears to have taken place in Arnolfo's head of Cardinal de Braye [52]. The features are softer, fleshier, and less severely formalized than those of Clement IV, but many of the seemingly most individual elements, together with similar dry, angular folds in the draperies, recur in the imposing seated figure of Charles of Anjou which, on these grounds, seems to have been carved in Arnolfo's studio, possibly, although not necessarily, in the period

around 1277, when he is documented as being in Charles's service. The cardinal's long but slightly snub-ended nose, the dimpled chin, the deep lines to the corners of the mouth, and even, to a considerable extent, despite the prince's sternly magisterial expression, the general treatment of the mouth itself, are all repeated, while the treatment of the lids and sockets of the prince's eyes recurs in those of several of the smaller figures on the tomb. On the other hand, the change in the general proportions of the face, from the jutting rectangularity of the prince to the broad oval of the cardinal, is also clear. The stiffer and less human quality of the Angevin may well reflect its being an official figure. The pose is directly dependent upon that of Frederick II's statue on the Capuan Gate in Charles's new southern kingdom, and the derivation could hardly be more apt, for it was Frederick's political ambition and his interest in natural history that provided the first impetus for the movement towards realistic portraiture that becomes apparent in Italian sculpture nearly half a century later.

It is important not to read too much into the few early written references to portrait realism. To take the most clear-cut example, Villard de Honnecourt's sketch-book, dating from about 1240, shows not only the wide range of works of art that he sketched upon his travels but also the severe limitations of what he meant by drawing from the life. His lion 'contrefais al vif' owes far more to the visible geometry of its construction and to contemporary artistic formulae than it does to nature. In Italy the movement towards the creation of unique, if anonymous, sculptured individuals on a small scale is already visible in Nicola Pisano's pulpit at Siena, and this same changing climate of ideas appears to be reflected in the large-scale figures carved at Naumburg by the latter's German contemporaries. Although these German figures of donors are startling in their lively individuality, there is no possibility of any portrait relationship to the long-dead figures that they represent. It may seem to be but a step from vivid naturalism of this kind to an attempt

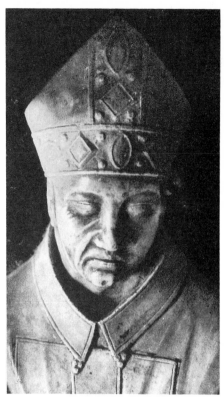

52. Arnolfo di Cambio:
Head of Cardinal de Braye, d. 1282, detail of tomb.
Orvieto, S. Domenico

to portray from the life the unique qualities of a particular, named person, but it is one that appears to have been a hundred years in the making. For all these qualifications, the impression of individual humanity created by the head of Cardinal de Braye remains one of the triumphs in the history of thirteenth-century Italian sculpture.[7] Finally, although Germany and not France was in the forefront of the similar developments in the North, it is perhaps not wholly coincidental that this new naturalism is connected with the effigies not only of a learned French cardinal and former archdeacon of Reims and of a French prince, but also with that of the French pope to whose

protection and patronage Roger Bacon owed so much.

Arnolfo's debt to Nicola Pisano in the de Braye monument can never be accurately assessed, as nothing is known of Nicola's possible activities as a tomb designer. What is certain is that Arnolfo, in turning the static wall-tomb into a stage for the enactment of the drama of personal salvation, was following directly in the footsteps of the man who had earlier completed a similar transformation of the sculptured pulpit.

Something of this same drama may also have distinguished the tomb of Cardinal Annibaldi della Molara, whose death in 1276 ended a career that had been intimately tied to the fortunes of Charles of Anjou. The remains of the tomb are now divided between the church and the cloister of S. Giovanni in Laterano, but an early drawing confirms that the severely simple effigy, lying with eyes closed, itself a dramatic innovation, was indeed backed by the surviving processional frieze of clerics, who are absorbed in various activities connected with the office for the dead. This type of relief is closely related to that found upon French architraves, and, quite apart from such works as the St Germer retable, is already present in the brilliantly original device of the mourners who surround the free-standing sarcophagi of the French tombs that were being carved from the mid century onwards. What is more, the general pattern is exactly that of the mid-century tombs of Bishop Martin Rodriguez and Bishop Rodrigo in the Cathedral of León, in an area noted for its French connections, and the Romanesque tomb fragments of the Porte Romane in the north transept at Reims confirm that Arnolfo's iconographic sources lay in France.[8]

It is primarily through these clerics, closely related to the de Braye tomb in facial type and in drapery cutting, that the connexion with Arnolfo can be established.[9] It is likewise against the canon established in the lower part of the de Braye tomb that the authorship of the three twenty-four-inch-high *Thirsting Figures*

and two '*Scribes*' in the Gallery at Perugia must be judged. Details of carving confirm that they are from Arnolfo's workshop, and there is no reason to doubt that they are fragments of the fountain for which he was paid during 1281.[10] The kneeling woman in particular is a masterpiece of dramatic economy [53]. The bulk of the figure and its concentration on its one desire – the plain smock taut to the point of tearing over knees and back – are reduced to their simplest terms. It is the stark embodiment of poverty and thirst. The second female figure, in which classical economy is replaced by an intricacy of pose that actually reflects a knowledge of the Antique river-gods, is possibly less moving, and the extreme anatomical abbreviations already noted in its companion-piece give way to some uncertainty in the treatment of the hips. Although such things may merely reflect the small scale of what were possibly minor elements in the scheme, it is likely that no more than a year or so separates them from the de Braye acolytes with their dazzling anatomical assurance. The extent to which these figures can be taken to add to our knowledge of the artistic personality of Arnolfo himself therefore depends quite simply on the weight to be given to such technical considerations in the face of their undoubted power to stir the imagination.

To reach yet farther back towards Arnolfo's origins, across a decade barren of all relevant landmarks, is to be plunged once more into the atmosphere of Nicola Pisano's workshop and into the problems that surround the execution of the Arca di S. Domenico in Bologna.

THE ARCA DI S. DOMENICO

At Pentecost 1265 the monks of S. Domenico asked their confrères at Montpellier for contributions to enable them to complete the Arca then under construction. The work had probably been set in motion in 1264 by Blessed Giovanni da Vercelli, the first prior of the Bolognese brotherhood, who was made general of the order in that year, and St Dominic's body was certainly translated to its new resting place

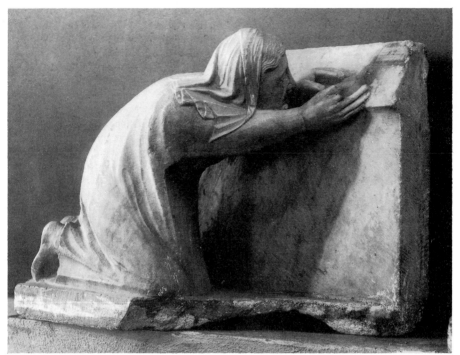

53. Arnolfo di Cambio(?): Thirsting Woman, *c.* 1281.
Perugia, Galleria Nazionale dell' Umbria

on 5 June 1267. Apart from a local literary tradition going back to the mid fourteenth century and connecting Nicola Pisano and his associate Fra Guglielmo with the work, there are reasonable stylistic grounds for seeing the Arca as a product of Nicola's workshop.

Of the tomb as it now stands, only the body of the sarcophagus, once supported by caryatid figures of cardinal virtues, archangels, and deacons, now dispersed in various museums, belongs to the original scheme.[11] The relief arrangement of the design, with the six scenes from the life of St Dominic and the history of the order articulated by standing figures of the Virgin and Child and of the Redeemer at the respective centres of each long side, and by the Doctors of the Church at the four corners, is essentially similar to that of the pulpit at Siena, which was probably begun less than a year later, the two projects being carried forward simultaneously. The composition of the reliefs on the Arca is, however, very different, being for the most part based upon the repeated verticals of figures standing approximately two-deep in regular rows. These ranks are gently agitated by the action into patterns that remain largely symmetrical even when two scenes are depicted side by side within a single panel. The large number of relatively small figures, combined with the even surface, means, however, that the relief style is as distinct from that of Nicola's Pisan as it is from that of his Sienese pulpit. Even allowing for the differing demands of the commission, Nicola does seem to have delegated most of the detailed work of design as well as the actual execution to his assistants, his personal contribution, once the architectural scheme had been established,

being apparently confined to the execution of a few characteristically superb heads.

Paradoxically, this relatively placid relief style is in some respects closer than any other product of Nicola's workshop to that of certain types of Antique sarcophagus. Conversely, the insistent boldness of the blood-red zigzag patterns of the almost perfectly preserved glazed pottery backgrounds constantly recalls the Gothic North.[12] It is no paradox, however, that this damping down of Nicola Pisano's fire produces a relief style that was to become far more widely influential, because more easily assimilated by the minor artists of the following century, than his most characteristic works of genius.

Taking Nicola's named assistants in ascending order of importance, and leaving aside the shadowy Donato, of whom nothing consequential is recorded, it is Lapo who remains the most insubstantial figure, since no signed or documented independent sculpture survives to form an anchor for his work before he fades away in a small sputtering of Sienese documents. These, after mentioning his presence in 1271, record him as a citizen in 1272, as an architect in 1281, and finally, in 1289, as supervisor of a demolition project. He is assumed to have been associated with a group of carvings centred on the Liberal Arts of the Siena pulpit and also including the two scenes on the front of the Arca, a charming seated *Virgin and Child* in Detroit, and, finally, the lower half of the holy water stoup at Pistoia.

The attribution of the stoup in S. Giovanni Fuorcivitas now to Nicola, now to Giovanni, now in part to Lapo, reflects its probable status as a work inspired by Nicola and carried out in his workshop soon after the completion of the Siena pulpit. Its mingling of severity and grace foreshadows the bronze caryatids at Perugia. Rising from their hexagonal base, the triple caryatid group of Faith, Hope, and Charity supports the busts of Justice, Fortitude, Prudence, and Temperance, opening out like petals to disclose the octagonal basin. The whole provides a simple foretaste of the complex, free relationship between the upper and the lower sections of the fountain at Perugia, although, as often happens, something that seems in a later work to reflect a purely aesthetic decision is first evolved in intimate, direct connexion with an iconographic programme.

The career of Fra Guglielmo da Pisa, the next of Nicola's supposed assistants on the Arca, gains substance through the pulpit, likewise in S. Giovanni Fuorcivitas, which is said to have borne his signature and the date 1270 [54]. The sculptor's fundamental conservatism is reflected in a return to the rectangular form of wall-pulpit popular before the advent of Nicola Pisano and exemplified in Guido da Como's work in near-by S. Bartolomeo in Pantano. The use of figure groups to support the three lecterns and the setting of the twelve scenes from the lives of Christ and of the Virgin in two layers also follow Guido's pattern. The style of the reliefs, on the other hand, depends entirely on the example of Nicola and his workshop. In composition and in carving it vacillates between reflections of the baptistery pulpit in certain scenes and of the Arca di S. Domenico in others, and in yet others hints at the more pictorial style developed at Siena. The Late Antique and Early Christian debt is acknowledged more openly than ever, but it is mingled with the powerful currency of Tuscan Romanesque in such a way as to exclude the possibility of understanding or exploiting the new coinage of French Gothic that so excited Nicola Pisano.

Of all Nicola's associates and followers apart from Giovanni, Fra Guglielmo is the one who most clearly revels in his technical dexterity. In some of the finest reliefs, such as the upper half of the double scene of the *Ascension* in which, appropriately enough, a vertical linkage replaces the horizontal continuity established at Siena, there is a wealth of undercutting, and similar tendencies deriving from the Romanesque tradition are charmingly reflected in the flock of birds, migrated from the pulpit at Siena, that now chatter in the right-hand of the two supporting capitals. This sculptural virtuosity

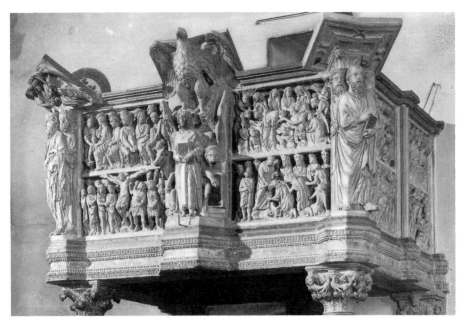

54. Fra Guglielmo: Pulpit, 1270.
Pistoia, S. Giovanni Fuorcivitas

was again enriched by the bold patterning of the backgrounds with heraldic lions, bears, and griffons, dark against the gold; by the glazed inscriptions, red on gold; and by the inlaid, Byzantine finery of ruby reds, deep reddish golds, and whites and greens that decorates the lecterns.

Although the details of design and carving in the pulpit confirm Fra Guglielmo's close relations with the circle of Nicola Pisano, the connexions with the Arca are more general than particular, so that his hand in it is even less distinct than that of Lapo. It is therefore doubly lucky that the detailed evidence for Arnolfo's participation is comparatively unambiguous, quite apart from the documentation of his delayed arrival in Siena. Although, since no other comparable reliefs by Arnolfo survive, there are no strictly logical grounds for ascribing the design of the more freely rhythmic panels on the back and sides of the sarcophagus to him, it may well be that it is to Arnolfo that

they owe their fluency. What is certain is that a number of figures, and even groups of figures, scattered throughout the series do appear to be connected to the canon established in the de Braye monument. The figure of the young Napoleone Orsini, so gracefully and so peacefully relaxed in his short sleep of death, and in facial type so surprisingly reminiscent of the acolytes of almost twenty years later, is especially noteworthy [55]. The most striking link of all, however, lies in the figure of St Dominic, upon whose prayer the miracle of reawakening depends. It is not merely in its psychological intensity of expression or in the tense pose of the body, but in the particularly vivid and characteristic play of volume and of light and shade as the expressive head thrusts out of the dark opening of the cowl, that this small figure shows its kinship with Arnolfo's independent work. Nevertheless, success in forging links of this kind in an attempt to trace Arnolfo's sculptural origins also underlines the

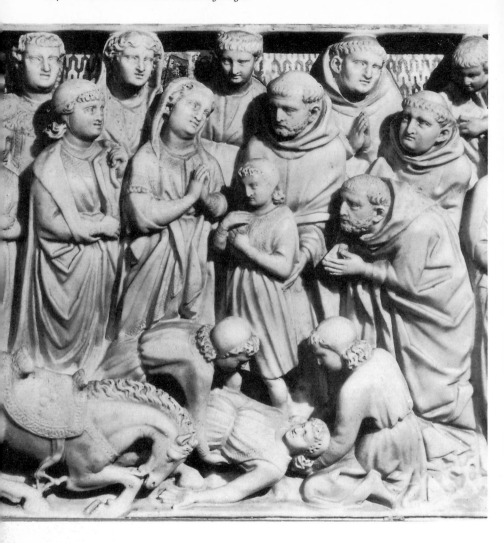

55. Arnolfo di Cambio: Arca di S. Domenico (detail), 1264(?)–7.
Bologna, S. Domenico

even greater difficulties that ensue in the Siena pulpit, where the influence of Nicola is much more powerful and more pervasive.

THE ALTAR CANOPIES
IN S. PAOLO FUORI LE MURA
AND S. CECILIA IN ROME

To move forwards from the de Braye monument, instead of groping back into the ever more uncertain past, is to return from the Pisa of Nicola Pisano to the Rome of Pietro Oderisi. It is even possible that the latter is referred to in the inscription 'Hoc opus fecit Arnolfus cum suo socio Petro' on the ciborium in S. Paolo [56]. This ciborium, completed in 1285, formed one part of the great scheme of redecoration on which Abbot Bartholomew was concurrently employing Pietro Cavallini with results that profoundly affected the course of Italian painting in the late thirteenth and early fourteenth centuries. But if the Petrus of the inscription is more likely to be Pietro Oderisi than Pietro Cavallini, the name remains a common one, and the style of the sculptor, as witnessed by the tomb of Clement IV [49 and 50], is no more directly reflected in the sculptural decoration of the ciborium than is that of the painter. It is a reminder that in the late thirteenth century surviving works should never be attributed solely, or even largely, on the grounds of their high quality or historical importance. But for the chance preservation of an effigy in Viterbo, no hint of the genius of Pietro Oderisi would remain, and only the further accident that a lost inscription has been recorded saves the surviving work from anonymity. When so much of the achievement and so many of the names in a period of exuberant artistic expansion are lost without a trace, the question 'who else could have done them?' never justifies the hanging of anonymous works like daisy chains about the necks of the few great artists whose name and fame happen to have been preserved.

In architectural terms the ciborium in S. Paolo is the supreme surviving example of what could be accomplished through the fusion of

56. Arnolfo di Cambio: Ciborium, completed 1285. *Rome, S. Paolo fuori le Mura*

the Roman Cosmatesque and Northern Gothic traditions. The profusion of spires and pinnacles, the crocketing, and the play of pointed trefoil arch- and niche-forms, do not disguise the four-square symmetry of plan, the essential rectilinearity of form, or the Cosmatesque flatness of detail. There is no continuous flow, no blending or interpenetration of part and part like that ensured by the elastic continuity of Northern columnar forms. Instead there is a careful separation of parts that is emphasized by the colour of the polished marble columns and of the glittering inlays and the gilded details set against the creamy, grey-white ground. It is this transmutation of the Gothic elements in a manner close in principle to that in S. Croce – this clarity within complexity – that allows the Gothic forms to harmonize with the smooth Roman classicism of the main and the subsidiary columns. The latter binds the canopy to the massive shapes supporting the uncompromising rectilinearities of the Constantinian basilica itself. It is typical of Arnolfo, as well as a further indication of the structure of his Roman workshop, which had probably been in existence at least since 1277, that a heightened sense of the Roman Antique heritage represented by this great fourth-century basilica should coincide with a new peak of enthusiasm for the Gothic forms of which he must have gained an intimate knowledge from the French architects known to have frequented the Angevin court.

The continuation of the trend towards the amalgamation of the Gothic and the Cosmatesque already seen in the de Braye and Annibaldi tombs seems to indicate that Arnolfo played a dominant role in the partnership as far as the architecture of the ciborium was concerned. The careful architectural containment of the figure sculpture, each of the four corner figures being carved in the round and set in the clear space of an open niche, appears to reflect the independent Arnolfo's characteristic concern for the interplay of void and solid. The relationship between figures and architecture also distinguishes his attitude from that of Nicola Pisano and his son Giovanni. For both of them the sculpture was the first concern, their figures readily overflowing or replacing the architectural members and subordinating them to the dramatic action. For Arnolfo, architecture could at times provide a stage for drama; but when it did, the figures were constrained to act according to the rules that it imposed.

Any assessment of Arnolfo's personal contribution to the carving of the figure sculpture is extremely difficult. Closest to the de Braye canon in its easy 'portrait' naturalism is the corner-figure of St Benedict, which even carries reminiscences of the Arca di S. Domenico. Elsewhere the technical and stylistic departures in the direction of a fundamentally Roman classicism are such that, in the light of an inscription stressing the collaborative nature of the enterprise, it would appear to be unwise to indulge in firm attributions.

The same is true of the signed and dated ciborium of 1293 in S. Cecilia in Trastevere [57], which also seems to have been included in a major scheme of redecoration largely carried out by Cavallini. Here Arnolfo's personal delicacy of touch may be revealed in the sensitive head of the aged pope with its slightly receding chin and scrawny flaps and folds of skin, but the draperies of this figure, and the modelling of the remainder, have a type of stiffness that again suggests a massive workshop intervention. The figure of St Martin riding forward, straight out of his niche, is, none the less, an interesting and unusual motif. Its earlier occurrence in very similar form in Castel del Monte seems to underline the extent to which the achievements of the sculptors who had furthered Frederick II's attempted re-creation of the Roman empire still remained a vital force in the late thirteenth century.

Apart from its diminished size, which may be a response to the less massive proportions of S. Cecilia, the most significant feature of this second ciborium is its definite return towards the Romanesque tradition exemplified in the stark simplicity of the eleventh-century masterpiece at Castel S. Elia. The main arches are

57. Arnolfo di Cambio: Ciborium, 1293.
Rome, S. Cecilia in Trastevere

hand, if Arnolfo the sculptor was indeed the designer of S. Croce and of S. Maria del Fiore during the nineties, an increased severity of outlook and a renunciation of the more extreme forms of Gothic excitement is exactly what one would expect of a ciborium dated 1293.

Although Arnolfo seems to have had little to do with the execution of the tomb of Boniface VIII, it is an impressive monument even in its present fragmentary state. There is a combination of severity and richness that is heraldic in its impact. The stiff, recumbent figure; the incised intricacies of sumptuous brocades and the stylized play of folds; the rhythmic freedom and the overall symmetry, must have produced a magnificent effect when the tomb still had its canopy and figure mosaic.[13]

THE SCULPTURE FOR THE FAÇADE OF THE DUOMO IN FLORENCE

A wholly appropriate climax to any discussion of Arnolfo's career is provided by the last great sculptural complex associated with his name: the figures and reliefs for the façade of the Duomo in Florence. Individually and as a group they are superb works of art, and whether taken as a group or one by one they also raise the problem of attribution in characteristically acute form. Although their former position on the façade is shown by a sixteenth-century drawing in the Opera del Duomo [58], no documents directly connected with them are preserved, and style is therefore the only guide.

The surviving fragments in which the connexions with Arnolfo's personal style as established in the de Braye tomb are perhaps most obvious are the reliefs of the *Angel of the Annunciation* and of an *Adoring Shepherd*, and the free-standing figure of the so-called *S. Reparata* [59]. In all three Arnolfo is recalled not only in the proportions and in details of the fold-forms and the like, but in the compact naturalism and solidity of structure and in the easy flow of movement that have been directly harnessed in the service of the spiritual and narrative drama. It seems typical of Arnolfo that the almost pure

now almost round. A purely classical wreath-and-ribbon motif emphasizes that the inset trefoil has become round-headed, while the visual effect of its shrunken and less pointed cusps is further diminished by their openwork design. The four simple pinnacles at the corners have become almost stumpy, and the multiplicity of subordinate vertical elements found in the earlier ciborium is eschewed. There is therefore little to offset the horizontal emphasis of the broad, low gables that replace the relatively steep equilateral triangles at S. Paolo. This reversion towards less strongly Gothic forms and proportions may well reflect the pressure of Arnolfo's workshop collaborators, since Grimaldi's drawing of the signed tomb of Boniface VIII, completed in 1300, reveals a naked conflict between the Romanesque base and the Gothic top of the canopy. On the other

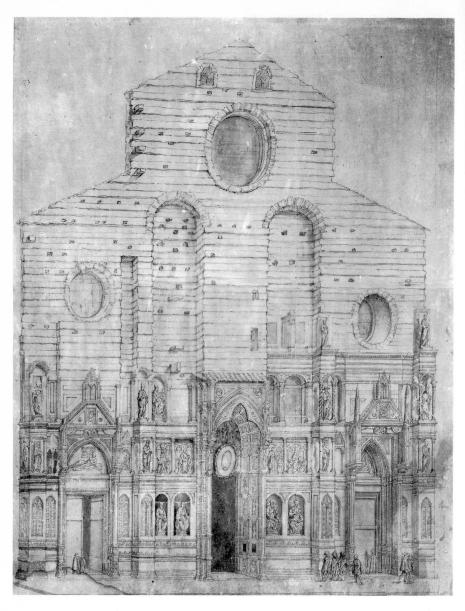

58. Drawing of the façade of the Duomo
in Florence, sixteenth century.
Florence, Museo dell'Opera del Duomo

classicism of the head of the *S. Reparata* should
paradoxically become a perfect vehicle for the
depth of Christian aspiration and emotion that
vibrates throughout this figure. The vivid, live

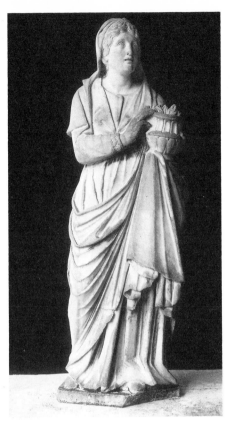

humanity of these works is further disciplined, intensified even in its impact, in the classically restrained Virgin and Mourning Apostle of the *Dormition* and in the reclining Virgin of the *Nativity* [60]. The second of these stylistically inseparable reliefs reflects Arnolfo especially clearly in the structure of the head and neck and in such details as the carving of the eyes. The recollections of Nicola Pisano's Virgin from the *Nativity* at Pisa are reinforced by the direct descent of the subsidiary relief of the *Annunciation to the Shepherds* from the prototypes established in Nicola's pulpits.

The artist's concern for the position and architectural function of the various pieces within the essentially flat pattern of the façade is vividly demonstrated in an oblique view of the reclining Virgin. This reveals a selective approach to the creation of solidity that is conditioned by the particular form of the relief. The head is presented as a fully modelled volume and the upper arm reduced to almost

59 (*left*). Arnolfo di Cambio: S. Reparata, by 1310.
Florence, Museo dell'Opera del Duomo

60 (*below*). Arnolfo di Cambio: Virgin, by 1310.
Florence, Duomo, façade

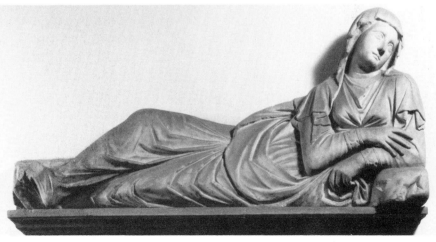

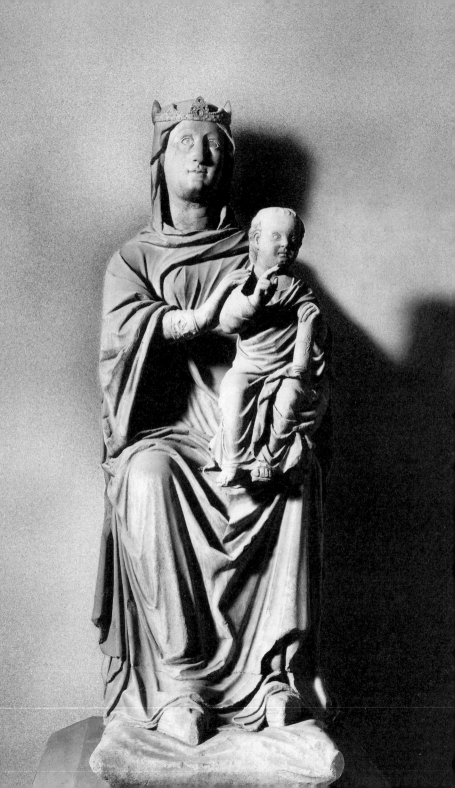

plank-like flatness in order to maintain the plane of the relief. Indeed, if there are any doubts about the extent of Arnolfo's personal share in this figure, it is perhaps significant that the pattern of the folds about the stomach and the apparent dislocation of the framed rectangle of the upper body resemble similar features in one of the figures from the Perugia fountain. Whenever there appears to be a deviation in detail from a strict canon of Arnolfo's style, the move is always towards the products of his own workshop rather than towards those of other shops deriving from Nicola Pisano, such as that responsible for the *Deposition* in Lucca, which foreshadows not only the placing but the monumental scale and emotional power, if not the austere discipline, of these later works.

The same is true of the massive seated group of the *Virgin and Child* in which the Roman and the Romanesque have been combined to form the basis for the creation of one of the great hieratic images of Italian Gothic art [61].[14] Designed for the deep niche above the central doorway, these are figures in the round. Volume is once again exploited to the full. A chasm opens where the arm lifts up; the massive column of the neck is dramatized by a dark sheath of space. The boldness in the undercutting brings out the easy articulation of the figures. This is as typical of Arnolfo as the sinuous sweeps and jagged crystallizations of the folds. For all the increased stylization and rigid simplification demanded by their function within the architectural framework of a vast façade, the sense of drapery as clothing, as something which can be removed – a separate material entity obeying the laws of its own nature, yet conditioned by the forms which, for the moment, it encloses and enhances and reveals – is just as striking as it was in the tomb of Cardinal de Braye [46–8].

61. Arnolfo di Cambio: Virgin and Child, by 1310. *Florence, Museo dell'Opera del Duomo*

The relatively firm enclosure of the sculpture by the architectural framework is in accordance with Arnolfo's conceptions, but the general relationship between the two arts as seen in this façade is new for Italy, and it is only within this wider context that the individual pieces take on their full meaning. The lunette above the central door was occupied by the Virgin and Child, possibly with St Reparata and St Zenobius, and four prophets filled the niches above and to either side. The tympanum above the left-hand door contained the *Nativity*, seemingly with the *Annunciation to the Virgin* on its left and certainly with the *Annunciation to the Shepherds* on its right. It is typical of Arnolfo's approach to the new principles of intercommunication seen already in his tombs that the shepherds, firmly set within their niche, once gazed and gestured to a splendid, distant star placed high up in the gable over the enclosing arch of the *Nativity*. Finally, the right-hand tympanum was reserved for the *Death of the Virgin*. This is as much as can be reconstructed of the sculptural decoration of the lower part of the façade.[15]

In its range and its coherence, and indeed in the actual design of the lateral tympana, this mariological programme represents an unusually close approach to the unifying schemes in several of the great Gothic cathedrals of France. In its predominantly pictorial tendencies, in the refusal to use figures as substitutes for major architectural forms, the sculptural pattern is, however, wholly Italian. In particular, the placing of reliefs beside the portals follows the tradition which had been established by the Romanesque sculptors of North Italy, but which was not at all uncommon farther south.[16] On the other hand, except in terms of iconographic unity, the contrast with Giovanni Pisano's scheme for the façade of Siena Cathedral could hardly be more extreme.

Although it is always difficult to make direct stylistic comparisons between sculpture and architecture, it can hardly pass unnoticed that nearly all the characteristics of the work of Arnolfo the sculptor throughout his career, but especially in its latest phase – the combination

of classical restraint and Gothic emotion; the intimate knowledge of Antique forms combined with an increasingly disciplined use of French motifs; the clarity of structure and the tendency to faceted forms and clear linear patterns; the sensitivity to massing and to movement; the tendency to subject sculpture to careful control by the architectural members within a unified and often dramatic iconographic scheme – all these might well be taken from the earlier description of the work of Arnolfo the architect. The conclusion that emerges step by step from these analyses is that the sculptor and the architect are indeed one man.

To trace the architectural development between the tomb of Cardinal de Braye [46–8] and the ciborium in S. Cecilia [57] is to be prepared for S. Croce and S. Maria del Fiore. To take in the swift-running line, the rectilinear framework and sure sense of space in S. Croce [9] with the crisp, octagonal clarity of its columns, is to sense the contrast and the homogeneity epitomized in the acolytes upon the tomb of the French cardinal. To move on from the planar discipline of the façade of the Badia [25] to the essential flatness and severity of incrustation that must have characterized the original façade of S. Maria del Fiore is to prepare the mind for the severe complexity of

form and richness of emotional content that find expression in the sculpture for the Duomo. If such imaginings seem over-fanciful, there is the comforting if prosaic fact that the search for some hint of the sculptor's personal style reveals that the ciborium of 1285, coincident in date with the foundation of the Badia in Florence; the ciborium of 1293, which coincides with the planning of S. Croce; and the tomb of Boniface VIII, erected while the Florentine Duomo was rising from the ground, all seem to be products of a highly organized Roman workshop and disclose a minimum of personal intervention by Arnolfo in their execution. The conflict of dates is therefore more illusory than real.

With the two complementary aspects of Arnolfo's genius finally united, his career, as it is seen through its few, rich remains, is that of a great sculptor who for twenty years expanded the horizons scanned by Nicola Pisano, and then proceeded to create in Florence an Italian Gothic architecture quintessential in its purity. It is the story of a man who died upon the threshold of achieving, in his plans for S. Maria del Fiore and its sculpturally unified façade, a final synthesis for which his whole life seems, if only in retrospect, to have been a continuous preparation.

GIOVANNI PISANO

It is in Italy in the late thirteenth century that, for the first time since Antiquity, the artist as a personality begins to re-emerge. For better or worse, the Christian anonymity of the medieval craftsman is slowly left behind. It is partly a real change, reflected in the production of new kinds of art; in the satisfaction and creation of new demands; in the beginnings of a rise in the social status of the artist; and in the gradual evolution of new attitudes to art and to each other by artist and patron alike. The apparent rapidity of the transformation is, however, partly an illusion, so that although the significance of these developments can hardly be over-estimated, their gradual nature must also be underlined. The distortion of the actual historical process occurs because with every passing decade of the thirteenth and fourteenth centuries proportionately more works by each artist tend to have been preserved, and what was once a barely perceptible trickle of documents and informative inscriptions speedily becomes a lively and varied, if erratic, stream.

Although these real and apparent changes begin to take on their full meaning in the career of Giovanni Pisano, Nicola's son and pupil, the limitations of the documentary rivulet remain only too obvious, despite its rapid growth. As with Arnolfo, the only logical stylistic anchor for Giovanni's sculpture is provided by a relatively late work: namely the Pistoia pulpit, signed and dated 1301. The results attainable in this case are, however, much less controversial. It therefore seems to be reasonable, as well as convenient, to follow his career in approximately chronological order.

Giovanni's signatures on his pulpits at Pistoia and at Pisa show that he was born a Pisan, and the first documentary reference to him is in Nicola's contract for the pulpit at Siena in 1265. The permissive wording and the payment of his salary to Nicola on his behalf imply that he was still in his teens. In such a situation it is impossible to say whether such few resemblances to his independent productions of twenty or even thirty years later as do occur upon the pulpit are evidence of his personal contribution, recorded in numerous payments of 1267 and 1268, or whether they merely represent those aspects of his father's work that fired his own imagination while he was engaged in mastering every detail of his trade.

Ten years of documentary silence follow before the mention in the main inscription of 1278 on Nicola's fountain at Perugia is accompanied by Giovanni's personal signature beneath the eagles on the lower basin. A fairly close relationship to the Ecclesia Romana on the fountain means that the unsigned, undocumented half-length group of the *Virgin and Child*, now in the Camposanto at Pisa, probably belongs to this or to the immediately succeeding period [62]. The soft draping of the head-dress round the neck, foreshadowed in the figure of Humility on the Siena pulpit, calls to mind such French works of the later sixties as the figure of Constance d'Arles upon her tomb in St Denis, particularly as the Virgin's crown is also based upon French types. The half-length figure is, however, common in Italian painting from the mid century onwards, and something close to a three-quarter length had already been exploited by Nicola and his shop in the figures for the pinnacled arcading of the baptistery at Pisa. The originality of the new group therefore lies in the tender, smiling intimacy that unites the child to its half-serious mother. The three-quarter poses of the heads allow of a rich spatial play for such a simple group, and that of the Virgin is particularly striking in its clear-cut planes and boldly modelled masses. The

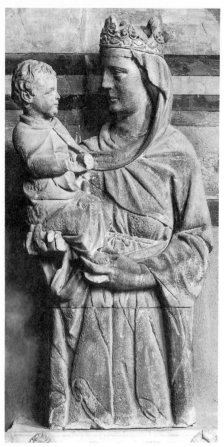

62. Giovanni Pisano: Virgin and Child, c. 1280.
Pisa, Camposanto

emphasis on the round volumes of her hand is taken almost to extremes, and everywhere the underlying forms are firm and clear beneath the lively pattern of the drapery. There is a simple-seeming subtlety throughout. The rocking rhythm of the folds combines with the firm, rectangular structure of support and with the formal reinforcement of the psychological intimacy by the sweeping, natural curve of the head-dress, linking with the infant's arms and cunningly continued in its cloak. Particularly when the spurious impression of flatness

induced by the modern base is overcome, it is anything but certain that this work precedes the fountain at Perugia, as is normally assumed.

THE FAÇADE OF SIENA CATHEDRAL

A document of 1284 confirms that Giovanni was working in the Pisan marble yard between his sojourn in Perugia and his transference to Siena at some time before September 1285. By then he had already been granted Sienese citizenship, together with the immunity from taxation which was often part of a well-known artist's payment for his work. Since Sienese citizenship carried with it a residential obligation involving the relinquishing of his Pisan status, Giovanni must already have been engaged upon some major task. This was presumably the project for a new façade for the cathedral [63], but although he was certainly connected with the Opera del Duomo by August 1287 at the latest, it is not until July 1290 that he is referred to in any of the documents as 'caput magistrorum' – the man in charge. It must also be remembered that none of the documents in fact refer to the nature of his work for the cathedral, much less to particular pieces of sculpture. Nor is there any mention of his having designed the façade as a whole, though this does not exclude the probability that he did so. Indeed, so much is this a 'sculptural' façade, so intimately are the figural and architectural elements combined, that it seems better to discuss this phase of the cathedral's growth in a sculptural rather than a purely architectural context.

Excavation has shown that the line of the original, plain façade of the building, and even the width of the original doorways, are unaltered,[1] and the work on the new front seems to have been carried forward in two main stages. The first, probably in the late thirteenth and early fourteenth centuries, took the façade to the level of the top of the arcades above the lateral doors. The second, in the late 1370s, was chiefly concerned with the insertion of the whole of the existing central feature, including the great window.

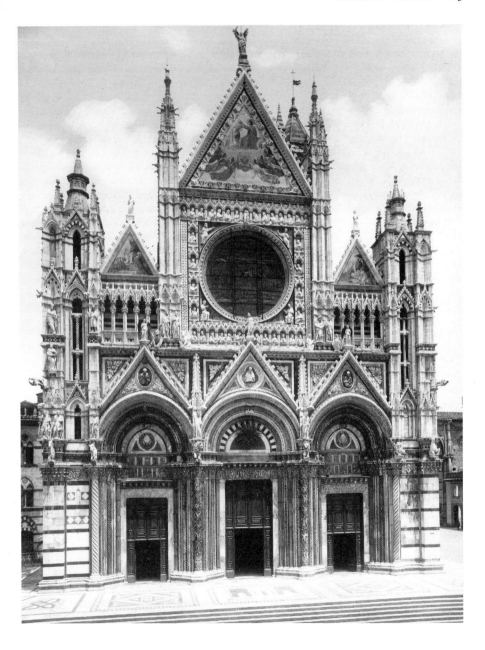

63. Giovanni Pisano and Giovanni di Cecco: Siena, Duomo, façade,
late thirteenth–early fourteenth centuries and late 1370s

As it stands today the façade is magnificent in its cream-whites, pinks and greens, yellows and reddish browns, and in the richness of the sculptural decoration that provides so fine a contrast to the simple, banded marble surfaces that clothe the body of the building and extend into the lower flanking zones of the façade itself. It is also something of an architectural puzzle. In the lowest zone the highly sculptured portals have been drawn together to form a mighty central group. Attention is drawn inwards from the simple wings, which subsequently, at the level of the architrave, appear to open out and to inflate with sculpture. What were initially simple walls with buttressed corners now develop into features that inevitably strike the eye as unified but asymmetrical flanking turrets in which all the weight is shifted to the outer edge. The dark void of the open window-niches is flanked upon the outer side by a richly articulated mass of masonry almost exactly twice as wide, and therefore twice as heavy, as its inner counterpart. This centrifugal tendency in the upper levels, despite the powerful pull of the great centrepiece, is aided and abetted by the fact that the verticals framing the central door are interrupted at the line of the main cornice, faulting outwards to continue in the piers that flank the central window. These upper piers, indeed, are insecurely set upon an architectural interspace and not upon a vertical support or even on the firm crown of an arch. Finally, a similar outwards shift is visible when the upper flanking pediments are related to the lower lateral gables. Planned vertical discontinuities are architecturally speaking rare, though not unknown. Where they do occur in Gothic architecture, as at Laon, they are normally concealed, and in a context such as this the displacement is unique.

The probable explanation lies in the original early-thirteenth-century decision to create a close-knit central group of three almost equal doors. This gave external expression to the approximate equality of nave and aisles in what was almost a hall church, but the flanking portals were consequently offset towards the nave and broke the general rule that the lateral doors should be aligned with the centres of their respective aisles. The relative diminution of the central portal meant that when the idea was bodied out in the late-thirteenth-century façade the piers between the doors were also shifted towards the centre and no longer represented a continuation of the nave walls. In Italy there is often little structural connexion between the façade and the body of a church, and even this attack on one of the few remaining links between the two would have led to no particular difficulties, since the roof of the mid-thirteenth-century nave would not have reached above the existing arcades over the lateral doors – arcades which seem on structural grounds to be a remnant of the late-thirteenth-century campaign. The portal zone of the façade reached almost to the full height of the church behind it. The upper part of the front would therefore have appeared as a free-standing screen-wall in the manner common in the Romanesque and Early Gothic churches of Lombardy and Emilia and also characteristic, in a locally varied form, of those of Pisa and Lucca. Since the whole main body of the church was already masked, the upper piers, like those below, could have been wholly free of structural connexion with the building behind and below them. There would have been no need for any dislocation of the verticals between the upper and the lower zones. It is consequently most unlikely that the original design in any way resembled the existing structure, as the narrowness of the central bay would have entailed an impossibly puny central feature. It is this, together with the unlikelihood of opening a central rose on to the void above the roof of the nave, which also excludes the possibility that the original design was a variant of the Pisan–Lucchese scheme, with a central mass supported by flanking triangular buttresses in the manner reflected in such late-thirteenth- and early-fourteenth-century frescoes as that of the *Mourning of the Clares* at Assisi and later adapted to the needs of the baptistery façade of Siena Cathedral itself [134].[2]

It is possible that in the original scheme, which is said in an anonymous fourteenth-century Sienese Chronicle to have been finished in 1316–17,[3] the existing intermediate arcading was carried right across the front, and highly probable that this was finally to have been crowned either by a single great gable, as in the cathedrals at Crema [150] and Cremona and elsewhere in Northern Italy (a pattern reflected on a small scale, after the turn of the century, in S. Caterina in Pisa), or else by a slightly stepped gable. The latter occurs both in North Italy and in Apulia, and, more significantly still, is a feature of that same Notre Dame la Grande at Poitiers which may have so strongly influenced the internal structure.[4] Some such unified form would explain the now disproportionately massive scale of the lateral turrets.

However important for the later history of Central Italian architecture, such matters are, of course, highy conjectural. What is certain is that when the existing upper façade was eventually completed in a period of great economic difficulty, following both the collapse of the Sienese banking houses, and the universal disaster of the Black Death, the nave had already been heightened. It therefore projected well above the level of the present arcades. In such a situation the existing solution, substantially following a pattern possibly first planned for the Duomo at Florence and later carried out at Orvieto, was the simplest and most economical way of completing the façade, of masking the obtruding nave, and of lighting the interior. That the ensuing dislocations were incidental inconveniences, as unconnected with late-fourteenth-century 'Mannerism' as they are with a non-existent late-thirteenth-century Mannerism, is shown by the complete avoidance of structural illogic of this kind in the various closely related façades that were planned or actually constructed during the later period.

The fact that the existing façade does not as a whole reflect the original project does nothing to confirm that any part of it dates back to the late thirteenth century. Still less does it prove

that Giovanni Pisano was the author of the subsequently altered design, and reasonably confident answers to such questions can only be given in the light of an analysis of the sculptural decoration. The programme seems to have revolved about the Incarnation, with particular emphasis upon the Virgin, after whom the church is named and who was celebrated in Siena not only as the mother of God but also as the governor of the city. It is, however, only in the portal zone that the surviving remains allow the reconstruction of the scheme with which Giovanni's name has been connected.

Immediately above the level of the lintels there are six half-figures of two horses and two lions, a gryphon and a bull, a grouping to which no precise symbolic meaning can at present be attached. Directly above them, in shallow niches that continue round the sides of the turrets, there were fourteen prophets and wise men and women of Antiquity, each with a scroll referring to some aspect of the Incarnation. Fortunately, despite the displacement of many of the figures before their removal to the Museo dell'Opera and replacement by copies, incised inscriptions on the façade itself record their original disposition. In the three niches on the side of the left, or north, turret were Haggai, a weakly constructed workshop production, seemingly in conversation with Isaiah (Ecce Virgo concipiet et pariet filium) and Balaam (Orietur stella ex Jacob). On the left of the front were Plato, looking straight ahead; a lost figure of Daniel; and, formerly, a Sibyl, probably the Erythrean (Et vocabitur Deus et Homo). Then, looking at each other across the central door were David and Solomon. On the right were once the figures of Moses and Joshua deep in conversation, and Habakkuk looking out towards the open square. Finally, on the flank of the right, or south, turret was Simeon, speaking to Mary, sister of Moses (otherwise known as Miriam), and to Aristotle.

As later in Arnolfo's Florentine façade, the distribution of the figure sculpture is such that, in accordance with the normal Italian practice and in contrast to the characteristic French one,

the jambs and voussoirs of the portals are left wholly free. More striking than the distribution of the figures, therefore, is the radically new conception of their function. In a typical French Gothic cathedral such as Amiens, the principal figures tend either to replace main architectural features like the columns in the jambs of the doorways, or else to be ranged across the façade like guardsmen, every figure rigidly within the architectural confines of its niche and all of them acting as enriched, but fundamentally architectural, features. At Siena, on ' the contrary, architecture has become a stage, a natural habitat in which cliff-dwelling figures walk and gesture, argue and discuss, crying their prophecies out across the architectural spaces. In French and German doorways two adjacent figures are often to be seen in quiet conversation, but such a general breaking of the barriers of architectural separation is unprecedented. The shrinkage of the niches at Siena into shallow, decorative background forms is everywhere exploited to the full in terms of figure movement, but the most startling imaginative stroke of all lies in the setting of the figures on the north and south sides of the flanking turrets. Here, two vestigial niches flank an unglazed, trefoil-headed lancet, not indeed a window, but a door into the dark interior of the tower from which the figures of Isaiah and of Miriam have come striding out into the sunlight with their message. Miriam, in particular, is still in motion, open-mouthed, head turned, vibrant with energy [64]. The only parallel, and that a distant if delightful one, is at Laon, where the herd of cattle that seems to have wandered up into the twin towers flanking the façade, to peer out in bewilderment across the town, evidently caught the fancy of Villard de Honnecourt as he passed through on his travels, towards the middle of the thirteenth century.

64. Giovani Pisano: Maria Moise (Miriam), between *c.* 1285 and 1297, *in situ. Siena, Duomo (now Museo dell'Opera)*

The subordination of architecture to sculpture at Siena is visible not merely in the figures moving freely on their ledges, but in the depth and richness of the decorative carving. The application of revolutionary principles, previously seen in tomb and pulpit, to the structure and decoration of a great façade is wholly consonant with the attribution of the scheme to a son of Nicola Pisano, and Giovanni's authorship of the figures is confirmed by an examination of the detail.

The broadly based, block-like form with its closed silhouette, and the relatively calm and static quality of the Erythrean Sibyl, recall the figures on the fountain at Perugia. The fold forms have naturally become more massive, but the general conservatism of the figure appears to show that it was one of the first of the Sienese works. The Plato and the Habakkuk, in which the tension in the gestures and the setting of the head increases and the open, speaking mouth is introduced, seem to complete this early group. The other pole of the development appears to be reflected in the clear relationship of drapery and body, the freedom from the block, the clear articulation, the complexity of movement, and the spiritual intensity of the Miriam, which, in each of these respects, is closely comparable to the seated Sibyls at Pistoia [68]. The late group, centred on this figure, almost certainly includes the Solomon, the Simeon, and the Moses. Certain distortions at Siena, such as the giraffe-like, forward-curving neck which thrusts the head of the Miriam into special prominence, or the unusually low-set knees of the David or the Solomon, seem to betray a desire to offset the effects of steep foreshortening in figures to be placed high over the spectator's head. These devices, which are positively startling in the figures now seen almost from eye-level in the Museum, have nothing to do with lowered standards of ability. Giovanni's growing concern with the effects of scale and height and distance, and with the need to make the figures tell against and dominate the sculptural and colouristic richness of their surroundings, is demonstrated both by the increasing stress upon broad gestures, sweeping movements, and powerfully characterized expressions, and also by the ever greater depth of cutting in the draperies and indeed by every detail of the figures. The breadth, the boldness, and the sensitivity that he finally achieved shine through the centuries of weathering which, but for a sense of structure rivalled only by that of Nicola or of Arnolfo and already comparable to that of Donatello or of Michelangelo in a later age, would by now have drained the life out of such heads as those of the Isaiah [65] or the Habakkuk.

65. Giovanni Pisano: Isaiah, detail of head, between *c.* 1285 and 1297.
Siena, Museo dell'Opera del Duomo

The seeming impotence of time and weathering and damage in the face of the very greatest works of art is nowhere better seen than in the gigantic figures carved by Nicòla Pisano for the

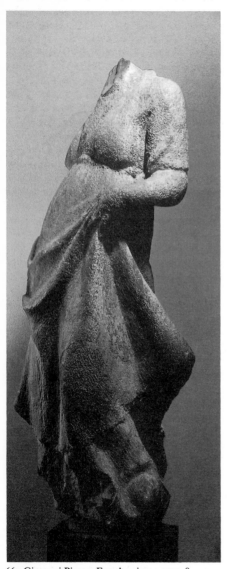

66. Giovanni Pisano: Female saint, c. 1297–8.
Pisa, Museo Nazionale di S. Matteo

gabled gallery on the outside of the Baptistery at Pisa, or in the now headless pinnacle figure of a female saint which Giovanni carved for it, seemingly after his return from Siena in 1297 [66]. This lilting, swaying, almost dancing figure with its firm structure and its sense of soft humanity is memorable indeed.

Even from these few indications it seems clear that, despite the silence of the documents, Giovanni's hand is to be seen in the design of all, and in the execution of the majority, of the Siena façade figures that have been discussed. It seems no less certain that however little of the façade may actually have been erected by the time of his departure in 1297, the architectural design of the lower half is inseparable from the planning of the sculpture that plays so unusual a role upon it, and therefore does indeed go back to the late thirteenth century.

The scheme of three almost equal arches, with the central one round-headed and the outer pair just fractionally pointed, follows a pattern imported from Burgundy by the Cistercians.[5] It is used in the late twelfth century in S. Clemente a Casauria, where it is also set within a flat, rectangular framework, and is later seen at Casamari and Priverno, also on one of the borders of Frederick's southern kingdom. The deeply carved central pair of columns with their inhabited acanthus scrolls seem, on the other hand, to reflect the similar features on the main door of the baptistery at Pisa. The architectural derivations therefore seem to be no reason for revising the attribution of the whole original scheme of the façade to Giovanni Pisano. Finally, for all the stress upon its sculptural quality, the architectural drama of the triple portals, towering above those entering the church and reaching almost to the roof of the building, gives some inkling of the things that might have been, in purely architectural terms, had the façade been finished to his plan.

For once the documents give some hint of the personal drama underlying the bare physical evidence of uncompleted work. Already by the end of 1288, less than four years after his arrival in Siena, Giovanni seems to have been deep in

one of those fierce professional rivalries which were as endemic in the medieval workshops of Italy as, upon a larger, bloodier stage, were civil strifes of every kind. In these the warfare between state and state, city and city, town and country, Guelph and Ghibelline, was threaded through with endless personal and family feuds and with the sharpening struggle between manufacturer and labourer which was now beginning to replace that of the noble and the merchant. Ramo di Paganello, the new rival, was himself apparently something of a stormy petrel. Banished for adultery, he had returned 'de partibus ultramontanis' in November 1281, and the hyperbolic description of him as 'de bonis intalliatoribus et sculptoribus et subtilioribus de mundo, qui inveniri possit' may partly be ascribed to the need for a convincing reason for his reinstatement. However that may be, not only Ramo himself but his brothers and his nephews were, in November 1288, to be assigned some 'good, beautiful, and noble work' on the cathedral, provided – and here, perhaps, the echoes of old struggles can be heard – that he did not interfere with Giovanni's work and that he carried out the latter's wishes. Unfortunately, nothing further is heard of him until he reappears in 1293 in the workshop at Orvieto, where, with the appointment of Lorenzo Maitani as capomaestro in 1310, he once more found himself in difficulties, this time seemingly not of his own making. Since no signed or documented work survives, it is no more than a pleasant fancy to attribute to him the four busts in high relief upon the inside of the lateral doorways of the façade at Siena, although the medallic purity of profile in the female head undoubtedly entitles it to rank among the masterpieces of the period.[6]

The hints of Giovanni's professional difficulties are followed by direct involvement with the law, for in July 1290 the General Council of Siena saw fit to absolve him, on payment of a fine, from a sentence passed by the Podestà. It is here that Giovanni is referred to for the first time as capomaestro and a man most useful and necessary to the Opera del Duomo. As is often the case where medieval, and not only medieval, municipal finances are concerned, the situation had its comic side. When, a fortnight later, the Opera was obliged to complain that without funds the work could neither be continued nor praiseworthily completed, the General Council's reaction was to assign them a total of 800 lire – exactly the amount of the fine that Giovanni had just paid! But even if Giovanni was at times engaged in paying his own wages, he was also able, in 1294, to buy a house hard by the Duomo. In August 1295, after a short visit to Pisa on business, he was elected, along with Duccio the painter and a number of minor men, to a commission to decide on the location of the Fonte d'Ovile in Siena, and in December he was out at near-by Bagni di Petriolo supervising the reconstruction of the fountain there, and being paid for exactly fourteen and two-thirds days' work.

Varied as were the tasks that a capomaestro was expected to perform, the troubles soon to burst about the Opera had more serious and deep-seated causes. Something of their nature can be gathered from the fact that between May 1296 and May 1297 it was solemnly decided that, in order to bring the work on the Duomo from 'a good beginning to a better end', the Nine Governors and Defenders of the Comune and the Consuls of the Guilds should elect a good, and legal, clerk of works who could read and write, since the present, unnamed occupant of the post could not, a situation which was causing considerable difficulty and damage. Worse was yet to come; for in May 1297 the General Council carried out a full investigation of the Opera and discovered that there had been no small confusion and loss of time and money. Large quantities of ready-worked stone were broken and unusable, and intact stones had been left lying about so long that they too were useless, as no one could remember what they were for! Indeed, the situation was so chaotic that unless the 'capomaestri or capomaestro and his associates' had collected all the material together inside the Duomo and carried the work forward more speedily and efficiently within

a month, they would all be open to coercive measures, not merely at the hands of the authorities of the Opera, but at those of the Council of Nine. Exactly how much Giovanni was personally held to blame, or how he succeeded in extricating himself from the increasingly dangerous slough into which the Opera had sunk, is not made clear. But whether he resigned with dignity or fled with ignominy, or was simply fired, he had made good his escape by December 1297, when he entered into an agreement with the cathedral authorities at Pisa.[7] Subsequent documents show, however, that he managed to retain not only his Sienese property and citizenship but also his immunity from taxation. Indeed, as is so often the case, it was very probably the reluctance of the civic authorities themselves to vote sufficient funds that was the root cause of the scandalous state of affairs which they then investigated with such indignation.

THE PULPIT IN S. ANDREA AT PISTOIA

It is only in the pulpit at Pistoia that the bite of Giovanni's chisel can at last be sensed unblurred by wind and weather and his measure taken in a major work directly comparable to those of Nicola and Arnolfo [67]. It is no surprise that Giovanni himself foresaw the inevitability of such comparisons. But it is perhaps a further indication of his character, and of the changing times, that he also took good care to see that his own views on the matter were recorded for posterity in suitably permanent form. The carved inscription on the pulpit, after giving 1301 as the year of its completion and recording the names of the donor and of the financial supervisors of the work, firmly declares that 'Giovanni carved it, who performed no empty work. The son of Nicola, and blessed with higher skill, Pisa gave him birth, endowed with mastery greater than any seen before.' So much for any undue filial piety.

If the tradition recorded by Vasari in the mid sixteenth century is correct and the pulpit took four years to carve, it must have been started immediately after Giovanni returned to Pisa. The debt to Nicola's first pulpit in the baptistery at Pisa [38] is as clear as that to its successor in Siena [42], still so fresh in Giovanni's mind. The hexagonal form and clarity of moulding of the baptistery pulpit are combined with the Sienese use of angle figures in such a way that the sculptural and iconographic richness of Siena, accompanied by a more violent scooping out of the relief in the main narrative panels, is given structural backbone through reevocation of the architectonic principles of the Pisan work. Whereas at Siena the contrast in scale between the reliefs and the intervening framing figures was minimized, since five of the eight angles were occupied by groups of figures, the largest of them sometimes less than two-thirds of the total height, at Pistoia only two of the six angles contain less than full-size figures. The way in which the framing figures at Pistoia stand out almost in the round, stressing the angles of the polygon and completing the strong vertical thrust that runs up from the supporting columns through the angle figures of the intermediate zone, accentuates the resulting contrast in scale. The impression of verticality, despite the boldly contrasted clarity of the horizontal mouldings, is confirmed by the slimness of the columns that support a casket greatly lightened in appearance by the depth of undercutting and by the introduction of sharply pointed trefoil arches to replace the earlier rounded type. The general delicacy and lightness of form reflects the Gothic tendencies of the day. It also harmonizes with the small scale of the church at the same time as it makes a lively contrast to the Romanesque simplicity and severity of its architecture.

The only major iconographic innovation lies in the accompaniment of the twelve prophets in the spandrels by three seated and three standing Sibyls. It is these latter figures which, despite the change in function and in scale, most clearly carry on and develop the achievements of the Siena façade. As Michelangelo remembered when he came to paint the corresponding figures on the Sistine ceiling,

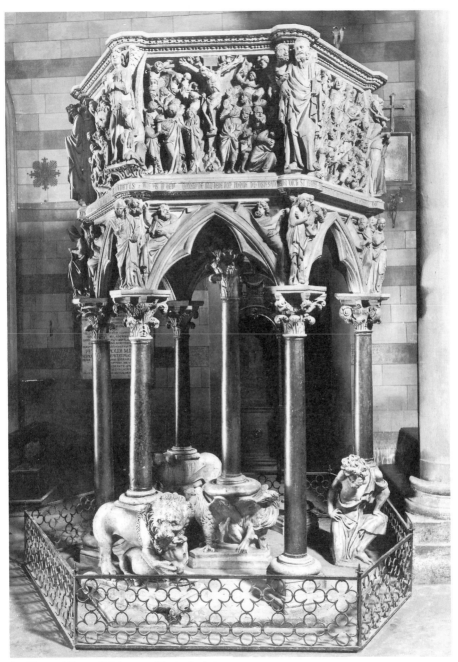

67. Giovanni Pisano: Pulpit, 1301. *Pistoia, S. Andrea*

each has its individual reaction to the prophetic message whispered by its hovering, attendant angel [68]. Intense spiritual communings seem to mix with human emotions ranging from a quiet humility and joy to a deep perturbation.

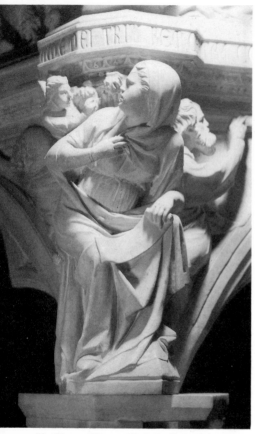

68. Giovanni Pisano: Sibyl, detail of pulpit, 1301. *Pistoia, S. Andrea*

They are expressed not merely in the subtlest sensitivities of modelling in the faces but in a wealth of movement which, as at Siena, gives corporeal substance to each shade of inner meaning. Now the earlier monumental gestures flower in complex, momentary, twisting motions. Moreover, the soft-flowing, rhythmic brilliance and variety of the draperies nowhere hide the sense of underlying anatomic structure upon which the whole of this new physical and spiritual world is founded.

His experience on the façade seems also to have freed Giovanni for a giant stride in the emancipation of the angle figures from the tyranny of the single viewpoint. Whereas the lower angle figures in Nicola's Sienese pulpit still confirm the basic frontality of the square-headed capitals on which they sit [42], those at Pistoia fully exploit the implications of the oblique recessions of the hexagons below [67 and 68]. Each figure has a carefully composed main viewpoint which, by its very nature, demands that the observer explore the equally rich and studied lateral views that open out obliquely upon either side. Seen for itself, each figure is the centre of a richly interacting, closed or open group that takes in the two prophets in the flanking spandrels. But if the observer, standing before the centre of an arch, turns to the right or left from his inspection of a narrative relief, he may well wonder if the lateral views of what are now the framing figures are not more beautiful and more important after all. Indeed, throughout the pulpit purely compositional means combine with glance and gesture to fuse the separate parts into a whole.

Despite the iconographic innovation of the Sibyls, the narrative reliefs confirm that Giovanni's originality lies in the treatment of his subjects rather than in their selection. As might be expected from the figures on the Siena façade, his every effort is devoted to increasing the humanity and heightening the emotional content of the scenes. In the opening relief [69], which shows the four scenes of the *Annunciation*, the *Nativity*, the *Annunciation to the Shepherds*, and the *Washing of the Christ Child*, and is therefore comparable to the similar reliefs at Pisa and Siena, the Virgin reaches out with fond anxiety to her child. The maid, who concentrates all her attention upon testing the temperature of the water, holds a kicking, apprehensive, weeks-old baby cradled in one hand, and not a stolid infant Hercules, symbolic of the godhead. The humble, tender joys of

human motherhood, invested with eternal meaning, have been taken as the dramatic essence of the scene of the Nativity – of God made man. The attempt to make the gospel story live before one's eyes; to see it as it might

truths, spearheaded by the ever-increasing army of the mendicants.

Reduced to its dramatic fundamentals, the preceding story of the *Annunciation*, as told by St Luke, is that of the arrival of an angel down

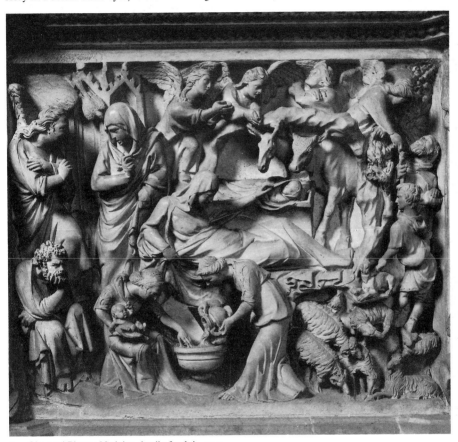

69. Giovanni Pisano: Nativity, detail of pulpit, 1301. *Pistoia, S. Andrea*

have been; to flesh it out with telling, homely detail and to tug at the heart-strings through the tenderness and suffering that it reveals; this has its literary parallel in the exactly contemporary Meditationes Vitae Christi of the Pseudo-Bonaventure. This manuscript is likewise a reflection of the growing power of the drive to popularize and humanize religious

from heaven, bringing joyous, overwhelming news to a young girl whose first reaction is of wondering fear. Where Nicola's interpretation is in terms of an imperial messenger, striding in with measured tread, whose proclamation to an empress-designate is greeted by a ritual gesture of inquiry and of grave surprise [39], Giovanni's angel rushes down in open-mouthed

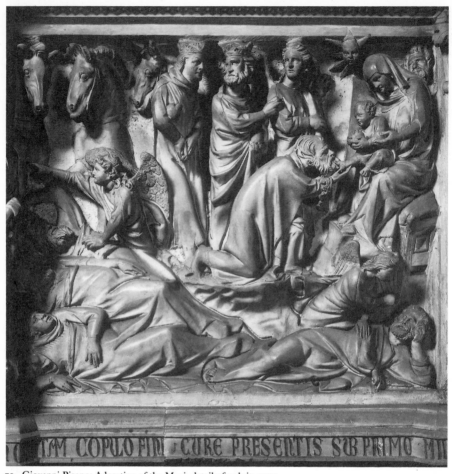

70. Giovanni Pisano: Adoration of the Magi, detail of pulpit, 1301.
Pistoia, S. Andrea

excitement. His wings are still aflutter overhead, and the momentum of arrival carries on into the startled recoil of the Virgin. Whereas in Nicola's angel anatomical description of his muscular, athletic build is thoroughly straightforward, the impression of excited movement in Giovanni's youthful messenger is heightened by distortion. The forward thrust of Gabriel's head on his long neck is quite impossible in relation to his shoulders and to the upright setting of his trunk. The turning back of Mary's wrist as she thrusts her hand in fear against her cloak is carried to the very limits of the anatomically possible, if not beyond them, and the same is true of the fond gesture of the Virgin of the *Nativity*. Extreme poses and actual distortions recur throughout the narrative scenes of the Pistoia pulpit and cannot be attributed to incompetence or studio intervention, or to the son's growing disinterest in the anatomical fundamentals so important to his father. Giovanni's interest and ability in this respect are

71. Giovanni Pisano: Massacre of the Innocents, detail of pulpit, 1301.
Pistoia, S. Andrea

shown, not only within the reliefs themselves by
the innumerable small, brilliantly characterized
figures, in which a wealth of complex movement
is described without distortion, but also by the
fact that outside the context of dramatic, nar-
rative scenes such liberties are rarely taken, and
then only in gestures that express extreme
emotion. The corner-figure of a Deacon, prob-
ably St Stephen, which, in facial type, in the
setting of its massive neck and shoulders, and
above all in its ease of pose, is so reminiscent

of Arnolfo's acolytes on the de Braye tomb of
almost twenty years before, reveals a structural
clarity and simplicity that, if demonstrated in
an extreme form, is typical of Giovanni when
there is no dramatic narrative to make him twist
and torture physical appearances for emotional
or spiritual ends.

Occasionally, as in the shepherd on the
extreme right of the opening relief, there seems
to be a decorative rather than an emotional
reason for the exaggeration or the dislocation of

a pose. More often in such cases it is a matter of a partial liquefaction, an extrusion rather than a dislocation, of the forms beneath the draperies. The beginnings of this process are visible in the leg and foot of the reclining Virgin and in the legs of the maiden pouring water, and it is far advanced in the succeeding panel [70]. There the rhythmic continuities created by the plastically flowing form of the limbs, not only of the sleeping Magi on the left, but more especially in those of Joseph lying on the right, require no further emphasis. It is, however, only within the complex decorative nexus of the narrative reliefs that such devices are exploited.

More surprising still, the reliefs on the Pistoia pulpit seem to show that it was not merely Giovanni's sense of line and structure that could be radically affected by the dramatic content of his subject matter as well as by its decorative demands. His handling of the chisel also seems to have been continuously varied in this way. The head of Gabriel, and the delicate detail throughout the joyful scene of the Nativity [69], the careful finish of the angle-figures of the Deacon or the Sibyls, together with the sensitivity of modelling in their heads, show that the value of Nicola's technical dexterity was not lost on his son, and this is everywhere confirmed by the unprecedented richness and variety of the undercutting. Yet, to move directly to the opposite extreme, in the emotional violence of the *Massacre of the Innocents* [71] Giovanni has dispensed with all the finish, all the delicate detail of hair and armour and tasselled drapery that is characteristic of the comparable scene on the Siena pulpit. The fully modelled infants have become crude, cubic block-forms. The direct furrowing by the chisel is left almost undisguised. Forms are suggested, not described or itemized. The extent to which Giovanni found his precedent for such expressive boldness in late Antique and Early Christian sarcophagi is revealed, not only by the many detailed echoes to be found in this relief, but elsewhere on the pulpit by such characteristic technical devices as the channelling that isolates the outlines of the

sleeping Magi in the *Adoration* [70].[8] This direct, impressionistic technique has nothing to do with the roughness of unfinished work, and is nowhere associated with the weaknesses that accompany studio intervention on a massive scale. Moreover, its selective use in scenes of extreme violence and tension seems to remove all doubt about its purposeful nature. It is a measure of Giovanni's astounding originality that not until the latest works of Donatello are such techniques again exploited, and then only in the more malleable bronze.

The germ of the evocative distortion in the angel Gabriel may well lie in the seemingly technically motivated dislocations in the necks of figures like the Miriam [64], designed to stand high up on a façade. Similarly, the deep drilling and bold undercutting which were probably evolved to make the distant figures tell against their background appear to underlie the eating out of the whole surface of the marble which so adds to the formal excitement of the pulpit at Pistoia. Now the figures stand out some two inches beyond the level of the frame as well as being cut six inches deep into the block. As in the Siena pulpit, the volume of the stone has been so fully utilized that only a mere skin survives to form the background. Though even the most violent gestures lie predominantly in the plane, the figures are so undercut that many of them are left almost in the round, the folds of drapery curving into depth and giving their full value to the volumes they enclose.

The drama of deep interspaces between forms in motion and of violently contrasted light and shade would originally have been intensified by the glazed backgrounds, of which many fragments have survived. The section visible in the Nativity behind the maiden pouring water has a bold design with green, and with large, brilliant, light red, patterned squares on gold. In the normal half-light of the Romanesque church these glazes would have showed as black, intensifying both the projection of the figures and the dark, suggestive quality of the depths behind them. In candlelight or in

reflected sunlight the strengthening cast shadows would have been accompanied by fitful gleams and flashes of rich colour, and only in the short time when the light was strong upon the panels facing the nave would space be flattened out, as in a manuscript illumination, by a clearly visible, patterned backdrop.

Apart from the inscriptions on the scrolls, the colouring of the figures was apparently reduced to a golden rimming of the edges of the draperies, the gilding of accessories such as crowns, and the painting of any exposed linings. Whereas the glazing of the background would actually have increased the broken quality of the play of light and colour, gilding of this kind would probably have accentuated the linear rhythms linking the figures across the intervening voids. Such linear, partial colouring, despite the discarding of the extensive carved fringes which in Nicola's work had probably marked its introduction, is fully consonant with French practice in the ivory diptychs that were becoming increasingly common in the final quarter of the thirteenth century. It is this pattern of gold edging and coloured linings, usually blue, against the natural, polished surface of the marble that predominates in the indoor sculpture of the early fourteenth century.

In spite of this accentuation of the linear rhythms, it might well seem that the violent movement in most of the designs, combined with the disruption of the even surface tension that unified the Sienese reliefs, must surely lead to compositional chaos. But if the relief style as a whole derives from the Siena pulpit, Giovanni seems to have looked to the pulpit in the Pisa baptistery for the means to control the forces that he was unleashing. In each design a solid compositional skeleton is clearly visible below the excited surface.

The swirling, womb-like patterns which cocoon the Nativity and Washing of the Christ Child are stiffened and enclosed on either side by an accentuated, vertical frame of figures [69]. In the most violent scene of all, the *Massacre of the Innocents* [71], the unified wall of figures of the Siena pulpit has become a surging crowd within a real, if undefined and steeply sloping space. Here Herod's sweeping gesture of command carries the eye down from the top right-hand to the bottom left-hand corner through a chain of action and reaction, swaying back and forth along the diagonal as mothers intercede and soldiers stride to the attack. A similar, less sharply accented diagonal of action and of high relief leads down from the top left-hand corner. The whole is further steadied by continuous verticals set, not only at the extreme left- and right-hand borders, but also at the centre, where a line of female heads in high relief completes the underlying symmetrical skeleton of this carefully organized scene of chaos.

The key to the formal analysis of the *Massacre* is Herod's gesture, which precipitates the whole dramatic action. This emphasizes the important point that with the great late-thirteenth- and early-fourteenth-century narrative realists such as Giovanni Pisano and Giotto, it is seldom possible to embark successfully on formal analysis except in terms of the essential dramatic content of the story. This was the artist's main concern and his own starting point.

Working on purely formal lines, as many patterns as there are observers tend to be put forward as the compositional basis of the *Adoration of the Magi* [70]. Verticals, diagonals, squares, circles, triangles, large and small, abound. Yet seldom do such exercises in the abstract manage to explain the odd fact that the normally emphatic central foreground is a total void. On the other hand, immediately the dramatic essentials of the story or stories – for three separate but connected episodes are shown – have been understood, the whole formal pattern becomes clear. The first scene shows the arrival of the Magi after their journey, and the adoration of the infant Christ. It is spread out symmetrically across the top of the relief, and the horses' heads provide a formal balance for the Virgin and Child about the triple vertical of the standing Magi and the angel. This symmetrical pattern makes a steady base for the acceleration from left to right,

expressive of arrival and culminating in the act of adoration. Continuity and balance are the keynotes of this joyful scene. Then suddenly, appearing in a dream, an angel warns the Magi sleeping at the lower left not to return to the murderously intentioned Herod, but to flee. His leftwards-pointing gesture makes a shape in marble of his urgent cry, while, in the far corner, a second angel points the opposite road and urges Joseph to escape the coming massacre and go down into Egypt. The formal symmetry of these two groups at the lower left and right expresses their essential similarity of content, while the seemingly inexplicable central void tells in dramatic, formal terms the whole explosive story of miraculous forewarning and of flight from hidden danger that succeeds the earlier joyful union.[9]

THE VIRGIN AND CHILD
FOR THE BAPTISTERY AT PISA

The structural clarity that underlies the emotional storms of the Pistoian work, and the ready adaptation of the lessons learnt on the vast reaches of the Siena façade to the small-scale problems of a pulpit for a parish church, prepare the way for the apparent contrast presented by the signed, full-length group of the *Virgin and Child*, now in the Museo dell'Opera del Duomo at Pisa [72]. This severely disciplined group was possibly carved while work on the pulpit was in progress, and its form is almost entirely conditioned by its intended position facing the cathedral in the shallow lunette above the main door of the baptistery. Only the single frontal view from the broad causeway linking the two buildings is at all important, and all the forms develop in one plane. None of the folds are made to circle round the body, and the whole pattern of the drapery is visibly complete upon the single surface. The hieratic treatment likewise seems to be dictated by its situation, and although the turning of the Virgin's head towards the Child betrays the emotional religious currents of the times, there is, for Giovanni, a minimum of

72. Giovanni Pisano: Madonna and Child, *c.* 1300(?). *Pisa, Museo dell'Opera del Duomo*

sentiment and a maximum of formal discipline. There is an almost schematic contrast between the pure profile of the Virgin's head and the stiff, frontal pose and full-face stare of the infant Christ as he gives his blessing to those entering the baptistery to be reborn into a new life of the soul. The figures are contained within a pair of almost perfect rectangles of which the smaller, bounded at the top by the Virgin's glance towards her Son and at the bottom by a powerful set of horizontal folds, concentrates the onlooker's attention. The lateral boundaries of the larger are accentuated by two series of vertical folds that are continued by the Virgin's arm on one side and by the infant Christ himself upon the other. Although the group of folds upon the right hangs from the hand supporting the figure of Christ, it becomes, in visual terms, a pyramid or pedestal that seems to bear the weight that actually rests upon the Virgin's hand and hip. As is so often the case, it is this calm and technically simple design, in which Giovanni's more personal characteristics are subdued as far as possible, that proved to be the most influential of his works. It is the one most readily understood and frequently copied by the minor men who knew his fame and feared his fire.

THE IVORY MADONNA AND CHILD

The range and contrast inherent in Giovanni's work is illustrated by the unsigned ivory *Madonna and Child*, once housed in a tabernacle over an ivory relief and accompanied by two angels,[10] which is still in the treasury of the Duomo [73]. The surviving figure is possibly, but not necessarily, that referred to in two Pisan documents of 1299 demanding the completion of a work in ivory, and this is a stylistically convenient date. The winsome quality of most of its French counterparts is exchanged for a grave monumentality. The breadth and simplicity of the head with its gentle half-smile recalls the early half-length *Madonna* in the Camposanto [62], while the grandeur of the sweeping fold-forms makes a virtue of the

73. Giovanni Pisano: Madonna and Child, *c.* 1299(?). Ivory. *Pisa, Duomo, Treasury*

unavoidable curvature of the tusk. It is the treatment of the figure, not its great size, for the group is almost two feet high, that begs comparison with monumental sculpture. Indeed, although many details, particularly of fold form, may be compared with those in a number of more or less contemporary French ivories, the closest parallel in France is not an ivory at all, but the startlingly similar full-scale *Virgin and Child* from the centre of the mid-thirteenth-century north transept door of Notre Dame in Paris. Even so, it is the ivory that has the greater weight and volume in its folds. In contrast to the Northern artist, who was not restricted by the nature of his medium, Giovanni has done his best to minimize the conflict between the anatomical demand that the lower shoulder and the standing leg should coincide and the physical fact of the curvature of the tusk. Normally he is careful to observe this fundamental rule of correct contrapposto, and one of the few exceptions is the signed *Virgin and Child*, accompanied by two workshop angels, which he probably carved about the year 1305 for the Arena Chapel at Padua. It seems as if this marble figure with its streaming folds and combination of formal restraint and delicate naturalism of detail was strongly influenced by his ivory-carving.

When it comes to the transmission of ideas in sculpture, the actual physical size of the works involved is often relatively insignificant. It is the conception that is usually all-important to the sculptor, and transpositions from small scale to large and back again to small are a commonplace. This is not to deny that a successful outcome may require great sensitivity in the artist, particularly where a mere increase in size without stylistic modification may magnify deficiencies that were relatively insignificant in the small-scale work. A predilection for the monumental is often said to explain the rarity of Italian Gothic ivories and the apparent lack of specialists of sufficient calibre to meet French competition in the medium. Certainly Giovanni's *Virgin and Child* appears to be numerically as well as artistically unique. It is,

however, hard to accept this explanation when, throughout the period, countless Italian goldsmith-sculptors were happily producing small-scale metalwork of the very finest quality.

Besides raising such general questions, Giovanni's ivory *Virgin and Child* inevitably draws attention to the problem of the nature of his own personal contacts with French art. Quite apart from things like the steady movement towards soft, continuous, curvilinear forms which connects Giovanni's sculptural development to the main contemporary stylistic trend in France, many examples of detailed similarities between particular carvings could be added to the few already mentioned. These links are not merely with works of the mid century and before, as was the case with Nicola. Several of the figures on the Siena façade, for example, are singularly close to others on the inside wall surrounding the main door at Reims. The latter seem to have been finished by c. 1260 and were probably being carried out in the late fifties. These figures are comparable to Giovanni's work not only in their formal details but also to some extent in their freedom of movement within the enclosing framework of their niches. Similarly the Deacon on the Pistoia pulpit has apparent connexions with French art not only through Arnolfo, but directly through the striking similarity to such figures as the angel with a chalice in one of the buttress tabernacles on the south side of Reims Cathedral.

The documentary silence in Giovanni's career between 1268 and 1277 provides a tempting opening in which to insert an apprentice's journey to the North, and there is a similar hiatus between 1278 and 1284. But even though such possibly fortuitous gaps in the record are unnecessary, since such journeys could be undertaken in a matter of months, there is no actual proof that Giovanni ever went to France at all, likely as such a visit may appear to be in view of the already centuries-old tradition of such expeditions to the North for budding or, indeed, established sculptors. How much of what he seems to have known of Northern art

may have been gleaned from manuscripts and panels, from small figures in ivory and in precious metals, and from the once numerous and now almost non-existent drawings of other artists, is only a matter of opinion. He could certainly have picked up far more information by such means than might seem probable from the relatively few surviving works. There, until new documents emerge, the matter must reluctantly be left, unless a part of the inscription on the base of his next major work, the Pisa pulpit, stating that 'Giovanni has encircled the rivers and the parts of the world trying to learn many things for no reward and preparing everything with heavy labour' is taken literally as referring to his travels. Although, in a medieval context, a metaphorical interpretation linking the four rivers and four corners of the earth to the figures of the four Evangelists and the four Cardinal Virtues supporting the pulpit might seem preferable on general grounds, the rest of the inscription favours the straightforward reading.

THE PULPIT IN THE DUOMO AT PISA

This, the last of the Pisani's pulpits, was commissioned in 1302 and was finished in December 1310 [74].[11] The two rhymed inscriptions are unusually revealing even for Giovanni.[12] The upper one contains, among other things, an oblique reference to the mounting factional struggles that were rending Pisa as its military and commercial power continued to decline, and confirms that Giovanni worked in wood and gold as well as in marble. It also states that Nello di Falcone 'exercised control not only of the work but also of the laws which governed it'. This is backed up by a direct challenge to the admirer of his 'noble sculptures and diverse figures' in the words: 'Let any of you who wonders at them test them by the proper laws.' It is impossible to tell what Giovanni means by these intriguing references to the laws of art, and certainly no easily reconstructed metrical systems of proportion seem to be involved. What is undoubtedly new, however,

is the explicit recognition of a direct relationship between the creative artist and his personal public, as well as the assertion that, providing the true standards of criticism are applied, his work will pass the test. But if the upper inscription hints at new relationships, the one below is a fascinating, open record of a state of mind. After the reference to the circling of the world there come the words: 'Nunc clamat' – 'Now he cries out: I have not taken good heed while the more I have shown forth the more I have experienced hostile injuries. But I bear this anguish with the heart of a man unwilling to fight [literally, of a coward] and with a serene mind. That I [the pulpit] may remove this malice, mitigate his sorrow, and beg honour for him: add to these verses the moisture of tears. He proves himself unworthy who condemns him who is worthy of the diadem. Thus by condemning himself he honours him who he condemns.' The somewhat querulous claim to mental calm that accompanies this outburst only sharpens the picture of a complex, persecuted character, as busy with self-pity as with self-advertisement, who suddenly and unexpectedly peers forth from behind what might have been, but what is definitely not, a standard self-laudatory inscription in the new manner. Giovanni Pisano is the first medieval man to whom such modern terms as 'artist' are applicable on documentary grounds.

The surviving records seem to show that trouble with Burgundio di Tado, the clerk of works, possibly reviving memories of his difficulties at Siena, was at least in part the cause of Giovanni's plaint. A number of payments from the autumn of 1302 for quarrying and carting marble, for the making of tools, and for a journey to Carrara, indicate that work went forward quickly at the start. But in April 1305 a confirmation of Giovanni's contract is accompanied by the further provision that in case of any conflict between himself and Burgundio, a good and loyal man who was satisfactory to the sculptor should be elected to replace the clerk of works. In this same year Burgundio paid for the making of documents

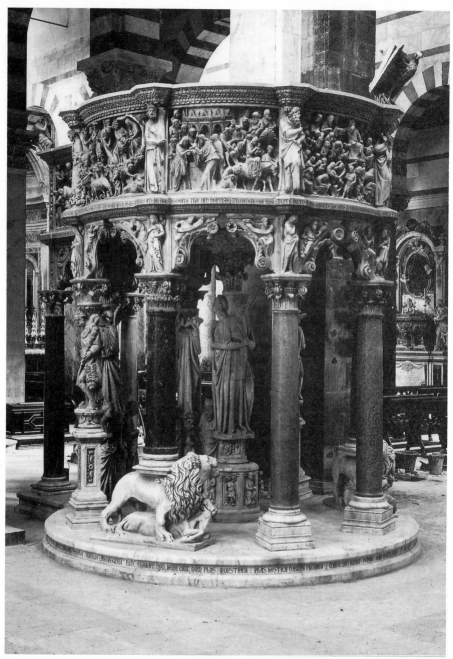

74. Giovanni Pisano: Pulpit, 1302–10. *Pisa, Duomo*

in an action against Giovanni, part of whose salary he appears to have held back and only to have made up finally in July 1307. It is this quarrel which explains both Giovanni's omission of Burgundio's name from his polemical inscription and the erection of a separate tablet by the latter. This records the dates of the commissioning and completion of the pulpit and states that he, Burgundio, was responsible for its erection.

The new structure is the most sumptuous as well as the most massive of the four Pisano pulpits. It is developed from an octagonal plan, but except for the two reliefs that flank the entrance to the casket, the narrative panels are all curved on a radius slightly smaller than that needed to enclose the whole within a circle. The result, a gentle undulation or pulsation of the forms, as if the casket walls were seeking to expand against the firm, restraining framework of the angle-figures, breathes life into the cold, pure circle of the base. A massive horizontality is now almost the dominant impression. The Gothic flavour of the spiky trefoil arches of Pistoia is replaced by the rich classicism of acanthus brackets. A great extension of the use of caryatid figures further reduces the vertical thrust, and by once more expanding the part played by sculptural forms opens out new iconographic opportunities. The Liberal Arts, surmounted by the Theological Virtues; Ecclesia and the four Cardinal Virtues; Christ and the four Evangelists, St John being accompanied by the figure of Giovanni himself; the single figures of St Michael and of Hercules; and finally the two lions and their prey, make up the main sculptural supports. An increased company of Sibyls, Prophets, and Apostles in the upper zones is matched by an expanded central narrative. Four separate episodes from the life of the Baptist and sixteen from that of Christ are fitted into the seven reliefs that lead up to a *Last Judgement* spreading, as in Nicola's Siena pulpit, over two full panels.

Giovanni's new commission, like the second and larger of his father's pulpits, meant the marshalling of a minor army of assistants, of whom Giovanni di Simone, the architect of the Camposanto, and Lupo di Francesco, who was later connected with S. Maria della Spina, are perhaps the most important recorded members. The intervention of these helpers seems to be obvious in the lowered quality of the Liberal Arts, as well as in the somewhat flaccid St Michael and in all the figures in the upper angles. There are also weakly executed passages in the *Adoration* and in the *Massacre of the Innocents*, although in the latter there are also parts in which the almost brutal blocking of the forms appears to be a continuation of Giovanni's Pistoian experiments. For similar reasons caution is needed in assessing Giovanni's personal share in the panel of the *Damned*. On the other hand the studio completion of the whole of the relief of the *Passion* and of much of that of the *Blessed* is hardly controversial. Nevertheless, the latter serves as a further warning against dogmatism, since it also contains such pure gems of invention as the furiously determined female saint in the bottom right-hand corner, who rushes forward, stomach out, arm raised, not so much begging as demanding entry into heaven for the fortunate protégé whom she hauls along behind her.

Apart from the matter of workshop intervention, it must have greatly taxed the artist's powers of invention to embark upon a second pulpit almost as soon as his first was finished. Since his other activities in the period seem to show that the Pistoia pulpit was actually carved in Pisa, the need to create something more than a mere second version must have been especially pressing. On the structural side the challenge was triumphantly met by exploiting the rich vein of classicism always present in his art and clearly visible in the architectural detail of the doorways at Siena. As regards the single figure, it was but one stride of the imagination from the Pistoian angle-figure of St Paul to the new world of the introspective, spiritual, Pisan Hercules [75], so different from Nicola's muscular, nude hero, and so reminiscent, in its wiry Gothic naturalism, of the similar figure in relief upon the portal at Auxerre. A like progression

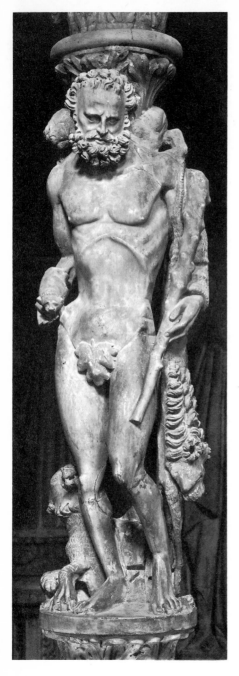

75. Giovanni Pisano:
Hercules, detail of pulpit, 1302–10.
Pisa, Duomo

links the calm, structural certainty of the
Deacon at Pistoia to the Pisan Fortitude and
above all to the Prudence [76], the solid virtue
of whose sturdy volumes so transforms the
sensuous Antique Venus Pudica from which the
figure must have been derived. In his own way
Giovanni closely resembles Arnolfo in his
ability to draw impartially, and with creative
understanding, on Gothic or on Antique proto-
types. It is a tribute to the power of Nicola's
artistic personality that he could so inspire
his two great followers. The Hercules and the
Prudence are not merely two of the chief glories
of Giovanni's Pisan pulpit: they rank among
the major masterpieces of Italian sculpture, and
it seems to be no more than a misunderstanding
of the range and nature of Giovanni's art, linked
to misreading of the detailed technical con-
nexions with his other works, that has occasion-
ally led to doubts about his authorship of the
Pisan Cardinal Virtues.[13]

When it comes to the narrative reliefs, the
lack of a sufficient interval in which to refresh
his mind and to consolidate new ground must
undoubtedly have been a major factor in keep-
ing Giovanni from complete success in achiev-
ing a new synthesis. Undue preoccupation with
the detailed weaknesses of handling attributable
to the workshop can, in such a situation, lead to
over-emphasis on Giovanni's inability to escape
his own immediate past, and consequently to a
failure to appreciate the nature of the series of
bold experiments on which he was apparently
engaged.

In the opening relief, devoted to St John,
Giovanni intensifies his effort to develop every
figure in the round; to indicate its structure
clearly while creating rhythmic forms that run
on with a casual cunning from one figure and
one scene into the next. The strength of the
formal scaffolding erected in this way is only
matched by the grave intensity of feeling that

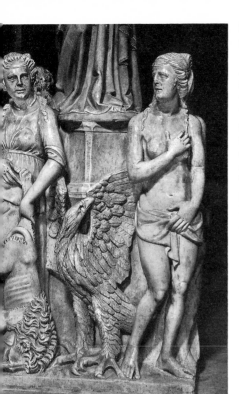

76. Giovanni Pisano:
Fortitude and Prudence, detail of pulpit, 1302–10.
Pisa, Duomo

ing all before them, rather than by additive or architectonic, constructional, means.

The streaming linear pattern of the Pisa *Nativity* is an extraordinary invention [77]. On one side it runs up from the handmaid pouring water, on into the Virgin's drapery, and round with the curving rock-forms and the joyous angels to return to the point of origin. On the other side it curves up through the leg of the same maiden to branch through the rock-forms out into the swaying figures of the shepherds. The entire design appears to grow on a single stem, like some great, heavy-laden vine. A similar impartial linear continuity is seen in the *Adoration* [74]. There the youngest Magus and the pointing angel merge into the rock in one continuous, circling curve. The rock becomes an angel's wing, and this in turn leads on into the drapery of the kneeling king, whose body seems to flow continuously out of that of the same standing Magus who describes one segment of the enclosing circle. In the *Presentation*, with its 'portrait' of the baptistery representing the temple at Jerusalem, linear continuity is combined with figure massing to create a kind of compositional unity which, in the succeeding panel, turns the crowded *Massacre of the Innocents* into a human whirlpool that revolves inexorably round the dominating figure of Herod, whose dramatic gesture sets the tragedy in motion. Even the panel of the Damned, once more so close to an Antique sarcophagus relief, is turned into a swirling vortex of despair and is, for the first time, formally contrasted to the calmly organized, horizontal layering of the Blessed. This visual opposition of the two reliefs, united by contrasting content in the single scene of judgement, draws attention to Giovanni's apparently increasing interest in tying separate panels into larger compositional groups. The symmetries built up by the *Nativity* and the *Adoration*, and by the *Presentation* and the *Massacre*, are particularly clear. The compositional principles which Cimabue had devised to unify the fresco cycles in the choir and transepts of the upper church of S. Francesco at Assisi, and which the Master of the St

pervades the whole. The new weight and scale, and the virtually free-standing treatment of each figure in what appears to be one of Giovanni's most personal creations, both in conception and in execution, are general characteristics of the pulpit. The forging of compositional unity by means which still derive, though in much altered form, from the columnar architectonics of Nicola's pulpit in the baptistery is, however, succeeded, in many of the remaining panels, by a marked accentuation of the swirling linear rhythms first exploited in the *Nativity* at Pistoia [69]. Still more impressive is the creation of great compositional surges that unite the forms by sweep-

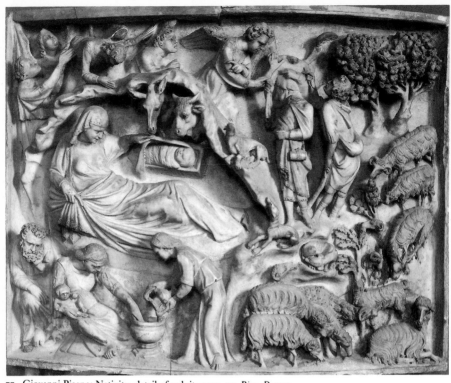

77. Giovanni Pisano: Nativity, detail of pulpit, 1302–10. *Pisa, Duomo*

Francis Cycle then elaborated in the nave, are here for the first time applied to sculpture.[14]

The steady increase in descriptive naturalism is a thread that joins the four Pisano pulpits, and it is in this respect that the reliefs on Giovanni's culminating work are revolutionary. In the *Nativity* an entire landscape is described in detail [77]. Sheep browse and dogs rest, the shepherds stand, and trees and bushes grow upon a hilly ground plane that is fully visible instead of being implied behind a screen of figures. This effort to achieve a new, pictorial landscape, all-embracing in its realism, is indeed remarkable, but it is the *Crucifixion* that is Giovanni's masterpiece [78]. In accordance with the pattern introduced in the Pistoia pulpit, the full scene of Calvary with all three crosses is displayed. Longinus on his horse

pierces the side of Christ, while other mounted figures in extreme foreshortening thrust their way among the crowd. The souls of the two thieves are carried to their separate dooms as the soldiers break their legs, and in the same sky Synagoga is banished and Ecclesia triumphs. Here is space and a great, milling crowd. As far as pictorial realism is concerned, it matches and surpasses the majority of the painted Crucifixions of the first half of the fourteenth century. Yet the very nature of Giovanni's achievement points to the supersession of the sculptural vision of the last half of the thirteenth century. In many of the fields in which the sculptors had held the primacy, the painters now assume the leading role.

Giovanni's *Crucifixion* is remarkable not merely for its wide descriptive scope but for the

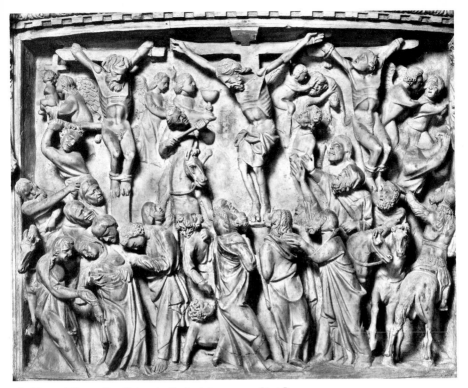

78. Giovanni Pisano: Crucifixion, detail of pulpit, 1302–10. *Pisa, Duomo*

emotional power with which the narrative is charged. Whether wholly or substantially carved by Giovanni himself, or executed under his direction, the stretched flesh and bone of the Pistoian *Crucifixion* is now reduced to a schematic starkness. A single plane describes the pectoral muscles as they pull upon the ribcage, growing paper-thin with strain as the armbones start out of their sockets. The dramatic crudity of the carving in the *Massacre of the Innocents* is replaced by a reduction of the human form to its bare geometric substance. Finally, the pictorial drama of the narrative reliefs takes on its fullest meaning only when it is seen within the carefully calculated architectural framework of the pulpit as a whole, in contrast to the calm structural clarity of the supporting figure sculpture. Each sets off the

other and gives formal being to the underlying complementaries of narrative realism and of deep symbolic meaning.

THE WOODEN CRUCIFIXES

Giovanni's obvious delight in Mary as a mother and in Christ as a human child is matched by his concern for Christ as a man in agony. This is confirmed by a series of unsigned, undocumented painted wooden crucifixes and one small, partially coloured ivory figure. The story of the painted crucifix in fresco and on panel is marked, throughout the thirteenth century, by increasing emphasis on the humanity and pathos of the suffering Godhead, but it is in wood sculpture that the climax is achieved. The development is not confined to Italy by any

means. Among the most exciting works are some belonging to the Rhenish and Westphalian schools of the late thirteenth century and the first decade of the fourteenth. In Italy itself a number of figures of German or of Italo–German origin still survive, and it is against this background that the crucifixes attributable to Giovanni must be seen. It seems, however, that his own influence on his Northern contemporaries was greater and more direct than any that they or their predecessors had exerted over him.

The figure on the crucifix in S. Andrea at Pistoia is extremely close in feeling, and in pose and anatomical detail, to that in the *Crucifixion* on the near-by pulpit and cannot be far removed from it in date. The slightly more developed figure formerly in S. Maria a Ripalta, which is now also in S. Andrea and is closely related to a fragmentary example in Berlin, can also be seen, following its recent cleaning, to be of the highest quality.[15] The reputation of the crucifix in the Museo dell'Opera at Siena has certainly been much damaged by burial of the original polychrome, upon its microscopically thin, fine ground, beneath a layer of flesh-paint on a thick and granular base [79]. The pull of muscle on the ribs, the modelling of each tense detail would reveal a wholly different sensitivity if freed from the present deadening overlay. The sideways swing of the body out and away from the Y-shaped tree of the cross allows the generation of enormously effective profile and three-quarter views, and the great simplification of the figure without a complete loss of softness seems to point to the period following that of the Pistoia pulpit. It is this design that is repeated in the ivory fragment, once again unique in fourteenth-century Italian art, that is preserved in the Victoria and Albert Museum in London. There the falling lock of hair hangs in a rather more decorative and less natural curve. The simplification of the highly polished torso, with the delicate caging of the ribs and intersecting cones of belly and solar plexus, is a little more extreme. As a result the contrast with the rich, deep folds of the loincloth is if

79. Giovanni Pisano: Crucifix, *c.* 1305(?). *Siena, Museo dell'Opera del Duomo*

anything intensified. In both these later works the relationship to the even greater, and to some extent less subtle, though essentially similar, stylizations of the figures in the Pisa Crucifixion scene is clear. The magnificent figure in Berlin is less actively dramatic, less emaciated, but in the untold depth of spirituality in the head, matched by equivalent sensitivity and power of anatomical selection in the torso, it is the suffering counterpart of the gentle Christ who stands beneath the Pisa pulpit.

THE LATE WORKS

Varied movement, emotional sensitivity, and rigid selectivity of detail were evidently characteristic of the tomb for Margaret of Luxemburg

which Giovanni is documented as having carried out in the period immediately following her death from the plague in Genoa in December 1311. The surviving fragments in the Palazzo Bianco, Genoa, which include two angels raising the dead queen to eternal life, show that the basis of this wall-tomb must have been a further development of the sepulchral drama of Arnolfo's monument for Cardinal de Braye.[16] It was probably in the interval between the coronation of Margaret's almost equally unfortunate husband as the Emperor Henry VII in June 1312 and his death of fever in August 1313, while he was still engaged upon the tomb, that Giovanni, once more working directly under Burgundio di Tado, started to carve the last of his surviving signed *Madonnas* [80]. This seated figure with the Child standing upon her knee, accompanied by the fragmentary kneeling figure of Pisa, also preserved in the museum at Pisa, and by the lost figure of the emperor himself, was destined for the tympanum of the Porta di S. Ranieri in the Duomo. The ruined Virgin and Child create a fully three-dimensional group, the main projections emphasized without foreshortening or evasion. Though the general pose is one that was becoming popular in French ivories towards the turn of the century, there is no curvilinear play in the complex naturalism of the folds cascading down over the solid forms. Yet the design is such that a continuous spiral is created. The Virgin sits upon a sloping seat, producing an organic, swaying twist within the torso which, together with the raising of one knee, the lowering of the opposite buttock, and the contrapposto of the Child, contributes to the final effect in what is possibly the finest example of Giovanni's ability to create a Gothic work of art by classical means. Even these ruined outdoor figures carry traces of the original colouring which still played so large a role in the completion of Giovanni's sculpture.

Despite the washings documented from as early as the final quarter of the fourteenth century, the Pisa pulpit still retains some traces both of colour and of glazing to confirm the

80. Giovanni Pisano: Madonna and Child, 1312/13(?).
Pisa, Museo Civico

late-sixteenth-century description of Ecclesia in a red dress and blue mantle. Surviving colour traces are, however, more in evidence on what is probably the latest of Giovanni's extant works, the unsigned, undocumented, but stylistically secure Madonna della Cintola in the cathedral at Prato. The statue was probably executed after 1312 in connexion with the reorganization of the shrine after the recovery of the Holy Girdle stolen in that year. In this final figure the sweeping hem-line and the heavy saucer folds appear to extend the hip still farther as it swings out to provide a stable platform for the Infant's weight. Nevertheless, the ultimate effect of swaying, Gothic S-curves

is built on the foundation of a figure in which the mass and placing of the anatomical forms are absolutely clear. The solid shoulders are correctly set. The resting leg, which itself contributes to the swinging rhythm, is as plainly indicated as the one that bears the weight. It is in such a context that high finish and fine decorative detail have been used to frame the mood-creating sensitivity of the modelling of the Virgin's clear-cut features as she gazes tenderly, and a little sadly, at her Child.

The date of Giovanni's death is now unknown, although a document referring to his Sienese property, as well as a majority decision of the Sienese Council to exact taxation, in spite of his still valid immunity, confirm that he was still alive in 1314. It was, indeed, in his adopted city of Siena that he was buried, and it is his embattled immunity from taxation, now at last no longer needed and in 1319 stricken from the register, that provides a postscript to his life, and a typical, dry, documentary terminus.

PAINTING

1250–1300

INTRODUCTION

Cavallini, Coppo di Marcovaldo, the Master of S. Bernardino, Cimabue, the Isaac Master, the Master of the St Francis Cycle, Guido da Siena: the very names epitomize a revolution in the art of painting. They also arouse an expectation of the still more famous painters who succeed them. In doing so they indicate that their achievements, self-sufficient though they be, are in another sense no more than a beginning, and, like the majority of great beginnings, owe much of their greatness to the strength with which their roots are bedded in the past.

The triumph of the papacy in its long struggle with the empire, and a pope who was himself a Roman with unbounded personal ambition and a deep sense of the power and significance of Roman history, provided the conditions that encouraged Rome as the first centre of rebirth. The continuing expansion and consolidation of the mendicant orders likewise provided both an opportunity and a spur to innovation. The surge of popular religion was accompanied by a natural desire to use increasing wealth in the decoration of the bare walls which were a major feature of the products of a vast campaign of building. Economic pressures and social evolution in their most straightforward senses were vital factors in ensuring that the second main focus of the new artistic developments should lie in Tuscany. Its towns were the banking centres for all Italy and most of Europe. The accumulation of capital and the beginnings of

industrial organization were not only generating wealth but rapidly attracting population. New, money-rich commercial classes were emerging, and new balances of power were in the making. The need to expiate the sins inseparable from commercial organization and success did much to open the purse strings of fresh classes of potential patrons. A shrewd assessment of the part that popular religion and the art that helped to make it attractive could and did play in controlling the new aggregations of cheap labour must be set beside the impulse of true piety. In decoration, as in building, civic pride and personal ambition were mutual and increasing stimulants.

The artists were inevitably affected by the changes in social and economic outlook. The new religious emphasis was placed on Christ as man as well as God, and God himself was to be reached through an appreciation of his goodness in creation. At the same time, a fundamentally static medieval community was undergoing the first hesitant evolution into a society in which change and development were seen as positively good. Pictorial craftsmen were no more immune than others to the urge for social and financial betterment. The growth of self-awareness and of personal ambition play their part in the first stages of the metamorphosis of craftsmen into artists. The beginnings of this process are, as has been seen, particularly clear in sculpture and in the careers

of the Pisani. The attention which they focused on the sculptural innovations of the Gothic North and on the achievements of Antiquity provided the essential basis for the intrinsically more complicated process of devising satisfactory pictorial equivalents of the appearances of nature. Another vital, and initially more important, factor in the evolution of new methods of pictorial expression was the influx of Byzantine art and influence in the century following the fall of Constantinople. The new vocabulary of form and the new techniques available to the Italian painters are the final elements in the pattern that conditions, but does not explain, the achievements of the men who dominate late-thirteenth-century painting.

PIETRO CAVALLINI

Some twelve years after the death of Frederick II in 1250 the French pope Urban IV summoned Charles of Anjou to Rome to lead the struggle against the growing power of Manfred, who was Frederick's favourite and bastard son. To Urban's successor, Clement IV, the only immediate legacy of this manoeuvre was the crushing need to raise enough money to maintain the impecunious Charles as an actual power in the land. Only by strenuous effort was a loan against Church property eventually realized through the swarm of petty merchants and small moneylenders that was representative of the weakly organized commercial life of Rome. The financial difficulties of pope and prince alike were quickly solved, however, and the aims of papal policy attained in full, when Manfred went to his death at the battle of Benevento in 1266, to be followed two years later by his seventeen-year-old cousin, Conradin, whose defeat at Tagliacozzo was the prelude to a swift judicial murder.

For the papacy the sudden extinction of the Hohenstaufen menace led to the inevitable paradox. Immediately, the pressing task became the containment and if possible the whittling away of the carefully nurtured and now swollen power of the Angevin. The new policy, inaugurated by Clement IV, was subsequently carried on by Gregory X, and it is possible that as a cardinal, Giangaetano Orsini had influenced its prosecution from the first. Certainly, from the day of his election as Nicholas III in 1277 to his sudden death in 1280 he became its ablest exponent in the face of a Charles who was by this time king of Naples and Sicily, senator of Rome, Imperial Vicar of Tuscany, and lord of much of Piedmont. Within the frame of Nicholas's policies it is not so much his acquisition of the Romagna for the Church, or his plans for extending papal power in Tuscany, as his relationship to Rome itself that immediately affects the history of art. As a leading member of one of the great noble families of Rome, the advancement of the Orsini was inextricably entwined in all his efforts. His nepotism soon became a byword to be duly catalogued by Dante. Nevertheless, when he had skilfully organized the peaceful departure of Charles in 1278 at the expiry of his term of office, it was Nicholas's careful cultivation of his personal as well as his official connexion with the city that resulted in his being offered the senatorship himself. The ground for this unprecedented political triumph had been well laid by the bull 'Fundamenta', in which Nicholas had played upon the role of St Peter and St Paul in making of the Romans an elect and holy people, and in establishing Rome itself as a city both of priesthood and of kingship, the very diadem of all the world. No opportunity had been lost to vindicate the papal sovereignty over the city by recourse to actual and fictitious history. Furthermore, it was laid down that in view of the sufferings of Rome in the preceding decades, no emperor, or king, or prince, or baron was henceforth to be elected senator, but only resident Roman citizens of whatever birth.

It was undoubtedly as part and parcel of his plans for the consolidation of the power and prestige of a politically independent papacy that Nicholas began the building of a palace for the curia upon the Vatican and embarked upon the restoration of St Peter's. The latter happened to be the basilica in which his family was buried and of which he was himself arch-priest. Again and again it can be shown that splendour and the show of power were essential elements of power itself in an age when actual forces were so small and popular allegiance so precarious. When economic or political, as well as ecclesiastical, ambition or success were everywhere in

Europe sanctified and given material expression in religious buildings and religious works of art, it is no surprise that Nicholas's short and vigorous reign should see the beginning of a great campaign of decoration. Indeed, the power of Rome, more than the power of any other city, lay predominantly in the realm of ideas; in the concept of the papacy and the empire as twin instruments ordained by God to regulate the world. This fact, combined with the economic weakness of the city, may well have influenced the concentration of the new campaign upon the refurbishing of the most important of the many venerable churches which appeared to be a standing, visible substantiation of the papacy's historically founded claims to spiritual and hence, increasingly, to temporal dominion.

THE FRESCOES IN
S. PAOLO FUORI LE MURA IN ROME

In fresco painting the most extensive of the new redecorating schemes appears to have been the one that covered the walls of the nave in S. Paolo fuori le Mura. Although the frescoes themselves were destroyed in the fire of 1823, their general arrangement is recorded in a number of prints and paintings, and the designs of the individual scenes are preserved in watercolour copies made for Cardinal Francesco Barberini in 1634. Since these drawings are but one part of an organized survey that is rich in surviving works, their accuracy can be carefully controlled. Luckily, the comparison of originals and copies shows that the latter are usually extremely faithful as regards the attitude and placing of the figures and the distribution, type, and structure of the buildings that have been represented.

The records show that each wall of the nave of S. Paolo was occupied by a narrative cycle ranged in two unbroken layers and articulated by fictive, twisted columns. Above the narrative scenes, in the intervals between the windows, were the standing figures of apostles, saints, and prophets. At the bottom of each wall, in the zone immediately above the supporting arches, there were roundels with portraits of the popes. This arrangement was substantially the same as the one in Old St Peter's, which appears to have dated back to a ninth-century redecoration of the basilica that was itself, in all probability, based upon a mid-fifth-century scheme.

A series of inscriptions, referring explicitly to Abbot John IV (c. 1278–9) and implicitly to Pope Nicholas III (1277–80), shows by its wording and by its wide spacing on the wall that all the frescoes of the *Lives of St Peter and St Paul* on the left of the nave in S. Paolo date from the years c. 1278–9.[1] The most likely explanation for the unevenness in style and iconography apparent in these scenes is that they are not the outcome of a wholly new beginning. They seem instead to be the fruits of a campaign of redecoration in which the artist or artists concerned were both faced with, and influenced by, an existing patchwork formed by an originally fifth-century cycle which had already been heavily overlaid by later alterations.[2] At times the work may even have amounted to little more than the restoration or reproduction of the existing patterns. The general air of uncertainty is strongly reflected in the architectural constructions that are used. In nearly half the scenes the buildings are completely flat. In all but one of the remaining buildings such solidity as is achieved is gained by using a foreshortened frontal setting in which one side is left lying undistorted, parallel to the picture plane, and anything that can be seen of the other walls, or of the roof or floor, is in recession. The one exceptional scene is that of the *Conversion of St Paul*, in which a definite attempt to set the figures at different depths in the pictorial space is accompanied by a bold, but not entirely successful effort to give solidity to a building by arranging it obliquely, with one corner jutting forwards and with both the visible sides shown in recession. The great size of this church, with its free-standing Romanesque campanile, in relation both to the scale of the figures and to that of the fresco field as a whole is another feature that is unique

among the scenes devoted to the lives of St Peter and St Paul. Like the very nature of the architectural detail that is portrayed, it acts as a distinctive pointer to the developments that take place among the scenes from the Old Testament painted on the opposite wall.

Although no date is recorded on these frescoes themselves, the figure of St Paul on the left-hand lower surface of the mosaic-covered arch to the left of the entrance to the nave was accompanied by the suppliant figure of Abbot Bartholomew (1282–97). It is therefore possible that the corresponding figure of St Peter on the right of the nave, together with all the work on the right-hand wall, was carried out during his abbacy. It will be remembered that it was he who about the year 1285 commissioned Arnolfo's ciborium for the high altar, and the probability is that the Old Testament scenes were also carried out during the eighties.

Immediately the drawings of the latter frescoes are examined it is clear that they fall into two distinct and homogeneous groups. The smaller of these is notable for its stocky figures

and simple, firmly constructed, foreshortened frontal buildings, invariably seen from a high viewpoint. It consists of what is seemingly a block of ten fifth-century scenes that was left substantially untouched in all the later restorations. The attribution is confirmed by the kinship with such surviving mid-fifth-century work as the mosaics in S. Maria Maggiore.[3] The remaining scenes belong with equal certainty to the late thirteenth century. In contrast to their opposite numbers, they reveal a stylistic unity that thoroughly transcends the variety of influence which has been absorbed and seems to indicate a much more thorough redesigning of those frescoes which were marked out for repainting. There is new confidence in the distribution of the figures and greater unity within the landscape backgrounds. In some designs, such as that of the *Building of the Ark*, the entire depth of an extensive and firmly constructed ground plane is exploited by active figures placed at varying distances from the observer and bound together by a series of diagonals of movement and attention. In the *Plague of*

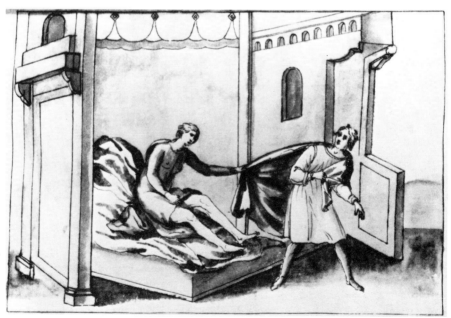

81. Pietro Cavallini: Joseph and the Wife of Potiphar, seventeenth-century copy of a destroyed fresco, c. 1282–97(?). *Rome, S. Paolo fuori le Mura*

Serpents there is even a whole circle of figures extending into space in intimate connexion with the architecture. All attention focuses across the hollow centre on the serpents that writhe in the foreground. In all these scenes the architecture has been stripped of partially digested Early Christian and Byzantine detail and has grown in scale and certainty of structure. Solidly built foreshortened frontal settings alternate with bold, oblique constructions such as that created for the scene of *Joseph and the Wife of Potiphar* [81]. In this design a single building almost fills the field, and the difficult problems involved in placing figures within an interior instead of merely in front of one have been attacked. A growing naturalism is also reflected in the normality of viewpoint that now replaces the Early Christian and Byzantine tendency to exploit a bird's-eye view. The fact that there is still an uncertain relationship between the floor and the left-hand wall serves only to accentuate the effort that is being made. The most striking feature of all, however, and the most important as an indication of the stature of the artist who composed the scene, is the way in which the jutting architecture sets the whole design in motion. Force is added to the swift diagonal movement of the figures as Potiphar's wife tears the cloak from Joseph's shoulders. So, for the first time in Italian thirteenth-century art, the role of architecture as a background accent, cunningly exploited by men like Nicola Pisano as a means of framing and of emphasizing major figures, is transcended. An inherently dramatic architectural form has been created and, intentionally or not, is used in such a way that it intensifies and focuses attention on the drama of the story that is being told.

Even the uninspired, if faithful, seventeenth-century copies hint at the electrifying quality of this new art born of the combination of a growing interest in narrative realism and the need to study and repaint an Early Christian fresco cycle. Some twenty-five years after Nicola Pisano had used Antique art as the jumping-off point for the sculptural revolution that Arnolfo and his Roman workshop were

even now consolidating and extending, these frescoes of the Old Testament appear, in the complexity of the ambition and achievement that they represent, to be as far removed from the small block of mid-fifth-century designs as these, in their simplicity and certainty, were distant from the recently reworked frescoes of the Lives of St Peter and St Paul upon the opposite wall. On the other hand, the formal boldnesses do not disguise the underlying iconographic continuity. The close relationship both to the western and the eastern branches of the great twin stream of medieval iconography is illustrated by comparisons with such works as the twelfth-century decoration of S. Giovanni a Porta Latina in Rome or with the Byzantine mosaics of Monreale. Direct inspiration from the common source is also clear. A number of the figure patterns, that of *Joseph and the Wife of Potiphar* among them, seem to show close linkages with the fifth-century tradition already established in the Vienna Genesis. Apart from his intimate knowledge of the fifth-century fresco cycle that he was actually replacing, and also of the Old Testament cycle of similar origin in Old St Peter's, the late-thirteenth-century painter may easily have known such manuscripts as the late-ninth-century Carolingian Bible from St Denis which is still preserved in S. Paolo, as well as other works in which the echoes of Early Christian iconography and Late Antique solidity of form reverberate with equal and unusual strength.

THE MOSAICS IN
S. MARIA IN TRASTEVERE IN ROME

Lorenzo Ghiberti, in his Second Commentary, which was probably written shortly before his death in 1455, first names the painter of the nave of S. Paolo as Pietro Cavallini, to whom he also attributes the extant mosaics in the apse of S. Maria in Trastevere and the now-mutilated fresco cycle in near-by S. Cecilia. The seventeenth-century copyists also record that a fragmentary inscription containing the word 'Petrus' once accompanied the dedicatory

mosaic still to be seen in S. Maria in Trastevere. It is this which constitutes the generally accepted if somewhat uncertain bridge between the recorded name and the surviving works. In the way of biographical detail there is little enough to add. A certain Pietro dei Cerroni, called Cavallini, who is mentioned in a notarial document of October 1273 preserved in the archives of S. Maria Maggiore in Rome, is probably identical with the artist who appears as Petrus Cavallinus de Roma in Neapolitan records of June and December 1308. The first is an agreement by Charles II of Anjou to pay him thirty ounces of gold a year for his services. In the second document this arrangement is confirmed by Charles's son Robert and a further two ounces of gold a year are allocated for the maintenance of a house. The final biographical titbit is a marginal note by Giovanni Cavallini, who was the author of a *Polistoria Papale* and appears to have been active between the years 1330 and 1360. It is a single sentence written in commemoration of his father, Petrus de Cerronibus, who lived to be a hundred and never wore a hat against the cold.

Despite the treacherous nature of the documentary evidence and the scarcity of surviving works, the skeleton of Cavallini's career emerges with quite unexpected clarity. A thoroughly unreliable reference to a lost date for the mosaics of S. Maria in Trastevere can be disregarded without a qualm,[4] for the works themselves appear to follow on directly from the stylistic premises established by the seventeenth-century copies of the scenes from the Old Testament in S. Paolo fuori le Mura. The mosaics consist of six scenes from the Life of the Virgin, together with a central votive panel in which Bertoldo Stefaneschi, the donor and an ex-major-domo of Nicholas IV, is presented to the Virgin and Child by St Peter [82]. The Latin verses that accompany each scene were evidently composed by Bertoldo's rather more famous brother, Cardinal Giacomo Gaetano Stefaneschi, who was, among other things, the author of a long historical poem, the *Opus Metricum*.

The new decoration was designed to form a base for the existing mid-twelfth-century mosaic of *Christ and the Virgin Enthroned* which fills the semi-dome of the apse. Throughout the narrative scenes the representation of space – and this includes the distribution of the figures and the perspective of the solidly constructed buildings, half of them in an oblique and half in a foreshortened frontal setting – appears to be an exact continuation of the development reflected in the copies of the Old Testament scenes in S. Paolo. The style of the architecture, and also of the soft and heavy drapery, likewise seems to point to a common authorship for the two schemes, with no great gap in time between commissions. The weight and softness of the drapery forms and the relatively subdued colour together help to confirm that these mosaics were designed, and their execution controlled, by a painter rather than by a man who was primarily a mosaicist in the then current Roman tradition. The draperies are modelled more by light than line. The sense of a surrounding atmosphere is strong, and the subtle use of golden highlights is particularly interesting. It has been shown that in the eleventh century golden highlights were in part a naturalistic means of bringing out forms hidden in the darkness of Byzantine semi-domes and cupolas. By the thirteenth century what had once been highlights had become a purely decorative hieratic feature, symbolizing the importance of a given figure in the heavenly hierarchy. Now, with Cavallini, the decorative, the symbolic, and the naturalistic functions have been combined in a fresh synthesis. Indeed, from every aspect, these mosaics are as fascinating as a contrast to the earlier work above them as they are beautiful when seen as its completion.

The nature of mosaic is such that the intervention of the artisan in transforming the original artistic conception into a finished work may be especially far-reaching in effect. It is therefore only through comparisons with autograph paintings by the same artist that the nature and extent of any distortions can be estimated. The constant tendency for the small,

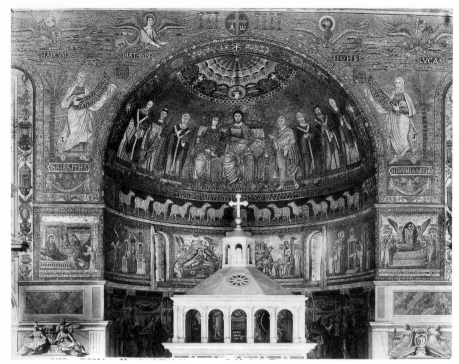

82. Pietro Cavallini: Mosaics of the Life of the Virgin, early 1290s(?),
beneath a mid-twelfth-century apsidal mosaic. *Rome, S. Maria in Trastevere*

inset cubes to fall away, and the ease with which
bad, piecemeal restorations can be carried out
across the years, leaving no tell-tale undercoat
or pigment-trace of what was there before, may
also pass a veil of mediocrity across a great
original conception. Nevertheless, in spite of
extensive known campaigns of restoration,
much of the subtlety of Cavallini's vision seems
to have survived, and the seventeenth-century
copies show that no substantial compositional
violence has since been done to his designs.

The solemn intimacy of the *Birth of the
Virgin* [82], with its rhythmic grouping, verifies
Cavallini's status in the field of the new
pictorial, narrative realism. It also makes an
interesting comparison and contrast with the
sculptural Nativities of Nicola Pisano, who, in
his restricted panels, could never afford the

luxury of a grouping so compact in its cohesion,
yet so airy in its spacing, nor, for all his efforts
in this direction, so easily and cunningly exploit
the unifying and articulating possibilities of a
fully visible background architecture [39].
Indeed, with the relatively bold enclosures of
S. Paolo still in mind, it is the extent to which
this small 'interior' fails to enclose the figures,
and is set behind them as a background, that is
unexpected. The probable explanation of the
shrinkage lies in a desire, not merely to create
a general harmony with the remaining scenes,
but to achieve some sort of balance between
this opening scene and that of the Dormition,
which completes the series [82]. These two
scenes are specially stressed, both individually
and as a pair, by their position close to the
spectator on the planar, forward-facing walls

83. Pietro Cavallini: *Presentation*, early 1290s(?).
Rome, S. Maria in Trastevere

that form the left and right flanks of the curving inlet of the apse. Because of its diminutive proportions, the interior in the opening mosaic occupies about the same proportion of the total field as do the figures piling into depth on either wing and forming a thin screen across the background of the final scene.

A different aspect of Pietro's interests is represented by the *Annunciation* [86]. In it, energy and mass are balanced and contrasted in the simplest terms. A Gabriel with flailing, multicoloured wings, Byzantine in their finery as in their actual derivation, surges forward, arm outstretched, his draperies fluttering behind his back and pulling taut across his thighs. Then, movement, space, and energy are suddenly congealed into the massive architecture of the Virgin's throne. No petty piece of indoor furniture,

this monumental throne, with all the architectural associations of a full-scale church or palace, lends a static, timeless quality to the Virgin's gesture of humility and of acceptance. The cross-vaults in the lower storey of the throne do nothing to create a Gothic feeling. With its Cosmati inlays and its coffered semi-dome and Romanesque columns, it reveals as little interest in Arnolfo's newly completed ciborium in S. Paolo as does the four-square altar canopy that Cavallini places at the centre of the *Presentation* [56 and 83]. Familiar as the Gothic innovations of men such as Arnolfo, alongside whom he may have worked on more than one occasion, must have been to him, it appears that Cavallini's inspiration lay in objects like the severe twelfth-century ciborium in Castel S. Elia. The building on the right of

the Presentation is, however, a reminder that Byzantine influence upon the formal, as upon the iconographic, side of Cavallini's art must never be ignored.

The simple yet effective three-four grouping of architecture and figures in the *Presentation* underlines the volumetric power which Cavallini generates in figures such as that of Simeon, who stands upon the right of the altar [83]. Columnar in its weight, it is columnar also in the severity of outline that shuts in the massive cylinder developed by the even progress of the modelling from highlight into shadow. Colour itself is handled with a similar discipline. Beginning on the left, there is an exact repetition of pale pink on blue in the first and third figures, and of blue on gold in the second and fourth. This alternation of two interlinking colour couples is a basic demonstration of the use of colour counterpoint in order to enliven a symmetrical design. The superimposition of this not quite simple beat on the existing three-four symmetry creates a subtle, syncopated rhythm, lively and grave, in which simplicity and intricacy are one and discipline has been divorced from dullness. Small and seemingly unpretentious as they are, the meaning of mosaics such as these for the history of Roman art is shown by a comparison not merely with the works of Cavallini's predecessors but with those of major contemporaries such as Jacopo Torriti.

JACOPO TORRITI

It is Torriti who is reported to have signed the lost mosaic for Arnolfo's tomb of Boniface VIII, but since no biographical facts about the artist seem to have survived, his fame rests solely on the two great Roman apsidal mosaics of S. Giovanni in Laterano and S. Maria Maggiore and on the attributed frescoes in S. Francesco at Assisi.

The Lateran mosaic, which is signed 'Jacobus Torriti Pictor', is approximately dated by the inscription of 1291 in which Nicholas IV records the rebuilding and redecoration with mosaic of the apse and the façade, which were the two surviving parts of the original fourth-century basilica. The existing mosaic is unfortunately only a thorough-going late-nineteenth-century substitute for the original by Torriti, which was, however, meticulously copied before its destruction. Yet it is almost wrong, in a sense, to speak of Torriti's original, for, as with much of Cavallini's work, if it is his, on the left wall of the nave in S. Paolo, the late-thirteenth-century mosaic itself appears to have been much more of a copy or a reconstruction than a new design. The miraculous bust of Christ that hovers in the clouds, the cross, and the baptismal waters of the four rivers of paradise which flow from it, together with all their wealth of human and animal life, appear to have been part of the mosaic of fourth- or possibly fifth-century origin which Torriti was commissioned to replace. Similarly, the insertion on a tiny scale of Nicholas IV, the first Franciscan pope, together with St Francis and St Anthony, the two main saints of the order, is evidence of an attempt to leave a pre-existing design as far as possible undisturbed.[5]

As was the case with Cavallini, the role of personal invention seems to have been much greater in his second, and this time genuinely surviving, work, the apsidal mosaic in S. Maria Maggiore [84]. The commission was again connected, according to a lost inscription, with the activities of Nicholas IV (1288–92), under whom the old apse was replaced by a new one set up in a slightly different position. It is also said that Torriti's existing signature once included the date 1295, although it is hard to see how this can ever have been part of the inscription as it now stands.[6] The scheme as a whole is a variant of that in S. Maria in Trastevere, though now a *Coronation of the Virgin* occupies the shell of the apse, and the scenes from the Life of the Virgin in the lower zone are differently arranged and only five in number. The luxuriant acanthus scrolls inhabited by peacocks, cranes, and partridges, and the river below, with its birds and boats, its fish and fishermen and river gods, are once more taken

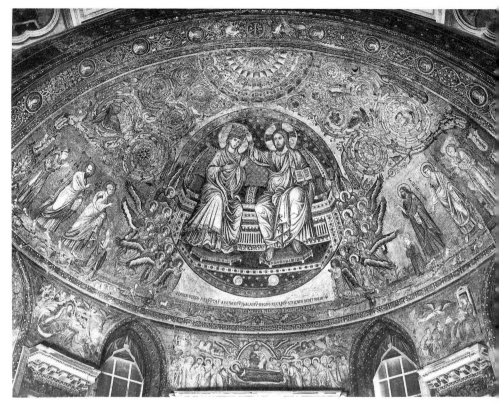

84. Jacopo Torriti: Coronation of the Virgin, 1296(?).
Rome, S. Maria Maggiore

over more or less directly from the pre-existing fifth-century mosaic. The latter was partially described in the twelfth century, and despite a certain ambiguity in the wording, it seems that the original design was somewhat similar to the one that is still preserved in Early Christian form in the portico of the Lateran Baptistery. A partial, later reflection of such a scheme is also to be found in the twelfth-century apse of S. Clemente [187] as yet another symptom of the conservatism and continuity, as well as of the recurrent classical and Early Christian revivalism, in Roman art. In the brilliant, supple naturalism of the animal life it seems, indeed, that Torriti has succeeded in retaining or recap-

turing the Late Antique vitality associated with the lost Constantinian mosaics of S. Costanza, the spirals and the riverside life of which are still recorded in a series of early-sixteenth-century copies.

The rest of the design, including the *Coronation* in its celestial circle, the supporting choirs of angels, and the row of saints on either flank, appears to be Torriti's own invention. Now the two Franciscan saints are present on an equal footing with the others and, though represented on the usual smaller scale, the figures of Nicholas IV and Cardinal Colonna, instead of being mere insertions, play a carefully calculated compositional role. An interesting

feature of the lower zone, between the windows, which is also clearly to Torriti's own design, is the placing of the *Death of the Virgin* in the large central field immediately underneath the *Coronation*. The ensuing break in the chronological sequence of the Life of the Virgin allows an effective decorative and thematic link to be forged between the upper and the lower zones. The germ of this idea may lie in the thematically similar vertical linkage of the magnificent, newly finished, stained-glass roundel at Siena [109].[7]

Throughout the main apsidal field Torriti shows himself to be the master of a thoroughly Byzantine style, invigorated by close study of the Late Antique naturalism of the fourth and fifth centuries. The fact that Torriti's interest in such matters was largely circumscribed by the nature of the work in hand is shown by the treatment of the small supporting scenes. The immediate background out of which he rises stands out very clearly in such a context. The direct reminiscences either of Cavallini's compositions in S. Maria in Trastevere or of a common prototype do not disguise the way in which Byzantine iconography retains Byzantine forms. When thinking of Arnolfo and of Cavallini it is all too easy to ignore the testimony of the few surviving panel paintings and forget that Rome immediately before their coming was merely one of the weaker outposts of the empire of Byzantine style. In Tuscany an influx of Byzantine art and artists served as a revivifying force throughout the first half of the thirteenth century. In Rome the contacts with the East are far less numerous and the results less striking. Even during the final quarter of the century the interest in more sculptural forms and greater naturalism seems either to reach back to wholly different sources or to be inspired less by fresh importations from the East than by the surviving artistic records of the earlier and more classical or hellenizing phases of Byzantine art. The latter were, in any case, by now an indistinguishable part of the common Antique heritage of Rome.

The flavour of Torriti's own Byzantinism is revealed by his *Annunciation*. In it Cavallini's swift and urgent angel gives way to a static, doll-like figure. The Virgin stands and gestures, upright, paper-thin, as if cut from the pages of some late, provincial pattern book. Behind her, the Cosmati-patterned throne lacks the convincing mass of Cavallini's architectural pile. The weaknesses of this particular idiom are what is stressed in such a starkly simple scene. Its qualities become apparent only in the more excited linear contours of the *Adoration of the Magi* or in the accelerating rhythm of the folds in the crowded scene of the *Dormition*.[8] In the main mosaic of the apse the freedom from the dominance of a single, relatively rigid iconographic pattern deriving from the need both to retain sufficient reminiscences of the original mosaic for its aura of sanctity to be transmitted to the new design and to insert the new central subject of the *Coronation*, seems to have resulted in stylistic liberation. The new feeling is visible not only in the observation of animal life but also in the increased softness and fullness of the draperies, especially those of the seated Virgin herself. Here, as in a number of figures in the supporting scenes, the complicated linear symbols for the folds are caught, like chrysalids in the very act of transformation, at the moment of their softening into rich, material forms. In the figure of Christ, with its slightly more conservative and less convincing pose in legs and feet, the process is less far advanced.

The simplified modelling of the heads, characterized by the regular, sweeping curve of the shadow along the jaw, is close to that in more or less contemporary work in Tuscany. This seems to be more in the nature of a common characteristic than a direct reflection of the increasing back-pressure that Tuscan art was exerting towards the end of the century against the expanding influence of the new developments in Rome. Apart, however, from the question of the modelling of the heads, which is carried out with plain, unglazed cubes, in contrast to the glazed, translucent tesserae of the draperies, it seems very likely that, in the figure of the Virgin at least, there is some echo

of Arnolfo's massive, seated figures, and possibly of Cimabue's pictorial experiments, as well as of those that Cavallini was engaged upon in Rome itself.

Torriti's real achievement lies, however, in the decorative whole to which each detail makes its contribution. The delicate colour – pearl, and rose, and lilac – that so helps to soften and flesh out the forms with gentle life, is set ablaze by golds and reds, deepens to azure blues, and shines out coolly in the clear, pale blues and greens. Translucent specks of highlight shimmer over every form. It is the last survivor in the long line of Roman mosaic masterpieces stretching back towards Antiquity. As seemingly irrational in its general structure as a butterfly, and as beautiful in its colour and its vividness of detail, it is, like any butterfly, at once a promise of warm days and a memento mori. It owes its special quality to the first, exciting impact on an essentially conservative art and an essentially conservative artist of those vital new ideas which were so rapidly to destroy that art and all that it had stood for through so many centuries.

THE FRESCOES IN
S. CECILIA IN TRASTEVERE IN ROME

The power of the new ideas is fully apparent in the surviving fragments of the fresco decoration of S. Cecilia in Trastevere. On the entrance wall there is the central zone of a *Last Judgement* [87]. This strip continues on one side wall with the remains of a gigantic Archangel Michael, followed by the *Annunciation*, and on the other with *Jacob's Dream* and *Isaac and Esau*. These fragments, which can now only be seen from the intrusive sixteenth-century nuns' choir, are enough to show that the original scheme, which according to Ghiberti covered the whole interior, must at least have included a full-scale Last Judgement and substantial cycles from the Old and New Testaments. The latter, framed by twisted columns, ran in parallel along the side-walls of the nave. Above, between the windows that were topped by painted quatrefoils,

are traces of the painted Gothic niches each of which presumably contained the figure of a saint or prophet. The decorative arrangement must therefore have been a close development of that in S. Paolo. The frescoes are not documented. Even their date is less secure than it is frequently assumed to be. The date 1293 on Arnolfo's new ciborium for the church is no guarantee that the frescoes were completed at the same time. Nevertheless, in the absence of more definite information a tentative assignment to the early nineties raises no particular problems.

The links between the mosaics in S. Maria in Trastevere and the frescoes in near-by S. Cecilia can be demonstrated in many ways. If only one example must suffice, the most rewarding and perhaps intrinsically the soundest course, since it alone involves a strict comparison of like with like, is to examine the two Annunciation scenes [85 and 86]. Despite the fragmentary nature of the fresco, it is clear that the Angel Gabriel shares the general pose and, within relatively narrow limits, the proportions of its counterpart in the mosaic. A similar sense of structure is revealed by the way in which the body shows beneath the clothing. The same swift urgency of movement is retained, and the intimacy of the relationship between the figures is even intensified by the narrower, vertically accented format. The tubular folds across the angel's thighs and the fluttering drapery behind his back remain unaltered. Even the down-thrusting joint of the farther wing, held at a slightly steeper angle in the narrowed field, is visible in the damaged fresco just to the right of the angel's head. The latter, with its long, straight nose, its luminous eyes, and the similar general styling of the hair, still bears a recognizable family resemblance to the somewhat differently proportioned head in the mosaic. No such variations differentiate the heads of the two Virgins, which, allowing for the altered medium, are transposable in general and in detail.

Comparisons such as these appear to show that the mosaics and the frescoes were designed

85. Pietro Cavallini: Annunciation, early 1290s(?).
Rome, S. Cecilia in Trastevere

and carried out under the same artist. This does not mean that the frescoes were entirely executed by one unaided man. The greatly increased sensitivity of the seated figures in the *Last Judgement* [87] seems to show that the frescoed *Annunciation* is one of several points at which assistants played a major part. With this proviso, it seems clear that if Cavallini was the author of the mosaics, he must also have been responsible for the frescoes. The relationship of one to the other, and of both of them to the lost frescoes in S. Paolo, supplies the necessary confirmation of Ghiberti's view that all three were the work of one great man.

As far as the Last Judgement itself is concerned, the surviving fragments, taken in conjunction with the preceding and succeeding versions of the subject both in Rome and elsewhere, have allowed of a reasonable reconstruction of the whole. Although it is itself probably slightly later in date, the great *Last Judgement* in the dome of the Kahrié Čami at Istanbul is a standing warning of the danger of seeing Cavallini's design in the evolutionary framework of a rather too exclusively Roman iconographic tradition. In Rome itself the vital document is neither the mid-thirteenth-century fresco in the church of SS. Quattro Coronati nor the possibly almost contemporary, or possibly late-twelfth-century, version in S. Giovanni a Porta Latina. It is, instead, the panel, now in the Vatican, which was signed by Nicola di Paolo and his son Pietro, both of them Roman citizens.[9] This panel, whether it dates from *c.* 1160–70 or *c.* 1235–40, is, despite such novel iconographic features as the dual representation

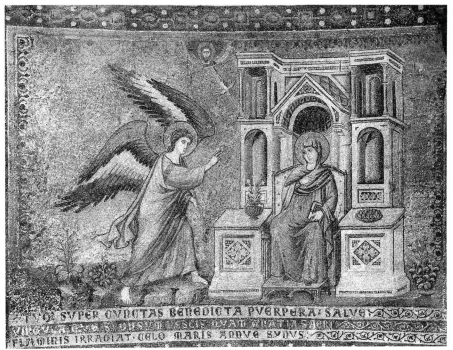

86. Pietro Cavallini: Annunciation, early 1290s(?).
Rome, S. Maria in Trastevere

of the figure of Christ, heir both to the North-West European tradition, long acclimatized in Italy, and to the Veneto-Byzantine pattern that is embodied in the mosaic at Torcello. Peculiarly, almost paradoxically, Roman is the placing of St Paul on the left and St Peter on the right of Christ, a feature which also occurs in SS. Quattro Coronati and is taken over by Cavallini. On the other hand, the representation of the altar with the symbols of the passion and the inclusion and expansion of the Byzantine motif of the leading to salvation of all manner of men, though they occur in the Roman panel, are in Cavallini's version closer to the Kahrié Čami fresco. It is unlikely, therefore, that the Roman panel is the direct prototype of Cavallini's design. Both may depend upon some lost *Last Judgement* connected to the Byzantine

tradition later to flower in the Kahrié Čami.

In Cavallini's fresco the majestic compositional symmetry peculiar to Last Judgements is primarily embodied in the great line of Apostles seated in their thrones on either side of the mandorla with its balanced frame of Cherubim and Seraphim. In what is now the lowest register, this symmetry is extended with unusual clarity not only to the pairs of trumpeting angels facing outwards from the central altar, but even to the three-fold accents of the angels who lead in the saved upon the left and who expel the unwilling damned upon the right, despite their anguished efforts to move back towards the centre with its promise of salvation. This superb arrangement of the angels serves at once to strengthen the symmetrical framework of the whole and to impart new rhythm

and intensity to the continuous movement that extends from left to right across the full width of the wall. The static symmetry established by the seated figures in the zone above is thereby both relieved and strengthened at a single stroke.

The scale of the existing major subdivisions and the manner of their linkage show that the

87. Pietro Cavallini: Last Judgement, early 1290s(?). *Rome, S. Cecilia in Trastevere*

paradoxically, held together by the ensuing half-turn to the centre on the part of each and every one. The concentration on the all-important central axis is accentuated by the three-quarter pose of many of the heads. It is re-echoed by the faces of the seraphim and finally confirmed by the inward-facing near-profile of the figures of the Virgin and St John on either side of the mandorla. This steady, balanced concentration is itself immediately

entire design must formerly have possessed two striking characteristics. The first was the unusually small number of constituent compositional elements. The second was the way in which Cavallini seems to have built these elements into a whole that was not only remarkable for its symmetry and grandeur but exceptional in its unity. The contrast to the highly compartmentalized character of all the earlier surviving examples of full-scale Last Judgements is accentuated by the setting of the thrones. Post-Renaissance naturalism would demand that they receded inwards to the centre of the composition. Here, instead, they are seen in regular recession outwards to the wings of the design. In this they follow the two small, sentry-box-like structures that flank the mosaic of the *Dormition* in S. Maria in Trastevere [82]. The whole long line of seated figures, which could so easily dissipate attention to the wings, causing the whole design to fall to pieces, is,

enlivened by the contrast with the boldly accentuated outward-facing symmetry of the trumpeting angels in the zone below.

The large, clear rhythms of symmetry and contrast and enlivenment that are sounded by the drumbeats of the major compositional elements, and fluently taken up and varied by the woodwinds of the individual drapery forms and figure poses, also constitute the basis of the colour harmony. In the centre is the figure of Christ in deep earth-red and blue. On the left this colour-couple is slightly varied in the somewhat lighter outermost apostle and in the one who is seated third from the centre. On the right, it is the second apostle from the centre and the last but one who repeat the same clear red over a garment that is now a bluish green or greenish blue. Not absolutely uniform in hue, not quite symmetrical in placing, this arrangement sets up a repeated, coupled colour accent that is a framework for less powerful

repetitions. The first and fourth apostles on the left echo a violet-tinted grey over a deep green. The fourth and sixth on the right repeat a pearl-grey over blue. Such repetitions also run from side to side as the pattern ranges from three unrepeated colours at one extreme to the absolute symmetries of the white-robed central angels, with their dull-green cross-belts, studded with deep-red lozenges, and their wings that run from a near-white to deep, dark

red, deep green, deep brown, and honey-yellow, at the other. There is a subtlety in every hue, a delicacy in transition, that is almost atmospheric in its final effect. The tonal unity that controls and disciplines this brilliant play of colour is more extraordinary still. The almost uniform range from dark to light across an extremely wide spectrum seems to have few precedents and is not matched again till Leonardo's day. In terms of line and tone and colour, and in the feeling of life and softness that they finally create, these few remains are truly revolutionary.

The new humanity and the warmth of presentation are not destroyed by the majesty and splendour of a setting drawn from earlier Roman and Byzantine art. Limitations of draughtsmanship prevent the heads from appearing to be fully in the round. They seem instead to stand out in relief against the ground plane of their haloes [88]. Nevertheless, it is

88. Pietro Cavallini: Head of upper right-hand Seraph, detail of Last Judgement, early 1290s(?).
Rome, S. Cecilia in Trastevere

clear that Cavallini is striving to create, not symbols on a wall, but living forms presented in the round. The convincing structure of the seated figures, each limb clear beneath its draperies [89], can only be compared with the sculptural clarity of Arnolfo's Virgin on the tomb of Cardinal de Braye [46]. In return, the clarity of design and the pictorial solidity of these undoubtedly familiar figures may well have encouraged the accentuated sculptural clarity and volumetric discipline of the *Virgin and Child* that Arnolfo was so soon to carry out for the Duomo in Florence [61]. The obvious relationship of many of the heads to the common Italo-Byzantine pictorial tradition is matched by the way in which others, such as the clean-shaven Apostles on the left, seem

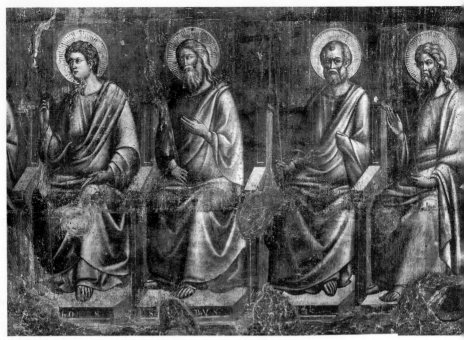

89. Pietro Cavallini: The four right-hand Apostles, detail of Last Judgement, early 1290s(?).
Rome, S. Cecilia in Trastevere

to demand comparison with Roman portrait busts. Comparisons with tenth-century Byzantine ivories are also apt, and these may well be carried over to the draperies, as far as their soft and heavy texture is concerned.

The weighty, woollen or velvet quality of Cavallini's painted garments was foreshadowed in many of the drawings of the frescoes on the right wall of the nave of S. Paolo. The development of drapery as a soft and self-existent entity can be compared with the similar evolution in Nicola Pisano's sculpture on the Siena pulpit [44] or in Arnolfo's work of the eighties. As an indication of structural form such drapery is magnificent. It may loop lazily over an arm, or hang in gentle folds, sometimes between the knees and therefore parallel to the picture plane, sometimes along the thighs, establishing the reality of volume and recession

[89]. It may be pulled taut into parallel, tubular folds by a sudden gesture or create a tight sheath for a hand in a manner reminiscent of the frescoes and ciborium in S. Paolo. These same form-defining folds are just as effective in building up a unified, repetitive, yet wonderfully varied formal rhythm across the surface of the wall. It is, indeed, the pattern-element in this drapery, so seemingly classical in its fundamental relationship with the underlying body, which shows that Cavallini was also deeply moved by the more purely formal aspects of the burgeoning Gothic art. The tabernacles of the painted framework of the cycle represent his first surviving use of Gothic architectural forms. But now, if one looks at the folds that hang down from the wrists or sweep diagonally across the chests, or if one runs an eye along the form of any hem, one suddenly discovers

that the broad, calm cup-folds, first exploited in Italy by Nicola and Giovanni Pisano in the Perugia fountain, are accompanied by a constant emphasis upon reiterated soft S-curves. As might be expected of so original an artist with so clear a vision of his Roman heritage, it is not in its superficialities but in its fundamentals that his understanding of contemporary Gothic trends is to be found. The enlivening, sinuous S-curve ceases, in his hands, to be merely a Gothic trade-mark. It presents no clash with the vision of Antique humanity which lies behind the budding Christian humanism of his style.

Knowledge of ancient Roman paintings then surviving, but now lost, may easily have contributed to the new softness and atmospheric quality of Cavallini's style. These qualities are certainly not based on a blurred or uncertain handling of the brush. The discipline that marks the structure of the composition as a whole or of each figure in it is founded on the discipline that controls each individual stroke in its relationship to the form that it defines. Almost any detail, like the head of the uppermost Seraph on the right [88], reveals the form-creating, form-defining continuity of Cavallini's brushwork. A flow of individual, brush-point strokes is used to turn the column of the neck or shape the varying curve across the brow. A similar current runs down from the temple over the smooth cheek and past the small, uncertain mouth into the shadow of the chin. The obvious limitations of descriptive power serve only to accentuate the brilliance of attack in such things as the swelling of the large and luminous eyes within their firmly sculpted sockets. A similar crisp stroke and sense of decorative and descriptive function underlie the continuous, parallel brushwork of the draperies or bring to life such features as the hair of the Apostle on the extreme right [89].

Here at last, if anywhere, the personal hand of the artist who has been identified as Cavallini may be seen. It is therefore possible to make a final, closer check upon the status of the mosaics in S. Maria in Trastevere. Comparison of the seated apostles with the Angel Gabriel in the *Annunciation* [86] betrays the intervention of the restorer in the sudden degeneration of the crisp, tubular folds beside the lower knee. Similarly, little or nothing of the original design survives in the Virgin's shapeless knees or in the amorphous folds between them. A series of such close comparisons reveals almost exactly how much Cavallini's personal ideas have been distorted by the intervention of the mosaicist or by subsequent damage.

Although the frescoes in S. Cecilia, notably the *Last Judgement* itself, are echoed in the Sabine church of S. Maria in Vescovio near Stimigliano, there are few surviving traces of Cavallini's impact in Rome itself. The most important of these few is undoubtedly the half-repainted fresco of *Christ, the Virgin, and three Saints* in the apse of S. Giorgio in Velabro. At best it seems to be no more than a workshop product and may date from the period following 1295, when a late-seventeenth-century source declares that Giacomo Gaetano Stefaneschi became cardinal deacon of the church and supervised its redecoration. This adds interest to the Stefaneschi origins of the mosaics in S. Maria in Trastevere. Finally, there is rather uncertain sixteenth-century evidence of a Stefaneschi link with S. Cecilia in the fourteenth century. If this was the continuation of a long-standing connexion, Cavallini's activity in Rome would seem to be an artistic reflection of the power of one of the great noble families which, between them, were the effective civic and ecclesiastical rulers of the city.

THE FRESCOES IN
S. MARIA DONNA REGINA IN NAPLES

The last great surge of Cavallini's art is to be seen in S. Maria Donna Regina in Naples. The church was only founded in 1307 and was substantially complete by *c.* 1320. The extensive cycle of frescoes covering the main walls of the nuns' choir and of the nave [170] cannot, therefore, be connected with Cavallini's documented activities in Naples during 1308.

Nevertheless, with its Last Judgement flanked by scenes from the Old and New Testaments set in three tiers and articulated by twisted columns; with the side-wall lighting organized as if it fell from the oculus high up in the end-wall; with its almost, but not quite, completely consistent attempt to show all the architectural framework, notably the complex brackets and angel-inhabited trefoil arches that supported the roof, as if seen from a low and central viewpoint, it remains one of the most complete and most important re-adaptations of the Roman scheme reflected in S. Cecilia.

The number of hands involved in the work; the differences in technique and variations in style when compared with the frescoes in S.

90. Cavallini Circle: David (detail), early fourteenth century.
Naples, S. Maria Donna Regina

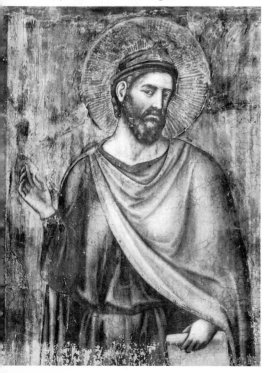

Cecilia; the manifest influence of early-four-teenth-century Tuscan art; all these make it extremely difficult to decide what part, if any, Cavallini himself played in the execution of these paintings. Recently the tendency has been to give him less and less. Even those parts most closely connected with his Roman style may conceivably be the independent work of one of the many men who were trained as his assist-ants. The standing figure of the *Prophet David* is perhaps the finest of a number of similar representations [90], and the one which seems to fit most closely into the apparent line of Cavallini's development. It shows a combina-tion of humanity and power, of soft materiality in the drapery and atmospheric delicacy and subtlety of transition in the modelling. These are accompanied by a strength of char-acterization and a firmness in the structure of the head, shown in three-quarter view, which clearly surpasses anything similar in S. Cecilia. Whether it be his own creation or the work of a man steeped in the knowledge of his tech-nical procedures and artistic aims, the figure seems to give some indication of the later trends in Cavallini's art. It is also characteristic that this set of over-life-size standing figures should recall the figures which Ghiberti says that he painted 'much greater than the natural' in the nave of St Peter's, probably many years before.

It is this mixture of conservatism and pro-found originality; this ability to revitalize old schemes, to accept an iconographic pattern and to transform it by the manner of its execution; to see, to understand, to learn from, and to recombine the Antique, Early Christian, Byzantine, and Romanesque elements in his artistic heritage in the light of nature, that is fundamental to Cavallini's achievement. Indeed, the rediscovery of nature through the art of Late Antiquity is as essential an element in Cavallini's painting as it was in Nicola Pisano's sculpture. In this particular, as in every other, Rome and Cavallini carry on in painting that same revolution which, in sculpture, is associated with the town of Pisa and the name Pisano.

COPPO DI MARCOVALDO AND GUIDO DA SIENA

Good, better, best; the bad is left behind. This is the burden of Vasari's epic of the rise of art out of the slough of medieval barbarism till, with Michelangelo, it overtops the high peaks of Antiquity from which it had once fallen. So irreplaceable is Vasari's knowledge of lost sources, so perceptive is his eye, so sure the scale of values upon which he works, and so persuasive is the telling of his tale, that his *Lives of the Painters*, first published in 1550, has had a mesmeric effect on subsequent historians. Even allowing for the accidents of time, this has contributed to the relative obscurity of artists like Coppo di Marcovaldo and Guido da Siena. The natural influence of Vasari's thought has been intensified by the very nature of historical study. What is easily described and catalogued tends to be quickly accepted and takes precedence over what is not. Line and composition are, for example, easier to record than colour. The statements made about them can more readily be checked away from the work of art itself. As a result the written history of art is largely monochrome. Then again, within a given class of works, closely related in format and in geographical and chronological distribution, a growing interest in the representation of the natural world is relatively easily charted. When great artists are abundant and an ever-increasing naturalism is a major aspect of their art there is an inevitable tendency to think in terms, not merely of historical change, but of continual progress and improvement. This attitude does not, indeed, originate with Vasari: it was already characteristic of many artists and their patrons and admirers during the late thirteenth and early fourteenth centuries. It is therefore very important to avoid implying that increased naturalism is necessarily synonymous with greater artistic value.

Nowhere is this truer than in the case of Coppo di Marcovaldo and his contemporaries.

COPPO DI MARCOVALDO AND THE MASTER OF S. BERNARDINO

Coppo is first mentioned as a shield-bearer in the list of Florentines conscripted for the disastrous struggle with Siena that culminated in the Battle of Montaperti in 1260. A year later he signed the *Madonna del Bordone* in S. Maria dei Servi at Siena [91]. It is not now known whether he was, at the time, among the many Florentine prisoners taken by the Sienese or was simply a master-painter under contract in the normal way. In 1265 and 1269 Coppo was working on lost frescoes in the Duomo at Pistoia, and in 1274 the cathedral authorities petitioned that his son, Salerno, be released from the debtors' prison for four months to help his father on a crucifix and two panels of the *Virgin* and *St John*. These were to be set up in the choir together with a second crucifix intended for a beam above the altar of St Michael. The authorities pointed out that otherwise so great a series of works could not be carried out, and anyway Salerno's earnings could be set against his debt. The now lost, but signed and dated, panel of the *Virgin* was completed by the end of January 1275, and one of the crucifixes still survives, in a somewhat damaged state, in the sacristy of the cathedral. Nevertheless, in 1276, six lire paid to Coppo for painting the ceiling over the choir were set against a sum of 100 lire which Salerno still owed to the Commune. Even the recent big commissions had seemingly failed to set this impecunious family of painters on its feet.

The story of Coppo's *Madonna* of 1261 shows how deeply ingrained the belief in the

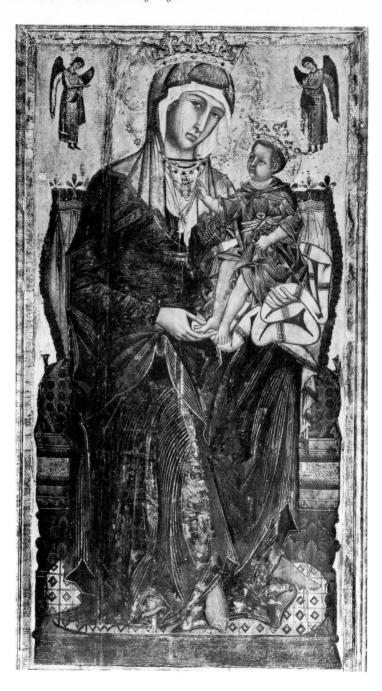

91 (*opposite*). Coppo di Marcovaldo:
Madonna del Bordone, 1261.
Siena, S. Maria dei Servi

92. Coppo di Marcovaldo(?):
Crucifix, late 1250s(?).
S. Gimignano, Pinacoteca Civica

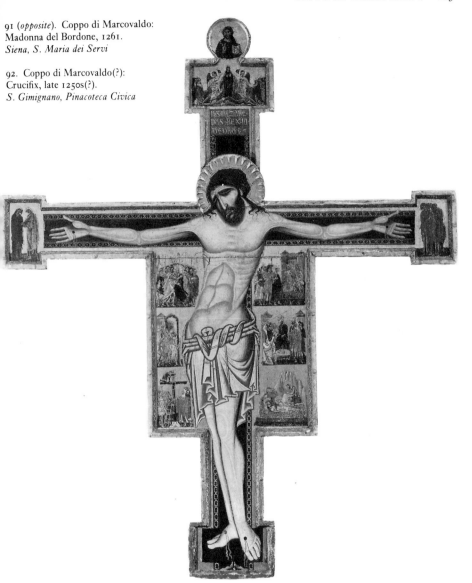

stylistic improvement of the arts already was in certain ecclesiastical circles in late-thirteenth- and early-fourteenth-century Siena [91]. It was itself an advanced work for its date. Yet it was probably only just over half a century later that the heads of the two main figures were beautifully repainted in the then triumphant manner of Duccio. Luckily the panel was not scraped before repainting, and the powerful stylizations of the original features of Coppo's *Madonna and Child* can still be seen in X-ray photographs.[1]

The panel owes its impact and historical importance to two things. The first is its actual size. Its height of 7 feet 3 inches and its width of 4 feet (2·20 by 1·25 m.) foreshadow the late-thirteenth-century tendency for panel paintings to approach the scale of frescoes. The second is the monumentality of the design itself. This is greatly enhanced by the rich, yet sombre colour, which is based on gold and brown, on touches of vermilion, and above all on the deep, brownish purple-lilac of the Virgin's gold-striated draperies. The latter owe their peculiar richness partly to an underlayer of silver. This recalls the technique for obtaining translucent colour which Theophilus recommended in his early-twelfth-century treatise. The effect may even have been enhanced by delicately tinted varnishes, though this has been a matter of continuous technical debate.[2] It is, however, certain that the crisp formalization of the golden lights would once have harmonized with the stylization of the heads. The decorative angularities of the segmental drapery folds, which reveal the stylistic premises but not the actual sources of the prismatic draperies of Nicola Pisano's Pisa pulpit, signed in the preceding year, are another aspect of its decorative power. As with Nicola, though to a much more limited extent, these decorative qualities do not disguise the quite new sense of volume and solidity that distinguishes this painting from its Romanesque and Italo-Byzantine forerunners. The new spatial feeling finds particular expression in the convincing diagonal setting of the legs, as well as of the upper torso and shoulders, of the figure of the Virgin.

The small, floating, spatially unrelated figures of the angels are the main surviving link between the *Madonna del Bordone* and the large *Crucifix* at S. Gimignano which is often attributed to Coppo [51 and 92]. The X-rays of the Virgin in Siena suggest, however, that originally the stylizations of the main heads would have provided a major reason for assigning the two works to the same hand. The head of the Crucified Christ has already been discussed in relation to Pietro Oderisi's sculpture (p. 98).

Now, its linear qualities, and those of the stylizations of the torso or of the bright, pale, blue-white loincloth, can also be related to the conventions which had earlier been evolved in the less tractable medium of mosaic. As often happens, it is just those artists who are beginning to take an interest in mass and volume who are most sensitive in their exploitation of the linear brilliance of their predecessors.

The belief that the S. Gimignano *Crucifix* is by Coppo may never harden into certainty because of the lack of strictly comparable works. Assuming that it is his, the very format of the *Crucifix*, which possibly antedates the *Madonna del Bordone* by a few years, confirms Coppo's strong dependence on the past. This pattern, with its six small scenes from the Passion on the apron, goes right back to the Late Romanesque forms current in Tuscany and Umbria at the turn of the twelfth and thirteenth centuries. Spoletan, Florentine, and Sienese examples of these early crucifixes have survived, although the finest and most numerous members of the group originate in Pisa. Indeed, the Pisan and Lucchese crucifixes provide a thumbnail sketch of the whole process whereby the open-eyed, triumphant Christ, which seems to have been the sole type favoured by Italian artists in the late twelfth century, was gradually superseded by the pathetic, swaying, dead, Byzantine Christ, so closely connected to the forms becoming popular in Northern Europe.

The figure on the S. Gimignano *Crucifix* only reflects the gentle curve and almost standing posture in such works as Giunta Pisano's signed *Crucifix* of *c.* 1235–40 in S. Francesco at Assisi. There is as yet no echo of the more pronounced sway developed by Giunta in his later signed works in the Museo Civico at Pisa and in S. Domenico at Bologna. The proof that this is due as much to Coppo's innate conservatism as to any need to leave sufficient space for the subsidiary scenes that may have been demanded by his patrons lies in the slimmer forms and greater sway, approximating to that in Giunta's later works, which is incorporated in the iconographically similar *Crucifix*, dating from 1274,

in the Duomo at Pistoia. The documents support the attribution of the latter's rather weaker stylistic character to Coppo's son Salerno. As far as Coppo himself is concerned, it is only through small scenes like those on the S. Gimignano *Crucifix* that an idea of his narrative powers can now be gained. Although, as might be expected, there is little that is grandly dramatic about them, a sense of liveliness and an occasional narrative inventiveness are everywhere enriched by highly developed powers of decorative schematization.

The only other work with strong claims to be by Coppo is the unsigned and undocumented *Madonna and Child* in S. Maria dei Servi at Orvieto [93]. The connexion with the Florentine order for which Coppo had previously worked, and the building of the church between 1265 and 1268, provide a preliminary framework for the attribution. This is based not merely on the general resemblance to the *Madonna del Bordone* [91], which includes the rich, distinctive colouring, but on numerous points of detail in the throne, in the draperies, and above all in the small attendant angels. The constant interplay between the forces of tradition and of innovation in the works associated with Coppo is again apparent. As the result of a more conservative pose, related to the Byzantine *Hodegitria* design, the figure of the Virgin is less organically coherent in the relationship of legs and torso and is spatially less convincing. There is also a distinct return from the relatively child-like Christ of the *Madonna del Bordone* towards the manikin figure common to Romanesque and to Byzantinizing art in Italy. Whether such changes rule out Coppo's authorship or merely reflect the impact of Guido da Siena, which is also felt in some of the iconographic and decorative details, is debatable. So also is the question as to whether a five- to ten-year interval can account for the altered proportions in the head of the Christ Child or the disappearance of the sweeping linear curves seen at the corners of the eyes of both the *Madonna del Bordone* and the S. Gimignano *Crucifix* [51]. The stylistic revol-

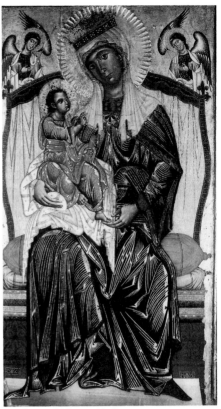

93. Coppo di Marcovaldo(?):
Virgin and Child, *c*. 1265–70(?).
Orvieto, S. Maria dei Servi

ution, involving even the technical details, which is undergone by Nicola Pisano's art in the five- to eight-year gap between the Pisan and the Sienese pulpits is a reminder that the problem is indeed a problem. Nevertheless, stylistic revolutions of this kind are rarely, if ever, documented in late-thirteenth-century painting, which appears in this respect to be considerably more conservative than sculpture. Such arguments inevitably cast a shadow on the attribution. On the other hand, the vigorously three-dimensional modelling of the heads; the emergence of a spatially considered relationship between the two supporting angels and the

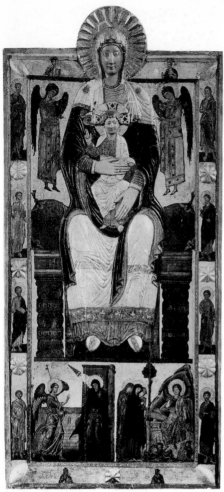

94. Coppo di Marcovaldo(?):
Virgin and Child, late 1260s(?).
Florence, S. Maria Maggiore

Apart from the large *Crucifix* in Arezzo, connected with Cimabue, only the altarpiece of the *Virgin and Child* in S. Maria Maggiore in Florence, which is unlikely to have been executed before the end of the sixties, can reasonably be attributed to Coppo's workshop or immediate following [94]. Part relief, part panel painting, the latter seems to be the work of several hands. The naïve conservatism inherent in this seldom repeated effort to give actual body to the figures of the *Virgin and Child* is essential to the power and charm of this example of late-thirteenth-century interpenetration in the arts. The combination of hieratic stiffness, softened by a half-smile, and of decorative animation, of lively realism and almost total unreality in the end result, is singularly attractive. It also provides a useful standard for assessing Coppo's sadly few but still formidable achievements.[3]

These can be brought into even sharper focus if the *Madonna del Bordone* [91] is compared with the anonymous, but once no less imposing and originally full-length, *Madonna and Child Enthroned* from S. Bernardino in Siena [95] which was notarized in the late eighteenth century as bearing the date 1262 before it was heavily cut down. The stylizations of the slightly more conservative and less child-like Christ Child in the latter represent the culmination of a long tradition, whilst Coppo's figure is a presage of what is to come. But if, on the surviving evidence, the strikingly unusual yellow headdress and the basic diagonal of the Virgin's legs are owed to Coppo, much is new. The yellow is dramatically intensified and Coppo's quiet colour scheme replaced by the bold clash of crimson and vermilion reds against deep blue which is to be the hallmark of Siena for the best part of a hundred years. The subtleties of Coppo's throne have given way to a single, sweeping curve, once boldly set against the angled forms of a more modern, pedimented frame. The setting of the legs is more emphatically diagonal and the great V-fold of drapery adds to the sense of life and movement which is everywhere apparent, and not least in the

throne; the more convincing recession of the planes throughout the throne itself; the firmer relationship between the latter and the seated Virgin, due in part to the sensitive and significant contour of the drapery folds upon the right, in contrast to the more purely decorative features on the left of the *Madonna* in Siena; these are innovations that exactly fit the experimental side of Coppo's artistic approach.

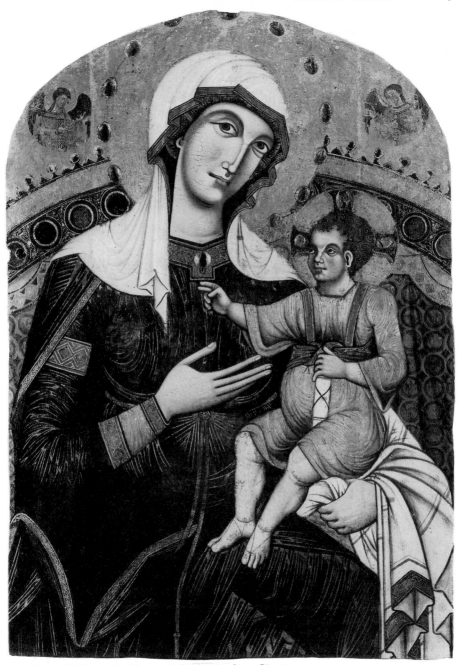

95. Master of S. Bernardino: Virgin and Child, 1262. *Siena, Pinacoteca*

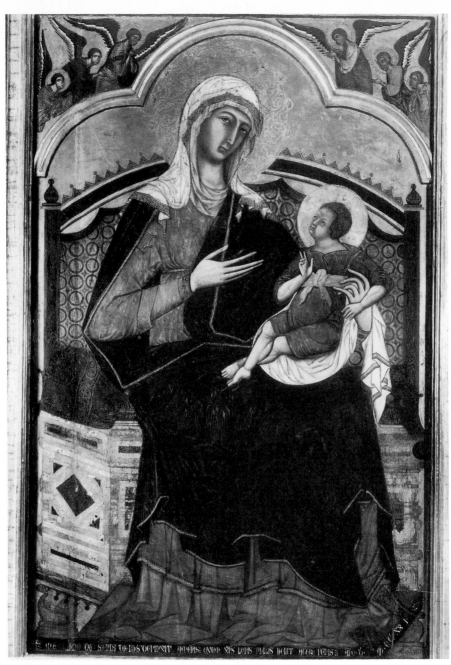

96. Guido da Siena: Virgin and Child, *c.* 1275–80(?). *Siena, Palazzo Pubblico*

brilliant white, blue-shadowed, cloth that cascades from the Virgin's arm despite the patent firmness of her grip. The greater naturalism so apparent when contrasted with the splendidly stylized forms of the similar cloth in Coppo's painting is only the most extreme of many subtle changes visible throughout the work which the Master of S. Bernardino painted only one year later. All in all, it is no surprise that his was the pattern which was to be followed by a veritable comet's tail of dependent works.

Unfortunately, the history of late-thirteenth-century art has been bedevilled by a persistent tendency to cluster as many of the few surviving, mostly anonymous, works as possible around the nearest named figure. The *Madonna* of S. Bernardino and its direct derivatives, such as the imposing *Virgin and Child Enthroned* in the Pinacoteca at Arezzo, in which the general lines of his design are seemingly fully recorded, though at a lower level of intensity as far as natural observation is concerned, have been mistakenly embedded in a large group of works connected with the name of Guido da Siena who has, as a result, been elevated from his true place as a follower of the Master of S. Bernardino to a position next to Coppo, but diametrically opposed to him, at the head of an almost purely decorative Sienese school.[4] This, in turn, has given rise to a distorted view of the whole artistic relationship between Florence and Siena in the late thirteenth and early fourteenth centuries.

GUIDO DA SIENA

Despite the multiplicity of Guidos found in contemporary documents, and several unconvincing attempts to connect him with otherwise identifiable personalities, the painter, Guido da Siena, is now known to us only through two surviving inscriptions. The first of these, on the enormous panel of the *Madonna and Child* in the Palazzo Pubblico in Siena [96], reads 'ME GUIDO DE SENIS DIEBUS DEPINXIT AMENIS QUEM XRS LENIS NULLIS VELIT AGERE PENIS ANO DI MCCXXI'. The inscription itself is highly controversial because of what appears to many to be the wild stylistic improbability, if not the downright impossibility, of the date. The situation is further complicated because the authorities, in their subsequent enthusiasm for Duccio's art, had the throne and the faces and hands of the main figures repainted in the early fourteenth century. The repaint has been removed from the hands and from the Virgin's headdress, but not from her veil. In the main heads the preparatory scraping of the panel means that even X-rays give no hint of what is lost. Among the faces, only those of the small angels in the spandrels survive in their original state. It is, moreover, uncertain that the separate gable originally belonged to the panel.[5]

Technical investigation has shown that the present inscription is not painted on top of an earlier version.[6] This is no proof that it antedates the Ducciesque repainting, since there may previously have been no inscription at all. Moreover, a number of curious pigment marks which may seriously affect the argument have not been satisfactorily explained. The inscription itself is both ill-spaced and crowded because of the narrowness of the strip on which it stands. Furthermore, the wording is identical with that of the surviving parts of the inscription on the low, gabled dossal with heavily moulded, round and trilobate arches which comes from Colle Val d'Elsa and is now in the Pinacoteca at Siena (no. 7) [97]. The cutting of this panel, with its half-length figures of the *Virgin and Child and four Saints*, has destroyed the beginning and end of the inscription. The name of the painter has disappeared, together with the last word of a date which now reads as 127–. Even allowing for the repainted areas in the altarpiece in the Palazzo Pubblico, the stylistic links between the two works are sufficiently close to confirm that the lost name is almost certainly that of Guido. If this is not so, there remains no basis on which a knowledge of Guido's personal handling of the features of the Virgin and Child can be founded. If, on the other hand, it is, then the distinction

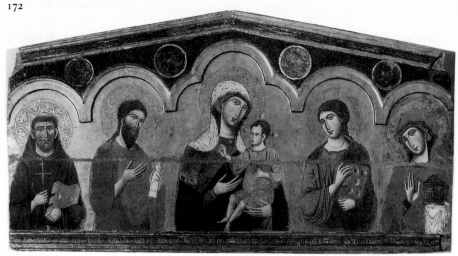

97. Guido da Siena: Virgin and Child and four Saints (polyptych no. 7), 1270s(?). *Siena, Pinacoteca*

between his work and that of the Master of S. Bernardino is thoroughly confirmed and it, together with the Palazzo Pubblico *Madonna*, forms the nucleus of a group of panels all of which date from well after the mid century and include an almost exactly similar dossal (no. 6, Siena, Pinacoteca) which, because of its lower quality, is normally assigned to Guido's shop or close circle.

The *Maestà* from S. Agostino in S. Gimignano,[7] now in the Pinacoteca Civica, amounts to another version of the Palazzo Pubblico *Madonna* [96]. Although the panel is cut at top and bottom, the base of the original pediment with the half-length figures of the Redeemer and Angels still survives. Whereas in the Palazzo Pubblico *Madonna* the pediment is detached from the main panel, with which it may or may not be contemporary, the S. Gimignano *Maestà* is in one piece. As in the *Madonna* of S. Bernardino of 1262 [95], the pose of the Christ Child is a variant of that established by Coppo in 1261.[8]

The catalogue of repetitions and near-repetitions associated with Guido is enough to show that he is an artist in whom, far more even than in Coppo, innovation marches hand in hand with stubborn conservatism.[9] He was open-minded enough to seize on the inventions

of Coppo and the Master of S. Bernardino and accentuate some of their salient features. After that he was content, with the assistance of his workshop, to repeat the new formula time and again with only minor modifications. The catalogue also demonstrates that the Palazzo Pubblico *Madonna* belongs to a very closely interwoven group of works of which all the other members must date from well beyond the mid century. This group includes on its periphery the horizontal, rectangular dossal of *St Peter and six Scenes from his Life*.[10] Although the panel probably dates from the beginning of the last quarter of the century, it continues a pattern already popular throughout Central Italy at the mid century. The scheme goes back at least as far as the dated Sienese panel of 1215.[11] The latter, together with the slightly later *Enthroned Madonna and Child* in the Opera del Duomo, is among the only surviving early-thirteenth-century dossals combining low relief and panel painting in a manner which reveals the long tradition preceding the late-thirteenth-century S. Maria Maggiore *Madonna* from Coppo's circle.

Neither the Sienese panel of 1215 nor any earlier or contemporary work, nor even any of the Sienese or other Central Italian panels datable to the succeeding thirty years, bears

the slightest stylistic resemblance to Guido's Palazzo Pubblico *Madonna*. There is not, throughout this period, even an echo of an echo of what would, if the date 1221 were correct, have been one of the greatest stylistic explosions in the history of Italian art. Apart from the curious nature of the inscription, its lettering fits happily into the final, rather than into the first third of the century, and many other features confirm a chronological place in the stylistic group with which it is so closely related. No other gabled or rectangular panel with an inscribed arch can be dated before the mid century.[12] The type of moulding is, moreover, closely connected with other examples from *c.* 1270 or later. Then again, the rich sinuous naturalism of the Virgin's superbly decorative halo, in which line and punching are combined for the first time in Sienese art, is only to be matched in later works. This is another innovation seemingly derived from Coppo's *Madonna* of 1261 [91]. Finally there are no remotely similar examples of the diagonal setting of the Virgin's legs in any Italian panels from the first part of the century. These very features, on the other hand, complete the pattern of the other works ascribed to Guido. Indeed, it is quite possible that the date 1221 refers, whenever it was painted, to the death of St Dominic in that year and not to the completion of the work,[13] although the existence of the almost identical Colle Val d'Elsa inscription, which does refer to a completion date, somewhat undermines this supposition.

If the breaking of the spell cast by the date of 1221 does finally allow Guido to take his true place as a follower, rather than a leader and an innovator in any fundamental sense, the achievement represented by his soon to be repainted masterpiece is none the less remarkable. The Master of S. Bernardino's great V-fold, with its reflections of the natural behaviour of material, is almost totally transmuted into line. Its speed and thinness, its near-rectilinear disregard for actuality, go together with a splendidly expressive elongation of the figure of the Virgin. The greater width of the panel in

relation to its height allows a general opening up of the design through the expansion of the intervals between the figures and the frame to give a new sense of spaciousness and freedom, even an informality, that is Guido's own [96]. It is a spaciousness so cunningly built up of repeated, boldly contrasted diagonals that the fullest values both of harmony and contrast are given to the smooth, swift planar arching of the now attenuated throne-back, to the even curves of the rounded trilobe above, and to the brilliant linear zigzags of the draperies.

A similar decorative precision is to be found in one form or another in the work of many of the Pisan, Lucchese, and Florentine artists who were making the first tentative moves towards the new conception of pictorial and narrative realism. It recurs in the boldly contrasted curved, rectangular and pointed forms of the *Last Judgement* at Grosseto,[14] which is probably a late product of Guido's shop. These qualities of sharp silhouette, firm stylization, and sweeping line are combined with a brilliant range of colour, running from intense, cold ultramarine to vermilions, yellows, pinks, and greens, which involves both figures and architecture alike in an exciting play of tonal contrast. The outcome is the dramatic and emotional power of the *Crucifixion* gable now at Yale, of the shutters of the *Lives of the Saints* in Siena, and of the twelve scattered narrative panels which must likewise have belonged to some large altarpiece.

The range of Guido's narrative designs is wide. At one end of the scale are the melodious simplifications of scenes like the *Stigmatization of St Francis*[15] and the vigorous dramatic realism of the Princeton *Annunciation* or of the *Flagellation* now at Altenburg.[16] At the other is the crowded naturalism and dramatic invention of the rare scene of *Christ mounting the Cross*, at Utrecht [98]. Expressive gestures, whether those of Christ and of the soldier hauling at his outstretched arm or of the flailing group formed as the Virgin rushes to protect her Son, are combined with a multiplicity of realistic details such as those of the nude thief seated on the right, or of the energetic hammering of the

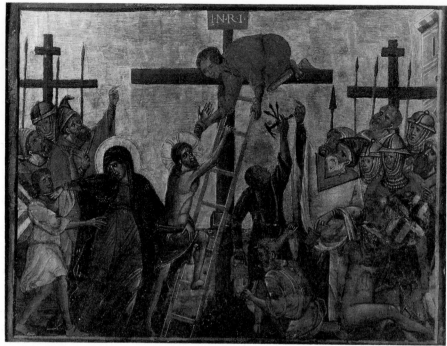

98. Guido da Siena: Christ mounting the Cross, 1270s(?).
Utrecht, Archiepiscopal Museum

nails. The whole is a colourful, small-scale prelude to the achievements of the fresco painters at Assisi and elsewhere.

Only a glance at the descriptive naturalism of the *Adoration* [43] on Nicola Pisano's Siena pulpit is finally required to set the limits upon Guido's role as an artistic innovator. The power of his art largely depends on qualities common to the Pisan and Lucchese painters of the first half of the century. A different art, more complex in ambition, more far-ranging in descriptive and associative emphasis, is soon to follow. Nevertheless, it would be hard to say that it was grander or more moving than the work of Coppo di Marcovaldo or the Master of S. Bernardino, or more rich in decorative drama and delight than that of Guido da Siena. Between them they reveal the fundamental unity of Tuscan art in the mid thirteenth century. It is a blend of Romanesque and of Byzantine elements, largely untouched as yet by the new movement under way in Rome. It overrides the fortunes of recurrent warfare and the subtle aesthetic distinctions that are often given an undue importance in the light of subsequent events.

CIMABUE AND THE UPPER CHURCH OF S. FRANCESCO AT ASSISI

The new part played by Rome in the history of Florentine painting during the late thirteenth century is nowhere seen more clearly than in the career of Cenni di Pepi, known as Cimabue. It is symbolized by his being recorded as a signatory of a legal document of 1272, preserved in the archives of S. Maria Maggiore in Rome, which also contain the earliest mention of Pietro Cavallini, dating from 1273. It is no less suggestive that his sole surviving documented work is to be found in Pisa, the great port of entry for Byzantine art and artists during the half-century after the fall of Constantinople in 1204. Rome and Byzantium: these are the formal poles between which flowed a current of ideas that welded a new art.

The reference in the Roman document of 1272 to 'Cimabove, pictore de Florencia' shows that he was already an independent master. The ensuing quarter of a century of documentary silence is only broken when, in September 1301, he took over the execution of the surviving mosaic in the apse of the Duomo at Pisa from a certain Francesco di S. Simone a Porta a Mare. The latter is otherwise unrecorded unless he is that same Francesco who in May 1298 had been discharged for unknown reasons from his work on the mosaics in the baptistery at Florence. From August onwards there are weekly payments to Cimabue at the same rate of ten soldi a day as had previously been assigned to Francesco. These continue into January 1302. Then, on 19 February, after doing ninety-four days work in all, according to surviving records, he is specifically stated, in connexion with a further payment, to have carried out the figure of St John.[1] Finally, a document of November 1301 records the commissioning of a lost altarpiece complete with a predella for the Hospital of S. Chiara in Pisa, and the last surviving mention is in July 1302.

THE MOSAIC IN THE DUOMO AT PISA AND THE S. TRINITA MADONNA

This short catalogue of fact shows that the figure of St John in the Pisan mosaic is the only means by which surviving works can be attached to the recorded name. The mosaic of *Christ enthroned with the Virgin and St John* is violently restored, and the figure of the Virgin is known from a lost inscription not to have been completed until 1321. There are therefore wide divergencies of handling within an Italo-Byzantine scheme which was originally developed for flat surfaces, and consequently looks a little uncomfortable among the bold, distorting curvatures of its new apsidal setting. Luckily the upper half of the St John, which is stylistically distinct from anything else in the mosaic, is relatively well preserved, the rising flood of restoration having left a tide-mark at the hips [99].

From this one figure of St John it is possible to move with reasonable certainty to the great altarpiece of the *Madonna and Child enthroned with Angels and Prophets* from S. Trinita in Florence [100]. The detailed treatment of the features of St John, and especially of the nose with the V-shaped nick at the junction with the forehead, as well as of the eyes, mouth, chin, and neck, and even of the hands, is very close to that found in the Angels and in the Christ Child of the altarpiece. The structure of the heads in the Child and in St John are strictly similar. The only half-successful attack on the problem of the three-quarter view results in an almost frontal face that splays and flattens on the right to show an almost profile head and ear. The similarity between the draperies on the right shoulders of the Christ and of the St John is even more convincing. Despite the golden highlights in the panel, the figures are

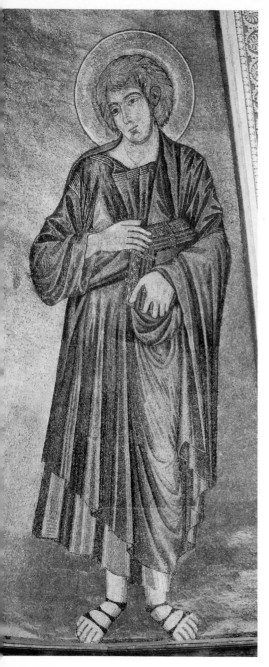

99. Cimabue: St John (detail), 1301–2.
Pisa, Duomo

close-linked by the lively, crumpled, textural quality of the folds. Another not too common feature that they share is the leaf-shaped gouging of the folds in the upper left arm of St John and in the arms of the lowest pair of angels in the panel. Finally, allowing for the change in scale, there is nowhere any point of conflict. Apart from all the positive connexions, nothing jars, and nothing militates against identity of authorship.

It is only in comparison with mosaic or with fresco that the *S. Trinita Madonna* is small. In terms of panel painting it is physically and compositionally monumental; 12 feet 8 inches high and 7 feet 4 inches wide (3·85 by 2·23 m.), it is twice the size of the average large thirteenth-century panel. It continues a trend already established in the works of Coppo di Marcovaldo and Guido da Siena, and overtops even the biggest of the earlier surviving panels by over three feet. There is nothing novel in the gabled modification of the rectangular Romanesque altar panel which seems, as has been seen, to have been introduced in Tuscany in the 1260s and to have rapidly become popular. The Italo-Byzantine elements in the poses of the two main figures, in the schematic highlights of the draperies, in the figures of the angels generally and in the heads of the four prophets in particular, are readily apparent. Nevertheless, it is the new, revolutionary elements in the design that claim attention. There is unprecedented weight, solidity, and grandeur in the throne that towers up and leads the eye in, stage by stage, towards the all-important figures of the Virgin and the Christ Child. These two are further accentuated by the height of the viewpoint indicated by the numerous, firmly constructed and clearly visible receding surfaces, which do not, however, actually focus on a single spot. The achievement of structural unity and of clear spatial recession within so complex a piece of architecture is a revolution

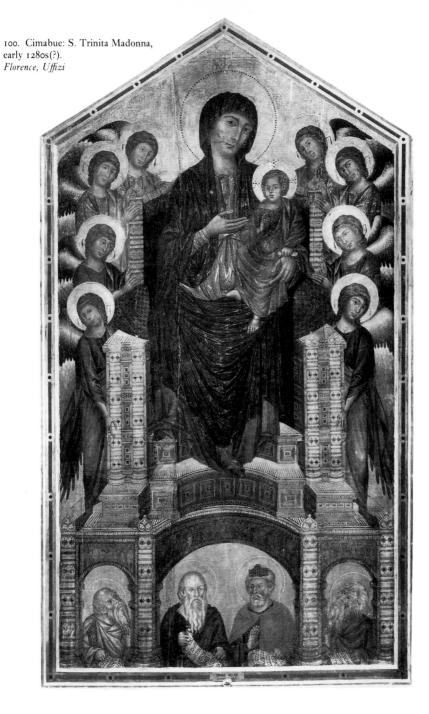

100. Cimabue: S. Trinita Madonna,
early 1280s(?).
Florence, Uffizi

in itself. Having achieved so much, the artist has as yet been quite unable to include within the terms of his construction any indication of its hind supports. The result, at once so solid and so insubstantial, still commands a willing suspension of disbelief from the knowing modern onlooker. It must have had an overwhelming impact upon men to whom the slightest and least thorough incorporation even of a hint of structural realism was an unexpected revelation.

As revolutionary in panel painting as the throne itself is its exploitation as a platform for the eight attendant angels. Once again a real relationship between figures and architecture is achieved without a final, logical explanation, for only the lowest pair are shown to stand on a firm surface. How solid and substantial these choir-boy angels are, and how unusual in such an iconographic context, is shown by a comparison with the tiny symbolic forms appearing on the altarpieces of Coppo di Marcovaldo and Guido da Siena [91–4, 96]. Finally, the compositional cunning with which the angels' heads and hands have been arranged to give both symmetry and variety, while once more leading the eye in with increasing firmness to the focal centres in the upper part of the design, is no less notable.

Variety, combined with symmetry, is also a feature of Cimabue's use of colour. The graduated hues of the angels' wings and robes are paired symmetrically across the altarpiece. They also play their part in a continuous colour chain that runs from intense coral red, through rose and lilac, down to lilac-grey, and then through warm and cool greys to grey-blue and, progressively, through darkening blues down to the fully saturated colour of the Virgin's robe. Despite the linkage with this subtle colouristic play, the golden ribbing on the draperies has lost the stylized a-textural clarity of Coppo's large, bold patterns. It acquires at times the broken, almost rumpled, quality of the underlying material. It is no longer purely a decorative symbol, but has become something between a naturalistic, or perhaps a super-naturalistic, highlight and an objective presentation of the golden-threaded textural delicacy that is now most commonly associated with the sari. This softening of the symbol in the service of a new humanity is everywhere. The linear stylization and the almost wood-carved splendours of the heads of Coppo's and of Guido's figures are barely hinted at in these more gentle, softly textured faces. The figure of Christ has moved another stage along the path from manikin to child already plotted in the work of Nicola Pisano. The contrast between the realism of the Christ Child's draperies in their relation to, and revelation of, the underlying body, and the treatment of the folds that hang across the Virgin's centrally placed knee, are further demonstrations of the intensity of effort attendant on the attempt to grasp the realities of the human form and find a counterpart in paint. Here, in the localized problem of the gold-striated draperies across the knee, traditional decorative and symbolic needs have evidently proved an insuperable obstacle to the simultaneous realization of new structural and descriptive aims. Throughout the first half of the following century such constancy of effort and unevenness of achievement are almost the hallmark of the revolutionary genius as he strides ahead regardless of the marginal cost.

CIMABUE'S FRESCOES IN S. FRANCESCO AT ASSISI: ATTRIBUTION AND SEQUENCE

From Florence and the *S. Trinita Madonna* the attributional trail leads on to Umbria and the lower church of S. Francesco at Assisi. There, upon the eastern wall of the north transept, stands the badly damaged fresco of the *Virgin and Child enthroned with Angels*, together with the now solitary figure of St Francis. The composition is essentially that of the *S. Trinita Madonna*, and many detailed linkages confirm identity of authorship. It is significant that the artist has again had trouble with the Virgin's forward knee although the child is now firmly seated on the raised leg and there is no trace of

ambiguity as to which knee is the forward one. Similarly, although the supporting structure of the less ambitious throne is clearly defined, its left-hand side is splayed towards the plane and is uncertainly related to the steps.

Substantially similar thrones are to be seen in the frescoes of the *Four Evangelists* in the vaults above the crossing of the upper church [101]. Here the inherent difficulties of the search for representational realism are accentuated by the need to fit the scenes into the awkwardly shaped, triangular fields which form

ing the central zones in either transept stand the figures of archangels and apostles. Finally, there are the main narrative elements of the decoration. These are divided into four parts. Firstly, the five-faceted apse is occupied by the *Life of the Virgin*. Secondly, five scenes from the *Lives of St Peter and St Paul* start on the lower part of the wall next to the apse and finish on the end wall of the north or right transept. Five scenes from the *Apocalypse* are similarly placed in the left transept. The lower part of the remaining wall in either transept, that adjoining

101. Cimabue: St Mark, *c.* 1280(?). *Assisi, S. Francesco, upper church, crossing*

the apex of a decorative scheme embracing the whole of the choir and transepts [102]. On the side walls of the latter, immediately below the vaults, are *St Michael and the Dragon, Christ in Glory, The Transfiguration*, and a wholly lost design. Then, behind the arcading decorat-

the nave, is then filled by a single great *Crucifixion*.

The entire scheme can be connected with Cimabue not merely through the intermediary *Maestà* in the lower church but by direct comparison with the *Madonna* from S. Trinita

102. Cimabue: Assisi, S. Francesco, upper church, scheme of decoration, *c.* 1280

KEY

A. Gathering of the Apostles
B. Dormition of the Virgin
C. Assumption of the Virgin
D. The Virgin and Christ Enthroned

1. St John on Patmos
2. Fall of Babylon
3. Christ the Judge
4. The four Angels
5. Adoration of the Lamb

1. St Peter healing the Lame
2. St Peter healing the Possessed
3. Fall of Simon Magus
4. Crucifixion of St Peter
5. Execution of St Paul

[100]. To take the two most obvious examples, the prophets in the lower part of the panel painting have almost exact counterparts in the crowd on the right of the *Crucifixion* in the left transept [108]. Similarly, the massive throne that piles up in the centre of the scene of the *Virgin and Christ Enthroned* on the right of the main apse, its concave, semicircular base now hidden by the choir stalls that destroy its full effect, is stylistically inseparable in weight and structure, and in decorative detail, from the throne in the panel painting. Despite the ruined state of the frescoes, it is even possible to compare the Pisan mosaic of St John [99] directly with the similar figure in the *Crucifixion* in the left transept at Assisi [108].

The deterioration of the frescoes in the choir and the transepts, many of them now transferred to canvas, makes both their enjoyment and their stylistic analysis extremely difficult. They were already 'consumed by time and dust' when Vasari saw them in the mid sixteenth century. Now, the flaking, falling, and fading of the paint-layer, and the total reversal of tonal values as a result of chemical changes in the pigments, have reduced the greater part of them to the equivalent of faded, ochreous negatives of unknown photographic prints. In spite of this their quality still glows and gleams in fitful embers. Enough survives to show that Cimabue himself was substantially responsible for painting the *Evangelists* in the vaults; the *Life of the Virgin* in the apse; the *Apocalyptic Scenes* and *Crucifixion* in the left transept, together with the angels in the arcading above; and, finally, the first two scenes of the *Lives of St Peter and St Paul* in the right transept. The three remaining apostolic scenes and the accompanying *Crucifixion* are of lower quality and seem to be no more than shop-work executed to his orders.

The situation in the upper part of the right transept is rather different. A separate artistic personality with strong northern, and possibly even English, connexions appears to be reflected in the bright blues and greens, strong reds and corn-yellows, as well as in the use of

Gothic architectural detail above the colonnaded galleries. What is more, a technical examination shows that it is he, not Cimabue, who began the painting of the upper church.[2]

The overlapping of the plaster at the boundaries marking the finish of one work-stage and the starting of the next shows that after the northern master had worked his way down the upper walls of the north transept, as far as the encircling passageway, he and his assistants were replaced by Cimabue's atelier, who began work on the upper part of the apse. They probably also started, more or less simultaneously, on the upper parts of the vault of the south transept, since in both areas the plastering preceded that of the crossing vault. Work on the lower parts of the latter, on the other hand, lies below, and was therefore done before, that in the corresponding areas of the south transept. This means that Cimabue probably erected a single great scaffolding at the start and that his vision of the entire volume of apse, crossing, and transepts as a single decorative, as well as thematic, unity was already enshrined in his approach to this most prosaic of preliminaries. When the work on the upper walls had been completed, the frescoing of the lower walls, below the encircling galleries, followed. It started in the south transept at the opening of the nave and then ran on in sequence to the apse, where it likewise seemingly proceeded steadily from left to right or south to north. Unfortunately, since the intervening clustered columns lie over the frescoes to the south, as well as over the first of the frescoes in the apse, it is impossible to be sure whether the lower frescoes in the latter precede or succeed those in the transept. In the north-west corner of the choir, the intervening columns lie under and not over the frescoes upon either side, and then the plastering and painting again followed the narrative sequence round the north transept to the opening of the nave.

Stylistically, the fact that Cimabue started at the top and then worked steadily downwards is demonstrated by the links between the wood-turned throne of the *Madonna* in the lower

church and those of the *Evangelists* above the crossing. In all of them Byzantine derivation is particularly clear, and they are very different in conception from the massive throne of the *Virgin and Christ Enthroned* on the lower wall. Here the establishment of the volume and recession of the limbs of the seated figures is achieved with a confidence that is clearly lacking in the lower church.

THE STYLISTIC SOURCES OF CIMABUE'S FRESCOES IN S. FRANCESCO

Cimabue's stylistic sources stand out clearly in the ruins of his frescoes at Assisi. The Byzantine element, whether received directly or through Tuscan intermediaries, is visible in endless details. The power of Byzantine style and iconography in southern and south-eastern Europe in this period is such that it is often vital to allow for unknown common sources when surviving works seem not to be directly linked. This is demonstrated at Assisi by the remarkably close iconographic and compositional relationship between the *Crucifixion* in the right transept and an apparently more or less contemporary fresco at Sopočani in Yugoslavia.

The second major element in Cimabue's artistic make-up, his intimate knowledge of Rome, is shown by the portraits of Roman monuments in the frescoes of *St Mark* [101] and of the *Crucifixion of St Peter*, and by the many references to classical architectural detail. The five scenes of the *Lives of St Peter and St Paul* are, indeed, directly derived from an extensive cycle once in the portico of Old St Peter's in Rome, and recorded in sixteenth-century drawings.[3] Finally, however much he may have learnt from Nicola Pisano's innovations in the Siena pulpit and in other works from the late sixties onwards, it is difficult to believe that the new, almost velvety softness in Cimabue's draperies is wholly unrelated to Cavallini's epoch-making experiments in Rome.

The native Tuscan element in Cimabue's work is surprisingly difficult to define. One

important factor is the lack of earlier fresco cycles in Tuscany and the extreme rarity even of isolated scenes or groups of frescoed images. The surviving evidence is that this contrast to the situation prevailing in Rome and its cultural dependencies is not entirely, and probably on surviving indications not even predominantly, due to loss. Nevertheless, apart from the many detailed reminiscences, in physiognomy and dress, of the Tuscan panel paintings already discussed, and apart also from a general liveliness in the approach to narrative, there is clearly something specifically Tuscan in the agonized sweep and vigour of the great autograph *Crucifixion* in the left transept of the upper church. Here Cimabue is the heir not only of Coppo di Marcovaldo but even more specifically of Giunta Pisano.

Except in certain matters of decorative framing, it is largely through a common ancestry in Giunta Pisano, whose lost Crucifix of 1236 once decorated S. Francesco, that Cimabue seems to be connected to the Umbrian S. Francesco Master, who had, seemingly by c. 1260-3 at the latest, painted the frescoes of the *Passion* and of the *Life of St Francis* in the lower church.[4] This is certainly true as regards the dated Crucifix of 1272 in the Gallery at Perugia, which is the most important of the few surviving works attributed to the unknown artist. The powers of the S. Francesco Master at his decorative and dramatic best are visible in the frescoed *Deposition* and in the dependent panel from a dismembered dossal now partially preserved in the Gallery at Perugia. His limitations become obvious, however, when the none the less magnificent Crucifix of 1272 is compared to that in S. Domenico in Arezzo, or to the one from S. Croce [103], now seriously damaged by the Arno flood of 1966 which in such devastating fashion called to mind such earlier inundations as the one of 1333 recorded by Villani.

Whether or not the connexions with and divergences from the known styles both of Coppo and of Cimabue should really be summarized by calling the Arezzo Crucifix a late product of Coppo's shop, an early work of

Cimabue, or a painting from Coppo's workshop in which the young Cimabue had a hand, it is certainly a work of the highest and most moving quality. Possibly, counter to current fashion, it should be placed among the works of the many great, but now anonymous, late-thirteenth-century masters. Whatever the answer, it undoubtedly foreshadows the more vivid anatomy and greater tension of pose in Cimabue's frescoed *Crucifixion* at Assisi. The latter in its turn gives reasonable grounds for placing the Uffizi *Crucifix* in Cimabue's workshop at a somewhat later date [103]. In this panel taut arms, reminiscent of the fresco, have replaced the earlier decorative curves. The unprecedented softness of the flesh and the diaphanous sensitivity of the draperies play against the increased drama of the pose. In short, the new pathetic humanity

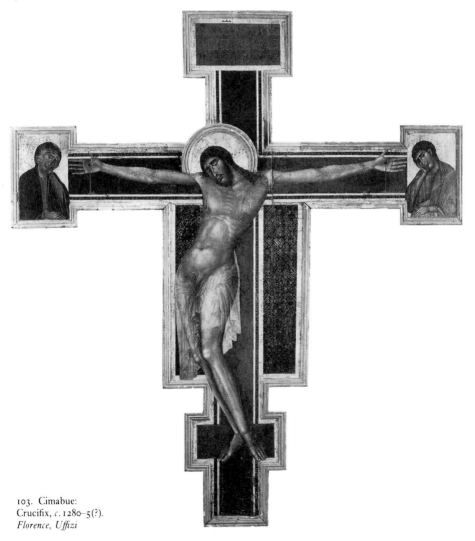

103. Cimabue:
Crucifix, *c.* 1280–5(?).
Florence, Uffizi

has not yet robbed the inherited, dramatic schematizations of their power to work directly on the eye and the emotions.

THE STAINED-GLASS WINDOWS
IN THE UPPER CHURCH OF S. FRANCESCO

Bare and inviting as the plain walls must have been when the upper church was substantially completed in the second quarter of the thirteenth century, the subsequent decorative campaign was not opened by the fresco painters. More pressing still was the need to glaze the broad expanses of the Gothic windows, which were the most novel elements in the imported northern architecture. The decision to embark on the expense of storiated stained glass seems to have been taken at an early stage, as the three twin lights of the choir appear, on iconographic and stylistic grounds, to have been carried out by German artists around the middle of the century.[5] The architecture of the period shows the speed with which the Franciscan order spread across the face of Europe. The same phenomenon is reflected in the fact that the closest stylistic linkage for these windows seems to lie in the glass put in soon after the completion of the Franciscan church at Erfurt in Central Germany, probably c. 1235. It was almost certainly the international connexions of the order that encouraged the commissioning of extensive stained-glass windows, despite the unusual nature of such a move in Italy at this time.

The four-light window in the right transept, of which only the upper rose and right-hand pair of lights are storiated, appears, like six of the eight windows in the nave, which were seemingly carried out by the same workshop, to be Italian in derivation and to date from the beginning of the last quarter of the century [104]. Connexions with the Master of St Francis in the lower church or with a Late Dugento Roman atelier have been suggested, though actual attribution is extremely risky.[6] Whatever the reasons for this break in the iconographic pattern, the purely decorative left-

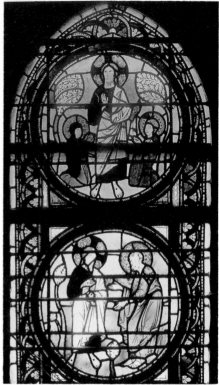

104. Stained-glass window, detail, c. 1275(?).
Assisi, S. Francesco, upper church, south transept

hand lights are probably not a later substitution or insertion. The new atelier is less delicate in its figure design. Deeper and less broken colour areas, predominantly blue and crimson, replace the more flickering patterns and diaper designs of the apsidal windows. Nevertheless, just as certain decorative motifs from the apsidal windows do reappear in the right transept, so there are limited connexions between the latter and the window in the left transept. This window, which may have been carried out at roughly the same time as that in the right transept by the workshop responsible for the two windows nearest to it on the right side of the nave, seems to show affinities with the stained glass of the Franco-German borderland. Again the change

in workshops is accompanied by a simplification and clarification of design that is particularly noticeable in the border patterns. White, and bright, clear greens and yellows play a dominant role, and the general tone is now much lighter. The combination of small history scenes above with large-scale figures below, to be seen in the nave windows, is not found in their northern prototypes and constitutes a particularly interesting and original feature. The presence of specifically English influences in the output of this thoroughly eclectic workshop may quite possibly derive from contact with the painters of the frescoes in the right transept in which English connexions have been suggested and, in this instance at least, the painters and the glaziers may even have worked alongside each other for a time.

Although the manufacture of these windows by at least three separate workshops probably extended over many years, the final effect is remarkably coherent. The pure and rather heavy form of the uppermost roundel of the *Fall of the Idols*, the only original fragment in the right-hand section of the left twin light of the apse, proves that the six apsidal lights were never intended to form a symmetrical group. The immediate framing of the scenes is otherwise formed by a varied series of quatrefoil and lozenge designs that effectively dominate the delicate circles that surround them. The colour, based on yellow, green, white, blue, and crimson, likewise constitutes an asymmetrical set of variations on a theme. In the four-light windows of the transepts, on the other hand, each pair of lights presents a distinct, identically repeated pattern. The latter is then enlivened by changes and reversals in the colour distribution. Blue grounds with predominantly crimson-draperied figures in one half give way to blue-

KEY

1. Creation
2. Fall
3. Female Saints
4. Female Saints

5. Foreshadowing of the Youth of Christ
6. Youth of Christ
7. Foreshadowing of the Ministry
8. Ministry of Christ
9. Foreshadowing of the Passion
10. Passion of Christ

11. Decorative designs
12. Decorative designs
13. Angelic Apparitions
14. Apparitions of Christ

draped figures against crimson grounds in the other. The elements of symmetry and regular contrast in each of the transept windows, and their mutual inter-relationships, are made a little more noticeable by the restriction of the narratives to the twin lights nearest to the nave. In the left transept those nearest to the choir are occupied by a series of female saints seated in architectural settings, and purely decorative patterns fill the equivalent twin lights in the opposite transept. Leaving these four lights aside, the whole of the choir and transepts is likewise embraced by a coherent iconographic scheme [105]. The sequence opens in the left transept with seven scenes of the *Creation* matched by seven of the *Fall*. Also beginning at the bottom in the northern manner, the three twin lights of the apse contain the Old Testament *Foreshadowing of the Youth of Christ* and the *Youth of Christ* itself, the *Foreshadowing of the Ministry* and the *Ministry*, and finally the *Foreshadowing of the Passion* and the *Passion*. Then, in the right transept, beginning at the top in the Italian manner, the *Angelic Apparitions* from the Old Testament foreshadow a full series of the *Apparitions of Christ* in which the theme of the *Ascension*, occurring in the right-hand light of the apse, is both repeated and elaborated.

THE DECORATIVE SCHEME IN THE
CHOIR AND TRANSEPTS OF S. FRANCESCO

The description of the subject matter and decorative plan of the stained-glass windows shows the extent to which Cimabue's frescoes in the choir and transepts were designed as a continuation of a coherent, all-embracing, and specifically Franciscan plan.[7] St Francis's special stress on the Passion, and his followers' desire to underline the parallels between his own life and that of Christ, were already reflected in the choice of frescoes for the nave of the lower church. The mystical tendencies of the saint were almost certainly the reason for the emphasis on the apparitions of Christ in the New and of the Angels in the Old Testament

among the windows of the upper church. When St Bonaventure's Legenda Maior was established in 1266 as the official life of St Francis, replacing such earlier biographies as that of Thomas of Celano, certain aspects of the saint's devotional life were underlined. Particular stress was laid upon his love of the Virgin Mary, the earthly mother and the heavenly queen, eternally interceding for mankind, and this is reflected in the frescoes of the choir. This love was shown as being inseparable from his love of the angels and, above all, of St Michael, the apocalyptic hero who fights the spiritual battle for mankind, 'who presents souls to judgement and who is zealous that all should be saved'. This, in its turn, is reflected on the upper wall and in the arcading of the left transept, as well as in the apocalyptic mysteries on the lower wall with their emphasis upon the last things. The saint's devotion to the apostles and especially to St Peter and St Paul, the leaders of Christ's earthly armies in the struggle for salvation, reflected in the arcading and on the lower walls of the right transept, as well as to Christ in the Passion, and above all to Christ crucified, are also given due weight by St Bonaventure. Pictorially this last point is made by the two huge frescoes of the *Crucifixion* which together form one of the many unique features of the decorative scheme. Each shows St Francis prostrate at the foot of the cross [108].

Apart from their particularly intimate relationship to St Bonaventure's record of St Francis's own devotions, the frescoes and glass together comprise an unusually self-contained and concise distillation of the four main sections of the Bible. The Old Testament and the New, the Apocalypse and the Acts, all find their allotted place. It is, however, the imaginative power with which the painter has translated and transformed the given content into one great, many-sided work of art that takes the breath away. The decoration of the walls does not merely endow the architectural shell, already fraught with symbolism to the thirteenth-century mind, with added meaning. It becomes an expansion and completion of the previously 'unfinished'

106. Cimabue: Angels, *c.* 1280(?).
Assisi, S. Francesco, upper church, south transept

architecture. In the vaults, the ribs are stressed by brilliantly coloured patterning, suggestive of rich marble inlays, and are then flanked by wide strips of foliate design. The effect is both to emphasize the structural, linking, and supporting function of the ribs and to bind them to the decorative field created on the surface of the vaults. At a lower level, arcades mark the stepping back of the upper walls and reveal the presence of a narrow passage running continuously around the church and passing behind the clustered columns that articulate the walls [3]. Here the enrichment of existing architectural elements gives way to the simulation of new architectural features. There is a positive expansion of the real architectural

space. This is particularly clear in the left transept where, upon each side wall, stand the brooding wing-spread figures of three angels [106]. Canopied, yet casually related to the six-part openings, the painted figures freely stand within the shadows of real architectural space. Immediately above there is a painted series of angelic half-lengths in a painted colonnade. The intention is unmistakable, and in transept and choir alike there is an astonishing sense of the equation of real and painted space, of actual and painted architecture. The real presence of angelic apparitions is suggested. Choirs of angels mingle praise with the monastic choirs within the earthly house of God and symbol of his heavenly home.

107. Cimabue: St Peter healing the Lame, *c.* 1280(?).
Assisi, S. Francesco, upper church, north transept

Immediately below the circling passage a row
of voluted brackets has been painted in regular
recession away from the central apse. The real
setting back of the upper walls is thereby par-
tially painted away. The passage is envisaged,
not as cutting into the wall and breaking it into
two distinct parts, but as jutting outwards from
a single unified surface. The even, parallel
recession of the brackets outwards from the
central apse, instead of inwards to it, har-

monizes with the outward flow of the narrative sequences as they round the transepts. Even this detail demonstrates the artist's vision of the complex area of the choir and transepts, and probably of the whole church, as a single unbroken space.

The bold illusionism of the central zone gives way upon the lower wall to calm acceptance of the decorative surface. The narrative scenes are framed by flat bands of putto-inhabited acanthus pattern which form a visual link with the similar elements in the vaults. The flat, banded inner framing of these scenes seems to show that their contents were not envisaged as illusory real presences, but were seen as tapestries or pictures hanging flatly on the flat walls of the church [107].

The represented space within the individual fresco is none the less presented with a vigour and immediacy which brooks no comparison with previous or contemporary works, apart from Cavallini's lost designs in S. Paolo. In these respects the scene of St Peter healing the Lame is typical of Cimabue's organizational methods [107]. The triple grouping of the buildings is directly used to emphasize the three-part distribution of the figures. The architecture is all in bird's-eye view, and, like the illusionistic cornice overhead, the flanking structures recede outwards. Instead of being urged towards the centre by the receding elements, the eye is held there by the verticals lying parallel to the surface and by the planar concentration of all the figures upon the centrally disposed main action. Only at the very edges of the composition is the eye allowed to run on into depth, to be almost instantaneously stopped by the decorative framing. The focused action and simple, heavily stressed, rhythmic pattern of these invariably symmetrical designs encourage the onlooker to see each scene as a unique and self-contained experience.

This concentration on the individual event is balanced by Cimabue's revolutionary conception of the decorative unity of the series as a whole [102]. In the course of his pictorial journey along the choir side of the right-hand transept the spectator soon becomes aware that the entire compositional structure of the St Peter healing the Lame is exactly repeated in the next scene of St Peter healing the Possessed. Then, upon the end wall of the transept, two similar, symmetrical, tripartite compositions, the Fall of Simon Magus and the Execution of St Paul, flank a central scene, the Crucifixion of St Peter, which is itself symmetrical. The figure of the crucified apostle is both the centre of its own design and the fulcrum upon which the entire wall is balanced. This same symmetrical sequence is essentially repeated in the apocalyptic scenes in the opposite transept, where the flanking compositions of Christ the Judge and of the Adoration of the Lamb are so alike as almost to be mirror-images of each other. Furthermore, the V-shaped background hills of the central scene repeat the pattern of the Crucifixion of St Peter.[8]

The shallow polygonal choir is decorated by four scenes from the Life of the Virgin. On the left the massive architectural framework of the Last Hours and the Dormition ensures that they are seen as a strictly related pair. They cannot, however, be equated with the Assumption and the Virgin and Christ Enthroned, which form a definite but not rigidly repetitive pair upon the opposite wall. At the one point at which awareness of the architectural and spatial symmetry of the church is inescapable, pictorial symmetry has been relaxed. The cumulative effect of the balanced relationships which have been described is already so strong that any further emphasis might well become oppressive and reduce the echoing symmetries and repetitions that now unite the complex spaces of the choir and transepts to elements in a mathematically rigid and mechanical exercise. It was, moreover, noted earlier that whereas the six lights of the windows in the apse present a series of variations on a theme in which there are no repetitions either in colour or in decorative detail, both the transept windows depend for their effect on contrapuntal colour and contrasted pairs of exactly repeated patterns.

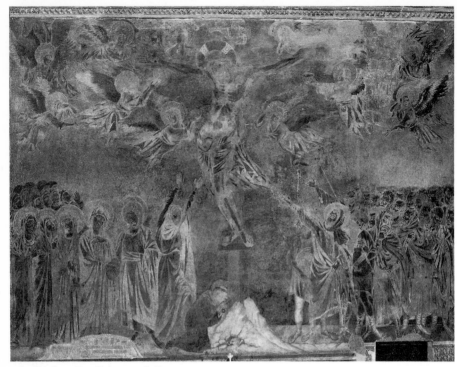

108. Cimabue: Crucifixion, *c*. 1280(?).
Assisi, S. Francesco, upper church, south transept

Such formal disciplining of an entire narrative cycle, its careful symmetries calling out across wide architectural spaces, is unprecedented in the history of Italian art. The ensuing sense of order, and of unity without rigidity, makes it difficult to believe that Cimabue did not see the whole of the choir and transepts as a single space to be enlivened by a single decorative design. The culmination, both in beauty and in meaning, lies in the twin scenes of the *Crucifixion*. The one in the left transept is, indeed, a microcosm of the whole [108]. Its firm, symmetrical design provides the framework within which the emotions seethe. The swaying S-curve of the crucified figure with its sweeping draperies, the violent gestures of the crowd below, and the threshing circle of tor-mented angels complete the picture of an art both grave and passionate, human and transcendent. It is an art as boldly experimental as it is severely disciplined. The conquest of new realms of realism and illusion is begun. The decorative sensitivities of an earlier age have gained a new dimension.

THE SIENA WINDOW AND THE
DATING OF CIMABUE'S FRESCOES
AT ASSISI

The question of the date of Cimabue's activity at Assisi bristles with difficulties: yet upon their resolution hangs the whole conception of the curve of a career that is one of the controlling factors in the development of Italian painting,

stained glass, and mosaic during the late thirteenth century.

The scanty documentary evidence opens with the Brief of Innocent IV that accompanied the consecration of the church in 1253. It speaks of the need to complete the structure and to decorate it with outstanding, but unspecified, works. It also authorizes the retention of offerings for these purposes. Then in 1266 Clement IV issued a bull, valid until 1269, permitting funds to be collected for the completion of the structure. Finally, in May 1288, Nicholas IV, who had been Minister General of the order, issued a further bull. His intention is stated in the words 'facere conservare, reparari, aedificare, emendare, ampliare, aptari et ornari praefatas ecclesias'. Though primarily concerned with building and repair-work, it is the only such financial document surviving from the last quarter of the thirteenth century, when Cimabue must have done his painting. This is no proof that his frescoes date from Nicholas's reign (1288–92). The subsequent history of S. Francesco is full of instances in which there is no record of the financial basis for decorative campaigns.

The only piece of internal evidence bearing on the date is a view of Rome in the fresco of St Mark upon the vault of the crossing [101]. In it a building convincingly identified as the Palace of the Senators is decorated with a series of shields, some bearing the letters S.P.Q.R. and others the Orsini arms.[9] If the presence of these arms has any significance at all, there is one, and only one, really important historical event to which it might refer. This is the offer of the senatorship to Giangaetano Orsini, who, as Nicholas III, would thereby have united the civil and ecclesiastical government of Rome for the first time in history. Nevertheless, if the intrinsic probabilities favour a reference to the reign of Nicholas III, a minute detail of this kind, which is virtually invisible from the ground, may be entirely without chronological or other significance. It may do no more than refer to some past personal connexion with the Orsini family, or merely be the only senatorial coat of arms that Cimabue could remember.

Outside Assisi three important works affect the problem of the dating of Cimabue's frescoes. The first is the lost cycle of the Lives of St Peter and St Paul, painted by an unknown artist in the portico of Old St Peter's in Rome. Unfortunately, though they seem to be the prototypes of the relevant scenes at Assisi, nothing can be said about their date except that they probably belong to the final quarter of the century. The second major relevant work is the panel painting of the *Rucellai Madonna*, now in the Uffizi in Florence [180]. Despite much argument, there now seems to be little doubt that this work, which fifteenth- and sixteenth-century texts mention as hanging in S. Maria Novella between the chapels of the Bardi and the Rucellai, is that referred to in a document of April 1285. In it the Compagnia dei Laudesi di Maria Vergine commissioned Duccio di Boninsegna 'to paint with the most beautiful painting a great panel in honour of the Madonna ... with the figure of the Virgin Mary and of her Almighty Son and other figures'. Oddly enough, Baldinucci, the seventeenth-century chronicler, mentions 'a Duccio of the people of S. Maria Novella', and the stylistic relationship to the other documented works of Duccio is sufficiently close to render nugatory any separate Master of the Rucellai Madonna. Accepting the link with the commissioning document does not actually date the panel, however. It merely shows that it was painted after March 1285.[10]

The third key work is the great round window in the choir wall of the Duomo at Siena [109]. The decision to glaze this window was taken in September 1287, and a reference to the work in May 1288 is followed, later in the year, by payments to Fra Magio, the Cistercian *operaio*. The window contains the *Burial*, *Assumption*, and *Coronation of the Virgin*, one above the other in three large, almost square, fields. These are flanked at top and bottom by the four Evangelists in separate compartments,

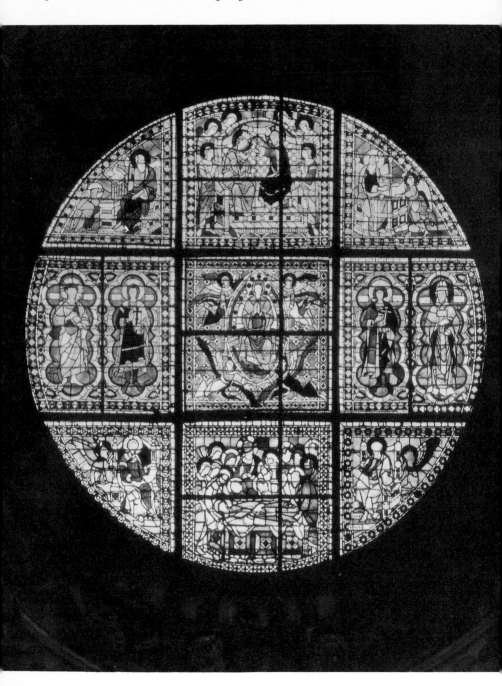

109. Cimabue(?): Stained-glass window, 1287/8.
Siena, Duomo, choir

and at the centre by the four saintly protectors of Siena.

The windows in S. Francesco form an isolated group without significant Italian progeny outside Assisi. That at Siena, on the other hand, is the first surviving, and probably in any case one of the earliest, examples of that thoroughly Italian phenomenon, the design of stained glass by a fresco painter working largely on the scale and in the manner appropriate to his customary medium. Despite the nature of the new material and the inevitable extremes of height and distance, the result is that no effort is required to take in both the figures and their actions. There is no direct relationshp to the traditions of design in European Gothic windows. The only, and possibly fortuitous, earlier parallel is with such grandly and simply designed Romanesque windows as the great early-thirteenth-century oculus in the cathedral at Poitiers. The intricate mosaic of contrasting colour and the minute complexity of leading and of decorative framing, characteristic of the tradition represented by the windows in the apse of the upper church of S. Francesco, is replaced by broad, calm areas of colour. The individual pieces of glass, selected for their evenness of tone, hue, and texture, no longer rely upon a jewelled inconsistency for their final decorative effect. They are bounded by a leading now so broad, so simple, and so carefully calculated that it is almost, but effectively not quite, submerged into the natural contours of the scenes and objects that are represented. The general tone is of a maytime clarity and lightness. The restricted range of colour is based upon a clear, light-blue ground that is reminiscent of the fresco painter's sky and is also used for the Virgin's draperies. Apart from a sparingly distributed white, the final effect depends on the bold juxtaposition of a bright canary and a golden yellow, a pale green, a pale but sometimes darkening wine-purple, and a blood-red ruby. These five basic colour notes are used

to play a composition founded on the simple, contrapuntal melodies of the *Coronation* and the *Assumption*. In the *Coronation* [111] the Virgin has a ruby vestment and blue mantle, Christ a ruby mantle and blue vestment. The left foreground angel has a green vestment and a wine mantle, that upon the right a green mantle and a wine vestment. The angels of the *Assumption* play a similar but more complex tune that results in a horizontal and vertical counterpoint and a diagonal symmetry. The top left and bottom right-hand angels have green vestments and ruby mantles lined with yellow, while those on the top right and bottom left have wine vestments and yellow mantles lined with ruby. In the wings of all four these same colours are analogously ranged. The result is that in this, the central scene, the maximum contrapuntal variety is obtained along the vertical and horizontal axes already stressed by the rectangular framework of the scenes. At the same time the diagonal symmetry calls attention to its function as the centre of a circle and emphasizes the links with the *Four Evangelists*. The final colouristic harmony is, however, as rich and complex in relation to these simple melodies as is the spatial design of the *Dormition* in comparison with that of the *Assumption*. The *Dormition* is, indeed, an unprecedented *tour de force* in terms of spatial structure and variety of pose [110]. The figures stand one behind the other, four and five deep, with no hint of the monotony of the usual row-by-row arrangement. More startling still, there is no loss of clarity, although this fact is only apparent in the glowing colour of the original, which identifies the spatial relationships without destroying the decorative integrity of the coloured surface. There is a similar cunning in the way in which the architectural solidity of the thrones, and notably of that in the *Coronation* [111], is combined with an apparently casual tendency for thrones, books, and angels' wings and haloes to overlap the decorative borders. This binds the narrative and decorative elements together and prevents the individual compartments from taking on disturbingly illusionistic qualities.

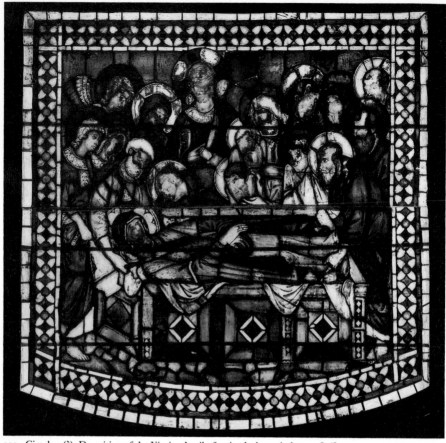

110. Cimabue(?): Dormition of the Virgin, detail of stained-glass window, 1287/8.
Siena, Duomo

This window, which must rank as one of the most important single monuments in the history of late-thirteenth-century Italian art, is generally accepted as the work of Duccio.[11] Nevertheless, at almost every point the main links are directly with the work of Cimabue. The spatially powerful construction of the various marble thrones and the natural disposition of the angels around that of the *Coronation* [111] would fit exactly into Cimabue's development a few years after the painting of the *S. Trinita Madonna* [100] and the completion of the work at Assisi in which the transition from Byzantine, wooden chair-thrones to marble structures was taking place. Furthermore, the habit of allowing thrones, wings, and haloes to overlap the decorative borders is endemic in the frescoes at Assisi [101].[12] It is unknown in the work of Duccio, the panel painter. The presence of large schools of northern glaziers at Assisi and Cimabue's presumably close acquaintance with them and with their work, to which his own was complementary, is thoroughly compatible with the subsequent expansion of the typical

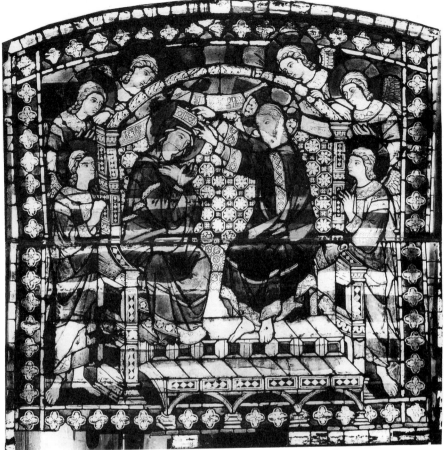

111. Cimabue(?): Coronation of the Virgin, detail of stained-glass window, 1287/8. *Siena, Duomo*

fresco painter's vision into the related but hitherto wholly distinct field of stained glass. With such a background, it is no more strange to find Cimabue obtaining a major commission in Duccio's Siena than it is to find Duccio carrying out an important altarpiece in Cimabue's Florence. The surviving modelling of many of the heads in the *Dormition* is closer to Assisi than to anything in Duccio, and certain of the less straightforwardly traditional heads, such as that of St Luke, are as typical of Cimabue as they are incompatible with Duccio's style. Similarly, the drapery of the angels, as well as their stance and proportions, fits the development adumbrated in S. Trinita and at Assisi, as also does the treatment of the folds along the Virgin's foreshortened thighs in the *Coronation* [111]. In short, there are good reasons for attributing the design of the window, and even the actual modelling of some of the heads, to Cimabue and not to Duccio. In any case, despite its geographical location, the window seems to be at the very least a product not of Duccio's but of Cimabue's workshop or close circle.

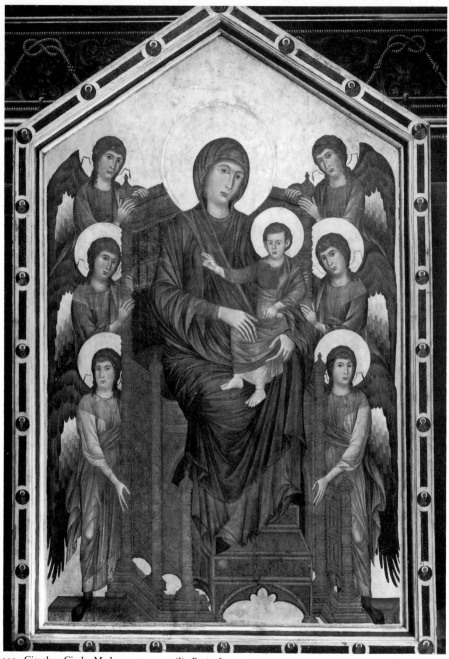

112. Cimabue Circle: Madonna, *c.* 1290–5(?). *Paris, Louvre*

The final work to be considered in establishing Cimabue's chronology is the *Madonna* from S. Francesco at Pisa, now in the Louvre [112]. In scale, in type, and in style, the connexions between this altarpiece, the *S. Trinita Madonna* [100], and the Assisi frescoes are obvious. It is, however, almost certainly a work of Cimabue's atelier or immediate circle and not a panel on which he worked himself. Despite enlivening and continuous colour variations over relatively small areas, a complete colour symmetry in the angels upon left and right, with even a tendency to vertical symmetry in each row, as for example in the wings, strengthens the compositional symmetry. The imposing grandeur of the altarpiece is accompanied by a notable turning away from the soft flesh modelling of the *S. Trinita Madonna* towards the more wood-carved appearance typical of an earlier tradition. Similarly, the Christ Child is much less a child and much more the young man or manikin of Cimabue's predecessors. The throne, in contrast to the latest pattern at Assisi, resembles that in the *Rucellai Madonna* [180] or in Cimabue's lower church *Madonna*. On the other hand, the revelation of form by drapery and the powerful structure of the Virgin's receding thigh are far in advance both of the *S. Trinita Madonna* [100] and of the latest developments at Assisi. The latter, moreover, seem to be reflected in the abolition of the gold-striated mantle. In short, the knowledge of Cimabue's most advanced characteristics, revealed in certain elements, is combined with archaism in others. When accompanied by a relative stiffness of handling, such contradictions nearly always point to a late product of a great master's shop or circle. In view of the relatively late position of the Louvre *Madonna*, it is particularly interesting that the small saints in the roundels on the frame should acknowledge a major innovation in the *Rucellai Madonna* [180]. In the *S. Trinita Madonna* similar roundels have no figure content and therefore remain directly in the tradition of Coppo and Guido and the artists of the mid

century [100]. Since there is no trace of the influence of the *Rucellai Madonna* in the panel from S. Trinita, which appears to be directly related to Cimabue's *Madonna* in the lower church at Assisi, it seems likely that the *Rucellai Madonna* (of 1285 or later) follows the *S. Trinita Madonna*. Not unexpectedly, Duccio's painting then exerts its influence on Cimabue and his atelier. The early date of the *S. Trinita Madonna* and of the frescoes at Assisi is confirmed by the advances in naturalism in the window of 1287–8. In matters of realism, large-scale altarpieces tend to be less flexible in the face of tradition than the individual elements of a fresco cycle. The *S. Trinita Madonna* could therefore follow the latest of the works at Assisi with which it is so closely linked on every count. In any case, the delicate balance of probability is that it does not precede the *Four Evangelists*, which are the earliest of Cimabue's works in the upper church. Perhaps the most attractive possibility of all, however, is that it may be the product of the long winter months when work could not continue on the frescoes and that it may actually constitute a major step in the development which leads from the wood-turned thrones of the crossing vault to the massive structure in the scene of the *Virgin and Christ Enthroned* on the lower wall of the apse. This would place the frescoes in the upper church before, and possibly considerably before, 1285. They may well date from *c*. 1280, the end of the reign of Nicholas III, to which the internal evidence points, if it means anything at all.

A tentative and inevitably controversial chronology of Cimabue's career therefore places him, on documentary grounds, as almost certainly being in Rome in 1273. His work at Assisi, with its many reflections of the new developments in Rome and possibly even of Cavallini's early work in S. Paolo, comes at the end of the seventies or in the early eighties. Because of the relationship to the frescoes, the *Crucifix* in S. Domenico at Arezzo fits, whatever its attribution, into the early or mid seventies, and that in the Uffizi into the early or mid eighties. The *S. Trinita Madonna*, whatever its

relation to Assisi, comes before the *Rucellai Madonna*, and the work on the window at Siena begins in 1287–8 and is followed, probably in the early or mid nineties, by the Cimabuesque altarpiece now in the Louvre. Then, in 1301–2, the story closes with the Pisan mosaic which, as the one surviving, fully documented work, provides the sole foundation for the reconstruction of Cimabue's career.

Whether or not participation in the mosaics of the baptistery at Florence should be added to the catalogue of Cimabue's extant work, his influence appears in certain of the latest scenes, such as the *Naming of the Baptist*.[13] These probably date from the end of the first quarter of the fourteenth century, when the work, already in hand in 1271, was drawing to a close. The scheme, with foliage and angels in the uppermost zone, contains extensive sequences from the Old Testament, the Life of Christ, and the Life of St John. These circle downwards through the four narrative tiers, which are, however, interrupted by a great *Last Judgement* occupying three of the eight facets of the octagon. In the two tiers of the Old Testament scenes particularly, the Roman connexions are as strong as those with Venice, which may have provided many of the artisans involved. The narrative style throughout is more the final flowering of a long tradition than the germ of new developments. Apart from the teeming decorative splendour of a scheme unparalleled in Tuscany, which marked yet one more claim to regional supremacy, its organization is significant. Like the mosaic on which Cimabue worked at Pisa, it had been designed for other purposes. The standard Roman pattern for the decoration of the side and end walls of a normal nave has been fitted into a centralized structure.[14] Yet this very adaptation has its own creative aspects, for the tiers of twisted columns that articulate the scheme in the traditional Roman manner and divide each of five facets of the octagon in three, are the exact continuation of the real columns and pilasters that support the dome [294]. The floating, immaterial heaven of the Byzantine formula has become an architectonic system. The architectural structure of the building is extended and completed by its decoration in a manner fundamental to the new pictorial art of the final quarter of the thirteenth century. Since the pattern must have been fixed fairly early, its chronological priority means that in this one respect at least its influence in Tuscany and Umbria must not be underrated.

In their own way the frescoes of the *Lives of St Peter and St Paul* in the nave of S. Piero a Grado, near Pisa, are an equally attractive combination of archaism and modernity. The main subjects derive from the lost cycle in the portico of Old St Peter's. But it is the decorative framework of the scheme which makes it memorable. In the spandrels of the nave arcading light is used with arbitrary brilliance to bring the forms of painted platter-mouldings into sharp relief. Above them half-length figures of the popes stand in a painted arcade which is seen from the left on both walls of the nave. Above and below the main scenes, with their gaily decorative architectural confusion, boldly three-dimensional beam-ends are no less consistently painted as if seen from the right. Over all, a line of deeply recessed, painted windows carries on the line of the real windows. Sometimes the painted windows are completely shuttered, sometimes one leaf swings half open or both shutters open wide, not on the sky, but into a dark void within which every now and then a bright angelic figure suddenly materializes. Throughout, a maximum of startlingly convincing detailed architectural illusionism is combined with a minimum of narrative realism in total disregard of any thought of 'viewpoints' or, indeed, of any attempt to link one wall with another in a visual organization corresponding to that of the real three-dimensional enclosure as a whole. Whoever the designer may have been, there is no doubt that this, the most complete surviving Tuscan fresco cycle of the end of the thirteenth century, is a monument to his inventive and naïve enthusiasm.[15]

THE LEGEND OF ST FRANCIS AND THE COMPLETION
OF THE DECORATION
OF THE UPPER CHURCH OF S. FRANCESCO AT ASSISI

It is probable that Cimabue's vision of the architectural and decorative unity of the choir and transepts of S. Francesco originally extended to the whole of the upper church [114]. Certainly the many men who worked upon the nave both understood his aims and harmoniously expanded his ideas. The new-comers were mostly either Romans or, like Cimabue himself, Tuscans who were deeply influenced by Rome. Once again the painting of the frescoes seems to have been preceded by the glazing of the windows. The glass mainly consists of paired monumental figures of apostles and saints supporting scenes from their lives. Apart from a group of scenes of French derivation, the stylistic links in these much-restored windows are predominantly with the late-thirteenth-century Roman school. The appearance of St Francis and St Anthony, together with scenes from their lives, may well show that at first the decorative plans did not incorporate so extensive and so icono-graphically original a fresco cycle of the *Legend of St Francis* as was eventually evolved.

Painting appears to have been started in the vaults nearest to the crossing. The first is blue with golden stars, only the second being dec-orated with roundels containing busts of Christ, the Virgin, St Francis, and St John the Baptist, together with pairs of supporting angels. The painted framework elaborates the pattern evolved by Cimabue. In the foliate borders the added richness of animal life is accompanied by increased classicism in the nudes, and the sides of all the ribs are now 'structurally' articulated by illusionistic brackets similar to those used by Cimabue to support the gallery and to unify the lower walls of the choir and transepts.

JACOPO TORRITI

The Roman connexions of Cimabue's work are emphasized by the fact that the artist who so readily took over his conception was probably Jacopo Torriti (see above, p. 152 ff.). Another name much canvassed is that of Filippo Rusuti, whose signed mosaic in the portico of S. Maria Maggiore in Rome is topped by an inhabited foliate band almost exactly comparable to that at Assisi. The ruinous restoration of most of Rusuti's work complicates the issue, but the many stylistic links between the figures of Christ, of the Virgin, and of the attendant angels at Assisi, and the central figures and supporting angels in the mosaic of the *Coronation* in S. Maria Maggiore seem, for example, to be strong enough to justify a very tentative attribution to Torriti. Allowing for the restrictions imposed by the format, a certain stiffness more comparable to what is known of Torriti's work in S. Giovanni than to the more supply natural style evolved in S. Maria Maggiore seems to point to a date just before or just after the period *c.* 1290–2.

The much ruined decoration of the upper side walls of the nave comprises, on the right, a series of sixteen scenes from the Old Testament ranged in two registers beginning at the cross-ing. The series runs from the *Creation*, under which a magnificent sinopia drawing of the head of the Eternal has recently been found [113], to the *Story of Joseph* and is opposed upon the left wall by a similar New Testament cycle ranging from the *Annunciation* to the *Resurrection* and continuing on the entrance wall with the *Ascension* and the *Pentecost* [114]. Torriti's stay in Umbria may well have been a relatively short

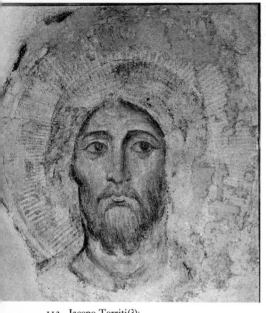

113. Jacopo Torriti(?):
The Eternal, sinopia drawing, c. 1290–2.
Assisi, S. Francesco, upper church

one and, apart from the frescoes in the vault of the second bay from the crossing, about which there is fairly general agreement, constant variations in both style and quality make the extent and nature of his participation, if any, on the walls of the first two bays very debatable. At times there are fitful hints of Cimabue's influence, accompanied by fleeting but occasionally magnificent reflections of Cavallini's new, soft style. The overall impression is of a somewhat unstable Roman eclecticism, and more than one atelier may well have been involved.

At this point the question not of by whom but of how the painting was actually done becomes even more pressing than it was in the choir and transepts. For practical reasons, the scaffolding was probably put up bay by bay with the work beginning in the vault and proceeding downwards in the usual way. This means that the frescoes on the walls were almost certainly not painted in their narrative sequence. Scenes 1 and 2 of the *Creation* on the north wall would

KEY
TO SCHEME OPPOSITE

Right upper wall: top row from crossing

1. Creation of the World	4. Fall	7. Destroyed (Sacrifices of Cain and
2. Creation of Adam	5. Expulsion	Abel)
3. Creation of Eve	6. Destroyed (Adam and Eve labour)	8. Cain killing Abel

Right upper wall: 2nd row

9. Building of the Ark	12. Abraham and the three Angels	15. Joseph lowered into the Well
10. The Ark	13. Isaac and Jacob	16. Joseph and his Brethren
11. Sacrifice of Abraham	14. Isaac and Esau	

Left upper wall: top row, from crossing

1. Annunciation	4. Adoration	7. Teaching in the Temple
2. Destroyed (Visitation)	5. Presentation	8. Baptism of Christ
3. Nativity	6. Flight into Egypt	

Left upper wall: 2nd row

9. Feast at Cana	12. Flagellation?	15. Lamentation
10. Resurrection of Lazarus	13. Way of the Cross	16. Resurrection and the Holy
11. Betrayal	14. Crucifixion	Women

Entrance wall lunettes

17. Ascension	18. Pentecost

114. Assisi, S. Francesco, upper church, scheme of decoration of the nave

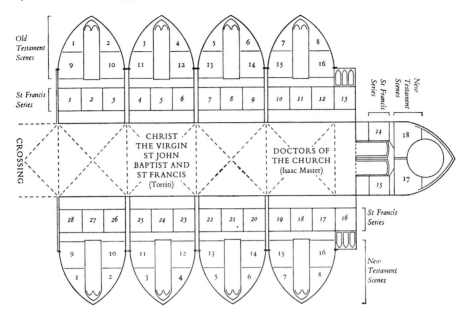

THE LEGEND OF ST FRANCIS

Right lower wall

1. St Francis and the Madman of Assisi
2. St Francis giving away his Cloak
3. Dream of the Palace
4. St Francis before the Crucifix in S. Damiano

5. St Francis repudiating his Father
6. Dream of Innocent III
7. Confirmation of the Rule
8. Vision of the Fiery Chariot
9. Vision of Fra Leone

10. St Francis and the Demons at Arezzo
11. Trial by Fire
12. St Francis in Ecstasy
13. Institution of the Crib at Greccio

Entrance wall

14. Miracle of the Spring

15. Preaching to the Birds

Left lower wall

16. Death of the Knight of Celano
17. St Francis preaching before Honorius III
18. Apparition at Arles
19. Stigmatization

20. Death of St Francis
21. Apparitions of St Francis
22. Funeral of St Francis
23. Mourning of the Clares
24. Canonization of St Francis

25. Dream of Gregory IX
26. Healing of the Man of Ilerda
27. Resuscitation of a Woman
28. Liberation of Peter the Heretic

have been succeeded not by scenes 3 and 4 of the *Creation*, but by the *Building of the Ark* and the *Ark* on the lower part of the wall, by the four scenes on the opposite wall, and by the four webs of the vault above the second bay. Scenes 3 and 4 in the narrative sequence therefore effectively become scenes 13 and 14 in terms of the actual order of execution, and the same situation arises in bays three and four, painted by the Isaac Master and his shop.

Since questions of light and climate make it unlikely that there was more than a six months' painting season, giving something in the region of 150 working days, there may well have been a year's gap between the painting of successive episodes in a given story. In such a situation it would be all too easy to attribute a stylistic jump to a change of workshops rather than to personal development or the change of hands within a workshop which actually caused it. It is therefore vital that the architectural structure of a building and its likely effect in terms of working sequences and procedures should always be taken into account.

At Assisi the great depth of the vaults and the strong architectural divisions between the bays certainly add to the difficulties of reading the story in its proper sequence at the same time as they encourage the observer to take in the typological relationships between the Old and New Testament scenes on the opposite walls of each bay. The *Creation of the World* and the *Creation of Adam* are visually much more closely related to the scenes immediately below them on the wall than they are to those which actually continue the story of creation at the top of the next bay.

If, for all sorts of reasons, the stylistic character is shifting and uncertain, the iconographic parentage is not. The dependence on the great paired cycles of the Old and the New Testaments in Old St Peter's in Rome, and on the recently refurbished Old Testament series in S. Paolo, is unequivocal.[1] Where, as in the *Building of the Ark* or the *Sacrifice of Isaac*, direct comparisons can be made through the seventeenth-century copies of the lost Roman works,

the compositional relationship is striking. Where, as with the *Nativity*, no record now survives, the links with Cavallini's mosaic in S. Maria in Trastevere seem to indicate a similar common parentage in the lost basilican cycles. Such novel elements as the unified and visibly receding coffered ceiling in the *Feast at Cana*, which can now be paralleled only in fifth-century manuscripts like the Vatican Virgil, may therefore, like the similar elements in Cavallini's work, be taken to reflect lost features of the Early Christian fresco cycles.

THE ISAAC MASTER

The various Roman painters active in the first two bays from the crossing seemingly stayed little longer than Torriti himself. No sooner had work begun in the third bay than they too left, to be succeeded after an unknown interval by yet another Roman workshop. This was headed by a painter of a wholly different calibre who is usually called the Isaac Master, after the scenes of *Isaac and Esau* [116] and *Isaac and Jacob* which mark the qualitative peak reached in the two bays nearest to the entrance of the nave. He himself probably carried out not only the design but part of the execution of some of the other scenes such as the *Lamentation*. In most cases, however, the stylistic variations clearly reflect the intervention of a large, well-organized workshop. The formal recognition of the pre-eminence of the Four Doctors of the Church and the declaration of a feast-day in the Liber Sextus of 1298 does not mean that the frescoes representing them in the vaulting of the fourth, or entrance, bay were necessarily painted after this date. The work of the preparatory commission of 1296 was one of codification, and this apparent innovation was but another example of the tidying up of a long-established doctrine.

The quality of the Isaac Master's brushwork and the power of his artistic vision can be seen in the heads of Isaac and of Jacob [115]. In the latter the continuous flow of the form-following, form-creating, brushpoint stroke is notable

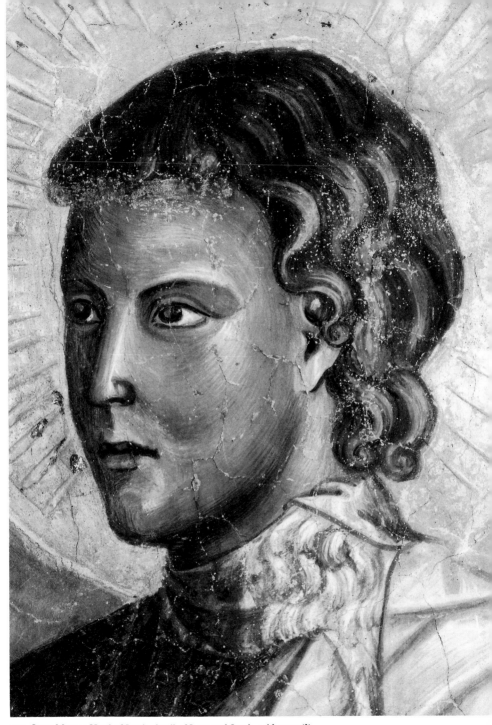

115. Isaac Master: Head of Jacob, detail of Isaac and Jacob, mid 1290s(?).
Assisi, S. Francesco, upper church

for its simplicity and directness. Firm, yet painterly, it betrays no linear harshness and no emphasis on calligraphic outline. There is instead a sensitive awareness of the role of light, whether falling softly on the hair or modelling the face with its crisp highlights. This sensitivity to light is wedded to a sculpturally decisive feeling for the firmly cut block of the head, with its well-defined and often boldly stylized planes. The chiselling of the nose itself, and the sharp characterization of the pull of skin from nose to cheek, are notable features of the gravely majestic head of Isaac. This method of modelling, paradoxically characterized by the very smoothness of the paint with its liquid individual strokes, is quite distinct from that of Cavallini, in which a dry and heavily bodied, near encaustic, quality of paint is used, in contrast, to create more smoothly rounded, gently flowing, fleshy forms. There is a comparable gulf between Cavallini's heavy velvet drapery folds and the Isaac Master's sharply creased and flatter patterns.[2]

A feature which the Isaac Master does share with Cavallini, quite apart from a number of detailed borrowings, is the majestic classicism of many of his figures. The looping swing of the bed-drapes, taking up the rhythm of the gestures in the scene of *Isaac and Esau* [116], and the joy in patterned surfaces like those of the curtains are qualities shared, at the turn of the century, by Arnolfo's shop. They are seen in intensified form in the tomb of Boniface VIII as well as in the work of many lesser sculptors active in Rome. The flat folds bring to mind the carving of Arnolfo's Virgin in the de Braye tomb of the early 1280s [46], with which, in its gravity and restraint, the fresco is more fully in tune. The sometimes grave and sometimes eager gestures, the firm stance and structure of the figures, clearly revealed by the carefully articulated draperies and their calm grouping within the simple, boldly constructed architectural space that now completely and convincingly encloses them, all help to create a sense of grandeur and of human drama. In his concentration on the human and dramatic

interest of the twin scenes of *Isaac and Jacob* and *Isaac and Esau*; in his sensitivity to subtle compositional rhythms and their role in reinforcing psychological distinctions; and in his feeling for proportional relationships, as well as his frequent iconographic boldnesses, the Isaac Master must be counted among the greatest of those few, exceptional geniuses who founded the new school of Italian painting. The pathos and unease of the blind Isaac, set off by the intensity of gaze in the two figures by his bed; the urgency of Esau's movement, and the secretive subtlety of gesture and expression on the part of his companion, mark this as among the most intensely moving and dramatic compositions in the history of Italian art.

Although the outside of the building is still plainly visible in both scenes, its structure marks a further stride towards the achievement of a true interior. The avoidance of conflicting viewpoints, the expansion of the building in relation to the figures until it presses up against the frame on every side, and the more naturalistic treatment of the recession in the upper surface of the bed, combine to increase the reality of the space portrayed.

The Isaac Master's consistent use of the low viewpoint, developing but not yet fully worked out in the complex architectural aggregations of the vaults of the *Four Doctors*, is another sign of an advance beyond the stage reached in the extant works of Cimabue or Cavallini. The development of architectural and spatial realism is, however, at its most interesting in the *Pentecost* on the entrance wall [117]. The beginnings of a centrally viewed interior, comparable to that in the ruined scene of the *Teaching in the Temple*, are firmly established, and the architecture is notable for its complexity as well as for its solidity and coherence. Gothic pinnacle and gable forms, directly reminiscent of Arnolfo's Roman ciboria and tombs, have been combined with Antique vase and flower motifs and with the sturdy, coffered barrel-vaults that recall the painted architectural illusionism of the fresco-framing in the transept of S. Maria Maggiore. The shrunken quality

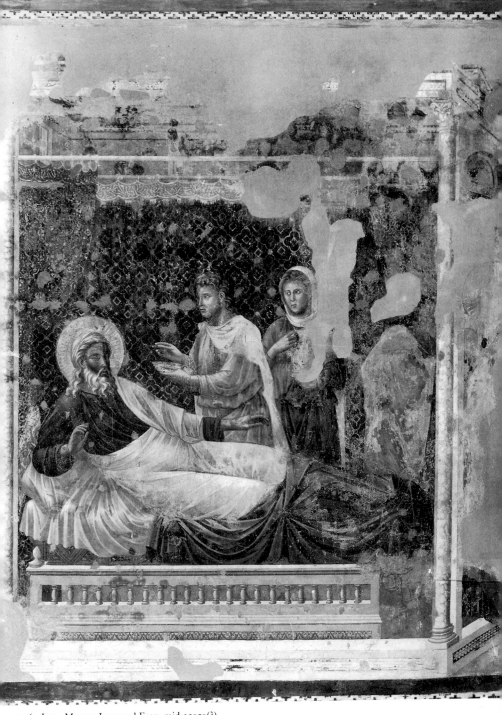

116. Isaac Master: Isaac and Esau, mid 1290s(?).
Assisi, S. Francesco, upper church

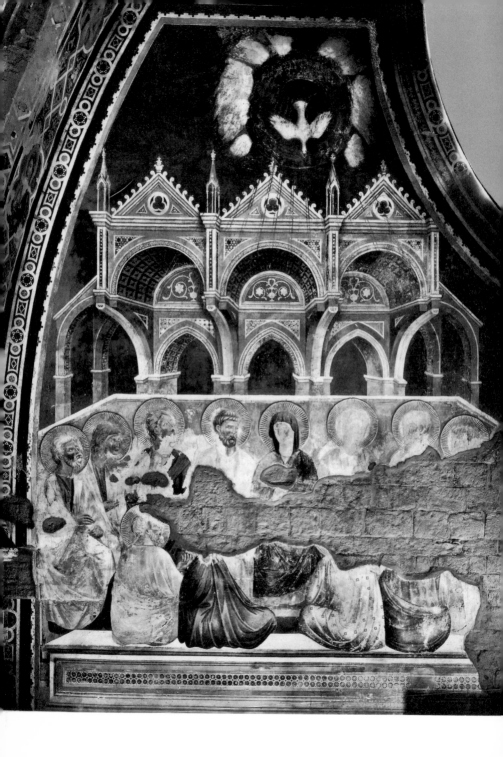

117. Isaac Master: Pentecost, mid 1290s(?).
Assisi, S. Francesco, upper church

of the building is partially explained by the awkward, L-shaped field. It is, however, emphasized if anything by the remarkable invention of the figure grouping. A complete rectangle of figures, those seated nearest to the onlooker all facing inwards with their backs completely turned, now gives an impressive sense of reality to the space which they enclose. Comparison with the wholly forward-facing figure rectangles of Cimabue's *Gathering of the Apostles* and *Dormition* in the apse reveals both the relationship to Cimabue's stylistic world and the advance beyond it in terms of visual realism. It is, however, symptomatic of the priority which the sculptors maintained in many aspects of descriptive realism until the final decade of the thirteenth century, that it is only towards the end of the century that compositional ideas already explored by Nicola Pisano in the Siena pulpit of the late 1260s are being exploited and further developed by the painters. Hitherto only isolated examples of inward-turning figures occur in painting, although the enormous percentage of losses means that this is possibly not the earliest revival of a motif previously popular in Pompeian, and presumably in coeval Roman, painting.

The *Pentecost* clearly lacks the simple-seeming power and harmony of the *Isaac and Esau* and *Isaac and Jacob* or the pathetic intensity of the *Lamentation*. Nevertheless, in architectural style and structure, in the harnessing of figures and architecture alike in the service of increased narrative realism, and in many details of the treatment of those figures, it is the immediate prelude to the frescoes of the *Legend of St Francis*.

THE ORGANIZATION OF THE LEGEND OF ST FRANCIS

The painting of the Legend of St Francis on the lower walls of the nave of S. Francesco is one of the supremely important events in the history not only of Italian but of European art. It is also one of the most controversial. The battle over dating is no more than a prelude to the veritable wars of attribution which have raged, and still rage, round these frescoes. A date in the 1290s seems to represent the most reasonable chronological solution, and one which may well come to be generally accepted on the existing evidence. It seems quite possible, on the other hand, that the question as to whether Giotto was or was not responsible for all or any part of the planning and execution of the frescoes will never be definitively settled unless fresh evidence is uncovered. The nature of the problem, and the factors that must be considered in any eventual solution, can however be laid out, and a tentative solution proffered. An attempt to do this will be made when all the major works attributed to Giotto have been surveyed. In the meantime, references to the painter as the Master of the St Francis Cycle merely reflect the existence of an unresolved dilemma in which the probabilities seem to favour the currently unfashionable view that Giotto was not the painter of the frescoes in question.

Whoever the presiding genius may have been, he was familiar with the great Roman schemes of painted architectonic decoration. He not only sympathized with Cimabue's illusionistic extension of the existing architecture of the church but fully understood its revolutionary significance. The new aesthetic starting point and the controlling factor is the division of the nave into four vaulted bays [3]. The clustered columns that articulate the side walls and support the vaults accentuate the contrasting flatness of intervening surfaces which, below the level of the circling passage, are otherwise uninterrupted. As in the choir and transepts, painted hangings form the lowest element in the decorative scheme. Above this level Cimabue's relatively flat framing and single, painted architectural cornice are replaced by a magnificent colonnade [119]. Now, massive twisted columns stand above rich mouldings and support a coffered architrave

topped by the painted brackets which hold up the real moulding of the upper margin of the field. The majestic verticals of the columns echo and extend the real architectural articulaton of the wall, and the unbroken painted cornices are powerful enough to forge a final equilibrium out of the interplay of vertical and horizontal painted and architectural forms. There is a crispness and a clarity, a decisive quality, that reaches back beyond the world of Cimabue and of Cavallini, and of the great refurbished schemes of Old St Peter's and of S. Paolo fuori le Mura which inspired them. The similar elements in the late-thirteenth-century decoration of S. Saba or in the basilicas of S. Maria Maggiore in Rome and Tivoli, and the complete tenth-century foreshadowing of the scheme in S. Crisogono in Rome, appear to dwindle in importance. Even the echoes of the lost fourth-century decorations of S. Costanza or of the Temple of Junius Bassus seem to fade before the memory of the real and painted architecture of the villas and town houses of Pompeii.

In S. Francesco the division of the wall-space into bays is more than merely passively accepted. Now, within the obvious architectural unity of the nave, the details of the painted architecture in each bay recede in parallel towards its centre, which becomes a separate focal point. The apparent recession outwards from the centre, favoured by Cimabue, is replaced by a new naturalism, and the close relationship to the observer is strengthened by the realistic low viewpoint. Nevertheless, determined as the artist evidently was, like Cimabue before him, to bring the painted histories to life before the very eyes of the amazed observer, he was no less concerned with the purely decorative pattern of the whole. Upon the basis of the rigid symmetries evolved by Cimabue for the complex volumes of the apse and transepts, the younger master seems to have evolved a freer and more subtle system to enliven the strict spatial unity of the nave.

The story of St Francis opens on the right of the first bay from the crossing, circles the nave, and closes on the left of that same bay

[114]. Immediately, as if to emphasize the over-riding architectural and iconographic unity of the church as the observer passes from the vortex of the crossing into the calm reaches of the nave, the three-fold grouping of the compositions at the end of the neighbouring transept is reiterated. Just as the bold V of the Roman monuments carried the eye down towards the figure of the crucified St Peter, so now the V-shaped Umbrian hills in the *St Francis giving away his Cloak* focus attention on the haloed head of the young saint standing at the very centre of the bay [118]. The rocky patterns of the hillside catch and echo in the folds of the saint's cloak. The balanced masses of the landscape background form a natural foil for a foreground group in which the cloak and the poor nobleman on one side and the palfrey on the other are in perfect equipoise about the axial figure of St Francis. Here, as in the transept ends, the flanking compositions, weighted now by similar architectural masses, balance evenly about the central scene.[3]

The next bay seems to show that this is no chance equilibrium. Despite their wholly disparate narrative content and distinctive architectural structures, the flanking scenes of *St Francis before the Crucifix* and the *Dream of Innocent III* create an instantly appreciated visual equipoise about the balanced central composition of *St Francis repudiating his Father* [119]. The fact that the heavy mass of the obliquely set church of S. Damiano on the left is designed to form the visual counterpart of the toppling Lateran Basilica upon the right is stressed by the broad red bands that draw attention to the base-lines of the two buildings. These, despite their differing descriptive function, run in to the centre at identical angles to the lower border. Even divested of all colour in a reproduction they confirm that these three very different narratives were intended to be seen as part of one united, balanced pattern, emphasized by the perspective unity of the architectural framework.

Once the decorative unity of each bay has been established by the repetition of strictly

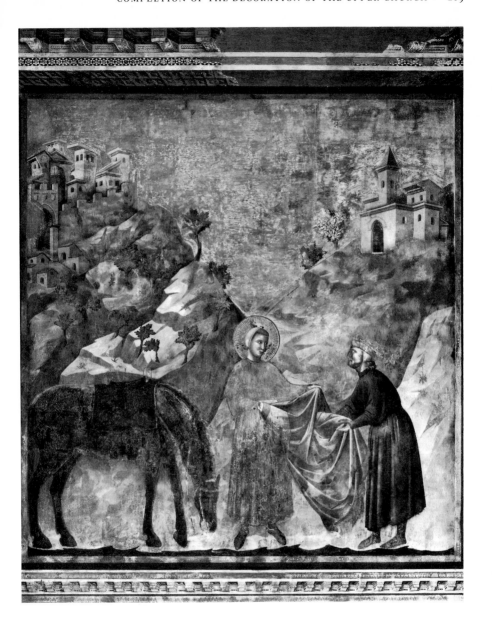

118. Master of the St Francis Cycle: St Francis giving away his Cloak, mid 1290s(?).
Assisi, S. Francesco, upper church

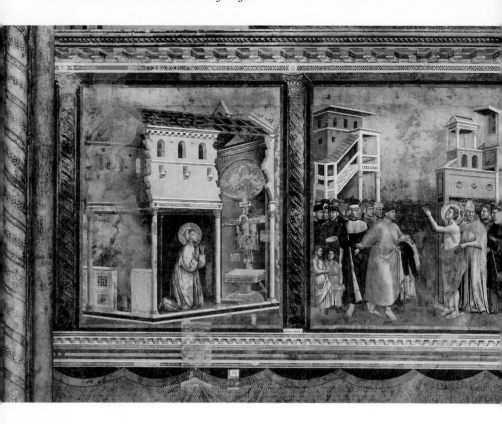

119. Master of the St Francis Cycle:
St Francis before the Crucifix,
St Francis repudiating his Father,
and the Dream of Innocent III,
mid 1290s(?).
Assisi, S. Francesco, upper church

symmetrical designs, the pattern is softened and varied in the two remaining bays of the long wall of the nave. Here there are themes and counter-themes, contrasts and echoes, and cunning repetitions both in details and in the general disposition of figures and architecture alike. On the other hand it is impossible to see strict symmetry in either bay. Consequently, the grouping of the wall as a whole falls into clearly asymmetrical halves. Two rigidly centralized and symmetrical bays are succeeded by two with a more open, freely rhythmic pattern. These are followed by concentration on the problems posed by the end wall. The latter forms the narrative link between the two main walls. It is also a static, balanced frame for the centrally placed twin doors, and is the last thing seen on leaving the church.

The two scenes of the *Miracle of the Spring* and the *Preaching to the Birds* which flank the doors are perfectly adapted to their several functions [120 and 121]. As two of the most popular episodes in the Franciscan story, they leave the happiest and longest-lasting memories with the faithful as they go away. They are also the only landscapes free of architecture. They therefore make a formal pair as nicely balanced as it is distinctive. This visual relationship is strengthened not merely by the perspective unity of the unbroken painted cornice that climbs above the arching doorways, but by every detail in two compositions carefully calculated to express the linking function of the wall.

Just as the cornice rises to surmount the doors, so, in the *Miracle of the Spring*, the figures enter on the left, the mule still only half in view [120]. They then move upwards to the right until the upturned face of the petitioning saint, the long diagonal of his companion's body, and the jagged uprush of the mountains thrust attention up and out over the doors and past the painted central roundel of the *Virgin and Child* to which St Francis seems to pray. When the *St Francis preaching to the Birds* is reached [121], the uprushing outward movement, bursting the bounds of the design, gives way to a soft, downward-floating motion as the saint leans slightly forward, looking down to bless the birds, assembled on the level ground in the manner first established in the lower church. A final stop is then provided by the thick trunk of the unusually massive tree. The calculated quality of these frescoes, with their varied functions and their visual and thematic symmetries, is stressed by their removal from their correct places in the official narrative by St Bonaventure on which the cycle depends.[4]

The crux in any attempt to assess the artist's formal intentions for the series as a whole lies in the succeeding bay, the first upon the left wall of the nave. This, like the last bay on the opposite wall, contains four scenes. The central pair, the *Preaching before Honorius III*, and the *Apparition at Arles*, which is the one remaining scene moved from its chronological position in St Bonaventure's text,[5] create a single architectural block articulated by similar Gothic arches [125]. The cornices of their respective roofs form one continuous line, and the perspective of the architectural frame recedes towards the dividing column in the centre of the block. The visual linkage of the scenes is stressed by the placing of their two main figures. In either case the one stands facing inwards on the left, connected by the action to the other, who creates an even stronger formal accent just to the right of the centre of the design. The flanking stories of the *Death of the Knight of Celano* and the *Stigmatization* are distinguished by the fact that one takes place in an interior and the other in the open countryside. The shrinkage of the 'enclosing' building and the

120. Master of the St Francis Cycle: Miracle of the Spring, mid 1290s(?).
Assisi, S. Francesco, upper church

121. Master of the St Francis Cycle: St Francis preaching to the Birds, mid 1290s(?).
Assisi, S. Francesco, upper church

use for its coved ceiling of sky blue, an unusual choice of colour which reduces the conflict with the landscape of the *Stigmatization* to a minimum, may well show, however, that the artist wished to balance these two lighter wings about the heavy central core. As far as the action is concerned, the movement down and to the right in the opening scene is balanced by the upwards and outwards motion in the closing fresco.

The probability of the correctness of an interpretation of the visual facts which might in isolation have seemed dubious is confirmed when the three scenes in the succeeding bay are seen to be arranged in strictest symmetry. In the two flanking scenes, each element in the one is faithfully echoed in the other. The division into upper and lower zones; the distribution of the colour; the massing and disposition of the figures as a whole; the placing and poses of the principal and even of subordinate actors in the drama – each detail of design is carefully repeated to build up the balanced pattern of the bay. Then, in the third, as in the fourth and final bay, which brings the series to a fitting formal close, there is a clear return to looser linkages like those in the two end bays on the opposite wall. There is no question of a general symmetry, and in the last three frescoes a steady decrescendo and asymmetry in the main architectural masses is accompanied by a balanced grouping of the figures, and by the introduction of two secondary scenes in which the action runs against the general left-to-right flow, helping, in visual terms, to bring the movement of the story to a final, gentle halt.

In short, there seems to be a definite attempt to supplement the spatial and proportional harmonies of the nave by a lively decorative balance. Within each architectural bay a group of frescoes in strict symmetry is opposite a freely rhythmic group. Then again, upon each wall, strict symmetry is observed in the first two bays in the narrative sequence and the second two are free. Consequently, whether the opposing side walls, linked by the carefully calculated pattern of the entrance wall, are considered half at a time or as a whole, there is

a similar contrast and a similar final balance between strictly and freely designed areas. The telling of the story of St Francis has allowed the entire volume of the nave and the spatial play and structural function of its main articulating elements to be exploited and enhanced.

Within so broadly conceived and carefully controlled a scheme, the precise form of innumerable details is as much controlled by the decorative demands of the larger units as by the narrative demands of the particular scenes in which they occur. The tendency to discuss each compositon as if it were an isolated phenomenon has led to much of the disagreement that exists about the artistic value of the frescoes.

If *St Francis repudiating his Father* is considered as an isolated illustration of a dramatic incident, it clearly leaves a lot to be desired [119]. Dramatic is hardly the adjective to apply. The heavenly Hand of God, to which St Francis prays, scarcely attracts the eye. It is more of a literary symbol than a formal factor in the design. The width of the central gap between the obliquely set, self-isolating groups of buildings, close-linked in Cimabue's manner to the densely packed crowds of figures that they support, is disproportionately large. The restrained gestures of the largely static figures appear to be incapable of forming a dramatic bridge across so wide a chasm.

Such partial, inappropriate methods of analysis have often relegated the Master of the St Francis Cycle to a place among the minor followers of Giotto. A work of art will often only spring to life when seen on its own terms in its own frame of reference. Seen in the context of the grand design created by the three linked frescoes of the bay, the gap becomes a central focus of a triptych, scaled exactly to its purpose. If it were narrower or less sharp in definition, it would prove inadequate upon this larger scale. It would become not more but less dramatic. The thrust of the perspective in the architectural framework of the bay, and the action and the formal structure of the flanking scenes, exert strong centralizing pressures.

These augment the forces tending to set up a bridge across the central gap. The design achieves a tension which in isolation it does not possess. In terms of what the artist was attempting, it becomes the worthy focus of a masterpiece.

To take another extreme example of the same phenomenon, the *Miracle of the Spring* is virtually nonsensical in isolation [120]. A half-seen donkey and two Franciscans walk in from the left. Their movement is continued as the praying saint stares up and outwards and the mountains sweep to the top right-hand corner of the scene. Below, the thirsty layman stretches out full length to peer in wonder down and out beyond the confines of the composition. Although the saint provides a satisfying formal centre for a carefully balanced pattern, it is hard to imagine any scene less self-sufficient or less self-contained. Yet as soon as its linking function is remembered and the saint is seen as praying, not to the top right-hand corner of the frame, but to the roundel of the *Virgin and Child* above the doors, the fresco is transformed from a loose though pretty pattern into a tight construction beautifully designed to satisfy the numerous, seemingly conflicting demands presented by its narrative content and its architectural situation. Each seeming weakness suddenly becomes a source of strength. What had seemed meaningless or misconceived in formal terms takes on dramatic overtones. The fresco practically becomes a new design, and much the same is true in differing degrees of every composition in the cycle.

The existence of a general scheme does not imply that one man painted all the frescoes. Indeed the problem of the nature of medieval workshop organization and of what is meant by attributing a series of frescoes to this or that hand is raised in its most acute form. Three main groups of works have been distinguished within the St Francis cycle, and each of them contains considerable stylistic variations [114]. The collaboration of many men, not merely the stylistic evolution of one artist, or of three, is revealed by examination of the brushwork.

The first group of works, comprising the opening scene of *St Francis and the Madman of Assisi* and the three concluding frescoes of the cycle, have been convincingly attributed to the so-called St Cecilia Master.[6] The Master of the St Francis Cycle himself appears to be generally responsible for the frescoes, numbered 2 to 19, running from the *Donation of the Cloak* to the *Stigmatization*. Finally, a third controlling hand is visible in the six succeeding frescoes. The borderlines between these groups are not clear-cut, however, and the activity of the Master after whom one group is named can readily be traced into its neighbours.

THE ST CECILIA MASTER

The St Cecilia Master is named after the altarpiece once in the destroyed church of S. Cecilia in Florence and now in the Uffizi [122]. The church was destroyed by fire in 1304 and only reconstructed in 1341. The panel was therefore probably painted either before 1304 or c. 1341. With its enthroned central figure, flanked by eight scenes from her life, it belongs to a type that was common in Tuscany throughout the latter half of the thirteenth century, and its appearance favours the earlier possibility.

Comparison of the altarpiece with the four related frescoes at Assisi immediately reveals a cleavage in the treatment of the architectural forms. Those in the panel are both different in type and much less realistic, whether considered in themselves or in terms of a sense of enclosure within an actual room or building. Against these difficulties two facts must be set. Firstly, differences in scale and medium often make an artist greatly modify his work. Secondly, whenever an artist joins a group, and particularly when he plays a subordinate role, his style is liable to an often radical shift towards a group idiom. Since the St Cecilia Master's work at Assisi is both architecturally and in certain other respects so very different from his panel style, it is extremely probable that the Master of the St Francis Cycle was the dominant figure in establishing the group style at

122. St Cecilia Master: St Cecilia Altarpiece, before 1304(?).
Florence, Uffizi

Assisi. The mapping out of the day-stages in the laying on of plaster shows that with the one major exception of the St Cecilia Master's opening scene, complicated by the intrusion of the rood-beam, the work was carried out according to the natural sequence on the wall. The technical facts therefore support the stylistic probability that this entire group of four frescoes, and not merely the three which close the cycle, was the last, and not the first work to be done.[7]

Attempts to bridge the gap in the St Cecilia Master's style would be extremely dangerous but for the close ties between the figures in the altarpiece and those in the frescoes.[8] Nevertheless, throughout the panel the tendency to rounded, softly falling, though often extremely simple drapery, exactly like that in the frescoes, seems to reflect the influence of Cavallini as well as that of the Master of the St Francis Cycle. In panel and in fresco alike the figures in the narrative scenes tend towards elongated, moderately volumetric, sack-like forms with very small heads and hands. The various types of profile are closely matched, and there is a similar leaning towards moon-like, full-face views in which the individual features seem to float like little islands in large empty seas,

revealing yet again the artist's limited interest in the fundamentals of anatomical structure. Comparison of any head from the opening fresco of the cycle with the Isaac Master's *Jacob* [115] emphasizes the St Cecilia Master's drier, less continuous and less blended brush-stroke, and his reduced feeling for light and greater dependence on line. In terms of structure and volume he tends to do his best work in the panel, rising to considerable heights in many of the smaller figures and sculptural details. That he was primarily a panel rather than a fresco painter seems to be confirmed by the richness of colour, set against a miniaturist's tooled golden backgrounds, and by the liveliness and variety in architectural design and figure grouping which make the St Cecilia altarpiece a significant landmark in the history of Italian art.

These qualities are shared by the altarpiece in S. Margherita a Montici, which is possibly the latest of the three main works attributable to the Master. Here the severe forms of the Romanesque, low, gabled dossal are echoed by the bold contrast between the standing central figure and the flanking scenes. They are reinforced by a new economy, severity, and discipline in architectural forms and figure groupings alike, and rendered lyrical by new

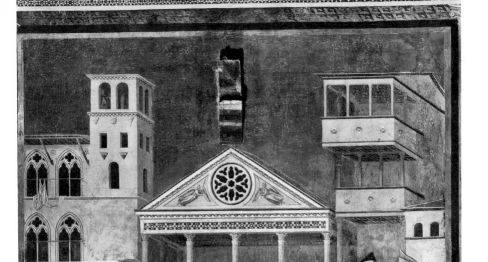

123. St Cecilia Master: St Francis and the Madman, mid 1290s(?).
Assisi, S. Francesco, upper church

interest in the play of light. The damaged
Madonna and Child enthroned in the same
church may be close in date and is the last
remaining reasonably secure attribution.[9]

The St Cecilia Master's knowledge of Rome
is proved by the reflections of Trajan's Column
and of other Roman monuments in the final
Assisan fresco of the *Liberation of Peter the
Heretic*. His charming ability to characterize a
building or a scene, to crystallize it in a sudden

knowing detail and yet to maintain the widest
freedom in the face of the facts, is shown in the
opening scene of *St Francis and the Madman*
[123]. The Temple of Minerva still stands at
Assisi, and the Gothic rose and flying angels
added to the pediment in the fresco, and the
substitution of a central column for a central
intercolumniation, show that archaeological
accuracy was no concern of architectural
portraiture at this early date. In the face of such

extreme reinterpretations of the known physical facts the omission of the storey added in 1305 to the campanile of the Palazzo del Comune, portrayed on the left of this same fresco, does not provide a reasonable *terminus ante quem* for the painting of the scene.

The probability that the up-to-date architectural portrait element found in the frescoes, but not in the panel paintings, is a sensitive artist's response to the special demands of the group project in S. Francesco, is to some extent confirmed by the figure designs. The strictly symmetrical arrangements consistently used in the four frescoes, and consummately fitted to the grand design of the cycle, are strikingly different from the free groupings characteristic of the panels. Faced with the problem of the disciplined subordination of each composition to the complex whole, and tackling the wide expanses of a wall, the St Cecilia Master's own solution is a lyric naturalism of setting and a calm but thoroughgoing exploitation of the space at his disposal. The figures stand in solemn groups within the slender, airy cages of his architectural interiors or before the backdrop of his townscapes. Just as the small features map the detail of his faces, and small heads and hands articulate the broad and sack-like bodies, so small gestures seek to span wide voids. It is the compositional skill evinced, the delicacy of design and the calm beauty of pictorial space, and not the dynamic tensions of dramatic narrative, that hold the individual scenes together. This calm and this restraint stand out against the bolder gestures and the swift, free movements that break out among the almost identical figures in the compact, relatively closely packed scenes of the panels. They reveal the stature and the flexibility of an artist, sometimes overpraised, but far too often characterized in terms of negatives and limitations.

THE MASTER OF THE ST FRANCIS CYCLE

The Roman background of the Master of the St Francis Cycle needs no further emphasis. On the other hand a simple comparison of heads reveals how much his brushwork and his whole approach to form and structure differ, not only from those of the St Cecilia Master, but also from those of the Isaac Master with whom he has often been confused [115 and 124]. A more organic relationship between the features and the basic volume of the head, which is more firmly carved in space, distinguishes him from the first. The drier, less fluently continuous stroke and the greater emphasis on contours separate him from the second. These distinctions are true of nearly all the individual painters grouped under the name of the Master of the St Francis Cycle. They are unaffected by the closeness of the drapery patterns in the earlier scenes to the sharp-folded forms of the Isaac Master or by the similarities in architectural design.

The second bay, in which the master's wider aims stand out most clearly, is the first of those for which he himself appears to have been almost wholly responsible. In it the novelty and limitations of the portrait naturalism echoed by the St Cecilia Master are immediately visible. The painting of the ruined church of S. Damiano on the left, although completely different from the real, surviving church, is no mere symbol but an actual ruin, lovingly described in all its details. Upon the right the major features of the Lateran Basilica are well enough recorded to disclose that the fresco is unlikely to have been painted before *c.* 1291. It was then that Nicholas IV, the first Franciscan pope, refurbished the twelfth-century portico which was, according to sixteenth-century descriptions, of the type shown in the fresco. Furthermore, a still surviving inscription refers specifically to the Dream of Innocent III, which is the subject of the painting.[10] This date therefore provides the one and only reasonably secure *terminus post quem* for the cycle as a whole.

The structure of the buildings in these scenes is quite as interesting as their portrait quality. Within the rigorous general pattern of the bay the jutting, extreme oblique construction in the left and central frescoes is combined with a

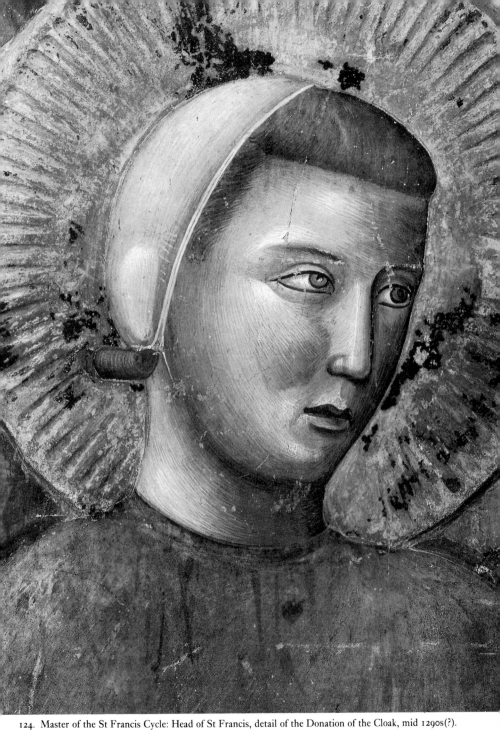

124. Master of the St Francis Cycle: Head of St Francis, detail of the *Donation of the Cloak*, mid 1290s(?).
Assisi, S. Francesco, upper church

220 · PART THREE: PAINTING 1250–1300

calmer, foreshortened frontal construction in the right-hand scene. This is the combination that occurs in Pietro Cavallini's work between 1280 and 1300. The ruined church of S. Damiano is precisely the solution for which Pietro was evidently seeking in his fresco of *Joseph and the Wife of Potiphar* in S. Paolo [81]. The residual structural difficulties have now been overcome. The containment of the figures by the architecture is fully realized, and the jutting, spatial solidity of the church thrusts home the poignancy of its present ruin.

The self-isolating quality of the extreme oblique construction, in which all the architectural horizontals slide off into depth, is evident in the central scene. It is quite hard to realize that all the buildings could be standing parallel to one another on the opposite sides of a street that ran diagonally from the left foreground into the right background. The mixture of the extreme oblique and the foreshortened frontal perspective settings, combined with a now consistent use of the realistic, low viewpoint, seems to reflect an early stage in the close observation of the visible world. The leading pictorial innovators were evidently becoming increasingly aware that if one actually looks at any cubic solid, all the visible sides will recede and be foreshortened as soon as more than one of them comes into view. Another aspect of the intensity of the problems facing painters at every point as soon as they returned from the symbolization to the representation of the three-dimensional world is seen when the patent struggle involved in the depiction of St Francis's nude torso is compared with the solidity and confident anatomical control attained in Nicola Pisano's sculpture over thirty years before.

One demonstration of the stature of the Master of the St Francis Cycle is the meteoric speed of his artistic development. The relatively timid half-interiors, half-exteriors of his first five scenes are followed in the sixth, the *Confirmation of the Rule*, by a great hall. Its barrel-vaulted roof-supports develop the Roman theme of the Isaac Master's *Pentecost* [117].

The side walls and the floor are not cut by the frame, and only in the ceiling area is there still a hesitation and a reminiscence of the old box-building that is so rapidly expanding into a true interior. By the time the left-hand wall is reached, with the frescoes of *St Francis preaching before Honorius* and the *Apparition at Arles* [125], still more realistic detail has been added, although the basic formula remains the same. Furthermore, the spatial disposition of the figures, wholly contained within the architectural space in one case and completing its definition in the other, undergoes a similar development. The loss of the solidity and personal identity of the individual figures to the concept of the group is much less marked. A crowd is on the way to becoming merely the sum of the well-defined and solid individuals that compose it. Nevertheless, it is perhaps in the *Institution of the Crib at Greccio*, at the end of the preceding long wall, that the greatest stride towards a true interior is made, although along a wholly different route [126].

In this alternative tradition, represented by the altar and ciborium that stand for the temple in Cavallini's mosaic of the *Presentation* in S. Maria in Trastevere [83], the interior is symbolized by means of its internal furniture. There is no hint of the enclosing architectural shell. The same is true of the *Institution of the Crib*, but now the furnishings, consisting of the altar with its canopy, the lectern, and the choir-screen, and the back view of the crucifix and of the pulpit and its steps, have been so cunningly disposed that the spectator seems indeed to stand among the crowd assembled in the choir of some small church, looking towards the nave and to the women pressing in out of the darkness. Later, in the *Funeral of St Francis*, the third main master tried to carry the idea still farther. Not only the rood-beam with its images, but also the lower side wall and the structure of the apse are shown. The roof is even implied by hooking the sanctuary lamp to the plain blue reaches of the sky. The result is, paradoxically, less real. The modern onlooker is suddenly less free than in the *Institution of*

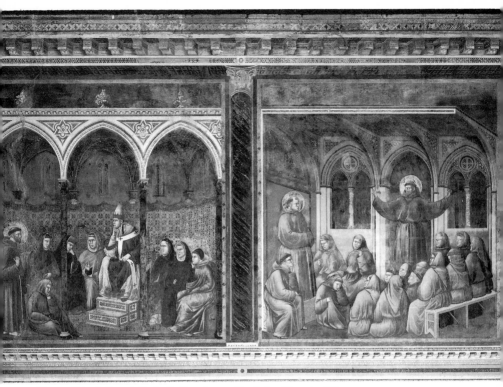

125. Master of the St Francis Cycle: St Francis preaching before Honorius III
and the Apparition at Arles, mid 1290s(?).
Assisi, S. Francesco, upper church

the Crib to 'see' the plain blue sky in terms of actual, though indefinite, architectural enclosure. The very attempt to venture farther down the *cul-de-sac* is proof that the late-thirteenth-century creators of these scenes saw things very differently. The belief that the *Institution of the Crib* indeed reflects the application of a new sense of spatial design to an ancient formula; that it carries with it no anachronistic implications; and that it does not, as is sometimes argued, necessitate a late date for the frescoes at Assisi, is confirmed by the knowledge that it leads nowhere. Although it ranks among the great achievements in the history of narrative description, it was never the inspiration to contemporary or succeeding artists that it now is to the modern onlooker, familiar with six centuries of the slice-of-life, the sudden partial view expressive of the whole. The idea of the interior as an enclosed, and enclosing, box was already well enough developed at Assisi to carry conviction. It is this conception which is echoed and developed throughout the fourteenth century.

The same sense of excitement, of continuous, explosive, but by no means regular advance, is visible in the Master of the St Francis Cycle's landscapes. Landscape as a backdrop, as in the *St Francis giving away his Cloak* [118], or landscape as void, as in the wholly unformed space of the gap between the buildings in *St Francis repudiating his Father* [119], is replaced, in the

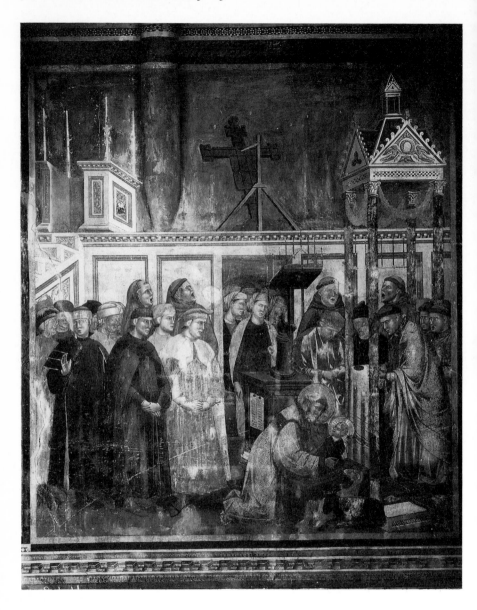

126. Master of the St Francis Cycle: Institution of the Crib at Greccio, mid 1290s(?).
Assisi, S. Francesco, upper church

Miracle of the Spring [120], by landscape as a platform, a continuum. Then, as with the interior, the artist turns to the parallel tradition. In the *Preaching to the Birds* [121], instead of showing more and more, and developing the vertical backdrop into a series of horizontal platforms, extremely little of the actual land- or ground-scape is to be seen. Instead, the trees, the isolated, outdoor furniture of the Romanesque versions of the scene, are planted firmly in the foreground. They are given scale and volume, and they take on such reality that the saint and his companions can be 'seen' by the imaginative eye to be enfolded in the wide space of a landscape. Such a tree and such a 'landscape' are not found again for a hundred and fifty years or so. More than a century of experiment with the simple landscape platform and the Romanesque–Byzantine bird's-eye backdrop is needed before background continuity can be given to a foreground such as this without destruction of its magic.

Despite a drop in quality, a similar sense of growing ambition and achievement characterizes the third and fourth bays on the left-hand wall. The balancing and structural control of the designs, and the open repetition or the cunning echoing of formal elements from one scene to the next, remain as clear as ever. The articulation of the figures may be less certain, but the increasingly complex foreshortenings characteristic of such scenes as the *Apparition at Arles* [125] continue to be attempted. The efforts to create and to articulate deep space by means of figures alone become still more ambitious. The wealth of faithfully observed detail, whether of church furnishings or dress, continues to increase. Indeed, the figures multiply until crowds, formerly suggested by the careful disposition of a few participants, are actually enumerated, ninety strong, and the balance between drama and description carefully maintained by the leading master is destroyed. Albeit in a manner that was revolutionary in its day, the gossip has replaced the story-teller.

It is a measure of the Master of the St Francis Cycle's success as a narrator that since his fres-

coes were completed it has largely been with his eyes that the story of St Francis has been seen. The wealth of sometimes simple, sometimes not so simple, descriptive detail seems to be ideally suited to the story of a saint whose love of God expressed itself so clearly through the love of his creation. Other major factors in the hold exerted by the frescoes are their location in the central shrine of the order and their close adherence to St Bonaventure's official life.

Difficult as it now is, it is important to forget for a moment such influential later embroideries upon St Francis's life as the mid-fourteenth-century Fioretti and to think of his own Canticle to Brother Sun, which is among the earliest glories of Italian vernacular poetry. Its shining simplicity slices like a knife through the artistic subtleties and complexities of S. Francesco. To stand amid the wonders of the upper church and read St Francis's first rule for the Friars Minor: 'when the brothers go through the world they shall carry nothing for the journey, neither purse, nor bag, nor bread, nor money, nor staff ...'; or to walk down the hill to the tiny portiuncula engulfed within the splendours of S. Maria degli Angeli, is instinctively to understand the internal strife over the rule of poverty which rent the order in the thirteenth and fourteenth centuries. S. Damiano, the small, smoke-blackened cellar of a church outside Assisi in which St Francis prayed before the speaking crucifix, gives the true scale of his personal life. He had no thought of building, and much less of decorating, churches. He would have hated S. Francesco for its size, its ostentation, its expense.

So simple and so strict was St Francis's rule that already in his own lifetime his intimate companions began to separate from those who wanted some relaxation of its saintly extremes. The explosive growth of the order meant that attitudes apt enough for a small wandering band of friends soon clashed with the need for proper administrative control over a vast European organization. Four years after St Francis's death Gregory IX declared not binding the

testament in which he commended the literal observation of his rule to his followers. The rule of poverty itself was at first accommodated by the legal device of turning over all Franciscan moneys to a papal 'nuncius'. Soon the opposing factions hardened into the distinct parties of the Spirituals, who wished to observe the strict interpretation of the rule, and the Conventuals, who did not. Even the bull of 1322 in which Pope John XXII declared the legal fiction to be fiction indeed, followed in 1323 by a decretal making it heretical to assert that Christ and his apostles were not the owners of the property mentioned in scripture, failed to end a battle at the heart of which stood such achievements as the church of S. Francesco at Assisi. Yet, if the story of the Franciscan order is a harsher reflection of those same pressures which eventually turned the followers of the ascetic St Bernard into the builders of some of the most sumptuous churches in Europe, S. Francesco remains a masterpiece of truly religious art. The Franciscan order, though no longer that enshrined in St Francis's little band, was, alongside that of the Dominicans, one of the greatest spiritual forces in the later Middle Ages, and S. Francesco is one expression of that power. Like all great works of art, its secret lies in the totality which so outstrips the mere summation of its parts. Cimabue, Torriti, the Isaac Master, the St Cecilia Master, the Master of the St Francis Cycle, and many others all contributed to the pictorial, decorative, and didactic unity that enriched the pre-existent clarity of the architectural structure. The emphasis upon the apocalyptic mysteries and apostolic narratives, on the life of the Virgin and on the Passion; on all those things which were especially dear to St Francis himself and particularly suitable for monastic meditation, is seen in the large-scale frescoes of the choir and transepts. The familiar typological parallels of the Old and New Testaments are confined to the small panels of the windows. Together, they compose a scheme that is complete within itself. Beyond the rood-screen, in the area reserved for the laity, the Old Testament stories and the re-enactment of Christ's life in the New are then writ large in fresco, with the Doctors of the Church to complement and balance the Evangelists, and the whole completed by the story of St Francis himself and by an assemblage of the saints in fresco and stained glass. Again it is a satisfactory, self-sufficient scheme. If the choir and transepts are considered as an architectural and liturgical unit, the content of the scheme is as rounded and complete as are its decorative aspects. In the church as a whole this lesser unity is then subsumed within a greater, the full range of the frescoes covering the same ground upon a grander scale.[11]

If the function and liturgical divisions of the church are borne in mind, the element of repetition ceases to be a symptom of confusion. The architectural and decorative unity can be seen in its true light as the embodiment of the thematic and doctrinal unity of the church militant. Each meaning and each visual consonance, each structural element and each decorative detail plays its part in the creation of one of the most compelling monuments of European art. And yet, by looking back towards the architectural structure and forward to the frescoes and stained glass of the lower church, it can be seen that the upper church and its decoration are themselves no more than one part of a greater complex. It is one in which the coherent organization of the upper church becomes a foil for the lively decorative and thematic confusion, for the sense of unplanned growth that is inherent in the lower church as in so much of medieval life itself.

ARCHITECTURE

1300–1350

INTRODUCTION

During the half-century that precedes the Black Death the desire to make the city as a whole a thing of beauty at least begins, perhaps for the first time since Antiquity, to rival the importance of the need to make it strong against internal and external enemies. It is not merely that palaces grow more palatial and less fortress-like and multiply in number. The first tentative moves towards conscious, visual organization accompany a changing attitude to practical considerations, and the idea of town planning begins to take on a new meaning. The building or the reconstruction of a major church or palace becomes the occasion for a conscious effort to impose a certain visual order on the outcome of long centuries of unplanned growth. What had been a mystical ideal, an inarticulate urge, or an unwritten code, begins to find a place in written regulations. However much the practical outcome may have fallen short of the intention, the theologians' ordered universe begins to find a counterpart not merely in the architectural symbolism of the individual church but in the shape of streets and squares. There are the stirrings of ideas that flower in the formal concepts of the Renaissance. The desperate struggle for survival and salvation is slowly modified by more ambiguous attitudes. Increasingly, the organization of the affairs of this world rivals the hope of heaven as a social force.

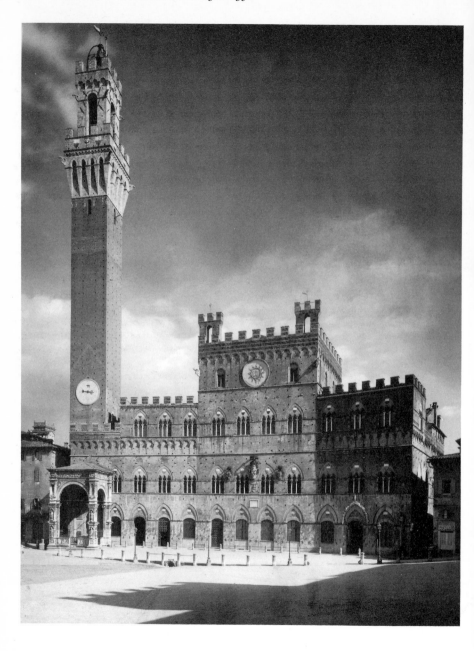

127. Siena, Palazzo Pubblico, begun 1298

SIENA

THE PALAZZO PUBBLICO

The new ideas take shape most clearly in Siena. The starting point lies in the plans for the Palazzo Pubblico [127 and 128]. These were first mooted in 1282, although a definite decision was not taken until 1288 and building seems to have started ten years later. In 1297, before the palace in the shell-like Campo or main square had even been begun, it was ordained 'that if any house or building should ever be built around the Campo, each and every window of such house and building, which should look out upon the Campo must be made with columns and without any balconies'.[1] This is precisely the form of window established in 1298 by the central section of the Palazzo Pubblico. Undoubtedly what was planned from

the first was an entire new city centre that would gradually take shape around the seat of government.

The original square central section of the Palazzo, with its stone ground-floor loggia and the rose-red brick of its upper storeys, is a cross between the Tuscan and Lombard forms previously discussed. Relatively low two-storeyed wings, intended as the quarters of the Podestà and of the Council of the Nine, were added in 1307–10 and only extended upwards in 1680–1. The spacious upper loggia at the back of the central section was begun in 1304. In framing a superb view of the countryside it provides vertiginous evidence of the scale of the substructures needed before the palace proper could be started. Internally, the vast retaining walls, the massive brick piers rising through

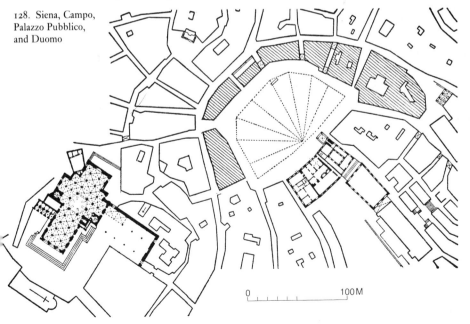

128. Siena, Campo, Palazzo Pubblico, and Duomo

0 ⸺⸺⸺⸺ 100 M

two storeys to an interpenetrating world of wide segmental arches and plain barrel-vaults, can now be seen in the exhibition centre under the left-hand section of the Palazzo. The completely unified façade disguises the complete separation of this entire section of the Palazzo from the main, central block by an alleyway which ran down from the Campo to the lower piazza.[2] Nothing could be more revealing of the new aesthetic attitude to planning. Finally, the new prison and the Salone del Gran Consiglio along the Via di Salicotto were built in 1327 and 1330–40 respectively, but the most spectacular addition was the Torre della Mangia, founded in 1325 but only built in 1338–48. It is typical of the period that the latter's crown should have been designed in 1341 by the famous painter Lippo Memmi.

In the mid fourteenth century the palace must have presented one of the most boldly contrasted skylines in Italy. Its effect is hard to imagine when faced with the relatively simple massing of the present building, in which a substantially horizontal main body and slimly-soaring angle tower are juxtaposed. The height, not only of the tower itself, but of the keep-like and initially free-standing central element, must have been greatly accentuated by the low wings, in which the horizontal stress was further increased by the lines of arches and first-storey windows running through from end to end without a break. Nevertheless, the view uphill towards the Palazzo dei Consoli at Gubbio in Umbria confirms that such staccato elevations, with extreme horizontal and vertical breaks and contrasts, were well in tune with current taste in Central, if not Northern, Italy [143 and 144]. The extraordinary height and slimness of the Sienese tower is less a novelty than a reminiscence of past glories. Like the tower that juts uncompromisingly from the rectangular bulk of the Palazzo Vecchio at Florence [136], it recalls the day when Siena, like S. Gimignano and like every major town in Italy, resembled a stone forest. The Torri degli Asinelli in Bologna, though decapitated, show that towers on this scale had long been built.

It was indeed the menace to the Commune represented by such private fortresses of the nobility and of the major family clans that led increasingly to their destruction. As a graceful record of the grim realities of a past by no means wholly exorcized, the Torre della Mangia stresses that the whole palazzo with its numerous wide, tripartite windows and the open arches of its loggia is much more a symbol of the power of government than an actual fortress. To look back at the grey stone façade of the Palazzo Tolomei (after 1267), with its uncompromising flatness, its thin cornices, and its wide areas of unbroken masonry, is to see how much the atmosphere had changed even in twenty years.

The inside of the Palazzo Pubblico is unusually well preserved, and its complexity and magnificence are commensurate with its external dimensions. The housing of all the offices and living quarters for the Podestà and for the Nine, as well as of the usual council chambers, in a single building created a unitary seat of government without precedent in Central Italy. The wide ground-floor arcading of the Cortile del Podestà, with its octagonal brick columns and stone capitals supporting round brick arches and groin-vaults, is impressive in its scale and regularity, although the well itself, despite the fine detailing of the windows, has a rather bitty quality. Successions of fine rooms of every size and shape achieve a climax in the Sala del Mappamondo, in which the customary large and well-lit hall gains architectural interest from four massive arches opposite the windows. These lead off into the entrance hall and into the dark and heavily-vaulted chapel and ante-chapel. The survival in so many rooms of the frescoed decoration by men like Simone Martini, Ambrogio Lorenzetti, Spinello Aretino, and Taddeo di Bartolo is, however, a reminder that for all their architectural grandeur the great civic palaces of Italy were as incomplete as any church until the fresco painter had successfully met the challenge of the vast, bare surfaces to which the modern eye is so responsive.

The designer of the Palazzo Pubblico is unknown. The building is, however, full of reflections of earlier Sienese practices such as were embodied, not only in such relatively recent brick constructions as the late-thirteenth-century Spedale di S. Maria della Scala, but in early-thirteenth-century structures like the travertine Casa di Via Cecco Angiolieri.[3] The most interesting of the men involved in its completion is the architect and sculptor Agostino di Giovanni. First mentioned in 1310, when he was married, he seems to have died by late 1350. He worked on the Palazzo Pubblico in 1331 and again in 1339, when he was also concerned with Lando di Pietro and others in the construction of the Fonte Gaia immediately in front of the building. In 1340 he was busy with two other architects on the projected reconstruction of the Palazzo Sansedoni, and a sketch establishing the detailed treatment of the street façade of this, the grandest of the private palaces that overlook the Campo, has survived on the original contract.[4]

This document, as the only known example of an illustrated contract from the period, is in many ways a landmark. It shows a fully measured elevation on a scale of 1:48, with all the main dimensions written in. The latter work on quarter-braccio increments based on the size of the brick which was, in fact, used. What is more, comparison with the existing building shows that it is the Florentine braccio which is involved. This confirms the penetration of Siena by the Florentine system which is seemingly indicated in many late-thirteenth- and early-fourteenth-century altarpieces. As a pure elevation, it is in marked contrast to the partly perspective representations which characterize the majority of early architectural drawings, even when they are done to scale. What is more, the indicated measurements appear to represent a translation into arithmetical terms of a geometrically based system of proportion, as the total height to the top of the uppermost storey is equivalent to the sum of the sides of two successive squares in a $\sqrt{2}$ series, the larger equalling the width of the building, or in other words a square on the width plus half its diagonal.[5] This transference from geometrical to arithmetical proportion is, of course, a prefiguration of what was to become an essential feature of Renaissance architecture. Finally, whereas it was the custom in Siena for there to be a decrease in the height of successive elements in a façade, here there is a steady increase. This may well represent a perspective adjustment designed to counteract the effects of the very steep viewing angle imposed by the narrowness of the street on which the façade fronts, in a manner analogous to the 'corrections' that were seemingly introduced by Giovanni Pisano in his façade sculpture, as well as creating grander spaces in the airier, better lit, upper part of the building.

As far as the side facing the Campo is concerned, the brick construction; the only slightly simplified window design; and the way in which the several sections hug the contour of the Campo, all obey the rules established in the Palazzo Pubblico. Indeed, the only significant change is the increased scale of the windows in comparison with the storeys that they light. The intervening areas of wall have dwindled into a framework for thirty-six elegant triple openings. Elsewhere in the city the palaces of the Salimbeni, Chigi-Saracini, Capitano di Giustizia, and Buonsignori are only the most splendid of a century-long set of variations played in brick, and brick and stone, upon the themes established in the Campo.

THE GATES AND FOUNTAINS

The city's gates and fountains show that the homogeneity of Sienese architecture in this period goes much deeper than such surface symptoms as the few surviving regulations. In 1325 the architect and sculptor Agnolo di Ventura, who was active between 1312 and 1349, provided plans for the largely destroyed Porta S. Agata. He was on the Council of the Duomo in 1333, and in 1334 was associated with a certain Guidone di Pace in the building of Grosseto Castle, the surviving tower of which

dates from 1345. The Sienese Porta Tufi of 1325 is sometimes attributed to him, and in 1327 he provided plans for the Porta Romana. The latter, with its keep-like main structure preceded by a curtain wall and outer defensive rectangle, with its battlements and false machicolations and frescoed tabernacle, is stylistically extremely close to the Porta Pispini of 1326, attributed to Muccio di Rinaldo. It is also related to the Porta Ovile.

A similarly solid brick construction, and the greater willingness to use the pointed arch which is a constant feature of non-military construction, are characteristic of the long line of the city fountains. These were all built in the form of vaulted chambers with arched openings. The dark and massive Fonte Branda, its simple pointed openings set within relieving arches, leads the way. First mentioned in 1081, it was enlarged in 1198 and rebuilt in 1246.[6] In the closely related Fonte di Follonica of 1249 a

similar weight of wall is accompanied by a less oppressive arch-within-an-arch design and by heavy ribbing of the vaults.[7]

This Sienese pattern was followed in 1265 in the Magazzino dell'Abbondanza at Massa Marittima, in which three simple, pointed arches, many feet thick, lead to the vaulted chambers of the fountain and support the public granary above. The six round-headed windows of the upper storey are linked by two plain cornices, so that the whole not only resembles the Central Italian versions of the Lombard civic palace but possibly reflects a Sienese practice now obscured by the destruction of the upper levels of Siena's thirteenth-century fountains.

The earlier Sienese formula is modified in the Fonte d'Ovile of 1262. The long, low format is replaced by a vertically accented, almost cubic design in which the two wider and taller arches of the main front are flanked by a similar

129. Siena, Fonte Nuova, begun 1298

opening on one of the short sides. This pattern is then followed in the Fonte Nuova, begun in 1298 [129]. Here the massive brick dividing column of the Fonte d'Ovile, and the plain rectangular section of the arches, common to all the earlier fountains, give way to an extensive series of decorative mouldings that lend an air of solemn, almost ecclesiastical sophistication to this, the most imposing of the later Sienese fountains.[8]

S. DOMENICO AND S. FRANCESCO

The variety of civil building and rebuilding in early-fourteenth-century Siena was matched by the multiplicity of churches that were being either started or enlarged. Among the latter, S. Domenico and S. Francesco rank as two of the most important brick constructions in Central Italy. Both were replacements for more modest buildings, and both flow directly from the thirteenth-century Tuscan mendicant tradition. The existing S. Domenico seems to date from after 1309, when materials for the east end were being amassed. Like the Palazzo Pubblico, the enormous brick pile of the choir and transepts, towering above the Fonte Branda, is built up from the hillside on a high substructure [130] which contains a vaulted crypt so monumental and so rich in its articulation as to be effectively a lower church.[9] Here, in the simple pointed openings into the substructure and choir chapels, in the enormous buttresses and vast, unbroken areas of transept wall, is brickwork on a scale that echoes ancient Rome. The massive, unadorned simplicity of the whole is epitomized in the great central window. In itself this has the quality of a brick wall set within a great relieving arch and pierced by two storeys of round-headed openings which are themselves surmounted by one large and two small roundels. Even more monumental and impressive in its absolute simplicity is the way in which the prism of the nave is shafted into that of the uninterrupted volume of the transepts. It is this relationship that dominates the interior. The nave, with its pitched roof and simple, pointed

windows, is separated from the crossing by a massive pointed arch that is a little flatter in its curve than the one which leads to the choir chapel. No arches separate the transepts from the crossing, and a single pitched roof runs from end to end. The expectation of a relatively sharp reduction in scale from nave to transepts, with an immediate subdivision into lesser volumes, is indeed confounded, and does not take place until the choir and the six flanking chapels have been reached. Even so, the chapels themselves create a sense of mass and of sheer scale which is not achieved in many larger and more richly detailed and articulated buildings. Simplicity such as this is not to be confused with mere insensitivity. The relative sizes of the chapels and their openings is so calculated that the inner, flanking pair become the intermediaries that link the smaller, outer four to the great central square. The harmonious grouping of the arches of the crossing, the chapel openings, and the windows is particularly striking when once the mid-point of the nave is reached and the pair of flanking chapels is fully visible. It is not only in religion itself, but in its architectural expression, that disciplined simplicity can be a vital force.

The new S. Francesco was founded in 1326. Although the church is longer and wider than S. Domenico by some 7 feet, its main dimensions being 191 feet and 72 feet 6 inches (58·3 m. and 22·1 m.) respectively, it is also lower and lighter. The nave, which was heightened by Francesco di Giorgio in 1475–84, was always higher than the transepts. As a result there is an easier hierarchy in the external forms [131]. It is only partly because the hill upon which it stands drops down less steeply that the buttresses are lighter and the sheer mass of the brickwork less imposing than in S. Domenico. The choir chapel steps up to the nave, the flanking chapels to the transepts, and the transepts once more to the nave, in restful stages that are made up of repeated forms. The windows are more delicate in their vertically accented tracery and the general effect, although far less sophisticated than in S. Croce, is very much closer

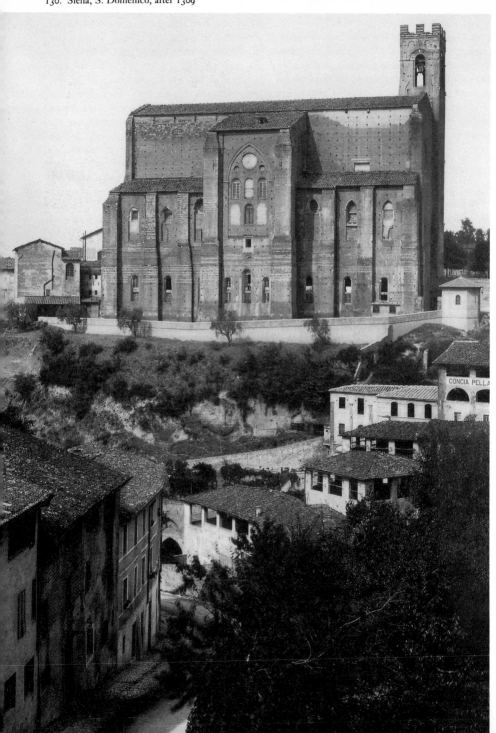

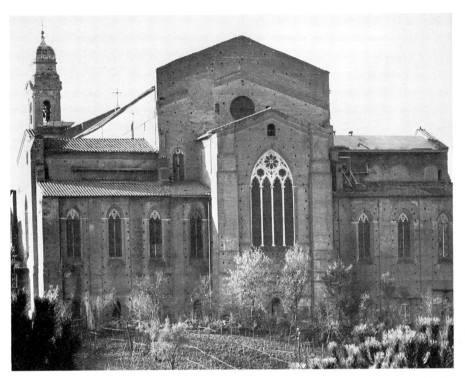

131 and 132. Siena, S. Francesco, founded 1326

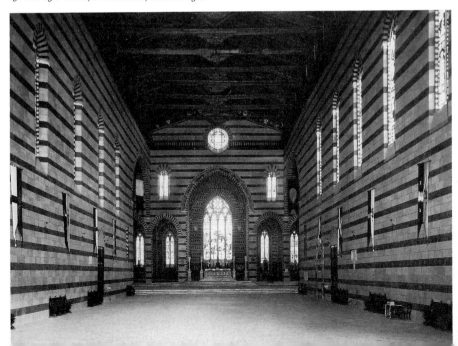

to that of the Florentine church. There is a similar internal relationship [132], since the nave runs to the choir wall without the intervention of an arch before the crossing, and the openings of the eight identical chapels flanking the choir are altogether slimmer and slighter than in S. Domenico. It is also noticeable that although the arches into the transepts are the same height as the choir arch, they appear to be both narrower and lighter when seen in foreshortening from the nave.

The relationship between the choir arch and choir window is almost exactly repeated in the arches and windows of the flanking chapels. It is, indeed, this delicately traceried choir window that mediates in scale between the choir arch and the entrances of the minor chapels. There is, however, a rather loose-knit quality about the openings in the entrance wall of the choir. This is chiefly caused by setting the vertical axes of the upper windows slightly outside those of the openings of the first two flanking chapels. Nevertheless, the general coherence of internal and external relationship is such that this is not necessarily a simple lapse in sensitivity. As soon as the nave is entered the three central chapels and the entrance wall of the choir are seen as a framed group. What is not immediately obvious is the fact that, both externally and internally, as more of the transepts becomes visible, the setting of these upper windows aligns them with the central rose and with the windows of the third pair of flanking chapels. This creates a triangle similar to that which links the central chapel to its immediate neighbours. Externally this establishes a continuity in the surface pattern of the windows similar to that which binds the volumes of the building to each other. Internally it encourages the visual linkage of the nave and transepts. The latter, being partly cut off by their entrance arches, are otherwise in danger of becoming somewhat disconnected spaces. As often happens, an apparent failure in some single detail is the clue that will lead us to an understanding of the struggle to achieve some greater goal.

THE DUOMO

It was not merely into these two churches, linked to the cathedral only by their internal zebra stripes, or into the related churches of the Austin Friars and the Servites that the Sienese poured their energies. In 1316, under Camaino di Crescentino, only twenty years after Giovanni Pisano's sudden desertion of the work on the façade, they began to extend the existing Duomo by building a new baptistery at the foot of the hill [133B and 134]. This was to provide substructures for a two-bay extension of the choir above [21]. By 1322, despite a communal enthusiasm which led squads of men and women to assist in excavation, second thoughts and fears came crowding in, and a commission was summoned for advice.[10] Such commissions of inquiry were a commonplace, and this one owes its interest to the presence of Lorenzo Maitani, the Sienese architect whose position as capomaestro at Orvieto stemmed from his advice and subsequent action in a similar case. The Sienese Nicola di Nuto and three Florentines were associated with him, and their report is a model of clear thinking and of the incisive presentation of unpalatable truths:

Item, the new foundations are inadequate and already sinking.

Item, the new walls are not thick enough. They are to be much higher than the old and should therefore be thicker, to bear the weight. But they are not. They are thinner.

Item, the unsettled foundations will not bond into the old and settled ones.

Item, it seems to us that the work should not proceed farther because of the necessity for demolition in the existing structure.

Item, that it should not proceed because this would gravely endanger the vaults and cupola of the old building.

Item, that it should not proceed because the cupola would no longer stand at the cross's centre, as it should.[11]

Item, that it should not proceed because when completed it will not have the measure-

ments of a church in length and breadth and height as postulated by church law.

Item, that it should not proceed farther for the old church is so well proportioned and its parts agree so well in breadth, length, and height that if anything were added to any part, it would be better instead to destroy the said church completely, wishing to bring it reasonably to the right measure for a church.

This last injunction makes it absolutely clear that the original structure was as yet unaltered. If the nave had already been heightened, with the patently disturbing consequences for façade and cupola alike which are still visible today, no such statement could possibly have been made. A similar concern with proportion and 'with all the measures that pertain to a beautiful church' then recurs in a subsequent, separate recommendation that a wholly new building should be undertaken.[12]

In view of Maitani's similar call to Orvieto and of the enthusiasm and confidence which he had aroused in the authorities there, the skilful ordering of this second report is particularly interesting. It is rendered doubly so because, unknown to himself or to anybody else, he had, at Orvieto, provided tangible evidence both of his lack of theoretical knowledge and of the limitations of his craftsman's expertise.[13] The way the new report gains force as it advances from a series of purely factual statements about structural shortcomings to reiterated warnings not to continue is impressive. The culminating argument, which now appears to be wholly aesthetic, must have been given added weight by the philosophical and symbolic importance of medieval systems of proportion. One cannot, however, help suspecting that the advice to start again at the beginning with an entirely new cathedral may have been influenced by the hope of building it himself.

Not taking the advice of specially convened expert commissions was already a well established governmental pastime in the Middle Ages. Nevertheless, it must have taken almost as much courage to go on in the face of such an unequivocal condemnation as it would have done to stop and start afresh. In fact, they carried on, and the vaulting of the baptistery was finished only three years later.

Maitani's visual sensitivity is witnessed by his work at Orvieto, and the effect of the existing building at Siena when Duccio's *Maestà* was flanked by Nicola Pisano's pulpit and almost immediately surmounted by the glow of Cimabue's window, only just beyond the architecturally dominant vortex of the crossing, must have been something which was neither soon forgotten nor easily relinquished. As at Orvieto, however, Maitani's structural forebodings were evidently less well founded, for the whole new building, with an even greater overburden than was originally intended, has already survived for a matter of six hundred years.

The desire to outshine Orvieto; to accommodate the ever-growing crowds that gathered upon state occasions; and to avert the increasing artistic threat from the Duomo of Florence by means of a building of unrivalled splendour, may well have influenced the project for enlargement. If so, that desire was not yet satisfied. The evaporation of one set of dangers, and the initial triumph of courage over calculation, apparently gave the impression that the laws of gravity were in abeyance.

In 1339 the authorities decided, amidst general acclaim, to expedite a grandiose plan that had been gradually maturing throughout the preceding decade. To supervise the scheme they sent to Naples for the Sienese Lando di Pietro, who is documented as receiving parchment for making drawings, but who died in the following year, to be succeeded by Giovanni d'Agostino, who in 1347 became capomaestro at Orvieto. The whole of the existing and still unfinished structure was to be no more than the choir and transepts of a monstrous new cathedral. The drawings for two versions of the project still survive in the Museo dell'Opera [133A]. One, which was finally discarded, apparently envisaged the abandonment of the two new, uncompleted bays of the choir and

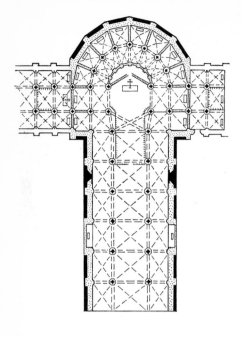

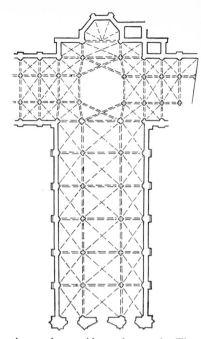

the suppression of the first three bays of the existing nave, though all of them are shown on plan. A great radial choir on the lines of Notre Dame in Paris, or of Pontigny, was to be the culmination of a unified, but no longer cruciform space. The support of the existing cupola would have entailed the substitution of a pier for the window that normally marks the longitudinal axis of such plans. It also generated most peculiar relationships between the hexagon and circle. A large smudge seems to express the reluctance to accept the setting of a pair of pillars almost back to back along the central axis of the building and immediately behind the altar. Such structural confusions, and the root and branch approach to the existing church, must have influenced the approval of the second plan, which is the one substantially embodied in the surviving ruins of the scheme. The old cathedral was to provide the uneven transepts, four and five bays long respectively, of a new, cruciform church. The new nave was virtually to double the height of the old and

was to be nearly as wide as the cupola. The latter would have been buried almost to its lantern. The effects of heightening what were to be the transepts are visible throughout the surviving building, and much of the original exterior of the drum appears inside the church above the original arches of the crossing. Already what was once intended as a vertical expansion appears as a great prismatic shaft sunk into the heart of the main body, and this impression would have been immeasurably intensified when the same forms were viewed from the projected nave.

The determination to respect Giovanni Pisano's architectural forms as far as possible in the design of the pier and niche forms and of the tabernacles of the gallery on the unfinished baptistery façade is no less obvious [134]. The interest of the executed fragment is, however, greatly increased by the survival of a complete design in colour by an unknown author probably working c. 1339 in connexion with the vast plans for enlargement which were then afoot.

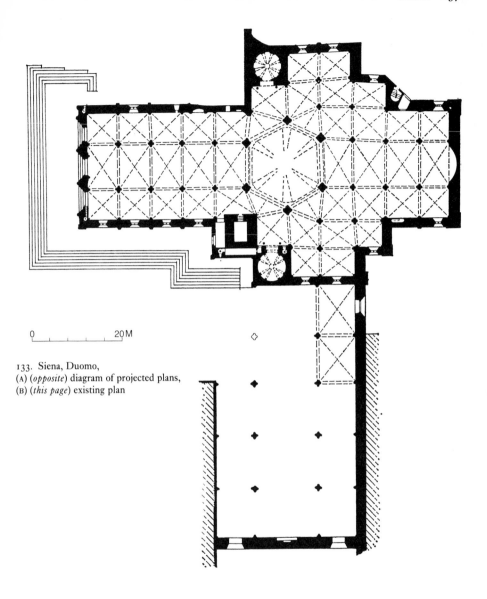

133. Siena, Duomo,
(A) (*opposite*) diagram of projected plans,
(B) (*this page*) existing plan

The unity of the drawing; the minor variations from the executed lower part of the façade, as well as the alternative solutions offered for various details in the upper areas; the incom-patibility of the complex oculus and its sub-stantially northern Gothic tracery with Cimabue's window, which was transferred to this position *c.* 1365; all these things point to a

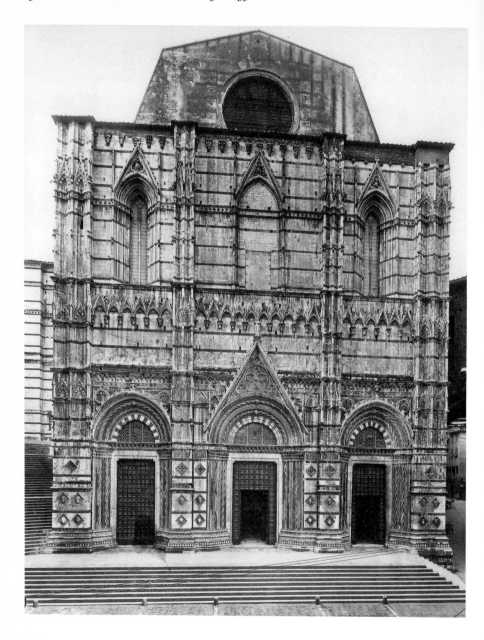

134. Siena, Baptistery, façade, founded 1316, left unfinished in the third quarter of the fourteenth century

135. Drawing for the façade of the Baptistery at Siena, *c.* 1339(?).
Siena, Museo dell'Opera del Duomo

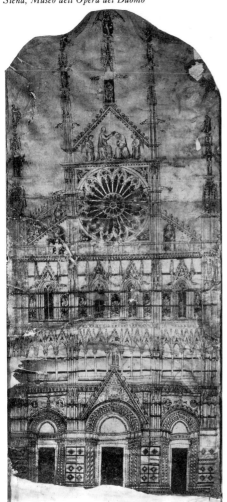

the second the incorporation of a large rose-window. In view of comparable attitudes in Florence, it is particularly interesting that every effort was made to damp down the extreme verticality of the basic form. This is shown in the drawing by the slimness of the piers and by their repeated interruption by heavily capped niches and by cornices. The horizontal banding of the marble and the accentuated horizontality of the three main storeys beneath the rose-window are even more apparent. Finally, the broad, low form of the pediments above the central door and over the rose-window; the suppression of those over the lateral doorways; the square frame of the rose itself; and even the gentle slope of the flanking buttresses with their alternative schemes of decoration, all help to reduce the vertical thrust. The contrary is true only in the free-standing continuation of the main piers. The form of these pinnacles is, however, wholly impracticable in architectural terms. They seem to represent a goldsmith's or a painter's concept, and in Siena at least the unquestioning assumption of the unity of the arts did not inevitably lead to happy consequences. The pictorial quality is emphasized both in the drawing and in the incomplete work by the extraordinary flatness of the design. All Giovanni Pisano's deep recessions and contrasts of light and shade [63] have been so thoroughly attenuated that even the façade at Orvieto [278] becomes three-dimensional by comparison.

Structural necessity undoubtedly played its part in restricting the recesses of the doors and in replacing Giovanni's real arcade by an almost depthless blind arcade. It may also have influenced the substitution of three windows flanked by solid wall for the four windows linked by deeply recessed niches containing half-length figure sculptures shown in the drawing. This latter alteration tends to reduce the lateral spread of the design and to increase its verticality, and aesthetic intent as well as structural necessity was probably involved. The diminution in the importance of the continuous blind arcading, through its reduction from parity with the upper storey to the equivalent

relatively early dating and confirm its status as a partially executed design [135].[14] Its closeness to the surviving work enhances the significance of its deviations from it.

The Sienese had clearly set themselves to adapt Giovanni Pisano's original design for the main façade to a situation involving two new elements: the first was a great increase in height;

240 · PART FOUR: ARCHITECTURE 1300-1350

of half the height of a doubled upper storey with windows breaking through the median cornice, also accentuates the trend. The large units thus created are more in keeping with the massive scale of the whole, and incidentally involve the suppression of the gesturing half-length figures of the prophets. The enormous sculptured figures of the *Annunciation*, which takes place across the bottom of the rose-window, would possibly also have disappeared in execution. In the drawing these figures carry on Giovanni Pisano's theme of sculptural intercommunication across wide architectural spaces. Their loss would mean that only the architectural incidentals of Giovanni's scheme would have survived. The triumph of pictorial and decorative values over sculptural and architectural drama would have been complete.

The effect on Giovanni Pisano's own façade of the heightening of the present nave has already been discussed. The form of the piers for the new nave, a few of which survive, embedded in the walls of the Opera del Duomo, is much more extraordinary. In accordance with the plan, they have almost the same section as those of the relatively humble arcading of the original nave. The height of the new structure is shown by its surviving entrance wall. The thrust from the wide vaulting of the aisles strikes far below that from the projected main vaulting, and is so great that the piers have bent like willow twigs under the strain. Fortunately, the financial difficulties of the forties, capped by the Black Death, stopped all work. The disaster which might otherwise have occurred is easily imagined, and the innumerable defects of the half-completed structure are inexorably listed in a report of 1356 by the Florentine Benci di Cione. This document confirms that the heightening of the nave had yet to take place, since it lists among the things which would have to be demolished 'all the vaults of the old church', which it explicitly distinguishes from those of S. Giovanni at the choir end of the church, on which work was going ahead in 1358 and on through the sixties. Two years later Francesco

Talenti, who was the capomaestro of Florence Cathedral, was paid for consultations, but the decision to demolish the obviously dangerous sections had already been taken in 1357. It is uncertain whether the abortive scheme was planned by Lando di Pietro, whose chief claim to fame is otherwise the fashioning of the crown of the emperor Henry VII, or by Giovanni d'Agostino the architect and sculptor, or by some adventurous unknown. It is clear, however, that the work which was actually carried out with such unfortunate results is as nothing to the feats of engineering that should have followed. The plan involved no less than the removal of two of the pillars supporting the cupola. These would otherwise have blocked the vista down the nave, and were to be replaced by a pair of intersecting arches. Imagination boggles at the thought of Maitani's reaction, had he lived to see what was proposed.

This almost incredible saga of ambition and incompetence is revealing. The erection of the new baptistery and the successful grafting of the choir upon the original building are extraordinary feats of architectural engineering. Yet the limitations of their theoretical knowledge were such that these same men pressed on for twenty years with the structurally preposterous folly that still dominates Siena like the skeleton of some long-stranded whale. Nevertheless, theirs was an airy if impracticable vision of a Gothic architecture wholly lacking in the Gothic structural elements that alone could make it viable. It was a dream of slender members and round arches soaring weightless over mighty spaces. The classical detail of the surviving parts shows their instinctive feeling for the forms that they were stretching far beyond the limits of the possible and underlines their sense of harmony with the Antique world with which such men as Petrarch and Ambrogio Lorenzetti were familiar.[15] It is a tribute to the qualities of these fourteenth-century Sienese that their most ignominious failure is more memorable than the successes of many other men.

FLORENCE AND THE REST OF TUSCANY

THE PALAZZO VECCHIO AND
THE PALAZZO DAVANZATI IN FLORENCE

It was in 1258 that the great Ghibelline clan of the Uberti had been expelled from Florence and their towers and houses razed. For forty years the ruins lay as a mute warning, and Giovanni Villani, the Guelph historian of Florence, writing in the early fourteenth century, says that it was to ensure that they could never be rebuilt that the area was chosen for the Piazza della Signoria. The Palazzo Vecchio itself was founded in 1299, when continuing internal strife meant that the Priors could no longer stay with safety in the house of the White Cerchi. The latter were a banking family and the leaders of one faction in the ferocious struggle between the so-called White and Black Guelphs. In the mid nineties this had replaced the earlier warfare between Guelphs and Ghibellines, and the years 1299 and 1300 were marked by a succession of atrocities and tumults. The peak of violence was reached with the triumph of the Blacks in 1301, and the ensuing terror lasted throughout 1302. It was then that Dante fled to escape a trial for his actions as a Prior two years earlier. The White Guelphs were proscribed as Ghibellines; nearly six hundred death sentences were passed, and the White exiles scattered throughout Italy.

The perilous times explain the speed with which the new Palazzo was erected. They also render it remarkable. The Priors were already installed in 1302 and the tower was up by 1310 [136]. The contrast to the slow rise of S. Croce and of the Duomo, both begun only a few years earlier, is extreme. The architectural conservatism of the grim and fortress-like exterior, reminiscent of Volterra and of the Bargello, must also be related to contemporary events,

although these cannot completely explain the contrast with the newer and more open forms appearing in towns like Siena which were no less prone to internal warfare. Villani's discussion of the new palace is interesting evidence of the strength of the general desire for regularity of form wherever it could be achieved. He attributed the trapezoidal plan to the wish to avoid building on land once owned by the hated Ghibelline exiles, and saw it as a major imperfection in a building which 'should have been given a square or rectangular shape'.[1] Nevertheless, the slight sharpening of the main angle increases the rock-like, jutting quality of a building already notable for size and grandeur of conception. The sense of volume is accentuated both by the texturing of its finely proportioned rustication and by the heavy overhang of the machicolated upper fortifications. Although it is only in the principal *bifore*, which with their voussoirs set the pattern for innumerable subsequent Central Italian buildings, that regularity is approached and, on the short side, actually achieved, there is a feeling of architectural discipline and control throughout. Clear definition and progressive diminution in the height of the three storeys and the regularity of the fortified upper gallery contribute to the final effect. The only element of architectural adventure is the partial seating of the campanile on the overhang of the machicolations. It is, however, not merely in the tower itself, with its characteristic combination of strength and lightness, but in the precision of its asymmetrical siting and in the relation of its own subtly balanced proportions to those of the main block below, that the secret of the visual quality of the whole resides.[2]

The Sala d'Armi on the ground floor provides the main internal evidence of the quality

136. Florence, Palazzo Vecchio, founded 1299,
and Loggia della Signoria,
construction supervised by Benci di Cione
and Simone Talenti, 1376–c. 1381

of the greatly enlarged and thoroughly trans-
formed original structure [137]. There is a
subtle blend of masculinity and grace in the six
bays of the vaulting, which are supported by
round arches resting on pilasters and upon two
central, free-standing, octagonal columns. The
sturdiness and severity of form do not disguise
close kinship with the crispness and simplicity

of detail, the precision in the use of sharply defined planar forms, that are fundamental to Arnolfo's sculpture and architecture. His influence seems undeniable, although the late tradition of his personal responsibility cannot be confirmed. The general Tuscan predilection for such forms is underlined by the severe, planar, and prismatic details of the courtyards of the public and private palaces of Siena.

137. Florence, Palazzo Vecchio, founded 1299, Sala d'Armi

massive fortifications.[3] Surrounded by a moat, they were some five miles in circumference. The walls were nearly six feet thick and forty high and boasted fifteen gates and seventy-two towers. Even the surviving section on the Oltrarno would hardly be enough to make the enterprise imaginable if such gigantic expenditures of civic energy were not a commonplace in the Late Middle Ages.

It is in size and situation, rather than in external style, that the Palazzo Vecchio differs from the private palaces and minor public

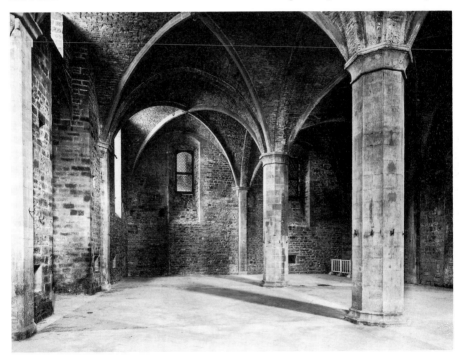

The creation of the Palazzo Vecchio was as deeply rooted in internal faction as in civic pride. It was external danger, first from the emperor Henry VII, and a decade later from Castruccio Castracane, that led to the completion of the third circle of the city walls between 1310 and 1328. Villani, who was in charge of operations, vividly describes these

buildings such as the Palazzo dell'Arte della Lana. The possible extent of such constructions is shown by the Palazzo Spini-Ferroni, but both in quality and state of preservation the Palazzo Davanzati, which was probably built towards the middle of the century, is perhaps the most impressive of these buildings [138]. The façade, topped by a loggia that evidently replaces the

138. Florence, Palazzo Davanzati,
mid fourteenth century(?)

facing of the first floor and the rough infilling of the upper levels. A small and seemingly crowded cortile, its arched loggia resting on octagonal columns with richly carved capitals, and its busy stairway bouncing and leaping upwards on a variously supported series of segmental arches, serves as a prelude to the internal richness that is seemingly belied by the austere façade. Each floor has a main room running the whole width of the building, together with other smaller, but none the less imposing, chambers. The survival of their handsomely carved and painted wooden ceilings, and of fourteenth- and fifteenth-century fresco decorations that include illusionistic brackets of the kind that earlier decorated the ribbing of the vaults in churches such as S. Francesco at Assisi, hints at the past splendours of Florentine city life.[4] The running of a well-shaft through the main rooms of the house from top to bottom and the provision of lavatories on every floor reflect the standards of comfort and convenience maintained by the rising commercial classes, not merely in the general disposition of their houses, but in every aspect of domestic architecture.

THE CAMPANILE OF THE DUOMO
AND ORSANMICHELE IN FLORENCE

The only surviving purely ecclesiastical monument of major importance, dating from this period of continuous civil expansion, is the campanile of the Duomo [139]. Designed by Giotto and founded in 1334, it seems that only the first storey of the socle was completed by his death in 1337. Andrea Pisano was probably responsible for the doubling of the base and the continuation of the work, with only minor modifications in the Giottesque sobriety of form, as far as the second main cornice.[5] The upper storeys were then completed by Francesco Talenti during the fifties. The general form of Giotto's project is probably reflected in a Sienese drawing in the Museo dell'Opera at Siena [140]. The resemblances to the lower parts of the existing structure are extremely

original castellation, is notable for its severity, its absolute regularity, and its harmony of form. Three wide arches, leading into a cross-vaulted loggia, mark the ground floor. There are five exactly similar windows in each of the three upper storeys. Firm demarcation of succeeding levels is provided, not only by the cornices that form the bases for the windows, but by the fine gradation of the stonework from the smooth rustication of the ground floor to the squared

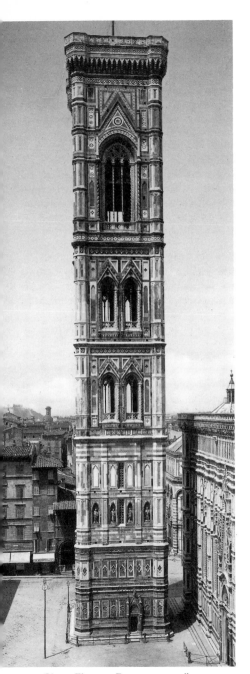

139. Giotto: Florence, Duomo, campanile,
founded 1334

140. Drawing for the campanile
of the Duomo at Florence, early 1330s(?).
Siena, Museo dell'Opera del Duomo

close. A fundamentally Arnolfan style of incrustation is developed in a highly painterly way in the linear, decorative elements of the lower half of the drawing. As the basic, square design is repeated storey by storey, the architectural features of the Gothic windows slowly take command and the structural and decorative patterns are substantially equated. The octagon, in its relationship of spire to gables, and in its slender forms, with its eight equal windows and its four tall pinnacles set on the diagonal to ease the transition from the square, while generally recalling the achievements of the Sienese goldsmiths, is extremely close in principle to the more or less contemporary tower of the Münster in Freiburg im Breisgau.[6] The drawn design is otherwise far more planar and less fussy than the executed building. The gradual multiplication of the window openings, which steadily increases the emphasis on the vertical elements in the drawing, is thoroughly traditional. On the other hand the steady development in decorative complexity and the gradual increase in the weight and richness of succeeding cornices are anything but usual. The outcome is a steady crescendo of architectural interest in which the lace-like octagon and spire are the climax to which every element in the carefully graded unity of the design makes its preparatory contribution.

Opinions have always differed, and will probably continue to differ, as to the external architectural merits of the campanile as it stands, but no one with an eye for spatial structure or a feel for architectural engineering can fail to be excited by the journey up through the interior of this as of so many similar Italian towers.

Although surviving ecclesiastical projects are few, there is abundant architectural evidence of the continued interpenetration of civil and religious life. There are obvious links between the logge of the larger palace courtyards, such as that of the Bargello, begun in the late thirteenth century, and the traditions of the cloister. The ecclesiastical ties of the two massive vaults, ballooning over the wide spaces of the Salone del Consiglio Generale, built by Neri di Fioravante some ten years after the fire of 1332 had destroyed the Bargello's upper storeys, are no less evident. The volumetric grandeur of the space that he created (at a later date four storeys were inserted for a time) is a far cry from the scale of the original rooms. Just like the ever-expanding outlines of the great cathedrals, and like those of the mendicant churches of Tuscany, it reflects a hundred years of constantly increasing architectural confidence and ambition.

The close bonds which continued to unite so much of civil and religious life are not confined to the realm of architectural form. They are enshrined in the very history of Orsanmichele. In 1285 the original small church, destroyed in 1239, was replaced by an open hall for selling corn. The latter became a place of pilgrimage when, in 1292, a painting of the Virgin started to work miracles and gave rise to a confraternity of Laudesi. The hall was burnt in 1304 and partially but insecurely rebuilt in 1307–8. In 1337, a new loggia was founded. This was completed after twenty years, and it was only in the sixties and seventies that the corn market was finally closed in to become a church. Even then the upper storeys, added at the end of this same period, were destined for grain storage.

Despite a wide-ranging network of stylistic linkages and the mention of many names in later documents, the original designer of the loggia, with its two central piers and its six bays of vaulting resting on round arches, is unknown [141]. Internally and externally its original elements testify that the development of fourteenth-century Florentine architecture depends as much on the refinement of the Romanesque vocabulary of form as on the evolution of a specifically Gothic idiom. The retention of the simplest rectangular and polygonal arch and rib sections, and the classicism of the almost square central piers and of the twin rows of acanthus foliage in their capitals, are of untold significance for the architecture of the second half of the century. Of more immediate interest is the attitude to architectural decoration revealed

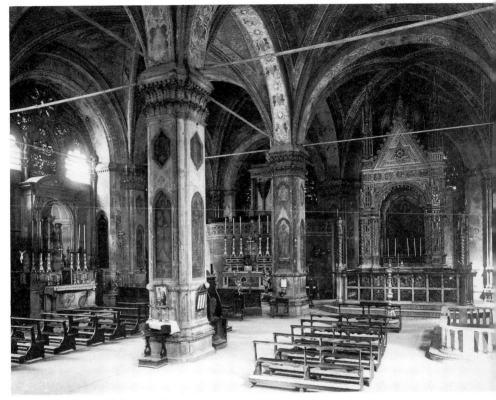

141. Florence, Orsanmichele, founded 1337

by the planned sequence running from the deep external niches, intended from the first for sculpture in the round, through the shallow framed recesses set into the surfaces of all internal piers and pilasters, to the Giottesque pierced lozenges of the painted decoration on the soffits of the arches. The middle term is particularly significant. Its hexagonal upper elements are directly related to the socle decoration of Giotto's campanile [139 and 140]. Its principal, lower panels only needed to be painted to become the apparently fully three-dimensional niches of the saints. The impact of the recent revolution in the visual arts was such that the architectural forms no longer merely passively facilitated subsequent painting: they actively demanded it. In so doing they provided a semi-three-dimensional transition from the volumetric world of the sculptor and the architect to the pure illusion of three-dimensionality which was by now an important aspect of the painted decoration that completed such buildings. In the late thirteenth century the genius of the Pisani led to the creation of a sculptor's architecture. Now the creative dominance of the painters was encouraging a move towards an architecture in which the unity of all the arts was asserted from the first and was not merely arrived at by a process of accretion. The present, fully-enclosed church scarcely hints at the range of sensation which must once have been experienced in moving from the sunny

street into the half lights, the deep shadows, and rich colours of a loggia which was both a market and a place of pilgrimage. In this one building the extreme commercial and religious poles of early-fourteenth-century Florentine life were brought together and the full range of the major arts explored.

PISA, PRATO, PISTOIA, AND LUCCA

The Florentine conservatism which creates a sense of continuity in a time of revolutionary change is very different from that of a city such as Pisa, now far past the turning-point towards continuous decline. There, work was continuing on the thirteenth-century Dominican and Franciscan churches of S. Caterina and S. Francesco which, between them, are a textbook of the simple subtleties that make or mar such buildings. In the first, the nave seems to be too high and the chapel openings too squat for mutual harmony, and the wide arches of the four flanking chapels are unhappily related to the central opening. The arches that surmount the transepts seem to strike uncomfortably upon the outer curves of those that flank the choir. Even the two vaulted bays that have been opened in the right wall of the nave, fine though they are, detract from the bare grandeur of the main space, yet establish no new spatial concept. Indeed, the massive columns of the added space diminish the importance of the choir. In S. Francesco, on the other hand, the relationship of nave and chapel arches is impressive, and the vastness and simplicity of the nave itself is capped by the high and airy spaciousness of the transepts. Moreover, the width of entrance and small depth of the transept chapels give the altars a feeling of openness and nearness that immediately expresses the ideals of the Franciscan order.

The oratory of S. Maria della Spina presents a total contrast both in scale and style [142]. It was probably an open loggia before its enlargement after 1323.[7] At first glance it apparently depends for its effect upon the interaction of extreme simplicity of basic form and extreme

complexity of decorative overlay. The depressed Pisan arches, the coloured marbling, and the pitched wooden roof are traditional. The surface richness is provided by a forest of pinnacles and crockets, of tabernacles piled on tabernacles or balancing upon the points of gables; corbelled out over the void or run together into an arcading. This then becomes a habitat for a wealth of sculpture by Giovanni Pisano's immediate circle and close following.[8] The size is small enough for the audacities of the metalworker to survive in stone on what might seem to be no more than a reliquary upon an architectural scale. In spite of this, it is by no means goldsmith's or even sculptor's architecture. The figures no longer wander freely through an architectural landscape: they are instead confined, in the French manner, by their architectural surroundings. This does not merely reflect the increasingly Gothic quality of early-fourteenth-century Italian architecture or the flickering of Giovanni's dramatic fire, now visible only in the tendency of all twelve figures in the main arcade to look towards the centre. For all its small scale, this is architect's architecture. Its complexities, which are fundamental and not merely superficial, are introduced by the three overlapping gables of the façade. Most Italian façades are designed to enlarge the apparent scale of the building behind them, which is therefore, if anything, an anticlimax. Here, both in the façade, in which the triple gables are seated far below the actual roof-line, and in the analogous treatment of the right flank, much is done to make the building seem much smaller, much more like a jewelled casket, than its actual dimensions warrant. As a result the plain interior has an unexpected spaciousness.

The façade itself is notable for its complexities of line and plane. Its forms express the relationship between the twin doors into, and the single roof above, the unified interior. They also reflect the triple vaults and entrance arches that articulate the sanctuary within. Externally this triple rhythm is immediately reiterated in the fantasy of the three polygonal pyramids in

142. Pisa, S. Maria della Spina, enlarged after 1323

their framework of single lateral and triple end-gables. It is, however, only when such things as the four-five rhythm of the lower lateral arcade and upper tabernacles, and the three-five of the middle zone of niches, have been noticed that the full significance of the façade, both as a key and a summation, can be seen. Its central focus is the tabernacle of the Virgin and

Child, framed by the five supporting taber-nacles. In the interlocking, one-two, two-three, three-four-five-six rhythms of its major elements, in its proportional relationships and its stylistic harmonies and contrasts, it acts as a template for the whole.[9]

There is sophistication of a different kind in the choir and transepts added to the old nave

of the Duomo at Prato from 1317 onwards.[10] As at Massa Marittima thirty years before, there is a marked attempt to harmonize old and new. The added parts have a coherent structural logic. The existing spatial continuity is maintained and an impressive vertical acceleration is created as the raised floor and the rising sweep of the pointed arches act together. The vaulting of the transepts and of the bay before the crossing, as well as of the flanking chapels, creates an impression of articulated unity. The only element of discomfort lies in the detailed structural adjustments that are needed as the pattern of the nave, with its striped stone, its smooth columns and round arches, is first modified and then transformed.

A rather cold elegance characterizes the outside of the baptistery at Pistoia which Cellino di Nese was commissioned to complete in 1338. Here a Florentine octagon and dome has been given greater verticality and lightness, while the marbling and the upper blind arcade have clear connexions with the Duomo at Siena. Nothing, however, gives a hint of the vertiginous pure volume of an interior in which a great, unmodified expanse of richly textured warm red brick, interrupted only by a single modest cornice, sweeps into the dome. The continuation of thirteenth-century traditions is as clear, or clearer, in the Palazzo del Comune at Pistoia,[11] enlarged in 1348–53 by Michele di Ser Memmo da Siena, also active as a sculptor and goldsmith, as well as in the opposing mass of the Palazzo del Podestà of 1367.

The stylistic conservatism of Tuscan private architecture outside the few great centres of expansion is well illustrated by the persistence of the thirteenth-century Pisan system of tall relieving arches with stone or brick infillings. This method, seen in the Palazzo Mediceo in Pisa, which has pointed arches running up the full three storeys of its façade, lightens the walls, and by concentrating the vertical stresses facilitates the use of piles in the foundations. The Lucchese variant with separate arches for each storey also retained its popularity and reached its apogee in the fourteenth-century complex of the houses of the Guinigi in Lucca. In this magnificent and rare reminder of the great clan concentrations which dominated and bedevilled life in the Tuscan towns, the brick construction creates a unified wall. The regular repetition of the round relieving arches over the wide Gothic *quadrifore* none the less creates a visual effect that is still redolent of the parent system.

ANGELO DA ORVIETO AND

THE BUILDINGS OF GUBBIO AND OF UMBRIA

THE PALAZZO DEI CONSOLI
AND PALAZZO DEL PRETORIO AT GUBBIO

The Umbrian town of Gubbio is a stone cascade upon the lower slopes of Monte Ingino. Whereas in Siena the Palazzo Pubblico closes in the lower boundary of the main Piazza [127], hiding the drop beyond, so that the inward-looking main façade gives no hint of the tall sub-structures upon which it stands, in Gubbio the fact that the Palazzo dei Consoli [143], the Palazzo del Pretorio, and a large part of the Piazza della Signoria are a single vast construction built out from the hillside is the dominant feature of a great design [144, A and B]. It is a piece of engineering on a Roman scale and is among the most remarkable single feats of civic planning in the history of medieval Italy.

The project was already under discussion in 1322 and building may have been started soon afterwards. The still unfinished palace was inaugurated on 21 April 1338, the anniversary of the foundation of Rome, which had two senators from Gubbio at the time. The consuls actually took up residence in 1346, and in 1349–56 the aqueduct leading water to the upper chamber was completed. Although the matter is highly controversial, it is likely on stylistic grounds that Angelo da Orvieto, the author of 'this work', begun in 1332, and of 'this arch', finished in 1337, according to the inscription over the main door, was responsible for the entire scheme, as well as for the whole of the Palazzo dei Consoli.[1]

Angelo da Orvieto is first mentioned in 1317, working on a fountain in Perugia with Lorenzo Maitani, who was the capomaestro of Orvieto Cathedral.[2] The Orvietan parentage of the Palazzo dei Consoli appears not only in such details as the cornice that surmounts and links the upper windows but in the fundamentals of construction. The whole first floor is taken up by a single barrel-vaulted hall, for which there are good Orvietan precedents. The hall itself rests on a series of transverse barrel-vaults in the manner of the Palazzo del Capitano at Orvieto [30]. Each of its long walls is articulated by three blind, round-headed relieving arches, their seating corresponding to the external buttressing. The windows are eccentrically set within this system, although the relative displacement is reduced to a minimum on the main façade.[3] The latter is the only part of the building in which strict overall symmetry is even approached.

The structure on the valley side of the main body was probably added at a very early date in order to provide a minimum of subsidiary chambers, notable for their continuation of the play of vaulting characteristic of the main structure.[4] In the lower room a barrel joins two cross-vaults, and there are four transverse corbelled barrel-vaults in the upper. At the top, a loggia with a lean-to wooden roof provides one of the best-exploited panoramic views in Umbria.

The entrance stairway of the palace, with its intersecting, flat segmental arches, sees the traditions of Umbria and Lazio at their finest [145].[5] The aerial linkage of the semicircular first flight to the rectangular, arch-supported balcony is a triumphant solution to the technical problem involved in providing a ceremonial entry to the main hall without impeding access to the two lower central chambers. The forms are such that the stairway seems to gather in the free space of the wide piazza and channel it to the arched doorway. In doing so it softens the impact of the flat, calcareous cliff of the

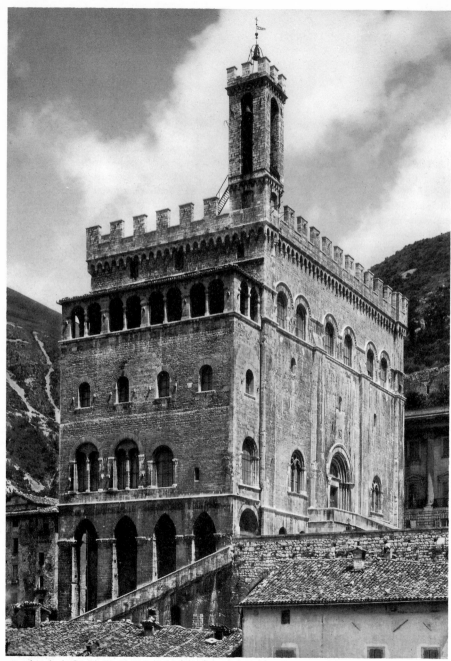

143. Angelo da Orvieto(?): Gubbio, Palazzo dei Consoli, begun after 1322

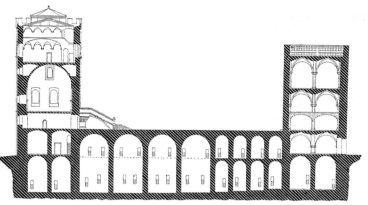

144. (A) Gubbio, Palazzo dei Consoli, begun after 1322,
and Palazzo Pretorio, begun 1349, with intervening substructures;
(B) Gubbio, Piazza della Signoria

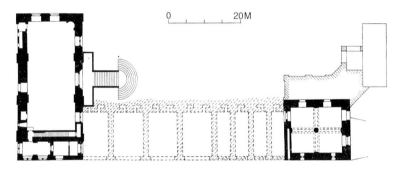

145. Angelo da Orvieto(?): Gubbio, Palazzo dei Consoli, begun after 1322, detail of steps

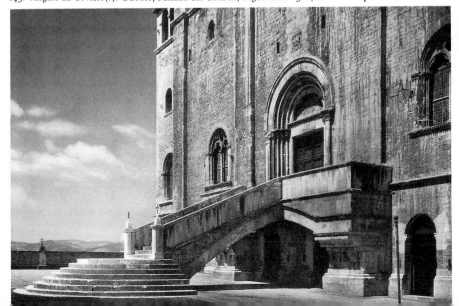

façade and gives it volume. The single complex movement that fulfils so many functions is an ideal prelude to the austere, barrel-vaulted council chamber. In grace and majesty of architectural form, as in its fitness to the widest range of ceremonial function and procession, it is unsurpassed.

The interior of the unfinished Palazzo Pretorio, begun in 1349, is no less interesting. The existing three-storey building is almost square in plan. The height of the second storey is such that a further floor could be inserted at a later date, and a single central octagonal column runs from top to bottom of the building. Three times it branches out into the simple rectangular and near-rectangular ribs of the cross-vaults that divide the ceilings of each room into four smaller squares.[6] Despite the use of banded stone, there is again a minimum of sculptural and decorative detail. As everywhere throughout the complex, it is in the architectural conception as such and in the structural engineering of its execution that Angelo da Orvieto's genius is expressed.

The adventurous design of the existing fragment is an indication of the internal loss involved in the failure to complete the Palazzo Pretorio. Externally, existing traces show that its main front should have extended as far as the first of the four enormous open vaults of the substructure. The latter, though only completed in 1481, indicate the outlines of the original scheme. Although no wider, the completed Palazzo Pretorio would have been twice as long as at present and somewhat higher. It would have divided the Piazza della Signoria into a major and minor square, and from the town below its broader, slightly lower form would have provided a dynamic counterweight for the narrower vertical of the Palazzo dei Consoli. The detailing of the surviving windows confirms the sensitivity of the free relationship which was to have united the two buildings. It is only a partial compensation that the still-open vaults beneath add greatly to the play of light and shade as well as to the change of scale and the variety of arch-form in the unfinished whole.

Although the precise function of the internal organization of the barrel-vaulted substructures of the Piazza is now uncertain, there is no doubt whatsoever about the architectural ingenuity of those parts that must have been completed before the Palazzo Pretorio was begun. Some twenty-seven built-in lavatories survive and, like the lavatories and slotted urinals of the Palazzo dei Consoli, they were cleaned by flushing rainwater through channels built in the thickness of the wall. Such sophisticated sanitary engineering is unusual even in an age more notable for such achievements than is usually realized. For a similar though differently intentioned ingenuity in the collection and control of water within the structure of a building, it is necessary to go back a century to the Castel del Monte of Frederick II.

The ramp that leads up under the tall, pointed arches, recalling those at the base of the Palazzo Pubblico at Siena, is another unfinished element [143]. Its completion would have added a sweeping diagonal to the general rectilinear design. Nevertheless, despite the blurring of the intended spatial, volumetric, and proportional relationships, the finished and unfinished parts provide a unique record of the breadth of vision and the unity of purpose with which civic planning could be approached in the early fourteenth century.

The scale of the existing achievement can be measured by comparison with the earlier buildings of Gubbio itself. The small thirteenth-century Palazzo del Bargello, with its pleasant, irregularly shaped main room, its plain dressed-stone exterior, its simple cornices, its gently pointed and virtually unadorned openings, irregularly placed except for the windows of the main, first floor, is similar in almost all respects to the many thirteenth- and fourteenth-century private palaces and smaller houses that survive in the Via Baldassini and elsewhere. The occasional combination of door and window in a single opening, which is also found in Perugia, goes back to the shopfronts of Antiquity. The so-called 'doors of the dead', placed high up in the wall, are merely

doorways that have lost the movable wooden steps or ladders that were the first line of defence not only here but in innumerable fortified town towers. Although their influence is clear in certain constructional details, the many features which distinguish such houses from the buildings attributed to Angelo da Orvieto increase rather than decrease the likelihood that the civic centre was designed by an architect from outside Gubbio.

THE PALAZZO COMUNALE
IN CITTÀ DI CASTELLO

The only other building with which Angelo da Orvieto can certainly be connected is the Palazzo Comunale in Città di Castello. The inscription on the main door refers to him as 'architector' and couples his name with those of Baldo di Marco and Bartolomeo di Gano,

who are described as 'superstite'. The date is made uncertain by the perishing of the first line of the verse. The favoured nineteenth-century reading was 1322, but attributions vary from 1312 to 1352. What is certain is that the outside of the palace [146], of which only the ground and the greater part of the first floors were ever built, is directly developed from that of the Palazzo Vecchio in Florence [136]. The forms of the Gothic *bifore* and of their voussoirs are extremely closely related, although the main arches of all the doors and windows of the Palazzo Comunale are much the more sharply pointed. Although pointed forms were fully acclimatized in the civil and ecclesiastical architecture of Gubbio long before the building of the Palazzo dei Consoli, they were never used at all in its main body. The rounded forms of Orvietan civil architecture were evidently preferred. Assuming that the Palazzo Comunale

146. Angelo da Orvieto: Città di Castello, Palazzo Comunale, mid fourteenth century(?)

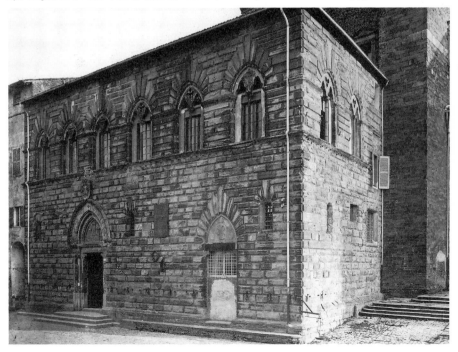

is indeed Angelo da Orvieto's work, it seems that it should be dated after the Palazzo dei Consoli and either just before or just after the Palazzo Pretorio. The more subdued external forms of the latter would then be explained by their incorporation in an overall design established at an earlier date.

The main feature of the façade of the Palazzo Comunale is the interplay between the symmetrical first-floor windows, the virtually symmetrical minor openings below, and the offset and unevenly sized pair of doors [146]. The regular, embossed pattern of the weathered, grey-beige, sedimentary stone is a polished variant of the Florentine rustication. It creates the impression of a greater symmetry and regularity than the building actually possesses. In combination with the simple block-form of

147. Angelo da Orvieto: Città di Castello,
Palazzo Comunale, mid fourteenth century(?)

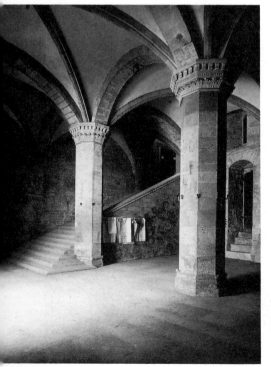

the whole, it presages the fifteenth-century Florentine Renaissance palaces.[7]

The main internal interest lies in the interaction between the almost glacial flow of a broad stairway of shallow, sloping, stone-faced brick flights and the low, vaulted entrance chamber with its round-arched ribs and two octagonal columns [147]. The vault itself creates a framing arch immediately before the stair turns to the right and disappears towards the upper room. This cunning solution of a difficult problem has a curious effect when one is walking up the stairs, since it accentuates both the lowness of the chamber and the great weight of its vaulting. On the other hand, the downwards view from the landing is extraordinarily effective. The broad flow of the steps, the bold diagonal shaft of the simple balustrade, the variously lit facets of the massive polygonal columns, the complex interplay of shapes in vaults which, being only partly visible, become impressive rather than oppressive in their weight, combine into a memorable vision.

THE CHURCHES OF GUBBIO

The prosperity and growth in population which had such dramatic consequences for the civil architecture of Gubbio are also reflected in its churches. The outcome is a group of buildings that are closely related among themselves and yet belong to a type which has its regional variants throughout Italy. Their main features are the diaphragm arches used to support a wooden roof in the manner already familiar in late-thirteenth-century civil architecture.[8] The local stylistic source lies in the tiny early-thirteenth-century Romanesque church of S. Donato. In this simple rectangle, measuring some $5\frac{1}{2}$ by $13\frac{1}{2}$ yards, two plain arches of rectangular section provide a practical solution to the structural problem in a way that hardly gives rise to considerations of aesthetic purpose. Despite a certain amount of very simple carving and the addition of a cross-vaulted, rectangular choir, the situation is hardly more complicated in the modest late-thirteenth-century church of

S. Giovanni Battista. Here four simple, pointed arches, corbelled on twin colonnettes, have been so widely spaced as not to give rise to a ribbed effect. The notable feature in what is virtually a plain, rectangular hall is the careful way in which the entrance to the choir reflects the proportions of the diaphragm arches.

There is a similar concern for simple relationships in S. Agostino, which, though consecrated in 1294, was still unfinished over half a century later. Originally the seven, pointed diaphragm arches that lead to the rectangular choir appear to have been corbelled from the walls, but an earthquake seems to have necessitated a reduction in the lateral thrusts externally absorbed by a series of semi-cylindrical buttresses analogous to the more robust forms seen in S. Francesco at Assisi.

The potential of the diaphragm arch is fully exploited in the Duomo, consecrated in 1366 [148]. In spite of some controversy, it seems as it now stands to be a wholly fourteenth-century building. The virtual engulfing of the left flank by the hillside probably explains the placing of the bell tower immediately above the choir. The side walls are buttressed by deeply recessed, round-headed blind arcading. This recalls such thirteenth-century South French churches as those of the Jacobins and the Cordeliers (destroyed) at Toulouse and their Carmelite and Augustinian successors, rather than the Romanesque cathedrals of Apulia. It is in thirteenth-century Catalonia and southern France, moreover, that the internal diaphragm arch attained its greatest popularity. At Gubbio there is a swift succession of ten such pointed

148. Gubbio, Duomo, consecrated 1366

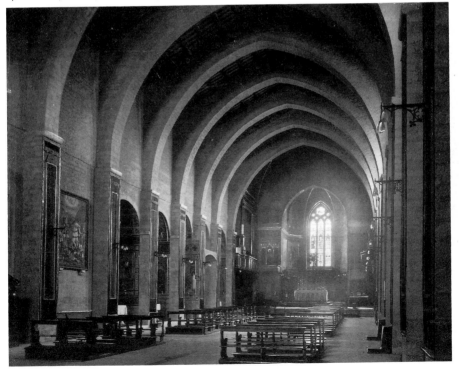

arches running virtually uninterrupted to the ground. Their plain, rectangular forms are unembellished but for simple mouldings acting as vestigial capitals. Except that all the forms are crisp and regular, sharp-edged and planar in a manner only possible in stone, the effect is reminiscent of an upturned boat. There are no windows in the left wall and those on the right are few and small, so that the large choir-window is the main source for the cool, calm lighting of the nave. The modern glass and tracery of this window and the atrocious frescoes in the choir accentuate the architectural failings of this eastern end. The wide arches of the nave and of the chancel entry are such a contrast to the steeply pointed window that the latter seems an intrusive rather than a variant form. Since every other volume in the building, from the five chapels let into the thickness of the left wall to the arches of the nave and the very roof beams, is rectangular in section, much the same is true of the curved ending of the choir. The greater effectiveness of a rectangular, or at least a planar, if polygonal, ending is shown by the churches of S. Agostino in Gubbio itself and in Massa Marittima.[9] The latter was largely carried out between 1299 and 1312, except that the polygonal choir chapel, dependent on that of the Duomo, was added in 1348. The rustic mass and grandeur, the sheer peasant weight, of the six arches of the nave reiterate that beauty and sophistication are not necessarily synonymous.

Two of the most interesting churches of this type to have survived elsewhere in Umbria are S. Francesco in Piediluco, inscribed in 1339 as being built by Petrus Damiani of Assisi, and S. Francesco in S. Gemini. In both cases plain, pointed masonry arches spring from high up on the walls, and at S. Gemini the relationship between the swift succession of the ribs of the nave and the arch and vault forms of the five-sided apse is particularly happy.

PERUGIA

The outside of the centralized S. Ercolano in Perugia, built between 1298 and *c.* 1326, when Ambrogio Maitani, Lorenzo's brother, was working on it, is closely related to the churches of Gubbio and their French forerunners by the tall, pointed blind arcading that enfolds and buttresses the octagon. Even if Angelo da Orvieto was not in fact the M. Angelo who supervised the early stages of construction, the family relationship between its doorway and that of the Palazzo dei Consoli at Gubbio is clear. On the other hand the original rib-vault of the interior recalls the Tuscan baptisteries.

The enormous pile of S. Domenico at Perugia seems to be a direct continuation of the thirteenth-century mendicant tradition. It is historically important as its interior originally appears to have been a vaulted hall with nave and aisles of almost equal height.[10] It was therefore heir to the same distinctive late-thirteenth-century Umbrian experiments in hall-church design that find a simpler outcome in S. Maria di Monteluce. The red and white marble squaring of the new façade of S. Giuliana, also in Perugia, is no less typical of local traditions. Indeed, it is the quiet continuation of the practices of earlier centuries, not only in innumerable minor churches, but in the mass of private houses and small palaces, that provides the base for experiment and innovation.

PIEDMONT, LOMBARDY, AND EMILIA

The first half of the fourteenth century is a time of relative architectural quiescence throughout the North Italian plain. Except in isolated instances, it is only in the Veneto, on its north-eastern fringes, that the fires of creativity seem to have more than smouldered. Even the surviving evidence of the constant activity of the mendicant orders, much of which was subsequently destroyed or overlaid, points rather to continuation in a minor key than to adventure into new forms of expression. Outside the ambit of the mendicants there is an inescapable feeling that the great creative period of the late twelfth and early thirteenth centuries, which saw the flooding of Cistercian Gothic forms into a wide, west-central area and the creation of such masterpieces as S. Andrea at Vercelli or the baptistery at Parma, is long past. The dying upsurge of Late Gothic vigour at the very moment when Renaissance forms are sweeping Tuscany is yet to come. In the area as a whole there was no economic revolution, no development of industry or capital to compare with that in Tuscany and its Umbrian border towns. In politics it is the moment of ebb-tide, at least as far as social consequences are concerned. The vigour of the communes in their struggle for freedom from imperial control was largely dissipated by the bitter feuds and the ensuing disillusion of disorganized liberty. The tide of the new local despotisms was still gathering, and power was still too newly gained or insecurely held to have, as yet, resulted in the ostentatious splendours of established tyranny.

One of the few important civic survivals of the period is the carefully restored Loggia degli Osii in Milan, begun in 1316 by a certain Scoto da S. Gimignano for Matteo Visconti, the Capitano del Popolo. The resulting combination of Tuscan and Lombard elements is notable for the airiness and grace of the two storeys of wide arches that reduce the wall to a mere framework. It is only in the uppermost storey, in which Lombard blind arcading is developed into Romanesque *trifore* and statuary niches, that a rather curious proportional relationship with the lower storeys and an abrupt change of scale and rhythm in the openings betray its hybrid origins in a less successful manner.

THE CATHEDRAL AT ASTI AND S. FRANCESCO IN PIACENZA

The renovation of the cathedral at Asti in the eastern borderland of Piedmont, south-west of Milan, begun in 1309, was followed by complete collapse in 1323, and the existing main body was probably up by about 1348, the year of the death of Bishop Arnoldo de la Rosette, whose arms appear on the dome.[1] The height and slimness of the windows, which once ran in an unbroken sweep almost from ground to roof, are the only hint that an undistinguished outer shell enfolds a lonely masterpiece [149]. Even a seventeenth- and eighteenth-century fresco decoration of the most carefree inappropriateness and marvellous completeness cannot hide the quality of the interior. Clustered brick columns with base-mouldings made vestigial by the raising of the floor appear to grow out of the ground and soar into the vaults, which were originally articulated by plain ribs. The height of the aisles is such that there are no clerestory windows, and the great, up-sweeping lancets are the only source of light. Five bays precede the octagonal crossing and three more lead on to the five-sided apse, which is repeated on a smaller scale at either end of the tall transepts. The outcome is a longitudinal balance of a similar order to that linking nave and aisles. A feeling of free-running continuity, enlivened by articulating pauses, embraces all three spatial

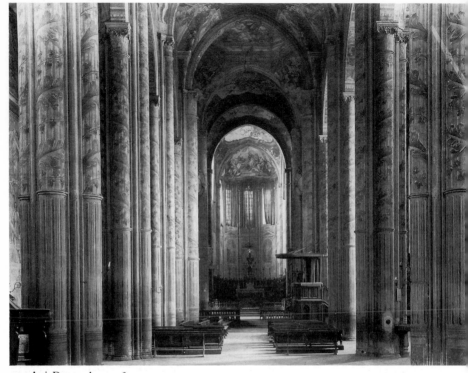

149. Asti, Duomo, begun after 1323

axes of the building. In plan, and in internal and external treatment, the close and sometimes scarcely modified connexions with the Lombard and Emilian Romanesque are obvious. The fundamental classicism of the detail, the calm treatment of the original vaulting and the fullness of the rounded forms necessitated by the brick construction, also reflect its geographical location. At the same time a community of outlook unites it with contemporary northern Gothic masterpieces such as those at Esslingen and Erfurt. They too are dependent upon the sensitive exploitation of simplicity.

In the case of the brick church of S. Francesco in Piacenza, begun in 1278 and largely built during the fourteenth century, the derivation is from the earlier Gothic of S. Francesco in Bologna. Massive drums replace polygonal columns, and the transepts are now the same height as the nave. The proportional relationships of wall and void are altered in the choir, and the polygonal chapels now no longer radiate beyond the ambulatory but are set on the same axis as the nave. Finally, the campanile is an integral element of the main body of the church. Such changes give distinctive character to a building that is none the less a set of variations finely played upon a given theme.

THE FAÇADES AND TOWERS
OF CREMONA, CREMA, AND MILAN

It is in architectural elements like façades and towers that the innate conservatism and ambition of Lombardy unite with the most extraordinary results. The simple, gabled

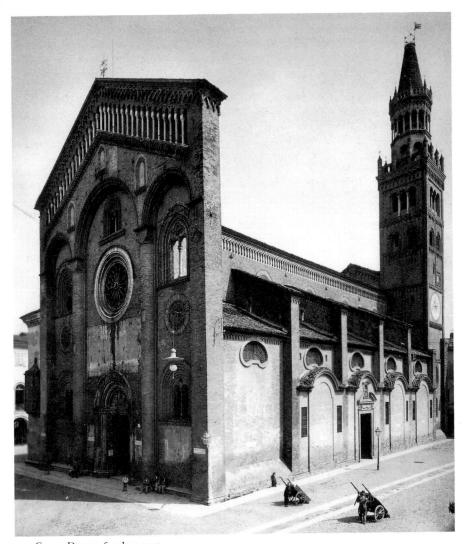

150. Crema, Duomo, façade, *c.* 1341

screen façade was already well established in the twelfth century. The flatness; the well-defined tripartite vertical divisions; the blind arcading following the line of the gable-top; the openings peppered into a blank face of wall, and the relative independence of the main body of the church, are all exemplified in the soft stone façade of S. Michele or the brick of S. Teodoro, both of them in Pavia. The façades that were added to the north and south transepts of the Duomo at Cremona in the late thirteenth and the mid fourteenth centuries reveal no change in principle. The height and narrowness of the new transepts are reflected in a change from a

horizontally to a vertically accented basic form. Turrets at the ends and centre of the gable carry on the upward movement. The latter is, however, somewhat softened, as in the Duomo and in S. Francesco at near-by Piacenza, by tapering away the inner buttresses before the now unbroken upper arcading is reached. The separation of the screen from the building is more extreme than ever. Even where the windows are not actually dummies, looking out upon the void, they are not, for the most part, used to light the interior.

A more modest and even more old-fashioned but more compactly designed variant of this pattern, without the upper arcading, occurs in the Badia at Viboldone and is dated 1348. Here the openings of doors and windows form a continuous circle round the main rose and create an interesting counter-rhythm within the simple, rectilinear framework. The façade of the Duomo at Crema (1284–c. 1341) is, however, the most striking of these near-mid-century examples [150]. Here the central buttresses take the form of columns and the verticals are linked by arches in a manner that develops ideas nascent in the Duomo at Casale Monferrato in Piedmont, c. 1200. The sense of light and shade and movement is thereby increased. There is greater compactness and control in the general design, and the haphazard effect of the odd relationships of size and shape and placement of the windows of most of these façades is much reduced. The façade as a whole makes an unusually well-calculated contribution to the total effect of a building in which it is balanced by a campanile which is part of the main body and represents a more modest version of the tower at Cremona.[2]

The celebrated Torazzo at Cremona is only one of the scores of spectacular bell towers that are among the most singular features of the Italian scene.[3] Its effect depends not only on its size but on the contrast between the simple rectangular thirteenth-century main body, with its relatively small, infrequent openings, and the wide-arched complexities of the octagonal upper storeys added about the turn of the century. Nevertheless, it cannot compete in elegance with the octagonal tower of S. Gottardo in Milan [151]. This tower, which is likewise set on a rectangular stone base, was inscribed by Fra Pecorari in 1336. There is great decorative sophistication in the enormously elongated and substantially free-standing angle columns· that run the full height of the main drum. All vestiges of structural function are denied by their corbelled bases. There is further evidence of sophistication in the proportions of the whole and in the severe control of details and of colour contrasts that could easily grow fussy but in fact do not. There is even greater fantasy in the treatment of the main arcade, in which an outer garland of columns stands on beams that jut out from an inner ring. A highly complex play of planes results, since the outer angle columns are also terminated at this level. The inner octagon is visible within three separate outer shells, each demarcated by their own columniation. This drum then rises to support the double columns of the open upper chamber, and a further simple cylinder supports the roof-cone. The final touch is provided by the way in which the lower windows spiral up the octagon to meet the circling upper openings. The clarity and detailed quality of the design, its elegance and gravity, for all the architectural wit that it displays, are underlined by an architectural joke of a different kind.

The seemingly early-fourteenth-century octagonal lantern towering above the crossing of the modest abbey church of Chiaravalle di Milano [152] owes its detail to the traditions of Lombardy and its general form to those of the Maconnais and of Toulouse.[4] Despite the extraordinary proportional relationship to the church beneath, its very multiplicity of storeys, windows, and arcadings, its textural and colouristic richness, create a feeling of exuberance that holds it in the mind when many much more cunningly considered structures are forgotten.

151. Milan, S. Gottardo, campanile,
inscribed in 1336

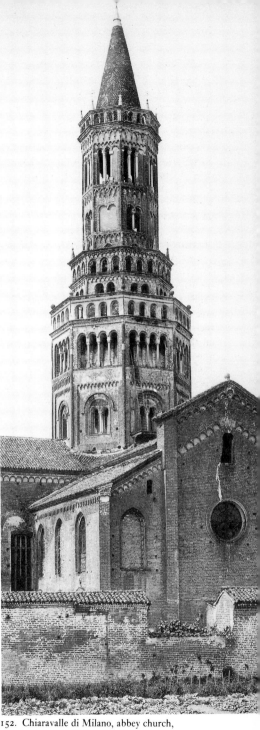

152. Chiaravalle di Milano, abbey church,
crossing tower, mid fourteenth century

FORTIFICATIONS AND CASTLES

No history of the Middle Ages is complete without the history of its castles. Their role was not peripheral but central to the social, economic, and political history of the times. In their combined defensive and offensive roles, as last retreats and as strong points for the control of trade routes or the domination of a town or territory, their influence was all-pervading. Not only are they architecturally interesting in themselves, but they play a fundamental part in the evolution and design of the majority of medieval towns and villages.

In southern Italy one great age of castle building passed with the death of Frederick II in 1250. In the north, however, during the next century and a half, the continuing activity of renovation and replacement gradually rose to a new peak. The progressive eclipse of the free communes went hand in hand with the growing ascendancy of such great families as the Scaligeri, the Carraresi, the Gonzaga, and the Visconti. The latter were not members of the ancient feudal aristocracy, but emerged, like the Medici of a later age, out of the urban classes who eventually submitted, either willingly or unwillingly, to their rule. In Tuscany, on the other hand, the castle, as the citadel of the local lord, was in decline. Instead, the towns and cities had themselves developed into civic castles, exercising over the surrounding territories all the classic functions of the lordly castle. In particular, they brooked no competition from the private fortresses of a nobility who had, increasingly, been forced to live under the commune's supervision and within the circle of its walls. The relationship of town to countryside depicted in Ambrogio Lorenzetti's frescoes of Good Government in 1338-9 [236 and 237] is essentially a development of the ancient Roman pattern, which had never been entirely overlaid by feudal concepts. The growth of the Italian towns was greatly aided by this continuity. The possession of a Roman wall was of inestimable help in gaining title to a town wall during the long struggles with successive emperors.[1]

The medieval walls were always practical and are often picturesque. Sometimes, as at Viterbo, they are works of art in every sense. The organization of defensive duties and the rebuilding or extension of the walls continually preoccupied innumerable Italian towns. The very continuity of habitation means, however, that there are few fourteenth-century examples of the planned establishment of a new town to set beside the great bastides of mid-thirteenth-century France, and none which can compare with them in grandeur. The Sienese townships of Paganico, planned at the turn of the century and walled in 1333, or Talamone, derided by Dante as a monument to vain ambition, are hardly rivals to Aigues Mortes. As in the French examples and in the further Sienese projects of Terranuova Bracciolini or the new town at Massa Marittima, both begun in 1337, the rectangular street plans reflect the general desire for a convenient regularity wherever possible.[2] At Massa Marittima the way in which the severely practical demands of military planning can give rise to abstract architectural forms of striking quality is seen in the great arch that leaps across the void between the outer ring-walls and the inner guard-tower of the gate. The slimness and apparent tension of the faintly pointed arch, and the contrast with the static solids that it links, are architectural poetry beside the heavy prose and business-like complexities of the viaduct that leads beneath a massive arch to the main entrance of Castruccio Castracane's fortress of Sarzanello. This castle, built in 1322 and subsequently modified, retains the mass but not the quality of masonry of

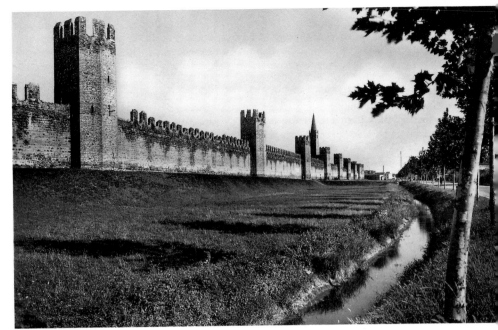

153. Montagnana, town walls, between 1242 and 1259

the earlier Hohenstaufen castles in the south. Indeed, rough stone of various kinds is used in most of those late-thirteenth- and early-fourteenth-century castles which were not brick-built. Even the castle Frederick built in Prato is largely in unfaced stone, and the fine masonry of the Torre dell'Elefante in Cagliari, built by the Pisans in 1307, is one of a few notable exceptions.

MONTAGNANA

Although most of the major walled cities now possess only a fraction of their medieval defences, there are a number of survivals as complete as any found in France. The most notable of these is possibly at Montagnana, where the ferocious Ezzelino replaced the original breastworks at some time between his capture of the town in 1242 and his death in 1259. The medieval sense of compactness and protective isolation is preserved by the unbroken stretch of open space beyond the now dry moat [153]. Originally there were two gates, one of them, the Porta Padova, guarded by a full-scale fortress. Two further gates were subsequently pierced, and twenty-four towers, mostly pentagonal, guard the walls. The south side is particularly fine. Externally there is a beautiful proportional relationship between the walls themselves and the regular succession of pentagonal towers. Internally the repeated voids of the open, inward-facing sixth sides of the towers are linked by the regular rhythm of blind arches which support the passage at the level of the battlements. Its circumference of over a mile is some 220 yards longer than that of Aigues Mortes. A similar survival on a smaller scale occurs at Villafranca di Verona, which was fortified by the Scaligeri and boasts a completely square plan and a rectilinear network of streets. There are also minor rustic centres such as the tiny hilltop circlet of Monteriggioni, near Siena, which caught Dante's

eye and which was walled and towered in the early thirteenth century. The walls of Staggia, also in Tuscany, probably date from the second half of the fourteenth century, as do those of Soave in the Veneto. The latter is a large-scale hillside variant of Montagnana in the flat lands, and the relationship between the castle, of uncertain origin but largely modified by the Scaligers, and the walled town dominated by it is instantly appreciable.

GRADARA

The classic relationship between the castle and the fortified township in its fully developed early-fourteenth-century form is given small-scale, textbook illustration by the brick-built complex at Gradara in the Marches [154]. The sloping site, commanded by the main building of the castle itself, is such that the whole plan

can be seen at a glance without the aid of wings. Although there are naturally some later modifications and the upper parts of the walls are heavily restored, the substance of the existing scheme was apparently devised for the Malatesta c. 1307–25. The only important deviation from the situation illustrated in the little Lorenzettian Townscape at Siena [239] is the replacement of the old-fashioned arrangement, with the keep at the centre of a circling curtain wall, by one in which the rectangular main block, with its courtyard and four corner towers, has only two of its sides within the walls. Ezzelino's fortress at Montagnana is similarly disposed in principle. The survival of the older pattern is illustrated in the castle at Este, rebuilt by Ubertino da Carrara in 1334–9 after having been sacked successively by the Scaligeri, the Carraresi, the Scaligeri once more, and the Visconti, in a matter of twenty years.[3]

154. Gradara, castle, c. 1307–25

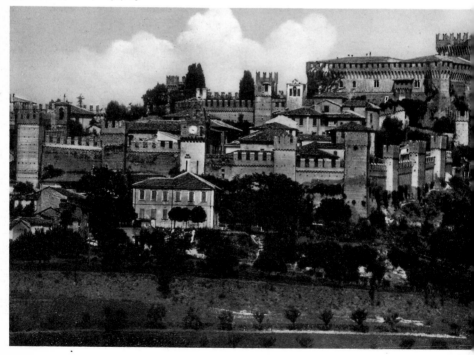

At Gradara the principal living quarters and the dominant tower or keep take up the outer corner of the main rectangular structure. The exposed flanks, with a major and a minor gate, were protected by a moat. Endless variations of this basic pattern were evolved in order to replace the static defences of the earlier keep-and-curtain-wall castles by a dynamic system. It had been recognized that a prime need in any defensive scheme was a built-in facility for outflanking the attacker and for making sorties in defence of any threatened section of the perimeter. The relation of the main buildings at Gradara to the walls as a whole therefore elaborates that between the regular series of towers and the intervening sections of wall which they permanently outflank. For similar reasons the polygonal corner tower of the main block is so situated that an inner ring of curtain walls strikes at the angle of the second and third faces from the left, and the outer ring attaches to the centre of the fourth face. The fifth of the exposed facets is right outside the walls. In this way, a sally port is provided both for internal reinforcement of the outer ring, which encircles the houses of the little township, and for the outflanking of the inner curtain wall, containing the castle enclave proper, should the breaching of the outer defences subject it to attack. This castle, with its pleasant living-rooms in the storey beneath the machicolated battlements, reflects a tendency common to many of its late-thirteenth- and early-fourteenth-century fellows. As in contemporary ecclesiastical architecture in its developed Gothic form, its effectiveness depends on richness of articulation and on the great elaboration of certain details. There is none of the sheer mass either of the earlier Romanesque and Frederican castles, which are no less closely linked to the ecclesiastical forms

155. Sirmione, castle, late thirteenth and early fourteenth centuries

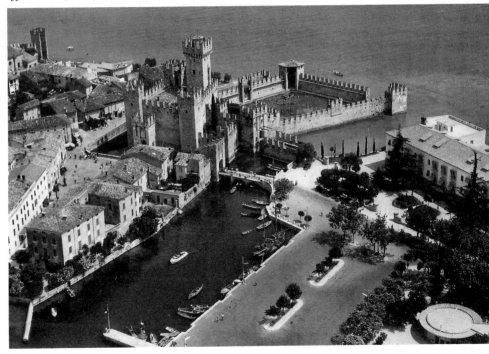

of the day, or of the later pure fortresses of the age of artillery. The complex forms reflect the military and social dynamism of the societies that such castles were built to serve.

SIRMIONE

The late-thirteenth- and early-fourteenth-century stone-built Scaliger castle at Sirmione on Lake Garda is a fascinating variant of the keep and curtain wall design [155]. Like so many of the outlying strategic fortresses built by the Scaligeri and their rivals, it was, unlike their central seats of power, intended more for purely military purposes than for residence. An interesting feature, which Sirmione shares with a number of Italian castles, is the close relationship between its keep and the tradition of the fortified town tower. The keep is unusually slim and extremely high in relation to the surrounding curtain walls, from which it is carefully isolated, if only by a matter of a foot or two in places. Its main entrance, originally reached by a wooden ladder, is twenty feet above the ground, and its interior consists of a series of barrel-vaulted, cross-vaulted, and wooden-ceilinged chambers. Apart from the walls that enclose the township, the castle boasts a trapezoidal fortified harbour. The principal near-rectangle of walls and towers, surrounding the keep and courtyard, is separated from both town and harbour by a moat. Since the latter is itself protected by a fortified wall at the lakeward end, it becomes an enclosed water barrier alongside the harbour wall.

The priorities of defence are neatly illustrated by the various gateways. The southern entry from the mainland consists of a fortified road over a stretch of water cutting across the isthmus. There are then a drawbridge and a gate; a trap or courtyard, about 11 yards by 5; a further drawbridge and a door or gate; another court, about 4 yards by 5; and finally a portcullis and a double door or gate. The latter consists of two sets of doors opening inwards within a few inches of each other, their vulnerable hinges being protected from the outside by the stepped recession of the wall. The other entries, whether from the mainland to the town or from the town into the castle, have only a single drawbridge and a single courtyard in addition to a system of portcullises and single and double gates. As in the majority of the fortifications of the period, most of the towers on the curtain walls are open on the inside, so that in case of treachery or capture by assault they could not easily be used against those manning the inner courtyards and defences. At Sirmione this defensive complexity results in a massing of successive walls and towers that is outstanding in its visual quality. Whereas at Gradara there is picturesqueness but not for the most part beauty of proportion, here, as one moves around the asymmetrically related walls and towers, the natural attractions of the lakeside setting are enhanced by a seemingly unending succession of finely related groupings.

FENIS

Although the day of castles such as Sirmione was by no means done, the future lay less in the direction of a finally self-defeating complexity of walls and towers than in that of a reversion to compactness. At the same time the demand for comfort at the very least, and often for a luxury comparable to that in the palaces of the commercial and financial princes, was becoming ever more insistent. The castle of Fenis illustrates a transitional stage in the working of both these pressures [156]. It was built c. 1340 for Aimone de Challant on a sloping meadowside in the Val d'Aosta. It still possesses a much restored set of outer and inner curtain walls [157]. These have, however, shrunk to a mere fifteen feet or so in height, and their closeness to each other is such that the steeply sloping upper meadow comes to within a very modest stone's throw of the main building that provides the real defensive strength. The tower above the gate is flanked immediately upon the left by a massive rectangular tower, which probably survives from an earlier date. A further round tower is only a

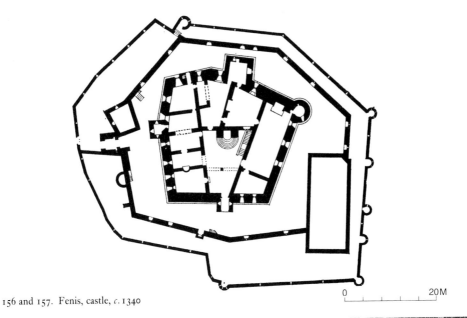

156 and 157. Fenis, castle, *c.* 1340

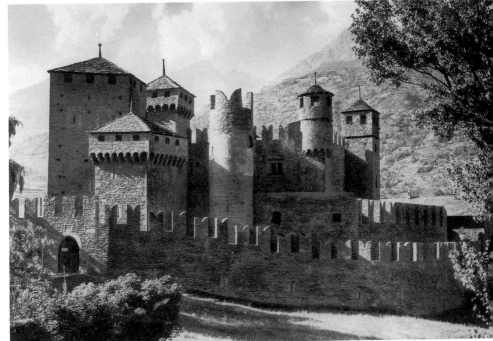

few feet distant on the right. A series of such towers dominates the irregular mass completely enclosing a small trapezoidal courtyard. However much restored or reconstructed, two wooden balconies that surround the yard undoubtedly represent the principal inner ring of communication and contain the only major stairway between the three main levels. The first stage of the stairway consists of eight semi-circular steps, leading to a small landing from which straight stone flights run upwards left and right to the first floor. Like everything else about this miniature-scale fortress, it constitutes a rustic echo of events in more sophisticated centres.[4] The main functional divisions of the building are horizontal.[5] The soldiery were housed on the ground floor and in a second-floor dormitory. The whole of the first floor was devoted to the principal suite of living and administrative rooms. These ranged from the grand hall, some two storeys high, that takes up one side of the castle, to minute bed and inner council chambers. The rooms themselves, not one of which is regular in plan, are pleasant, and the six-foot thickness of the walls is not oppressive. The tortuous circulation from one room to the next, with deviations into guarded strong points in the towers, is, however, such that the need for a ring of balconies, making nonsense of the internal defensive maze, is even more apparent than it was in the sophisticated symmetries of Castel del Monte a century earlier. The demands of normal life and of defence run counter to each other. It is this conflict that is largely resolved in the great castle-palaces of the later fourteenth century.

CHAPTER 20

VENICE AND THE VENETO

Sea and hinterland – the history of any port is written by the interaction of these two, and early-fourteenth-century Venice is no exception. Ringed though she was by the hostile power of the Scaligeri of Verona, which at one time stretched from Parma in the west to Treviso in the east and even boasted a Tuscan outrider in Lucca, the architecture of the two important churches of the period, the Frari and SS. Giovanni e Paolo, is evidence not only of the ubiquity of the Franciscans and Dominicans but of the ties stretching from the Lombard and Emilian plain across the shifting boundaries of war. Conversely, the influence of the sea and ships is surely visible in the complicated wooden roofs that are the glory of so many churches in the area.

SS. GIOVANNI E PAOLO IN VENICE

The tradition established by S. Corona and S. Lorenzo in Vicenza [19] and followed in many of the details of S. Anastasia in Verona, a building notable for the fine external massing of the transept, choir, and campanile, reaches its climax in the Dominican church of SS. Giovanni e Paolo in Venice [158]. It was founded in the mid thirteenth century, but the present structure seems to have been begun about 1333. The choir is apparently late-fourteenth-century, and the consecration took place only in 1430. The external connexions with the brick and stone constructions of the northern plain are evident. The choir and transepts form a richly articulated group in which the massive

158. Venice, SS. Giovanni e Paolo,
begun c. 1333

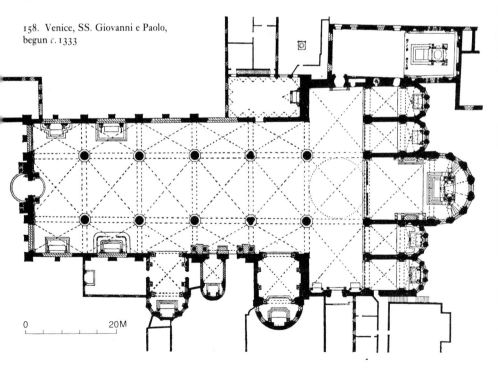

0 20M

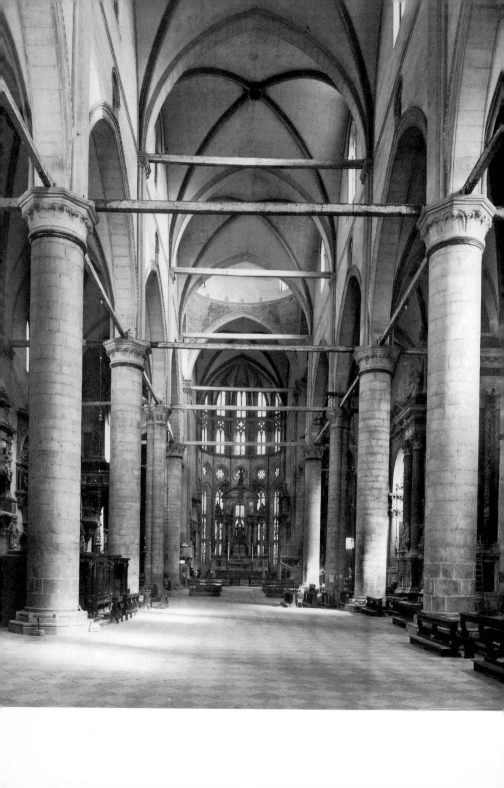

central polygon is flanked by the swelling and receding surfaces of four chapels, leaving no straight wall before the ends of the transepts have been reached. The verticals of the flanking chapels in particular are emphasized by the simple buttresses and by the repeated subdivision of the windows.

Internally the first impression is of light and air [159]. The ultimately Cistercian origins of the plan are as clear as in many of the thirteenth-century mendicant churches of Tuscany. The unity of the main space is ensured by the narrow aisles and wide intercolumniation. Here, however, the effect of the transepts only builds up slowly as one moves along the nave, and there is no attempt at a clear framing of the lateral chapels in considered vistas. The height and verticality of the nave are emphasized by the treatment of the later choir, in spite of the horizontal accent slightly over half-way up. Indeed, the relationship between nave, choir, and transept chapels results in a series of finely balanced contrasts. The massive simplicity of round stone columns, leading up to simple brick pilasters and calm areas of wall, is set off by the almost skeletal delicacy of the choir. The lace-like, light-filled quality of this seven-faceted polygon is accentuated by the preceding areas of blank, fresco-begging wall. The same is true to a lesser extent in the supporting chapels. The residual plain wall surfaces half-way up the apse are vitally important in this context. Without them there would be no link with the main body of the church. The contrasts which have been discussed would lose their tension and no final balance would result.

Interesting comparisons can be made with S. Francesco in Bologna, of a century earlier [6], or even with the derivative fourteenth-century S. Francesco in Piacenza, and the extent to which the Northern Gothic verticality and dissolution of wall surface is assimilated in this brick and stone Venetian building is remark-able. Nevertheless, the structural difficulties involved in building tall, wide arches on the wooden piles that sink into the mud of the lagoon are dramatized by the wooden vaulting of the nave and by the forest of lateral and longitudinal wooden ties inserted to ensure stability. The caging and scaffolding of the upper spaces greatly modifies the total impression. At times it almost entirely destroys the effectiveness of the dome above the crossing, which, related though it is to the Venetian taste for domed Byzantine forms, is also clearly connected to the domes of the Romanesque cathedrals of the northern plain.

S. MARIA GLORIOSA DEI FRARI IN VENICE

Tie-beams, reaching across every arch and banked in double tiers across the nave, are no less obvious in the Frari. Once again stone columns are surmounted by the lighter brick pilasters, and the decreased height and verticality, together with the greater sense of breadth and thickness in the forms of the Franciscan church, may well be less dependent on a differing aesthetic than on greater caution in the first place and a wish to have stone vaulting in the second. Whereas in SS. Giovanni e Paolo the nave seems to be earlier than the east end, the opposite appears to be true of the Frari [160]. The main apse was, however, reconstructed in the fifteenth century, and the church as a whole replaces an earlier building facing in the opposite direction. Work seems to have started in the early 1330s and finished in the 1440s. The particularly fine campanile with its rectangular main body and octagonal upper element, recalling the towers in Crema and Cremona, was begun in 1361 by Jacopo Celega and finished by his son in 1396. The change from the clustered columns of the chapel entries, reminiscent of Northern Gothic architecture, to the simple drums and brick pilasters of the nave was probably influenced by the earlier parts of SS. Giovanni e Paolo, which is closely similar in basic plan.

159. Venice, SS. Giovanni e Paolo,
begun c. 1333

274

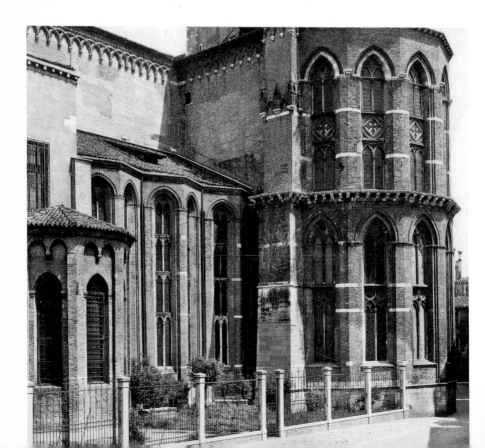

160 and 161. Venice, S. Maria Gloriosa dei Frari,
begun early 1330s,
plan (*above*) and choir and transepts (*below*)

The survival of the fifteenth-century choir enclosure in the bay immediately before the crossing is a relatively rare reflection of an arrangement which was extremely common in the mendicant churches of the period and was once to be seen in S. Maria Novella and S. Croce in Florence. Visually it reduces the immediate impact of the spatial organization of the whole and increases the complexity of its ultimate effect. Architecturally, however, the chapel windows are probably the most interesting features of the church [161]. In every case the central element is a mullion, not a light, and in this respect the later central window almost certainly reflects the original pattern. As none of the chapels is straight-ended the external effect is extraordinary, especially in the near views, which, in such a crowded city, are often an important aspect of a building. The outcome is a concertina pattern of pierced surfaces. The ending of each 'apse' in a point or angle, not in a flat surface, greatly accelerates the rapid rhythm of advancing and retreating forms. Especially in the main apse, the eye runs on from plane to plane expecting a flat termination. At times the problem of orientation can only be solved with confidence by checking on the line of the main wall of the transept.

S. NICOLÒ AT TREVISO

In both of the hemmed-in Venetian churches that have been discussed, the external massing of the east ends becomes much less impressive when the chapel shapes are related to the major forms of the transepts. In this the otherwise closely related Dominican church of S. Nicolò in Treviso presents a total contrast [162]. The church was seemingly begun *c.* 1303, although work continued throughout the century and the nave was not completed for four hundred years. The massing of the choir, the transepts, and the campanile is one of the finest architectural achievements of the mendicant orders [163]. There is a notable compactness in the movement from the rectilinear transepts through the inner pair of apsidal chapels to the great nine-faceted central polygon. The ancestry of the entire scheme in the central tradition of Italian Romanesque architecture is stressed by the softening of the angles of the polygonal chapels until a virtually cylindrical effect has been obtained. The volumes of the projecting side chapels are no less cunningly related to the stepped-up rectilinear masses backing them. The clarity and simplicity of the Romanesque is not destroyed, but the intrinsic verticality of tall volumes in repose is turned to a dynamic purpose through the light and shade and linear movement of the unbroken, constantly repeated, upward-streaming accents of flat buttresses and narrow lancets.

The outer form of the church is an accurate expression of the main internal volumes. The simple cylinders of the columns, with the tie-beams set so high as not to interfere with the spatial dynamism; the plain wall surfaces; the crystal clarity of lighting; the extreme, accentuated verticality of the transepts; the

162. Treviso, S. Nicolò, begun *c.* 1303

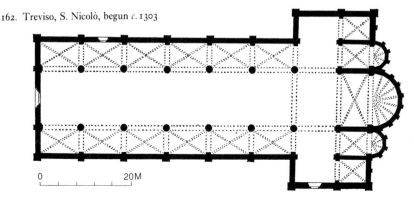

0 20M

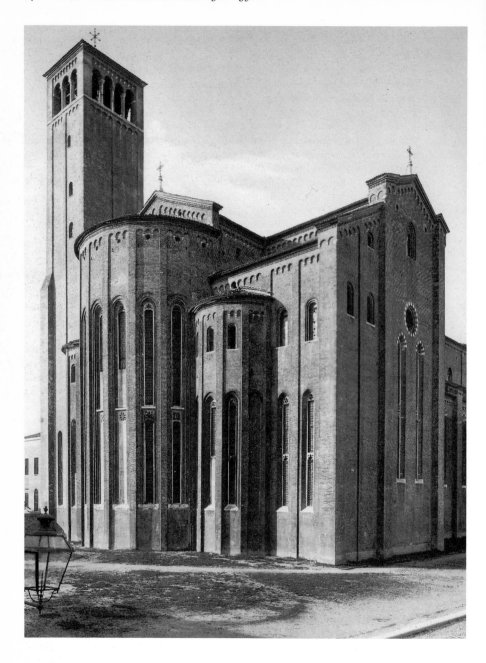

163. Treviso, S. Nicolò, begun *c.* 1303

164. Verona, S. Fermo Maggiore, ceiling *c.* 1320

undulating wall of windows at the east end; all these contribute to a final impression which owes much of its distinctive character to the capping of the nave by a five-lobed keel-roof. The complex forms of the latter create an interesting play of wave-shapes where they run into the end walls. They also form a series of narrow, tramline surfaces with a slim central rail-bed of cross-ties, which has the curious effect of greatly accelerating the movement normally created by continuous ceilings of this type. Not only are the breadth and spatial freedom of the lower volumes counterbalanced by the pilaster-accented verticality of the upper nave, but the steady march of columns is replaced by a head-long rush.[1]

THE WOODEN CEILINGS AT VERONA AND PADUA

A series of such wooden roofs is one of the Veneto's most interesting contributions to Italian fourteenth-century architecture. The most ambitious of them is the extraordinary polylobe construction hanging, dark and low, like the wings of some great bat, above the short, wide nave of S. Fermo Maggiore in Verona [164]. Red and black diamonds and diaper designs upon the ridges of the panelling, the painted busts of saints in the two vertical arcadings on each wing, and scroll designs in red, grey, black, and blue, add gleams of colour which were once undoubtedly much brighter.

In spite of this, the sense of breadth and weight must always have reduced the swift flow of S. Nicolò at Treviso to a heavy surge.[2]

The likelihood that the local popularity of such roofs, and the traditions of craftsmanship involved, are connected with Venetian ship-building is perhaps increased by the existence of the vast upturned-boat construction covering the Palazzo della Ragione in Padua [165]. This

trapezoidal upper hall, some 90 feet high and averaging 260 feet in length by 90 in breadth (27 by 79 by 27 m.), is the most imposing homogeneous volume built in fourteenth-century Italy.[3] It is characteristic of the period that the essential link between the roof-ribs and the buttresses upon the lower wall should be provided by the painted architectural frame-work of the three hundred and thirty-three

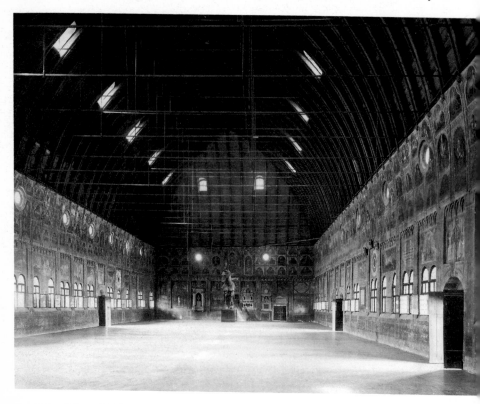

165. Padua, Palazzo della Ragione, ceiling c. 1306

ribbed wooden hull, restored in the eighteenth century, continues curves built into the upper walls of the storey added by Fra Giovanni degli Eremitani c. 1306, when he built the double-tiered arcadings that lend light and shade and delicacy to the stark mass of the outside of the early-thirteenth-century structure. The

astrological scenes which were apparently repainted in the early fifteenth century on the basis of the original fourteenth-century scheme.

THE DUOMO AT VENZONE

The fourteenth-century Duomo at Venzone, inscribed by Giovanni Griglio da Gemona in 1308, typifies the variety and beauty, partly

achieved by design and partly by accretion, in innumerable smaller churches not only in the Veneto but throughout Italy. The heavily buttressed polygons of the east end are flanked by a pair of relatively slim towers recalling S. Abbondio at Como and the northern Romanesque traditions. They create an interesting play of void and volume, particularly in three-quarter views that include the gabled ends of the transepts. No less interesting, though possibly less calculated in its outcome, is the stepping up of masses, and the accompanying growth in the height and slimness of the openings, created by the chapels that were added on the south side of the church. The continuous group formed in this way includes the transept and the southern tower.

Internally the addition of open chapels on the nave side of each transept creates an instantaneous contrast to the firm enclosure of the nave by its bare and virtually unbroken walls [166]. Since arches open from these chapels both into the nave and into either transept, the full width of the latter tells immediately and gives a feeling of expansion and release of energy. A complex play of arches is created, those to the transepts being visible through the ones that open from the nave. The pointed forms of these nave openings are succeeded by the heavy, rounded arches leaping almost ponderously across the transepts to connect the truss-roofed volume of the nave to the rib-vaulted polygons of the eastern end. The weight of form which, for the most part, marks these unsophisticated subtleties of interpenetrating volume is similar to the rustic charm and sudden sensitivities of the sculpture which enlivens the interior and decorates each door and pinnacle outside. In its planned and unplanned beauties the whole church becomes a microcosm which reflects the centuries of instinctive visual acuity that have invested every vista, each turn of a corner, in innumerable towns and villages and country lanes in Italy, with a quality that makes considerations of what is and what is not art seem futile and the writing of art history a hopeless task.

166. Venzone, Duomo, inscribed in 1308

NAPLES AND THE SOUTH

There is an almost democratic air about the growing local despotisms of North Italy when compared with the entrenched autocracy of the south. The clustered churches of the Angevins in Naples, no less than the scattered castles of the Hohenstaufen, speak of occupation, if in gentler terms. No Neapolitan civil architecture of before the fifteenth century has survived, and the churches that reflect the great constructional campaigns of the late thirteenth and early fourteenth centuries are only a fraction of those built by a ruling house as notable for intensity of personal devotion as for temporal ambition. To the Hohenstaufen, in the first half of the thirteenth century, the mendicant orders had represented the rival power of the papacy and were treated accordingly. Charles I of Anjou (r. 1266–85), the champion of the papal cause against the empire, had naturally reversed this policy and opened up his territories to the friars, who were initially installed in existing monasteries. Their presence then led, under his successor Charles II (r. 1285–1309), to the building of a distinctive series of Neapolitan churches.

Whereas under Charles I the documents speak exclusively of French architects,[1] except in connexion with the southern castles, it seems clear that under his successor an increasing share of the work was done by Neapolitan masters. Although their style was substantially moulded by that of the northern immigrants, it was by no means wholly divorced from the local traditions which had already influenced the nave of S. Lorenzo in Naples. The richness of French detail is subdued. The homogeneous complexity of articulation, inherent in a fully vaulted building even when refined in the Cistercian manner to its structural fundamentals, is exchanged for a seemingly simple contrast between wooden-roofed main volumes and

vaulted secondary spaces. The outcome is a characteristically Italian separation and accentuation of the various parts of the interior. Something that seems in S. Lorenzo to be merely an architectural fact, arising primarily from an interrupted building sequence, seems later to have been developed as a positive aesthetic preference.

S. PIETRO A MAIELLA IN NAPLES AND THE DUOMO AT LUCERA

The particular lucidity of Angevin architecture at its best is evident in S. Pietro a Maiella, founded early in the century [167]. The simple volume of the nave, with its telling interplay of plain arches and plane surfaces, is clearly demarcated. No less clear is its expansion into the richer darkness of the vaulted aisles and of the rectangular vaulted chapels beyond. The latter are contained within the originally almost square outlines of the plan in the manner of S. Lorenzo and of the preceding mendicant tradition. Longitudinally, the crossing arch leads past the caesura of the tall, wooden-roofed transept to a rectangular choir in which the combination of wide surfaces of wall and window, and plain vaulting, mediates between the contrasting extremes of nave and aisles. The single detail that epitomizes the simple, balanced contrasts of the building and contains within itself the essence of the transition from the wall-dominated, planar spaces to the rib-dominated aisles is, however, the fusion of columns and flat piers in the nave arcading. This feature has a South Italian history reaching back to the predominantly French forms of S. Sepolcro in Barletta in the late twelfth century. It was evidently present in its developed form in the subsequently transformed S. Domenico Maggiore in Naples. The latter was built at the

167. Naples, S. Pietro a Maiella, founded early fourteenth century

behest of Charles II between 1289 and 1324 and was the model for the much smaller S. Pietro a Maiella.

A simpler variant of the flattened pier and half-column motif (simpler because the aisles are also, like the nave, unvaulted) occurs in the Duomo at Lucera, founded by Charles II in 1300 and completed in 1317. The width and thinness of the nave piers give them an unusually strong directional thrust. This helps to bridge the gap created between the nave and the polygonal apse by the powerful transverse accent of the transepts with their single uninterrupted pitched roof. Particularly at the eastern end, there are close relationships with the more or less contemporary hall church of S. Francesco, which boasts an extremely fine polygonal choir. The impact of the chaste, cool

clarity of the interior of the Duomo is increased by the relative complexity both of the brick and stone façade with its single, asymmetrically incorporated tower, and of the east end, in which the internally separated chapels are fused into a single undulating mass.

S. CHIARA IN NAPLES

Externally S. Chiara in Naples is undoubtedly the most impressive of this group of buildings. It was founded by Sancia di Maiorca, who was Robert's queen from 1309 to 1343. She had sacrificed an early vocation to the order, and her fervent support for the Franciscans was only matched by that of her husband, who died in the habit of the Third Order. The church, begun in 1310 and substantially completed

168. Gagliardo Primario(?): Naples, S. Chiara, begun 1310

during the twenties, may have been built by Gagliardo Primario of Naples. Detailed reflections of S. Eligio and S. Lorenzo are, however, accompanied by many seemingly direct connexions with Provence. These include the bold massing of the façade.[2] Seen from close at hand, the latter is one of the most imposing exercises in solid geometry in the whole of Italian Gothic architecture. The stepped, rectangular outline of the grey stone entrance makes a dramatic contrast to the dark shapes of the three plain entrance arches. Its hollowed block-form is accentuated by the way in which it overlaps the solid verticals of the tower-like, rectangular buttresses. These lie in a slightly deeper plane and extend to the level of the mid-point of the central rose. The circle of the window is cradled by the rectilinear solids both of buttresses and porch. It enlivens the actual plane of the façade and gives it focus as it rises towards its simple

gable from behind the interpenetrating solids that support and introduce it.

There is a similar but rather stranger and less fully integrated play of shapes in the interior [168]. It is not merely in plan but in three-dimensional terms that the lateral chapels are almost entirely contained within the tall, rectangular hall. The total height is stressed by the slim lancets in the upper wall, and since the chapels support no superstructure other than the four feet or so of wall that crowns their arcaded entrances, the galleries thus formed create a curious impression of internal viaducts leading nowhere. The lack of any form of chapel at the eastern end of this extremely long and anything but centralized building intensifies the impression. In conjunction with the setting of small windows high on the end-wall and the backing of the altar by the enormous tomb of Robert of Anjou, it even creates a sense of

disorientation and lack of focus. One seems to have entered only to confront another entrance wall. The need to allow for the enclosed nuns'

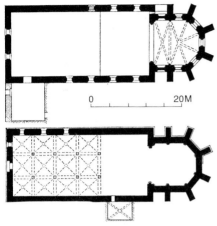

169 and 170.
Naples, S. Maria Donna Regina, 1307–*c.* 1320, plans at upper and ground levels (*above*) and view from below nuns' choir (*below*)

choir, seemingly built by Leonardo da Vito at the same time as the main body, explains this odd arrangement. Although it is only two bays deep, this choir has a central section with a pitched roof and two vaulted aisles, as if it were a slice cut from the main body of an aisled, longitudinal church, and the resulting sense of airiness and space is increased by the three large windows in the straight end-wall.

S. MARIA DONNA REGINA IN NAPLES

The other church of the Neapolitan Poor Clares, S. Maria Donna Regina [169], founded in 1307 by Mary of Hungary, the wife of Charles II, and evidently finished *c.* 1320, presents a very different internal structure. Here the entrance lies beneath the even groin-vaults of the nuns' choir [170].[3] The effect is to draw the observer forward through the dark but by no means heavily constructed forms of a low, vaulted hall towards a blaze of light. This light floods down into the expanding spaces of the

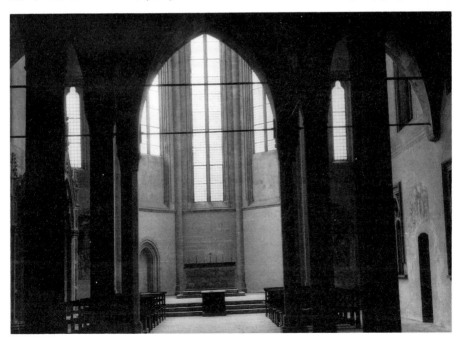

wooden-roofed nave from the soaring windows of a sanctuary bay that leads to a five-sided apse. If, as seems likely, there were originally seven lights instead of five, the upper elements of the eastern end would have been a veritable cage of glass above the simple facets of the lower wall. As it is, the contrast between the vertically accented forms of the windows and those of the low, preliminary vaulting is dramatic. Despite the even lighting, the forward pull is no less marked in the nuns' choir itself, since the promise of the verticals plunging to the unseen altar is not fulfilled until the forward balustrade is reached. The sharpness and simplicity of the fundamentally French detail of the windows are such that, while they contribute to the contrasts inherent in the interplay of wooden-roofed and vaulted spaces, of interpenetrating and expanding volumes, there is no disharmony with the plain areas of wall which were to be so notably enriched by Cavallini's followers.

SOUTHERN ITALY AND SICILY

A very different architectural climate is reflected in S. Maria del Casale at Brindisi, founded c. 1300. The grey and gold stone striping of the façade breaks into a patterned fantasy that recalls the geometric pottery of Greece. The pendent *protiro*, for all its simple Gothic forms, recalls Byzantine ambones, and the blind arcading is now Early Gothic and now Romanesque in its allegiance. There is nothing very surprising about this, for the late-twelfth-century Romanesque of the cathedral of Bitonto was still a living idiom when the cathedrals of Bitetto (c. 1335) and Altamura (after 1316) were being built. Similarly strong traditions worked on the designers of the few great palaces of the period that have survived in Sicily. There are echoes of the Arabic and Norman past in the interlaced round arches of the Palazzo Sclafani of c. 1330 in Palermo. The massive, brownish-grey stonework of the block-like Chiaramonte palace of Lo Steri, begun in 1307 and also in Palermo, is notable for the traditional Arabo-Norman dark brown lava inlays that enliven the successive planes of the window arches.[4] Other windows, facing the courtyard, have heavily channelled dog-tooth and concertina patterns of similar origins. The two types between them forge the closest of links with a whole series of buildings connected with the Chiaramonte family. Lava inlay is at its most effective in the chaste design of the planar early-fourteenth-century doorway of S. Agostino in Palermo. The organization of dog-tooth and concertina patterns, found in the late-thirteenth-century parts of the Chiaramonte castle at Favara, reaches a peak of richness in the Badia of S. Spirito at Agrigento, founded in the 1290s. In terms of clarity and refinement the doorway (after 1302) of S. Francesco at Palermo represents a similar climax [171]. It is in the few surviving details of this kind that the history of fourteenth-century architecture in the far south trickles out like sand between the fingers.

171. Palermo, S. Francesco, doorway,
after 1302

PAINTING

1300–1350

INTRODUCTION

In this half-century, in which Italian painting dominated European art and Tuscan painting dominated Italy, the foundations of the Renaissance were laid. The achievements of the sculptors during the preceding fifty years were matched in painting. New and specifically pictorial realms were opened up. The structure and appearance of the human form were explored with growing intensity, and the range and subtlety of psychological description so extended that a new pictorial dimension was created. The principles of dramatic narrative painting, embodied in their clearest and most analytic form in the work of Giotto, were elaborated, but hardly superseded, even in the High Renaissance. Alongside him, and no less conscious, in his very different way, of the Pisani and their work, stands Duccio. His urge to synthesize rather than to analyse produced an art which, whether seen directly or through that of his immediate follower, Simone Martini, made a fundamental contribution to the subsequent development of the International Gothic style.

The constant background to these experiments was the exploration of pictorial space. Increasing mastery in the representation of a three-dimensional world upon a two-dimensional surface necessarily led to a fundamental re-evaluation of the roles of line and tone and colour. New means had to be devised in order to control the increasingly complicated relationships between the decorative and two-dimensional aspects of painting and the growing appearance of three-dimensionality. The simple and insistent spatial unity which is characteristic of so much of the architecture of the period clearly had aesthetic as well as practical attractions. It is not surprising that the extension of that unity to include the complexities of the pictorial world should be a major goal. Indeed, something that had at first been primarily designed to increase the impact of the sacred stories quickly came to be appreciated for its own intrinsic qualities. The Romanesque delight in patterned surfaces was giving way to the enjoyment of the descriptive patterns of pictorial illusion. New ways, never previously attempted and subsequently unsurpassed in the whole history of art, were being found to exploit the omnidirectional possibilities inherent in the reading of pictorial designs and visual narratives, as opposed to the unitary and invariable, linear flow of written language. The revolution which was under way is comparable to that achieved by Dante and by Petrarch in the handling of the still youthful verbal language of the vernacular. In some ways, even, it is more extreme.

The growth of civic organization and the expanding programmes of civil building led to the evolution of secular themes within the previously almost exclusively religious framework. The period is also notable for the first attempts to develop landscape backgrounds

into landscapes. It is only in historical retrospect that this era of unprecedented growth appears, in certain contexts, as a closed compartment. In the mid 1340s the immediate potential of the experiments in which the Lorenzetti brothers were involved appears to have been unbounded. Men must have wondered what new miracles of pictorial invention the coming decade held in store. Then, in 1348, the Black Death killed the dreamers and the dreams.

Even catastrophes on such a scale do not, however, break the continuity of history. The cutting of what seem to be the major lines of growth merely leaves room for other strands to swell and take on a new vigour. The influence of the great artistic innovators of the early fourteenth century was in many cases fully operative only upon a rigidly restricted circle of wealthy and of cultured patrons. Their effect on the majority of their fellow artists should not be minimized and cannot be denied, but the tendency is always to lay emphasis on what they changed. The historian of the fourteenth century inevitably feels the pressure to prepare the ground for the chronicling of subsequent events. Moreover, at a time when change is in the air, great art and great innovation are particularly prone to coincide. The fact remains that ways of seeing, gradually evolved during a thousand years, do not change overnight. Apart from the extent to which even the greatest innovators still remain within conventions handed down from the immediate past, the degree to which their fellow artists were unmoved by what they did is as notable as their often very partial borrowings. This great, slow-moving current of conservatism must not be forgotten. In addition to its intrinsic importance and its significance as the environment of revolution, it alone explains the greater part of the artistic evolution of the later fourteenth century. Eventually it becomes the background against which the tiny circle of Renaissance innovators can alone be understood.

DUCCIO DI BONINSEGNA

All history is the creation of historians. It is a new reality, or at worst an unreality, linked to the happenings of the past much as a landscape painting to a landscape. Each can be no true reflection but a new, if meaningful, creation, bound by the laws of language or of paint, of personality and viewpoint. This is clearly shown in the conditioned reflex that makes Padua spring to mind on mention of Assisi. Many things conspire to make it simple to forget that one may just as easily move on to Siena. The 'Giotto problem' and the nature of the ingrained concept of artistic progress are among the most important of them. Even less commendable is the tendency to make separate mental pigeon-holes for frescoes and for panel painting. Yet it is the direct journey from Assisi to Siena that establishes Duccio as by no means being merely a magnificent conservative, the two-dimensional counterpart of a three-dimensional Giotto, but also as the glorious innovator that he is and that he seemed to be in his own day.

'Duccio pictori' is first mentioned in a payment of 1278 for painting twelve account book cases, and again in 1279 for painting the covers for such books. Similar records of the eighties and nineties are interrupted only by a substantial fine, levied in 1280, for an unknown misdemeanour, and in 1285 by the commissioning in Florence of the picture now identified as the *Rucellai Madonna*. In 1295 he cooperated with Giovanni Pisano on the preliminaries for the erection of the Fonte d'Ovile in Siena. A number of other documents deal with the acquisition of property, with loans by Duccio, with fines for debt and unspecified wrong-doings, and for not going with the citizens' militia to fight in the Maremma. In December 1302 Duccio was paid for work on a *Maestà* for the Chapel of the Council of Nine

which appears to have been restored, for unknown reasons, by Segna di Bonaventura in 1319 and 1321. Then, from October 1308 to June 1311, there are documents concerning the still surviving *Maestà* for the Duomo of Siena. Finally, in 1318–19, the painter, who left behind a wife and seven children, is referred to in the past tense.

Only two points of contact between the documents and existing paintings emerge. The first is the once controversial *Rucellai Madonna* of 1285 [180]. The second is Duccio's masterpiece and latest surviving work, the signed and documented *Maestà* of 1308–11 [172–6, 178, 179]. Between them these two works, the first one virtually, and the second absolutely, certain in its attribution, provide the only sure foundation for a concept of his style. On them depend the other eight surviving works which are all that can reasonably be attributed to him and to his shop.

THE MAESTÀ

Notwithstanding Masaccio's Pisa polyptych of a century later, the now dismembered *Maestà*, preserved for the most part in the Opera del Duomo in Siena, is probably the most important panel ever painted in Italy. It is certainly among the most beautiful. Compressed within the compass of an altarpiece is the equivalent of an entire programme for the fresco painting of a church. It is a remarkable response to the need to enhance the iconographic content of a building from which frescoes were precluded by the embodiment of the colours of the Commune in the black and white striped marbling of exterior and interior alike. The main frontal panel with the *Virgin Enthroned* [172], attended not merely by a discreet group of angels but by a thronging court of worshipping and interceding

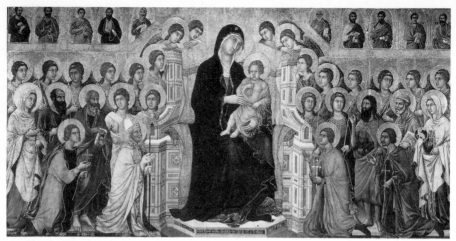

172. Duccio: Maestà, main front panel, 1308-11.
Siena, Museo dell'Opera del Duomo

saints, is revolutionary in itself. Although the origins of the theme may well lie in the long tradition of apse decoration, it represents a major milestone on the road from the medieval, hieratic image to the fifteenth-century *sacra conversazione*. Both the inclusion of the four patron saints of Siena and the inscription interceding for the city and for the painter himself reflect its function as a replacement for the famous *Madonna degli Occhi Grossi*, through whose mediation the Florentines were routed at Montaperti fifty years before. The great Cosmati-Gothic marble throne records the impact of the Roman school, transmitted, probably, through Cimabue and Arnolfo, while the implied octagon of the footrest, emphasized by the inscription, echoes the form of Nicola Pisano's near-by pulpit [42] and links what is the central focus of the whole cathedral with the architectural hexagon and dodecagon of the crossing within which it stood [21]. The obvious Byzantinism of the heads combines harmoniously with the Gothicism of the softly hanging draperies, epitomized in the sinuous rhythms of their golden edgings. Throughout there is a glowing colour unattainable in fresco. There are no words for the delicacy, range,

and richness of the deep and pale blues, lilac, cinnabar, wine-red and olive, ivory, golden brown, pale green and yellow. So exciting is the play of line and colour that Duccio's work, which seems to have been confined to panel painting, is often seen exclusively in terms of decoration. The mutilation and dismemberment of his masterpiece in 1771 has made it doubly difficult to appreciate the underlying logic of his art. The adventurousness, the extent, indeed the very nature of his contribution to the development of the new pictorial language, usually associated primarily with the Roman and Florentine fresco painters, tends to be ignored or undervalued. The decorative piling of the figures and the flat pattern of the elaborately tooled, pale golden haloes, set against the dark gold of the ground of the main frontal panel of the *Maestà*, are balanced by the open spacing of the foremost, kneeling, row of saints; by the firm, though only moderately receding platform of the throne; by the clear, but never massive, volumes of the Virgin and Child; and by the recession outwards to each flank, beyond the central rank of standing saints which would have been apparent before the panel was cut down to left and

right. The part played by this subtle sense of volume in the final harmony of Duccio's art is visible not only in the whole but in each detail. The pattern of cloak and halo, the soft flow of fold and edging in the head-dresses, the hair-fine delicacy of parallel brush-strokes that make Cimabue's panel paintings seem to have a heavy-handed vigour better suited to monumental fresco; all these depend for their complete effect upon the delicate suggestion of humanity, even of actuality, conveyed by subtle textural variations, or by the careful drapery tenting of the half-hinted and half-indicated volumes of a head or of the firm half-column of a neck. It is typical of Duccio's decorative sensitivity that the general symmetry of the attendant saints is reinforced by the absolute symmetry of the angelic heads. Within so varied a design the result is richness without chaos and discipline without rigidity, since the observer is seldom consciously aware of the full extent of the symmetrical repetition.

The novelty of the *Maestà* is not confined to the scale and complexity of the main frontal panel or, indeed, to the very fact of its double-sidedness, which was probably inspired and certainly conditioned by its unusual position under the dome. It extends to the whole altarpiece, much of the original disposition of which can, despite the uncertainties of reconstruction, be established with a reasonable degree of probability [173 and 174].[1] Both sides clearly boasted a predella. This new feature is earlier recorded in the lost altarpiece commissioned in 1302 and is prefigured in the arcade of prophets in the base of the throne in Cimabue's *S. Trinita Madonna* [100]. Once more it is Duccio, or possibly Cimabue, from whom an altarpiece with a predella was commissioned in November of the previous year, who seems to have established the pattern common to the majority of subsequent Italian altarpieces. It is, moreover, in the front predella [173] that the story, which chronologically precedes and formally surrounds the main scene of the court of heaven, is begun. There, seven episodes from the *Early Life of Christ*, separated by standing figures

of prophets, start with the *Annunciation* and culminate in the *Teaching in the Temple*, which prepares the way for the likely complement of nine scenes from the *Ministry* in the rear predella [174]. Here too, the final scene of the *Raising of Lazarus* both thematically and compositionally prepares the way for the twenty-six scenes from the *Passion* and the *Resurrected Life*. These were surmounted in their turn by pinnacle panels dealing with the further *Apparitions of Christ* after the *Crucifixion*. Here again, particular attention has been paid to the choice and treatment of the final scene of *Pentecost*. The Virgin, who is not mentioned in the Acts as being present, not only appears for the first time among the pinnacle panels but is the centre and focus of the whole design. By this means Duccio prepares the way for the return to the forward surface of the altarpiece which is crowned by the *Last Days of the Virgin*. These begin with the *Annunciation of the Death of the Virgin*, placed vertically above the first *Annunciation* in the front predella, and end with the *Burial*, which was probably the prelude to lost central scenes of the *Assumption* and *Coronation of the Virgin*. The outcome of all this meticulous planning was that, with the addition over the pinnacle panels of the Angels mentioned in an assessment document of 1308–9, not only were the front and rear faces carefully interconnected, but the thematic unity of the whole was emphasized on both of them by the coherent upward progress of a story starting with the earthly scenes that form the base and ending with the heavenly episodes and figures that once crowned the pinnacles. Such grandeur and complexity of structure and of content are unprecedented.

The Passion cycle, which is a recension of all four gospels, is among the most comprehensive to have survived. The unusual weight given to Christ's several appearances before Pilate, Herod, and the High Priests is possibly only a filling out of the normal, smaller selection of episodes, but it may also reflect the emphasis on these particular scenes in medieval mystery plays. The Passion certainly seems to have been

173. Duccio: Maestà, 1308–11,
reconstruction of front

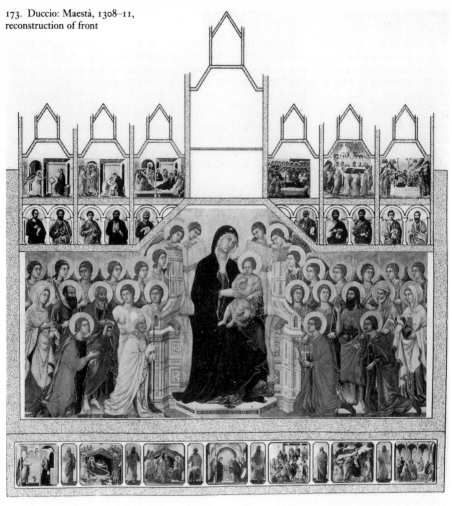

performed in Siena at least from the beginning of the thirteenth century. Unfortunately, it is impossible to say much more than that there must have been strong visual and iconographic links between the early mystery plays and the panel paintings which were likewise being produced in ever increasing numbers in the later thirteenth century. On the visual side the paintings are just as likely to have influenced the rudimentary settings of the plays as the other way about, as is so often assumed. So many of the box-like, open-sided interiors, common to Duccio and to all the more progressive artists, seem to be closely connected with Late Antique and Early Christian art. It is therefore dangerous to presume that their roots lie in the new forms of the popular mystery play. The human scenes of the Infancy and Passion of Christ were already stressed in the abbreviated cycles of the Pisani's pulpits, and in the context of contemporary religious movements it is natural that in this fuller cycle

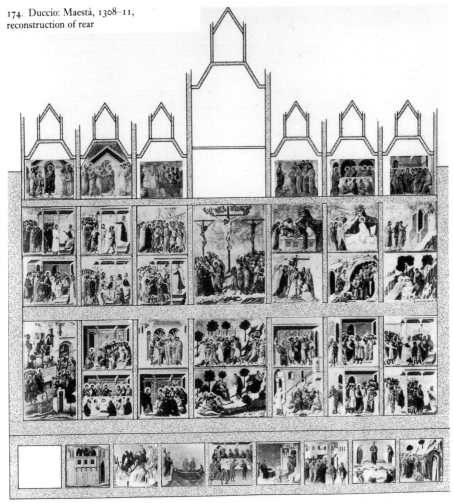

174. Duccio: Maestà, 1308–11,
reconstruction of rear

the emphasis on the Passion should be correspondingly increased.

The invention of an iconographic scheme unique in the whole history of Italian altarpieces is accompanied by abundant innovation in the individual scenes. Nevertheless, just as the dominant rectilinearity and angularity of structure reveal a cleaving to the Italian Romanesque tradition, despite the added Gothic complexity, so Duccio's revolutionary approach to narrative description is firmly based on the closest understanding of Byzantine prototypes and was only rendered possible by his refusal to abandon the conventions that were challenged by Cavallini and by the Master of the St Francis Cycle and cast aside by fundamental realists such as Giotto.

The rapidity of Duccio's artistic growth under the stimulus of a great commission can be seen in many ways. Apart from its double-sidedness, the general form of the altarpiece is a landmark in the steady evolution from the

pictorially framed, rectangular and gabled altar-pieces of the thirteenth century to the fully architectonic designs developed during the twenties and thirties of the fourteenth.[2] The general forms of the Sienese altarpieces of *St John Enthroned* of *c.* 1265–70, of *St Peter Enthroned* of *c.* 1275–85, or of the Florentine *St Cecilia Altarpiece* [122] of just after the turn of the century, are almost interchangeable with that of the top half of the main, rear panel of the *Maestà* [175]. A prime example of the simple, gabled form is Duccio's own *Rucellai Madonna* of *c.* 1285 [180], while notable examples of low, gabled dossals with inscribed arches are altar-pieces 6 and 7 [97] in the Pinacoteca at Siena, painted by Guido da Siena and his shop or circle. The reluctance to abandon this tradition of closed outline and uniform, relatively flat framing can be seen in Meliore's Florentine altarpiece of 1271 or in Vigoroso da Siena's *Madonna, Christ, and Four Saints*, seemingly of 1280, in which the unified main surface and three sides of a flat, pictorial frame survive as a container out of which emerge the broken contours of five gables. The next stage is most clearly represented by polyptychs 28 and 47 [183] from Duccio's own workshop, and in a constellation of dependent Sienese altarpieces, and it seems likely that it is precisely at the head of this particular transitional group, with its residual wrap-around frames, its multiplicity of subsidiary compartments, and its pinnacles and pinnacle panels that Duccio's *Maestà* belongs, although, apart from its unusual double-sidedness, it was more advanced in its incorporation of the fully developed narrative predella and more conservative, if more spec-tacular, in its retention of the unified, main frontal panel.

The surviving evidence as to the structure of the *Maestà's* original, complex, and inevitably massive frame, and the fact that all the painted surfaces and framing elements alike were over-laid by a continuous covering of fine linen into which were keyed the layers of gesso which likewise spread impartially over every element, makes it virtually certain that the altarpiece was a unified construction something like 4.99 m. high and 4.68 m. wide. This comes out at exactly eight of the one-braccio units formed by the widths of the lateral pinnacle and *Passion* panels measured to the mid-lines of their fram-ing pinnacles. Since, in these circumstances, all the carpentry would have had to have been complete before any painting could begin, it seems that Duccio developed his design and gave his orders to the carpenters in terms of a proportional system based on the $1:\sqrt{2}$ relationship between the sides and diagonals of a square. The written references to its use stretch from Vitruvius in Antiquity to Villard de Honnecourt, the medieval mason, and on into the Renaissance with Alberti and Matthäus Roriczer. Whatever the initial unit of measure-ment, a progression based on this relationship generates a lively, alternating series of rational and irrational numbers which are easily obtained by simply doubling or halving the original pair.

How important it is to appreciate these matters of proportional planning and structural design, of carpentry, and of workshop practice in general, can be seen by the way in which attention to them makes it possible to show that the two triptychs of the *Crucifixion and Saints* in Boston and of the *Madonna and Saints* in London [182] were certainly made and dec-orated in a single workshop whether, as seems likely, it was that of Duccio himself or of some other closely related member of his circle.[3] The measurements and proportions and the details of internal structure, down to the millimetre, the external marbling of the shutters with their repeated patterns of whirling $\sqrt{2}$ squares, and the identical incisions of the gold, internal borders leave no room for doubt.

In the *Maestà*, the height and width of the main panel, the width of the lateral pinnacle and *Passion* panels in relation to those of the central elements, including the *Crucifixion*, down to the details of the framing, such as the width of the pinnacles, all lie on a $\sqrt{2}$ series. Among Duccio's other works, the dimensions of the *Rucellai Madonna* [180] and its frame at one end of the scale, and of the surviving

painted surface of the tiny *Madonna of the Franciscans* [181] at the other, together with the complex structure of polyptychs 28 and 47 [183], are all controlled by this same system. It was also used by figures as diverse as the Master of the St Peter Altarpiece, Cimabue, Simone Martini, and Lorenzo Maitani in the façade of the Duomo at Orvieto, and can be traced in innumerable works of art and architecture created both in Italy and elsewhere in the later Middle Ages. Often, as in the London [182] and Boston triptychs from Duccio's own workshop, these geometrically based dimensions were combined with simple, whole-number, mathematical relationships.

The main rear panel of the *Maestà* [175] shows how freely and creatively such a system could be used. Despite the great central column leading up from the thematically linked pedestal for the whole sequence of the *Passion* which then zigzags up, across, down and across, through the two lower registers before repeating the pattern in the upper pair. The *Entry* is then dynamically balanced by the dual scene of *Christ before Annas and the First Denial* immediately beyond the *Agony* and *Betrayal* and by the visual echo in the landscapes in the upper right-hand corner. Similarly, the lowering of the roof-line in the scene on the right of the *Betrayal* allows the six scenes on the bottom right to form an almost perfect counterpoise for those on the upper left, in which the *Way to Calvary* alone lacks architecture and therefore reveals a comparable expanse of golden sky. Apart from line and colour, other unifying factors are the constant left-to-right fall of the light upon the architecture and the careful observation of the unity of place, which

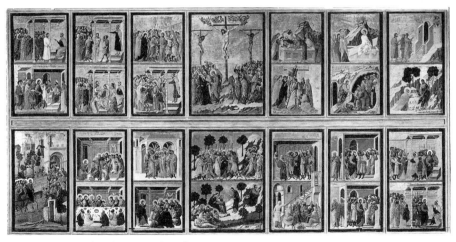

175. Duccio: Maestà, main rear panel, 1308–11.
Siena, Museo dell'Opera del Duomo

of the *Calling of Peter and Andrew*, the *Feast at Cana*, and *Christ and the Woman of Samaria* [178] in the predella, through the *Agony*, the *Betrayal*, and the *Crucifixion*, no rigid symmetry is imposed. Through its doubled size, the lower left-hand scene of *The Entry into Jerusalem* [176] marks the point of departure means that a single interior may reappear as many as six times. This unity of place, although already observed by Cimabue and the Isaac Master at Assisi, and by Giotto at Padua, is in itself a novelty in panel painting.

The Byzantine elements in the type and structure, and in the movement, of Duccio's

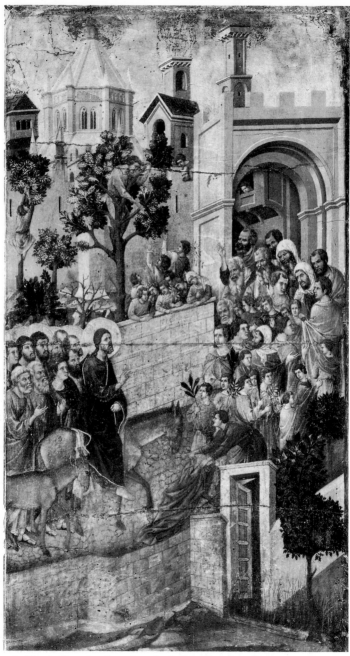

176. Duccio: Entry into Jerusalem, detail of the Maestà, 1308–11.
Siena, Museo dell'Opera del Duomo

figures, as well as in the iconography of many of his scenes, are so strong that he may himself conceivably have travelled to one of the Near Eastern centres of Byzantine art. To mention only the nearest of the great commercial ports, the constant to-and-fro of trade between Siena's ally, Pisa, and the Eastern Mediterranean makes it highly probable that painters fired by the example of the Byzantine artists, artefacts, and works of art still flowing into Italy, made such journeys to the East. The *Entry into Jerusalem* shows how closely Duccio's achievement is bound to his acceptance of the Byzantine and Italo-Byzantine heritage which was almost certainly reflected in lost Byzantine or Byzantinizing manuscripts and pattern books [176]. Comparison with the relevant mosaic in the Cappella Palatina at Palermo shows that the figure types and the disposition of Christ and his apostles, of the welcoming crowd, and of the hillside and the city gate, all follow the Byzantine models. Yet out of these traditional elements, however handed down, Duccio creates an organism far beyond the reach of any earlier medieval artist. The climbing composition of the Byzantine pattern is not merely accepted: it is accentuated by conversion into a tall, rectangular design. At the same time the cunning readjustment of the placing of the buildings and the establishment of their uniformly low viewpoint, together with a novel sense of spatial continuity, make it possible to see within this surface-climbing composition the reality of a steep road winding up towards, and finally levelling out within, the hill town of a Sienese Jerusalem.

The temple-baptistery that dominates the town may well reflect not only an iconographically significant reference to the centralized church of the Holy Sepulchre in Jerusalem and a personal knowledge of such buildings as the baptistery at Florence, but the constant interplay of painting and goldsmithery. The Gothic detailing recalls the more sumptuous forms of the Reliquary of S. Galgano with its gilt and silver gilt, its precious stones, its green and red and blue enamels, and its oriental

177. Reliquary of S. Galgano,
late thirteenth or early fourteenth century.
Siena, Museo dell'Opera del Duomo

delicacy of incision [177]. The combination of a solid, bulky central structure, decorated by rounded trilobate arches, and the lacy detail and fully Gothic form of the niches at the angles; the Cimabuesque arcaded half-lengths; the Byzantine undercurrents in the heavy relief with its massive figures and simple narrative realism almost wholly devoid of Gothic elements; all confirm a late-thirteenth- or early-fourteenth-century origin. It represents the moment of transition from Romanesque weight and gravity to Gothic grace and lightness, and presages the imminent flowering of the Sienese goldsmith's art.

The simple scenes of the reliquary accentuate the subtlety and boldness of Duccio's *Entry* [176]. The scale of the city gate in relation to the town and to the people crowding out of it, as well as to the near-by trees, is as remarkable as that of the trees themselves, compared to the children clambering in or standing underneath them. Alongside the achievement represented by the suggestion of extensive countryside and teeming city, such minor inconsistencies as the contradictory low viewpoint of the small gate at the roadside or the insubstantiality and lack of structural conviction in many of the figures are of little consequence. Indeed, these very inconsistencies, these compromises with an earlier tradition, lie at the root of Duccio's success. Only the partial incorporeality of the individual figures and the lack of a consistent logic in the details make such crowd scenes and such compositional daring possible at all.

A comparison with the *St Francis and the Demons at Arezzo* in S. Francesco at Assisi, in which an attempt to show a city is combined with a change of scale suggestive of diagonal movement into depth, confirms the quality of Duccio's achievement. There is a similar relationship between the Assisan *Miracle of the Spring* and Duccio's *Agony in the Garden* [120 and 175]. Both artists accept exactly the same Byzantine rock conventions, yet Duccio substantially resolves the uncertainty as to whether rocks or mountains are intended. The convention is handled with a new softness, and the

presence of two episodes within a single scene does nothing to detract from the way in which the figures now inhabit almost the full depth of a substantial landscape platform. Even the realistic blue of the fresco painter's sky, as against the panel painter's gold, does not redress a balance weighted even further by such added touches as the clovered carpeting in this scene, the scattered bursts of flowers in the *Noli me Tangere*, or the sudden contrast between living trees and dead, found in the *Entry* [176].

The St Cecilia Master's interest in including figures in a townscape, though not his detailed portraiture of buildings, is left far behind in the predella panel of the *Healing of the Blind*. The large figures, reasonably in scale with the clearly coordinated buildings, full of openings and views into depth, almost conceal the fact that only the well on the right reaches the very foreground. The self-isolating, extreme oblique patterns of the *Repudiation* at Assisi [119] show how much Duccio's success in organizing complex scenes depends on his complete acceptance of the foreshortened frontal architectural construction.[4]

Although there is no mention of collaboration with, or employment of, other established masters in the documents, and at one point Duccio bound himself to furnish 'all that which pertains to the craft of the brush', it is clear that he had numerous assistants in his workshop and that the actual painting of the *Maestà* was a truly collaborative endeavour. This does not mean, any more than it had on Nicola or Giovanni Pisano's pulpits or, as was later to be the case, on Lorenzo Maitani's Orvieto façade, that the back or indeed any other part of the *Maestà* can be neatly divided, like a jigsaw puzzle, into separate segments each of them attributed as a whole to this hand or to that.[5] The collaboration was clearly of a much more fully integrated kind. The variations and similarities within any of the groupings which have been suggested are quite as noticeable as those across the boundaries between them and their neighbours. What can much more readily be discerned, especially on the rear face of the

altarpiece [174 and 175], is the development of
Duccio's ideas as he and his assistants worked
their way down, register by register, from the
topmost pinnacle to the predella panels sixteen
feet below.

In the pinnacle panels of the *Apparitions*,
only the *Pentecost* shows any serious attempt to
represent a true interior which does not lie
behind, but actually contains, the major figures,
and both of the interior constructions in the
upper left-hand quarter of the main panel are
still of the hybrid type in which external and
internal elements are combined. However, by
the time the scenes surrounding the *Last Supper*
in the lower half of the main panel have been

reached, the development in the direction of a
true interior is striking and, in the predella, in
the *Feast of Cana* it is startlingly ambitious.
Indeed, it is only because the maintenance of
the unity of place meant that the relatively
undeveloped and conservative designs estab-
lished in the opening pair of scenes in the top
left corner of the main panel had to be repeated
in the block of four scenes in the bottom right-
hand corner, that there is not a positively dis-
turbing compositional clash between the upper
and lower halves of the altarpiece. A com-
parison between the spatial inconsistencies of
the *Road to Emmaus* in the top right-hand
corner of the main panel and the rigid con-

178. Duccio: Christ and the Woman of Samaria, detail of the Maestà, 1308–11.
Lugano, Thyssen-Bornemisza Collection

structional logic of what amounts to a reworking of the same design in the predella scene of *Christ and the Woman of Samaria* [178] provides another illustration of the distance travelled. It is quite clear that, in terms of representational realism, things that had been readily acceptable when work began were becoming wholly unacceptable by the time the half-way stage was reached.

The change in attitude is shown with maximum dramatic force within the compass of a single scene. The composition of the *Entry* [176], which was earlier compared with its Byzantine prototypes, is not the scene that was originally completed. Even the naked eye reveals that the red, cobbled road once stretched from half-way up the existing upper wall as far down as the base of the retaining wall which now appears below it. If the now much more realistic road is still tiptilted to the modern eye, this is as nothing to the extended vertical cliff to which the figures were originally pinned. A major feature of a composition which must have seemed adventurous in its realism when it was first painted was, by the time the altarpiece was nearing its completion, seen as being so unsatisfactory as to need a very substantial redesigning.

Another of the many striking witnesses to the growth of Duccio's ideas among the lower, later executed scenes, is undoubtedly the *Temptation on the Temple*, in which the once distant baptistery of the *Entry* towers in the foreground, more than two full storeys high [179]. Its roof is now truncated by the frame and the action takes place on an upper balcony. Both main storeys of the complex, vaulted interior can be glimpsed through door and window, and throughout there is a new sense of solidity and grandeur which, a century later, may have caught the eye of Brunelleschi.[6]

A similar partial view, a similar boldness and complexity, and a corresponding closeness to the onlooker are found in the interiors of the *Presentation* and the *Teaching in the Temple* in the front predella in which the details show that Duccio has given a new meaning to the unity

of place by carrying it past the intervening *Massacre* and *Flight* in order to create the impression that the onlooker has moved along the cloister, which can just be seen on the right of the *Presentation*, into a different part of one great, complex architectural structure. Nevertheless, the dual scene of the *Denial by St Peter* and *Christ before Annas* on the main rear panel is the most extraordinary, and yet in many ways the most typical, of Duccio's compositions [175]. Below, a courtyard opens through an archway into the farther court of an obviously extensive building. Behind the figures seated in the nearer space a stairway climbs up to a balconied landing and to further steps. These lead into the upper room in which Christ meekly stands for questioning at the very moment of Peter's denial in the courtyard below. The accusing finger of the serving-woman, vertically beneath the high priest, forms a visual link with the diagonally climbing balustrade. The unity, not merely of the architectural structure, but of the tragic content of the two scenes is pressed home. It is typical that in giving intensified visual reality to this momentary drama Duccio rides rough-shod over several kinds of structural logic. There is uncertainty in the relationship between the uprights of the lower archway and in the perspective of the stairs and of the circular seat. There is visual ambiguity in the intensely meaningful juxtaposition of the serving-woman and the stairway. The relationship between the upper and the lower rooms shifts constantly, for the side walls of the former reach the borders of the composition, so that it appears in one respect to be behind and in another to be immediately above the lower courtyard. Yet all such ambiguities are ignored. The overriding concern is the imaginative recreation of one supremely pathetic moment. The end result lies far beyond the reach of any of Duccio's contemporaries.

There are many similar structural inconsistencies among the Passion scenes on the main panel. Columns have capitals in one plane, bases in another. Important figures standing

179. Duccio: Temptation on the Temple, detail of the Maestà, 1308–11.
Siena, Museo dell'Opera del Duomo

in the middle-ground quite often overlap the architectural features in the foreground and the many centralized and foreshortened frontal interiors are freely intermingled without optical relationship to one another. Yet Duccio also shows a thoroughly up-to-the-minute tendency to make the receding lines of single planes all vanish to a point.

It is a mark of Duccio's stature that it was by no means his most adventurous designs that were most influential. The relatively unambitious *Annunciation of the Death of the Virgin*

fired the imagination of Pucelle and all his school, setting the pattern for a century in France.[7] It was in simple scenes like the *Noli me Tangere* that Italian sculptors such as Tino di Camaino found their starting points [175]. Often – for Duccio is essentially a gentle dramatist – it is in quiet scenes, such as the *Maries at the Tomb*, in which the reminiscences of the calmest of Giovanni Pisano's Gothic figures, the Sibyl for the façade of the Duomo, blend with the general Byzantinism, that his most memorable visions are embodied. His is

a drama as controlled, as delicate, and as devoid of all extremes as is the sense of form and line and colour out of which it is created. Only extraordinary subtlety of treatment prevents the nine different scenes of Christ before Annas, Caiaphas, Herod, and Pilate from becoming monotonous, despite a sixfold repetition of one setting and a threefold repetition of the other. Within a dramatic range that has none of Giovanni Pisano's violence, the gradually intensifying pathos of St Peter's three denials is moving in the extreme. The first spreads over two whole scenes. The second is then concentrated in a single episode. In the third, St Peter is brought almost shoulder to shoulder with the blindfolded, beaten Christ. As the complexities of the rhythm of his art reveal themselves, it gradually becomes self-evident that Duccio's experiments in naturalism, his formal division of the panel as a whole, and his detailed use of line and colour only achieve full meaning in the light of the narrative that they serve.

The doubled size of the *Entry*, with its glorious natural detail and its emphasis on life and bustle, is a peal of joy that echoes through the panel and intensifies the mounting tragedy of the Passion scenes that follow. First comes the quiet sadness of Christ, still surrounded by his loved apostles, as the preparations for betrayal are begun. Then, in the lower half of the great central axis, there is the spiritual crescendo of the *Agony* and the human bitterness of the *Betrayal* itself. In the succeeding section of six scenes the quieter rhythm of questioning contains the rising tension of the three denials and of the beating and derision of Christ. The upper left-hand section sees the continuation of the tragic counterpoint of question and answer and has its own dramatic climax in the *Scourging* and the *Mocking*. The Passion culminates in a *Crucifixion* almost as extensive as four normal scenes. There follows the sad aftermath that gradually gives way to puzzlement and then to joy, until finally the firm movement of the figures and the up-sweeping road of the *Journey to Emaus* lead to the scenes that crowned the

altarpiece and reached their climax in the joyous *Resurrection* and *Ascension*. In short, each section of the complex whole contains its own narrative crescendo as it mounts towards the final triumph. What is more, within each chapter it is often possible to find an alternative, visually and thematically significant path by reading straight across each section of three scenes. Even when Giotto's less extensive and more carefully disciplined experiments in the Arena Chapel, Padua, are taken into account, the *Maestà* appears undoubtedly to represent the most extreme attempt in the whole history of art, at least until the second half of the twentieth century, to exploit the omnidirectional qualities of the visual image in order to express the richness of association and the depth and the complexity of interlocking meanings which reside within a complex narrative.

The very process of development did, however, have one unforeseen and unforeseeable consequence. In the *Legend of St Francis* at Assisi, and later in Giotto's Arena Chapel frescoes, the sequences of execution which provide the context for a steady growth in representational realism flow in harmony with the narrative towards a single climax. In the *Maestà* on the other hand, the decision to begin the story at the bottom of the altarpiece and to move steadily upward, in order to reflect the rising theme implicit in the narrative, contradicts the downward flow of execution and stylistic change. The introductory scenes in the rear predella are visually the richest designs in the entire altarpiece and the narrative crescendo in the pinnacle panels is incorporated in the least developed and least supple compositions. This has certainly made its contribution to the lack of understanding and appreciation, and even possibly to the confusion in the actual reading of the story line, which have until quite recently appeared to dog the *Maestà*.[8]

Nevertheless, it is not only on the grandeur of the whole but also upon little things, on delicacies of expression and of movement that Duccio's dramatic power is founded. Just such

a touch occurs in the *Deposition*, where the normally sinuous flow of the golden edging of the Virgin's cloak is suddenly drawn taut into a single sweeping curve. It is, throughout, a combination of simplicity and sophistication, adventurousness and diffidence, of spatial and descriptive range, of linear and colouristic sensitivity and narrative subtlety, that gives the *Maestà*, and Duccio's art as a whole, its renewed hold on subsequent generations. For Duccio's own fellow citizens the *Maestà* was evidently all and more than they had ever hoped to get, and a mid-century Sienese Chronicler records the way in which they turned the day of its delivery, 8 June 1311, into a major civic and religious festival:

'On the day on which it was carried to the Duomo, the shops were locked up and the Bishop ordered a great and devout company of priests and brothers with a solemn procession, accompanied by the Signori of the Nine and all the officials of the Commune, and all the populace, and all the most worthy were in order next to the said panel with lights lit in their hands; and then behind were the women and children with much devotion; and they accompanied it right to the Duomo making procession round the Campo, as was the custom, sounding all the bells in glory, out of devotion for such a noble panel as was this.'[9]

THE RUCELLAI MADONNA AND THE PANEL PAINTINGS PRECEDING THE MAESTÀ

Despite the confusion caused by its long-time attribution to Cimabue, there now seems to be little doubt that the *Rucellai Madonna* [180], now in the Uffizi, is indeed the altarpiece commissioned from 'Duccio di Buoninsegna' by the Confraternity of the Laudesi for their chapel in S. Maria Novella. As was frequently the case, the panel was supplied to Duccio ready-made, though doubtless to his orders. At 14 feet 9 inches high and 9 feet 7 inches wide (4.50 by 2.92 m), it is by far the largest of its kind to

have survived, and the price of 150 lire for painting it was commensurate with its size. Looking back in time, the drapery of the Virgin's throne is closely related to the original decoration of the chapel by Cimabue's workshop or, more probably, his immediate circle, and the stylistic links with Duccio's own superbly crafted *Crevole Madonna* in the Opera del Duomo at Siena, which was probably painted *c*. 1280, are clear. Forwards, the connections with the *Maestà*, particularly in the faces of the lesser figures of the angels, which are those least subject to development, are just as striking given the almost quarter of a century of intense development which lies between them. The innovation represented by the sometimes swiftly sinuous, sometimes convoluted flow of the golden edging of the Virgin's cloak in the *Rucellai Madonna* is the perfect prelude to the more consistently disciplined and carefully generalized Gothic rhythms of the many similar edgings in the *Maestà*. The spatial and structural coherence of the throne in the earlier altarpiece; its very boldness for its date; its combination of small Gothic details and Byzantine general form, are exactly what might be expected of the adventurously conservative Duccio. The same is true of the fundamental contrast between the developing earthly realism of figures and throne alike, and the wholly visionary and supernatural placing of the angels who not merely hold the throne but hold it up in what, as in the myriad comparable altarpieces, is a scene of heavenly, not of earthly glory.

This being so, and given the tentative placing of Cimabue's frescoes at Assisi in the late seventies or early eighties, the S. *Trinita Madonna* [100] being bracketed with them at a slightly earlier date than that of the *Rucellai Madonna*, it is no surprise that, while Duccio initially resisted Cimabue's extreme experiments with the new type of massive throne, the influence of the latter's angels should be clearly visible. Neither in line nor yet in the colour, which is organized in terms of straightforward counterpoint, does Duccio succumb to Cimabue.

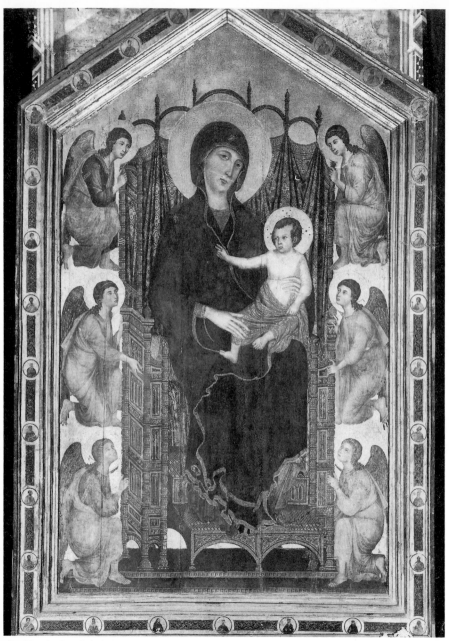

180. Duccio: Rucellai Madonna, commissioned 1285. 4.50 by 2.92 m.
Florence, Uffizi

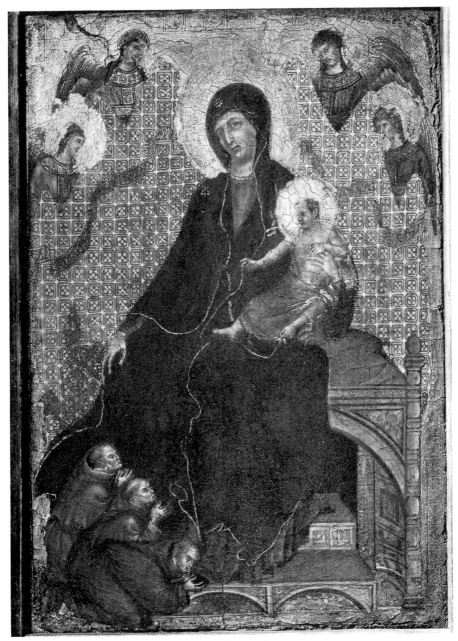

181. Duccio: Madonna of the Franciscans, *c.* 1290–5(?). 23.50 by 16.00 cm.
Siena, Pinacoteca

Nevertheless, Florentine influence is at its peak, although in the main poses it is combined with the strongest reminiscences of Guido da Siena. What is often not remarked, however, is the fact that the structure of the bodies of Duccio's angels is more, not less, strongly defined than in Cimabue's altarpiece. The Christ Child with foot pressed and ankle flexed against the Virgin's thigh is both more complex in its pose and firmer in its structure than are any of Cimabue's comparable figures. The quality of craftsmanship, the delicacy and precision of technique throughout this massive altarpiece would represent a fine achievement in a miniature. The rough and ready aspect of the comparable detail in the S. Trinita Madonna [100] is almost rustic in comparison, but it was probably not solely admiration for good craftsmanship and certainly not the desire for a more decorative and less forward-looking work that led the Confraternity of the Laudesi of S. Maria Novella to look to Duccio for their panel rather than to Cimabue. It is much more probable that they were simply looking for the best, and that, in terms not only of technique but in the whole range of the panel painter's rapidly developing art, seems to have been precisely what they got.

The inherent qualities of the Rucellai Madonna are such that its echoes in the Louvre Madonna [112], which probably emanates from Cimabue's circle at a slightly later date, are as strong as, or even stronger than, those of Cimabue's S. Trinita Madonna itself. Such closely related works as the early Crevole Madonna and the Madonna in Perugia, of a couple of decades later, show the quality which Duccio's workshop steadily maintained. That quality is confirmed, were confirmation needed, in the tiny Madonna of the Franciscans in the Siena Gallery [181]. Here a miniaturist's touch is accompanied by a sweep and grandeur of design and by a compositional inventiveness that quite transcend the limitations of objective scale. The Gothic diapering of what was once a softly folded curtain held by the angels, the augmented depth and spatial power of the throne, the increased swiftness and fluidity of the linear rhythms, all combine to place this panel after the Rucellai Madonna but still fairly early on the road that leads to the Maestà. The retention of a wooden as opposed to a marble throne points to a probable dating before the mid nineties. The subtlety of the design is timeless, on the other hand. The volume of the throne seen from the left is balanced by the enveloping, linear down-sweep of the Virgin's cloak and by the three small, kneeling monks. This latter major diagonal within the balanced whole is reinforced by the iconographically original position of the Virgin's hand, by the inclination of her head, and by the sweeping gesture of Christ's benediction.

Far closer to the Maestà in its combination of a basically Byzantine formula with melting Gothic rhythms is the Madonna in the Stoclet Collection, in which a similar balancing of architectural and figural forms is achieved by means of a Cimabuesque parapet with foreshortened brackets reminiscent of Assisi. Another link is provided by the triptych in the National Gallery in London [182] which, in structural terms, is twinned with that in Boston. Here the facial types and linear play in the main figures are extremely close to those of the Stoclet Madonna. On the other hand the female saint on the right wing is, in the almost purely Gothic rhythm of her draperies, the prelude to such figures as that on the left of the main frontal panel of the Maestà. Finally, as likely workshop products which, despite their largely ruinous condition, are a prelude to the Maestà, there come polyptychs 28 and 47 [183] in the Pinacoteca at Siena. If these works do indeed stem from the early years of the new century, all that remains of Duccio's reasonably attributable work has been assembled. The completion of the pattern shows that Cimabue's impact was no momentary matter. It is only in the Maestà that Duccio is finally able to make use of Cimabue's monumental throne and to exploit and to expand the idea behind the latter's solid, standing angels.

Seen in this context, the great window of 1287–8 in the Siena Duomo becomes a natural

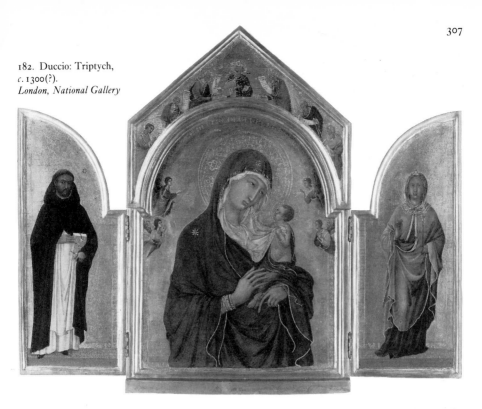

182. Duccio: Triptych,
c. 1300(?).
London, National Gallery

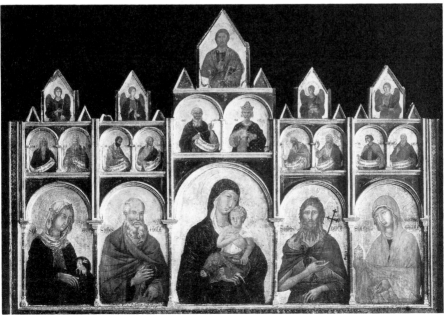

183. Duccio: Polyptych no. 47, *c.* 1305–8.
Siena, Pinacoteca

medium for the transference of Cimabue's vision [109–11]. The vertical linkage of its scenes may well have inspired the axial stiffening of the narrative compartments on the back of the *Maestà* [175]. At the same time the catalogue of Duccio's remaining reasonably certain paintings seems to confirm that the window is not to be placed immediately after the *Rucellai Madonna*, commissioned in 1285 [180], and before the *Madonna of the Franciscans* [181] as one of Duccio's own works. The thrones of both the latter Madonnas are very different in conception.[10] Furthermore, in Duccio's output of the eighties there is no hint of the broad, monumental style so intimately connected with fresco painting. Even in the *Entombment of the Virgin* in the *Maestà*, painted over twenty years later, Duccio the panel painter does not achieve the variety and complexity of spatial grouping seen in the stained-glass *Dormition*. Throughout the window the drapery forms differ widely from the tightly creased folds of the Rucellai angels, and nowhere are there any indications of the linear sinuosities already apparent in the *Rucellai Madonna* herself and so increasingly obvious in all Duccio's later works as almost to become an artistic trademark.[11] For the development of Duccio during the late eighties the window represents a veritable cuckoo in the nest, and any consideration of the several charming but more doubtful attributions, such as the little *Maestà* in Bern or the triptych in the Queen's Collection, London, only accentuates the gap which separates the rhythmic character of Duccio's own work from that of the great window which inspired him.

GIOTTO

O vana gloria dell'umane posse,
Com' poco verde in su la cima dura
se non è giunta dall'etati grosse!

Credette Cimabue nella pittura
tener lo campo, ed ora ha Giotto il grido
sì che la fama di colui è oscura.

<div align="center">Purg. xi. 91–6</div>

When Dante, in these famous lines upon the fickleness of fortune, spoke of Giotto, he was recognizing the newly gained pre-eminence of the one artist whose name can in any sense stand on a level with his own; of a man whose fame, like his, would be increased instead of diminished by the achievements of his successors. He was also unwittingly preparing the ground for a pattern of art history, firmly centred upon Florence, which was consolidated by Ghiberti and Vasari and followed by the majority of modern writers. Nevertheless, although Giotto plays what is for an artist a uniquely prominent role in early chronicles and literary sources, our knowledge of his life is not commensurate with his fame. Not one of his surviving works is documented.

Giotto is first mentioned in 1301, as living in the parish of S. Maria Novella, and the documentation of his presence in Florence in 1307 and in eleven of the seventeen years from 1311 to 1326 mainly concerns his family, which eventually totalled eight children by two wives, and his extensive business activities. He made his will in 1312, and in 1313 a claim for the return of household property in Rome implies a longish but not very recent stay in that city. In 1314 six notaries were pursuing debtors in the courts on his behalf. Various dealings in land are recorded of him, and he also hired out looms. The latter was a standard way of putting money to work without infringing the ecclesiastical prohibition of usury, and work it certainly did, at a rate of about 120 per cent a year! If Giotto did indeed write the song on Poverty which is ascribed to him, his distaste for the evils flowing from that Christian state is logical.

A previously independent painters' guild appears to have been incorporated, c. 1315, as a junior partner in the greater Guild of Medici e Speciali in which Giotto seems to have been inscribed, at least by 1320, along with Bernardo Daddi and many others.[1] In December 1328 Giotto was assigned a monthly salary by Robert of Naples. He became a member of the royal household, and payments for lost frescoes and panel paintings are recorded from September 1329 to April 1332, when he was granted a pension. In April 1334 he became capomaestro of the Duomo in Florence. He died in January 1337.

THE ARENA CHAPEL AT PADUA

Despite the dearth of documents, the reconstruction of Giotto's artistic personality is generally agreed, on the evidence of secondary sources, to be founded on the fresco decoration of the Arena Chapel. This leads, as will be seen, to the paradox that he probably signed the three surviving works that bear his name precisely because he had not, for the most part, actually painted them himself.[2]

Giotto is one of the earliest artists to have left his documentary mark, not as a craftsman, but as a man of affairs manipulating capital in

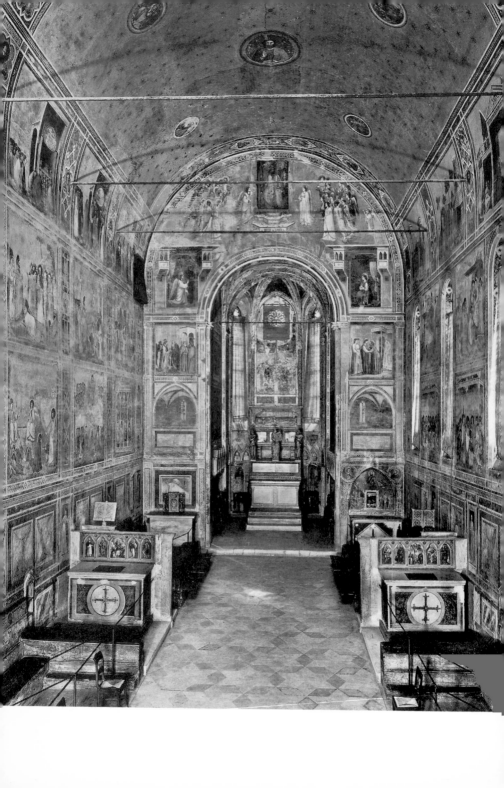

the then nascent world of industry and commerce. Fittingly enough his major surviving commission came from Enrico Scrovegni, heir to the greatest fortune in Padua, and the Arena Chapel may well have been built to atone for the usury, still officially condemned yet unofficially condoned, by which Scrovegni's father made his money. It was for this that Dante placed the latter in the seventh circle of Hell. According to a lost inscription the foundation stone seems to have been laid in 1303, and in March 1305 tapestries from S. Marco in Venice were lent for the consecration. Giotto's frescoes were therefore seemingly painted between 1304 and 1312–13, the probable date of Riccobaldo Ferrarese's *Compilatio Cronologica*, in which he states that Giotto worked in the chapel. By 1313, moreover, Francesco da Barberino had, in his poem, *Documenti d'Amore*, described the figure of Envy, which he attributed to Giotto. This was, because of its position at the bottom of the wall, among the last parts of the decoration to be completed.[3]

The keynote of the existing chapel is its internal and external simplicity.[4] The main body consists of a modest, barrel-vaulted rectangle some 67 feet long, 28 feet wide, and 42 feet high (20·8 by 8·5 by 12·8 m.), preceding the simplest of Gothic choirs [184]. Externally the bare brick surfaces are articulated by plain pilasters linked by pendent blind arcading. Inside there are no pilasters and no columns, nowhere any cornices or mouldings, no ribs running in the vault. Six plain, round-headed windows, totally without surrounds, are the only interruption in one otherwise unbroken side wall. Nothing interrupts the other. Without the painter there is only the inarticulate, bare wall. So clearly is the building planned for painting that it is conceivable that Giotto himself designed it. On the other hand it is obvious that

184. Giotto: Padua, Arena Chapel, painted between 1304 and 1313, looking east

this rich man's chapel is the heir to a long tradition of bare, fresco-begging, tunnel-vaulted country churches like St Francis's own S. Damiano, the Portiuncula, or the Vittorina in Gubbio.[5] A more direct argument against Giotto's architectural authorship is the dislocation in the ordering of his fresco cycle caused by the interruption of the south wall of the chapel by six openings instead of five.

Since there is no competition from the building itself, the painted architecture of the Arena Chapel is, if for no other reason, very different from the massive fictive structure which both complemented and completed the real architecture of the nave of S. Francesco at Assisi [3 and 119]. Here everything is flat, from the painted marble panelling that lines the bases of the walls to the thin, shallow mouldings and Cosmati-work that frame the individual scenes [193]. Similar flat bands of painted marbling run up over the blue barrel of the vault to mark the ends and centre of the space. Competent realism, strictly limited depth, and absolute subordination to the needs of the narrative scenes are the essence of Giotto's painted architectural scheme. The inherent decorative unity is further strengthened by the way in which the light falls upon all the frescoed architecture in the chapel as if from a single source in the window over the entrance. The marble framing is everywhere foreshortened approximately as though seen from normal head-height. The centre of the chapel is, moreover, stressed by the centralized recession of the painted pilasters framing the choir and entrance walls, and by the two small painted chapels which flank the choir. The latter represent the sole attempt at a thoroughgoing illusion of deep, three-dimensional, architectural space.

The story told within this framework is that of man's Redemption and his final Judgement [185].[6] Christ and the Virgin, Saints and Prophets occupy medallions in the vault. Their scrolls occasionally hang over the roundel-rims as if through port-holes in the sky. Over the choir arch God the Father, painted upon panel and therefore a vital and all too often ignored

witness to Giotto's style in this medium, presides over the meeting of the heavenly hosts at which the Virgin was chosen as the means of salvation. Here Giotto makes immediate use of the brand-new text of the Pseudo-Bonaventure's *Meditationes Vitae Christi*. This work only appeared in 1300 or just afterwards, and was itself an attempt to flesh out the sparse gospel narratives with added verisimilitude and human interest. Then, in the uppermost row of frescoes on the side walls, there follows the Life of the Virgin. Starting on the right of the choir arch with the *Expulsion of Joachim*, the story circles the nave to finish on the left with the *Bridal Procession of the Virgin*. Here again the story is elaborated. This time the source is chiefly that more ancient gold-mine, the Apocryphal Gospel of St James the Less, into which, with the surge of popular religion, preacher and painter alike were digging with an enthusiasm only matched by that for Jacopo da Voragine's *Golden Legend* (1263–73).[7] On the choir arch itself, the *Annunciation*, stemming from the scene of heavenly decision above, leads, by way of the *Visitation* on the right face of the arch, to the succeeding eleven episodes of the Youth and Ministry of Christ, beginning with the *Nativity* and the *Adoration of the Magi* with its vivid, up-to-the-minute reference to the appearance of Halley's comet of 1301[8] and ending with the *Expulsion of the Money-Changers*. *Judas receiving the Bribe*, on the left face of the arch, then leads on to the third row, with scenes of the Passion running from the *Last Supper* on the right of the choir round to the *Pentecost* on the left. Where Duccio, following the Roman precedent of the frescoes in St Peter's, gave particular prominence to the *Crucifixion*, here in Giotto's scheme it has no special emphasis. For him and for all those for whom he worked the final climax was not to be reached until at last they came, as all must come, to their own, individual judgement day. In the small quatrefoils between the major scenes appropriate Saints and Prophets and the Old Testament prefigurations of the neighbouring New Testament stories are presented.

Then, at the base of the whole scheme, the painted marble dado is interrupted by grisailles of the *Seven Virtues* on the right and the *Seven Vices* on the left. These are the spiritual qualities that govern human destiny. They represent acceptance or rejection of the opportunity of salvation that is presented to fallen man by the story of Christ's Incarnation, Death, and Resurrection. Finally, the whole entrance wall is occupied by the *Last Judgement*. Here is the climactic moment. Here at last the spiritual drama of mankind is finished, and in the upper sky two angels start to roll away the curtain of the heavens. With them the transient features of the sun and moon are folded up. The flux of history and the flurry of material being is all ended. Now, eternity begins.

Just as the revolutionary painted architectural framework that was to set the pattern for a hundred years was based upon the almost purely decorative articulations of preceding centuries, so too the content of Giotto's scheme derives from earlier models, though the balance has been changed. The *Annunciation* on the choir arch and the *Last Judgement* on the entrance wall, with the Old and New Testament stories in between, is a pattern common in surviving South Italian and Byzantine schemes. Judging from the existing fragments, this may also have been Cavallini's plan for the decoration of S. Cecilia. The coherence and many-sided completeness of the scheme are once again a compact reflection of the late medieval encylopedic tradition. Though now the stress is heavily on Christ's redeeming role, this modest frescoed chapel is a pocket version of the vast stained-glass and stone compendia of the Gothic cathedrals of the North. New, in this context, is the calculated cunning with which the narrative is made to move in a continuous spiral down the walls, revolving about the onlooker as he stands at the clearly indicated centre of the chapel, or leading him from scene to scene, much in the way that Dante and his guide were soon to follow the circling paths that led them ever closer to the visionary heart of the Divine Comedy. The germ of Giotto's innovation is,

KEY

South Wall

1. Expulsion of Joachim
2. Joachim's Return to the Sheepfold
3. Annunciation to Anna
4. Sacrifice of Joachim
5. Vision of Joachim
6. Meeting at the Golden Gate

7. Birth of Christ
8. Adoration of the Magi
9. Presentation of Christ
10. Flight into Egypt
11. Massacre of the Innocents

12. Last Supper
13. Washing of the Feet
14. Judas' Betrayal
15. Christ before Caiaphas
16. Mocking of Christ

East Wall

1. Perspective of chapel
2. Judas receiving the Bribe
3. The Angel of the Annunciation

4. God the Father sending the Angel Gabriel

5. The Virgin of the Annunciation
6. The Visitation
7. Perspective of chapel

North Wall

1. Birth of the Virgin
2. Presentation of the Virgin
3. Wooers bringing the Rods
4. Wooers praying
5. Marriage of the Virgin
6. The Bridal Procession

7. Teaching in the Temple
8. Baptism of Christ
9. Feast of Cana
10. Raising of Lazarus
11. Entry into Jerusalem
12. Cleansing of the Temple

13. Carrying of the Cross
14. Crucifixion
15. Lamentation
16. Resurrection and Noli me tangere
17. Ascension
18. Pentecost

*The decorative dividing panels between the separate story panels are not included, and account for the blank spaces marked * on the extreme left and right of the south wall.

185. Giotto: Padua, Arena Chapel, scheme of decoration, between 1304 and 1313

186. Giotto: Expulsion of Joachim, between 1304 and 1313.
Padua, Arena Chapel

however, present in the solution of a special problem represented by the then unfinished downward-circling narrative mosaics in the great dome of the baptistery in Florence.

Another element long in history and new in treatment is the personal secondary theme that has been woven into the decorative pattern. Enrico Scrovegni, later banished from Padua, himself appears in the *Last Judgement*, on the same scale as the Saints, as he kneels to offer an accurate model of his chapel to the welcoming Virgin. The special emphasis upon the dia-

bolical nature of Judas's Bribe, which stands immediately opposite the hell side of the Last Judgement with its own prominent Judas, may also refer to usury and to the expiatory purpose of the building. Whether or not the two illusory chapels framing the choir arch originally represented painted funerary chambers for Scrovegni and his consort, the subsequent erection of Enrico's tomb behind the altar completed the coherent pattern of this private chapel.[9]

Brilliant as is the decorative and thematic planning, only the individual scenes fully reveal

Giotto's stature. Within the centralized and unitary scheme each fresco is a world unto itself. Each story has its own completeness. Each individual frame is viewed from its own centre-line, so that the architectural perspective never tends to draw the eye away towards some other focus of attention.

The opening earthly scene, the *Expulsion of Joachim from the Temple*, immediately discloses the essentials of Giotto's narrative approach [186]. As in Giovanni Pisano's sculpture, it is only through the story that Giotto's compositions can properly be understood. Here it tells how, at the feast of Dedication, the Jewish people came up to Jerusalem to make their offerings, and Joachim alone, because of his childlessness, an open sign of God's displeasure, was turned away by the High Priests. Giotto has cut the story to the bone. The throngs of those whose offerings were accepted are reduced to a single man, only his head appearing as he kneels within the sanctuary to receive his blessing. On the right a second priest turns Joachim away. The fundamental drama – the stark contrast of acceptance and rejection – is reduced to its simplest terms. Furthermore, by leaving a void upon the right of the design, Giotto has found a way of giving formal, visible expression to a state of mind. The High Priest, who is pushing Joachim away with one hand and wrenching at his cloak with the other, and Joachim's own furrowed brow and his unwilling turning motion are expressive enough. It is, however, the ensuing compositional hiatus that brings out to the full the pathos of this dark night of the soul, and the emptiness of life. When he steps down from the platform of the temple there is nothing, nowhere any hope or consolation, only a dead, brown strip of earth and endless, empty blue. That this is in fact a planned compositional device, and not a chance effect, is indicated by its uniqueness. It is the only example of an open-sided composition in the whole of Giotto's surviving output. This extraordinary ability to find a formal counterpart in terms of areas of paint and colour for the intangibles of spiritual and psychological

states, whether by conscious planning or by intuitive means, is demonstrated over and over again upon the walls of the Arena Chapel.

Every detail of the *Expulsion of Joachim* reveals this same fundamentalism and economy of means. Physically, man has weight and volume. He is vertical. He stands upon the horizontal and unyielding earth. So Giotto concentrates on simple, solid volumes in his figures and gives them the firmest and most clearly horizontal platform that he can. Since the temple is essential to the story, a platform-temple, set obliquely in the manner of Cavallini or of the Master of the St Francis Cycle, is provided. Its every jutting angle testifies to volume, solidity, and recession. The blunting of the forward corner of the platform as it strikes the frame is eloquent of the artist's purpose and of the compositional difficulties which he set himself. At this stage the establishment of a sufficient platform for the action is the term of his ambition and ability. Space ends abruptly at its boundaries, clinging to the sharp edges of tangible reality.

Although he cleaves to the Early Christian and high medieval tradition of representing a building by the principal objects which it contains, there is unprecedented formal cunning in the way that Giotto has used his simple elements to enclose and exclude, to separate and yet connect, to frame and emphasize, the two contrasting groups of figures. The significance of this seemingly peculiar building is not, however, solely structural and formal. The temple, like the action, is reduced to its essentials – to an altar with the ark upon it and a pulpit. It is seen as the prefiguration of the Christian church of which the two central aspects are the sacramental and the predicant. Firstly the church is, through the sacraments, the only channel of God's grace to fallen man, and the prime sacrament is that embodied in the sacrifice of the Mass upon the altar. Secondly it has to tell mankind the good news of redemption and of possible salvation through God's grace: hence the pulpit. As always, every element in Giotto's spare and economical

design is fraught with meaning both for mind and eye. What is more, his own contemporaries would instantly have recognized his temple as no mere symbolic doll's-house structure but an accurate portrayal of an actual twelfth- and thirteenth-century sanctuary enclosure such as still survives as the liturgical and functional focus of such Roman basilicas as S. Clemente [187], with their intimate associations with the Early Christian world. In real life as in fresco, such structures almost beg to be walked round, and Giotto's *Presentation of the Virgin* [188] is, albeit in a form adjusted to the needs of that particular event, a vivid record of the changing spatial relationships between ciborium and pulpit which occur when this is done.[10] In this way Giotto gives new meaning to the third, as well as to the temporal, dimension of the painted unity of place which he, like Duccio, invariably observes in order to bring home to every onlooker the actuality of the unfolding sacred story.

It is already clear how little the descriptive incidentals of Assisi mean for Padua and how thoroughly, in his reading of the text, the Paduan Giotto strips the narrative to the dramatic core. Wherever he does add to or depart from the written sources, it is to underline the spiritual significance of the episode or stress the human drama that is central to it, and often to do both at once. The *Annunciation to Anna* is a good example of the transposition of the incidentals of a story [189]. In the Apocrypha this indoor scene with its significantly empty bed is set in a courtyard, when the location is specified at all. The dramatic fundamentals, the arrival on earth of a messenger from heaven with glad tidings for a suppliant, are brilliantly realized in the sweeping diagonal that knits the whole design together. The structure of the building, the presence of the serving-maid mentioned in Pseudo-Matthew, each plays its part in setting the necessarily static areas of immobile paint in motion. If the stairs and maid are blanked out for a moment, the sense of rushing movement dwindles to a hesitant trickle. The angel sticks in the window, and

187. Rome, S. Clemente, *c.* 1100

static verticals dominate the architectural design and its unbalanced figure content. Awareness of the serving-maid's vital role in building up the continuous diagonal that runs down to the spindle hanging from her outstretched hand, creating a sense of movement in the mind, also reveals the purpose of the particular architectural form of the enclosing building.[11] The placing of the geometric centres of the main and secondary spatial openings on the all-important diagonal connecting the figures becomes as obvious as the function of the parallel diagonal created by the relationship between the high-lit frontal areas of pediment

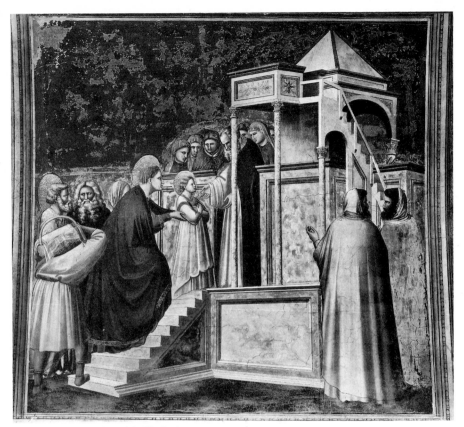

188. Giotto: Presentation of the Virgin, between 1304 and 1313.
Padua, Arena Chapel

and balustrade. The geometric and visual centre of the building as a whole shifts down from the centre of the main opening towards the haloed head of Anna. Her central significance is emphasized and movement is again created, this time in the purest geometric terms. Again, the maid has more than merely formal meaning. Taking up the implications of the text of Pseudo-Matthew, she represents mankind outside the revelation; man unknowing and unmoved by the sacred mysteries. Through her is finally created a dramatic contrast that gives added poignancy to the joy that struggles to the surface of the barren Anna's careworn face.

This same little building reappears in the *Birth of the Virgin* [190], for Giotto anticipates Duccio in the strict observance of the unity of place, repeating a single structure as many as three times when necessary. Instead of vitiating the preceding formal analyses, the repetition strengthens their validity by showing that this convincing spatial enclosure is not merely a single building that happens to have been re-used, but is one that is ideally suited to its dual role. Birth takes place in bed. Consequently the bed, once empty, which in the previous scene was realistically foreshortened, is now revealingly up-tilted. With simple logic, everything

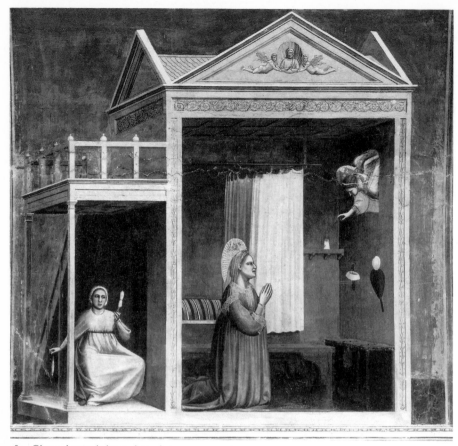

189. Giotto: Annunciation to Anna, between 1304 and 1313.
Padua, Arena Chapel

in the main scene of the *Presentation* of the child and in the secondary episode beneath is horizontally disposed and all the incidental furnishings are similarly rearranged.[12] The repeated verticals of the figures and the horizontal line of heads, enforcing the horizontal of the bed, are carried by the action through the doorway into the subsidiary space. Everywhere the rectilinear relationship of verticals and dominant horizontals is emphasized. The geometric separation of the two spaces, which was so obvious before, is now destroyed, and the

diagonals inherent in the architectural structure are damped down. So firm a vertical and horizontal grid is formed that the building now seems specially designed for this one purpose.

The frequent use of geometric terms in analysing Giotto's designs is symptomatic of the importance of the positioning of figures and architecture upon the pictorial surface, in relation both to each other and to the various compositional diagonals and other obvious dividing lines and subdivisions that reflect the inherent geometrical properties of the pictorial

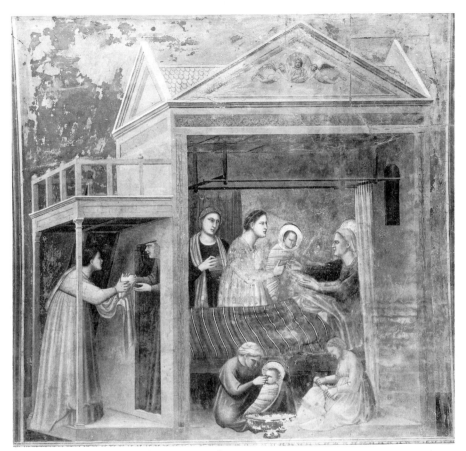

190. Giotto: Birth of the Virgin, between 1304 and 1313.
Padua, Arena Chapel

rectangle.[13] It is almost as vital to the final effect as are the individual solidity of the figures and their interaction across convincingly described pictorial space. The role of Giotto's carefully restricted range of colour is no less essential. It is softer both in hue and texture than that of his Romanesque predecessors. Yet for all the new descriptive naturalism with which it is employed, it still performs the decorative functions so familiar in the older art. Identical colours are still used for figures and for buildings, and for the intervening architectural framework of the scenes, and every aspect of the chapel's decoration is united in a harmony of clear-struck notes. But, in addition, colour is often used directly as a link between one closed and carefully focused composition and another. Time and again the flanking figures in one scene are dressed in the same colours as the central actors in the next.

The basic attitude revealed in the three designs already discussed is both confirmed and amplified in the *Massacre of the Innocents* [194]. Comparison with the organized chaos of Gio-

vanni Pisano's slightly earlier *Massacre* at Pistoia [71], which Giotto almost certainly knew well, or with the swirling drama of the probably more or less contemporary Pisan version, accentuates the fundamental qualities of Giotto's art. Like the sculptor, he concentrates upon the essential ingredients of the gospel story and upon the visual interpretation of its inherent dramatic potential. Herod's order, the army of his executioners, the murdered infants, the resisting mothers; these provide the starting point. Unlike Giovanni, who only builds a compositional scaffolding sufficient to sustain the horror and the wild emotion unleashed by the violent action, Giotto endows the self-same narrative ingredients with the abstract clarity of a mathematical equation. Herod is set apart upon the left. His clear and lonely gesture sets the tragedy in motion. The opposing forces are then marshalled, with the horrified onlookers and the soldiers chiefly on the left and the innocents and their mothers crowded on the right. The conflict of opposing forces is compressed to flash point at the centre in the single stabbing thrust of the foremost soldier's sword and in the immobile and eternally hopeless running pose created momentarily by the foreground child as it is done to death. The bodies of dead children are piled up immediately below to emphasize that this dramatic concentration signifies not murder but a massacre.

Once again each secondary detail has its formal and symbolic meaning. The secular palace on the left, the source of human evil, is opposed to the transcendent spiritual power of the church upon the right. The latter is not just a church but recognizably a Tuscan baptistery. It symbolizes baptism and the accompanying promise of salvation cruelly denied to these unknowing protomartyrs. Whoever will may also read in a contemporary relevance to the continuing struggle between emperor and pope, between Guelph Florence and her Ghibelline enemies and neighbours. These same buildings are not only full of meaning but are formally essential to the design. Seen by themselves the foreground figures create a continuous wall or

bas-relief, closed in at either end, so that the opposing clash of forces is by no means fully expressed in compositional terms. If, on the other hand, the figures are ignored for a moment, there is no continuity, no rest, no centre in the upper half of the design. The empty blue is instantly appraised, and attention then inevitably oscillates between the architectural poles. It is this ceaseless background to-and-fro that activates the clash of forces in the foreground. It splits attention, adds unease to the closed formal unity of the figure design, and isolates the central figure in which the tragic action is epitomized.

Such an elaborate analysis of so simply subtle a design might seem at first to have little to do with the probable methods and intentions of an early-fourteenth-century fresco painter. Its relevance becomes more obvious when it is seen that, just as the open-ended composition of the *Expulsion of Joachim* [186] is unique at Padua, so this single scene designed in terms of open conflict is the sole example of the inclusion of two separate buildings that create opposing centres of attention. Elsewhere throughout his carefully closed designs, with their framing, inward-facing figures, he permits himself only a single building and a single point of architectural concentration. Only at a much later stage in his career, and in the light of a greatly increased compositional skill, does Giotto seem to have felt that the new, realistic, and even aggressive solidity that he demanded of his architecture allowed him to incorporate more than a single structure without endangering the unity of his designs. Indeed, if Giotto's architecture, like his landscapes, is always something more than a mere attribute or habitat, and always plays a positive role in building up his unified and meaningful design, often on several levels, it is also most revealing in itself and in its own development.

The twelve architectural constructions in the uppermost registers, devoted to the early life of the Virgin, may for convenience be divided into four main groups. The first of these, confined to the building repeated in the *Annunciation to*

Anna and the *Birth of the Virgin*, maintains the surface-stressing, foreshortened frontal construction. This was invariably used by Cimabue and by Duccio and is regularly seen, together with the extreme oblique setting, in the work of Cavallini and of the Master of the St Francis Cycle. It is the latter construction that is used by Giotto in five of the remaining scenes in the upper registers. These include the *Presentation*, in which he elaborates the jutting solidity and forty-five-degrees' recession of the architecture of the *Expulsion of Joachim*. Now only the cunning disposition of the enclosing figures, standing to left and right and forcing attention inwards towards the central figure of the Virgin, stops the plunge on into depth along the main lines of recession and blunts the sharpest edges of the forward-thrusting cubic masses. In such a design only a system of checks and balances, thrust and counter-thrust, allows the self-same pictorial elements to act harmoniously both as the basis of the three-dimensional realism of the individual scene and as an integral part of the overall, surface-respecting decorative pattern of the wall. Much the same composition recurs in the *Meeting at the Golden Gate*. Here one arm of the St Andrew's cross which forms the ground plan and concentrates attention on the central action is established by purely architectural, and the other by predominantly figural, means. The close relationship between both scenes and that of the *Mourning of the Clares* at Assisi is consequently underlined. The weakness of connexion, introduced by the absolute horizontal of the bier which at Assisi made a formal link with the adjoining scenes, no longer exists. Here each enclosed and concentrated composition is balanced in and for itself. The figures move convincingly across the bridge or up the steps that stand unambiguously at right angles to the dominant architectural mass. As always in Giotto's work there is clear movement through a clearly constructed space. The *Meeting at the Golden Gate* does, however, differ both from the Assisan fresco and the Paduan *Presentation* in that the steep forty-five-degrees' recession of

the architecture has been modified. Its main front has been swung round closer to the plane, and the shortness of the secondary receding faces, together with their nearness to the border, restrains any apparent tendency for the architectural masses to burst through the surface of the wall. This modified setting is the one which is consistently developed and perfected by Giotto in the scenes from the Childhood, Ministry, and Passion lower down the walls.

It is in Giotto's work that it at last seems possible to test the validity of the belief that this modified, or softened, oblique construction, which becomes almost the hallmark of Giotto's architectural designs, is, like the extreme oblique constructions seen in Rome and at Assisi, connected with a new awareness of the actual recessions that are visible when real solids are examined. The crux lies in the thrice-repeated temple in the scenes of the *Wooers bringing the Rods to the Temple*, the *Wooers praying*, and the *Marriage of the Virgin* [191]. Here the approximations to an accurate vanishing point set slightly to the right of centre, and even to an accurate proportional diminution of the two succeeding squares of the coffered ceilings, are landmarks in the evolution of perspective.[14] They are, however, accompanied by a minimal recession to the left in all the apparently frontal surfaces of the building. The threefold repetition of this slight but definite recession, which recurs in the seemingly foreshortened frontal balcony of the neighbouring *Wedding Procession* and is quite unnoticed by the casual observer, precludes the possibility that it is an accidental rather than an intentional effect. There seems to be no escaping the conclusion that, as he worked on the upper wall at Padua, Giotto was trying out the possibility of combining the wall-hugging quality of the foreshortened frontal construction with the immediate truth to nature which he saw in the oblique construction. It is this alone that can have made it worthwhile to preserve the latter's peculiar qualities even when so refined as to have ceased to all intents

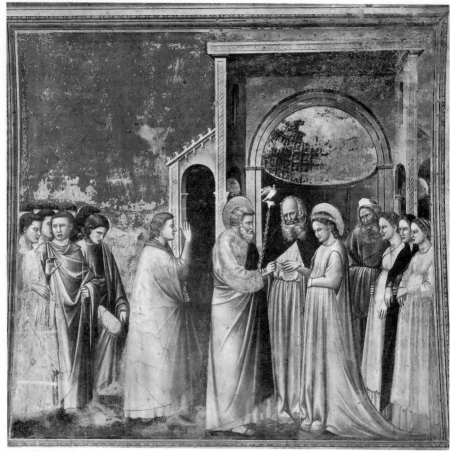

191. Giotto: Marriage of the Virgin, between 1304 and 1313.
Padua, Arena Chapel

and purposes to be a visible factor in the composition. Reduced to a mere intellectual trace, they form a valuable clue to the fundamental nature of the artist's vision of pictorial reality as the counterpart of nature.

Apart from the development of increasingly solid and capacious softened oblique exteriors, the spaciousness and complexity of his interiors grow as Giotto works on down the wall. Beginning with the representation of the interior by means of its internal furnishings, as in the *Expulsion of Joachim* [186], and continuing with

the cut-away constructions of the *Birth of the Virgin* [190] or the *Marriage of the Virgin*, Giotto rapidly develops a near approximation to a true interior. The *Teaching in the Temple* reveals a broad and rhythmically articulated space in which there is abundant head-room for the figures [192]. The outer boundaries of sides and ceiling only just remain within the limits of the frame, which speedily cuts short the vaulted aisles extending to the left and right. As in all but the very earliest of Giotto's buildings, the full depth of the construction is

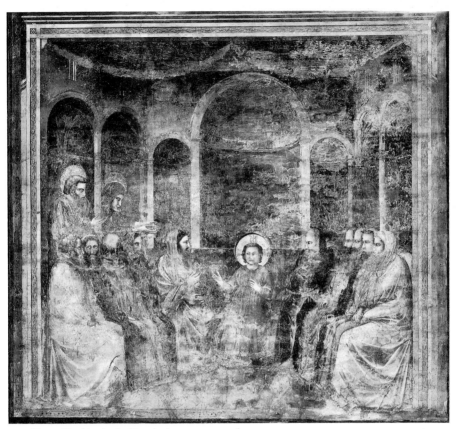

192. Giotto: Teaching in the Temple, between 1304 and 1313.
Padua, Arena Chapel

inhabited by the figures. The curve by which they carve out and define the reality of the space they occupy immediately recalls the Assisan composition of the *Preaching before Honorius* [125]. Now it is more pronounced and is uninterrupted. Still more significantly, it has been organically connected with the hanging curve created by the succession of round-headed arches. The fact that all these space-creating curves also possess a decorative function in the build-up of a surface pattern on the wall is indicated by the green festoons above. These hang completely in the plane. Caught at the ends and centre of the foremost edge of the ceiling, their swinging forms reiterate and stress the architectural pattern of the arches. The cunning, casual way in which these same green swags hang right across the major three-dimensional junctions formed by the meeting of the side walls and the ceiling, means that they mask an otherwise too abrupt intrusion of rectangularity into the curving pattern of the scene. They stop the composition punching out a box-like cavity in the wall. Instead, the whole design

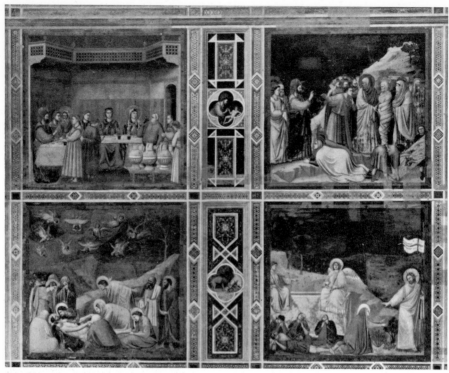

193. Giotto: Feast at Cana, Raising of Lazarus,
Lamentation, and Resurrection, between 1304 and 1313. *Padua, Arena Chapel*

is tied together. Spatial simplicity combines with decorative subtlety. The interplay between, and actual visual equation of, curves lying on the surface and curves set in space leads to a full appreciation of the alternating, dual role of each and every part of the design.

An even more sophisticated example of the same compositional process occurs in the *Feast at Cana* [193]. Here an L-shaped table creates a clearly defined figure-space, the impact of which is carefully softened, but not destroyed, by the servants masking the angle and by the placing of the wine jars and of further standing figures on the right. This arrangement simultaneously permits the creation of a complex, rhythmically articulated grouping of the figures as a whole and becomes a vehicle for a

varied counterpoint of interest and attention, and of individual reaction to the miracle. The space so carefully established and controlled in the lower part of the design is strengthened by the deeply shadowed ceiling canopy. Here again, however, the finials and a tall central vase are used to maintain contact with the surface-stressing, patterned red and green separation bands that mediate between the pictured scene and the realistic marbling of its architectural frame. A demarcation line between these upper and lower areas of controlled spatial definition is formed by the top of a gaily striped wall hanging. The sharpness of the contrast in terms of colour and of pattern make it a striking element in the design. Indeed, a special emphasis is placed upon a virtually straight line that

none the less turns through a right angle at each corner of the room and so encloses the whole pictured space. Features like these become significant precisely because of the new spatial content of such scenes. The way in which they are compositionally stressed places them in a different category from the incidental, space-enclosing straight lines hidden in almost any sufficiently complex architectural perspective.

The emphatically ambivalent, space-enclosing straight line recurs in such later scenes as *Christ before Annas and Caiaphas*. It is among the most revealing of the constant signs of Giotto's concern for the decorative integrity of the wall as an architectural reality. At Assisi this concern was expressed by the visual balancing of scene against scene within a larger decorative pattern. Here, with sixteen or eighteen compositions set in three tiers on each wall, such simple symmetries are no longer possible.[15] It becomes essential that the decorative control of a more and more convincing pictorial space should be obtained within the confines of each individual design. Nevertheless, whenever opportunities do occur to link one scene with another, whether in terms of composition or of meaning, they are invariably taken.[16] The offsetting of the frescoes by the windows in the south wall more or less prevents connexions across the chapel. The most obvious linkages are therefore vertical. The *Raising of Lazarus* is above the *Resurrection* [193]. Furthermore, the bold diagonal of the *Raising* runs down through the *Lamentation*, which itself creates a single formal triangle with the adjacent *Resurrection*. The gospel meaning of the *Raising* as a prefiguration of both lower scenes together is thus visually explicit. Similarly, the *Entry into Jerusalem* is above the *Ascension*; the *Cleansing of the Temple* above the *Pentecost*; the *Baptism of Christ* above the *Crucifixion*; the *Adoration of the Magi* above the *Washing of the Feet*; and the *Massacre of the Innocents* above the *Mocking of Christ* [194 and 195]. In the last three cases the relationship in terms of content is underlined by the clearest compositional connexion. In others, where the link is superficially less obvious, as in the *Teaching in the Temple* and the *Carrying of the Cross*, the formal emphasis upon some special element points to a theologically or devotionally important connexion such as that of the Seven Dolours of the Virgin which was taking definitive form about this time. There are enough such linkages to make it likely that the choice of subjects was influenced to some extent by a desire for maximum frequency. It does not seem to be merely a question of exploiting such casual coincidences as were bound to occur in any extensive cycle ranged in tiers upon a wall.

However much pre-planning may have been involved, there is clear evidence that Giotto's vision and ambition as well as his technical powers expanded rapidly as work progressed. At Assisi stylistic growth was seen within the framework of a team of powerful individuals held to a master's plan. At Padua a single artist with a small group of assistants grapples with a complex problem. There is the same fertile inconsistency, the same shifting, mobile attack, characteristic of expanding genius, which, two centuries later, leaves its mark upon the Sistine ceiling. There is abundant technical evidence of Giotto's willingness to change his mind and modify a composition during execution, and his expanding powers reveal themselves not only in the increasing subtlety and realism of his architectural constructions, but in his growing ability to handle complicated figure fore-shortenings and to use the overlying draperies to describe the underlying forms. Those parts of the relatively restricted areas painted *a secco* in which the uppermost layer of pigment has fallen away to reveal a fully modelled underdrawing are especially interesting in this respect. Whereas such brilliant, descriptive *tours de force* as the sleeping Joachim of the fifth scene are rare upon the upper wall, the boldest of foreshortenings become increasingly common lower down. Conversely, the sack-like standing figures in which the draperies reveal little of the underlying anatomical structure, their smooth, rounded surfaces broken only by the gentlest of fluted or tubular folds, are

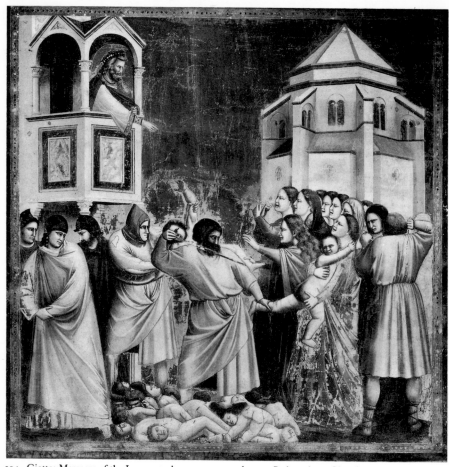

194. Giotto: Massacre of the Innocents, between 1304 and 1313. *Padua, Arena Chapel*

common in the upper scenes. Lower down there is increasing softness, depth, and complexity in the hanging folds. The drapery becomes more obviously the covering of an underlying form and not a full description of the form itself. As the looping patterns created by the stress of movement increase in depth and richness, they tend to lead round into space, creating volume as they disappear from sight instead of lying, more or less completely visible, within the confines of a single surface plane. In its fundamentals the evolution of Giotto's fold forms

is extremely close to that revealed when Nicola Pisano, and after him Giovanni, tackled this same problem.

A growing mastery of the human form is accompanied by increasing compositional fluency. Often, in the earlier scenes, the inward-facing flanking figures which emphasized the central group were isolated from it by a strong caesura. In the lower, later episodes a similar concentration and emphasis upon the centre is obtained within a more supply rhythmic and continuous grouping. The simple ground-plans

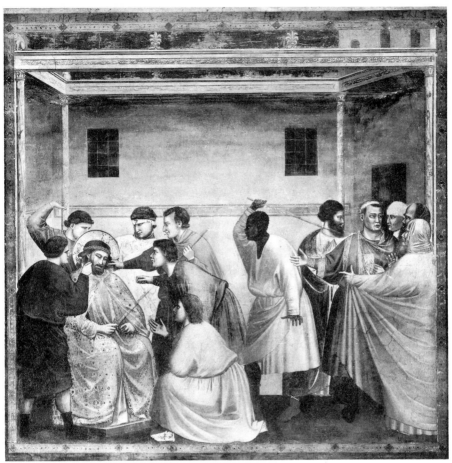

195. Giotto: Mocking of Christ, between 1304 and 1313. *Padua, Arena Chapel*

that described the spatial positions of individuals or connected groups give way to the complexities exemplified in the *Mocking of Christ* [195]. Although the boldest of individual foreshortenings play their part, such scenes as this are chiefly remarkable for the intricacy of the spatial pattern created by the figures, and for the extent to which the group has ceased to congeal into a solid entity, a sort of complex single figure, and has developed, increasingly, into a gathering of physically separate but dramatically connected individuals.

The growing formal complexity of Giotto's compositions never becomes an end in itself. It is merely the vehicle which he uses in his efforts to extend the psychological content and increase the subtlety and variety of individual reaction to a dramatic event. The struggle to increase the emotional and spiritual range of his designs reaches its climax in the *Lamentation* [193]. Except upon the extreme left, each member of a single, rhythmically connected group is an individual entity. Each is individual not merely in the physical terms of volume and spatial

setting but by virtue of a personal reaction, expressed by the inner anguish that sometimes bursts forth into extremes of violent gesture and sometimes is so rigidly restrained and deeply buried as to find its physical outlet only in the tilting of a head. Each figure is worth studying for itself alone. Each makes its own distinctive contribution to a complex, tightly concentrated moment of tragedy which is rendered all the more moving by the severe formal control to which its pictorial expression is still subjected.

The landscape of the *Lamentation* shows that at Padua a growing technical mastery is not expressed in a mere increase of naturalistic detail. As a description of a place, or of natural appearances, it hardly goes beyond the early scenes. There is no attempt to emulate the detailed descriptive realism of Duccio or the Master of the St Francis Cycle. There is a single, leafless tree. All nature is in mourning. A single sweep of rock echoes the great cry and intensifies the anguished gesture of St John. It pins the whole design together, thrusting to its dramatic heart, where the Virgin cradles her dead Son. The function of the landscape is descriptive only to the minimum that is demanded by its primary purpose, which is the intensification of the human drama and the visual expression, not so much of physical movement, as of spiritual outpouring.

The conquest of new heights of naturalism is nevertheless one of Giotto's main achievements. It was seized upon by the earliest commentators and extolled as if it were an end and justification in itself. That it was never seen by him in such a light is proved upon the choir arch of the chapel. In the *Annunciation* [184] the primary need is to enforce the connexion across the intervening space. It was seemingly in order to make them harmonize with the awkwardly shaped field, and to emphasize the flow of the connecting arch, that Giotto constructed his buildings with their side walls receding, not towards the centre, but outwards to the wings, in the manner of the thrones in Cavallini's *Last Judgement* in S. Cecilia in Rome [87]. This allows the gaze of the two painted

figures, as well as the spectator's glance, to slip across the sloping inner walls with ease, instead of being hemmed in by the jutting balconies. The deliberate nature of this device is shown by the almost perfect naturalism of the two small funerary chapels lower down the wall. Here there are no human figures, no dramatic narratives, no psychological dramas. Consequently nothing interferes with the demands of realism, and the two chapels both recede convincingly towards the centre of the space in which the spectator stands. It was apparently neither ignorance nor disinterest in distinctions that were unimportant to him that led Giotto to the suspension or reversal of the rules of realism: it was his own acute though probably intuitive awareness of the role which naturalism played in the totality of his art. As yet there were no theories of perspective, no set rules to hypnotize the artist. Methods were still empirical, still based on inherited skill, on personal observation, and upon the craftsman's sense of what, in any given situation, would produce the most satisfactory total outcome. While the greater part of Giotto's life was occupied, upon one level, by an attempt to see and represent the natural world with an ever greater understanding and fidelity, on another it was principally concerned with translating human spiritual values into visual terms. On the rare occasions when there is a direct conflict between physical realism and the compositional service of spiritual or psychological ends, Giotto is never in the slightest doubt that realism is, in art, a means and not an end.

Although the Arena Chapel everywhere reflects the impress of a single personality, this does not mean that there is everywhere an absolute uniformity of brushwork. After full allowance for damage and restoration, there are still, to take a single example, qualitative and technical differences between the superb head of the Virgin [196], leading the blessed into judgement, and those of the less important figures in the same scene. Such things could be affected not only by a change in hand but also by the speed of execution. The areas of plaster

196. Giotto: Head of the Virgin, detail of the Last Judgement, between 1304 and 1313. *Padua, Arena Chapel*

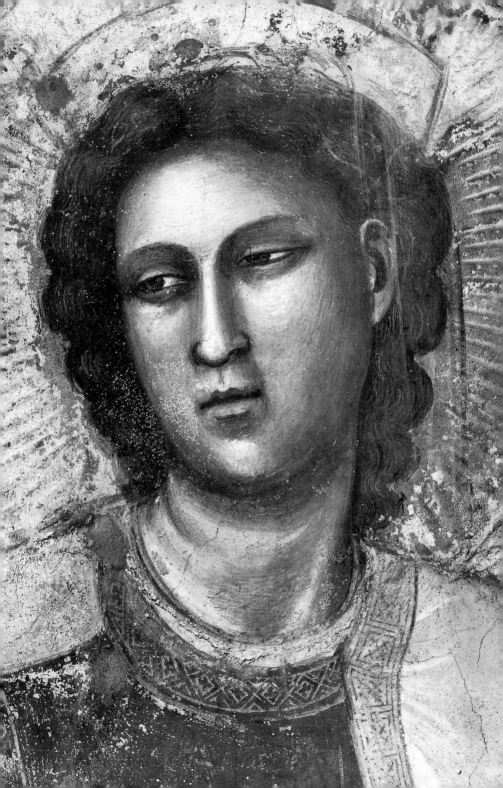

laid down for a day's work show the great divergence between the slow care with which the most important elements were painted and the rapidity with which the less significant were finished. Nevertheless, there are none of the extreme divergences of handling that are characteristic of Assisi. Furthermore, comparison of a single head with any of those in the St Francis Cycle [e.g. 124] is enough to show that the different texture of paint, attributable to a different underlying surface, is only the beginning of the distinctions that must be made between the two sets of frescoes. At Padua there is great continuity in the form-following, form-creating brushwork. The treatment of the fall of light is more organic and more subtle. There is a greater feeling for the softness of flesh and a more dramatic sense of volume, based upon a different approach to form and contour, and accompanied by changes in proportion as radical as those apparent in every individual brush-stroke.

Marked changes of a different kind, involving altered stylization and proportion and different brushwork, despite a similar continuity of stroke, also distinguish the Paduan Giotto from the Isaac Master [115]. Nevertheless, the Roman origins of many aspects of Giotto's style are evident enough. The debt to Cavallini can be seen throughout his work, and not merely in the relationship between the two *Last Judgements*. It is often hard to tell if a particular motif is derived directly from a lost Roman source or indirectly from the latter's reflection in S. Francesco at Assisi. The thrice-repeated temple in the upper register at Padua appears to be a development of that seen in more purely Roman form in the *Teaching in the Temple* at Assisi. There the placing of the figures, but not their relation to the architecture, is, moreover, extremely close to the Paduan version of the *Teaching*. The sweeping rocky diagonal of the Paduan *Lamentation* is a brilliant realization of the potential of the similar, though largely unexploited, rock-form in the Isaac Master's *Lamentation* at Assisi. The elaborate Paduan Cosmati work is yet another direct or indirect

reflection of Roman influence. With certain of the architectural forms it recalls similar developments during the previous twenty years in the architectural and funerary sculpture of Arnolfo di Cambio.

Giotto's essentially sculptural attitude to form is obvious enough. In view of the close similarities between his own basic approach to dramatic narrative and that of Giovanni Pisano, however different the formal result, it seems to be more than coincidental that Scrovegni should have chosen Giovanni to carve the *Virgin and Child* and two attendant *Acolytes* for the main altar of his chapel. The flowing vertical folds of the sculptured Virgin's draperies, breaking as they reach the ground, resemble those of the central figures in the Marriage scene [191]. The looping folds over her hip occur again and again in Giotto's paintings. Although Giovanni's work may not have arrived in Padua in time to influence Giotto directly, it is likely that the latter was thoroughly familiar with the pulpit in Pistoia, a few miles from Florence. If Giotto was patently disinterested in the extreme dramatic Gothicism of Giovanni's narrative figures, there was still much that he could have learnt from the pulpit. The straightforward, solid naturalism, the simple folds and bulky forms of figures such as that of the *Deacon* lead directly to the many similar figures in the Paduan frescoes.

This leads on to a realization of the extent to which Giovanni Pisano, Duccio, and Giotto were not contrasting figures set in opposition to each other, but three men united in the effort to create a common visual language as innovatory as the new vernacular being forged by Dante and his fellow poets. Each spoke a different dialect and each had his own personal vision to express, but the degree to which they were, in their own ways, developing a single language is most easily demonstrated by comparison of three scenes, taken one from each.

As has been stressed already, one of the most fundamental problems with which the new element of three-dimensional realism faced

them all was the need to maintain two-dimensional coherence in their compositions and to link the background landscapes or townscapes to the foreground figures in the service of the story. The continuities and connexions which inform Giovanni's *Adoration of the Magi* on the Pisa pulpit[17] have their counterpart in Giotto's *Noli Me Tangere* [193], where the rock which runs up from the *Lamentation* now sweeps down, past the once bushy trees which draw attention to the empty tomb, to meet the angle of the angel's wing and shoulder. Then, once the fact of resurrection has been taken in, his other wing curves down to blend into the rock form which sweeps on until it is abruptly halted by the vertical of the most important figure, Christ. Furthermore, as Christ looks back and gestures to the Magdalen, ensuring that the human and the spiritual relationship between them is given its full weight, the angle of the rock-slope changes to accommodate and cup his movement, and his outstretched thumb and fingertips appear, as lightly as a feather, to caress the background hillside many feet behind him in pictorial space.

Giotto may well have read Giovanni's message if, as seems quite likely, the relief was carried out soon after the commissioning of the Pisa pulpit in 1302. Duccio surely did so. This is amply demonstrated in his *Harrowing of Hell* upon the *Maestà*. There, the fallen gateway curves into the sweeping countercurve of an exactly similar rock opening. What is more, it meets it at the very point at which Christ grasps the wrist of Abraham to haul him into Heaven. Later, in the *Entry* [176], with exactly these same principles in mind, he made the newly modified base line of the upper wall coincide precisely with the ass's neck which previously had stuck out in the middle of the red road as a contrasting, isolated, and distracting form.

As always in an artist of Giotto's calibre, the contributions of his predecessors are often so thoroughly absorbed that they are difficult to trace. Although the Gothic quadrilobes of the subsidiary fields are French in origin, they had already become acclimatized in Italy through such works as the stained-glass windows of the choir of S. Francesco at Assisi. Just as ivories may well have been stylistic intermediaries for much of Giovanni's sculpture, so the close stylistic connexions between Giotto's paintings and the plain-speaking, life-size naturalism of such mid-thirteenth-century French Gothic sculpture as the *Queen of Sheba* [197] from the west portal at Reims may well be explained by similar intermediaries. Nevertheless, such

197. Queen of Sheba, mid thirteenth century. *Reims Cathedral, west portal*

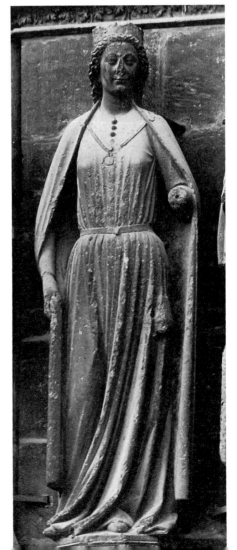

questions are always difficult to resolve and the links with the general figure style, the linear clarity, and the simple weighty fold forms of such monumental sculpture as the *jubé* from Bourges are extremely striking.[18] More subtle still is the relationship expressed in the carefully articulated clarity of parts, the emphasized duality and coordinated unity of space and plane, of line and volume, and the growing sense of geometric discipline, which are common both to Giotto's painting and to the finest flowerings of Italian Gothic architecture.

THE NAVICELLA, THE ARENA CRUCIFIX, AND THE OGNISSANTI MADONNA

Leaving aside the problem of Assisi, the only reasonably firm point in Giotto's earlier career is the cut-down mosaic of the *Navicella* in St Peter's in Rome.[19] A wide range of dates preceding and succeeding the Paduan frescoes has been suggested for its execution. The Holy Year of 1300 was only officially decided upon in February. Despite a traditional connexion with the Jubilee, the immediately succeeding years, therefore, provide the earliest likely date for the mosaic, which was commissioned by Cardinal Stefaneschi. A fairly early date seems, moreover, to be supported by the increased range of gesture and of psychological reaction achieved in the Paduan frescoes.[20] The originally rectangular design was on a scale so vast as to invite comparison with Michelangelo's *Last Judgement*, and as with so much of the Roman work of the preceding thirty years, it was evidently a replacement for a late-fourth- or early-fifth-century forerunner. Two tondo heads of angels, now in the Vatican Grottoes and at Bovile Ernica, have been convincingly connected with the decorative framework of the design. If the attribution is correct, they show the extent to which Giotto, like Cavallini before him, had been inspired by the surviving fifth-century Roman mosaics. The relatively schematic, linear quality of much late-thirteenth- and early-fourteenth-century work is wholly absent. The impressionistic technique and

range of colour both derive from the fifth century. It is impossible to say how much this technique reflects the ideas of Giotto himself and how much those of the skilled mosaicists working under him. The two heads are, however, closely related both to the work of Cavallini, whose art still dominated the Roman scene, and to the basic type of physiognomy developed on the walls of the Arena Chapel. Like the Paduan frescoes they confirm the extent to which Giotto's early style was influenced by the greatest painter of late-thirteenth-century Rome.

Turning from this sole possibly pre-Paduan work to the period contemporary with and immediately succeeding Giotto's activity in the Arena Chapel, two paintings claim attention. The first is the *Crucifix* from the Arena Sacristy. It is linked to the frescoed *Crucifixion* by a virtual identity of style and is undoubtedly a contemporary product of Giotto's workshop. The quiet spirituality and pathos, the soft naturalism of anatomy and flesh which separate Giotto's pictorial 'dolce stil nuovo' from the dramatic thirteenth-century formalism that remains so marked a feature of Cimabue's crucifixes are notably translated into terms of panel painting.

Although it is certainly no minor workshop product, the precise extent of Giotto's personal contribution to the Arena *Crucifix* is problematic. This is emphatically not so in the great altarpiece of the *Virgin and Child Enthroned* from the Church of Ognissanti in Florence [198]. Apart from the ruined panel of God the Father embedded in the frescoes of the Arena Chapel itself, this painting, which everywhere reveals the closest possible affinities with the Paduan frescoes, provides the principal touchstone for the quality of Giotto's work on panel. Not only is its general form so closely developed from the grisaille Justice low on the Arena wall, but the character of the facial details is so similar to that at Padua that it must at least belong to the immediately succeeding years.

The panel is still cast in the late-thirteenth-century mould and demands comparison with

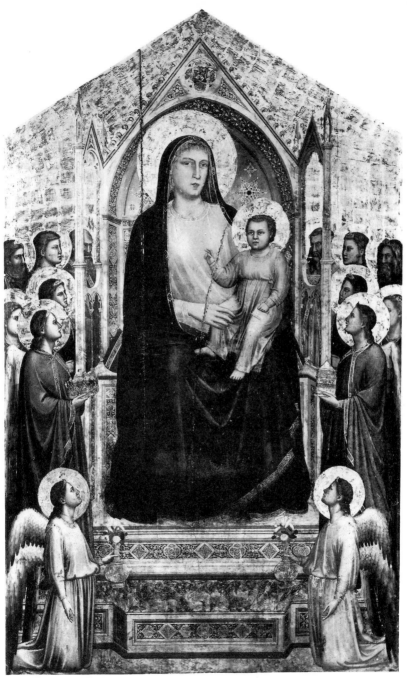

198. Giotto: Ognissanti Madonna, *c.* 1310–15(?).
Florence, Uffizi

Cimabue's *S. Trinita* and Duccio's *Rucellai Madonnas* [100 and 180]. The loss of rhythmic drama and the decreased power of the linear stylization are compensated for by the increased humanity and by the calm rationality of clear volumes set in a clear space. The absolute compositional symmetry of the earlier works is retained, and is reinforced by a simple symmetry in most of the colour and by careful balancing of the few asymmetrically disposed areas about the centre. The fresh, pale clarity of the reds and greens and yellows is an ideal foil for the new simplicity of form. Whether the panel as a whole or any detail is inspected, the calm grandeur of the fresco painter's art suffuses it and gains new sharpness and intensity from the delicacy and precision of stroke permitted by the different medium. It is no wonder that it should be the most influential single painting of the entire fourteenth century. Like the major works of Coppo and of Guido, of Cimabue and of Duccio, it has never, on its own terms, been surpassed.

199. Giotto:
Florence, S. Croce, Bardi Chapel,
scheme of decoration,
c. 1315–20(?)

THE BARDI AND PERUZZI CHAPELS

Complete uncertainty surrounds a possible trip to Avignon of which all trace is lost. The documented Neapolitan works of 1328–32 are all destroyed. This means that Giotto's culminating achievement as a fresco painter now lies in the decoration of the adjoining chapels of the Bardi and Peruzzi families in Arnolfo's then unfinished church of S. Croce in Florence. Despite the lack of documentation and the probable lapse of more than a decade, the stylistic links with Padua are so close as to allow no doubt of Giotto's authorship, although the hands of several helpers are particularly apparent in the Bardi Chapel [199], which is almost certainly the earlier of the two, and quite wide variations in technique, especially as regards the *Dance of Salome*, are also visible in the Peruzzi Chapel.[21]

Here, in the monastery which was the 'university' of the Franciscans, Giotto, the artist-businessman, was working for two of the richest of the banking houses on which the Florentine financial empire was based. Both were leading bankers for the papacy and for the allied kingdom of Naples. Ridolfo de' Bardi was, indeed, an especially favoured agent of King Robert. The desire to forge yet closer links between Guelph Florence and Angevin Naples,

as well as the completion of the iconographic pattern, was clearly furthered by the chance to depict St Louis of Toulouse, King Robert's brother. A tendency to use haloed representations as part of a propagandist process for the promotion of a canonization renders it uncertain that the Bardi Chapel was painted after St Louis was canonized in 1317, although on stylistic grounds a latish date involves no difficulties. The same crisp, pale Cosmati work as in the Arena Chapel reiterates the colouristic play of the figures and architecture incorporated in the narratives. It enlivens a painted framework that is used as a positive support of the real architecture of Arnolfo's Gothic chapel. The ribbing of the vaults is now held up by painted columns, and the painted niches of the saints elaborate the interaction with the real architectural forms.

Within this crisply illusionistic and yet largely planar framework the six scenes from the life of St Francis alternate from wall to wall. The lunette on the left, with St Francis's *Renunciation*, demonstrates Giotto's ability to combine a jutting architectural mass that fully exploits the semicircular field with a centralized figure design that fills the forward plane. While the architectural knife-edge, blunted by the figure of St Francis himself, emphasizes the all-important centre of attention, the receding side-wall of the massive structure bridges the dramatic gap across which the straining father tries to rush. The contrast with the composition at Assisi, the wholly different principles of design and of narrative description evolved at Padua, and here confirmed, are clear enough. The question is whether the lapse of years and the altered organizational problem offered by this restricted cycle are a sufficient explanation, or whether a different guiding hand must be envisaged.

A Paduan economy and concentration are combined with a new sophistication in the *Apparition at Arles* [200]. The planar stress and careful limitation of clearly defined architectural space, characteristic of all the Bardi frescoes; the concentration on the central figures; the seemingly organic growth of a design

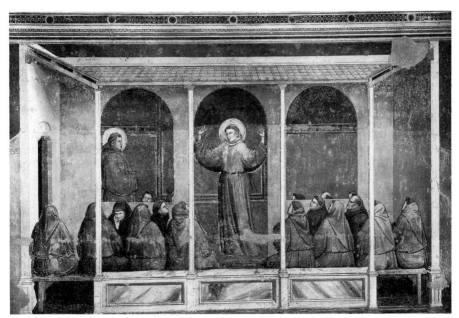

200. Giotto: Apparition at Arles, *c.* 1315–20(?).
Florence, S. Croce, Bardi Chapel

that fuses figures and architecture for a single, meaningful, dramatic moment, are present in all their simple-seeming subtlety. Plane succeeds plane within an almost wholly unadorned architectural structure. The building provides a frame for each of the main figures. The triple arches pull attention in from either wing. The simple vertical formed by St Anthony on the left runs up into the linking arch above, and a horizontal cornice gives material substance to the direction of his gaze. The hands of the stigmatized St Francis close and repeat the curve of the arch above him. Over his shoulder in the background looms a frescoed Crucifix. Considered by itself, the comparable scene in S. Francesco, so well adapted to its own particular context, seems, despite the similar framing of the principal figures and the semi-architectural function of the audience, to be cluttered, gay, and casually descriptive [125].

Nevertheless, it is perhaps the *Trial by Fire* on the other wall that sets the seal on Giotto's narrative genius [201]. At Assisi the design

moved steadily from the right: first the Sultan giving the command; then St Francis walking to the fire to prove his faith; the fire itself; and finally the Muslims turning from the flames in fear. It is a simple, flowing, non-dramatic sequence of events. In S. Croce, on the other hand, by placing the Sultan high upon his throne at the centre of the shallow courtyard space, with St Francis on the right, facing inwards to the fire, and the Muslims on the left, Giotto has given formal being to the latent drama. It is the very embodiment of the idea of judgement. The eye goes back and forth, back and forth, from left to right and right to left, during the endless moment of decision, searching to see which way the scales will tilt, and savouring the instant of dramatic resolution as the saint steps forward and his adversaries shrink away. Domenico Ghirlandaio could do no more in S. Maria Novella a century and a half later, and Raphael was happy to adapt this same solution to his scene of Judgement in the Sistine tapestries.

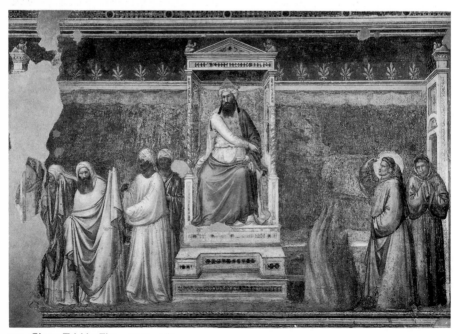

201. Giotto: Trial by Fire, *c.* 1315–20(?).
Florence, S. Croce, Bardi Chapel

An interesting detail of the *Trial* is the way in which the Muslims' cloaks, freed from strictly form-defining functions, fall into Gothic folds of an unprecedented decorative quality. Indeed, the treatment of these figures recalls the back of Duccio's *Maestà* [175], and Giotto may well have seen and appreciated this recently completed work, which must have been the talk of Tuscany. Certainly a new delicacy and sensitivity of colour distinguish the entire scheme. The only other point at which Giotto seems to have felt himself free to experiment with the northern decorative forms is in the figure of St Elizabeth in her niche. The similarity to the niche-enclosed rows of figures on the entrance wall of the nave at Reims is striking.[22] The equally close stylistic bonds between the Reims figures and those of Giovanni Pisano, and the abundance of French Gothic ivories undoubtedly available in Italy by the second decade of the fourteenth century, seem, however, to show that here is one more witness to the faithfulness with which the patterns of French monumental art could be transmitted across Europe.

In the Peruzzi as in the Bardi Chapel, light falls on the painted architecture from the real windows, and the perspective of the scenes is approximately related to a spectator standing just inside the chapel. The decorative separation bands that intervene between the framework and the scene itself are only dispensed with in the uppermost frescoes. The meaningful nature of this distinction in degrees of illusionism, already observed upon the side walls of the Arena Chapel, is stressed by the fact that it is only where the frame becomes an unmodified window through into a new reality that the figures, whether in the Paduan *Last Judgement* or in the Peruzzi *St John on Patmos*, are allowed to overlap it and break down the separation of the real and the pictorial worlds. Instead of the centralized construction of the Bardi Chapel it is, with one exception, the Paduan, softened oblique construction that is developed here. For the first time in Giotto's work the architecture of the scenes is boldly cut by the frame where formerly there was a mere truncation of sub-sidiary elements. This may well reflect the superimposition of Duccio's bold innovations on Cavallini's isolated experiments with similar effects. Now, carefully coordinated architectural complexes can be incorporated in a single fresco, and the domination of the single, isolated block is broken.

The *Dance of Salome* at the base of the left wall, which is devoted to three scenes from the life of St John the Baptist [202], that opposite being given to St John the Evangelist, exemplifies the new, controlled complexity and continuity of design [203]. The relatively small size of the figures may reflect the unusual demands of the continuous narrative, but there is no doubt that the detailed handling also differs in a number of respects from that in the *Assumption of St John* on the opposite wall and elsewhere. On the other hand, the steady six-stage downward march of the scaffolding which reached from wall to wall, each level being plastered as a whole before, in this case, being painted *a secco*, proves that variations of this kind emerged within the confines of a single, unified campaign. The fresco's central theme is picked up by the dancing delicacy of the architectural forms with their numerous classical reminiscences. The loss of the decapitated body of St John from the facsimile of the Roman Torre delle Milizie upon the left destroys the balance of this rare example of Giotto's use of the multiple scene. Nevertheless, the rhythmic linkage of the figures, cunningly related to the smoothly articulated flow of architectural space, is still appreciable. The sweep of drapery which unites the two representations of Salome on the right reflects the same imaginative subtlety as the diagonal stripes on the musician's tunic which, when seen together with the cocking of the wrist that signifies the end of one stroke and the beginning of another, sets his bow in rapid motion. In the *Assumption of St John* it is a similar flight of genius to have devised the optical trickery of converging golden rays to lift the sack-like figure of the Evangelist into leaping movement through the air. There, however, it is the final

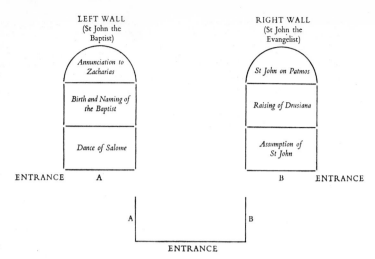

LEFT WALL
(St John the
Baptist)

*Annunciation to
Zacharias*

*Birth and Naming of
the Baptist*

Dance of Salome

ENTRANCE A

RIGHT WALL
(St John the
Evangelist)

St John on Patmos

Raising of Drusiana

*Assumption of
St John*

B ENTRANCE

A B

ENTRANCE

202. Giotto: Florence, S. Croce,
Peruzzi Chapel, scheme of decoration, mid 1320s(?)

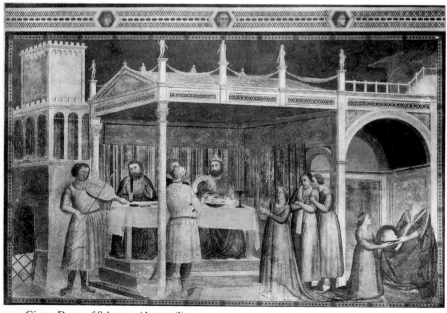

203. Giotto: Dance of Salome, mid 1320s(?)
Florence, S. Croce, Peruzzi Chapel

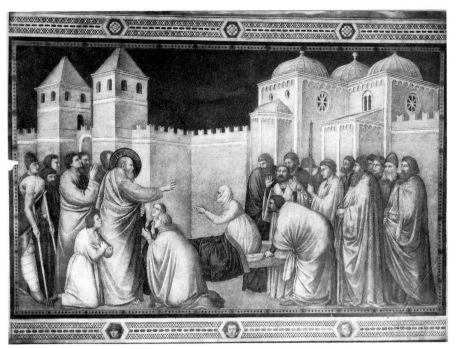

204. Giotto: Raising of Drusiana, mid 1320s(?).
Florence, S. Croce, Peruzzi Chapel

flowering of Giotto's ability to display the
psychological response to a miraculous event
that is all-important. The range of gesture and
reaction constitutes one of the early textbooks
on the subject. It is one which Michelangelo
was not ashamed to use almost two centuries
later.

Nevertheless, the peak of Giotto's achieve-
ment is possibly the *Raising of Drusiana* [204].
Here, not a single massive building, but a for-
tress city, towering above the mighty figures
gathered in the foreground, is suggested. It is
a long stride from the world of Cimabue to
these buildings that are likewise used to em-
phasize and to express the relative masses of the
foreground figure groups. Stretching con-
tinuously in soft recession to the left, from one
side of the composition to the other, the central
reaches of the wall make an ideal, calm foil for
the dramatic moment of return from death. The

frame in no way marks the limits of the wall or
suggests that its ends lie just outside the picture
space. The tyranny of the single solid, with its
limited, clinging envelope of space, is ended.
The spatial continuity towards which Giotto
had been striving from the start is finally estab-
lished, and a similar continuity and coor-
dination characterize the figure groups. The
Paduan experiments of such scenes as the
Mocking of Christ [195] have been consolidated.
Not only strictly limited groups but crowds can
now be represented without danger of con-
gealing into solid blocks. The sense of inter-
penetrating space and of the individuality of
the grandly monumental figures is consistently
maintained. The structure of each figure is
sufficiently secure for the Gothic, form-defining
folds to be allowed new richness. Instead of
hanging free, as in the Bardi *Trial* [201], they
invariably curve round in space, establishing

the underlying volumes from which they themselves are none the less distinct.

The frequent mention of the great Renaissance artists reflects both Giotto's stature and the fundamental nature of his achievement. These small chapels were the schools of the Renaissance. They were used by artists whose own technical powers, even in their youth, extended far beyond the range of Giotto's dreams. Nevertheless, a comparison between the *Raising of Drusiana* [204] and Duccio's *Entry into Jerusalem* [176] shows exactly at what cost in terms of discipline and concentration Giotto's advances were achieved. Nowhere in Giotto's output, much less in his own Paduan *Entry*, are there such a sense of landscape, such reflections of the pulsating, casual multiplicity and varied beauty of the natural world. Yet these are equally valid aspects of experienced reality. For Giotto the hill-climbing compromise derived from the tip-tilted flatness of Byzantine prototypes was inconceivable. The fundamental physical reality of man is vertical solidity upon a solid, horizontal ground. The fundamental quality of the earth is flatness, and no depth was meaningful to him unless it could be measured out on level ground. No modified solidity in his figures was acceptable for the sake of greater numbers. His dogged assault on the representation of certain fundamentals of the physical world, upon the portrayal of man's spiritual and psychological reactions to events, and of the deep significance which he saw in these events, was only rendered possible by a concentration of interest and effort similar in intensity to the concentration of attention characteristic of his compositions. It was through the creation of a strictly limited ideal that he was able to encompass so much of the real.

To turn from the Roman, pre-Renaissance *gravitas* of the Peruzzi Chapel frescoes to Giotto's three major signed panel paintings is to move into another world. The weakness of the actual brushwork of the *Stigmatization of St Francis* in the Louvre [205] when set against the handling of the Ognissanti *Madonna* [198];

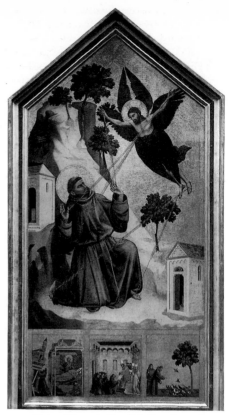

205. Giotto: Stigmatization of St Francis, early fourteenth century. *Paris, Louvre*

the stiff, almost unmodified Assisan pose of St Francis when compared with the lively torsion and iconographic originality of the fresco over the entrance to the Bardi Chapel, are alone enough to prove that this is for the most part no more than a workshop product. The abysmal drop in quality in the signed altarpiece in Bologna is redolent of the same state of affairs. Even in the qualitatively superior *Coronation of the Virgin* in the Baroncelli Chapel in S. Croce, its particular qualities of colouristic delicacy and structural softness do not appear to stem from Giotto's own hand. Undoubtedly his alone, however, is the compositional innovation

of turning the five compartments of the Gothic polyptych, now encased in a Renaissance frame, into a unified arcade through which a single space and one continuous composition, concentrating all attention on the central action, can be glimpsed. It is the counterpart in panel of the spatial and decorative unity which he alone could have achieved in the frescoes of the Bardi and Peruzzi Chapels.

Attributionally speaking, the prime significance of these three panels is precisely that they seem to show that Giotto signed those major products of his workshop which he had largely not himself painted.[23] These were the works that were in need of the protection of a signature to prove their provenance. In the panels that he carried out himself his brushwork was its own endorsement. This, if true, reveals the not unexpected extent of the commercial organization of his workshop. It also shows, though paradoxically, the degree to which this artist, of whom Petrarch says in his will that his great excellence was little understood by the common run of men,[24] was himself conscious of the nascent modern concept of personal style which Giovanni Pisano's querulous inscriptions had already partially expressed.

The extent to which the new conceptions had taken hold, or to which they correspond to the modern concept of personal production, must not, however, be exaggerated. A fresco painter's normal quota of assistants might, as in S. Francesco at Assisi, become a veritable army that contained a number of independent masters. In sculpture this was also true of Nicola and Giovanni Pisano's later pulpits. Throughout the thirteenth and fourteenth centuries a number of hands would often play a greater or a lesser role in the actual painting of a single fresco or panel. The first stage in the execution of a fresco was a rough, sinopia sketch upon the wall itself or on one of the underlayers of plaster that provided the foundation for the final surface.[25] In this, the fresco painters substantially followed the mosaicists' method. The actual painting could be carried out in one of two techniques. It could be done in what is called true fresco, while the plaster was still wet, so that the earth pigments, suspended in the lime water, became bonded into the surface of the plaster. This difficult technique, which demands great speed and accuracy, only became popular in the late thirteenth century. The painting could, on the other hand, be done *a secco*, after the drying of the final layer of plaster. In this case some organic glue, often of egg-yolk, as in tempera painting upon panel, would be added in order to obtain adhesion to the hardened surface. The paint remains, however, as a superimposed layer, and it is impossible to match the bonding effect and consequent durability of true fresco by these means. Since certain colours such as vermilion, azure blue, or verdigris could only be painted *a secco*, the majority of late-thirteenth- and fourteenth-century frescoes are, if only for this reason, painted in a mixed technique. Often the heads and hands alone would be painted in the wet plaster. It is because of this, and not because of the selective zeal of generations of restorers, that the heads may stand out as if freshly painted from an otherwise entirely ruined fresco. Apart from the completion *a secco* of forms begun in true fresco, there is finally a compromise, known as *fresco secco*, in which the previously dried plaster is re-wetted before the pigments, suspended in lime water, are applied.

In the Arena Chapel an unusually high proportion of the work was carried out in true fresco, *a secco* painting being largely confined to the colours which it was technically impossible to handle in this way. As at Assisi, this meant that only enough of the final layer of plaster for a single day's painting could be laid at once, so that the progress of the work and the divisions of day stages can still be estimated. Particularly where large numbers of assistants were involved, however, much more work would be done *a secco* on the basis of the underdrawing. Giotto's underdrawings, usually executed on the final surface, were frequently, though not always, much more than mere compositional sketches to be used as a general guide for himself or his assistants: they were

fully worked-up drawings which could then play their part in the final modelling of a set of draperies. In the Bardi Chapel rather more work than at Padua was done *a secco*, and in the Peruzzi Chapel, as was earlier mentioned, the plaster was applied half a scene at a time and almost all painted *a secco*.

Except that in panel painting the wooden surface was covered by a layer of gesso which bore the underdrawing or the incised guide-lines; that all the painting was *a secco*; and that between the underdrawing and the final processes of modelling, various kinds of under-painting, as for example a flat layer of green beneath the areas reserved for flesh, would nor-

mally intervene, the sequences of work in the two media were similar. Even in panel painting several hands could work at one time or another on different, often closely adjoining, areas of design. The various subsidiary techniques of gilding, such as the punching and incising of designs on draperies as well as on haloes, further complicate the division of labour. It is less immediately obvious that different men could also carry out successive stages in the painting of the same area. This is vitally important in matters of attribution and of the separation of hands, which are too often considered solely in terms of area. The extent to which the suc-cession of processes within a single area or detail

206. Giotto Circle: Stefaneschi Altarpiece, late 1320s–early 1330s.
Rome, Vatican

can render confident assertions meaningless is far too seldom recognized. Similarly, innumerable permutations could, and evidently did, occur in wall paintings executed in a mixed technique. As will be seen in discussing the façade of Orvieto Cathedral, the succession of processes is still more complex where sculpture is concerned.[26] The resulting situation is therefore correspondingly more confused.

These purely technical considerations are a major factor in creating the aura of uncertain and continually contested attributions that surrounds each fourteenth-century artist's name. Even an unqualified attribution to a given artist amounts to no more than the assertion of a certain degree of stylistic similarity, and while the continuing effort to refine the concept of an artist's style is always valuable, there will, inevitably, always be a large proportion of late medieval works of art for which the attributional definitions can only be given greater precision exactly in so far as they grow more and more meaningless in relation to the way in which the work involved was actually produced. These observations are directly relevant to such apparent products of Giotto's Florentine workshop as the panel of the *Dormition* from Ognissanti in Florence, now in Berlin. This panel, with its grandeur of conception and fluc-

tuating quality, is the last important work that can with any confidence be attributed to this source. The altarpiece which, in 1342, was stated, in the necrology of the same Cardinal Stefaneschi who was so closely connected with Pietro Cavallini, to have been commissioned from Giotto for the high altar of St Peter's [206] presents a different kind of attributional complication. Stylistically it can hardly be the work of Giotto, nor yet of his Florentine workshop. If the necrology is right, it can only be the product of some temporary atelier set up by Giotto during one of his Roman sojourns.[27] The shop may well have been commercially controlled by him, but only in the vaguest sense does this imposing altarpiece seem to reflect the artistic personality that lies at the foundations of the Renaissance. To move still farther afield, the S. Maria Novella Crucifix, persistently attributed to Giotto on uncertain documentary grounds[28] and reminiscent both of the Isaac Master and of work by various hands in the *Legend of St Francis* at Assisi, exemplifies a class of major paintings of all kinds which are clearly related to this, that, and the other, yet are of patently uncertain authorship. The understanding and appreciation of such works are better served by realistic anonymity than by irrational assignment to some famous name.

THE ASSISI PROBLEM

The first of the interlocking questions involved in any reasoned attack on the problem of whether or not Giotto is one and the same man as the Isaac Master, or the Master of the St Francis Cycle, or both, is that of the date of the *Legend of St Francis* at Assisi.

The obvious possibility is that the initial source of the commission was the Bull promulgated by Nicholas IV in May 1288 – 'facere conservare, reparari, aedificare, emendare, ampliare, aptari, et ornari praefatas ecclesias'. Certainly the *Dream of Innocent III* [119] is reasonable proof that this, the sixth fresco in the series, was not carried out before the completion of Nicholas IV's reconstruction of the Lateran portico in 1291.[1] If, on the other hand, the fresco of the *Four Doctors* in the entrance vault is held not to have been painted before the institution of their feast day in 1296, and the Isaac Master's frescoes on the side walls are also placed after this date, then it is unlikely that the *Legend of St Francis* was painted much before the turn of the century. This chain of argument is, however, anything but secure.[2] Despite the story promulgated by Vasari in 1568, it is also slightly unlikely, although by no means impossible, that the commission followed the installation of Fra Giovanni di Muro della Marca as Minister General of the Order in 1296. In any case he can hardly have been directly connected with it, since he was specifically appointed to try to close the widening breach between the Observant and Conventual factions in the Order over the meaning of Franciscan poverty, and such a commission would have been well calculated to exacerbate an already difficult situation.

Since the opening fresco can no longer be argued to refer to events preceding 1305, there is no secure internal evidence about the date by which the cycle was completed.[3] The earliest

terminus is provided by Giuliano da Rimini's Boston altarpiece, signed and dated 1307 [257]. It is, however, only valid if it is accepted that, in a panel revealing a general dependence on fresco painting, the extremely close, detailed relationship between the *Stigmatization of St Francis* and the corresponding scene at Assisi demonstrates Giuliano's direct dependence on the fresco cycle. Nevertheless, the relative rarity of the particular iconographic pattern established in this, the last of the scenes normally attributed to the Master of the St Francis Cycle himself, and the undeniable dependence of the figure of St Clare on that in the Chapel of St Nicholas in the lower church, increase the likelihood that the supposition is correct.[4] If this date is, none the less, rejected, then the only other possible and reasonably early *terminus* is that provided by the assertion in Riccobaldo Ferrarese's *Compilatio Cronologica* that there was work by Giotto at Assisi. This appears to have been written between 1312–13 and c. 1318, with the probabilities favouring the earlier date.[5] Unfortunately, there is no proof whatsoever that the statement refers to the *Legend of St Francis*.

Isolated from purely stylistic considerations, the dating evidence for the *Legend of St Francis* leads to the conclusion that it was carried out almost certainly after 1290–1, not necessarily after 1296, and very probably before 1307. The similar, but wholly secure bracket for Giotto's decoration of the Arena Chapel is from c. 1304 (that is between the foundation of the chapel in 1303 and its consecration in March 1305) to 1313. By that time Francesco da Barberino's *Documenti d'Amore*, in which one of Giotto's lowest and therefore latest frescoes is described, had definitely been written.[6]

If the Bull of 1288 is accepted as the source of the commission for the St Francis Cycle, the

question then arises as to whether it is also the source of Cimabue's work in the choir and transepts and, indeed, of the whole of the decoration of the upper church. If it is, then this entire sequence of work with its considerable stylistic range, involving at least four main groups of painters, must be seen as representing, not a chronological sequence, but a more or less contemporary confluence of masters, belonging to separate though related schools, whose differing stylistic backgrounds were reflected in varying degrees of conservatism or modernity. Such a view would be more tenable were it not for the seemingly quite steady stylistic development that stretches from the vault of the choir to its lower walls, and onwards from the vaults of the nave to its own lower surfaces. It is rendered even more improbable by the evidence, in the *Presentation* on the upper left wall of the nave, both of an interruption or cessation of the work and of the actual over-painting of the stylistically more antiquated elements.[7] If the work either of Cimabue or of the Master of the St Francis Cycle is, on the other hand, to be removed from the shelter of the Bull of 1288, the movement must be made upon stylistic grounds alone. This would lead to the not unusual situation that neither the source of the commission nor the method of payment could now be explained. None of these points need any substantial modification if attention is switched from the Master of the St Francis Cycle to the Isaac Master.

It has already been shown that the reference to the Orsini family in Cimabue's fresco of St Mark probably reflects the union of temporal and spiritual power in the person of Nicholas III (1277–80).[8] If it does not, it may refer to any of a number of scattered dates spanning the whole of the last quarter of the thirteenth century. Furthermore, a connexion with the Bull of 1288 is difficult to maintain in face of the apparent relationship between Cimabue's frescoes and the spatially more advanced design of the Siena oculus of 1287–8.[9] There is, therefore, no particular reason to dispute the actual existence of the apparent chronological gap that

separates the work of Cimabue from that of the Isaac Master or, more radically still, from that of the Master of the St Francis Cycle. On the other hand the acceptance of such an interval does not necessitate a dating later than the early nineties for either of the latter artists' frescoes in the nave. Such a dating might well be modified by five or ten years for other reasons. Complete rejection, rather than modification, could, however, only be justified by the impossibility of accepting the validity of the historical development sketched in the preceding chapters, and by refusing to believe that such narrative richness and such detailed multiplicity of natural observation could have been achieved so early.

If, despite the inherent difficulties, rejection of the idea of a simultaneous campaign throughout the upper church is still combined with a desire to connect Cimabue's activities with the Bull of 1288, a number of further factors must be considered. If either of the series of frescoes attributed to the Isaac Master or the Master of the St Francis Cycle are to be assigned to Giotto, they must, upon stylistic grounds, be dated before the Arena Chapel frescoes of between c. 1304 and 1313. It is inconceivable that any of the frescoes at Assisi could have intervened at any subsequent point in his career. Problems of date and style can seldom be divorced, however, and the attribution of the Assisan frescoes to the pre-Paduan Giotto immediately involves the problem of his date of birth.

Acceptance of the birth date of 1266–7 implied in the *Ottimo Commento*, which was probably written by Ser Andrea Lancia, who was active in Florentine affairs in Giotto's lifetime, would entail no difficulty at Assisi. On the other hand the reference to Giotto as being 'satis juvenis' – 'young enough' – at Padua, contained in Benvenuto da Imola's Dante Commentary, might seem to be rather unusual, if technically defensible, as a medieval description of an artist of at least forty. If, instead, reliance is placed on the birth date of 1276 given by Vasari after the lapse of a hundred and fifty years and repeated by Billi, identification with

the Isaac Master or the Master of the St Francis Cycle may entail Giotto's being in control of an extensive workshop or of a large team of independent masters while still in his late teens or early twenties.[10]

As far as Giotto's connexion with Assisi is concerned, the early literary sources present one major difficulty. The author of the *Ottimo Commento*, who lived in Florence, who emphasized his personal knowledge and stressed that Giotto 'was and is amongst the painters known to men the most outstanding and is of the same city of Florence', nevertheless fails to mention the artist's activity at Assisi. No modern concepts of the significance or otherwise of juvenilia would have influenced a medieval commentator dealing with what must have then ranked among the most important modern fresco cycles in Italy and among the largest of the painter's commissions. What he does specifically mention is Giotto's activity in Rome, Naples, Avignon, Florence, and Padua. With the exception of Avignon, for which no reasonable evidence one way or the other now exists, all these references are confirmed by surviving or by documented works. The omission of Assisi is therefore extremely serious.

It is, however, on the stylistic level that the difficulties entailed in accepting Giotto's responsibility for any of the frescoes at Assisi become acute. If his personal hand is identified with that of the Master of the St Francis Cycle himself, the many important stylistic variations between Assisi on the one side and Padua and Florence on the other must be explained. Although the radically different approach to painted architectural framing and to compositional methods, whether within the individual scenes or in the cycles as a whole, may well be linked to some extent to the contrasting characteristics of the real architecture, the profoundly differing attitudes to narrative and to the portrayal of nature are not so easily reconciled. Furthermore, the transformation in the organization of the brush-strokes and in the manner of laying on the paint, as well as in such matters as facial proportions and the detailed

drawing of eyes and mouths and so forth, still need explaining, even when allowance has been made for the modifications that the concept of an artist's personal hand must undergo when dealing with the cooperative craftsmanship of a medieval painter's workshop. Notwithstanding the memory of Nicola Pisano's stylistic transformation in the short five years between the Pisan and the Sienese pulpits, this is no mean task. Even Nicola Pisano himself can provide no ready parallel when the apparent stylistic development at Assisi is correlated with that seen at Padua and continued in S. Croce. It involves accepting the idea of an artist who, having at Assisi tentatively begun to tackle the detailed problems of descriptive naturalism, gradually developed an increasingly complex and controlled technique for handling anything from crowds to landscapes or interiors or anatomical foreshortenings. Then, moving on to Padua, he totally discards the descriptive richness already achieved in order to restart a precisely similar advance from simplicity and hesitance to complexity and confidence in natural description. This he steadily maintains for the succeeding twenty years. The Giotto that emerges has no parallel whatsoever in thirteenth- or fourteenth-century Italy and few if any among the major representational artists of whatever age or country. If, on the other hand, identification with the Isaac Master is preferred, the same considerations apply with almost equal force, since the illustrative complexity of many of the scenes executed under his direction is much greater than that of those in the upper registers at Padua. The discrepancies in technique and in stylistic detail are again considerable, and it is only in dramatic power and in the basic attitude to narrative that the gaps, though of a different nature, are substantially reduced.

If this kind of uniqueness is considered too improbable, Giotto's general supervision of the Assisan frescoes, but not his personal intervention with the brush, may be posited instead. The problem of detailed stylistic variations is then evaded, but in view of what has been seen

of the frescoes themselves, it is replaced by the extraordinary hypothesis of the closest supervision of the general design of every fresco in the cycle and of personal intervention in the execution of none. Moreover, the larger problems of the cleavage in descriptive, narrative, and compositional approach, and of a disjointed pattern of artistic development, are only slightly modified. If Giotto is equated with the Isaac Master, the supervisory hypothesis becomes almost entirely meaningless.

If such difficulties appear to be insurmountable, a pre-Paduan dating may be maintained while denying Giotto's connexion with Assisi. Three things then have to be explained. The first is Riccobaldo's attribution of unspecified Assisan work to Giotto during the artist's lifetime. The second of them is the signed *Stigmatization* in the Louvre [205] with its repetition of designs from the St Francis Cycle. Finally, there are the compositional similarities between a number of the Paduan frescoes and designs in both the *Legend of St Francis* and the Isaac Master's frescoes.[11] In each case the explanations seem to be much simpler than those called for under any of the previous hypotheses.

Riccobaldo Ferrarese says in his *Compilatio Cronologica* of between 1312–13 and 1318 that there were works by Giotto 'in the churches of the Minors at Assisi, Rimini and Padua and ... in the palace of the Comune at Padua and in the Arena church at Padua'. Although Giotto's frescoes in S. Croce were probably not yet painted when Riccobaldo wrote, the omission of the *Navicella*, almost certainly completed during the first decade of the fourteenth century, casts some doubt on his reliability. In the eyes of his contemporaries and of the chroniclers who followed, the *Navicella* was Giotto's most famous and important work. It is, for example, the sole achievement mentioned by the fourteenth-century historian, Villani. There is, moreover, naturally no mention of Giotto's later, documented activity at Naples, and the assertion that he worked at Rimini cannot be confirmed. In short, there is no exter-

nal check on any of his statements about work outside Padua which, since they all concern the Friars Minor, may conceivably derive from the Chapter General of the Franciscans, held there in 1310. Even as regards Padua itself, only the reference to the Arena Chapel can now be demonstrated to be right. Finally, quite apart from Riccobaldo's poor showing against the known facts when compared with the author of the *Ottimo Commento*, he, like the latter, never indicates the nature of the works concerned, which need not have been frescoes at all.

The significance of the signed *Stigmatization* in the Louvre has already been discussed.[12] The fifteenth- and sixteenth-century traditions associating Giotto with Assisi have not been considered because the subsequent attribution of an important monument to the greatest, roughly appropriate name is a recurrent historical phenomenon that is as often misleading as revealing. The day it was completed, the St Francis Cycle became the canonical pictorial version of the saint's story. It illustrated St Bonaventure's official account and was hallowed by association with the main shrine of the order. Although the *Stigmatization* is often accepted as conclusive proof of Giotto's responsibility for the St Francis Cycle, there is therefore no difficulty, in the light of contemporary attitudes to art and of medieval workshop practice, in believing that an artist such as Giotto might be offered, and be prepared to accept, a commission to produce a panel in which the official Assisan iconography was reproduced. The intensified realism in some of the details of the smaller scenes is as compatible with the theory that Giotto was, consciously or unconsciously, modifying a pattern not completely in accord with his own pictorial vision, as it is with the belief that he was reworking his own earlier efforts in the light of greater knowledge. That his own conception of the artist's role and of the implications of his own genius was not the one with which he is often credited by later writers, is shown by the fact that it was only the workshop products that needed the protection of his name

that seem to have been given the honour of his signature.

Thirdly, the similarity between various compositions at Padua and in the two Assisan cycles under consideration can very reasonably be explained by the supposition that Giotto was personally familiar with the revolutionary, late-thirteenth-century Roman school of painting and had studied and learnt much from its latest achievements in S. Francesco.

The last of the possible solutions to the problem is to exclude the attribution of the St Francis Cycle to Giotto or his workshop by dating it after Padua and even moving it as far as the 1320s or beyond.[13] The usual accompaniment of this hypothesis by types of formal analysis that are excellently designed to reveal the greatness of the Paduan frescoes and to mask the very different qualities of those in S. Francesco is neither here nor there. Any solution involving a misunderstanding of the Assisan achievement or an assessment of the frescoes as late, derivative works, ignoring the internal evidence of hard-won development, seems to be thoroughly unrealistic. Apart from the complications introduced by Giuliano da Rimini's panel of 1307, the main impediments to the theory are the close connexions between the Isaac Master's frescoes and the opening scenes attributed to the Master of the St Francis Cycle; the intimate relationship between the latter and the St Cecilia Master; and the seemingly close ties that bind the St Francis Cycle to late-thirteenth-century Roman developments. Any attempt to remove the St Francis Cycle to a radically late date must, it seems, carry with it the work of the Isaac Master, thereby breaking these apparently close connexions and creating more difficulties than it solves. There is of course no possible justification for considering the Isaac Master to be a late Giottesque or even to be Giotto himself at a late stage in his career.

The very process of setting out the several major possibilities and the chief objections to which each is open shows the extent to which the situation is still fluid and is likely to remain so in the absence of fresh evidence. The fact that the solution favoured here is the currently unfashionable view, firstly that the St Francis Cycle dates from the 1290s and is not by Giotto, and secondly that Giotto is not to be identified, either conjointly or alternatively, with the Isaac Master, is of much less importance than a realization that an interim decision one way or the other must be made.[14] The historical pattern, and the very nature, of the development of late-thirteenth-century Italian painting, and of the careers and personalities of artists of the highest rank, hang on the answer that is given.

SIMONE MARTINI

It is for the ethereal qualities of his art; for the other-worldliness and the imaginative poetry praised by Petrarch; for sensitivity and grace; for harmony of line and colour that Simone is chiefly remembered. It is, however, typical of early-fourteenth-century Italy in general, and of Siena in particular, that this seeming paragon of the ivory tower should make his entrance with two major paintings, one of which embodies a civil oligarchy's ideals of statecraft, while the other has the openly polemic aim of bolstering an ambitious king's political legitimacy.

Nothing is known of Simone before he signed and dated the frescoed *Maestà* of 1315 which almost fills the whole of the end wall of the Council Chamber in the Palazzo Pubblico in Siena [207]. By this time Simone, who had evidently grown up in the orbit of Duccio, was a mature artist. His fresco is almost a commentary upon the older master's altarpiece of 1308–11, but one in which his own sense of scale and proportion is as immediately apparent as his feeling for the subtleties of space and line and colour. There is harmonious grandeur in the rectangle created by the wide, wall-clinging marble frame within the near-square of the wall, and the roundels of the saints recall the roundel-studded framework of the *Rucellai Madonna* [180]. The general richness of this painted marble frame acts as a foil for the chaste inner moulding in perspective, heralding the illusion of a sumptuous extension of reality. Much as, in S. Francesco at Assisi, Cimabue's choirs of angels supplement the friars' chorus, here the saints have gathered to preside over the earthly conduct of affairs of state. A gaily patterned, russet canopy softens a rectangle in space into a set of flattened curves. The latter mediate between the rectilinearity and flatness of the architectural framework and the complex rhythms of the figures gathered in the space

beyond. The kneeling and the standing groups, recalling Duccio's *Maestà* in the Duomo [172], though actually ranged in five straight, horizontal ranks, seem, through their subtle spacing, to be set in rows which curve back into depth and echo the space-defining contours of the baldacchino overhead. The rhythmic patterns of the draperies, which are as unprecedented in complexity of fold and fall and linear pattern as in the variety and the harmonious depth of their now largely perished colour, are disciplined by a symmetry that is almost as absolute as that in Duccio's altarpiece. The painting of the mural largely *a secco* rather than in true fresco, and the liberal use of gold on every surface must, when it was new, have given it a texture and a sumptuousness to rival that of any tapestry or golden-threaded, oriental hanging.[1] It is no wonder that so magnificent a scheme was echoed within only two years in near-by S. Gimignano.

The breadth and the unusual decorative weight of Simone's design are matched by its gravity of content. The bold massing of the composition and the isolation of the Virgin, present both as Queen of Heaven and as earthly Governor of the city, are the formal embodiment of the solemn message spelt out in a long inscription realistically enclosed in the pictorial space.

The angelic flowers, the rose and lily
With which the heavenly fields are decked
Do not delight me more than righteous counsel.
But some I see who for their own estate
Despise me and deceive my land
And are most praised when they speak
 worst ...

The fields of heaven could not be more fair than fourteenth-century Siena. Yet these words

have a bitter taste, and they were probably intended to be more than pious generalities. It was in April of the very year that they were painted that the entire city took to arms as the long-smouldering feud between the families of the Salimbeni and the Tolomei once more burst out into open fighting. Twice in the next ten years this blood-feud led to insurrection, and in 1326 the Sienese, like the Florentines before them, sought relief by calling in the Duke of

208. Simone Martini: St Louis of Toulouse, 1317.
Naples, Galleria Nazionale

Calabria, son of Robert of Naples, to impose the peace they could not keep themselves. To the historian, as to its earliest admirers, Simone's *Maestà* is, to some extent, yet one more monument to the suicidal warfare which is part and parcel of the achievements and disasters that are characteristic of the late medieval history of almost every town and city in the land.

Simone the painter and the Cavaliere Simone to whom King Robert of Naples assigned an annual grant of fifty ounces of gold in July 1317 are possibly, but by no means certainly, one and the same.[2] About Simone's signature on the panel of *St Louis of Toulouse* in Naples there is no doubt whatsoever [208]. Although its rich, deep reds and browns and russets are now flaked and faded and the lavish jewellery and goldsmith's work are lost, this huge, dynastic icon, its broad frame embossed with the French lilies set on a blue ground, still smoulders with the power and beauty that once blazed within it. The sinuous counterpoint of contour, line, and silhouette survives. The hook-nosed portrait profile of King Robert still retains its cunning. The punched tooling of the inner golden frame of fleur-de-lis still links the deepest background to the outer frame, annihilating space, much as the frozen, ritual gesture and the motionless, medallic contrast of pure profile and full-face arrests the march of time. The saint who sacrificed his earthly crown and gave it to his brother; who so unwillingly received the bishopric of which the insignia and the burden all but hide the simple habit he fanatically sought and loved, impassively receives the greater crown of sanctity as he unendingly confirms the legitimacy of the brother who was none the less called a usurper by his enemies. As countless actions following his death confirmed, the saint had now become a major weapon in the struggle to assert Angevin supremacy, not merely in its Neapolitan stronghold, but across the whole of Central Italy. The man who scorned all worldly power became not merely the celestial champion of the Franciscan Strict Observants but the patron of the Parte Guelfa. The latter, besides being Robert's instrument in Florence as well as in previously Ghibelline Siena and throughout Tuscany, was the omnipresent symbol of the ceaseless fight for power that ebbed and flowed and eddied and dissolved on every level from imperial to personal. It is probably this same effective combination of religious cult and temporal necessity that put St Louis and the red and white associated with the Guelph Commune of Florence so prominently on the walls that Giotto painted for the Bardi in S. Croce in Florence. Economic forces, and the usurer's need to expiate the sin essential to his trade, thus add further no less paradoxical dimensions to the role played by St Louis from the day in 1317 when the rite of canonization, for which his family had laboured from the moment of his death exactly twenty years before, was finally performed.

The five supporting predella scenes of the story of St Louis mark a new stage in the evolution of pictorial organization. They are the first surviving example of the perspective grouping of several scenes about a clearly defined central axis. The new relationship between the observer and the painted narrative, nascent in Giotto's Paduan frescoes and further developed in the vertical ranges of the Bardi and Peruzzi Chapels in S. Croce, is unequivocally defined. The central panel of the *Serving of the Poor* reveals a rigid, vanishing axis system. Uniform, parallel recession replaces Duccio's tentative advance towards the focusing of receding lines upon a single point. In a composition otherwise directly derived from Duccio it is, however, no surprise to find a contradictory, foreshortened frontal setting in the table that fills the centrally designed room. The four flanking scenes, linked as they are by the emphatic horizontals of their architecture, are structurally more consistent. The orthogonals of each recede in parallel towards the centre of the predella. The outcome is emphatic visual unity. The stress already placed on the central axis of the altarpiece by the division of the predella into five is reinforced and a firm base is provided for the slightly offset balance of the main design.

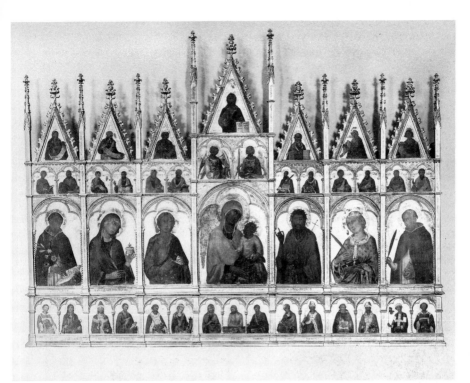

209. Simone Martini: S. Caterina Altarpiece, 1319.
Pisa, Museo Nazionale di S. Matteo

The full range and the liberating power of Duccio's inspiration is revealed with the realization that the original format of Simone's altarpiece was evidently generated from a section of the front face of the *Maestà*. When it still had the monumental flanking pinnacles seated on the wings of the predella and was capped, as was almost certainly the case, by a gabled panel showing either Christ or God the Father, its structural outlines would have closely matched those of a pinnacle panel with its Angel panel overhead, its pinnacles on either side, and an embryo predella in the arcade of Apostles underneath.[3]

Simone's next signed work, the polyptych declared by a fourteenth-century chronicler to have been installed in the Dominican church of S. Caterina in Pisa in 1319, is as complicated in appearance as it is straightforwardly devotional in content [209]. It is also a reminder of the importance and, as far as surviving works and records are concerned, at times the seeming dominance of Dominican, as opposed to Franciscan, patronage in Siena, as in many other centres during the late thirteenth and early fourteenth centuries.[4] Within the new, fully architectural form which, with its complement of pinnacles and main pilasters, constitutes a Gothic church façade in miniature, the constant repetition of the half-length figures, framed by rounded, trilobate arches, is transformed from dullness to delight by the sensitivity of the forms and by the subtle combinations of brilliant colour set off by the simple blacks and whites of the Dominican saints. Simone's linear and chromatic magic sets a personal seal upon

this work, in which there is, if anything, an increase in the openly Ducciesque qualities. A year later; Simone, who seems on documentary grounds to have been in Orvieto, where work on the façade of the cathedral was proceeding at full speed, appears to have painted an exactly similar altarpiece for Trasimondo Monaldeschi, the Bishop of Soana and a member of the most powerful family in Orvieto. Five of the main panels and part of the date and signature survive, and workshop intervention is again appreciable. Since there is some doubt about the authenticity of the inscribed date of 1320 on the unsigned panel of St John in the Barber Institute at Birmingham, the next apparent landmark has, for a long time, been thought to be the fresco of Guidoriccio da Fogliano dated 1328 [210], high on the wall of the Council

Nothing could better illustrate the intensity of the problem facing the historian of late medieval art, the extraordinary inconclusiveness of unaided iconographic and stylistic analysis, and the vital importance of what might be called the archaeology of art, than the controversies which have blown up in recent years around the Guidoriccio. Whoever may in fact have painted it, the inscribed date probably refers to the year of the great condottiere's victory over Castruccio Castracane, the even more celebrated Ghibelline general, and to the successful outcome of the seven-month siege of Montemassi. Not only are the salient features of the town identifiable, but its encirclement by palisades and the erection of an imposing battifolle or siege castle, all of them facts enumerated in Agnolo di Tura's Chronicle,

210. Guidoriccio da Fogliano, c. 1330(?).
Siena, Palazzo Pubblico

Chamber in the Palazzo Pubblico at Siena, directly opposite Simone's own Maestà painted in 1315 [207]. Apart from documentary references to lost works, including some very minor decorative tasks such as the gilding of lilies and lions, the only certain fact about the intervening years is that in 1324 Simone married Giovanna, the sister of Lippo Memmi, who was the most important of the artists in his immediate circle.

are prominent features of the fresco. There is also record of the payment of sixteen lire to Simone in 1330 for depictions of Montemassi and Sassoforte as part of a continuing series of representations of Sienese conquests, another of which has recently been uncovered below the Guidoriccio. The documentary evidence is also confirmed by Agnolo, who declares that in 1330 Simone painted both Montemassi and Sassoforte 'a l'esemplo come erano'.[5]

If it is by Simone at all, the representation of the famous condottiere marks a return to painting as an instrument of politics in a form more undiluted than ever before in his surviving works. It is also a unique example of a form of portraiture which is more often seen in sculpture than in painting and which, in either art, is otherwise confined to a strictly funerary context during the Late Middle Ages. There were, indeed, to be funerals enough in 1328–9, both in Siena and throughout the land, as general famine added to the miseries of interminable petty warfare. Inevitably this was followed up by pestilence and, in Siena as elsewhere, by rioting and repression; by institutional incomprehension both of the ensuing problems and of possible solutions; and, not least, by heroic personal attempts to alleviate the suffering untouched by social and economic systems ill-equipped to deal with such calamities. Nevertheless, if Giovanni di Tese Tolomei, the Rector of the Civic Hospital, was, in human terms, the Sienese hero of these years, it would be no loss to art if, as the grip of famine tightened, Guidoriccio was indeed immortalized as the much needed symbol of political and military success.

What has thrown the art-historical situation into turmoil is the simple fact that recent technical investigations have been said to show that in the much damaged corner of the wall on the right of the fresco the plaster underneath the *Guidoriccio* appears, at one small and as yet undefined point, to lie on top of, and in consequence to be later than, that of the *Battle of Sinalunga* painted by Lippo Vanni in 1363. If this observation, which has now remained essentially unsubstantiated for a considerable period of time, is eventually confirmed, and holds good for the fresco as a whole, the *Guidoriccio*, whether a faithful copy or a new invention, cannot be by Simone and cannot antedate the later fourteenth century.[6]

When it comes to the present appearance of the fresco, there seem, apart from extensive indications of reinforcement, to be major differences to the way in which a triangular section in the upper right hand corner and the whole of the left end of the fresco, including the town and castle, have been painted. How complicated matters of this kind can be is easily seen when it is realized that clues as to when and why damage and repainting may have occurred may well lie on the far side of the wall on which the fresco stands. There, in Ambrogio Lorenzetti's *Well-Governed Town and Country*, there is damage and what appears to be early repainting on the extreme left. This does not affect the problem of the *Guidoriccio*, since the configuration of the two rooms means that it lies far beyond the latter's right-hand margin. However, a further area, running down diagonally towards the bottom corner from the neighbourhood of the right-hand roof beam, at a distance of about $8\frac{1}{2}$ feet from the end wall, and indicated by a clearly visible crack, appears to have been repainted. The level of the ceiling above Ambrogio's fresco more or less coincides, in the adjoining Council Chamber, with the base line of the *Guidoriccio*, from which the area of repainting runs vertically upwards at a distance of about $9\frac{1}{2}$ feet from the end wall. It therefore seems to be extremely likely that a single cause, possibly lying within the wall itself, is at the root of both phenomena. What is more, the left end of the suspect area at the top right of the *Guidoriccio* is within a foot of coinciding with the right-hand vertical of a tall, bricked-up arch, about 7 feet wide, which originally looked out through the continuation of this self-same wall in the loggia above.

Whatever the eventual outcome, the entire controversy makes two things very clear. The first is that statements of a technical nature remain mere assertions until they are supported by scientifically acceptable documentation in a manner long familiar in the field of archaeology. The second is the indissoluble bond which binds the history of a fresco, whether still in situ or not, to that of the building in which it stands or once stood, and the vital importance of understanding any medieval building and its decoration, however complex they may be, as a single, interactive whole.

In many ways this single fresco, whether painted by Simone or some later artist or by several at whatever date or dates, remains a distillation of the fundamental qualities of much of Sienese painting. It is also a reminder that while the historical significance of a work of art may alter with a change of date or authorship, its own intrinsic qualities do not. Until the art historian calls upon the art restorer, even the most radical of reassessments as to date or attribution do not move one molecule of pigment. However and whenever the existing fresco was brought into being, it is still, as it now stands, a masterpiece.[7] Conservatism and imaginative innovation, fact and fantasy, decoration and illusion, are combined in a poetic vision far removed from, yet more real than, the reality itself. It is a work in which new heights are reached, not by resolving, but by intensifying the contradictions and contrasts inherent in late medieval art. The simple architectural framework of the scene is realistically foreshortened. The plump condottiere is portrayed with vivid truth to life. The detail of the Sienese encampment on the right is faithfully reproduced. The silhouettes of town and castle, stark against the deep blue of the sky, grip the imagination, and the sudden change of scale accentuates the vastness and recession of the empty landscape. Yet, at the same time, this is a cardboard cut-out world of symbols. Who can say exactly where the charger walks or glides; over or on the landscape or the frame, or partly upon both? Whether the foreground palisade is set in front of, or beyond, or under the high-stepping hooves is both impossible to tell and, in its context, immaterial. What is intensely meaningful is the heightening of Guidoriccio's importance and reality by the total absence of other human beings. Abundant signs of life – abandoned shields and spears, flags fluttering in the wind – accentuate the emptiness and stillness of a landscape drained by war. Here Guidoriccio alone is in the present; real, commanding, vividly alive. Each detail of design is used to emphasize his living, moving actuality as he parades, caparisoned in gold, across the foreground. Facing the sunlight, horse and rider breast the wind that stirs the distant flags. Their draperies blend into a single flow of movement, and the sweeping curves of the compelling diamond pattern, echoing the decoration of the architectural frame, increase the sense of forward motion. Even the structure of the landscape works to the same end. The palisade becomes a sinuous, forward-leading path. The larger town ahead, though balanced by the smaller camps and castles scattered on the right, attracts attention forwards. There is greater space before the rider than behind; a longer pause before the static verticals of a town are reached. The silhouette of the horizon closes on the right with a steep, leftward-sweeping hill-slope. The descending line that runs through the large town upon the left accelerates in sudden, swift descent and is left sharp against the sky, whereas the right side of the hill is blurred by flags and spears and palisades. Such details all increase the sense of movement at the heart of what is none the less a balanced and harmoniously centralized design, heraldic in the brilliance of its colour and the boldness of its stylizations.

After 1330 three more years of documentary silence follow. They are moderated only by a number of tantalizing references to lost works, including a figure of Marcus Attilius Regulus. Then, in 1333, Simone and Lippo Memmi, his brother-in-law, signed the Uffizi *Annunciation*. Already in 1317 Lippo Memmi had signed the frescoed *Maestà* in the Palazzo Nuovo del Podestà at S. Gimignano on which a contemporary document says he collaborated with his own father, Memmo di Filipuccio. The outcome of this was a stiff reworking of Simone's *Maestà* of two years earlier. Apart from a once signed fresco fragment in Siena, the core of Lippo's other surviving work is represented by signed Madonnas in Siena, Altenburg, and Berlin. The last is the left half of a diptych, and the *St John* originally on its right carries a date of 1333.[8] A certain stiffness in execution, a growing elegance and decorative brilliance in design, and increasingly close

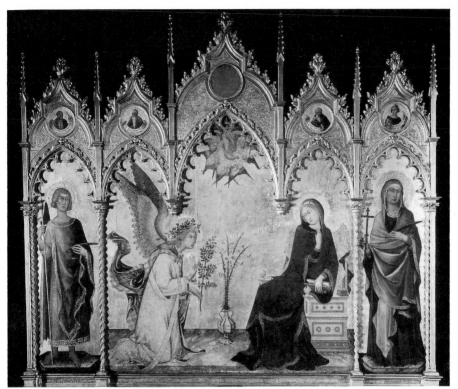

211. Simone Martini and Lippo Memmi: Annunciation, 1333.
Florence, Uffizi

reflections of Simone's art are characteristic of these panels. Like the Orvietan polyptych now in the Gardner Museum in Boston, Mass., which is often attributed to Simone himself, they show the heights to which men working in Simone's shadow could aspire. In Lippo Memmi's case the final proof of quality lies firstly in the several works attributed in this way, now to him and now to his more famous brother-in-law, and secondly in his much-argued collaboration on the Uffizi *Annunciation* [211].[9]

The endless, seemingly contradictory permutations that result from attempts to divide the *Annunciation* into patches attributable either to Simone or to Memmi again reflect the dangers inherent in too keen a desire for attributional certainty or in an oversimplified view of the ways in which late medieval artists could collaborate. Although the only specific reference to Memmi in the documents is a payment for gilding and ornamenting the lateral panels of the lost original frame, the modelling and tonality of the flanking saints have much in common with Lippo's work. A simple attribution of these figures to Memmi seems, however, to be extremely dangerous when the general, volumetric design and the drapery construction of the *S. Giustina* are compared with those of Simone's *St Mary Magdalen* at Assisi [217], or when the *St Ansanus* is compared with the Altomonte *St Ladislaus* or with

the *St Louis of France* at Assisi. Similarly, the strongly oriental cast of the Virgin's head has at least as much to do with Memmi's usual manner as with Simone's, even if the final brushwork be largely given to the latter. In its conception and in its subtlety of silhouette and rhythmic flow the altarpiece as a whole is certainly outside the range of anything of which Memmi would otherwise seem to be capable. Nevertheless, there are everywhere innumerable hints of both men's normal styles and also innumerable departures from them. The design as a whole may be Simone's. On the other hand, however strong and eloquently argued the convictions of opposing factions, the proof of who may have contributed which element to what layer of which part of the altarpiece during the many stages of its journey to completion seems in principle to be no longer susceptible of logical demonstration. About the subtle placing of the figures in relation to the frame; about the quality and almost abstract purity of a linear rhythm that paradoxically helps to turn the golden ground into an ambient atmosphere; and, finally, about its decorative sensitivity as well as richness, there need be no argument. Nor need there be any argument that here, as elsewhere in Sienese painting, the ties with sculpture are, in their own way, as close as those in Florentine productions. Only a profound misunderstanding of the true depth and richness of Sienese art has, at times, disguised the fact. Duccio's debts to Nicola Pisano's Siena pulpit in his *Adoration* and *Massacre*, to Giovanni's pulpits in his *Crucifixion* with its three crosses, and to the Siena façade sculpture in his *Maries at the Tomb* are only the most obvious of many. The link between the Virgin and standing Child of Simone's *Maestà* and Giovanni's *Madonna of Henry VII* of a couple of years earlier, or with the wooden *Madonna* at Orvieto associated with Lorenzo Maitani, is just as clear. What is more, the already mentioned stylistic connexions between Simone's *Mary Magdalen* and the *S. Giustina* are anything but skin deep. The links between the Magdalen and earlier sculptural niche figures both in Italy and

France are patent, and the *S. Giustina*, like the companion figure of St Ansanus, is clearly identified by its hexagonal base as representing polychrome wood sculpture of the kind which then abounded in Italian churches. It therefore represents a different level of reality from the central *Annunciation*.

For Simone himself the trail leads on through various Sienese legal documents and payments of 1340 to his departure for Avignon and to his death there in 1344. The only signed work from this latest period is the little *Holy Family* of 1342 at Liverpool [212]. Apart from the lyrical subtlety of the simple-seeming design with its vibrant interrelationships of blue, vermilion, and deep lilac, the panel is important in revealing a polarity that is a key to the understanding of Simone's evolution as an artist. St Joseph has a rhythmic insubstantiality and lack of structure reminiscent of the shepherd on the right of

212. Simone Martini: Holy Family, 1342. *Liverpool, Walker Art Gallery*

Giovanni Pisano's Pisa *Nativity* [77]. In principle, such a figure would hardly cause surprise among the works of Jean Pucelle or of the Maître aux Boquetaux. There is, however, no such insubstantiality about the figure of the young Christ, and providing that the modern tendency to observe only the linear elements in Simone's art is countered for a moment, a soft solidity and mass become apparent in the modelling of the main volumes of the Virgin. Just such a contrast reappears in an acute form in the frontispiece to Servius's *Commentary on Virgil*, which Petrarch had lost in 1328 and recovered in 1340, and which was subsequently decorated by Simone [213]. The couplet:

Mantua Virgilium qui talia carmina finxit
Sena tulit Symonem digito qui talia pinxit

shows the depth of the great humanist poet's esteem.[10] The miniature itself, on the other

213. Simone Martini: Frontispiece to Servius's Commentary on Virgil, between 1340 and 1344. *Milan, Biblioteca Ambrosiana*

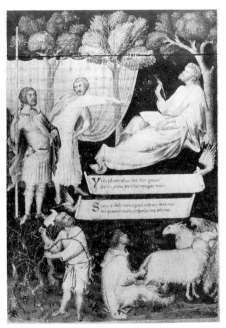

hand, reveals the length of the road still to be travelled in the visual arts before the Gothic world gives way to that of the Renaissance. Petrarch's friendship for Simone is proved by the references in Sonnets 57 and 58 (77–8), particularly that beginning:

Ma certo il mio Simon fu in paradiso
Onde questa gentil Donna si parte;
Ivi la vide, e la ritrasse in carte;
Per far fede qua giù del suo bel viso.
L'opra fu ben di quelle che nel cielo
Si ponno imaginar, non qui tra noi,
Ove le membra fanno a l'alma velo.

'L'alto concetto', to which Petrarch later refers, was embodied in a lost portrait of Laura which Simone evidently drew or painted for the poet.[11] There is a cunning literary conceit in Servius's drawing of the veil from the reclining Virgil. The surviving colour is delicate, and the continuous figure circulation, once more reminiscent of Giovanni Pisano's Pisa pulpit, is a brilliant solution of the problem posed by the need to incorporate and emphasize a written text. Changes of scale are handled with such subtlety that the integrity of the flat surface of the page is recognized despite the continuous recession of the landscape. The latter is not merely undisturbed by the floating cartellinos held by the winged hands but is in harmony with them. There are even reminiscences of Ambrogio's peasants in the landscape of *Good Government* completed just before Simone's departure for Avignon [237]. Considerations of this kind, when linked with many detailed points of style, seem to confirm an attribution that contains within itself exactly the polarity observable in the Liverpool *Holy Family* of these same years [212]. This time the contrast is between the poetic, swaying insubstantiality of the main figures and the tub-like bulk of the seated peasant in the foreground. This tension in Simone's late work – this emphasis upon opposing extremes – is fundamental to the problem of the three great unsigned and undocumented works which must, despite their bitterly controversial dating, find a natural place

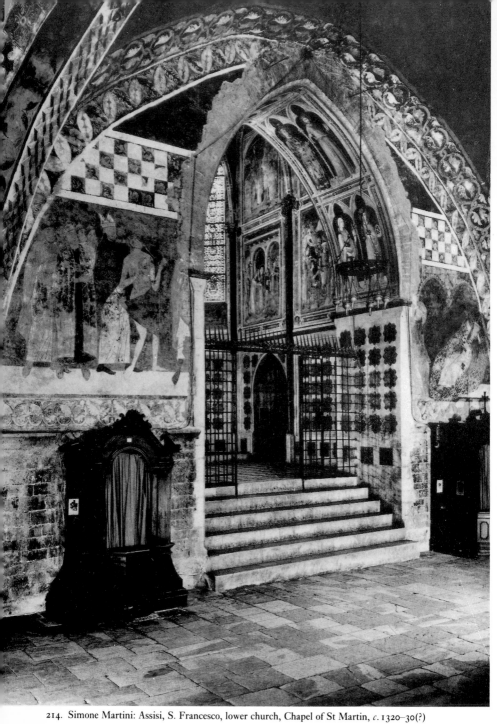

214. Simone Martini: Assisi, S. Francesco, lower church, Chapel of St Martin, *c.* 1320–30(?)

within the tenuous lines of growth so far established. Of these three, comprising the altarpiece of the Blessed Agostino Novello; the six panels of the dismembered Antwerp polyptych; and the frescoes in the Chapel of St Martin in the lower church of S. Francesco at Assisi, it is the latter which appear to hold the key to the problem.

Simone Martini was probably directly or indirectly responsible for every part of the decoration in the Chapel of St Martin [214 and 215]. The patterned marble inlays on floor and lower wall, the frescoed vault and upper walls, and the glowing stained glass of its three twin-lighted windows therefore make it the most unified, as well as the most complete, Gothic decorative scheme to have survived in Italy. Paired saints in niches have been painted on the under-surface of the entrance arch, and *St Martin receiving Cardinal Gentile da Montefiore* occupies the inner surface. Ten scenes from the *Life of St Martin* are so arranged that either side wall contains two tiers of two scenes each,

a final pair, adjoining the entrance wall, continuing upwards to meet at the crown of the vault. Painted half-length saints in niches fill the window embrasures, and the glass itself raises the colour of the frescoes to a new pitch of intensity and luminosity.[12] Compared with the earlier Assisan windows, the clarity and discipline of the designs, extending even to the complex patterning of the surrounds, is notably increased. Though white is used consistently in all six lights, the impression, as in French glass, is of rich, full colour. Yellow is dominant, and also used consistently. Otherwise, a constant counterpoint, emerald for purple, blue for crimson, red for deep green, deep green for light blue, enlivens the like details in each pair of lights. The whole scheme throbs and glows. The frescoed story of the saint, as it ascends by stages to its heavenly climax, is told as a magnificent chivalric tale that fully exploits the sophisticated extremism and parti-coloured fantasy of contemporary high fashion [216]. There is, however, nothing uncontrolled about

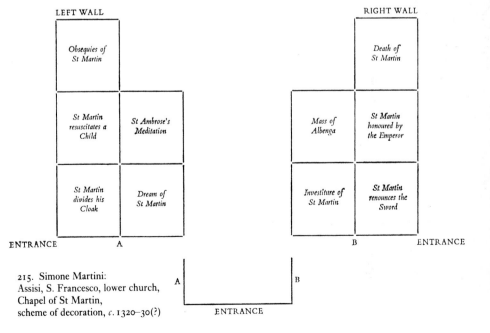

215. Simone Martini:
Assisi, S. Francesco, lower church,
Chapel of St Martin,
scheme of decoration, c. 1320–30(?)

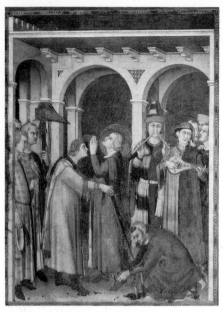 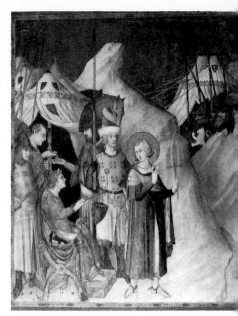

216. Simone Martini: St Martin invested, St Martin renouncing the Sword, c. 1320–30(?).
Assisi, lower church, Chapel of St Martin

its planning. The centralized perspective of the three interiors among the frescoes nearest to the entrance arch establishes the onlooker's position immediately in front of them. The foreshortened frontal settings of the four buildings in the frescoes nearest to the altar, and the realistic foreshortening of the niches in the window-embrasures, complete a coherently organized perspective scheme which elaborates the ideas formulated by Giotto in the Bardi and Peruzzi chapels. That perspective organization was possibly more, and certainly not less important to Simone than perspective illusion is shown by the way in which the parallel recession of Duccio's vanishing axis system is so standardized that in the *Death of St Martin* the axis itself materializes. The receding lines create an even herringbone pattern within the confines of the architecture itself, instead of merely meeting invisibly when extended in the mind, as is the usual case.

The impact of the St Francis Cycle in the upper church is especially strong in the crowded compositions of the upper, earlier frescoes such as the *Obsequies of St Martin*. In the lower frescoes, which at times reveal a sudden, startling power of individual characterization, the alternation of a dream-like, solemn pageantry with scenes of the utmost economy of design reveals Simone at his most impressive and most personal. Stylistic contrasts of the kind already mentioned now add to the difficulty of the dating problem. The form-concealing, almost form-destroying, simplification of the drapery folds of Christ in the *Dream of St Martin* is reminiscent of St Joseph in the Liverpool *Holy Family* [212]. At the other end of the scale a highly complex and intensely decorative play of line is paradoxically used to give impressive bulk to the figure of *St Mary Magdalen* and places her among the richest and most magnificent of his creations [217].

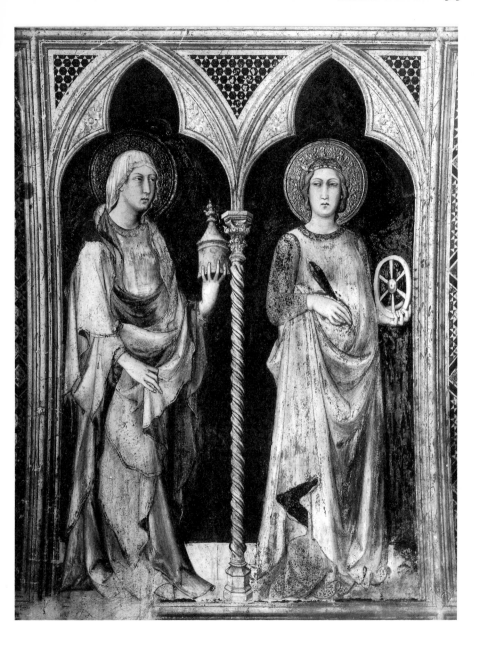

217. Simone Martini: St Mary Magdalen and St Catherine, *c.* 1320–30(?).
Assisi, S. Francesco, lower church, Chapel of St Martin

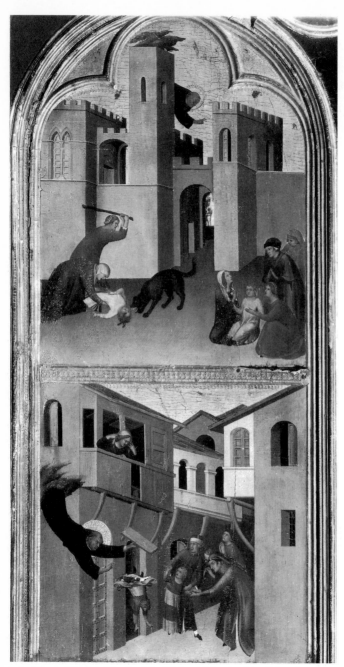

218. Simone Martini: Miracle of the Wolf and Miracle of the Fallen Child,
detail of the altarpiece of Blessed Agostino Novello, *c.* 1333–6.
Siena, S. Agostino

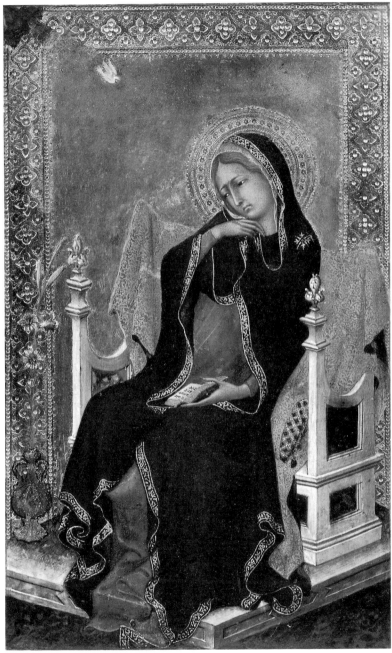

219. Simone Martini: Virgin Annunciate, early 1340s(?).
Antwerp, Koninklijk Museum voor Schone Kunsten

The suggested dates range from just after 1317 to shortly before 1339,[13] and the situation is further complicated by the existence of the altarpiece of Blessed Agostino Novello in S. Agostino in Siena [218].

This altarpiece, with its huge central figure and small flanking scenes, is a fourteenth-century continuation of an early-thirteenth-century pattern. It is characterized throughout by an extreme sophistication and clarity of design. In terms of abstract formal values, and in the pure geometry of spatial composition and figure grouping, it seems to mark the peak of Simone's achievement. The buildings are more clearly massed and more complex in their volumetric pattern than any at Assisi. The extended ground plane of the *Miracle of the Wolf* [218], with its complicated and coherent background architecture pierced by a passage leading past a silhouetted tree into a golden distance, creates an architectural depth unprecedented in Simone's work. The exploration of the spatial possibilities of the golden ground is everywhere remarkable. The abstract pattern of the architecture, whether in the street scene or in the complex, box-like building of the *Miracle of the Fallen Child* [218], is matched by the purity of silhouette and by the sureness and simplicity of volume in the figures which, when taken in conjunction with those in the *St Louis* predella, datable *c.* 1317, preclude the attribution to Simone of whole scenes in Duccio's *Maestà*. It seems that the many detailed points of contact are enough to justify the attribution of this masterpiece to Simone Martini himself. If so, the blending of Assisan formal experience with a Ducciesque sense of placement and design in some respects recalls the early works of Bernardo Daddi, which he may well have encountered by this time. Since certain details of dress seem to allow the work to be placed with unusual accuracy in the years 1333–6,[14] the most probable, if tentative, chronological position for the Assisan frescoes appears to be in the period preceding the documented activity in the Palazzo Pubblico, which is possibly associated with the painting of the *Guidoriccio*

c. 1328–30, and perhaps even as early as *c.* 1317–20.

The final problem, that of the signed but dismembered Antwerp polyptych, is no less thorny. In the *Procession to Calvary*, the *Crucifixion*, and the *Entombment*, with a false background landscape painted over the original gold ground, the closest reminiscences of Duccio accompany a figure treatment that seems, once more, to reflect Assisan concepts of bulk. The powerful, oblique setting of the throne of the *Virgin Annunciate* [219] also seems to develop perspective patterns which, not unexpectedly, make their earliest tentative appearance at Assisi. The closeness of the head of Gabriel to that of the Liverpool Virgin of 1342 is also notable. Despite the forceful arguments supporting an early date,[15] the Antwerp altarpiece, with its constant swings between decorative linearity and an emphasis on simple bulk, between a by now almost archaic treatment of space and a powerful definition of abrupt recession, may well belong to the final period of Simone's career. It is at Avignon that, possibly as a result of his contact with French art, the conflicting currents in his style are at their most apparent and are combined with an unsurpassed brilliance of colour and delicacy of detail.

Simone's stay at Avignon is marked by the ruined frescoes in the cathedral, including a *Redeemer* and *Angels* under which a magnificent series of sinopie has been discovered [220]. The power, and subtlety of expression, in the head of Christ, in particular, adds immeasurably to our understanding of Simone's art. No less important in its own way is the iconographic invention of the *Virgin of Humility*.[16] This design, reflected in the dependent Virgins Annunciate at Leningrad and Brussels, is the culmination of a constant tendency to accentuate the gentle, human qualities of the mother of Christ, the *mater omnium* and the supreme mediatrix, which was already apparent a hundred years earlier. The stylistic affinities of the various dependent versions of the fully developed form, in which the Virgin feeds Christ

220. Simone Martini: Christ, sinopia, early 1340s(?).
Avignon Cathedral

at the breast, appear to show that a lost panel by Simone was the origin of what proves to be one of the key symbols of Italian panel painting for the rest of the century. The earliest dated example is that in Palermo, signed by a certain Bartolomeo da Camogli in 1346 and inscribed 'nostra donna de Humilitate' [221].[17] It has a predella with the symbols of the Passion flanked by kneeling members of a flagellant confraternity. Four of the latter wear the hooded robes with circles cut into the backs to bare their bodies to the scourge. Two years later such a painting might have seemed to be a response to the cataclysm of the Black Death. Actually the disaster, which was only the worst of many similar visitations, merely intensified an existing urge to violent self-mortification. From the mid thirteenth century onwards this compulsion had not merely involved the formation of small societies of zealots, but had led to intermittent popular frenzies that seized whole towns and regions and were often accompanied by rioting and violent outbursts of anti-clerical feeling.

It is typical of Simone, and of Siena, that the painter of the courtly and chivalric, the civic propagandist, and the master of the massive public altarpiece should also have created in the *Madonna of Humility* one of the most tender images of an age of personal devotion. This aspect of his work is so important that it has coloured the whole subsequent approach to his art. The shape and significance of his career has been distorted, and the isolated panels of dismembered altarpieces are predominantly seen in terms of his few surviving intimate productions. In reality an increased intimacy is only a single element in the new monumental art. It is, however, true, particularly in Simone's later work, that the links between

panel and fresco painting and manuscript illumination become increasingly strong. The same holds good for associated artists like the closely dependent Master of the St George Codex. Indeed, the latter's *St George killing the Dragon*,[18] with its verses by Cardinal Giacomo Stefaneschi, the probable donor of the Avignon *Madonna of Humility*, itself appears to be derived from a lost fresco in the cathedral.

The influence of Duccio and of Simone Martini on the development of French illumination, and the importance of Avignon and of the papal court as an artistic melting pot, can hardly be exaggerated. Yet little enough of any consequence survives of all the comet's-tail of minor masters who followed Simone North. Matteo Giovanetti da Viterbo, with his delicate colour and somewhat mannered grace, is perhaps the most important of these minor luminaries. Even so, the most intrinsically interesting of these scant remains are possibly the anonymous hunting and fishing scenes in the wardrobe tower. Being in fresco, they recall Pompeian garden rooms while presaging the glories of the Gothic *mille-fleurs* tapestries. In Siena, on the other hand, the situation was entirely different. There, men of equal if not greater stature, and of very different interests from Simone's, were coming to the full height of their powers. Nevertheless, it is Simone's art, the supreme embodiment of a vision of grace and waning chivalry set in a shifting borderland between a secular and a religious world, which has, in its own way, exerted as powerful an influence on history as the economic and political actualities of the time. In delicacy of line and colour, in pageantry, in spiritual emotion, and in all the indefinable subtleties of style that grip the imagination, Simone's name stands on its own.

221. Bartolomeo da Camogli: Madonna of Humility, 1346.
Palermo, Galleria Nazionale

222. Ambrogio Lorenzetti: Madonna and Child, 1319.
Vico l'Abate, Pieve

AMBROGIO AND PIETRO LORENZETTI

In the range and quality of his surviving work Ambrogio Lorenzetti is possibly the last fourteenth-century painter who can reasonably be placed alongside Cimabue and Giotto, Duccio and Simone Martini. The intertwining of his career with that of his brother Pietro emphasizes that the history of fourteenth-century art is not only the story of the growth of given personalities, great or small, but a constant flux of interaction and impingement as infinitely complex as the individuals who contribute to it.

Ambrogio Lorenzetti's known career begins with the uncompromising statement of the unsigned but reliably attributed Vico l'Abate *Madonna* of 1319 [222]. The commission for Pietro's signed polyptych in the Pieve at Arezzo follows in 1320 [224]. In 1321 some of Ambrogio's goods were seized for debt in Florence, and a sale of land in 1324 is followed by evidence of continued Florentine connexions through his matriculation in the Guild of Medici e Speciali, probably in the period 1329–30.[1] Next comes Pietro's signed and dated Carmelite altarpiece of 1329 in the Siena Gallery, and in 1335 a joint inscription recorded for the lost frescoes on the façade of the hospital of S. Maria della Scala in Siena implies that Pietro was the senior. In 1338 Pietro was licensed to carry arms within Siena, and during the two succeeding years Ambrogio was at work on the frescoes of *Good Government* [234] and *Tyranny* in the Palazzo Pubblico. Pietro signed his small *Madonna*, now in the Uffizi in Florence, in 1340, and his final masterpiece, the *Birth of the Virgin* [231], already commissioned by November 1335, was only signed in 1342, the year of Ambrogio's panel of the *Presentation* [232]. The latter's last surviving dated work, the *Annunciation*, follows in 1344 [233], when Pietro is finally recorded in connexion with a sale of land on behalf of Tino di Camaino's children. After a reference to an address in Council in 1347, Ambrogio too fades out of sight. Both may have died in the Black Death of 1348.

The Romanesque frontality of the Virgin and the Romanesque angularity of the frame of Ambrogio's early Vico l'Abate *Madonna* are accompanied by a diagrammatic severity of spatial construction and geometric inlay [222]. His sense of interval and area is such that the position of each form from hand to halo, every relationship of curved and straight, each silhouette and solid, has an aura of inevitability. The thrust of the wooden arm-rests has its counterpart in the bold foreshortening of the Infant's foot and naked hand, as well as in the glove-like tension of the cloak on its clenched fist and in the grasp of the Madonna's fingers. The absolute evenness of stylization and complete control of representational means give unique impact to the human qualities disciplined within the hieratic image. That Giotto and the Florentine Romanesque should dominate Duccio's Siena in this work from the immediate neighbourhood of Florence does not betray a malleability of artistic temperament: it indicates that Ambrogio was to be, throughout his life, and to a greater extent than most of the artists of his day, a freeman not merely of Siena nor of Tuscany, but of the whole of Central Italy. The catalogue of his surviving inscribed or documented paintings is such that this first panel can only be authenticated through a chain of reference leading to the signed works of 1338–44. The ease with which this can be done immediately establishes the artistic constancy of a man no two of whose surviving works emerge from the same mould. The infant Christ carries the artist's personal stamp more clearly than do the majority of paintings by those who seldom strayed outside the limited and lucrative

223. Ambrogio Lorenzetti: Madonna del Latte, mid 1320s(?).
Siena, S. Francesco

224. Pietro Lorenzetti: Virgin and Saints, 1320.
Arezzo, Pieve

field of Madonna-making. The latter was only one of Ambrogio's interests. Its importance to him is, however, shown, not only by the many workshop and related panels grouped under the names of the 'Petronilla', 'Roccalbenga', and 'Rofena' Masters, but by his own slightly later *Madonna del Latte* in the Seminary at Siena [223].

Ambrogio's subject is the love that hints at the Divine and fuses all the richness and complexity of human feelings into passionate simplicity. The forms that are his sole means of expression are handled with the elegance of a great equation. The angularities of the frame are set against the rhythmic interaction of curves ranging from slow modulations in the Virgin's head-dress to the liquid sinuosities of the Infant's robe. Its rectilinearity is picked up in her arm and in the formal harshness of her straining hand. Its symmetry and its rigidity play against the Virgin's offset pose and complete the discipline of the rocking rhythms and dynamic balance that distinguishes every other asymmetric form. Volume and silhouette, light tones and dark, are held within a similar dialectic. By methods such as these the tender sweetness of the curly-headed Child, kicking against his mother's arm, and the gentle gravity of the

Virgin's ever-loving gaze are given their transcendent meaning.

The extent of Ambrogio's early independence can be measured through his elder brother's Pieve altarpiece commissioned in 1320 [224]. The predella and the whole of the frame, together with its substantial flanking piers, are now missing, but despite a greater rhythmic interpenetration and variety of architectural form, derived from Duccio's *Maestà*, it closely resembles Simone Martini's Pisa polyptych of 1319 [209].[2] Giovanni Pisano's influence in the central figures is as clear as the pervasive, but selective, references to Giotto and the Florentines as well as to Duccio and Simone. The grave humanity of the Virgin and Child is given transcendental meaning by the moderate plasticity and subtle linear rhythms. The colour harmonies, with their emphasis on white, light grey, and yellow for the major figures, are the crowning glory of the altarpiece.[3] The lightness of Pietro's colour is prophetic of the major tonal change which was to transform the appearance of fourteenth-century Italian stained glass. Prophetic also of another Sienese paradox, to set beside the political motivation of so many works in which the primary visual characteristic is an otherworldly sense of grace and colour, is the combination of the latter with a lively interest in illusion.

At first it is the gravity of the *Annunciation*, and the subtle asymmetries that set it off against the rhythmic balances of its surroundings, that attract the eye. A sense of grandeur, enhanced by sensitivity in the relation of the figures to the frame, is as apparent here as everywhere throughout the altarpiece. Only a closer look reveals the wooden columns of the frame to have been the forward elements of the painted architectural supports. The precedent of so many earlier frescoes has been followed. The barriers between the real space of the observer and the carefully unified pictorial world, with its eager, rhythmically solid and majestic figures, have been set aside. This small scene is a major portent of the possibility of fruitful, close collaboration between two characters

who were as artistically diverse as the brothers Lorenzetti.

By implication, the polyptych raises the whole question of Pietro's early work and most especially the thorny problem of the dating of the attributed frescoes in the south transept of the lower church of S. Francesco at Assisi [225]. These are part of a major scheme which extended from the Chapel of St Nicholas at the end of the north transept to that of St John the Baptist at the end of the south. Both of these chapels were built by Cardinal Napoleone Orsini, presumably just before or just after he took up his post as Papal Legate in Umbria in 1300.[4] The decoration of the chapel of St Nicholas certainly seems to have been complete by 1307. Investigation of the plaster in the crossing and transepts shows that, in the main, the work then ran quite steadily from north to south. It began on the northern end wall with the *Annunciation* and ended with the final scenes of Pietro's *Passion* cycle on the corresponding southern end wall.[5]

Since Pietro's frescoes were largely carried out in tempera on dry plaster, which had been laid on in some three hundred and thirty work-stages, his activities probably extended over several years. There is, however, no reason to assume, as is all too often done in similar cases, that the Arezzo altarpiece must either precede or succeed the frescoes. The latter can perfectly well have been carried on before, during, and after the painting of the altarpiece. Artists often had a number of commissions going forward simultaneously in their workshops, and panel painting could well occupy the winter months of years in which the spring and summer were devoted to campaigns of fresco painting. Nor should it be argued or assumed, without specific evidence, that civil or political disturbances of the kind which affected Assisi in the years from 1319 to 1322 would provide a terminus for a decorative scheme of this kind. Civil disorders

225. Pietro Lorenzetti:
Scenes from the Life of Christ, *c.* 1320–30.
Assisi, S. Francesco, lower church

were a commonplace, and there is endless evidence that, for the most part, artists worked away wherever they happened to be at a given time, regardless of the turmoil which quite frequently surrounded them.[6]

Another thing which close examination of Pietro's frescoes in the south transept makes quite clear is that, as in Simone's Chapel of St Martin, large teams of painters were involved, and that the work was shared out piecemeal, even major figures such as that of Christ being painted, partly or entirely, now by one hand, now by another, in exactly the same way as is so readily apparent, in terms of panel painting, in Duccio's *Maestà*. Flexibility within a clearly defined general scheme is no less obvious as regards the overall programme. The symmetries of Cimabue's frescoes in the choir and transepts of the upper church were evidently well appreciated in his own day, since every effort was made, over a considerable period, to achieve a comparable unity in the choir and transepts of the lower church. The painted frames of Pietro's frescoes in the south transept echo those in the earlier cycle in the north. Again, as in the upper church, there is a Crucifixion scene in either arm. What is more, the matching altars at opposite ends of the eastern walls are surmounted by very closely similar painted altarpieces. That in the north transept is attributable to Simone Martini; that in the south, beneath his own frescoes, is by Pietro Lorenzetti. These represent the continuation of a well established tradition in S. Francesco, originating with Cimabue and continued in the elaborate, round-arched, painted altarpiece and architectural frame, of quite astonishing realism, above the tomb of Giovanni Orsini in the Chapel of St Nicholas. This was then repeated, in updated form with pointed arches, by Pietro in a similar tomb-related position in the chapel of St John. The latter, since it is the most closely Ducciesque surviving work attributable to Pietro, is likely to have been the first of his commissions in the lower church and probably precedes the Arezzo altarpiece by a number of years.

Simone's north transept altarpiece appears in general style and in the distinctive, and even at times identical, details of the superbly ornate halos to belong to the same period as the decoration of the Chapel of St Martin. It also seems to be less highly organized and much less clearly integrated into the general decorative scheme than Pietro's version in the south transept.[7] The latter is, on technical grounds alone, quite certainly the last of Pietro's works to be completed, and a flamboyant ending it is. Below it to the right, immediately above a real aumbry, he has painted a deep rectangular niche containing two glass pitchers and a flat box, whilst underneath the end-wall saints, at ground level, he has actually set an illusionistic, drapery-covered bench which is seen and lit from the centre of the transept and casts a bold shadow on to the wall and mouldings beyond it. Tentative cast shadows can be seen at various points in the *Legend of St Francis* in the upper church and elsewhere and appear again in Pietro's own *Passion* scenes, but there is nowhere anything to match the boldness and ambition of this intrusion into the spectator's real world. In short, unless Simone's painted altarpiece marked the opening of his campaign at Assisi, it appears that Pietro's frescoes not only followed those in the crossing and north transept but were also completed after those in the Chapel of St Martin. It therefore seems to be quite likely that although Pietro's *Passion* series may have been begun before the painting of the Arezzo altarpiece *c.* 1320, they may not have been finished until well into the decade.

The upper, and therefore earlier, scenes, such as the *Entry into Jerusalem*, the *Last Supper*, or the *Road to Calvary*, with their lively figure crowding and mass of incidental, naturalistic detail, flow directly from Duccio's work as represented, most conspicuously, in the *Entry* on the *Maestà*. They also point the road that leads towards Ambrogio's *Presentation* of 1342 or Pietro's own *Nativity of the Virgin* of that same year. Whatever they may lack in drama and in formal concentration they make up in charm. The putting of one of

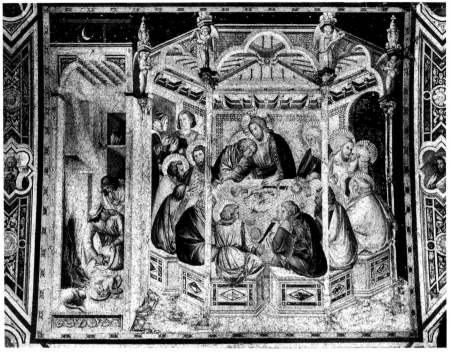

226. Pietro Lorenzetti: Last Supper, c. 1315–25(?).
Assisi, S. Francesco, lower church, south transept

the Pisanos' pulpits to a novel architectural use in the *Last Supper* [226] is a reminder that from Pietro's Arezzo altarpiece to Ambrogio's Palazzo Pubblico frescoes, there are constant references to the sculptors' works in both the Lorenzetti brothers' paintings. The fire-lit secondary scene, with its contented cat and its puppy doing the washing-up with its tongue while a servant does the drying with a dishcloth, leads on to Taddeo Gaddi's experiments with light in S. Croce, Florence. They also presage the way in which, from the second quarter of the century onwards, architectural adventure, structural jumble, and a keen eye for attractive detail are the characteristics of innumerable minor masters.

Pietro's masterpieces at Assisi are, however, his four frescoes on the end wall of the transept.

Their Ducciesque iconographic base is progressively refined by profound understanding of Giotto's principles of dramatic concentration. The process reaches its peak in the *Deposition* [227], for which the iconographic and, to a surprising extent, the formal starting point is the comparable fresco by the lower church St Francis Master. In mass, simplicity, and linear clarity, these figures seem to be the direct fulfilment of the promise of the *Annunciation* in the Arezzo altarpiece [224]. Volume and surface pattern; space and plane; the momentary and the eternal, no less than the human and the visionary, are combined: and yet there is no sense of compromise. When the diagonal of the ladder which links the figures to the bare verticals and horizontals of the cross was still complete, the sinking drama of the

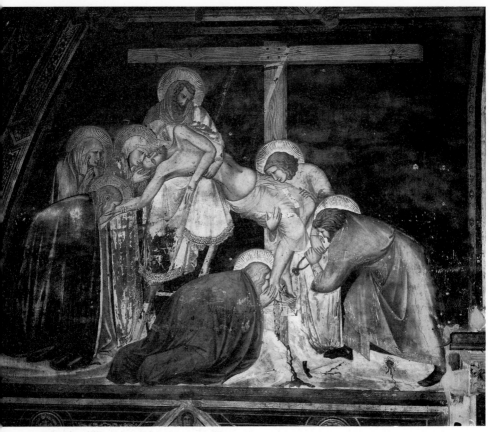

227. Pietro Lorenzetti: Deposition, 1320s(?).
Assisi, S. Francesco, lower church, south transept

pyramid in space or of the triangle upon the surface of the wall, the blending of time past in the eternal present, would have been immeasurably increased. The visual means by which the progress from stark horror to a tender, numbing sorrow has been captured are epitomized in the subtleties whereby the forms which in an actual pyramid or triangle would be straight lines, are here compounded of innumerable inter-penetrating, overlapping curves which none the less maintain an everpresent hint of recti-linearity. The closed contours that enfold the unbroken chain of action are held together by

a figure of Christ which is dramatic in its bold distortions. There is no dissipating the emotional charge. Each figure of compassion and each tender action adds intensity to the next. The human and the spiritual content are as inexhaustible as the formal discipline is unsurpassed. Inevitably there is anticlimax when this single episode is seen as but one element in the carefully balanced pattern of four frescoes that enframes the central arch. Nevertheless, to return from the softer, more continuous curves of the *Entombment*, where the pyramid of figures almost sinks to the low

rectangle of the sarcophagus into which Christ's body gently disappears, is to re-experience the mounting pressure of emotional and visual excitement with new formal and new narrative dimensions added. The sensitivity with which Pietro must have studied the careful decorative balancing of the upper church becomes the basis of a drama of design that far outstrips the sources of its inspiration.[8]

The huge fresco of the *Crucifixion*, on the other hand, certainly betrays a massive workshop intervention. Whilst certain elements seem to reflect Simone's work at Assisi, it also reintroduces the question of Pietro's interaction with Ambrogio and his apparent cooperation with him in the chapter house in S. Francesco at Siena, where his own simpler version of the *Crucifixion* once stood alongside major frescoes by his brother. The subtlety and sensitivity, as well as the power, which Pietro generated in these circumstances are well illustrated by the now detached and isolated figure of the *Resurrected Christ*.

Ambrogio's *Reception of St Louis* in Siena extends ideas embodied in Simone's Neapolitan version of the scene and in Giotto's *Apparition at Arles* in S. Croce in Florence. Recession is established plane on plane to a far greater depth and is fully articulated by a rich complexity of vaulting. The forward limits of the space and the intervals between each plane are established with fresh clarity, and the variety of pose in the serried ranks of figures is unprecedented. The discipline and logical crispness of this scene is stressed by a comparison with the predella panel in Pietro's signed and dated Carmelite altarpiece of 1329. Pietro's version seems to be a slightly muddled attempt to reproduce the existing complexities of the fresco and not a prior stage in their achievement.[9] Indeed, the altarpiece, which apparently confirms the early dating of the Sienese as well as of the Assisan frescoes, is chiefly memorable for its luminous colour and atmospheric delicacy.

The second of Ambrogio's frescoes, the *Franciscan Martyrdom*, is notable for the coherent extension of a hollow square of figures by

the architectural perspective of a complex Gothic building. The figures themselves display innumerable complexities of movement and foreshortening, and also reveal an interest in Eastern physiognomy that matches the Simonesque delight in contemporary fashions visible in the preceding fresco.[10] The reverberations of the expansion and political consolidation of the Mongolian empire; the opening up of trade, and missionary activity, in Central and Far Eastern Asia; a series of publications, culminating in Marco Polo's *Travels*, issued in 1298, and in such works as Oderico da Pordenone's description of the Far East, written in 1330; all such activities increased the fascination of the oriental world. Not only carpets, spices, silks, and jewellery, but Mongol slaves were imported in increasing quantities. The thirteenth-century abolition of indigenous slavery in Italy seemingly began a process greatly accelerated by depopulation following the plague of 1348. Special legislation for the regulation of slavery was introduced in Siena in 1356 and in Florence in 1369, and the resulting records show that there must have been many thousand male and female Mongolian slaves in late-fourteenth-century Northern and Central Italy. In his oriental figures Ambrogio was evidently drawing on personal experience of a growing commonplace of Tuscan city life.

Far and away the most important artistic effect of the Mongolian expansion was, however, its impact on textile design. Byzantine, Persian, Arabic, and Moorish patterns, mirroring the closely woven threads of Mediterranean culture, had all contributed to the splendour of the twelfth- and thirteenth-century silks from Sicily and from the South Italian centres established by Frederick II. With the fall of the Hohenstaufen many of the South Italian weavers evidently moved to the great Tuscan–Ghibelline textile centre of Lucca, and the fresh impulse which they gave to local manufacturers prepared the way for a vigorous response to the challenge of Far Eastern textiles flowing in through Pisa at the turn of the century. The process which had freed the

228. Lucchese satin brocade, mid fourteenth century.
Uppsala Cathedral, Treasury

229. Venetian brocaded silk, late fourteenth century.
Krefeld, Gewerbesammlung der Stadt

heraldic beasts of Middle Eastern textiles from their framing roundels is accelerated. Horizontal ranks give way to free diagonal patterns. Heraldic forms take on the vividness of life. Swift running movement, flowing curvilinear forms and spiky, energetic patterns, often incorporating actual or mock cufic lettering [228], add new excitement to the brilliant play of colour in a rapidly expanding repertory of designs. The Chinese contributions are often translated into Western terms, but the trailing ribbon clouds and oriental animals are sometimes directly copied. Almost invariably the technical refinements of diasprum and silk damask give rise to new ventures in design. This changing pattern of external influence is symbolized in the imported textiles buried with Cangrande della Scala (d. 1329). The intricate patterning of his tunic has Middle Eastern origins, and the Far Eastern patterns visible in the brocaded surcoat mingle, in the funeral drapes, with Arabic inscriptions.[11]

Well before the mid century, probably assisted by a further migration of textile workers, this time out of Lucca, cloth of similar design and quality was being woven in Florence and in a number of North Italian centres, the most important of which was Venice. There the Lucchese and the South Italian streams appear to have intermingled to produce a no less sumptuous, but at times a broader, calmer style in which a softer, increased naturalism is apparent [229].

The importance of Italian fourteenth-century production does not end with its unique position in the history of European textile design or with the impact of imported Italian cloth on every major cultural centre from Burgundy and England to the Balkans. Whereas Italian embroidery, which reached its qualitative peak in Florence and is best represented by the altar-frontal now in S. Maria in Manresa, worked by Geri Lapi and Jacopo Cambi, is notable for its direct translation of the new pictorial styles into a textile medium, the Lucchese and Venetian silks and damasks make significant contributions to contemporary

painting and sculpture. In sculpture the survival of full polychrome is largely confined to a relative handful of wood carvings, but as the century wears on the actual treatment of the stone or marble surface is increasingly affected by concepts of patterning that derive from textiles. In painting, the part played by textile design is not confined to the splendid costumes worn by Simone's courtiers or Ambrogio's dancing maidens. In Ambrogio's own small *Maestà* in the gallery at Siena [238] and in innumerable altarpieces of the second half of the century, whether in Orcagna's Florence or in North Italy from Bologna to Milan, or in the Venice dominated by the shimmering tradition established by Paolo and continued by Lorenzo Veneziano, the whole surface of the panel is often virtually transformed into a textile pattern. In many cases the designs used by the painters may have been founded on contemporary fabrics, and the general influence which the subtleties and brilliance of silk textile colouring had upon the painter's palette is incalculable. The effect of the now vividly alive, yet highly stylized, textile patterns on the painters' sense of line and interval and two-dimensional design must also have been profound.

In Pietro's *Crucifixion* at Assisi, the crowding and complexity, and the added interest in contemporary fashion, may well reflect his brother's influence as well as that of Simone Martini. Indeed, Ambrogio himself may quite conceivably have even helped to plan the composition, and the maintenance of separate workshops would have been no bar to an intermittent sharing of assistants. Pietro's subsequent, straightforward compositional borrowings and the details of facial type in either brother's works show that stylistic interpenetration was much greater in the late twenties than it had been ten years earlier. The documented collaboration of 1335 is therefore no surprise upon stylistic grounds.

The two brothers' continued close relationship during the thirties, at least as regards facial types, is confirmed by Ambrogio's Massa

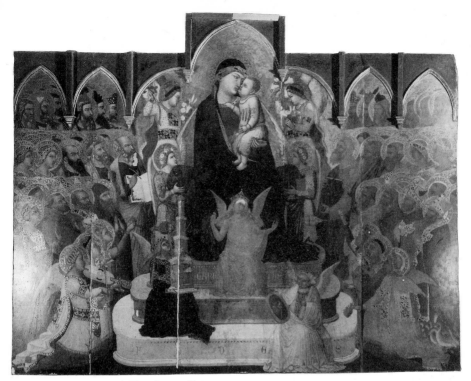

230. Ambrogio Lorenzetti: Maestà, 1330s(?).
Massa Marittima, Palazzo Pubblico

Marittima *Maestà* [230]. Here, the Virgin sits upon a cushion held by angels. Their wings form the curving back-rest of her throne. Faith, Hope, and Charity are seated on the massive steps, and they transform the meaning of the altarpiece. The transcendental emphasis and the unusual depth of theological significance are matched by striking compositional originality. The weighty figure of the Virgin becomes the apex of a formal pyramid of unprecedented grandeur and solidity. The white of Fides and of the step on which she sits is a dramatic contrast to the black of Spes and to the apple green and pinkish red of the succeeding steps. The colour harmony that is built upon this basis is as complex and original as the formal structure, and both are dominated by the broad, calm areas of the Virgin's dark blue cloak. The

volume of the pyramid is accentuated by the firmly spatial setting of the flanking figures, and it is typical of Ambrogio that its diagonal thrust in depth should be completed in the purely surface diagonals of the winged back-rest of the throne. The pyramid in space becomes, alternately, a triangle upon the surface. In its subtlety and deliberation this design prefigures similar experiments which later taxed such painters as Masaccio, Leonardo, and Raphael. Even the early-fourteenth-century difficulties in handling crowds have been transformed into a virtue. Although no realistic change of scale occurs, Ambrogio's compositional manipulation is so delicate that bank on bank of half-glimpsed heads and haloes seem to bring about, not the collapse of otherwise convincing space, but a suggestion of infinity, as tiers of heavenly

231. Pietro Lorenzetti: Birth of the Virgin, 1342.
Siena, Museo dell'Opera del Duomo

hosts stretch back into the distance. Needless to say, the splendour of tooled gold and the numerous small, broken forms intensify the calm simplicity of mass, of contour, and of colour in the central figure. Characteristically, it is in this intensely Christian context that the study of Antiquity, for which Ambrogio was still famous in Ghiberti's time, led him to create the diaphanous, close-wrinkled robe through which the underlying female forms of Charity are faintly visible.

The *Birth of the Virgin* painted by Pietro in 1342 [231], at the height of his powers, proves that compositional originality was not Ambrogio's monopoly. The altarpiece, which has lost its pinnacles and their supporting twisted columns and which once boasted a full-length saint on either flank and a predella below, is a

full-scale elaboration of ideas embodied in the Arezzo *Annunciation* [224]. The painting and its frame become the elements of a single architectural construction, convincing in its simulated three-dimensionality.[12] The framework is so cunningly extended into the articulated vaulting of the bedroom that, oddly enough, it is only the further depths of space upon the left, where a corridor leads onwards to a many-storeyed courtyard and to the temple beyond, that prevent the altarpiece from degenerating into a well defined and shallow, open-sided casket. As it is, this glimpse into a much more extensive architectural complex, derived from that in Duccio's *Denial of St Peter* [175] and his *Feast at Cana*, successfully maintains the association with a more monumental reality. Approximations to actual vanishing points hold good for all but the left-hand section of the design, and these intensify the unifying action of the succession of planes in floor or chest or gaily chequered bed. The horizontal extension of the bold perspective pattern of the coverlet into the right-hand section of the triptych, or the unprecedented daring which allows the bisection of one figure by the right-hand central column of the frame itself, is no less carefully calculated to create the impression of a complex yet coherent space. The precision with which the simple contours of this figure also help to emphasize the centre is only matched by the subtlety with which the whole design is balanced. Within the framing symmetry the perspective centre has been offset slightly to the right and the figure centre slightly to the left. A similar asymmetric balance is maintained by the two flanking panels. The instinctive sensitivity of design; the Giottesque simplicity of the volumes and contours of the figures; the majestic calm with which they act, permit the vivid colour, the bold patterning and multiplicity of observed detail, to bring a sense of gaiety into this solemn moment without detracting from its meaning or diminishing the awe of great and supernatural events.

The *Birth of the Virgin* marks the surviving peak of Pietro Lorenzetti's career. Such charm-ing minor works as the Uffizi *Madonna enthroned*, in which the absolute identity of shape between the opening L and the final numeral of the inscription leaves no alternative to a date of 1340, assist the many associated signed or reasonably attributed works in fleshing out the body of Pietro's artistic personality. They no more add to his artistic stature than do the intrinsically fascinating, related groups of paintings attributed to Ugolino Lorenzetti and to the Ovile Master. Despite continuing attributions to Pietro, the stylistic character of the altarpiece of the Beata Umiltà (Uffizi), with its brilliantly effective simplifications of lightfall and of architectural form, is such that there can be little reasonable doubt that it is neither from his hand nor yet a workshop product, and that it is not to be dated 1316, instead of 1341 as indicated by the repainted inscription. It is a masterpiece in which the reflections of Simone Martini and of Pietro Lorenzetti, mingled with certain Florentine elements, are as clear as the prefigurations of the colouring and doll's-house clarity of form of fifteenth-century Sienese artists such as Sano di Pietro.

Although in terms of visual imagination there is no interior like the *Birth of the Virgin* among Ambrogio's surviving works, there is every reason to believe that he was the leader in the perspectival studies underlying such achievements. There is some evidence of this in his contemporary panel of the *Presentation* [232]. Despite retention of the relatively archaic compositional formula of a building that is half-interior, half-exterior, it contains a number of important innovations. Whereas the normal Sienese or Florentine interior of the time has much more width than depth, Ambrogio's temple, which is three bays wide, is fully six bays deep. The disposition of the weighty foreground figures adds thrust to the unusually accurate and insistent vanishing-point perspective of the floor. The unaccustomed richness of the massive architecture, which allows new head-room for the figures and is reminiscent in its sculptural decoration both of Giotto's *Dance of Salome* and of Giovanni

232. Ambrogio Lorenzetti: Presentation, 1342.
Florence, Uffizi

Pisano's Sienese façade, is matched by firmness of construction and by subtlety of observation. Among the figures, both these latter qualities reach their peak in the thumb-sucking infant Christ, kicking against the swaddling bands.

Ambrogio's last surviving work is his majestic *Annunciation* of 1344 [233]. The approximation to true vanishing-point perspective in the completed flooring as well as in the complex system of preparatory experiments still discernible beneath the surface, confirms the intensity of his investigations during the last years of his life. It is hard to guess how many Renaissance technical advances might have been anticipated if the Black Death had not intervened. The self-deprecating, homely gesture of the angel, whose compact bulk was originally completed by wings of comparable grandeur, blends with the Virgin's concentration on the supernatural event, the coming of the Paraclete.[13] The massive volumes and calm silhouettes accentuate the simple spatial

233. Ambrogio Lorenzetti: Annunciation, 1344.
Siena, Pinacoteca

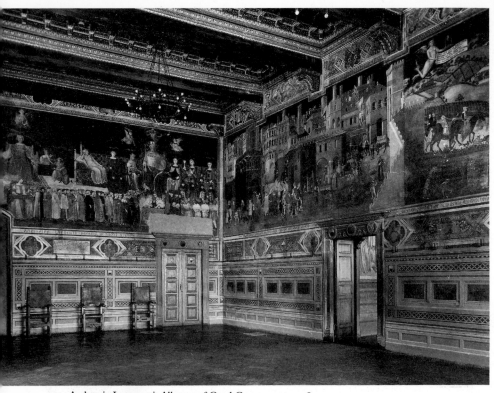

234. Ambrogio Lorenzetti: Allegory of Good Government, 1338–9.
Siena, Palazzo Pubblico

clarity. There are no distracting architectural incidentals. It is a grave, compelling image, and it is typical of Ambrogio that his earliest and latest works should both combine a sense of rigid discipline with the excitement of unusual experiment.

The seal is set upon Ambrogio's intellectual and artistic stature when the thoughtful, almost introspective panel of the *Annunciation* is placed beside the teeming *Allegories of Good Government and Tyranny* in the Palazzo Pubblico in Siena. The frescoes, which he painted in 1338–9, cover three walls of the Sala de' Nove. The fourth is taken up by windows opening on a panoramic view of the *contado*. The *Allegory of Good Government* itself is

opposite the windows [234], and its effects on town and countryside are illustrated on the right-hand wall [236 and 237]. The left-hand wall displays the *Allegory of Tyranny*, followed by *Ill-Governed Town and Country*. Each wall therefore contains a major and a minor centre. The primary centres of the side walls are, moreover, exactly opposite each other. In the main allegory the labels of the various figures and the lengthy rhymed inscriptions give the meaning. On the left, Justice in her distributive and commutative aspects leads to Concord, seated at her feet. The citizens, united by the common cord that stretches from the scales of Justice through her hand, choose for their ruler the Common Good, who holds the other end and is enthroned

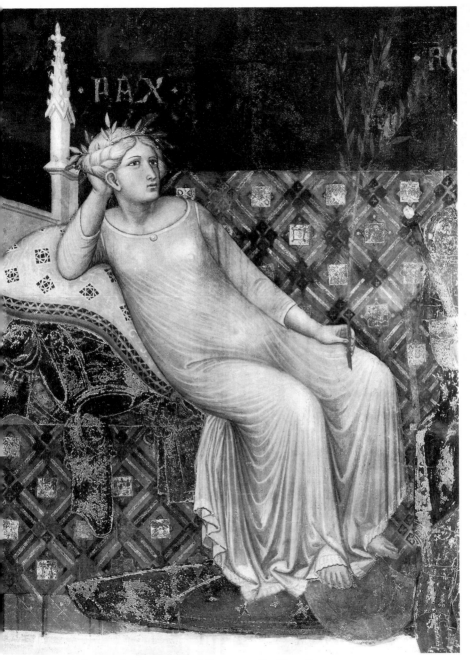

235. Ambrogio Lorenzetti: Allegory of Good Government (detail), 1338–9.
Siena, Palazzo Pubblico

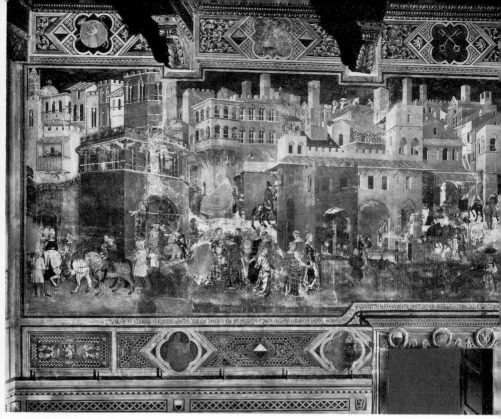

236. Ambrogio Lorenzetti: Well-Governed Town, 1338–9.
Siena, Palazzo Pubblico

upon the right. Charity, flanked by Hope and
Faith, hovers above his head. He is surrounded
by the governmental virtues. His bench-like
throne is shared upon the left by Prudence,
Fortitude, and Peace, and on the right by Mag-
nanimity, Temperance, and Justice. There are,
moreover, literary counterparts for the typical
medieval play on words involved in the
repainted initials around the ruler's head. These
seem originally to have read C S C V – 'Comune
Senarum Civitas Virginis'. The Common Good
and The Good Commune are identical.

Ambrogio's approach to the Vices round the
throne of Tyranny is no less interesting than
his treatment of the Virtues, in which public
blessings such as Peace and Concord are added
to an expanded list of the predominantly
private, Christian virtues of scholasticism.

Among the Vices, Cruelty sits side by side with
War and Treason and Division. The encyclo-
pedic summary is then completed in the
framing medallions, some of which have been
destroyed. The Trivium and Quadrivium of the
Liberal Arts are there, and the benign planets
of the Sun and Moon, Venus and Mercury, and
the fruitful seasons, Spring and Summer, are
opposed to Saturn, Jupiter, and Mars; to Nero
and the Tyrants of Antiquity; to Autumn and
to snow-swept Winter. The close stylistic links
between the figures of the Liberal Arts and
their counterparts on Giovanni Pisano's Pisan
pulpit draw attention to the extent to which
Ambrogio, like Giotto, and like Duccio and
Simone, drew on sculpture for his inspiration.
Even more striking is Securitas' dependence on
a Roman Victory still preserved in the Pina-

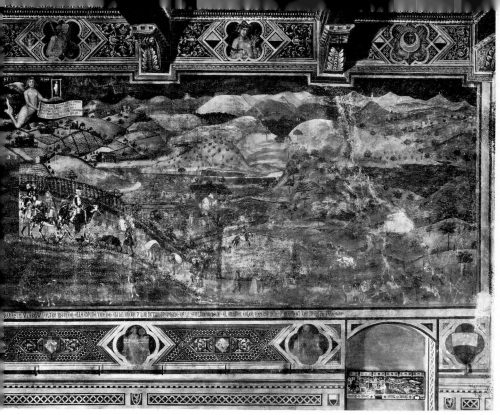

237. Ambrogio Lorenzetti: Well-Governed Country, 1338–9.
Siena, Palazzo Pubblico

coteca at Siena. Indeed, her sister figure Pax is
the most deeply felt and thoroughgoing re-
evocation of Antique, close-folded, sculptural
forms in pre-Renaissance painting [235]. Her
pose and the diaphanous simplicity of her robe
echo the figures of Security on Roman coins.

Despite the reference to ideas embodied in
Simone's and in Duccio's versions of the
Maestà, these frescoes constitute an essentially
secular programme and reflect the changing
emphases of mid-fourteenth-century life. On
the right-hand wall the medieval world of alle-
gory blends into a vision of observed reality
[236 and 237]. The Florentine constructive
compositional skill and powers of abstraction
become the foundation for an all-embracing
natural panorama that is typically Sienese.
Subtle constructions that derive from Giotto

and Maso permit the fulfilment of the promises
implicit in Duccio's *Entry into Jerusalem* of
thirty years before [176]. The composition radi-
ates from the centre of the well-governed city,
where the maidens dance in Lucchese silks of
the very latest fashion. It is from this point that
the painted light shines out to left and to right
over the houses, on into the countryside,
running against the natural flow of light from
the windows on the farthest right. Here too is
the perspective centre of the wall. The buildings
all reveal a highly developed version of the
naturalistic, softened oblique setting developed
by Giotto.[14] The main roof-lines are all seen
from a realistically low viewpoint and all slope
down gently to left or right. The figure dimi-
nution does not merely run from foreground
to background in the usual way: it also spreads

from this same focal point to left and right across the surface of the fresco, ending, on the far right, with the tiny figures in the foreground of the countryside. Pictorial diminution follows the same laws as natural diminution. It radiates in all directions from the onlooker. This reading of the composition is encouraged by the figures moving out to either side as if cast off by the snaking, whip-like motion of the central dance. They are, as always, large for their surroundings, yet their placing and apparent movement play a fundamental, not an incidental, part in the compositional subtleties that control so wide an area of wall.

Just as the well-governed town is Ambrogio's hill-city of Siena, so the painted landscape is the one still to be seen outside the windows. The original purpose of this portrait panorama was undoubtedly to emphasize the home-town relevance of the political ideas that it embodied. Now, it is a mine of information on the fourteenth-century scene. The fashions and occupations of each class in town and country are portrayed. A building still under construction even shows one of the climbing platforms of the scaffolding. The anchorage for the supporting beams in this extremely economical system is provided by the pigeon-haunted holes which pock the faces of so many medieval buildings, including the Palazzo Pubblico itself [127]. The builders used the unfinished walls of church or palace as their own scaffoldings, reducing temporary timber-work to the minimum.[15] The wooden struts and balconies which once sprouted in profusion even from stone palaces are also carefully portrayed. They were once common in Siena, as in every medieval town, but now, apart from modern reconstructions, they are represented only by a few survivals in such centres as Bologna. The emphasis throughout is heavily upon town commerce and its agricultural base. The flying figure of Securitas and her inscription, and the entire compositional and thematic structure of Ambrogio's allegory, express the achievement of the total military and economic domination of the surrounding countryside for which the towns had

struggled over previous centuries. The fresco illustrates the fundamental economic changes which were taking place throughout Central Italy, whatever form of government held local sway. More than that, it is an almost perfect depiction of the governance of Siena itself. The diminished emphasis upon the fully fortified country castles that had been the seats of feudal power; the confinement of the nobles, whether by statute or from economic preference, to their castellated city palaces; the stress on commerce and the dominance of a civil oligarchy, are all shown.

However much is to be learned of Sienese life and customs from this fresco, it still represents the ideal, rather than the real, state of affairs. There had, indeed, been peace and relative stability in the preceding decade. Enormous wealth had been accumulated, and the frescoes are a firm reminder to the ruling classes that cohesion and the common good, which meant the common good of the commercial oligarchy, were the only means by which the supremacy of the Nine, who acted as the guardians of their interests, could be maintained. It is a call to unity, and there is naturally no reference, even in the scenes of Tyranny itself, to the real nature of the constant struggles which by now divided the upper and lower levels of the new commercial society, and which had long replaced the battles between the emergent bourgeois classes and the feudal aristocracy.

This element of idealization is also a reminder that allegory and symbolism were not rigidly separated from descriptive realism. The strict sumptuary laws controlling dress and the prohibition on dancing in the street, together with the fact that the rural occupations are not those of a single season but cover all the spring and summer months from March to September, point to the possibility that the activities in town and country alike are representative of the seven Mechanical Arts and therefore intended both to complement the seven Liberal Arts and to complete the encyclopedic pattern of the whole.[16]

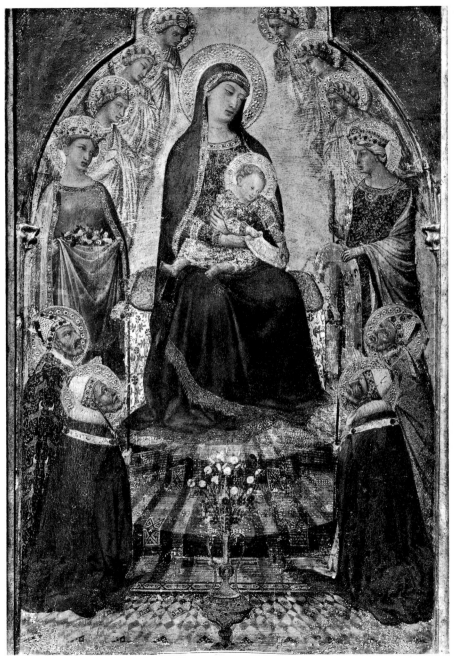

238. Ambrogio Lorenzetti: Maestà, 1330s(?).
Siena, Pinacoteca

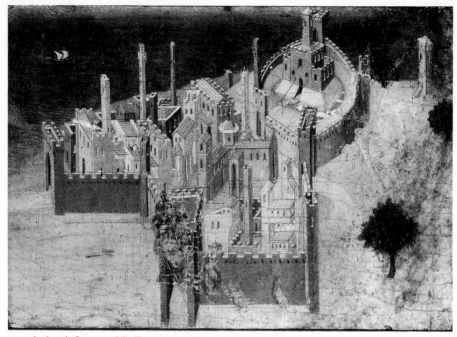

239. Ambrogio Lorenzetti(?): Townscape, mid 1320s(?).
Siena, Pinacoteca

The almost unheralded emergence of a unitary landscape panorama on this scale is, however, a reminder that the decades which precede the Black Death are a revolutionary period in Tuscan art. Time and again experiments which had been begun were never finished in the changed conditions, whether theological or social, economic or artistic, of the second half of the century. Time and again the surviving achievements of the major masters are not followed up for fifty years or more and therefore appear as isolated phenomena. They may even seem to be anachronistic if ill-founded formal canons are arbitrarily established and the history of the period misread. The little *Maestà* in the Siena Gallery, assignable to Ambrogio, is a case in point [238]. The attempt to create a coherent, circular space, and the limitations to which the attempt is subject, are wholly compatible with the attribution.

Similar experiments occupied Pietro and his shop and are echoed in the Ovile Master's *Assumption*. Although accentuated by the way in which the heavy incisions have increased the fragility of the paintwork, the dissolution of the angels' forms by the golden rays of majesty is strictly comparable to the treatment of the figure of God in the spandrel of Ambrogio's own *Annunciation* [233]. The innovations in the *Maestà* are thoroughly consistent with the experiments in composition, in perspective, and in the use and control of light on which Ambrogio was engaged. The richness of design and pose within so small a format are as remarkable as the demonstration that in the hands of great artists, and in such hands alone, objective size becomes irrelevant to a sense of monumental scale.[17]

Whether or not the two small landscapes in the Siena Gallery are also by Ambrogio himself,

240. Ambrogio Lorenzetti(?): Landscape, mid 1320s(?).
Siena, Pinacoteca

they fit extremely well into the pattern of his career in the mid twenties [239 and 240].[18] Both of them retain the convention of the bird's-eye panorama, and the walled city of the townscape is closely related to those in Duccio's *Temptation of Christ*. Despite the doll's-house quality, there is both truth to nature and remarkable economy in the description of a typical medieval town with its encircling walls, its centrally placed cathedral, and its towers and palaces and lesser churches [239]. The various gates within the encircling walls even include the complex Sienese type of the actual Porta Romana. Whether or not the little town is actually, as may well be the case, an idealized representation of the newly recreated port of Talamone, no textbook could describe more briefly or more clearly the arrangement of the innumerable major and minor centres throughout Italy which are connected to, and domi-

nated by, the castle of the local overlord upon its natural or artificial eminence. The castle's role as part of a protective system against common foes and as a final refuge in defeat is demonstrated. The way in which it holds the town defenceless by its interruption of the outer wall, yet is itself defended from the insurrection of the subject citizens, is as obvious as its own internal hierarchy of defence and domination. The moated keep, defended against internal treachery or the breaching of the outer walls, yet subject to the menace of the central tower which is the ultimate retreat and seat of power, is clearly shown. It is against this feudal pattern of control that the communes had long fought. It is the destruction of this pattern that Ambrogio's city of good government celebrates. And finally, it is to this pattern that so many communes, weakened by their misuse of freedom, were reverting.

In contrast to the *Townscape*, which boasts a virtually obliterated nude beneath the tree in the right foreground, it is the way in which the all-pervading signs of human husbandry and habitation are accompanied by an absolute emptiness of animal or human life that lends the little *Landscape* its particular hold on the imagination [240]. It is the first pure landscape painting since Antiquity to have survived. Although, like many of the most remarkable rediscoveries and inventions in the history of art, it has no immediate progeny, it remains one of the many indications of a changing attitude to the natural world. The boldest of late medieval experiments in theme or composition are often attempted in such minor panels or in miniatures, and both these paintings are remarkable for the continuity of the ground plane. It runs unbroken to the upper border, so that no horizon and no sky are to be seen. In the landscape there is even an ingenious attempt to explain the bird's-eye view by means of jutting foreground mountains, on some higher peak of which the onlooker may see himself as standing. These same rock forms play a vital role in the system of compositional checks and balances by which each seemingly haphazardly placed or casually truncated form is so exquisitely controlled. The outcome is an apparently unpremeditated slice of life in which each element contributes to the sense of wholeness and inevitability that characterizes so many great works of art.

A similar combination of control and casualness is the secret of Ambrogio's *Well-Governed Town and Country* [236 and 237]. The road that climbs to the hill-city provides a coherent explanation for the landscape panorama.[19] The planar continuity from the right foreground to the centre of the far-off range of hills is an achievement not to be repeated for a century or so. Still more remarkable, the hills themselves sit in the landscape, as do real hills. They represent no break in continuity and no reversion to Byzantine, surface-climbing formulae. The road that casually runs from the plains to disappear among the whaleback contours only underlines a point made in the very structure of the hills themselves. It is this Florentine feeling for the structural qualities of observed phenomena that gives Ambrogio, the imaginative heir of Duccio, the basis for an evocation of the free and teeming multiplicity of the natural world that has no parallel in range or quality until the time of Bruegel. In itself the Florentine system of visual analysis, with its creative simplifications and logical reconstructions of essentials, had been, and remained, incapable of capturing the fertile casualness that is one major aspect of the natural world. The Florentine achievement lay in other fields entirely, and it is unlikely that the lost scenes of Good Government in the Bargello in Florence, attributed to Giotto by Vasari, were Lorenzettian in character. Indeed, it is precisely because he harnessed Florentine analytic powers to the Sienese synthetic vision that Ambrogio's accomplishments are, in their own way, far beyond the reach either of Giotto or of Duccio.

The barren, war-torn landscape and ruined town under the rule of Tyranny reflect Ambrogio's suppleness of mind and his determination to give intellectual concepts formal counterparts well able to support intense emotional charges. Light now flows naturally, as if from the real windows. Tyranny, unlike the Common Good, spreads only blackness and despair. In contrast to the buildings on the opposite wall, Duccio's foreshortened frontal pattern is exclusively employed. There is no linear continuity. No window-line or balcony runs onwards from one building to the next. Changes of tone and colour are incessant and abrupt, and in conjunction with the flow of light create a flickering jazz-pattern from the jumbled forms. There is no easy flow of movement in the figures. Isolated warring groups are in deliberate disharmony with their architectural surroundings. The distribution of the figures in the main piazza creates an empty, hollow look. In order to transform the intellectual dialectic of a medieval Summa into art, Ambrogio has not merely illustrated the thematic contrasts and substituted ruins for sound

houses: he has contradicted, broken, or inverted each one of the canons of harmonious design established with such care and sensitivity upon the opposite wall. The principles which Giotto formulated with such clarity, and which proved so entirely enigmatic to the great majority of the contemporaries and followers who aped the husk and surface of his style, have been applied with a deep understanding to a wholly different context. Here, under what might seem to be the most unpromising conditions; burdened by a weight of interlocking allegorical, political, theological, and philosophical meaning; hedged about by the hair-splitting subtleties of logical distinction, Ambrogio once more demonstrates the inseparability of form and content in great works of art. The deeper the familiarity with the texts, the clearer it becomes that art is untranslatable and that the forms create a content set outside the realm of words. No poem has a prose equivalent, and visual beauty has no verbal counterpart.

TUSCAN PAINTING

There is an inevitable conflict between the splendour and complexity of the works of art with which the historian tries to come to grips and the poverty and paucity of the words with which he must communicate his findings. To rediscover, to relate, to reconstruct; to bridge some of the barriers of prejudice; to provide an introduction to direct experience; these are the art historian's tasks. They all tend to become more difficult, if not impossible, when faced with the few paragraphs which must suffice for the so-called minor masters or with the sentences by which whole schools of painting are strait-jacketed. The beauty and variety of the works concerned, and the subtle developments within the output of the most cautious and conservative of painters, are not less real because they are to some, or even to a large, extent conditioned and inspired by the achievements of still greater men.

THE SIENESE PAINTERS

The intertwining of the works of Cimabue and Duccio is reflected not only in the *Maestà* in S. Maria dei Servi at Bologna, which is predominantly connected with the former, but also in the *Maestà* at Badia a Isola and in the related *Maestà* once in the Argentieri Collection at Spoleto. The latter is normally associated with Duccio's output during the final decades of the thirteenth century. The Cimabuesque elements in these works extend beyond the derivations from the window of 1287–8 in the Duomo at Siena, and the general pattern remains Florentine even in the highly Ducciesque *Maestà* in the gallery at Città di Castello. This painting forms the nucleus of another restricted group of works, and the rhythmic sinuosities and the fullness of drapery characteristic of Duccio's later style are the catalyst through which the

final synthesis of elegance and grandeur is achieved. From this work it is no great step to the more massive forms of the Ducciesque *Maestà* in the Collegiata at Castiglion Fiorentino, signed by Segna di Bonaventura, Duccio's cousin [241]. The close packing of the figures, like the gold striation of the Virgin's cloak, recalls the thirteenth century. It greatly increases the impact of the central paradox whereby material bulk has been allied to a visionary abruptness in the change of scale. The huge figure of the Virgin is immediately juxtaposed not merely with the smaller saints and angels at her side but with the tiny figures of the donors at her feet. Another of Segna's signed works, the *Virgin and Three Saints* in the Pinacoteca at Siena, allies Ducciesque elements with traces of Simone's early style, and the latter's influence is paramount in the draperies of the Christ Child in a panel in the Seminary at Siena which may be connected with a document of 1317. An important series of large crucifixes, one of them, in Moscow, including a signature, and the signed triptych of the *Virgin and Saints* in the Metropolitan Museum in New York, complete the nucleus to which further works may be attached. Most of the documentary references to a career that stretches from 1298 to a final mention in 1326 and to a death some time before November 1331 are to modest activities like the painting of book covers. The lost signature on a fragmentary painting in the Prepositura at Casole d'Elsa is much more significant. It reportedly ran 'Hec in Apothega Segnae pictoris Senensis'.[1] The relatively low quality of the work implies that the inscription bears on the then germinating modern distinction between personal and workshop production. It adds point to conclusions reached in discussing Giotto's surviving signatures and represents a refinement

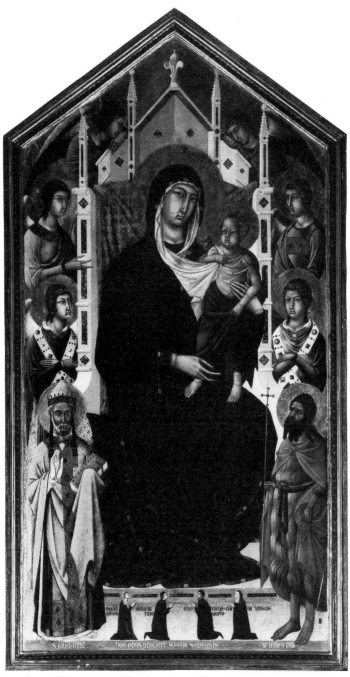

241. Segna di Bonaventura: Maestà, *c.* 1305–15(?).
Castiglion Fiorentino, Collegiata

of the sense of personal achievement so richly documented in Giovanni Pisano's sculpture.

A lost inscription on the dismembered altar-piece from S. Croce in Florence and possible documentary mentions in 1317 and 1325 are all that survive to stabilize the career of Ugolino da Siena. Allowing for a reduction in artistic power and for the personal flavour that attaches to the output of even the most derivative of artists, the latter is virtually *Duccio redivivus*. The case of Meo da Siena, who was active in Perugia in 1319 and who signed an altarpiece preserved in the gallery there, must, however, dispel any misconceived idea that only the great are influential or that beauty only lurks in mas-terpieces. The Umbrian reverberations of his charming, stiff eclecticism, based, but only based, on Duccio, echo down into the Marches, the Abruzzi, and beyond. They form the basis of a whole vernacular lovingly spoken with the various inflexions of their local dialect by innumerable minor artists.

THE FLORENTINE PAINTERS

Giotto's acknowledged pre-eminence among the Florentine painters creates certain psycho-logical difficulties for the historian. There is a tendency either to forget that he was not the founder of the early-fourteenth-century Flo-rentine school or to assert the existence of a non- or even anti-Giottesque school of painting in the city. There is also a temptation to see Florentine art as being far more homogeneous and more clearly bounded than is justifiable. It seems to be more reasonable, on existing evidence, to see Giotto as gradually achieving dominance in a school founded as much on late-thirteenth-century Roman style as on native Florentine tradition. It is a school, moreover, that is more or less continuously fertilized by contact with the art and artists of Siena. From his experience of Rome itself, of Pisan sculp-ture, and of the Umbrian melting pot of Flo-rentine and Roman trends in S. Francesco at Assisi, Giotto evolved a monumental personal style. From the second decade of the century

onwards this, to a greater or lesser extent, directly or indirectly affected the work of every Florentine artist. Those least affected are not to be seen as anti-Giottesque. They were simply continuing, with relatively little disturbance, in a tradition of which Giotto's own style is in some senses the most extreme and most import-ant development. To view Giotto, in the light of this all-pervading influence, as the maker of a programme which his Florentine con-temporaries and successors then attempted to follow as best they could is likewise to distort his real significance. To do so is to imply that most of his fellow Florentines before the advent of Masaccio are to be seen as failures. This they were not. They were, instead, men taking what appealed to them, and what they needed, and each making his own contribution to a stream enriched by a man whose work was probably as little and as seldom understood in its full implications as his fame was great. Florentine art in general was at once less intellectual and less austere than Giotto's. More limited in its departure from tradition, it was correspond-ingly more popular in its appeal.

One of the most obvious characteristics of all European Romanesque and Northern Gothic painting is that it is as at home upon the manu-script page as on the wall. Late-thirteenth- and early-fourteenth-century painting is the first non-Byzantine art since Antiquity to evolve a style which is not merely happy on the wall but is in many respects increasingly incompatible with a miniature format. Conservatism among the panel and fresco painters of early-four-teenth-century Florence is therefore reflected in a style that is easily transferable to parch-ment, even if the artist may not be known to have painted a miniature in his life. Among the miniaturists, on the other hand, the sign of modernity is often an attempt to reproduce the breadth and sweep of fresco painting.

The Crucifixion page [242] in a late-thir-teenth-century Missal in the Laurentian Library in Florence (MS. Conv. Soppr. 233, f. 127 r.) has a breadth and clarity of structure that is only matched in the finest of the panel

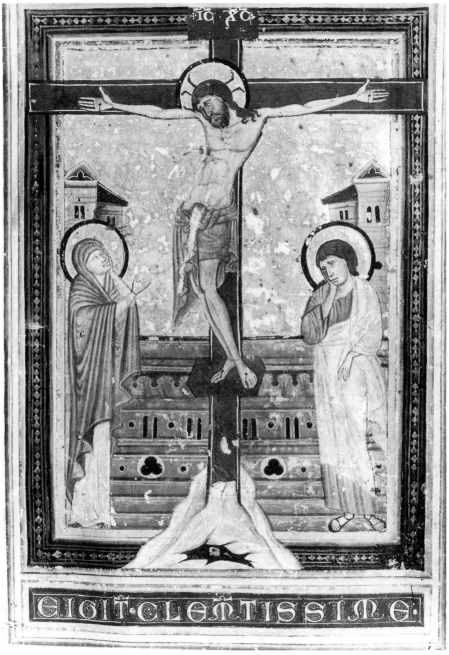

242. Tuscan: Crucifixion from a missal, late thirteenth century.
Florence, Biblioteca Laurenziana

paintings by such men as Guido da Siena. The brilliance of the colour is accompanied by a sense of monumentality recalling Cimabue's frescoes. Nevertheless, in the subtle, plane-harmonious interleaving of the sequence of elements that runs from the outer bordering and inscription to the Crucifixion, and thence to the inner bordering, to the supporting figures, and finally from the innermost border to the architectural background and gold ground, there is a most sensitive accommodation to the decorative demands of the illuminated page.

PACINO DI BONAGUIDA

Strong Roman iconographic echoes with occasional Sienese inflexions, and even stylistic elements derived from the circles of Cavallini and Torriti, can be seen in the illumination and panel paintings of Pacino di Bonaguida. He is first mentioned in 1303 and was probably active during most of the first half of the century. His one signed painting, the polyptych of the *Crucifixion*, confirms the attribution of his major surviving work, the panel of the *Tree of Life* which is likewise in the Accademia in Florence. The line leads from the latter to the series of illuminations in the Pierpont Morgan Library in New York and thence to a long series of more or less closely related manuscripts.[2]

As in the late-thirteenth-century miniature of the *Crucifixion*, already discussed, the significant and not uncommon feature of the full-page miniatures of the Morgan manuscript is that the compositions are simpler and less fussy than those in the majority of equivalent panel paintings. The colour is brilliant, but limited in range, and is distributed in broad and simple areas. The feeling for space is sometimes quite strong, and there are seldom more than four or five figures in one scene. Although few vigorous movements are depicted, the result is an effect of boldness, even of drama, that is beyond the ability or interest of fresco painters of like calibre. *The Tree of Life* itself is virtually an illuminated manuscript both in intention and

in treatment. It follows every detail of St Bonaventure's text and illustrates each of his forty-eight chapters in a separate roundel.[3] These pictograms are notable for their simplicity and clarity and, like the Morgan manuscript and its fellows, they owe much to Giotto and the fresco painters.

Pacino's combination of line and soft bulk; the sense of decorative abstraction that accompanies the earnest didacticism; and finally his dogged textual faithfulness are seen at their imaginative peak in the large gold relief of the *Communion of the Apostles* [243]. This forms the centrepiece of the Tabernacle of the Blessed Chiarito. The formal inventiveness with which the mystery of the Eucharist is given visual body is typical of a wide range of popular devotional works created by minor masters throughout Italy. A special quality is achieved by the union between the abstract gold relief and the panel painting of the mass below. The change of medium and of scale as the heavenly vision gives way to the earthly celebration is the perfect counterpart of the inherent contradiction of the theme. Whether intentionally or otherwise, it exactly expresses the abrupt change of plane from extreme metaphysical abstraction to intensely felt reality that lies at the heart of each great mystery. To a lesser extent it is precisely on such ever-shifting conflicts that paintings like the *Tree of Life* depend for their often curiously haunting power.

THE FRESCOES IN THE LOWER CHURCH OF S. FRANCESCO AT ASSISI

The speed with which the news of Giotto's Paduan achievements was disseminated is most easily seen in the decoration of the lower church of S. Francesco at Assisi. Giuliano da Rimini's panel of 1307 proves that the Chapel of St Nicholas in the lower church, in which reflections of the Paduan style are combined with reminiscences of the St Francis Cycle, was likewise painted before this date.[4] This is confirmed by the similar echoes in the altarpiece, dated 1308, in S. Maria at Cesi. An artist of very

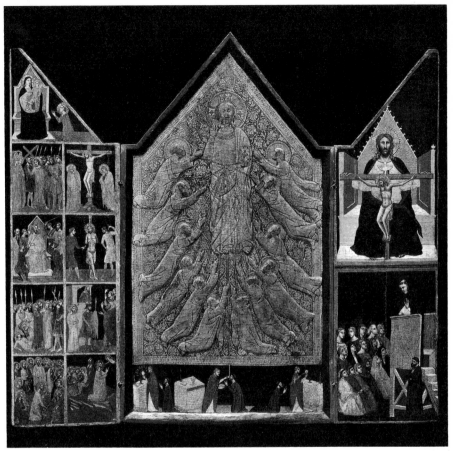

243. Pacino di Bonaguida: Communion of the Apostles, fourteenth century, first quarter. *Malibu, J. Paul Getty Museum*

different calibre, who derived his *Noli Me Tangere* and *Raising of Lazarus* directly from the Arena Chapel, painted the Chapel of the Magdalen at Assisi, probably between 1314 and 1329, during the episcopate of Tebaldo Pontano, the donor. There is a notable concentration and stillness in the scene of *St Mary Magdalen with a Hermit*, and a charming fantasy in the panoramic seascape and harbour of *St Mary Magdalen's Journey to Marseilles*. The survival of the hieratic principle whereby the various figures are scaled according to their importance, and not according to any law of lateral or inverted diminution, and certainly not according to their distance from the main figure, is particularly clearly demonstrated in the latter. The painter's most remarkable achievements are, however, the many single figures of the saints. In the majority of panels and in many frescoes the abruptness of the change of scale merely accentuates the manikin minuteness of the donors. Here, in the *St Mary Magdalen* [244], the kneeling figure of Tebaldo keeps its human scale and lends a superhuman

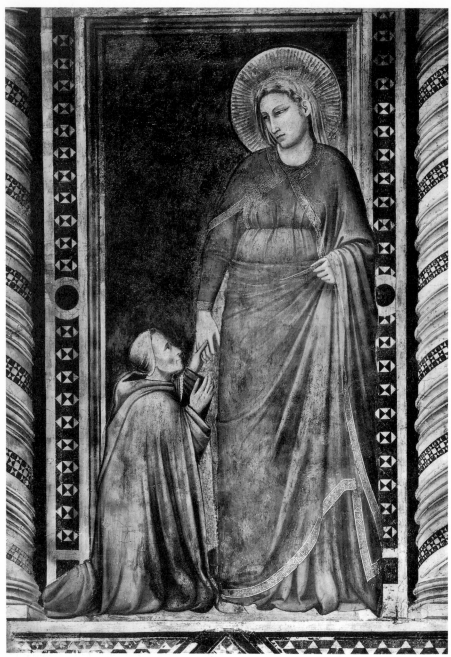

244. Giotto Follower: St Mary Magdalen, *c.* 1314/29(?).
Assisi, S. Francesco, lower church, Chapel of the Magdalen

grandeur to the massive saint. Both figures overlap the painted framework, and the sheer bulk of the Magdalen is intensified by the realism of the painted marbling that seems to thrust her forward into the spectator's world. Yet in the last analysis it is the gravity and calm, the quality of tenderness, that raise what might have been a mere eye-level essay in the handling of pictorial illusion to such memorable heights.

No similar qualities had transformed the crowded *Allegories of Franciscan Virtues* probably painted somewhat earlier in the crossing of the lower church. The gentle, even lyrical, minor talents of their unknown painter and his associates, overpowered as they are by the demands of complex theological abstractions, had already found their own level in the *Early Life of Christ* in the right transept. Wherever possible the borrowings from Padua are direct, but Giotto's compact compositions have been loosened up and filled with incident. A drawing

245. Giotto Follower: Visitation (detail), fourteenth century, first quarter(?). *Florence, Uffizi*

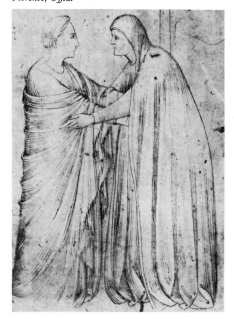

in the Uffizi [245] which is almost identical with the frescoed *Visitation*, but which gives broader, more directly Giottesque proportions to the figures, is especially interesting, as its penwork reveals exactly the same approach to the building up of form as does the brushwork of the panel or fresco painters of the period or the parallel striations of the claw-chisels used in the penultimate stage of the carving of the figures on the façade at Orvieto.[5] The artist's powers are not by any means confined to his handling of the pen or brush. The connexion between the *Presentation in the Temple* and Ambrogio's similar panel of 1342, or between the *Christ among the Doctors* and the fresco of the *Reception of St Louis* in S. Francesco in Siena, is more than skin-deep. Both scenes are notable not merely for the depth, the richness, and the clarity of architectural space, but for the incorporation of an accurate vanishing point. The distance-point construction which was subsequently popular throughout Northern Europe was almost certainly the method used.[6] In it, the rate of diminution is controlled by the convergence of the diagonals of the receding squares. The result, particularly in the *Christ among the Doctors*, with its rectangle of seated figures and succession of receding planes, its firmly constructed coffering and cross-vaults, is indeed remarkable for its likely date and presages the spate of perspectival experiments that characterizes the decade preceding the Black Death.

BERNARDO DADDI

The vigour of Sienese artistic life in the second quarter of the fourteenth century, as well as the stature of the Lorenzetti brothers, is shown by their ability to work alongside Simone Martini without being drawn into his orbit, and to take nourishment from Giotto with no trace of indigestion. In Florence, there were no men of such stature working side by side with Giotto. Only the sculptor Andrea Pisano stands direct comparison, and it is significant of the relative strength of the two great schools of painting, in

qualitative if not in quantitative terms, that, next to Giotto, Bernardo Daddi has reasonably been acclaimed as the major Florentine painter of the first half of the century.[7] Daddi's prolific output is indeed the clearest illustration of the general drift of Florentine art in the two decades preceding the Black Death. The catalogue of his work is based on the reasonable stylistic association between the documented altarpiece painted in 1346–7 for Orcagna's Tabernacle in Orsanmichele and the several panel paintings signed 'Bernardus de Florentia'. The first of these is the Ognissanti triptych now in the Uffizi. It was painted in 1328, about a decade after his name was entered in the Guild of Medici e Speciali, and the spacing of the inscription indicates the possibility that it is not a cut-down polyptych but one of the earliest examples of a new form of altarpiece. Daddi's career is often arbitrarily fragmented by a false contrast between a Florentine early period and a Sienese late phase, but the contrast between the stiffness and remoteness of the half-length figures in this altarpiece and the intimacy of the tabernacles and altarpieces of the thirties cannot be explained in these terms. In it, diluted reflections of the St Cecilia Master, and to a lesser extent of Giotto, are combined with the retention of the decade-old pattern established in Simone Martini's Pisa and Pietro Lorenzetti's Arezzo polyptychs of 1319–20 [209 and 224]. The pose of the central figures is almost exactly that of Simone's work, and the increased centralization results from the concentration from polyptych to triptych form. Far from undergoing a sudden change of orientation, Daddi reflects right from the first the fusion of the specifically Sienese and Florentine contributions to the Tuscan tradition.

The frescoes of the *Martyrdoms of St Lawrence and St Stephen* in the Pulci-Berardi chapel in S. Croce in Florence show Daddi's limited ability to cope with the problems of the new monumental style. There are hints of the St Cecilia Master's sense of space, but Bernardo's architecture is both fussy and inconsequential in its relation to the figures. Although there are

reflections of Giottesque solidity, the physical activity, anecdotal busyness, and abundant use of gesture are no substitute for Giotto's psychological intensity and cannot hold the overextended compositions together. Their beauty lies in such details as the man intent on pouring out his coals, or in the ritual ballet of St Stephen's executioners set against the empty backcloth of the sky.

Bernardo's reputation rests on a very different kind of achievement. This stems from a swift conversion from the somewhat remote conservatism of the Ognissanti triptych and an appreciation of the growing needs of personal devotion. He so transformed the small-scale, portable tabernacle, with which Duccio and his circle had already experimented, that from being a relatively rare form it became the centre of an industry. To the already intimate scale and jewelled colour he added intimacy in design and iconography. The demand for small altarpieces for personal use grows naturally from the century-long emphasis on the personal and human aspects of the divinity, backed by the fervent emotionalism of contemporary preaching, on the one hand, and the continued creation of new wealth and the enlargement and diversification of the newly emergent middle classes in the great cities on the other. Like all successful innovations the new form greatly increased the strength of the demand it was designed to satisfy. The pattern that Daddi established was repeated in innumerable variations throughout the century. Its developed form emerges in what, if its heavily restored inscription is reliable, is the earliest securely attributed and dated, though unsigned, surviving example. This triptych is now in the Bigallo, or Foundling Hospital of Florence, for which it was evidently painted [246]. In the central panel spatial grandeur is combined with an insistent surface pattern. The latter is partly established by the steeply rising planes of a monumental throne. It is intensified by the cunning interplay of the latter's curves and pinnacles and gables, and of its plain and trefoil arches, with the repeated trefoils and plain

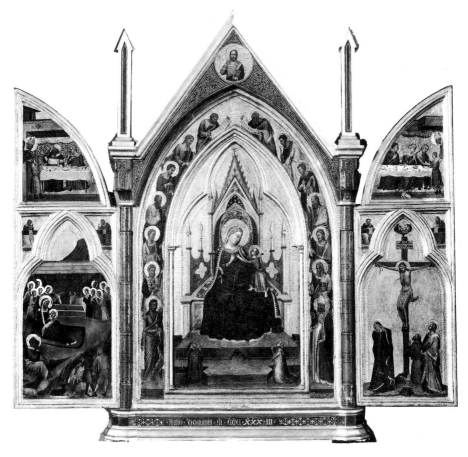

arches of the framework of the pinnacled and gabled tabernacle itself. The element of three-dimensional realism is also balanced by the decorative separation and wholly unnaturalistic disposition of the rim-like arch of attendant saints and prophets. The monumentality of design and the association with the theme of the Queen of Heaven is countered by the intimacy of scale and by the fond humanity of the relationship of mother and child. This intimacy is accentuated in the Virgin humbly seated on her palliasse in the *Nativity*.

In the last analysis the visual quality of the triptych depends upon its clarity of design. This clarity, harking back to Giotto's Ognissanti

Madonna [198] and constituting Daddi's true debt to his great contemporary, embraces both the pictorial content and the colour, and extends to the form of the tabernacle itself. It alone allows a mass of detail to be accommodated without descent to fussiness. There is great subtlety in the apparently simple device whereby the rigid symmetry of the central panel is enlivened by an emphatic diagonal of movement. The elements of symmetry and counterpoint are no less skilfully combined in the colour. The accentuated contrast and asymmetry of the *Nativity* and *Crucifixion* are similarly disciplined by the virtual, yet not total symmetry of the remaining features of

the shutters. In all these things the triptych is the antithesis of Daddi's huge yet muddled frescoes.

To speak of industry in connexion with Bernardo's many tabernacles, altarpieces, and devotional panels is no mere form of words. Of his four surviving signed works, only the triptych of 1328 reveals no obvious workshop intervention. Indeed, the S. Maria Novella and Gambier-Parry altarpieces of 1344 and 1348 respectively may have been almost entirely executed by an assistant to whom a whole group of further paintings has been assigned.[8] Bernardo's attitude to the meaning of a signature therefore seems to be very like that previously attributed to Giotto. In catering to what was by earlier standards a mass market, Daddi, too, established a large workshop, and the contributions of his many assistants are apparent in innumerable permutations in most of the shop's output. There is, however, further confirmation that the attitude ascribed to Giotto in connexion with the Louvre *Stigmatization* is not improbable.[9] In 1334, Taddeo Gaddi, Giotto's most important assistant and pupil, was perfectly happy to sign what amounts to a straightforward copy of Daddi's Bigallo tabernacle of 1333. It is true that it has no gable and no pinnacles. The arches and the mouldings of the frame are heavier and rounder. The figures are, as might be expected, somewhat bulkier, and the throne has been slightly reduced in scale in order to accommodate a disproportionately heavy pair of twisted wooden columns. The latter, though virtually the trademark of the Giottesque fresco painter, serve only to upset the intricate checks and balances of Bernardo's design. None of these minor changes affect the fact that Gaddi was active in a world in which the craftsman's largely unchanged attitude to his work was still the background for the major social and artistic revolutions.

The centre panel of a tabernacle signed Bernardus and dated 1334 in the Uffizi in Florence reverts to the main tradition established by Cimabue and Giotto. This pattern, in which the Virgin's throne is surrounded by saints and angels, remains the most popular among the many related and derivative panels, and in such major altarpieces as that from S. Pancrazio, probably painted in the early forties and now in the Uffizi. Though crammed into a misbegotten nineteenth-century frame, the latter is the most complete surviving full-scale work substantially painted by Daddi himself. In such scenes as the *Meeting at the Golden Gate* in the predella, the backwash from Taddeo Gaddi's frescoes in the Baroncelli Chapel in S. Croce may now be added to the familiar blend of elements from Giotto and the Lorenzetti. The fluency and occasional complexity of design seen also in the Vatican predella, datable to the late forties, clearly show the influence of fresco painting. The nature of Daddi's interest in the representation of space as such is charmingly illustrated in the tiptilted bed of the *Birth of the Virgin*. Here, a chaplet of figures, similar to that which harmonizes with the landscape of the *Nativity*, is contrasted with the rectilinear architectural setting.

As might be expected in a period dominated by the fresco painters, narrative plays an increasingly important role in the predellas of polyptychs and the wings of tabernacles. Daddi is, however, typical of the vast majority of Florentine panel painters and miniaturists in that his approach is episodic rather than dramatic. This is reflected both in the construction of single scenes and in his lack of concern with the creation of compositional sequences. He is equally disinterested in balancing or contrasting scenes in order to create a compositional counterpart for the narrative as a whole. It is when the individual design is reduced to the simplest possible terms and no attempt is made to indicate locale or to incorporate descriptive detail that his art does take on a dramatic quality. The much damaged *Vision of St Dominic*, possibly belonging to a lost altarpiece of 1338, is one example [247]. The outcome is not psychological but visionary drama, and the vehicle is the abstract play of colour, line, and silhouette. The rushing figures of the two

247. Bernardo Daddi: Vision of St Dominic, 1338(?).
New Haven, Conn., Yale University Art Gallery, James Jackson Jarves Collection

apostles gain acceleration from the sudden tightening of the curve of the containing arch. The black of the Dominican cloak stresses the visual drama of the bulky, static silhouette that once accentuated the needle-sharpness of the proffered sword. The interlocking curves give positive compositional force to the stark, rect-angular strip of ground. It is as memorable in its very different way as Andrea Pisano's *Presentation of the Baptist's Head* [296], which surely played a part in its creation.

The peak of Daddi's narrative invention occurs in the *Adoration* on the outside of the shutters of the tabernacle of 1338 in the Seilern

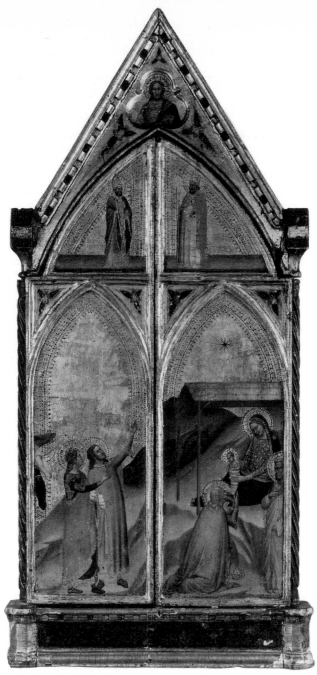

248. Bernardo Daddi: Exterior of triptych, 1338.
London, Seilern Collection

Collection [248]. The camels' heads are virtually reduced to abstract, disembodied shapes against the elaborate tooling of the golden sky. The sweeping, bare, diagonal union of the two compartments and the cunning compromise between the needs of either leaf and of the whole design, the subtleties in the placing of each element, are only matched by the continuously fertile balancings of decorative and descriptive needs. In the left-hand panel the tension between the central placing of the figures and the outward sweep of hand and rock is as effective as the reiteration of the pyramid of mountain in a pyramid of figures on the right. In the latter case there is a mutual reinforcement not merely in terms of silhouette but in those of volume and spatial disposition. The relationships that bind the columnar, half-seen figure of St Joseph to the horizontals of the shed roof, and then, by means of similarity instead of contrast, link this same roof to the ground planes of the upper compartments, are no less subtle or less visually taut. The placing of the single saints within these upper compartments is exactly calculated to draw the eye to God the Father in the crowning trefoil. In this way the final bonds of form and content and of architectural, figural, and decorative patterns have been forged. A total arch or pyramid of figures is created, and the tension that unites the linked and yet contrasting arch forms of the frame, or ties the pyramid of mountain to the upper pediment, or, through the punched work in the haloes and the sky, unites the individual figures to the frame, becomes an all-embracing principle of design. The self-same elements that lie inertly or coincidentally combined in other tabernacles of the type are raised to a new, vibrant level of existence in the seemingly calm context of this little altarpiece.

The traces of several hands both here and in the Bigallo tabernacle confirm that even on the smallest and most intimate scale the cooperative processes that created monumental masterpieces like the Orvietan sculptures or the frescoes of the St Francis Cycle at Assisi were still used. The gulf that separates Bernardo Daddi from Taddeo Gaddi and the ties that bind them can be seen in the new elegance of the reiteration of Taddeo's twisted columns on the main face of the tabernacle. Here, too, the complicated counterpoint of Daddi's colour scheme can be fully appreciated.[10]

The constellation of lesser lights profoundly influenced by Daddi's highly sophisticated and yet seemingly undemanding response to the changing and continually increasing needs of private devotion and public worship is not bounded by his assistants and anonymous immediate followers. Jacopo del Casentino, who probably died in 1358, seems to have been active throughout the first half of the century. His oeuvre is based on the signed tabernacle in the Cagnola Collection in Milan and includes such variations on a thirteenth-century theme as the S. Miniato altarpiece. It moves from an eclectic manner, based in the first place on the tradition epitomized in the work of the St Cecilia Master and in the second on that of Duccio and his circle, towards a fluctuating style in which Sienese and Giottesque elements mingle with the closest reflections of Daddi's manner. The latter's immensely successful formulae are embodied in a number of his altarpieces and tabernacles.

Both Daddi and Pacino contribute to the artistic formation of the illuminator of Domenico Lenzi's *Biadaiolo Fiorentino* (Bibl. Laur. MS. Tempi 3).[11] This Mirror of Humanity, treating of the sale of grain, must surely rank among the most attractive manuscripts ever produced in Italy. In the full-page scenes of *Harvest* and of the *Corn Market in a Year of Plenty* nature sings, the angels trumpet, and the sky is sown with flowers [249]. His work is full of humorous observation and precise description, and besides the details of commercial life there are three broadly patterned, gaily jumbled full-page townscapes. Especially interesting is the way in which the figures in the altarpiece or tabernacle of the Virgin in the *Market in a Year of Famine* are given a reality indistinguishable from that of the crowd that struggles round the corn-bins or of the devil hurtling

249. Master of the Biadaiolo Fiorentino:
Corn Market in a Year of Plenty,
from the Biadaiolo Fiorentino, *c.* 1335–40.
Florence, Biblioteca Laurenziana

through the sky. Above all he is notable for the
breadth of his design and for the boldness with
which he creates, abolishes, and recreates a
spatial situation. He insists on the firmness of
his figure volumes or upon the circular group-
ing of the heavy corn-tubs, and then sits sacks
and figures down upon the wide, flat border.
The figures slip between the patterned stripes
or walk across them on to the flat, parchment
page. In front of or behind, under or over, on
or into, it is all the same to him, and yet the
vigorous associations with the three-dimen-
sional world of day to day still seem to grow.
Such wit and gaiety, such happy juggling with
pattern, form, and colour and the visual facts of
life, are as irresistible as they are unusual in the
field of Florentine illumination. The prolific
and closely related but distinct artistic person-
ality of the Master of the Dominican Effigies,
with his more limited solidity and his temper-
ing of gaiety with restraint, is perhaps more
fully representative of the central stream of
Florentine illumination.

TADDEO GADDI

The only member of Giotto's immediate circle
whose artistic personality has survived in a con-
vincing form is that of his reputedly long-time
pupil and assistant, Taddeo Gaddi. His earliest
major works are the frescoes of the *Life of the
Virgin* in the Baroncelli Chapel in S. Croce
[250], which were probably carried out soon
after 1328 when the building of the chapel was
begun, and Taddeo is likely to have helped in
the painting of Giotto's own altarpiece for the
same chapel.[12] The signed triptych in Berlin,
derived from Daddi and discussed above, is
dated 1334, and Vasari states that the frescoes
in the choir of S. Francesco at Pisa, of which
only the figures in the vault remain, were signed

and dated August 1342. At some time probably
after 1348, the authorities of S. Giovanni Fuor-
civitas at Pistoia placed Taddeo at the head of
a short list of 'the best masters of painting who
are in Florence'. The four remaining names
were those of Stefano, the far-famed but elusive
follower of Giotto whom Ghiberti characterized
as 'the ape of nature', Andrea Orcagna, his
brother Nardo, and a certain Francesco,
working in Andrea's shop. Taddeo received the
final payment for the still-surviving altarpiece
in 1353. This was two years before he signed
and dated the *Madonna Enthroned* now in the
Uffizi. Finally, in 1357, 1364, and 1366, the year
of his death, he was a member of commissions
called in to adjudicate upon the plans for the
new Duomo.

Compared with Giotto's concentrated and
severely disciplined works, the frescoes in the
Baroncelli Chapel, for which Taddeo also seems
to have designed the windows, are characterized
by two apparently conflicting developments
[250]. A growth in both the quantity and com-
plexity of the descriptive detail is accompanied
by increased emotionalism. A greater emphasis
on human intimacy and a tendency to mysticism
develop hand in hand. In these respects Gaddi
is both typical of his own time and the source
of one of the main streams of later-fourteenth-
century Tuscan painting. In abstract, archi-
tectural terms, it is noticeable that the intro-
duction of an almost febrile and a-structural
twist into the familiar motif of the spiral
columns is accompanied by the painting of two
small but startlingly realistic shelved niches in
the fictive marble dado. The disposition of a
few liturgical necessities that include the bread,
decanters for the water and the wine, a pyx, a
prayer-book, and a paten give full value to the
interplay of empty space and simple solids.
Historically, these aumbries, like that by Pietro
Lorenzetti in S. Francesco at Assisi, form a
link between the similarly disposed still-lives of
Antiquity and the illusionist *intarsia* cupboards
of the Renaissance.[13]

The way in which the handmaid in the *Birth
of the Virgin* squats like a peasant on the floor,

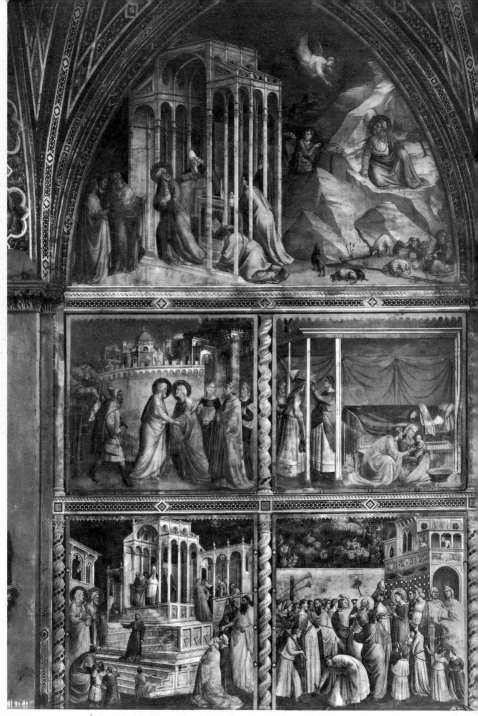

250. Taddeo Gaddi: Scenes from the Life of the Virgin, probably soon after 1328.
Florence, S. Croce, Baroncelli Chapel

dandling the swaddled infant, while her companion, kneeling on one knee, leans forward with a sweeping gesture of affection to grasp its hand in hers, is typical of the human intimacy shared with Daddi and the Lorenzetti. There are even overtones of melodrama in the theatrical and over-life-size quality of the gestures in the *Expulsion of Joachim*. Here, however, the transition from the merely theatrical towards the visionary is accomplished partly through the lighting and partly through the strangeness of the soaring, spidery architecture of the temple. This resembles nothing so much as three bays cut from the nave and aisles of an uncompleted church, and may reflect the visual impact of the then unfinished Duomo. The immediate juxtaposition of the lurid, rocky landscape of *Joachim's Vision* adds a final unexpected touch.

The use of light for its emotive qualities recurs in the *Annunciation to the Shepherds*, in which the barren landscape and contorted figures startled from their sleep are bathed in an unearthly glare that marks a definite advance in the exploration of night lighting. Emotional and descriptive aims are similarly linked in the treatment of the *Virtues* in the vaults. The vibrant intensity of the figure of *Faith* far outstrips the demands of mere symbolism. *Hope*, reaching for the crown that floats beyond her grasp, seems caught within the spinning treadmill of desire [251]. The clash between the three-dimensionally realistic foreshortening of the barrel-openings and the unreality of the total spatial situation becomes a positive factor in the impact of these memorable images.

Taddeo's interest in descriptive detail reaches its climax in the latest scenes of the *Presentation* and the *Marriage of the Virgin*. Together they form a weighty compositional base for the increasingly less crowded and more vertical designs on the upper wall. In the marriage scene the introspective, grave procession and solemn ceremony of the Arena Chapel are telescoped into a thronging carnival. The sacramental core is virtually submerged by the external trappings. On the other hand, for all its complicated unreality, the architectural

251. Taddeo Gaddi: Hope, probably soon after 1328. *Florence, S. Croce, Baroncelli Chapel*

structure of the *Presentation* constitutes a new development in the coordination of solid objects. The perspective is less consistent than Giotto's and far less subtle. Nevertheless, the jutting solidity of the extreme oblique construction used by Cavallini, by the Master of the St Francis Cycle, and by Giotto in his earlier Paduan frescoes is fully exploited. Every variant of the Giottesque oblique construction, from an almost imperceptible modification of the foreshortened frontal setting onwards, is used with fine impartiality in the Baroncelli frescoes. Yet this particular composition, recorded in a remarkable fourteenth-century drawing that is free of the confusions introduced into the fresco during restoration,[14] is the

252. Taddeo Gaddi: Ascension, c. 1330.
Florence, Accademia

one which excited later Northern artists such as Pol de Limbourg. Though such theatricality is seldom seen in later-fourteenth-century designs, it is the extreme version of the oblique setting, rather than its subsequent refinements, that was most often intermingled with other, contradictory constructions. It was seemingly valued for its direct impact by a host of minor artists who were little concerned to analyse the representational subtleties of the visual world.

To turn from the frescoed *Presentation* to the twenty-six pierced quatrefoil panels and two semi-lunettes of the cupboard that Taddeo painted, presumably at about the same time, for the sacristy of S. Croce is to move from one extreme to the other. In the *Ascension* there is

unprecedented clarity in the spatial disposition of the circle of apostles looking up in amazement at the flying figure of Christ [252]. A notable economy and lack of crowding, a cunning disposition of simple, architectural elements and a concentration on dramatic essentials characterize each of the thirteen quatrefoils on the *Life of Christ*. As in the striking image of the Christ Child in the star in the Baroncelli *Story of the Magi*, the tendency towards increased humanity is illustrated by the kneeling Virgin of the *Adoration of the Shepherds* or the kneeling Christ in the *Baptism of Christ*. Like the continued use of emphatic, emotionally charged gestures, such things appear to be connected with Taddeo's acquaint-

253. Taddeo Gaddi: Tree of Life, Lives of the Saints, and Last Supper, c. 1340–50.
Florence, S. Croce, Refectory

ance with the Umbrian mystic Fra Simone Fidati.[15] The friar was certainly in Florence at least from 1333 to 1338, and his *De Vita Christiana* provides parallels for such changes. The scenes of the *Life of St Francis*, on the other hand, are for the most part closely derived from the Assisan canon and its Giottesque modifications in S. Croce itself. The contrast seems likely to stem from the specifications of his Franciscan patrons or from the overwhelming impact of Giotto's own recent inventions in the neighbouring Bardi Chapel, or from both. Despite their understandably greater descriptive content, the gospel scenes are strictly comparable to Andrea Pisano's more or less contemporary reliefs for the baptistery

doors. In their compositional cunning they seem to be specifically designed to fit their complicated frames, whereas, with certain notable exceptions such as the *Stigmatization*, the Franciscan scenes all have the air of being scaled-down frescoes, ill-adapted to their new surroundings.

By 1353, when he completed the altarpiece for S. Giovanni Fuorcivitas at Pistoia, Taddeo had, like most of the Tuscan artists under the influence of Daddi and Martini and the Lorenzetti, moved towards a highly decorative style with transcendental overtones. Elaborate damasks and a decorative play of folds, together with a cunning relationship between pictorial masses and the greatly increased structural and

decorative complexity of the gilded frame, are noticeable features of the work which had probably been begun by other hands as early as 1345. No less significant is the replacement of the corporeal, earth-bound, standing angels that traditionally surround the Virgin's throne by the disembodied, winged heads of the Seraphim. When, in his *Madonna* of 1355, Taddeo followed more directly in the trail that Giotto blazed in the Ognissanti *Madonna* [198], the decorative elaboration was no longer spiritually transmuted in this way. In a society increasingly concerned with a synthesis of the practical realities of commerce and the transcendental demands of religion, the Sienese contribution to its art was clearly an essential and invigorating force. It was not, as is commonly supposed, a softening and weakening element. It was internal need and not external chance that motivated the eclecticism of Taddeo Gaddi and Bernardo Daddi. Taddeo, in particular, was successful precisely in so far as he escaped from Giotto's towering shadow to create his own union of opposites.

The fresco combining the *Tree of Life* with the *Stories of St Benedict, St Louis, St Francis,* and *St Mary Magdalen* and with the *Last Supper* reflects a rather different aspect of the general trend of Florentine art [253]. It fills the whole end wall of the refectory of S. Croce like an enormous frescoed altarpiece, and the differences which separate it from such works as Pacino's panel of the *Tree of Life* are as important as the similarities which link them. The general sophistication, and the conscious decorative intent in the handling of the writhing scroll-work, are quite unknown to Pacino. There is a constant juggling with shifting levels of reality. The transition from the mystic tree to the realistic grouping of the figures at its feet is no less complex than that between the mystical and didactic central scene as a whole and the complex spatial settings and detailed landscapes of the flanking histories. The shift from these contrasting forms, so carefully contained within the flat, decorative marbling of the common framework, to the *Last Supper,*

spread before the entire structure as though on another trestle table set within the real space of the refectory, is even more extreme. The confidence with which such feats of illusion could now be attempted, virtually at eye level, is an earnest of how much both the painters and their public had learnt in a little over half a century. The range, from allegory and pure didactic painting to illusion, is wider, and the balancing of three-dimensional with planar, decorative considerations is more complex and more carefully controlled than in any other fourteenth-century Florentine fresco. Whether or not the outcome is more moving than Pacino's comparatively restricted image, it is certainly more daring and more revealing of contemporary complexities of thought and of artistic vision.

MASO DI BANCO

Except that his belongings, including his painting equipment and unfinished work, were sequestrated by Rodolfo de' Bardi in 1341, and that he appears in the Guild Books in 1343 and in 1346, and in the Register of the Compagnia di S. Luca in 1350, nothing factual is known of Maso di Banco. There is, however, an uncontested tradition, originating with Ghiberti, that he painted the frescoes of the *Life of St Sylvester* in the Bardi di Vernio Chapel in S. Croce. Comparison with Taddeo's work reveals a sensitivity of quite another order. The clarity of design, not merely in the carefully restricted compass of a quatrefoil, but on a monumental scale; the subtlety in composition and the feeling for the structure and appearance of the natural world are such that Giotto and Ambrogio Lorenzetti come immediately to mind. The frescoes probably date from the late thirties. It is therefore significant that there are soft lateral recessions, strictly comparable to those in Ambrogio's *Well-Governed Town* [236], in both of the centralized interiors on the main wall, as well as in the final, outdoor scene of *St Sylvester and the Dragon* [254]. None of the main frontal surfaces of any of these build-

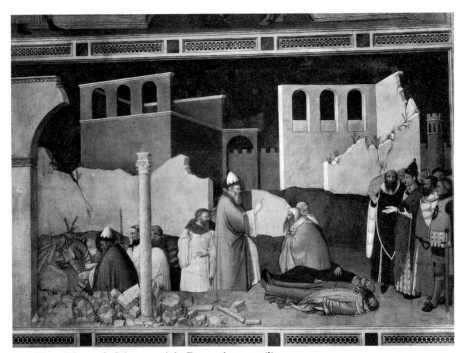

254. Maso di Banco: St Sylvester and the Dragon, late 1330s(?).
Florence, S. Croce, Bardi di Vernio Chapel

ings is parallel to the plane of the wall. The recessions to left and right across the surface, as well as the normal diminutions towards a vanishing axis, therefore inescapably reflect a way of seeing normally aligned objects. They cannot simply be a record of the objective relationships of an obliquely disposed series. Since the chapel is both tall and narrow, the final effect is remarkable. Strong vertical foreshortenings complete the pattern established by the painted recessions into and across the surface of the wall. The eye supplies the curves the artist has implied, and an apparently completely curvilinear world is generated. Such thoroughgoing exploration of the meaning of Giotto's pioneering investigations into the subtleties of visual appearances are rare. The implications of the lateral recession in the upper part of the *Feast at Cana* at Padua are, however, also taken up by the artist, closely related to Maso,

who introduced a series of lateral recessions into the Latin-cross church in the fresco of *St Stanislas raising a Youth* in the lower church of S. Francesco at Assisi. Moreover, in Maso's case the total absence of separation bands between the frescoed architectural framework and the painted scenes shows that already, a hundred years before Alberti gave the idea geometric definition, the solid walls were fully opened up as windows through into a new, if not yet scientifically organized, reality.

Maso's compositional skill, as well as his acuity of perception, is demonstrated in the fresco of *St Sylvester and the Dragon* [254]. Here, two successive episodes involve the dual representation of most of the figures. At first the action is compositionally relaxed. On the right the stupefied magicians lie upon their backs before the emperor and his retinue, and St Sylvester calms the dragon on the left. A

moment later, and the saint comes to the centre; the magicians wake. The discrete elements are drawn together and attention focused at the apex of a formal triangle that coincides with the perspective centre. The architectural recession to the wings then reasserts its gentle pull and the perpetually self-energizing cycle can begin again. Every return increases awareness of the subtle part played by each casual-seeming detail. The arch that frames the central figure of the saint; the linking figure, half turned from the earlier action, yet fully a participant in the final climax; the foreground column and the broken arch that draw the eye towards the left and help to frame, but not to isolate, the action; the asymmetric balance that includes both form and colour; the alternating tonal contrasts between light and dark, and dark and light, that reach their climax in the stark forms of the windows cut into a white wall – blind and empty eyes pierced by the darkness of the sky; the process of discovery is as never-ending as the paradox uniting discipline with freedom and clarity with complexity is complete.

Restoration has greatly altered the quality of the actual brushwork. Fortunately the decoration of the chapel is completed by the stained-glass windows. Here, in the head of *Trajan*,

255. Maso di Banco: Head of Trajan,
detail of stained-glass window, late 1330s(?).
Florence, S. Croce, Bardi di Vernio Chapel

which is one of the best preserved sections, the power of Maso's draughtsmanship can still be seen [255]. Though painted in monochrome upon the glass, it has the quality of a monumental, finished drawing.[16] The full force of the Florentine draughtsmanship, so often softened by the transition into paint, has been retained. The colour scheme of the windows is based upon symmetrical contrasts. In the three lower pairs of figures the dominant green and yellow of the emperors on the left is balanced against the dominant red and purple of the saints upon the right. The transposition of the upper pair of St Sylvester and the Emperor Constantine also creates a cross-over of colour. Any rigidity in the pairing is, however, obviated by the interpenetration of each dominant by small areas of its opposite. As in the great round window in the Duomo at Siena, every pane is notable for its absolute evenness of tone and colour. The calmness of the frescoed colour areas is emulated in a heightened key of brilliance and translucence.

Maso's originality is no less evident in terms of more familiar subject matter. In one of the tombs in this same chapel a fresco fills the niche above the sarcophagus and completes the sculptured monument.[17] In it the dramatization of the theme of personal salvation attempted by Arnolfo in the tomb of Cardinal de Braye is carried a stage farther. The dead Bardi kneels in prayer on his sarcophagus before a desolate, rocky landscape. The trumps of doom are sounded in the sky and an impassive Christ in a mandorla, flanked by angels with the symbols of the Passion, makes the ritual gesture, palm upturned and palm depressed, of welcome and of condemnation. It is significant of a new age, and of the load of guilt and of uncertainty, as well as hope, sustained by the great banking families, that this should be no simple scene of joyful introduction to a merited reward. It is in every sense a personal Last Judgement. It is a recognition that upon that awful day each soul is for a moment quite alone, stripped bare of all pretence, uncertain and afraid, under the gaze of God.

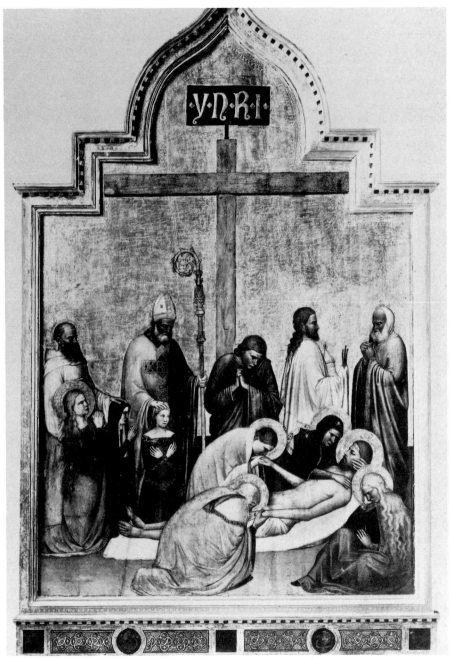

256. Unknown Florentine: Pietà di S. Remigio, fourteenth century, second quarter.
Florence, Uffizi

The sense of personal involvement, of personal participation in the narrative of salvation, which was the theme of so much of contemporary preaching takes on a different but no less original form in the closely related *Pietà di S. Remigio* in the Uffizi [256]. In this panel, which is the subject of continuous attributional controversy, two donors kneel, a saint's protecting hand upon each head, and pray among the mourners. They are there. And yet in the same breath, the so real scene with all the trappings of corporeal actuality has become, once more, a mystery and a symbol. It is no longer the intensely felt, particular historical event that a preceding generation of great artists had struggled to portray and to transpose by art into the present: it has become eternally actual and eternally remote. As men felt the practicalities of this life draw them farther from a natural and unquestioning godliness, the urge for union became more fevered. Here, the Giottesque gravity and the calm corporeality remain, but the changing attitudes that dominate the next half-century are already immanent. The cross stands as a pregnant symbol, bare against the intricacies of the surrounding frame. Joseph of Arimathaea holds the nails upright and undefiled by contact with his hand, as if participating in a solemn ritual. St Peter faces him and prays. There is a stillness over all. A timeless, quiet sorrow is beautifully expressed in the slow and intricate rhythms of the composition. It is a fitting close to the chapter of mid-fourteenth-century Florentine achievement.

RIMINESE, BOLOGNESE, AND VENETIAN PAINTING

There is as yet no certainty about the provenance of the group of small panels which are usually considered to form the nucleus of an early-fourteenth-century Riminese School, but which have also been attributed in part to the Romagna.[1] They are linked to each other by their miniature scale, by their almost jewelled execution, and by the iconographic originality of the multiplicity of small scenes into which the majority of them are divided. Whatever solutions are eventually accepted, they are closely connected with the documented works of known members of the Riminese School and their stylistic origins are certainly as hybrid as the outcome is distinctive. Although the influence of the mosaics of Venice and Ravenna is so transmuted as to be barely definable, Byzantine elements are as obvious as the relationship to miniature painting and to the tradition of the many-storeyed Romanesque panels of Umbria and the Marches. In the earliest examples, produced about the turn of the century, the influence of Cavallini's soft style is extremely strong. Very soon, however, reminiscences of the St Cecilia Master and of the Roman painters working at Assisi, together with sometimes distant, sometimes direct echoes of Giotto and his early followers, begin to predominate. Nevertheless, it is not so much the ingredients as the blending and the personal contributions of the anonymous minor masters who created them that are important.

A vertical panel with six scenes from the *Life of Christ* in the Palazzo Venezia in Rome is typical of these early Riminese works. The delicate shell-pink and varied shades of blue vie with Byzantine golden highlights set on a dark ground, and the emphasis on tonal contrast and gradation constitutes another distinctive feature

of the school. In many similar panels it is the interplay of light and dark that dominates the whole design.[2] The panel in Rome is also interesting for its affinities with some of the output of one of the earliest named members of the school, the miniaturist Neri da Rimini. Signed works of 1300, 1308, and 1314 survive, and his consistently conservative style fluctuates from an almost purely Bolognese to a substantially Riminese extreme.

The impact of the new Assisan style upon the School of Rimini was such that direct copies of Assisan frescoes were incorporated in Giuliano da Rimini's signed and dated altarpiece of 1307 [257] and in the anonymous Cesi altarpiece of 1308. In the latter the insistent volumes of the standing saints accompany violent contradictions in the perspective of the Virgin's throne. The greyish bone-white of the complexions in Giuliano's panel and the richness of the colour scheme are typical of the finest Riminese productions. When the gold-patterned damask of the Virgin's cloak still retained the orginal deep crimson that contrasted with the grey-white of her tunic, she became the apex of a central triangle of white based on the inner pair of female saints. Her crimson cloak was a similar focus for the concentration of bluish-reds in the three upper and outer right-hand figures. The vermilion cloak and brown tunic of Christ become respectively the apex of a triangle of red, both based on, and confined to, St Catherine and St Agnes, and the focus of the greys and browns that dominate the three remaining upper and outer saints upon the left. These principles of concentration and of linked and balanced contrasts form the disciplined base on which the further intricacies of the colour harmony are built. They enliven and assist the centralizing tendencies of the figure poses and add a new dimension to the simple

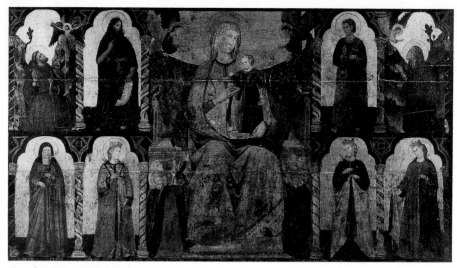

257. Giuliano da Rimini: Virgin and Saints, 1307.
Boston, Mass., Gardner Museum

formal symmetry of the design with its Assisan architectural framework and limited interest in volumetric structure.

It was probably only a few years later that an unknown master painted the much damaged scenes from the *Life of the Virgin* on the walls of a chapel in S. Agostino at Rimini. His talent, not unlike that of the St Cecilia Master, was essentially for static, widely spaced designs. Where crowds occur, as in the *Dormition*, they are ranged in orderly, calm rows. The various episodes in the scene of the *Nativity, Washing, and Annunciation to the Shepherds* are unusually dispersed. It is, however, in the one scene of the *Presentation* that his qualities are summarized and his very limitations act as virtues [258]. The four figures are spaced as evenly as columns. Small gestures of affection, slow, grave movements, echoes of Giottesque ideals of bulk and drapery pattern, all contribute to the solemn ritual taking place before the slender, gay, and soaring architecture of the temple. The detailed reminiscences of Giotto's temple in the Arena Chapel [191] and the analogies with Herod's palace in the Peruzzi Chapel

in S. Croce [203] form the basis of a quick and complex architectural rhythm that recalls the paintings of Pompeii. The appearance of so many elements common both to Giotto and to Ambrogio Lorenzetti seems indeed to argue not so much a mutual interaction as a common source in Late Antique designs then extant but now lost. No long journey separates the pure, calm colours, the restraint and lyricism of the Third Style decorations in the Tablinum of the House of Marcus Lucretius Fronto in Pompeii from the chaste and Christian gaiety of the Riminese design.

Provincial schools of painting often tend to venture to extremes avoided in the more sophisticated centres. The School of Rimini is no exception. The miniaturism characteristic of so many works at one end of the scale is matched by gigantism at the other. The sheer size of the figures on the end wall of the choir in S. Agostino at Rimini, and particularly of the *Enthroned Christ and the two St Johns* at the top of the wall, is accompanied by great bulk. They are still impressive in their mass and colour when seen from the entrance to the church,

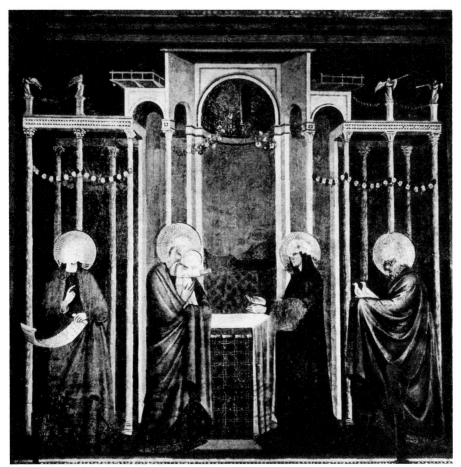

258. Unknown Riminese: Presentation, early fourteenth century.
Rimini, S. Agostino

the better part of 180 feet away. The contrast between the static style of the somewhat Cavallinesque *Last Judgement* on the triumphal arch, as well as of the presumably slightly earlier frescoes of the chapel previously discussed, and the paintings on the side walls of the choir is no less extreme. Here, crowds and rushing movement, riotous activity and eccentric formal accents are the rule.[3]

Apart from Pietro and Francesco da Rimini, Giovanni Baronzio, who, like his immediate circle, is chiefly remarkable for iconographic originality, is the only remaining named personality of any importance. Giovanni was certainly dead by 1362 and possibly died much earlier. Setting aside the *Crucifix* of 1344, signed by a Johannes Pictor, who is by no means certainly Baronzio, the nucleus of his surviving work is the polyptych in the Gallery at Urbino, signed and dated 1345.[4] Visually, the altarpiece is notable for the naïve incongruity with which its various elements are thrown together.

259. Giovanni Baronzio(?):
Crucifixion,
right half of diptych,
mid fourteenth century.
Hamburg, Weddel Collection

Thrown is the operative word, although the iconographic scheme is thoroughly coherent and the outcome charming. The closely related altarpiece in the church of Mercatello shows an even greater tendency to lateral extension, but is considerably less interesting. It lacks such wholly original iconographic touches as the Christ Child standing on the ground and reaching upwards to embrace a Virgin who is seated almost sideways at one end of the happy architectural jumble of her throne. It has none of the added interest of the narrative scenes which, in the Urbino altarpiece, form the bridge to a number of related panels. The diptych of the *Dormition* and the *Crucifixion* in Hamburg is among the most extraordinary of these latter works. In the *Dormition*, the frenzied Jews attempt to tear the coverlet from the bed. In the *Crucifixion* [259], small originalities in the treatment of the main scene, such as the figure carrying the ladder with his head stuck through the rungs, accompany an enumeration of the full list of fantastic happenings associated with Christ's death. The relative quiet of the casting of the lots is over. Now, the soldiers slash the seamless robe. The temple veil is rent. The dead rise from their graves and chasms open in the earth. Such iconographic boldness does not stand alone. The sudden change of scale, dependent not on relative position but on relative importance; the arbitrary piling of the crowds beside the cross; the patchwork brilliance of the colour and the emphasis on strangely shaped and powerfully contrasted silhouettes, likewise contribute to the final fantasy.

A similar breathless narrative invention characterizes the crowded frescoes probably painted soon after the mid century in the Chapel of St Nicholas in S. Nicola at Tolentino. These have been attributed not only to Baronzio or his followers but also, possibly more reasonably, to the following of Pietro da Rimini. The latter, besides painting a *St Francis* dated 1333, signed a *Crucifix* in Urbania and probably painted frescoes in S. Chiara in Ravenna, as well as a panel of the *Deposition* in the Louvre. Whatever the answer, there is no gainsaying the ebullience

of a decorative scheme in which black plays a dominant role alongside deep red, blue, and ochre. The *Evangelists* in the vaults, their books piled helter-skelter in and on a plethora of desks and shelves and tables, faldstools, footstools, cupboards, drawers, chests, and boxes, instruct the Doctors of the Church with wide, pen-wielding gestures. High upon one wall a very small Christ, being gently hauled home after teaching in the temple, turns to clutch another wayside flower in his fist. It is in the accumulation of genre detail of this kind, in constant crowding and activity, that these late members of the School of Rimini express themselves.

THE BOLOGNESE SCHOOL

The medieval fame of Bologna is inseparable from that of its university and law school. In art its glory lies in its illuminated manuscripts. As elsewhere in Northern Italy, a Romanesque idiom, strongly indebted at times to direct injections of Byzantine formulae, was dominant in the late thirteenth century. The most remarkable of the several major stylistic groupings that have been distinguished is centred on bibles in Paris (Bibliothèque Nationale, Lat. 18) [260] and London (British Museum, Add. 18720) and

260. Unknown Bolognese:
Detail of page from a Bible, late thirteenth century.
Paris, Bibliothèque Nationale

includes that in the cathedral at Gerona, signed by Bernardino da Modena. The expansion of the figure decoration to the margins, previously reserved for foliate designs, is significant for the whole development of fourteenth-century illumination. Moreover, like certain manuscripts illuminated in the Latin kingdom of Jerusalem, these bibles show the extent to which the supposedly backward miniaturists, working in a very different style, prefigure the interest in anatomical solidity that is often too exclusively associated with the frescoes of Cavallini and Giotto. The diapered background and linked roundels call to mind French manuscripts and also French stained glass and its direct or indirect derivatives in centres like Assisi. Although the delicacy both of drawing and of colour, and the balanced relationship of text and decoration, are outstanding, it is the strength and nature of the Byzantine borrowings that are the most extraordinary feature of these manuscripts. The solid construction of the draped figures is only matched by the firmly shaded volumes of the heads and naked limbs. The richness and complexity of movement and foreshortening undoubtedly have much to do with the bold inventiveness of Giotto's teeming *Hell* in the Arena Chapel. The almost Carolingian classicism of certain figures is no less startling. One wonders if the scholarly Ambrogio Lorenzetti may have known illuminated manuscripts of this class. The influence of the style extends, indeed, into the field of illuminated legal codices for which Bologna was already famous, and is reflected in the Book of Canons (MS. Vat. Lat. 1375) signed by Jacopino da Reggio.

The existence of such traditions in the late-thirteenth-century Romanesque–Byzantine ateliers of Bologna does much to explain Giotto's almost instantaneous impact on what is often considered to be a highly conservative art. As Cimabue was surpassed by Giotto, so, in Dante's view, did Franco Bolognese outshine Oderisi da Gubbio. Unfortunately there is no particular reason why the manuscripts already discussed, or the further group connected with the droleries, the genre scenes, and the mixture of French and Byzantine stylistic elements in the Infortiatum of Justinian at Turin (Bibl. Naz. MS. E. I. 8), should be assigned to Oderisi. Similarly, no documentary evidence links Franco Bolognese with the rich, Giottesque volumes, the broad brushwork and bold compositional sweep of the miniatures of the Gradual at Modena (Este. Lib. MS. R. I. 6) often associated with him. Variants of this manner occur in a long list of early-fourteenth-century Bolognese manuscripts. Many of them are notable not only for the richness and invention of their architecture, but for the complexity and competence of the spatial settings of large groups of figures. The list includes legal codices and secular romances, as well as service books and bibles, and extends to such prosaic products as guild statute and matriculation books. The new, soft, volumetric style derived from Giotto, yet retaining hints of earlier traditions, is particularly finely represented in the *Statuti dei Merciai* of 1328 [261].

The influence of the Bolognese School of manuscript illumination was felt all over Italy and spread as far as Angevin Naples. There, it blended with French forms and with the echoes of the style of Cavallini, and above all with the Sienese manner, to create a school hardly less varied in its products. Numerous versions of Peter of Eboli's poem on the baths of Pozzuoli were illuminated. There is a copy of Boethius (Bibl. Naz. Napoli MS. V. A. 14) in which the miniature of *Music and her Court* represents a somewhat isolated peak in the achievement of the court style. There are important versions of Dante, of the tragedies of Seneca, and a full range of ecclesiastical manuscripts. In particular, a fine scriptorium in the Badia at Cava dei Tirreni remained active far into the second half of the century. The *Speculum Historiale* of Vincent of Beauvais (Badia di Cava MS. Membr. 26), dated 1320 and reasonably attributed to this workshop, typifies a whole class of Neapolitan manuscripts characterized by multiplicity of illustration and liveliness of invention.

261. Unknown Bolognese: Page from the *Statuto dei Merciai*, 1328.
Bologna, Museo Civico

Outside the field of illumination, Vitale da Bologna is the only important Bolognese painter to emerge in the first half of the fourteenth century. He was already a painter by 1334 and had died by July 1361. Two paintings, seemingly with strong Sienese connexions, form the nucleus of Vitale's surviving production. The first is the signed and much repainted *Madonna dei Battuti* in the Vatican Gallery. The second is the signed *Madonna dei Denti* of 1345 in the Galleria Davia-Bargellini in Bologna in which the splendid golden gryphons on her cloak recall the heraldic patterns on contemporary Lucchese silks. The rather uncertainly documented polyptych of 1353 in S. Salvatore in Bologna may be added on stylis-

262. Vitale da Bologna(?):
Adoration of the Magi, mid fourteenth century.
Edinburgh, National Gallery of Scotland

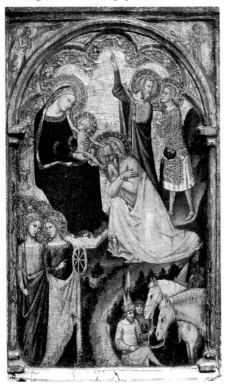

tic grounds. The lateral panels, in which the central figures compare in delicacy and in decorative intensity with such works from the Lorenzetti circle as the Ovile Master's *Assumption*, form the essential link with several other works. These include the frescoes from the church of Mezzarata, which are now in the Pinacoteca Nazionale at Bologna; the frescoes at Pomposa, the earliest of which is dated 1351; and the attributed panels of the *Adoration of the Magi* in the National Gallery of Scotland in Edinburgh and of *St Anthony* in the Pinacoteca Nazionale at Bologna.

The Edinburgh panel is the calmest of these latter works [262]. Its colour is brilliant and its tooling rich. The hieratic diminution of the figures, dependent on their relative importance and not on their imagined separation from the onlooker or from any spatial centre, is strikingly interwoven with now coherent, now fragmented indications of volume and distance. The pattern is by no means flat, either in terms of individual figures or of general structure. The way in which space is continually created and denied generates an unusual decorative and associational tension that infuses the whole panel and is not merely dependent upon the intense and burning glance of every figure. The spatial disconnexion in the panels of St Anthony Abbot is more violent still. Each gesture and movement has the strange exaggeration of a dream. The spatially coherent maelstrom that surrounds the Virgin in the Manger scene from Mezzarata is also composed in terms of surges of emotion [263]. Sweeping, melodramatic gestures accompany each slightest action. No figure of St Peter cutting off the ear of Malchus ever moved with more dramatic sweep than Joseph as he pours the water for the infant's bath. The swarming turbulence of the angels at their joyful prayers is more commonly associated with the paroxysms of grief in a *Pietà* or *Crucifixion*. The running of the greens and yellows, reds and blues, into intense white highlights, now much perished, must have added to the strong emotional charge at which Vitale clearly aimed.[5]

263. Vitale da Bologna: Nativity (detail), mid fourteenth century.
Bologna, Pinacoteca Nazionale

264. Vitale da Bologna: Frescoes, 1351.
Pomposa, Abbey Church

Emotional intensity is again apparent in the burning glance and the bold striping of the mandorla in the *Christ in Majesty* that dominates the frescoes of 1351 in the apse of the abbey church at Pomposa [264]. Vitale was probably personally responsible for this section, but the Old and New Testament scenes on the side walls and the *Last Judgement* on the end wall, on all of which a number of men undoubtedly collaborated, may be slightly later in date. The decorative scheme is still remarkably complete. Again it is a crowded, animated world of sweeping and dramatic gestures. At times the simply modelled figures achieve a sack-like volume, and simple folds create a certain grandeur. More often there is a naïve excitement as limbs dislocate in the achievement of some violent

movement. There is a wealth of colourful iconographic detail, and it is typical that in the *Baptism* Christ stands on a serpent in the midst of the fish-swarming river.

The free and rapid rhythms of the individual compositions are accentuated by a continual variation in the size of the scenes. This entirely depends on compositional needs, and there is never any vertical coincidence between the borders of the upper and lower rows. There is no attempt to achieve solidity in the mass of imitation marbling either in the frames of the main scenes or in such elements as the gaily decorated soffits of the arches that take up and vary themes established in the mosaic and Cosmati pavement. The nature of the decorative unity, and the disposition of the cycles,

set the scheme in the direct line of the Romanesque tradition and its Early Christian prototypes. The frescoes are a perfect complement to the simple architectural forms. There is nothing so Gothic as to disturb the Romanesque structural severity or so illusionistic as to destroy the calm of the continuous surfaces of wall. Even the dominant earth-reds and ochres harmonize with the warm red brick of the external structure, and the decorative unity is enhanced by the way in which the layer-cake *Last Judgement* echoes the layered apse. The story in the main scenes runs continuously from the right of the altar. It begins with the *Creation* and the *History of the Maccabees* in the upper register and finishes with the *Life of Christ* in the lower. The reading of the stories is encouraged by the free-running rhythms of the continuous frieze that occupies the spandrels and surmounts the arches of the nave. They establish a generally swift left-to-right movement, enlivened by sudden reversals. Even here, however, there is a certain discipline. With one exception, every column is continued in a single stationary or moving figure. Similarly, the great size of the *Crucifixion*, which accentuates the centre of the left wall, is matched by the formal weight of the *Presentation*, with its heavy architecture and its altarpiece in actual low relief, on the other. Time and again a single, balanced composition is created out of two or more designs.[6] Elements from Bologna, Rimini and the Romagna, and distant echoes of Assisi or the work of Giotto, are as gaily intermingled as the Romanesque past and the unmistakably mid-fourteenth-century present. The spell is so complete that even the inset majolica plates and the patterns of red and yellow brick and yellowish stone, carved with a running interlace, of the eleventh- and twelfth-century exterior become a presage of the internal combination of sensitivity and almost rustic charm.

VENICE

The political history of Venice in the fourteenth century is dominated by the consolidation of its oligarchic governmental system and by the continuing battles with the Genoese for a maritime supremacy finally achieved in 1380-1. The system of consultation on which the doges had previously relied was given definitive form by the estalishment of the Maggior Consiglio in 1297.[7] The pattern of Venetian rule was completed when a further Council of Ten was set up in 1310 in order to ensure the security of the state.

Although the statutes of the Venetian painters, going back to 1271, are the earliest in Italy, the immediate results of their institution were minimal. The artisan status and outlook of those covered is shown by the undifferentiated lists of products, such as 'escutcheons, shields, chests, caskets, patens, tableware, diningtables, altarpieces',[8] mentioned in various regulations. From the last quarter of the thirteenth century until the thirteen-forties and fifties, when the mosaics of the baptistery and of the Chapel of St Isidore were undertaken, there even seems to have been a lull in the work on the mosaics of S. Marco. Only a few fragmentary late-thirteenth- or early-fourteenth-century frescoes, such as the *Deposition* and *Entombment* in SS. Apostoli, now survive, and the most striking of the few remaining panels is that of *S. Donato* in S. Donato in Murano, dated 1310. The mixture of coloured relief and pure painting recalls the more complicated late-thirteenth-century Tuscan essays in the same technique. Its historical interest lies precisely in the extent to which the dominant Romanesque and Byzantine elements are modified by echoes of the new style spreading out from Rome and Tuscany and already firmly entrenched in Padua. Echoes of an earlier Padua, that of the illuminator Gaibana, seem to survive in some of the finest Venetian miniatures of the early fourteenth century. Throughout the period Venetian illumination is marked by the interplay between a conservative Byzantinism, refreshed by continual impulses from the lively empire of Byzantine art covering the eastern Adriatic, Aegean, and eastern Mediterranean coasts on the one hand, and the influence of

265. Paolo Veneziano: Tomb of Doge Francesco Dandolo, d. 1339.
Venice, Frari, Chapter House

various Italian centres of illumination in or on the confines of the Veneto on the other.

The modification of a dominant Byzantinism, which is the main theme in the history of painting throughout the period, is nowhere more obvious than in the career of Paolo Veneziano. He has the distinction of being not merely the first named Venetian painter whose work has survived in any quantity, but of representing the highest achievement of an otherwise modest school. The panel from the Arca di S. Leone Bembo in the cathedral at Vodnjan (Dignano), which is dated 1321 and already shows the characteristic mingling of Byzantine and Central Italian stylistic elements, is possibly his earliest known painting. The core of his achievement lies, however, in four later, signed and dated works. In the earliest of these, the altarpiece of the *Death of the Virgin* of 1333 in the Gallery at Vicenza, Byzantine iconography and rhythms dominate the central panel and simple Giottesque modelling begins to be apparent in the flanking figures.[9] The panels of the covering of the Pala d'Oro in S.

Marco in Venice, with their reminiscences of the St Cecilia Master and his circle, which Paolo signed together with his sons Luca and Giovanni in April 1345, are followed, in 1347, by the *Madonna Enthroned* in the parish church at Carpineta. Finally, in 1358, 'Paolo and his son Giovanni painted' the *Coronation* now in the Frick Museum in New York.

Paolo himself died before 1362, and one of the most interesting, undisputed additions to the group of signed works is the lunette of the *Madonna and Saints* over the sarcophagus of Doge Franceso Dandolo (d. 1339) in the chapter house of the Frari [265]. The tomb sculpture is notable not for detailed quality of carving, but for the fine sense of rhythmic grouping, the clear pauses and bold contrasts that enliven its basic symmetries. Similar qualities of symmetry and rhythm underlie Paolo's contribution. Originally, however, the blue and gold of the fully polychromed sarcophagus and the rich, reddish, golden yellow of the painted curtain held by the angels, with its green and

blue sunflower pattern and vermilion lining set off by the sombre browns and greys and grey-whites of St Francis and St Elizabeth, and of the doge's wife, must have made its colour the crowning glory of the monument.

The links between the polyptych (no. 21) in the Accademia in Venice [266] and such signed works as the *Coronation of the Virgin* in the Frick Museum allow of none of the uncertainties reflected in the varied attributions of the altarpiece of 1349 in the oratory of S. Martino in Chioggia or of the group of works dependent on the polyptych of 1354 at Piran (Pirano). Vivid colour and sumptuous decorative quality; an almost harsh brilliance, as if of precious stones or metal; and an intermingling of Byzantine elements and Umbro-Tuscan iconography and decorative detail are the principal features of the Accademia polyptych. The architectural forms of the framework have a decorative complexity reminiscent of S. Marco, and the painted panels yield to no mosaic in their brilliance. Their original effect has now been

266. Paolo Veneziano: Polyptych with Coronation of the Virgin, late 1350s(?). *Venice, Accademia*

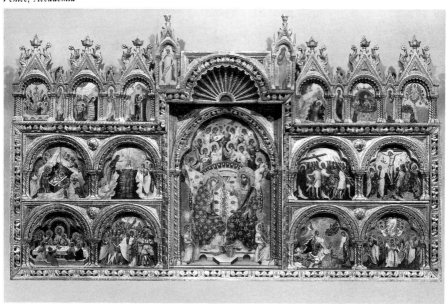

restored by the replacement of the central panel of the *Coronation of the Virgin* formerly in the Brera in Milan. In the latter, such is the intensity of golden patterning in damask draperies which rival the most sumptuous creations of the Sienese that Christ and the Virgin in their round, star-spangled glory almost blend into each other and into the backcloth of their thrones. In the narrative scenes of Christ and of St Francis even the landscapes glow with colour. An apocalyptically red mountain frames the *Stigmatization of St Francis*, and in the *Baptism of Christ* one river-bank is red and one a golden yellow. In the related altarpiece in S. Giacomo Maggiore in Bologna, a similar Byzantine fantasy sets St George in blue on a vermilion saddle and pink horse to kill a grey-green dragon.

PART SIX

SCULPTURE

1300–1350

CHAPTER 30

INTRODUCTION

The relationship between sculpture and painting which generally holds good in Tuscany throughout the second half of the thirteenth century and the first decade of the fourteenth is fundamentally transformed in the succeeding period. As Giotto had finally achieved a sculptural monumentality and solidity of form, so Giovanni Pisano had unlocked the secrets of pictorial narrative. The painters had previously looked as much to sculpture as to earlier painting for a lead, while sculptors largely turned to their own sculptural heritage. Now, though painters still look closely at the sculpture of their own and of preceding periods, the sculptors tend increasingly to lean on painting for their inspiration. Where mass and volume had once been the formal goal of both the arts, now, in sculpture as in architecture, linearity and grace become the primary vehicles for the new humanity in an age still notable for works which are, by any standard and in any context, sculptural masterpieces.

TINO DI CAMAINO AND THE MINOR SCULPTORS
OF SIENA AND FLORENCE

TINO DI CAMAINO

The name of Giovanni Pisano echoes through the history of early-fourteenth-century Italian sculpture. Not only is Tino di Camaino, son of Camaino di Crescentino, long-time servant of the Opera del Duomo in Siena, the most gifted of his many followers, but his work epitomizes both the continuity that links the master to his pupils and the contrasts that so clearly separate them from him. Out of the Pisan power and passion with its sudden stops and surges, Tino abstracts and gradually elaborates a lilting melody. It is a delicate, Sienese refrain that runs unbroken through a lifetime punctuated by a reasonably documented series of sepulchral monuments.

The earliest work frequently attributed to Tino because of rather tenuous connexions with his later sculpture is the altarpiece of S. Ranieri in the Camposanto at Pisa. This altarpiece, which on documentary grounds is probably of *c*. 1306 and is complete with a predella in the manner soon to be so generally accepted by the panel painters, differs fairly radically in style from the surviving fragments of a font for the Duomo of Pisa, recorded in a lost inscription as being signed and dated in 1311.[1] It is somewhat closer to a signed *Madonna and Child* now in Turin, in which, however, the reflections of Giovanni's emotional force are much stronger. This residual charge left by undoubted contact with Giovanni, and possibly by direct collaboration with him, is again apparent in the dismembered tomb of Henry VII [267]. Tino, referred to for the first time as capomaestro of the Opera del Duomo, signed the contract in February 1315, a little more than a year after the emperor's sudden death during his expedition

from Pisa to destroy the power of Robert of Anjou in Naples. The sarcophagus itself, with the recumbent effigy, is still in the cathedral, and the free-standing figures of the emperor and four of his councillors, together with some minor figures likewise in the Camposanto, were probably also part of a tomb which in effect elaborated the pattern established by Arnolfo's monument to Cardinal de Braye.[2] To what extent there were connexions with the original form of the even more fragmentary tomb of the Empress Margaret of Luxemburg, which the emperor himself had commissioned from Giovanni Pisano in 1312, there is now no way of telling. Giovanni's influence is, however, obvious in the relief of eleven standing figures on the face of the sarcophagus.

At first sight the simple, block-like bulk and the austere simplicity of dress and fold-form in the life-size figures of the emperor's councillors seem to belie the previous generalizations. The most severe of Giovanni's figures appear to be richly articulated by comparison, and the superficial relationship to the simplest and weightiest examples of Giotto's early Paduan manner, which must by this time have been widely known in Central Italy, is very striking. Nevertheless, this is no matter of Pisano's sense of structure allied to early Giottesque simplicity. The cross-legged incomprehensibility and fundamental instability of pose in the figure on the right of the emperor show that bulk and organic structure are not the same thing. Even the pot-bellied, bulldog figure of the Podestà of Pisa on the extreme right, which is completely successful on its own terms, reveals the extent to which, in every case, the features tend to be scratched into the surface of the stone instead of emerging from the

267. Tino di Camaino: Henry VII and his Councillors, detail of tomb of the Emperor Henry VII, 1315. *Pisa, Camposanto*

underlying structure. Only in the head of the recumbent emperor himself do the general massing and the individuated, bony structures of cranium, jaw, and cheekbone clearly play the fundamental sculptural role. Significantly enough, the thinly aristocratic, wholly unstable figure on the emperor's left, and not the jowly, four-square Podestà, prefigures the male type which later becomes Tino's principal stock-in-trade.

The simplicity, and almost sketched-in quality, of these major figures, as compared with the fully detailed minor elements of the tomb, may well reflect the likelihood that they were set at a relatively high level and were entirely polychrome. The sculptural forms probably provided no more than the base on which the painters subsequently worked. The existing traces of colour are supported by the

documents which show that six painters worked on the tomb for forty-five days. They must in that time have produced a blaze of colour startling to contemplate in view of the existing drabness. The final point is that the whole of the monument was substantially completed between 12 February and 26 July, upon which date Tino, for reasons now unknown, failed to collect a final five days' wages. His disappearance may well be connected with internal political disturbances preceding the Battle of Montecatini. This was the battle in which Uguccione della Faggiuola, after ravaging the territories of Volterra, S. Miniato, and Pistoia, and being forced to raise the siege of Montecatini, suddenly doubled back and routed the superior forces of the Guelph League under the Angevin Philip of Taranto. It took place on 29 August 1315, five days after the dedication of

268. Tino di Camaino: Monument to Cardinal Petroni, *c.* 1318.
Siena, Duomo

the tomb, and it is typical of the fratricidal times, with their endless internecine routs and turmoils intermittently erupting into full-scale war, that when the armies met, Tino was fighting for the Guelphs of Florence and Anjou, together with those of his native Siena and even of Pisa itself, against the victorious Ghibellines, who marched back in triumph to find awaiting them the monument that he himself had just erected to their erstwhile imperial champion.

Although he escaped capture, Tino was naturally deposed from his job as capomaestro.[3] Despite the shock of battle, his subsequent return to his native Siena coincided with a period of intense cultural activity. The university was on the verge of a complete reorganization. Duccio's *Maestà* was by now a four years' wonder, and in 1315 itself Simone Martini's frescoed *Maestà* was painted. Overshadowing the town, the Duomo was, within a year, to start expanding like a gorgeous plant, sickly from overgrowth, and on its walls Tino was soon erecting a monument to Cardinal Petroni, who had died in Genoa in 1314 and who was re-interred in Siena in March 1317. This tomb, though reconstructed, is the best preserved surviving evidence of Tino's work in Tuscany [268]. Its shape appears to follow the tradition already reflected in the tomb of Henry VII. Artistically, it is the series of reliefs on the sarcophagus which forms the high-point of this layer-cake construction, in which the feathery pinnacle is balanced vertically by caryatids that give grace to the somewhat heavy central section and recall, not merely Giovanni Pisano's pulpits, but the pattern set by his father's Arca di S. Domenico of fifty years before. The simple seriousness of these scenes recalls such goldsmith's work as the panels which Jacopo d'Ognabene completed for the silver altar of S. Jacopo at Pistoia in 1316, although the *Noli Me Tangere* and *Doubting Thomas* both derive from Duccio's *Maestà*, while the *Resurrection* carries on a pattern very possibly derived from Duccio and also taken up in Ugolino da Siena's predella to his S. Croce altarpiece.[4]

In 1320 Tino is referred to as capomaestro of Siena Cathedral in succession to his father, who appears to have been appointed in 1317. By February 1321 he seems to have moved to Florence. Whether or not the tomb which he erected in S. Croce for Gastone della Torre, patriarch of Aquileia, who died in August 1318, was actually carried out before the move and immediately after the Petroni tomb on which Tino is documented as working in that same year, he had certainly completed the signed, and likewise dismembered, monument to Antonio degli Orsi, bishop of Florence, by mid July 1321. The inscription on this monument in the Duomo reads 'Tino, son of Master Camaino of Siena, carved every side of this work on this site in Florence'. In characteristic contrast to the burning egotism of Giovanni Pisano, Tino's

269. Tino di Camaino:
Monument to Bishop Antonio degli Orsi (detail),
completed 1321. *Florence, Duomo*

deference was such that he evidently did not wish to be called Master during his father's lifetime.

In spite of this the Tuscan fires still smoulder in this monument. The seemingly original motif of the dead, seated figure of the bishop, the head developed and refined through the experience gained in the previous effigies to which it is so closely related, is perhaps the most powerful and moving achievement in Tino's whole career [269]. There is a raw-boned strength, combined with sensitivity, in the simple head of this heavy-handed and severely frontal figure, now relaxed in the calm sleep of death, as if still seated on the throne it occupied in life. There is at the same time a linear and decorative subtlety and control that is also apparent in the flatter, Lorenzettian figures of the *Virgin and Child* upon the Sedes Sapientiae. Here, the planar accent is offset by the sharp diagonal of attention. Weight is indicated not by depth of carving but by breadth of form. The garment-folds of mother and child are united in a single, swinging, rhythmic pattern similar to that which flattens and breaks up the bony structure of the caryatid figures. The latter are transformed into drawn silhouettes or arabesques in stone, mere decorative symbols of support, though none the less delightful for so being. Here too, in the sarcophagus relief, the Ducciesque device of symmetries so complex that they barely reach the consciousness of the beholder points the static, decorative road that Tino was to travel when, early in 1323, he set out for the cultural hothouse of the Neapolitan court. The Franco–Tuscan atmosphere of Naples seems to have been exactly calculated to bring out the lyrical tendencies of his art and to suppress the elegiac severity that is a fundamental aspect of his earlier work. Tombs without tragedy, death without drama – a serene and lilting life and a calm sleep – this is the message of his Neapolitan monuments.

Tino's responsibility for the tomb of Catherine of Austria in S. Lorenzo, which was under construction in May 1323, has been contested. Although on stylistic grounds it is unlikely to be by Gagliardo Primario, the probable architect of S. Chiara, to whom it is sometimes attributed, the severe and rather heavy Gothic architecture of the open double-sided tabernacle is Neapolitan. It alone, of all the monuments connected with Tino, is not a wall-tomb in the Romano-Tuscan manner. Nevertheless, the Tuscan form of the sarcophagus and the carving of the elaborate, mosaic-backed reliefs, of the recumbent effigy, of at least one of the four accompanying saints, and of the caryatid figures of Hope and Charity with their rich foliate backgrounds all betray the hand of Tino and his shop. Moreover, the elegantly elongated, moon-shaped faces, derived from Simone Martini and characteristic of the greater part of Tino's Neapolitan production, appear for the first time. The similarity may well have been increased when all these figures glowed in their original full colour, adding their decorative brilliance to the clear, uncluttered forms of this free-standing tomb.

It was to Gagliardo Primario and Tino di Camaino conjointly that the tomb of Mary of Hungary, widow of Charles of Anjou and mother of St Louis, was entrusted in her will of March 1323 [270]. The existing wall-tomb in S. Maria Donna Regina was under construction in February 1325, and marble for it was bought in Rome by two of Gagliardo's assistants. A crisp, linear Gothic, scintillating with mosaic in the Roman manner, now replaces the solid, almost rustic, though no less heavily decorated forms of the earlier monument. Beneath the canopy Tino plays a courtly variation on the theme of the Petroni tomb. Four caryatid Virtues now support a sarcophagus on which the gospel stories have been replaced by seven of the queen's eight sons, flanked by four counsellors on the shorter sides. A certain portrait quality is achieved by minimal adjustments of the contours of Simone's basic oval and by slight changes in the disposition of the features. It may well be the effort of portrayal as much as the intervention of assistants that for the most part drains these heads of the soft, inner glow of life

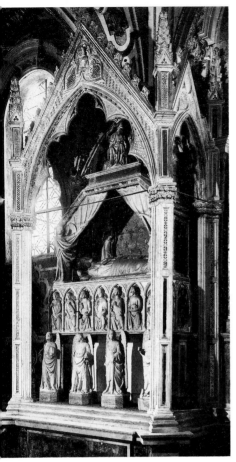

270. Tino di Camaino and Gagliardo Primario:
Tomb of Mary of Hungary,
under construction 1325.
Naples, S. Maria Donna Regina

which is common to the Virtues and to the
angels holding back the curtains of the tented
baldacchino. Nevertheless, in its cold elegance
the head of Charles Martel, the brother of St
Louis, is a memorable image.

How great the role of colour must have been
and how far Tino's interests are removed from
the fundamental realism of Arnolfo's generation
are disclosed by many details. The curtain

which the left-hand angel holds is, for example,
virtually indistinguishable from the drapery
which he wears, so smoothly do the wax-like
forms flow into one another. The final vestiges
of the drama of the Orso monument have ebbed
away. Now all is elegance and splendid show.
The polygons which Nicola devised to fit so
perfectly into the volumetric harmonies of the
Pisan baptistery [38] or made to interact with
the twelve-sided crossing of the Duomo at
Siena [42] aroused enthusiasms that soon led to
pulpits such as Giovanni's at Pistoia in which
the polygon is wholly unrelated to its archi-
tectural surroundings [67]. Now, Arnolfo's
moving drama of salvation has become a
tableau. In all the myriad tombs, echoing at
first or fifteenth hand the formal patterns of the
monument to Cardinal de Braye, the acolytes
that closed the curtains on a mortal life fade
into angels holding back the draperies for the
benefit of the pious and the peering. Yet it is
only by draining formal realism and dramatic
content from the sculptural image that the
untrammelled, elegant serenity of Tino's art
could be achieved.

Repetitive workshop reliefs of king and coun-
sellors and mourners do nothing to disturb the
calm of the tomb of Charles of Calabria in S.
Chiara (1332–3) or to reverse the tendency for
the architectural framework to play an increas-
ingly important role. The architecture is no
longer primarily seen as a scaffolding or habitat
for figures, as it was with the Pisani: figures and
architecture have become equal partners in a
richly painted, fundamentally pictorial group.
Although it is here that the final thinning out
of Tino's interest in sepulchral monuments is
evident, the aesthetic impact dulled by a lack-
lustre workshop, it is on the neighbouring tomb
of Mary of Valois, for which Tino's widow was
still being paid in June 1339, almost eighteen
months after the sculptor is mentioned as being
dead, that three of his finest figures can be
found. The melting innocence and sweetness in
the head of the recumbent effigy [271] and the
tranquillity and freely articulated grace in the
supporting figures of Hope [272] and Charity

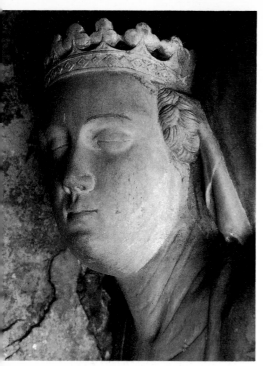

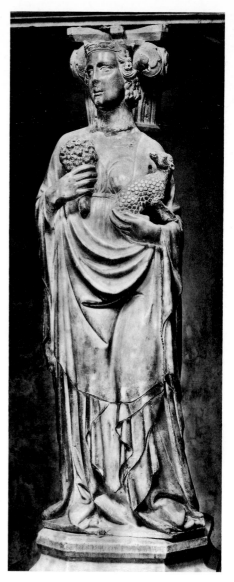

271. Tino di Camaino: Head of Mary of Valois,
detail of tomb, 1333–7.
Naples, S. Chiara

272 (*right*). Tino di Camaino: Hope,
detail of tomb of Mary of Valois, 1333–7.
Naples, S. Chiara

are unsurpassed in Tino's art. A crisp incis-
iveness in the cutting of the draperies and a
new variety and suppleness in the disposition
of their folds, a greater clarity and logic in the
linear play, compared with such works as the
reliefs for a dismembered altarpiece in Cava dei
Tirreni, may well mark Giotto's impact. In
1336, following the latter's visit in 1329–33,
Tino was supervising the execution of frescoes
in the chapel of the Castel Nuovo in which
Giotto had worked, and a comparison between
Tino's *Hope* and Giotto's *St Elizabeth of*
Hungary shows how much the late infusion of
new vigour into Tino's art may be dependent
on this contact.[5]

The seemingly innumerable tombs and altar-
pieces carved with gradually increasing crudity

by Tino's modest and conservative followers for Neapolitan churches such as S. Chiara until as late as the end of the first quarter of the fifteenth century show his enduring influence.[6] In Southern Italy, outside Naples, Niccola da Monteforte's grafting of Gothic figures and of some minor decorative detail on to the fundamentally mid-thirteenth-century ambones, now destroyed, which he carried out in the cathedral of Benevento is a symbol of a sculptural tradition which remained substantially untouched by the Angevin dominion over Sicily and Naples or by the visits of a few gifted artists from the north. In a land where seventeenth-century Romanesque is not unknown, it is no surprise to find that the Romanesque liveliness of the portal of Altamura follows the earthquake of 1316, or that the slightly more firmly pointed arch of the Bitetto doorway, which is fundamentally Romanesque both in its general disposition and in its lace-like, repetitive detail, but which is tinged with Gothic softness in the figures, was not carried out until 1335, when it was signed by Lillo di Barletta. In Siena, on the other hand, the situation was very different, and Tino's birthplace produced a number of men of lesser but by no means inconsiderable stature.

GANO DA SIENA

The first of these is Gano da Siena, who probably died in 1318 and whose only certain work is the signed monument to Tommaso d'Andrea, bishop of Pistoia, which from the wording of the inscription must have been executed well after the latter's death in 1303. The breadth of treatment and the portrait quality of the recumbent figure in this rather pedestrian, Romanesque-cum-Gothic wall-tomb in the Duomo at Casole d'Elsa have led to his being credited with a far more impressive monument. This is the near-by upright, fully Gothic wall-tomb in which the equally portly figure of Ranieri del Porrina (d. 1315) stands hatted and cloaked and book in hand [273]. Echoes of Giovanni still persist in the supporting figures,

273. Gano da Siena: Ranieri del Porrina, d. 1315, detail of tomb.
Casole d'Elsa, Duomo

but those of Tino no longer dominate the straightforward and entirely unmannered naturalism of the main figure. The vivid characterization of the pensive, yet half-smiling, plump-faced Podestà, with its suggestion of sensitivity as well as sensuality imprisoned in the porcine flesh, is a milestone in the art of portraiture. It has the immediacy of a life-mask and is a unique prefiguration of late-fourteenth-century northern and mid-fifteenth-century Italian portraiture. If it is by Gano, he indeed deserves a measure of the fulsome self-praise in the inscription on his one signed work.

GORO DI GREGORIO

The Arca di S. Cerbone in the Duomo of Massa Marittima [274], which Goro di Gregorio signed in 1324, reflects a very different side of the Sienese approach to nature. The scenes from the saint's life are characterized by an almost naïve attempt to carve the figures in the round and to endow the buildings in the piled-up settings, otherwise almost devoid of any depth, with a straightforward, three-dimensional actuality. At first sight the result, in combination with the boldly patterned backgrounds, is an anecdotal, doll's-house unreality. Manuscript illumination springs immediately to mind, and the similarity must have been much closer when the full polychromy reflected in surviving traces of blue, green, red, and gold was in its pristine state. The soapy, alabastrine surface and the sketchy crudity which is particularly noticeable in much of the figure detail and which has nothing to do with Giovanni Pisano's purposive boldness with the chisel, would then have been disguised.

274. Goro di Gregorio: Arca di S. Cerbone, 1324.
Massa Marittima, Duomo

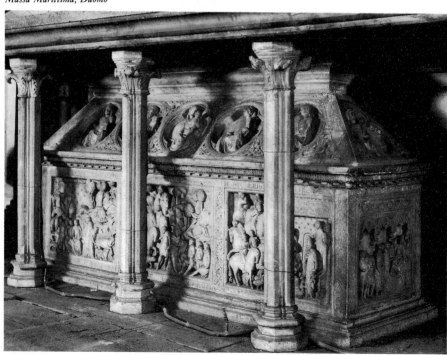

The jagged, zigzag prisms of the rocks and the multifarious decorative repetitions would have told to the full. The clean lines of the sepulchre as a whole and the careful way in which, despite the fact that his narrative ambition far outruns his compositional ability, the masses and main lines of the three scenes on front and rear are balanced about a central caesura in the manner of the second bay of the St Francis Cycle at Assisi [119] are eloquent of Goro's sensitivity. His qualities and limitations are again apparent in the signed wall-tomb of Archbishop Guidotto de' Tabiati, dated 1333, in the Duomo at Messina. Here, among the four scenes from the Life of Christ, a greater delicacy in the detail and less overweening narrative ambition enable him to make a minor masterpiece of his *Annunciation*.

AGOSTINO DI GIOVANNI AND AGNOLO DI VENTURA

A similar ambition, greater competence for the most part, and less charm invest the masterwork which Agostino di Giovanni and his alter ego, Agnolo di Ventura, signed in 1330. This is the tomb of Bishop Guido Tarlati in the Duomo at Arezzo [275]. Many-tiered and soaring slab-like up the wall, to be topped by an airy, pedimented barrel-vault, it must in general design be among the most uncomfortable concoctions of Italian fourteenth-century art. Seen for itself, however, the main relief, containing the two halves of a funeral service or procession, attains a rhythmic unity and emotional intensity unmatched in the remainder of the tomb. The swaying linear pattern of the simple forms in low relief, the sense of scale and grouping and dramatic purpose, all reach far beyond the garrulous puppetry of the narratives in high relief and of the repetitive columns of supporting bishops.[7]

The Tarlati monument may have limitations as a work of art, but as a social document and symptom of a changing climate of ideas it has few equals. The calm civic and religious symbolism of the Pisani's Perugia Fountain or the quiet concern with personal wisdom, personal sanctity, and personal salvation enshrined in the drama of Arnolfo's monument to Cardinal de Braye no longer serve. Their place is taken by the sixteen stanzas of a happy anthem to the facts of medieval city life; to the brute force and cunning which, in prince or bishop or condottiere, meant the difference between survival and expansion or subjection and destruction. *Tarlati made a Bishop* (1312), *Proclaimed Signore of Arezzo* (1321), the *Commune despoiled*, the *Commune restored by Tarlati* – the first four scenes provide a quiet, partly historical and partly allegorical opening. Then the fun begins. The *Rebuilding of Arezzo's Walls* (1319); the *Surrender of Lucignano* (suppliant burghers kneeling, 1316); the *Siege of Chiusi* (soldiers kneeling); the *Siege of Fronzola* (1323); the *Taking of Castelforcognano* (further suppliants, 1322); the *Assault on Rondine* (the bishop, like an emperor, sits enthroned beneath a canopy, directing operations); the *Conquest of Busine* and that of *Caprese* (1324) then give way to the last stanzas celebrating further triumphs. The *Razing of Lateria* (1325) is followed by that of *Monte S. Savino*, with the enthroned bishop supervising every detail of destruction, and finally after the *Coronation of Louis of Bavaria* (1327) comes 'La Morte di Miseria' – unhappy death after a life well spent. It is on such a record of achievement, replete with every evidence of divine approval, that innumerable medieval prelates must have claimed their entry into heaven. Here, commissioned by his partisans and faithfully executed like a manuscript in marble, surviving the subsequent mutilation by his enemies, is a monument without hypocrisy. It is a simple and self-confident proclamation of the laws by which Italian cities, towns, and castles, and their rulers, lived and died, each, when they thought of it – which was often – confident that God was on their side. If much the same was true of earlier centuries, it was only under the impact of commercial and social revolution, and of the increasing secularization of life, that such a monument and so naïve an ecclesiastical catalogue of secular triumph could have been conceived and

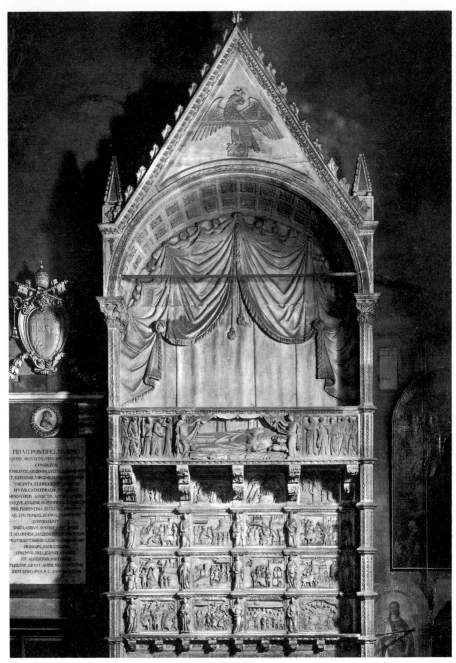

275. Agostino di Giovanni and Agnolo di Ventura: Monument to Bishop Guido Tarlati, 1330.
Arezzo, Duomo

executed. It is the fourteenth-century counter-part of Trajan's Column, which in many ways it much resembles. Its very simplicity sets off the range and depth and subtlety of the theories and the dreams of justice, peace, and civic dignity, built on similar factual foundations, that were painted ten years later in Siena by Ambrogio Lorenzetti.

Both Agostino di Giovanni and Agnolo di Ventura were probably more active as architects than as sculptors, and the remaining sculptural attributions are unimportant. Only the tomb of Cino de' Sinibaldi in the Duomo at Pistoia which, if it does not come from their workshop, is closely related to its products, has any distinction. In 1337, the year of Cino's death, Cellino di Nese, himself a mason, wrote that

the work was to be carried out by a Sienese master. The austere, seated figure of the poet, towering above his standing audience of scholars or talking to his class in the equally smoothly and severely sculpted relief, compels attention both for its formal qualities and as a further illustration of the growing secular interests of the Tuscan cities. As the earliest monumental attempt in Italy to show a scholar in his setting, active in pursuit of his life's work, it is well able to withstand comparison with its numerous successors in the genre.

GIOVANNI D'AGOSTINO

Giovanni d'Agostino was, like his father, Agostino di Giovanni, continuously active in archi-

276. Giovanni d'Agostino: Angel appearing to St John, detail of font, *c.* 1332–3(?). *Arezzo, Pieve*

tecture as well as in sculpture. His documented career, which runs from 1332, when he was working in the Pieve at Arezzo, to a final mention in 1347, includes a period as capomaestro, firstly of the Duomo of Orvieto, and secondly of that of Siena (1340–5). His one surviving signed work is a small high relief of the *Madonna and Child with Angels* in the Oratory of S. Bernardino in Siena. This was probably carried out before his stay in Orvieto. In the search for a soft, rhythmic grace, it is redolent of Simone Martini and of the early work of Tino di Camaino. Giovanni's technical limitations as a sculptor, which, judged by the highest standards, are extreme, are even more obvious in the only other important work attributable to him, namely the hexagonal font for S. Maria del Pieve in Arezzo. The three storiated reliefs are distinguished from those on the main body of the Tarlati monument and from the related reliefs of the *Lives of SS. Regolo and Ottaviano* in the Duomo of Volterra by the emotional qualities which they share with the mourning clerics of the Aretine tomb. The feeling of spiritual intensity is increased by the heavy crudity of the carving and by the rudimentary, almost rustic anatomical structure of the figures. The result is a naïve lyricism that, to modern eyes, is moving in the extreme [276]. There is a kind of rapture in the *Angel appearing to St John* that recalls, as few works of the period do, St Francis's Canticle to Brother Sun.

277. Giovanni and Pacio da Firenze: Scene from the Life of St Catherine of Alexandria, *c*. 1343–5(?). *Naples, S. Chiara*

GIOVANNI AND PACIO DA FIRENZE

The tomb of Robert of Anjou in S. Chiara in Naples is also the principal monument to Giovanni and Pacio da Firenze, who are mentioned in the documents of 1343–5. The Gothic tabernacle is an elaboration of that in Tino's monument to Mary of Hungary [270]. Niched figures and reliefs cut into every available architectural surface, and the tomb itself has been expanded into a four-storeyed structure with the dead king prominent at every level. At the centre of the arcaded relief on the front of the sarcophagus he is enthroned among his family. The recumbent effigy with the mourning Liberal Arts takes up the next level. On the third, he reappears, a grandiose figure almost in the round, enthroned among his courtiers. Finally, on a more suitably discreet scale, he is presented to the Virgin by St Francis and St Clare. With every detail carefully picked out in colour, replete with frescoed angels at the topmost level and with imitation mosaic and frescoed courtiers immediately below, the tomb makes up in pomp and splendour what it lacks in grace and subtlety of design. In the finest parts, which are presumably by Giovanni and Pacio themselves and which include the sarcophagus and effigy with its attendants and the Virgin and Child

above, the stylistic currents deriving from the circle of Andrea Pisano and from Tino di Camaino are blended with a high degree of technical accomplishment. Occasionally, as in the curtain-holding angels or certain of the somewhat repetitive figures of the Arts, there is even an element of spiritual expressiveness.

Apart from a fragment of the tomb of Louis of Durazzo (d. 1344) in S. Chiara, the only other important attribution is the now largely destroyed series of eleven scenes from the *Story of St Catherine of Alexandria* which was once built into the choir of S. Chiara. Delicately carved in white marble against a dark green marble ground, these simple-seeming scenes possess a cameo-like quality, a clarity and sophistication that confirm the heights to which Giovanni and Pacio could rise [277]. The medium is derived from Tino, but the precision of design recalls Andrea Pisano's doors, and the comparison with, and contrast to, the narrative styles evolved by the four Sienese sculptors just discussed is fascinating. Freed from the need for courtly splendour and conspicuous expenditure, the clear-cut gestures, the economy of movement, setting, and expression, and the clear-sighted exploitation of the simplest colour contrasts reveal a very different aspect of the art of these two Florentines.

LORENZO MAITANI AND THE FAÇADE OF ORVIETO CATHEDRAL

No short history of art can give more than an inkling of the rumbustious, ant-heap turmoil of the fourteenth century in Italy. The pullulation of ideas and works of art, the surge and sway of populations, classes, factions, systems, the cost in failure for the glories shining from a seething, cut-throat, vital age are hard to capture. Even the great cathedrals such as that of Orvieto, brooding stalagmitic on its tufa island or flashing gold from its mosaics in the sun, now gives little hint of the momentary fears and frenzies, the sustained excitements of whole populations, which were part and parcel of their building. Occasionally, and this is so at Orvieto, documents provide haphazard, dehydrated evidence, and then the chanciness, the flexibility of mind and communal vitality that underlie the seeming calm of the completed monuments become apparent.[1]

The new cathedral was agreed on in 1284 and founded in 1290. By 1309 the first roof-beam was up, and exuberance was giving way to panic. The new building was still Romanesque in form, round-arched, and anchored in a centuries-old tradition of masonic craftsmanship, and architectural ambition was expressed in terms of scale. The vast dimensions of the plan and great height of the nave led, at the crossing, to a need for vaults and arches of unprecedented height and span. No sooner were they going up than the authorities began to fear an imminent collapse and called on the Sienese Lorenzo Maitani for advice. Apart from his marriage in Siena in 1302, the Orvietan document of 1310, which already refers to him as 'universalis caputmagister', is the first surviving reference to this enigmatic man. After mentioning the reasons for his summons, and his success in the work of building and repair, the document states in breathless Latin that since Lorenzo 'was and is thorough and experi-

enced in buttresses roof and wall figured with beauty which wall must be made on the front part and with all the other masteries and ornaments appropriate to this same fabric', he should be granted Orvietan citizenship, together with the privilege of carrying arms at will, and should remain in Orvieto with his family all his life as capomaestro of the cathedral and overseer of bridges and civic buildings. To secure his interest in the city, Lorenzo promises to invest a substantial sum, and further on is authorized 'to retain the disciples he shall have desired for the designing figuring and making of stones for the above mentioned wall', which is undoubtedly the new façade [278].

The lower part of this façade, as it now stands, consists of four almost flat piers decorated by marble reliefs. These cover Genesis; the Tree of Jesse and the Old Testament Prophecies of Redemption; the Prophets and the Life of Christ; and the Last Judgement. Four bronze symbols of the Evangelists stand on the cornice immediately overhead, and in the lunette above the central doorway a bronze baldacchino and flanking angels shelter a marble Virgin and Child.

Apart from Maitani's activity in Perugia in 1317 and another call for help in 1319, there is documentary silence from 1310 to 1321. From then until his death in 1330 there is a massive but haphazard record of the work on the cathedral. The four Evangelistic symbols were being made by the end of 1329 and during 1330, and the assignment to Lorenzo of 1,400 odd pounds of bronze for the casting of the Eagle

278. Lorenzo Maitani (in charge):
Orvieto, Duomo,
façade, begun 1310

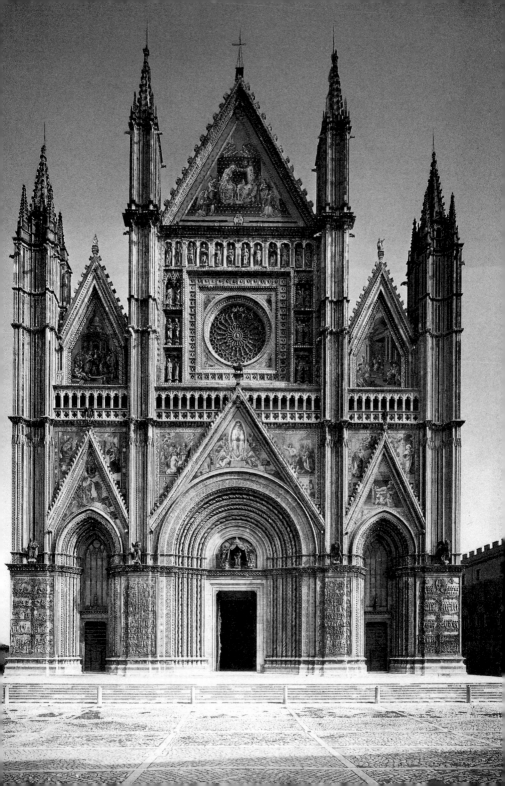

of St John is specifically mentioned. The question is therefore whether Maitani himself, rather than some unknown or one of the minor masters referred to in the documents, actually modelled the eagle. If it is assumed that he did, and further assumed that he modelled the Angel of St Matthew [279], on the logically tenuous grounds that this is also an Evangelistic symbol, there can then be little doubt that Maitani was the principal sculptor in the atelier which carved the Genesis stories on the first pier and the Last Judgement on the fourth, as well as the upper scenes on the two central piers, since these reliefs are closely linked in style to the bronze Angel of St Matthew and to the angels of the baldacchino. There is no documentary proof that Maitani was a sculptor, and none that he was not. All that is certain is that he was in complete control of all the multifarious activities on the façade in the twenty years between 1310 and 1330. The controversies surrounding the façade are greatly complicated because the major sculptural workshop was certainly not responsible for most of the carvings

279. Lorenzo Maitani(?): Angel of St Matthew, 1329–30. *Orvieto, Duomo*

in the lower registers of the two central piers. It has been suggested that these reliefs were planned, and probably carried out, before Maitani's arrival in Orvieto. This raises the whole question of how the sculpture was planned and executed.

THE PLANNING AND THE EXECUTION OF THE RELIEFS

The first distinctive feature of the Orvietan plans is that two large drawings, carried out in pen on parchment, are preserved in the Opera del Duomo [280 and 281]. It is the earliest case in the whole history of Italian architecture in which preliminary designs for an entire project have survived. Such drawings, like the subsequent design for the baptistery façade of Siena Cathedral, beg comparison, both in general and in detail, with the Strasbourg sketch B of c. 1275.[2] Still more dramatically than in the case of Giotto's painted model of the Arena Chapel, they show what early-fourteenth-century artists could do in terms of accurate representation when they were solely concerned to pass on factual information.

The first of these two drawings differs from the existing structure in its emphasis upon a soaring central mass, reinforced by the absence of lateral gables and by the dominance of the main portal over the relatively narrow embrasures and steeply angled gables of flanking doorways for which the main piers leave comparatively little space.[3] The linear clarity and crispness, as well as features like the piercing of the horizontal gallery by the gables over all three doors, create close linkages between the lower parts of the design and the ends of the transepts of Notre Dame in Paris. The increased planar emphasis in the simple rose and square of the upper section nevertheless reflects an openly pictorial tendency exploited with the utmost brilliance in the mosaic of the *Coronation* in the main gable. The architecturally massive, pinnacled throne plays a delightful spatial variation on the theme of the four similarly pinnacled and detailed piers that

modulate the plane of the façade. This fundamentally Italian scheme is based, like so much of the finest art and architecture of the age, on deep awareness of French forms and on ability to blend them into a fresh artistic synthesis.

Many of the existing sculptural features already approach their final form in this first drawing. The Evangelists and their symbols, later to be replaced by the symbols alone, already stand, in a manner reminiscent of Siena, on the platform of the lower cornice. The ancestry of the free-standing stone and bronze group of the *Virgin and Child Enthroned with Angels* in the painted altarpieces and stained-glass designs of Cimabue and Duccio and their circle is revealed. The project for a series of reliefs on the main piers is adumbrated. Their subject matter and general disposition have been established, though the geometrically perfect circles that enclose the figures at this stage are reminiscent of the French manuscript and stained-glass traditions already acclimatized in Italy. Though it is clearly in the tradition of S. Zeno in Verona and of other similar Romanesque decorative schemes, there are no precise prototypes for the final design. The reminiscences of the freer patterns of Antelami's reliefs on the baptistery at Parma or echoes of the foliate columns on the Pisan model, introduced into Siena by Giovanni Pisano, do not, however, disguise the possible influence of the great areas of relatively freely flowing inhabited acanthus that were common in mosaic from Antique and Early Christian times, and were re-established in the public and artistic eye by such major late-thirteenth-century reconstructive and recreative schemes as that in S. Maria Maggiore in Rome.

The second drawing is even closer to the existing façade in general and in detail [281] and may well be that described in an inventory of 1356 as 'a large parchment by the hand of Master Maitani'. A new breadth and horizontality possibly reflect Arnolfo's project for Florence Cathedral. Compared with the previous design, the articulating piers are slimmer,

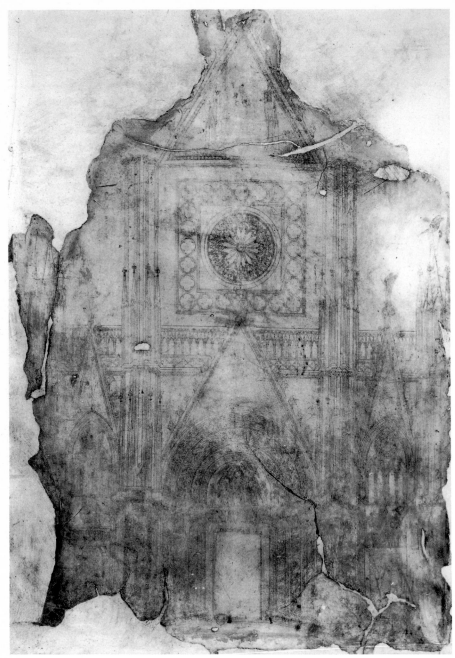

280. Drawing for the façade of the Duomo at Orvieto, *c.* 1310(?).
Orvieto, Opera del Duomo

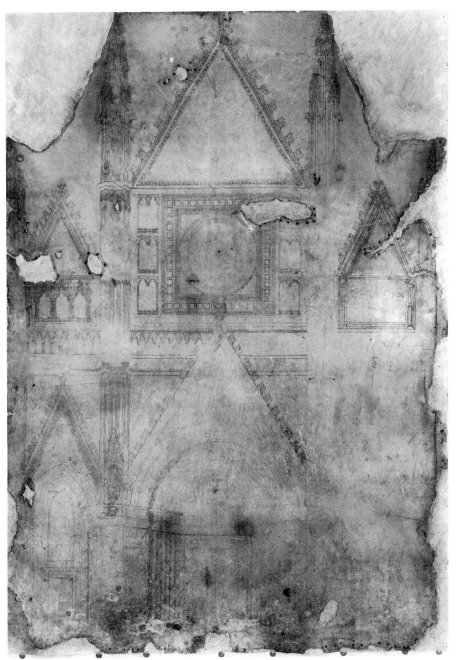

281. Lorenzo Maitani(?): Drawing for the façade of the Duomo at Orvieto, *c.* 1310(?).
Orvieto, Opera del Duomo

leaving more space for the wider and more flatly splayed embrasures of the flanking doors whose broader gables no longer pierce the horizontals of the gallery above. The piers themselves no longer taper, and the needle-sharp subsidiary pinnacles become relatively blunt, cap-like features set in horizontal ribbons that accentuate the stopping effect of the cornices with which they are much more intimately linked. The general reduction in vertical thrust is accentuated by the broad, rectangular flanking elements, each capped by a gable and containing three wide niches. The reflection of the central feature on either wing increases the apparent breadth of the façade and draws attention outwards. The previous concentration is dispersed. Even the directionally neutral circle within a square of the central feature itself is now enclosed within a horizontally accented rectangle.

Another noticeable change is that the interpenetration of a few relatively large and simple parts gives way to a multiplicity of clearly bounded minor elements. The unfinished sections of the drawing show how smaller units are built up within the firmly closed and frequently rectangular compartments. The new divisibility, the clarity of separation, and the consequent measurability of the minor parts are once more strongly reminiscent of Arnolfo and reflect an attitude that prepares the way for the modular architecture of the early Florentine Renaissance. Indeed, the second project seems, in contrast to the first, to be governed by an adaptation of an ever-popular medieval proportional formula.[4] It is, perhaps, significant that it was Maitani who, in 1322, declared of the extension of the Duomo at Siena that any addition to the existing church would so disturb its harmony of proportion in which 'its parts agree so well in length and breadth and height' that it were better to destroy it utterly and start again.[5] Whether or not this second drawing is actually by Maitani, its forms are almost identical with those embodied in the lower parts of the façade, and these were erected under his supervision. Substantial deviations only occur in the upper areas, executed after his death

by Andrea Pisano, Orcagna, and others. These deviations constitute a partial return towards the principles, though not the pattern, of the first design, and chiefly concern the increased verticality of the redesigned central feature and its flanking gables.[6]

The words first and second carry no necessary chronological implications. There is no way of telling whether the obvious differences between the two projects should be attributed to a lapse in time or merely to the different interests and backgrounds of two men competing simultaneously for a commission. Certainly, the French elements in the first scheme in no way justify its attribution to the shadowy Ramo di Paganello, by whom no certain work of sculpture or of architecture is now known.[7] His recorded presence in one of the multitude of quarries supplying stone for the Duomo means little in this context. Although a Sienese document refers to him as having crossed the Alps, this was no rare occurrence, and a thorough knowledge of French art and architecture at first or second hand was almost a commonplace among leading Italian artists. Sketchbooks such as that of Villard de Honnecourt were already being made in the first half of the previous century, and the very existence of the Orvietan drawings shows how easily and how accurately knowledge could be spread. The one thing that is absolutely clear from changes in the design of the base-mouldings of the façade is the extreme unlikelihood that any part of the first project had been built before the definitive scheme, associated with Maitani, was produced.

The most striking fact about the actual execution of the Orvietan reliefs is that they were never finished. The resulting opportunity to examine almost every phase of the individual and group activities within a team of medieval workshops tackling a really important and extensive project is unique. Here, as nowhere else, the chisels still ring in the inner ear, and the honey-coloured marble, amber-like, reveals its secrets.

A tide-mark of completion, running across all four piers just under half-way up, is but the

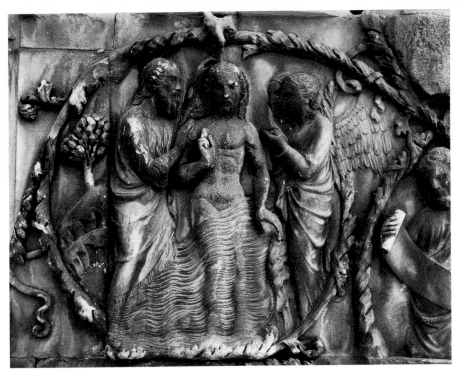

282. Lorenzo Maitani(?): Baptism of Christ, *c.* 1310–30(?).
Orvieto, Duomo, third pier

first of many indications that the entire work was both begun and carried forward as a single enterprise. The frequent adjustment of the outlines of the blocks to follow the contours of the figures and avoid the cutting of some detail [283], and the few surviving errors and discontinuities between adjoining slabs, prove that most of the carving was done on the ground before erection. This, together with the evidently regular progress of the work, implies extensive planning. Such planning did not extend to anything like modern quantity surveying or to the careful calculations that produced the even stonework of Antiquity. There seems to have been no ordering of blocks of standard size, nor even any detailed correlation between the shape of a given block as it left the quarry and its eventual use. The endlessly varied shapes and sizes of the blocks, set in an apparently haphazard relationship which has little connexion with the symmetry of the subsequently carved designs, argue a patchwork process in which the available and roughly appropriate material was fitted together so as to cause a minimum of difficulty in carving the figures. Whenever this resulting jigsaw led, as it inevitably did, to some fantastically difficult join, the Orvietan sculptors relied on their almost unbelievable competence as craftsmen to redress the balance upset by their relatively undeveloped organizational powers.

The first of the surviving projects was probably preceded by lost sketches for the sculpture itself. Since the executed reliefs differ from the project, further drawings presumably succeeded it, and these may well have given way

to fairly large-scale studies for the reliefs alone. A superbly detailed mid-fourteenth-century Sienese pen and brushpoint design for a storiated and elaborately decorated polygonal pulpit, presumably to be erected in Orvieto, is now dispersed between Orvieto, London, and Berlin, and it gives some idea of what may have been done.[8] How much the final planning was consigned to parchment or to rough wooden panels of the kind used for stained-glass designs, or how much it consisted of summary indications on the surface of the stone itself, is uncertain. The host of men known to have been involved, and the extreme complexity of the maze of stone through which they had to work with pin-point accuracy, argue preliminary planning. Its existence is confirmed by Maitani's authorization to retain disciples for 'the designing, figuring and making of stones'.

Although the planning process is only partially recorded even at Orvieto, the sequences of execution are laid bare in their entirety. In places the rough surface of the block, squared off with a variety of heavy tools – the adze, the trimming hammer, the chisel, and the punch – survives much as it left the hands of the quarrymen [282]. An instance of the second stage, the trimming of superfluous stone and the general blocking out of areas of high and low relief, is also to be seen [282]. At the third stage, visible in many details of the upper sections of the first three piers, the whole design was evidently roughed out with a heavy punch. Then, progressively lighter and more delicate varieties of this same simple tool, held at right angles to the surface of the stone in the manner favoured by the archaic Greek sculptors, were used to define the final forms with quite extraordinary precision [282 and 284]. In the process the previous heavy pitting gives way to an even stippling of the stone. The earlier part of this third stage was evidently the last point at which the block or scene was treated as a whole. The succeeding major process was the smoothing of this granular surface with the aid of a series of progressively finer claw-chisels [282]. The delicacy of the task was such that the skin of

stone to be removed was usually no more than millimetres deep. The tools seem mostly to have been only 3–5 mm. wide, the four teeth of the standard chisel measuring less than a millimetre, with intervening gaps of half the size. The unity of the arts is nowhere to be seen more clearly than in the way that the modelling of the figures was developed with these tools exactly as the fourteenth-century draughtsmen modelled with their pens or as the painter built his forms up on the under-plaster or carried out the final brushpont modelling of the flesh. The corduroy-like, evenly striated surface left at the end of the fourth main working stage can be compared, in its form-following, form-creating regularity and precision, with the brushwork of the greatest painters, such as Giotto, Duccio, or Simone, or of any of the men who were continuing and refining the unbroken modelling stroke of Cavallini or the Isaac Master. It is impossible to say how much the bold simplifications introduced in this third stage may have influenced the clear-cut chiselling of form towards which major fourteenth-century painters tended. The noses, for example, are reduced to three clear planes, and the ridge itself appears as a single, flat, and straight-edged surface [282]. The extent to which the intermediate processes as well as the finished forms of one art may have influenced another in its completed forms as well as in its working stages should not be underrated. At Orvieto, pen and brush may well hold precedence over the handling of the claw-chisel. Certainly the influence of painting on the sculptural vision bodied out in the completed compositions of *Creation* and *Last Judgement* needs no emphasis.

The fifth and final stage in execution was the smoothing of the rounded forms, apparently with pumice or some other abrasive for the most part, and the sharpening of linear details with the straight-edged chisel until no trace of what had gone before was left upon the marble. Last of all, the entire surface was coated with an iron-based ochreous lime, not only giving the white marble a protective skin, but creating

the impression that the entire, glowing, golden brown façade was carved from precious alabaster.[9]

The piecemeal process that begins with the completion of the roughing out with the heavy punch is particularly interesting. In many cases a half-finished block emerges as a veritable patchwork of differently worked surfaces [282]. Each detail of the composition is held at some distinctive point in its journey to completion. The mass of evidence is such that the whole process of work-sharing seems to be revealed. After the blocking out was done, presumably by a limited circle of the leading men, the minor and repetitive jobs appear to have been handed on to the recorded army of assistants. Their very numbers meant that the less artistically complex and significant sections of the work advanced more rapidly. The backgrounds and the decorative rinceaux are invariably finished or all but complete [282]. Landscape and architectural forms provided further clearly defined areas of specialization and, since trees and buildings are relatively rare, moved far ahead of the figures [282]. Even within the confines of the latter, work was shared. Hair specialists used their own particular tools, the straight-edge chisel and the drill, and worked away regardless of the state of the remainder of the figure. They consequently far outstripped the men responsible for the more extensive and more complicated carving of bodies and draperies [282]. Wings, too, were treated as a separate task, and every one of the six or seven further processes involved, after the completion of the third main stage of their design, in order to convert the plain, smooth blanks into the finished product, can be seen. In flesh and drapery, on the other hand, even the least finished parts of the design are never separated from each other by more than a single stage [282]. Punch-stippled heads are coupled with striated draperies. Striated hands emerge out of punch-stippled sleeves. Completed forms accompany others still in the penultimate stage. The diaphanous draperies and the forms they covered were probably not handed out to

different men, but worked impartially by a small group who, whether they shared a single figure or took one or more through all the final stages to completion, still habitually finished one stage on drapery or flesh before beginning the same process on the other.

At Orvieto, minor never means inferior, and it would take a bold man to distinguish one hand in the faces and another in the hair, or the possible intervention of as many as four separate individuals, in such perfect, finished figures as the angels in the *Creation of Eve* [283]

283. Lorenzo Maitani(?): Angels, detail of Creation of Eve, *c*. 1310–30. *Orvieto, Duomo, first pier*

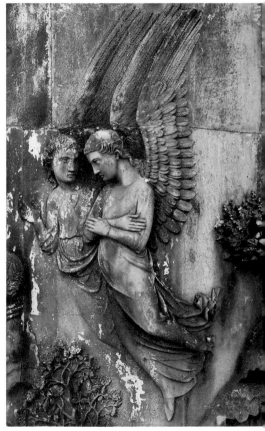

which have now been so disastrously vandalized. Its sculpture is the proof of something that can only be surmised in painting and is never to be doubted in the minor arts; namely, that tasks in medieval workshops were not invariably shared only in terms of areas. A single finished detail of a single figure could involve the separate contributions of a number of men, and a completed Orvietan figure would inevitably do so. In venturing on sculptural or pictorial attributions it is therefore often wise to do no more than to distinguish the activities of a group and the stylistic variations to be seen within their products. Greater apparent precision may be more impressive but less relevant to processes so complex that, when once the work is finished, the detailed chemistry of its creation cannot be unscrambled.[10]

The stylistic bonds connecting the output of the major Orvietan workshop, seemingly responsible for the bronze angels, for the reliefs of the first pier, for the upper parts of the two central piers, and for the lower parts of the fourth are very obvious. Whether the upper parts of the fourth pier should be attributed to the group itself or to affiliates is much less clear. Since the figures on the upper areas of the first pier are only in the third stage of their preparation [284], they undoubtedly have as much, or even more, right to be seen as works of consummate artistic genius and astonishing anatomic confidence as have the finished figures

284. Lorenzo Maitani(?):
Cain killing Abel, c. 1310–30(?).
Orvieto, Duomo, first pier

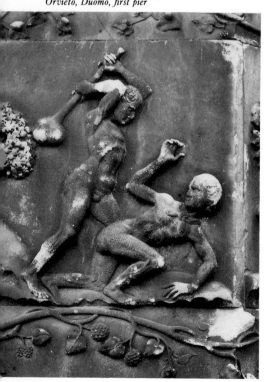

285. Lorenzo Maitani(?):
Damned Soul, detail of Last Judgement, c. 1310–30(?).
Orvieto, Duomo, fourth pier

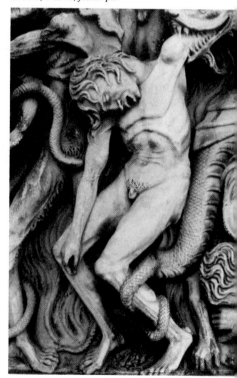

of the *Last Judgement* at the base of the fourth pier [285]. In the unfinished upper parts of the two central piers the remaining processes might have brought them closer either to the first pier or to the upper part of the fourth. As they are, there seems to be no reason to distinguish them from the products of the major workshop. Nevertheless, even within the most restricted, seemingly homogeneous areas, many nuances and variations of style occur.

The entire output of the main group is notable for its pictorial subtlety. In this it follows the tendencies not only of Giovanni Pisano's late work but of the whole development of late-thirteenth-century Italian sculpture. Actual reminiscences of Giovanni's manner are, however, largely confined to figures seen in violent action, such as those of *Cain and Abel* on the first pier [284] or the *Resurrected* and the *Damned* on the fourth [285]. Only in the latter, with their direct stylistic references to Antique as well as to French Gothic sculpture, do deep cutting, crowded figures, and emotional intensity bring the relief style as a whole at all close to Giovanni's. In general, Trajan's Column and the atmospheric delicacy of Late Roman and Pompeian stucco decoration come more readily to mind. It is a sign of the artistic stature of this workshop and its leader that individual figures such as the angels of the *Creation* conjure up the late work of Ghiberti. In reproduction many a detail from the lower part of the *Last Judgement*, so admired by Pius II during his mid-fifteenth-century travels, might be passed as a Renaissance work by the unwary. The series of bronzes in the round produced by this same group and its specialist collaborators is technically and artistically unique in fourteenth-century Italy. The degree of realism and the decorative skill with which the figures in relief are placed in their extensive landscape settings are sculpturally unprecedented. The sense of atmosphere and of recession is only matched by the melting, dream-like linear grace and elegance of the figures in the *Creation*. These very qualities have often led to an underestimation of the physical,

if not of the emotional, power which this same workshop generates when violence and brutality are demanded by the story. Grace and a feeling for landscape, reminiscent more of Duccio than of Assisi, make it quite likely, though they do not prove, that the Sienese Maitani was indeed the leader of this major group of sculptors, who must also have carved the closely related wooden crucifixes in the Duomo and in S. Francesco in Orvieto.

The minor group responsible for the lower scenes in the two central piers [286] presents a very different approach within the limits of the overall design. The figures are heavier in build and higher in relief. They are more solemn, more imposing, and less graceful. The draperies are less diaphanous and sharply linear. In con-

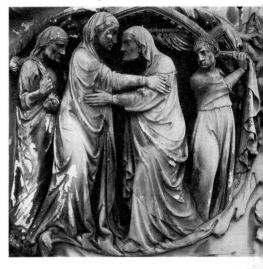

286. Unknown Master: Visitation, *c.* 1310–30. *Orvieto, Duomo, third pier*

trast, they are softer, richer, and more complex in their fold-forms. The depth and richness of relief is accompanied by a denser grouping of the figures, by a greater interest in detail, and by less concern for the relationship of figures to environment. Solidity replaces atmosphere. As in the closely related wooden *Virgin and*

Child now in the Museo dell'Opera at Orvieto, the highest quality in conception and execution accompanies a basically more conservative approach. In scenes such as the *Visitation* [286] direct reflections of Giovanni's Pisan pulpit, which was under construction in 1302–10, coexist with a solemnity akin to that of Nicola Pisano.

Between the major and the minor groups, and straddling the dividing line between the finished and unfinished areas on both central piers, lies a transitional area. The working sequences and procedures are unchanged, and the stylistic affiliations are such that they may easily reflect the cooperation and interaction of the same two workshops. Furthermore, the transitional areas include the two lowest blocks on the left and right of the third pier. If the supposition of a steady upward progress of the work is correct, the appearance of the stylistic influence of the main group at the bottom of this pier can only mean that no work was begun at any point before the major atelier, associated with Maitani, had arrived.

Finally, the documents concerning activity on the façade support a relatively late dating for the sculpture, since the portals were under construction throughout 1321 and were not yet finished in 1337. In 1325–30 the bronze figures at the top of the zone occupied by the reliefs were under way, and the level of the main transverse gallery seems only to have been reached in 1337–9. The documentary and visual evidence therefore combines to place the reliefs substantially within the period between Maitani's confirmation as capomaestro in 1310 and his death in 1330. It is also reasonably clear that if the sculpture cannot definitely be assigned to Maitani, none of the rival attributions carry conviction. Fra Bevignate, although responsible for the early stages of the construction of the Duomo, is nowhere documented or referred to as a sculptor. Ramo di Paganello's candidature is supported only by wisps of conjecture. Finally, the only surviving documented works of Nicola di Nuto, who is repeatedly mentioned in the Orvietan documents between 1321 and 1347–8 and who is the last of the seriously supported candidates, are the busts of St Francis and St Dominic which he carved for the choir-stalls in 1339. These show him to be a man of very minor talent.[11]

WOOD AND METALWORK AND STAINED GLASS

Although they are predominantly concerned with the façade, the interest of the Orvietan documents is not confined to their bearing on an unsolved attributional problem: they give a fascinating insight into the extent of the organization that enabled a small medieval town to engage successfully, with the help of the surrounding *contado*, on the erection and decoration of so vast a building. Among the swarms of names a Rollando di Bruges and a Pietro Spagnolo, and men from Siena, Gubbio, Assisi, Como, and many other centres are recorded. A long list of quarries to supply the many different kinds of marble, stone, and alabaster that were needed involves not only the provinces of Orvieto, Siena, and Pisa – Carrara being specifically mentioned – but also Rome and Castel Gandolfo. At many of them several masons were employed. At Montepisi there were five and at Albano nine. There were carpenters at Orvieto to build the work-sheds and the scaffoldings. Payments were made to smooth the roads for the fragile leaves of alabaster for the windows. Eight names other than Maitani's are recorded in connexion with the bronzes. Others worked not only on the architectural structure but to make the tesserae for the decorative mosaic that enlivens almost every architectural moulding. Workers both in mosaic and in glass were paid for frequent trips to Venice to obtain materials, and in 1386 the mosaicist Piero di Puccio, on an established salary of four florins a month, declared that he would not work any more for less than six. At this a commission composed of wise and aged clerics and senior citizens was set up to adjudicate and agreed a solemn contract at five florins and a half. Andrea Pisano was paid in 1347 for colour-

287. Choir-stalls (detail), early 1330s. *Orvieto, Duomo*

ing the marble statue over the main doorway and, although there is no certain proof elsewhere, the coloured inlays of the sarcophagus lids in the *Last Judgement* may mean that the original intention was that all the reliefs were finally to be painted or part-painted to complete the variegated pattern of the coloured marbles and the architectural and pictorial mosaics. Another small army of men, including Nicola di Nuto, worked upon the choir-stalls. Many of these were Sienese, like Giovanni Ammanati, who was predominantly a wood carver and directed operations in the early 1330s.

The choir-stalls, now in the apse, were formerly before the altar, and though much restored are possibly the finest extensive examples of fourteenth-century Italian woodwork to have survived [287]. They are predominantly rectilinear and planar in conception. Their carefully differentiated surfaces are decorated by delicately complex foliate designs in low relief, picked out in variously coloured woods. The half-length figures of the saints in high relief are overshadowed by the chaste trefoil arches of the baldacchino, supported on its foliate brackets. These choir-stalls, with their intermingling of classical severity and Gothic articulation and decorative detail, take their place alongside S. Croce in Florence on the one hand, and the finest of Italian goldsmith's work upon the other as key examples of the peculiar qualities of Italian Gothic art. The intarsia gable of the *Coronation of the Virgin* is a complex variant of the design for the mosaic on the main gable of the façade. It is linked in feeling with the art of the miniaturist and of the enameller, as well as of the fresco- and the panel-painter, and, like the massive lectern also preserved in the Museo dell'Opera, is a prelude to the fifteenth-century triumphs in the medium.

The chasteness of design, the linear purity, the carefully controlled complexity that leaves a final feeling of simplicity; all these are seen again in the wrought-iron nave screen [288]. This was carried out in 1337–8, with the aid of his son Giacomo, by Conte di Lellio Orlandi, the locksmith who had two years earlier signed

288. Conte di Lellio Orlandi: Nave screen (detail), 1337–8. *Orvieto, Duomo*

a grating in the transept of S. Croce in Florence. The ascendancy of Sienese craftsmen in the so-called minor arts is epitomized in the two masterpieces which the goldsmith Ugolino di Vieri and his fellow workers contributed to the enrichment of the Duomo. The whole cathedral was a shrine for the blood-stained Corporal of the Miracle of 1260, when the bleeding Host restored the wavering faith of a German priest. If, in form and colour, the façade, with its pictorial mosaic decoration and its narrative reliefs [278], may be considered as an altarpiece or reliquary on an architectural scale, di Vieri's gold and silver shrine for the Holy Corporal with its translucent narrative enamels is, in colour, form, and content, a façade in little [289]. Indeed, nothing is more revealing of the fundamental and, in some respects, the growing unity of the arts throughout the period than the way in which pinnacled and gabled screen-façades and metal reliquaries alike express,

289. Ugolino di Vieri: Reliquary of the Holy Corporal, 1338.
Orvieto, Duomo

through almost identical formal means, the same visual approach as does the typical painted altarpiece or carved polyptych. These in their turn repeat and elaborate the arch-forms and the planar grouping of the chapel openings

290. Ugolino di Vieri and Viva di Lando:
Reliquary of S. Savino,
fourteenth century, second quarter. *Orvieto, Duomo*

characteristic of the east ends of a high proportion of the mendicant churches for which so many of them were intended.

Dated 1338, the reliquary of the Holy Corporal falls early in the known career of Ugolino, who is recorded from 1329 to 1385. The reliquary is 4 feet 7 inches (1·39 m.) in height and contains thirty-two main narrative scenes which deal with the *Miracle of Bolsena*, the *Passion*, and the *Early Life of Christ*. Pictorially these reliefs outstrip most of the contemporary panel paintings and even frescoes in the spaciousness and complexity of their architectural settings, in the soft fullness of their draperies, and in the crowded liveliness of their figure designs. As might be expected, Duccio's *Maestà* is the inspiration for most of the Passion scenes, although the crowding and descriptive detail recall the Lorenzettian frescoes in the lower church of S. Francesco at Assisi. In the nine scenes of the *Miracle* and in those of the *Early Life of Christ*, on the other hand, the relationship to Simone Martini and above all to Ambrogio Lorenzetti, particularly as seen in his frescoes in S. Francesco in Siena, becomes extremely clear in general and in detail. Nevertheless, the goldsmith's joy in minute patterning and linear excitement, together with the translucent brilliance of the colour, creates a feeling more akin to northern Gothic art, and the same is true of many of the figures in the round. The earliest example of translucently enamelled silver relief is Guccio di Mannaia's signed chalice of between 1288 and 1292, which was produced for Nicholas IV and presented by him to Assisi, where it is still preserved. Comparison with such earlier masterpieces demonstrates the explosive growth of technical and aesthetic ambition and achievement that is characteristic of early-fourteenth-century Sienese goldsmithery. It underlines the grievous nature of the loss of all the certain works by men of such great fame as Lando di Pietro, Toro da Siena, and Pietro di Simone. It also explains their widespread influence not only throughout Italy, but on European goldsmith's art in general.[12]

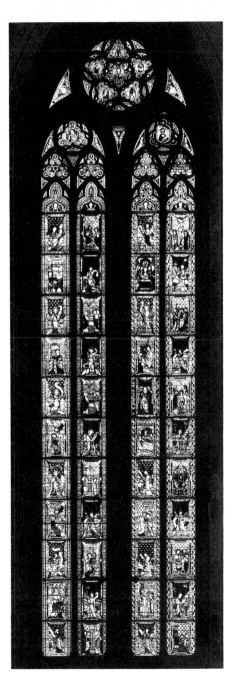

Ugolino's second work at Orvieto, the reliquary for the cranium of S. Savino, was carried out together with a certain Viva di Lando, who is otherwise unknown [290]. The latter may, however, well have been responsible for the main statuette of the *Virgin and Child* which, in its Giottesque solidity and calm, differs so greatly from the free-standing figures on Ugolino's previous work. Nevertheless, the change in style may also partly derive from the relationship with the airy three-dimensionality of a truly architectural space. Standing before this calm and graceful shrine with its restraint and clarity of architectural detail, its set of variations on a hexagon focusing by way of the twelve-sided inner cupola on the columnar figure group, it needs no great imagination to see why the master goldsmiths were so often called on to design and execute great architectural projects.

There is a close relationship between the translucent hues of Ugolino's enamelled reliquary of 1338 and the vast choir window completed by Giovanni di Bonino in 1334 and strongly influenced, if not designed, by Maitani, assuming that he was the leader of the major sculptural workshop.[13] The glass, which incorporated the latest technical innovations from France, stands squarely in the main stream of the now established Italian tradition [291]. It is

291. Giovanni di Bonino:
Stained-glass window, completed 1334, with detail.
Orvieto, Duomo, choir

characterized by clarity and simplicity of design and colour massing. The basic rectangle of the individual compartments is stressed. There is no figure crowding, no undue attempt at three-dimensionality in the architectural and landscape backgrounds. The inherent conflict between narrative and decoration which so often rises to the forefront in stained glass is masterfully controlled. The gospel stories, alternating with the figures of prophets, climb up each of the four main vertical lights and are so arranged as to create a similar alternation horizontally. The backgrounds of the narratives are sapphire rimmed with ruby and those of the prophets ruby, starred with white and rimmed with blue, in the first and third, and an unbroken, blue-rimmed ruby in the second and fourth lights. Since the backgrounds of the narratives are much more heavily masked by figures and architecture, the underlying symmetry becomes the basis for a sustained yet subtly varied counterpoint enriched with white and golden yellow, light blue, emerald, and purple.

It must not be thought that this succession of so many and such varied masterpieces, each unique in its own field and representing a sustained cooperation in the arts for more than half a century, was merely the reflection of a period of peaceful civic growth in Orvieto. There were ten years of unity, beginning in the early nineties, during which the Angevin domination was succeeded by cooperation between nobility and people, Guelphs and Ghibellines, in the face of varying external threats and ventures, but these were followed by ten years of internecine struggle. When finally, in 1313, menaced by Henry VII's armies, the Guelphs succeeded, after five full days of bloody strife and fluctuating fortunes, in shattering the forces of both internal and external Ghibellines, the leaders of the two opposing factions, the Monaldeschi and the Filippeschi, had become enough of a byword to be used by Dante as a symbol of such fratricidal warfare. The rule of the Five, an oligarchy of Guelph nobles, lasted from 1313 to 1315. It was succeeded by Poncello Orsini's Popolo, which lasted seven years, marked by the increasing power of the artisan and trading classes and followed by a gradual reassumption of power by the nobility. All the time, external wars and military excursions, for one of which Lorenzo Maitani was himself conscripted in 1325, are the background for the endless crises and *coups d'état* of internal economic and political struggles. It is typical that throughout this half a century or more of ferment, one of Orvieto's constant political enemies was that same city of Siena which provided such a high proportion of the architects and masons, master goldsmiths, glaziers, metal-workers, and wood carvers who, from capomaestri to quarrymen, contributed to the realization of a dream of piety, of civic grandeur and artistic unity, that has long outlived its dreamers, and which, like the finished sculpture from the teeming Orvietan workshops with their economic and artistic rivalries, shows few traces of the processes through which it was created.

ANDREA PISANO

One of the ironies of the history of Italian thirteenth- and fourteenth-century art is that where so much is known about so many unimportant details, the greatest artists and the finest works of art so often still emerge unheralded. The first surviving record of Andrea d'Ugolino da Pontadera, known as Andrea Pisano, is the masterpiece of his maturity, the bronze doors, signed and dated 1330, for the baptistery at Florence [292]. His entire life seems to hang upon their hinges and his whole life's work to be compressed within the compass of the great cathedral with its baptistery and campanile.

The project for new baptistery doors, probably of wood sheathed in metal, was broached in 1322, when Tino di Camaino was working on the building. It was only in 1329, however, that the goldsmith Piero di Jacopo was sent to Pisa 'to see those [doors] which are in that city and portray [ritragga] them and then to go to Venice to look for some master to work on the moulding of the said metal door'.[1] This document shows the paucity of skilled workers in Florence, which had no living tradition in the medium, whereas the openwork intricacy of Bertuccio's signed and dated doors of 1300 for S. Marco helps to explain the current reputation of Venetian masters. It is also the earliest surviving documentary proof in Italy of the practice of drawing existing works of art for comparison or record, or as the basis for a new creation. On indirect evidence, such proceedings must have been common by this time. On 22 January 1330, Andrea, already referred to as 'maestro delle porte', began his work. By 2 April the wax model for the entire door was finished, though this presumably only concerned the framework. In 1331 two assistant goldsmiths were appointed, and in 1332 Leonardo d'Avanzo, a Venetian who, with two assistants, was in charge of the casting, is mentioned.

The first leaf seems to have been finished by the end of 1332 and the second was being gilded in the latter half of 1333. In 1335 unspecified but evidently serious flaws had to be remedied by Andrea himself, and it was not until June 1336 that the weighing of the waste bronze dust and chippings signalled the completion of the work. Four years later, in 1340, Andrea is mentioned as capomaestro of the Opera del Duomo, and in 1347 he took up a similar position at Orvieto. By July 1349 he had been succeeded by his son Nino, and it is generally assumed that he was carried off by the Black Death.

When Andrea accepted the commission for bronze doors, appropriately decorated with scenes from the life of St John, the baptistery's titular, he faced a set of problems as severe as any that have ever confronted a sculptor. The technical difficulties were more than matched by the aesthetic problem. The need to send to Pisa for information shows that then, as now, there were no more recent patterns to consult. Bonanno's lost Porta Regia of the Duomo is recorded as dating from 1180 and was probably close in time and style to the surviving Porta di S. Ranieri. Furthermore, cycles of the life of the Baptist such as that in the baptistery at Parma were surprisingly uncommon in Italian art. Andrea, with no alternative source of inspiration, was therefore faced on the one hand by the recently completed but stylistically archaic cycle of fifteen mosaics in the dome of the Florentine baptistery itself, and on the other by Giotto's three presumably newly painted and certainly revolutionary frescoes in the Peruzzi Chapel in S. Croce. Three further considerations undoubtedly added to his troubles. Firstly, Giotto's originality in these particular frescoes lay in their hitherto undreamt-of architectural, spatial, and descriptive realism. Secondly, on technical if upon no other grounds,

292. Andrea Pisano: Bronze doors, 1330-6. *Florence, Baptistery*

there was not at that date the remotest possibility of matching, much less of surpassing, such pictorial realism in terms of bronze. Thirdly and possibly the most dauntingly, Andrea must have known that whatever his solution, he would inevitably face comparison with Giotto at the hands of the most critical, the most sophisticated, and the most artistically conscious city in Italy.

Andrea's initial stroke of genius was that, by reducing the rectangular 'pictorial' fields, which he took over from Bonanno, by means of decorative inset quatrefoils, he was able both to use the source material ready to his hand and to avoid competing on the painter's ground. The diminution of the narrative field and the limitation of the pictorial possibilities by the seemingly intrusive angularities of the immediate framing is not a disadvantage suffered for the sake of fashionable Gothic decorative qualities, but an actual liberation and the necessary condition for the development of Andrea's uniquely concentrated narrative style.

By this date there is no need to search the sculpture of Paris, Bourges, and Rouen or to turn to northern metalwork or miniatures for the source of the pierced quadrilobe. Giotto had used it in identical form fully twenty years earlier to frame subsidiary scenes in the Arena Chapel, and it was probably familiar to Andrea in lost Florentine works by Giotto and his circle. Since Andrea eschews the wide upper and lower horizontal fields used by Bonanno to vary the purely rectilinear grid of his design, the quadrilobes effectively enliven the potential monotony of the twenty-eight identical rectangles into which he decided to divide his own doors. They also allow him to give unprecedented depth and strength to the rectangular framework itself. Enlivened as it is by the decorative studs and embossed lions' heads that replace Bonanno's relatively flat rosettes, the framework acquires a powerful architectural quality without losing contact with the narrative reliefs. It can support a gilding of the studs and bosses, as well as of the figures in the narrative scenes, that would have swamped the archi-tectural connotations of Bonanno's flatter framework. Within Andrea's scheme the crisp contrast between gold and bronze is allied to the similarly balanced contrasts between raised and flat, rounded and pointed, rough and smooth, linear and planar, discontinuous and continuous forms. They all of them enhance the fundamental balance between the figural and abstract, and the decorative and structural elements from which the final harmony is built.[2]

Of the fourteen panels on each leaf, the bottom four contain the single figures of the Virtues, with Humility bringing the total up to eight. The story reads like a book from left to right and top to bottom on each leaf or page, and there seem to be definite technical and stylistic indications that the order of execution followed the narrative sequence.[3] As in the baptistery mosaics and in Giotto's frescoes, there is strict adherence to the gospels and virtually no embroidery from apocryphal or legendary sources. Though many scenes are cunningly adjusted to the points and lobes of the quatrefoils, the essential contact with the structural framework of the doors is maintained through the rectilinearity of compositions that are chiefly built of simple verticals and horizontals. The figures stand, in all but the five landscape scenes, on wedge-and-pole-supported platforms that tantalizingly recall stage structures. Their proportions are such that the resulting compositional rectangles softly stress the horizontal. Once again the outcome is a balanced contrast, this time with the gently vertical stress of the main structural compartments which is only echoed in the single figures of the Virtues at the bottom of the doors.

Despite Andrea's Pisan background, the direct reflections of Giovanni's work are few, apart from a general similarity between the *Birth of the Baptist* and the comparable scene upon the Pisa pulpit. As with Tino, the relief style marks the end of the era of Nicola and Giovanni Pisano's neo-Antique, continuously carved relief and a return to the Italian Romanesque and French Gothic traditions with which they had so briefly flirted on the Perugia

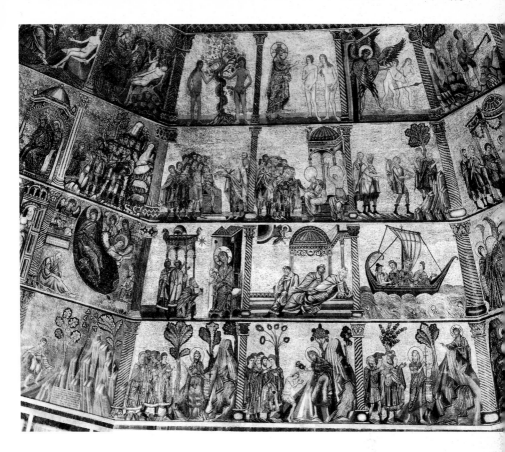

293 (*opposite*). Andrea Pisano:
Naming of the Baptist,
St John entering the Wilderness,
Preaching of St John,
Presentation of Christ, St John baptizing,
Baptism of Christ,
detail of bronze doors, 1330–6.
Florence, Baptistery

294 (*above*). Detail of mosaics, completed *c.* 1325(?).
Florence, Baptistery

Fountain. The contact with northern metalwork
is clearest in the extraordinary crispness and
delicacy of the final chiselling. This influence
was felt by almost all the greatest Italian gold-
smiths of the period and is generic rather than
particular. Andrea may therefore owe as much
to indirect as to direct connexions with French
artefacts. In figure style the influence of Giot-
to's fold-forms is supreme, but where the
painter has to fight for three-dimensionality,
the sculptor has it as of right. Andrea's swing-
ing, linear rhythms, in which hints of Duccio
and of the Orvietan carvings flicker, conse-
quently quite transform the sombre, relatively
static Giottesque patterns. The resultant mel-
lifluous plasticity is Andrea's own. Although

such figures as *Hope* may be connected in detail with their Paduan counterparts, much as the *Visitation* is linked by the positioning of the hands to the Orvietan version, external influence is so digested as to be of little more than academic interest in the end result.

It is in compositional matters that Andrea's art has been most open to misunderstanding and in which his independent genius paradoxically shines most clearly, although of the twenty narrative designs only the *Carrying of the Baptist's Body* is without a counterpart in the baptistery mosaics or in the Peruzzi Chapel. The subtlety of his compositional methods is most easily seen in the continuous sequence of five landscapes in the middle of the left-hand leaf [293]. They form a group in which the gospel order has been changed to bring the two baptismal scenes together as the culmination of the opening chapter of a narrative continued at the top of the right-hand door. In the scene of *St John entering the Wilderness* the sense of intimate relationship between landscape and figures is already intense. In the comparable mosaic [294], a man-sized youth upon the left advances swiftly towards the formal rocks assembled on the right. On the doors, a little boy appears, already buried in the craggy depths of a wild landscape, marching forward, head down, with his cross held boldly to the fore. A casually placed, unbroken precipice provides a frame for the small figure and continuous forward movement is suggested by diagonal rock-clefts.

In the mosaic version of the next scene, the *Preaching of St John* [294], the crowd is on the left, succeeded by a central tree. St John stands to the right of the centre, and a tree-clad rocky mass on the far right attracts attention as an empty formal balance for the people on the left. As almost invariably when Giotto offers no alternative design, Andrea starts from the mosaic. The subsequent transformation is always considerable, however, and in the relief each figure group is backed by a rocky outcrop in the manner of Cimabue in his frescoes at Assisi. The crowd upon the left, reduced to four, stands on a lower level than the Baptist on the right [293]. Behind the crowd, a low, diagonally-topped rock mass and a tall tree lead upwards in a single sweep that helps the eye to leap the central cleft towards the higher, slimmer pinnacle behind the isolated figure of the Baptist. Each seemingly casual element of landscape is designed to emphasize, to separate sufficiently, and at the same time to connect, the figures.

In the *Presentation of Christ* [293] there is a similar tightening of the loose but none the less expressive mosaic design [294]. Each nuance of a complicated psychological moment is defined as the Baptist points towards 'one mightier than I . . . the latchet of whose shoes I am not worthy to unloose'.[4] The Baptist is the central actor in the drama upon these, his doors, and he stands clearly isolated at the centre. He is emphasized not merely by his central placing, and by being set in high relief at a slightly higher level than the crowd upon his left, but by a great bare face of rock that towers up behind him. The least important element, the crowd upon the left, stands at the lowest level and is given landscape emphasis by the relatively soft forms of a tree. The latter balances the most important form of all, the figure of Christ upon the extreme right. Standing high above the other figures, he alone is haloed and alone stands clear against the sky in contrast to the rest. The mountains and the steadily ascending rock floor lead towards him. The unwavering gaze of the spectators is directed past the Baptist to him, and the meaningful diagonal is further strengthened by the staff which the Baptist holds, symbolically clear, between himself and Christ, so that the cross upon its head is closer to the Saviour. It is not merely the Baptist's firm gesture that declares 'not I but He'. The swinging drapery folds lead upwards to the right from the foremost member of the crowd and on through those of St John himself. The goal once reached, straight-hanging folds enclose the static column of the imposing figure of Christ, encouraging the eye to go no farther. Each detail of design is subtly differentiated from the

similar element in the preceding scene. Each formal aspect of a composition cut to the bare bone is calcuated to bring out the inherent subtleties of the story at the same time as it builds a satisfying visual harmony. Andrea does not copy the surface incidentals of Giotto's art: he applies its underlying principle.

The *St John Baptizing* again reveals Andrea's varied skill in using landscape to distinguish and to emphasize the figural components of his compositions [293]. Here, a single figure out of the anonymous, bystanding crowd assumes importance through the act of baptism. This subtlety of meaning is exactly expressed by the way in which his lower body merges with the crowd behind him, while his head stands clear and separate in the baptismal act. The connexion with the flowing water and the Baptist's bowl creates a vertical, accentuated by the smooth trunk of a tree. It forms a visual and significant central axis for the asymmetric

balance of the whole design. The comparison and contrast with the traditional iconography of the next-door *Baptism of Christ* needs no elaboration, and the landscape background once again gives visual expression to the inner meaning. The angel on the left is lowest, Christ is central, and the Baptist higher on the right.

The fundamental role played by the draperies, which by their freely flowing yet descriptive lines enrich the doors with a decorative rhythm quite unknown in Giotto's art, is at its clearest in the *Carrying of the Baptist's Body* [295]. The swinging folds of the left-hand figure suggest its rapid motion. The rhythm slows down in the central bearer until, in the figure on the right, the hanging folds loop vertically down to form an almost static column. The three left-hand figures all glance back and concentrate attention on the Baptist's face, while the right-hand three look forwards in the direction of movement. By these means a sense of

295. Andrea Pisano: Carrying of the Baptist's Body and Burial of the Baptist, detail of bronze doors, 1330–6. *Florence, Baptistery*

rhythmic motion is incorporated in a balanced composition sitting comfortably within its frame. How rich and full of interest for themselves, as well as for description of the underlying forms; how softly falling and how complex Andrea's draperies could become when freed of narrative demands is shown in the single figures of the Virtues. The difficult problems involved in foreshortening the thighs of seated figures in relief have not been wholly solved, but the variety of form and pose within a necessarily restricted compass is remarkable. Such formal subtlety, combined with naturalness and freedom in the fall of folds, is nowhere seen again before the flowering of the Renaissance in the early fifteenth century.

The *Burial of the Baptist* is among the finest examples of Andrea's use of the mosaics while maintaining his independence both in detail and in principles of design [295]. In the mosaic a wide canopy supported by thin columns upon either wing creates an a-b-a compositional rhythm.[5] The massing of the figures on either side, with the single mourner at the centre, who emerges from behind the sarcophagus and seems to carry out a symbolic rather than an actual lowering of the Baptist's fully visible corpse, creates a rhythmic contrast – b-a-b. In Andrea's design, however, the pierced quatrefoil of the frame allows a complex Byzantine–Gothic canopy to form an almost abstract, floating, and yet wholly stable architecture for which the two columnar framing figures supply the 'structural' support. Figures and architecture combine to orchestrate a single a-b-a rhythm. The hieratic demand for the full visibility of the Baptist's body is ignored. His head and feet alone appear. The rest is hidden by the bearers. The slow bending of their backs that concentrates attention on the Baptist's head so vividly expresses the whole theme of the eclipse of life, of loss and burial, of solemn ceremonial, and of physical and emotional strain, that the body almost seems to sink before us. The theme of burial is not merely represented but made actual in all its overtones, and with a strict and thoroughgoing economy

of means that Giotto himself could never have surpassed.

The subtlety and depth of the true relationship between the painter and the sculptor is apparent in the *Presentation of the Baptist's Head*, in which Andrea is superficially at his most dependent [296]. In the Peruzzi Chapel *Dance of Salome* [203] Giotto's compositional problem was the unification of three separate episodes. These comprised the *Decapitation of the Baptist*, known from a copy by Lorenzo Monaco to have occupied the tower on the left, the *Dance of Salome* itself, and the *Presentation to Herodias* on the right. The necessary interconnexion is principally achieved by the repeated verticals of the figures, by the freely continuous line of heads, and by the unbroken continuity of roof and cornice. The need for a firm horizontal linkage leads Giotto to turn the two representations of Salome into veritable Siamese twins, linked by their trailing robes. The vertical of the dancing Salome is matched by that of her kneeling counterpart. Herodias sits on a low throne, reducing the disparity of head-height to a minimum and allowing the flattened curve of arms and hands to settle almost into horizontal balance. A halo and the corner of the room itself attract attention to the Baptist's head, and the semicircular arch above echoes the figure-curve below. The figures and the architecture blend into a single, mutually supporting whole. Finally, in the top right-hand corner, Giotto inserts a flight of steps and the side wall of an upper storey, not so much to accentuate Herodias, the interval being somewhat wide, as to provide an end stop for the gently sloping, downwards recession of the main roof-line. The latter would, without them, seem to slide away uncomfortably towards right.

Andrea, in his version of the scene [296], transforms the curves of Giotto's building into straight lines. These forge the necessary links with the rectilinear panelling of the doors. The steps and wall, which are a functional detail in the fresco, are seized upon and turned into a castellated tower which forms a major element

296. Andrea Pisano: Presentation of the Baptist's Head, detail of bronze doors, 1330–6. *Florence, Baptistery*

in the design. It gives a strong diagonal accent to the entire architectural pattern and creates an emphatic canopy for the enthroned Herodias. The latter, by suborning her unthinking daughter and subjecting the weak king to her will by trickery and strength of

personality, sets the tragedy in motion and provides its driving force. The subtlety with which Andrea bodies out this drama makes his painted prototype seem stiff and lifeless by comparison.

297. Andrea Pisano: S. Reparata, 1330s(?).
Florence, Museo dell'Opera del Duomo

Simplicity and grace blend in a manner that is not Giottesque. The young princess kneels low, subservience in every curve, and proffers the head upwards like the filial slave she has become. Pensive, Herodias bends her gaze down to her daughter. As their glances meet, the severed head materializes as the thought that lies between them. Salome's swinging draperies pick up the rapid rhythm of linked hands and wrists which then reverberates throughout the framing quatrefoil. The figures merge in one diagonal of movement and emotion which is strengthened by the architectural forms. But for the unusually complete description of a rectangular architectural enclosure, no such sweeping stroke of compositional genius could have been achieved without destroying the rectilinear pattern carefully maintained throughout the narrative designs and stressed in the surrounding architectural scenes. After a hundred years Andrea's doors were to be taken from their place of honour opposite the Duomo to give way to the first of two sets by Ghiberti. Nevertheless, their balancing of structural and decorative elements remains unique. However far they were eventually left behind in terms of technical achievement, artistic values are not necessarily subject to a similar evolution. As doors, and in their combination of narrative and architectural function, Andrea's masterpieces may never have been surpassed.

Since no other documented works exist, any further attributions to Andrea must be tested by their stylistic relationship to his bronze doors. The two small, highly polished marble standing figures of Christ and of S. Reparata [297] in the Opera del Duomo have all the requisite qualities.[6] They are stylistically identical with such figures as the Christ of the *Presentation of Christ* [293], and every formal element can be matched upon the doors. The draperies are not deeply cut and the detail has a goldsmith's delicacy of touch. The outlines are unbroken and the solidity of the slightly curving, tubular mass is undisturbed. These two exquisite, solemn figures underline how

little Andrea's Gothicism in the doors depends upon extravagant or swaying forms.

Antonio Pucci attributes the first of the reliefs set in two ranges round the base of the campanile of the Duomo to Giotto. Later on, Ghiberti gives them first to Giotto and then, elsewhere, to Andrea. The lower part of the campanile certainly seems to date from 1334 to

298. Andrea Pisano: The Weaver, c. 1334–7.
Florence, Duomo, campanile

1337, when Giotto is reliably reported to have been in charge. However much Giotto may have intervened in the early stages of design or later on in a supervisory capacity, the style of the reliefs appears to show that they were by Andrea and his circle. The lower, and presumably earlier, set of hexagons is devoted to the Creation of Man and to man's own subsequent activity as a creator and inventor in the arts and sciences. The three scenes from Genesis, which Pucci and Ghiberti both connect with Giotto, are those in which, allowing for the change in scale and medium, the general figure style and the carving of hair and similar details are virtually identical with that on the doors. The unaccustomed lushness of the vegetation simply reflects the subject matter of the earthly paradise. The reliefs of *Hercules* and *Cacus*; of *Dedalus*; of the *Sculptor*, which is among the most attractive compositions and is stylistically inseparable from the doors; of the *Horseman*, the *Ploughman*, the *Navigator*; and finally that most subtly monumental of all Andrea's reliefs, the *Weaver* [298], are all convincingly attributable to his own exertions. Whether here or in the fourteen scenes in which the variously lowered vitality of the carving seems to indicate that workshop intervention was extensive enough to affect the final outcome, the sensitive shaping of the figure content to the new design of frame is very noticeable.[7] It is this short canon, established in the doors, confirmed in the Christ and the S. Reparata, and continued in the finest of these reliefs upon the campanile,[8] that assures Andrea Pisano of his place among the greatest of Italian sculptors.

GIOVANNI DI BALDUCCIO AND NORTH ITALIAN SCULPTURE

GIOVANNI DI BALDUCCIO

While Tino di Camaino was softly echoing the Pisan sculptural message at the Neapolitan court, Giovanni di Balduccio was proclaiming it in similarly dulcet tones in Lombardy. The documentation of his career is sparse. He is known to have worked in a minor capacity in the Opera del Duomo in Pisa during 1317–18, shortly after Tino's departure. There follow the signed tomb of Guarnerio degli Antelminelli, the son of Castruccio Castracane, in S. Francesco at Sarzana, probably, judging from the inscription, carried out after his father's death in 1328; the signed wall pulpit in S. Maria del Prato at S. Casciano Val di Pesa; the Arca di S. Pietro Martire in S. Eustorgio in Milan, signed and dated 1339; and lastly the doorway of the destroyed church of S. Maria di Brera in Milan, signed and dated 1347. The final record is the Pisan decision to elect him capomaestro in 1349. His answer, if any, has not survived.

The wall-tomb for Castruccio's son is a heavy, somewhat piecemeal concoction, loaded with distant reminiscences of Giovanni Pisano and, in the reliefs, of Giotto. The pulpit, on the other hand, with its marble polychrome, its clear rectangular form, and its clean lines, recalls the Romanesque tradition that preceded the Pisani. The delight in drill-work looks back to the self-same sources, but the Gothic figure style, shared with the tomb, the busy draperies and the delight in still-life detail, all bespeak the non-dramatic, narrative interests of the minor masters of the third decade of the fourteenth century. The reliefs of *St Dominic* and *St Peter Martyr* are stylistically almost identical with the figures of *St Dominic* and *St Petronius* which may derive from the lost high altar of S. Domenico in Bologna, commissioned after 1331. The early signed works also point back

to the somewhat Lorenzettian *Madonna and Child* from S. Maria della Spina in Pisa, and forward to the figures of the Baroncelli monument and of the *Virgin Annunciate* in the round in S. Croce in Florence [299]. In its intensity of expression and its soft complexity of fold form the latter gives the first hint of the powers to be released once Giovanni moved away from Tuscany. The date of, and the reason for, his transfer to Milan are unknown. He may have been called by Azzo Visconti himself, whose multiplicity of Pisan connexions included Castruccio Castracane. It is also possible that his move was linked with the construction of the 'most beautiful' arca in which Beatrice d'Este was buried in S. Francesco Grande in Milan in 1334.

The state of Lombard sculpture when Giovanni and his by then extensive local workshop embarked upon the Arca di S. Pietro, which he signed in 1339 [300], may be gauged from the major works of the first half of the century. The opening decade is represented by the tombs of Ottone Visconti (d. 1295) in the Duomo of Milan and of Berardo Maggi (d. 1308) in the Duomo Vecchio in Brescia. The smoothly polished forms of both are hard-won from the tough, red marble of Verona. Only in the latter do the Lilliputian mourners catch a purely iconographic whisper of Arnolfo's distant innovations and reveal in dress that these are not pure masterpieces of the Lombard Romanesque, but works contemporary with Giovanni Pisano's Pisan pulpit or Giotto's Paduan frescoes. Hardly more disturbed in their slow course are the masters likewise probably from Campione, near Lugano, the ancestral breeding ground of Lombard sculptors, who, with the sole concession of a heavy, pointed arch, carved out the simple, massive, and harmonious forms of Guglielmo Longhi's canopied wall-tomb,

484

299. Giovanni di Balduccio:
Virgin Annunciate, early 1330s(?).
Florence, S. Croce

built upon the Veronese model, in S. Maria
Maggiore at Bergamo *c.* 1320.[1]

Against this background Giovanni's Arca is
as revolutionary an intrusion of Pisan sculptural
innovation as was Nicola Pisano's Arca di S.
Domenico in the Bologna of three-quarters of
a century earlier. The latter is the prototype
of Giovanni's more elaborate construction, but
there are now eight caryatids instead of six,
and a tripartite vertical division is created. The
crowning tabernacle recalls that on the façade
of the Camposanto at Pisa, and the general
outlines are almost exactly those of Tino di
Camaino's tomb of Cardinal Petroni in the
Duomo of Siena [268].

The Seven Virtues and Obedience, each
standing on their paired symbolic animals, form
the caryatids. The eight scenes from the life of
St Peter Martyr on the casket are articulated
by Sts Jerome, Thomas Aquinas, Eustorgio,
Augustine, Ambrose, Peter, Paul, and Gregory.
Above them, eight of the angelic choirs –
Cherubim, Thrones and Dominations, Virtues,
Powers, Principalities, Archangels, and Angels,
derived from the *Areopagitica* of Pseudo-
Dionysus with the aid of symbols taken from
Gregory the Great – prove that the iconographic
originality of the Pisani was not yet dead. The
Seraphim, closest to God, then find appropriate
place beside the Saviour on the topmost flanking
pinnacles. The Virgin and Child, together with
St Dominic and St Peter Martyr, are housed
beneath, in the tripartite tabernacle, and upon
the lid of the sarcophagus are Sts Catherine and
Nicholas, and Sts John and Paul, flanked by a
suppliant royal pair and other kneeling laity
and clerics.[2] The Arca was originally em-
bellished both with coloured marbling and with
blue and gold paint, and its rising iconographic
temperature must have achieved a final flame-
like quality when all the angelic figures had the
metal wings for which their backs are slotted.

The wings would have reiterated the spiked forms of the pinnacles and given an added airiness and vertical acceleration to the upper ranges of the tomb. The impression of lightness which the open base and top, the slender caryatids, and the free-standing upper figures still engender, despite the heavy body of the tomb, would have been greatly enhanced.

The intervention of a massive workshop in the years between the first proposal for the monument in 1335 and its signature in 1339 is demonstrated by the variable quality of its detail. The qualitative peak lies in the caryatids. These show every sign of being substantially executed by Giovanni himself. Only the Hope, and Justice [300, extreme left] with its long neck and small head, show structural uncertainty. The backing of each figure by a column allows a maximum of graceful slimness in the apparent supports, and this is accentuated by the allegorical beasts beneath their feet. The result is suavity without sway, sufficient but never obtrusive anatomical description, and a constant variation of expression and emotion without violence or passion. The eager Charity, with its upturned face and parted lips, and the Prudence, with its neat solution of the problem of the double visage [300, extreme right] and smooth subtlety of sculptural simplification in the main face, are especially notable. The finest of them all is possibly the Temperance [301]. It is among the loveliest, the fullest, and the most subtle evocations of feminine grace and spiritual tenderness since Nicola Pisano's Humility on the Siena pulpit of 1268. There is a shining simplicity and quiet naturalism in the smooth, rhythmic flow of the freely hanging drapery folds. These qualities are for once combined with a sense of void and solid which, in its gentler way, recalls the dramatic depth of undercutting in Arnolfo's Virgin and Child for the Duomo in Florence [61]. The humanity that infused such Early Gothic statuary as the Queen of Sheba on the main west door at Reims [197] is here restated in more subtle terms. Dante's Beatrice or Petrarch's Laura are not more beautiful in the mind's eye. To have chis-

elled even one such figure out of the reluctant stone is to be proved no minor sculptor but, in terms of quality, a major artist.

Except in the figures in the tabernacle, the intervention of Giovanni's Lombard workshop is more or less apparent throughout the remainder of the Arca. Among the saints and in the reliefs it is overwhelming. A tendency to elongated bodies, long necks, and small, thin-faced heads in certain figures contrasts with the heavy hands and pendulous jowls of another extensive group. The chief executant of the crudely piled up compositions and squat figures of the Burial and Canonization reliefs later appears to dominate the highly coloured tomb of Lanfranco Settala in S. Marco in Milan. Much closer in certain of the heads to Giovanni's own style, but evidently almost wholly a workshop product, is Azzo Visconti's (d. 1339) own tomb in S. Gottardo in Milan. The one relief upon the Arca which moves appreciably beyond the range of the Arca di S. Domenico of so many years before is that of the Miracle of St Peter Martyr, which is almost filled by a great ship on a surging sea [300]. The figure of the saint and the lovingly described intricacy of detail make it likely that Giovanni himself was more than usually concerned in the execution of this vivid narrative, which calls to mind so many later panel paintings of miraculous salvation from marine disaster.

Reminiscences of the relief style of the Arca, as well as of ivory carving and metalwork, together with a simple narrative garrulity that recalls the panel painters and more specifically still the Bolognese and Lombard schools of miniaturists, recur in the marble altar triptych of the Story of the Magi which is also in S. Eustorgio. It may even be the independent work of the sculptor who collaborated on Giovanni's relief of St Peter curing the Dumb. If so, his natural, naïve vivacity and technical dexterity are given a free rein among the teeming figures that invigorate the balanced repetitions of his altarpiece.

In practical terms nothing certain is known of Giovanni's personal development as a sculptor

300 and 301. Giovanni di Balduccio:
Arca di S. Pietro Martire, 1339 (*opposite*),
with detail of Temperance (*left*).
Milan, S. Eustorgio

after completing the Arca. With the possible exception of the *Virgin Annunciate*, the fragments from the doorway of S. Maria di Brera of 1347 seem hardly likely to be more than independent workshop products protected by his signature. If the three wafer-thin free-standing figures above the doorway of the Duomo of Cremona are indeed by him, as they may conceivably be, judging from certain liquefactions of the folds, their uncertain, swaying stance reveals a diminished interest in structure and an increased reliance on French Gothic art. The *Virgin*, in particular, recalls an ivory, despite her monumental scale. Yet if structure takes a second place to decorative grace, the detailed portrait realism of the clean-shaven figure of *St Omobono*, his aged flesh sagging on the strong bones beneath, accentuates the grasp of anatomic fundamentals as well as the ever-present technical skill which the Tuscan sculptor of these figures could summon up when it was relevant to his purpose.

GIOVANNI DA CAMPIONE

Campione, on the shores of Lake Lugano, already famed for builders, masons, and sculptors in the twelfth and thirteenth centuries, comes into its own once more in the mid fourteenth century. Giovanni da Campione is the only Lombard rival of Giovanni di Balduccio whose stylistic personality has in any sense survived. The inscription 'MCCCXL IOHANNES' on the baptistery at Bergamo probably refers to Giovanni da Campione and to the reworked figures of the Virtues in the external niches at the angles

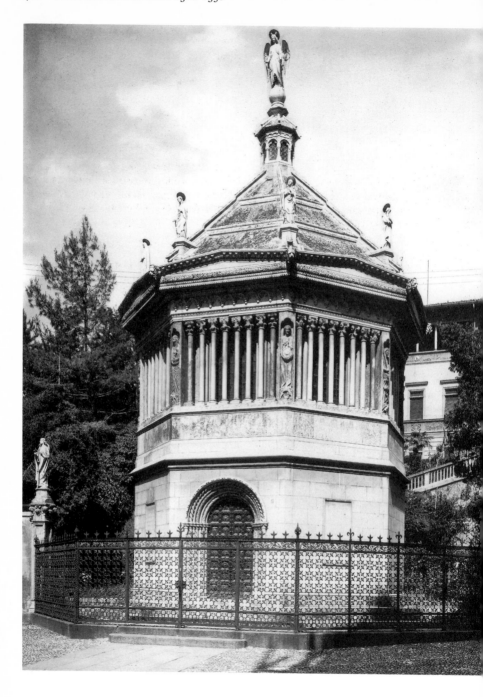

302. Giovanni da Campione:
Bergamo, baptistery, inscribed 1340

of the building as well as to the reconstructed building itself [302]. This is shown by the similarity between these figures and those on the north portal of S. Maria Maggiore with its explicit lower and upper inscriptions of 1361 and 1363. Since, in the documents referring to the doorway, Giovanni figures chiefly as the entrepreneur of the whole work, the carvings may, on the analogy of Orvieto, merely reflect his employment of the same workshop for the sculptural elements of both projects.

The baptistery Virtues are closely related iconographically to those on the Arca di S. Pietro, presumably completed only a year before. The extreme elongation of these figures, carved in brownish Veronese marble and dominated by the Procrustean dictates of their architectural setting, is accompanied not only by a stiffening of form and a hardening of expression that are undoubtedly due in part to subsequent tampering, but also by a tendency towards a flat, Romanesque linearity in the drapery. The soft rhythms of Balduccio are clearer in the Angels within the baptistery, as well as in the four opening reliefs of the eight panels of the *Life of Christ*, influenced though they are by local traditions of the kind that affected Balduccio's own work. In the violent final scenes of the *Betrayal, Crucifixion,* and *Last Judgement*, on the other hand, distant reverberations of Giovanni Pisano's relief style are combined with strong Germanic accents. The latter are a recurrent element in Lombard sculpture. Combined with reminiscences of Nicola Pisano, they appear somewhat earlier in the figures of the Loggia degli Osii in Milan. Ten years later they re-emerge in the silver altarpiece in the Duomo at Monza, signed by the Milanese Borgino dal Pozzo.

Although the heavy, free-standing figures of the parti-coloured north door of S. Maria Maggiore reflect exactly the same stylistic point of departure as the baptistery Virtues, the less

restricted situation allows of an increased fullness and softness in the draperies. Giovanni's art appears, however, to be at its most artless and its most effective in the stiff, block-like figures of St Stephen and of the equestrian St Alexander. If the ultimate sources of this rigid group of horse and fully-armoured, smiling rider once more lie in Germany on the one hand and in the Romanesque Italian equestrian monuments, rooted in Antiquity, on the other, the immediate prototype seems to be the infinitely more sophisticated figure of Cangrande della Scala (d. 1329) on his monument in front of S. Maria Antica in Verona.

VERONESE TOMB SCULPTURE

The close sculptural ties which bound Lombardy and Emilia during the preceding centuries are still visible when the early-fourteenth-century sarcophagus of Alberico Suardi in the Villa Secco-Suardi at Lurano is compared with that supposedly belonging to Alberto della Scala (d. 1301) in front of S. Maria Antica in Verona. In the latter the Lombard equestrian figure on the forward face is linked to the Byzantine decorative elements on the short sides and to the firmly Veronese relief upon the rear. The massive, squat, and uncompromising rectilinearity of this sarcophagus reaches back even beyond the still vital Romanesque past of Northern Italy towards the latter's Byzantine and Early Christian origins. The same red marble of Verona and the same fundamental form, with figured antefixes at the corners, can be seen in the sarcophagus in S. Giovanni in Canale in Piacenza. A similar equestrian relief, this time upon the lid, is there combined with reminiscences of goldsmiths' work or of late-thirteenth-century polyptych forms in the relief arcading and in the openly byzantinizing character of many of the figures. Byzantine elements are no less strong in the firmly rectangular and highly decorated tomb of Bartolomeo Dussaimi, which is set against the wall of S. Pietro Martire in Verona beneath a pointed, cusped arch. Very similar

303. Tomb of Guglielmo di Castelbarco, d. 1320.
Verona, S. Anastasia

architectural elements are exploited in the presumably more-or-less contemporary free-standing tomb of Guglielmo di Castelbarco (d. 1320) outside S. Anastasia in Verona [303]. The four decorated gables of the canopy are surmounted by a severely simple pyramid with a cubic base that recalls the even simpler pyramids upon the massive, many-columned, late-thirteenth-century Tombs of the Glossators outside S. Francesco in Bologna. The

sarcophagus itself is a lighter derivative of the Lombardo–Emilian types of those of Berardo Maggi and Alberto della Scala.

The basic formula of the Castelbarco tomb is vertically elongated in that of Cangrande della Scala (d. 1329), which is set against, and finally soars above, the wall of S. Maria Antica, also in Verona [379]. The new feeling of pomp and solemnity lent to the monument by the recumbent figure stretched on the draped bier above the sarcophagus gives way to sheer pleasure when the somewhat crudely carved, dead figure of Cangrande down below and the living, fully-armed equestrian figure up above are seen to be grinning like a pair of Cheshire cats. The inspiration for this feature seems to lie in the substantially Romanesque wooden image of S. Zeno in the Veronese church named after him. No more delightful memorial to a triumphant despot can well be imagined than the plump and beaming visage of Cangrande as he leans back in his stirrups to survey a suddenly truncated lifetime of achievement [304].[3] Personally brave, a bold and clever military leader and despite his youth an invariably skilled and often wise politician, as well as a patron of the arts and sciences who, like Bartolommeo, his brother and predecessor in power, gave Dante shelter for a time, Cangrande represents the finest of the class of despots who, in the late thirteenth century, gradually gained power in the once free Lombard and Emilian communes. The autocratic rule of the Scaligers was characterized, like that of the Caminese in Treviso and of the Carrarese in Padua, by a broadly democratic base. These neighbouring and therefore often warring dynasties were all of them elected by a general council of citizens who conferred a personal dictatorship upon them, and it was not until 1359 that a hereditary principle was established in Verona. In spite of their fully dictatorial administrative, legislative, and judicial powers, the commune under them still retained its organization and identity and sent its representatives for such acts as treaty signing. The outcome was a kind of constitutional dictatorship, maintained for motives

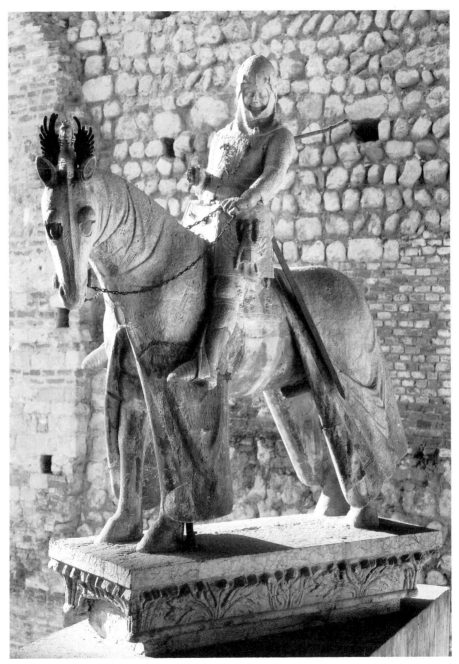

304. Equestrian figure from the tomb of Cangrande della Scala, d. 1329.
Verona, Castelvecchio

of self-preservation and, under men of the calibre of the Scaligers, as popular as it was absolute. It is no simple war-lord who is represented on Cangrande's tomb, but a singularly complex representative of a class of rulers who embodied one form of the aspiration to good government in a part of Europe which was both the most civilized and among the most unstable of its time.

The quality of carving in the equestrian group matches the skill of its design. It is the counterpart in stone of the fresco of *Guidoriccio da Fogliano* which, with its very similar sense of line, was probably painted (if it is indeed by Simone Martini) within a year or so of Cangrande's sudden death [210]. A feeling of life is achieved by balancing the charger's for- ward-leaning posture and gently curving neck against its rider's straight-legged, backwards lean. The horse's four-square stance, required for structural stability, is not allowed to root the group in Bergamasque immobility. The heads of horse and rider are half turned, and the horse's trappings, incised on every square inch of their surface, ruffle in the wind and, like the similar elements in Simone's painting, suggest both life and movement and potential locomotion. The later Scaliger tombs are more elaborate, but they are not more vivid in their portrait quality or more effective in their contrasts between life and death or between the fluttering sinuosities of the figures and the largely rectilinear severities of the architectural forms.

ARCHITECTURE

1350–1400

INTRODUCTION

As far as architecture is concerned the second half of the fourteenth century is largely a period of consolidation and of the completion of unfinished business. There are several reasons for this. The most obvious is the number of major projects which had been begun when both the Central Italian towns and the new religious orders had been in the midst of vigorous expansion. In most of the towns and cities from Naples to the Alps it must have been impossible to walk for more than a few hundred yards before encountering an unfinished church or palace. Well before the middle of the century, the mendicants had been nearing saturation point, and economic difficulties had further slowed the spiral of new building starts in many Tuscan centres. When populations were in any case so small, and their resources often stretched to the utmost in grandiose constructional campaigns, the effect of the Black Death in sweeping off one man in every two is difficult even to imagine, let alone assess. Only in the Duomo at Florence does the slow process of completing a major project seem to have led to a transformation so complete as virtually to create a new design.

The social and economic disruption following the plague was naturally most noticeable where new methods both of political and of economic organization, involving greater segments of the population, were most highly developed. Men whose trade is war find profit in disaster, and in Northern Italy the effect was chiefly to complete the regression to autocracy. The survivors of old ruling houses and the leaders of the new consolidated their position. Their subjects were more disorganized than ever, and civic leaders were more than ever willing to shelter from the forces of disruption beneath the wings of the greater war-lords who alone were able both to control the rabble and to exercise some check upon the swarms of lesser tyrants. The refurbishing and strengthening of existing fortresses to meet the ever-changing needs of defence and the building of new castles and castle-palaces were not merely continued but if anything accelerated. At one end of the scale the increasing tendency for military needs to be accompanied by a demand for greater comfort affected even the most severely practical of such buildings. At the other it led not so much to the construction of palatial fortresses such as had existed long ago in Frederick's southern kingdom as to the evolution of the fortified palace.

Venice, as always, is a special case. The rapidity and strength of her recovery, based on a flourishing oriental trade and secured by a relatively stable, oligarchic governmental system, is reflected in the splendours of the doge's palace. By the end of the century, however, well established tyranny was providing the rest of Northern Italy with a background for general prosperity. The two great

churches founded in the last years of the century, the Duomo in Milan and S. Petronio at Bologna, yield no ground to Florence in terms of sheer scale of endeavour. Their different geographical location and differing social foundations condition them as the final and triumphant flowering of Italian Gothic architecture at the very moment when the Gothic cathedral of Florence was to be capped by the great dome that heralds the Renaissance. They also draw attention to the short duration and relatively restricted penetration of the tide of Gothic architectural form in Florence. Orsanmichele, the Bigallo, and the Loggia dei Lanzi, three of the most significant structures set up in the centre of the city in the final two-thirds of the fourteenth century, are all emphatically round-arched. This is a factor which is also of profound importance when it comes to any assessment of the elements of change and continuity in the visual arts in the same period.

In the first quarter of the fifteenth century the Gothic architecture of North Italy had no future, but a glorious, if dependent, past and present. That of Florence was already being blended into a new style that seems at first sight to owe nothing to the transalpine North which it was finally to transform. How much Early Renaissance architecture does in fact owe in articulation, scale, and linear grace to earlier experiments with the ingredients of what was, at least initially, a foreign style, only the sympathetic study of Italian Gothic architecture for its own sake can reveal.

FLORENCE AND SIENA; CENTRAL AND SOUTHERN ITALY

The differing fortunes of Florence and Siena during the half-century following the Black Death, the changing balance of economic power between these thirteenth-century enemies and fourteenth-century allies, are summarized in a single chronological coincidence. In 1357 the Sienese cut their losses and began, on Florentine advice, to tear down the most dangerous parts of the grandiose, half-finished extension of the existing cathedral. In that same year, in Florence, the plans for a further expansion of Arnolfo's new and partially erected Duomo were finally passed. Indeed, from the mid century onwards neither the aftermath of the great plague nor a recurrent series of lesser plagues, nor virtually continuous war, whether against the papacy or Pisa or against the steadily encroaching power of the Visconti, nor even the increasingly violent internal struggles of the lesser guilds and the manual workers against the tyranny of the greater guilds, could stem the growth of the cathedral. From its inception it became the symbol of Florentine power. Although in 1330–1 responsibility for the building had been transferred to the Arte della Lana, the richest of the guilds, it was to the citizens at large that the administrators turned at every moment of decision or of crisis.

THE DUOMO IN FLORENCE

A fascinating picture of the general procedures followed in erecting the new building emerges from the surviving mass of documentary detail, but unfortunately many of the key problems remain unsolved.[1] Francesco Talenti, who is first recorded as capomaestro in 1351, when Neri di Fioravante, Alberto Arnoldi, and a number of other masters are also mentioned, eventually succeeded Andrea Pisano, who may have been dismissed in the early forties. During most of the fifties he was seemingly engaged in completing the campanile, but in August 1355 he was also commissioned to supply a wooden model to show 'how the chapels at the rear should be correct without any defect, and the defect of the windows corrected'.[2] There are no good grounds for assuming that this refers to defects in Arnolfo's original design, since documentation is sparse before the mid fifties and there may easily have been intervening modifications of the original project. The wording, which possibly implies but does not state that the defective windows were in the choir, says nothing about the shape of the choir and crossing, since any conceivable arrangement would have involved 'chappelle di dietro'. By mid July a commission of twelve, including prominent lay members from the Portinari and Albizzi families, was appointed to consider the model. It included not only Giovanni di Lapo Ghini, who was to play a leading, if losing, part in the subsequent struggles for control of the design, and Fra Jacopo Talenti of S. Maria Novella,[3] but also Neri di Fioravante, Alberto Arnoldi, Benci di Cione, Taddeo Gaddi the painter, and several others, who formed the nucleus of the commission that emerged victorious some ten years later.

On 19 June 1357 the articulation of a three-bay long, vaulted nave, with 34-braccia inter-columniations, was finally settled by a full commission and the first main pier founded [305]. Talenti is again expressly referred to as capomaestro, and 'that day all together they measured the church. It was: long 164 braccia exactly within the chapels. Wide $66\frac{7}{8}$ braccia net in the front part. In the part of the chapels below where the cupola must come, wide exactly from the chapels 62 braccia.'[4] These dimensions have been interpreted in many ways, but the most likely solution is that what

305. Florence, Duomo,
original plan *c*. 1294, redesigned 1357,
new plans 1366

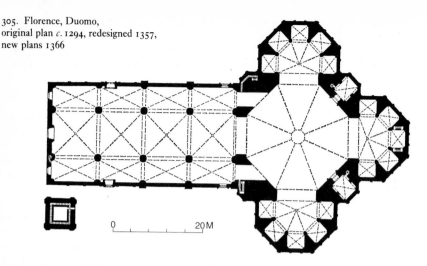

0 20 M

had now been settled and begun was Talenti's new scheme, involving a modified internal disposition of vaulted nave bays within the outlines established by the existing foundations of Arnolfo's church.[5] Nevertheless, the wording could refer to a standard cruciform plan with chapels off the aisles of the nave and a cupola over the crossing;[6] to a miniature version of the existing building [306] which, in the light of the excavations referred to above, seems to be the most probable answer;[7] or to one of the innumerable other designs, whether radial or not, which would both differ substantially from the existing building and allow of longitudinal measurement 'from the chapels'. At this stage the new building was rising all round, and even within, the still standing church of S. Reparata. The width of the latter, including its transepts, was roughly that of the present nave and aisles. Every so often, as in August 1357, a wall had to be breached without disturbing the roof, and it was only then that the destruction of the old campanile and the demolition of all the houses still standing within the new walls were ordered.[8] A fascinating yet entirely normal picture of piecemeal growth out of the midst of older and decaying structures therefore emerges, and something of the complexities and, not infrequently, the confusions attendant

on such enterprises can readily be sensed by visiting the excavated areas now permanently on display beneath the floor of the existing nave.

The decision to go ahead with the nave and the founding of the first main pier do not even mean that Talenti's scheme for this part of the building was settled in detail, and many competing drawings and models in plaster and stone for capitals and bases were considered, and decisions taken and reversed, before one of Talenti's offerings was finally accepted. Andrea Orcagna, the painter, sculptor, and architect, now appears for the first time, both as a member of the relevant sub-committee and as a competitor, but even when at one point his own plaster model was preferred, the tabernacles which he had incorporated were rejected. This is particularly interesting in view of the subsequent design of the capitals in the Duomo at Milan. In the meantime, by June 1357, a design for the façade had been commissioned as the basis for another general discussion.[9] No name is mentioned, but in September 1359 Alberto Arnoldi was commissioned in consultation with Francesco Talenti to complete the arch over the main doorway according to the already partly existing scheme, and the appearance of what is traditionally known as Talenti's façade is preserved in a sixteenth-century drawing in the

Museo dell'Opera [58]. By then it seems that many modifications had been introduced into a scheme which was never carried higher than the complicated tabernacles above the doors. The outcome is a jumble of incoherent detail that would seem extraordinary in the most provincial centres of Northern Italy or in the mountain fastnesses of the east or extreme south, but even the original design can have reflected little interest in broadly architectonic considerations. The projected sculptural decoration was clearly more complicated and the coloured marbling more intricate than anything envisaged by Arnolfo. If the design had ever been completed, its florid complexity would have rivalled Orcagna's tabernacle in Orsanmichele [141] and made the Loggia del Bigallo look extremely restrained [310].

A decision not to increase the height of the columns was taken in October 1358. In November a commission decided that the nave was to have one pilaster and one window for each bay, and that Talenti's design was to be followed rather than that of Ghini, his constant rival. The internal construction and external cladding of the nave continued throughout 1359, and it is the chronicler Marchionne di Coppo Stefani who seemingly throws a first, tantalizing shaft of light on the kind of plan that was in the air.[10] He says that in 1360 it was decided that a cathedral 297 braccia long, with a main body $62\frac{2}{3}$ braccia wide and $62\frac{2}{3}$ braccia high, was to be built. It was to have a cupola no less than 72 braccia wide and 144 braccia high. These are the internal measurements of the existing cupola, completed by Brunelleschi in the fifteenth century. Whereas the present building has three tribunes and fifteen chapels, this design had 'five chapels at the crossing', each of them 72 braccia high, and fifteen chapels 'round the choir beneath the cupola', each 14 braccia wide. The total width of the 'crossing' was to be 190 braccia, and the altar was to be beneath the centre of the cupola, as it now is. The whole design appears to have been a more complex version of what was eventually carried out [306]. If so, the great dome would have been

surrounded by a complete ring of supporting elements. Marchionne's 'chapels at the crossing' is not a very precise term, and what is meant may even be a fantastic version of a northern radial termination of the kind developed in Northern Italy and considered for the extension of the Duomo at Siena.[11]

There is no valid reason for thinking that this project was evolved by Ghini, who is first mentioned as capomaestro in February 1363. Nevertheless, the description is so circumstantial that the plan seems almost certainly to have existed.[12] Whatever its precise form it shows that at least by 1360 the key feature of the existing building, the compromise between a longitudinal and a centralized church, was being considered. By September 1364 the gallery round the interior and the question of whether the upper lights of the nave were to be oculi or normal pointed windows were being discussed. In October a commission made a number of vital recommendations. They show that the existing limitations on the verticality of the nave are the outcome of carefully discussed, positive decisions. The commission not only decided, against the advice of Orcagna and others, that the springing of the main vaults was to be as low as possible above the cornice or gallery surrounding the nave, but that the brackets supporting the gallery were to be set as low as possible on the wall.[13] Both these proposals were carried out in the existing building [306]. The brackets run immediately above the crown of the main arcading, and the springing of the vaults begins so rapidly that it is hidden from the ground by the overhang of the gallery.

In the meantime Francesco Talenti was gradually losing his position. In December 1364 it was decided that he should cease work in January. The following July Ghini is again referred to as capomaestro, this time in a context clearly implying general control, and a year later Talenti is expressly confined to work on the gallery.[14] Then in the summer of 1366 the final shape of the present building was established by a series of definitive decisions.

On 20 July 1366 three separate advisory panels of sculptors, goldsmiths, and painters were appointed.[15] The painters included Taddeo Gaddi, Andrea Orcagna, and, for the first time, Andrea Bonaiuti, known as Andrea da Firenze. The goldsmiths made the subsequently adopted recommendation that there should be four nave bays instead of three, and all three panels advised that work on the nave should be suspended and that a beginning should be made either behind, or at, the 'capella maggiore'. Again the use of a term associated with a normal Latin-cross plan shows the care that must be taken in drawing precise conclusions from the imprecise terminology of these particular documents. It is of course conceivable that a Latin-cross plan with a cupola was still the official project even at this late date. Certainly, the painters added a rider to their recommendation, asking that a month be allowed 'for drawing how it seemed to them that the said building should proceed'. A week later a commission of twenty-five painters, sculptors, goldsmiths, architects, and laymen was appointed in order to carry out the recommendations of the painters' panel. On 3 August a 'little church', evidently a model by Ghini, was rejected, and on the 13th the assembled experts considered not only Ghini's model but one by Talenti's son, Simone di Francesco, as well as the commission's design. The commission's model was the one chosen, and Francesco Talenti added a separate, concurring opinion. The destruction of all the unsuccessful designs was ordered a week later. Even so, the controversy continued. The chosen design was said not to be strong enough, and further models were made in stone. The citizenry at large was called in to adjudicate, and long lists of those who gave their opinion were recorded. Finally, in December 1368, after a further order for the destruction of all competing designs, a formal declaration was drawn up to bind all future capomaestri under oath to do no work of any kind except in absolute conformity to the commission's model.[16] This formal injunction was administered to new capomaestri on numerous subsequent occasions, and it is clear that, except for the part of the nave which was already complete, the existing building substantially follows the commission's design. The fourth bay of the nave was being erected in the late seventies, and work on the eastern end continued steadily until, at the end of the second decade of the fifteenth century, the technical problem of the cupola was solved by Brunelleschi.

The documentary evidence that the main lines of the commission's project were never altered is confirmed by Andrea da Firenze's fresco of the mid sixties in the chapter house of S. Maria Novella [347]. In it the 'Arnolfan' first bays of the nave and all the external marbling are ignored. Pointed windows are shown in the clerestory instead of oculi, and there is a simplified and fully Gothic treatment of the flanking chapels. The omission of the tambour may, like the removal of the campanile to the eastern end, be intended merely to leave more room for the other elements in the fresco.[17] Whether the deviations in the fresco represent the usual artistic licence or indicate Andrea da Firenze's personal opinion of what the commission of which he was a member should have proposed, the main distribution is fundamentally that of the existing building.

The whole story of the building of the cathedral demonstrates the intensity with which architectural controversies were fought. Even after the delivery of a seemingly firm verdict, defeat might not be accepted. Substantially the same decision had often to be reached several times before the lobbying ceased. Only the full weight of public opinion was finally enough to silence the arguments between the experts. Not only did the new cathedral grow up piecemeal in the midst of existing buildings, but major changes of plan could be, and were, proposed long after construction had begun. There was an endless willingness to venture into the unknown. Each technical problem was faced as it came and not before. Each successive stage was fundamentally rethought when the time came to begin construction. Procedures which

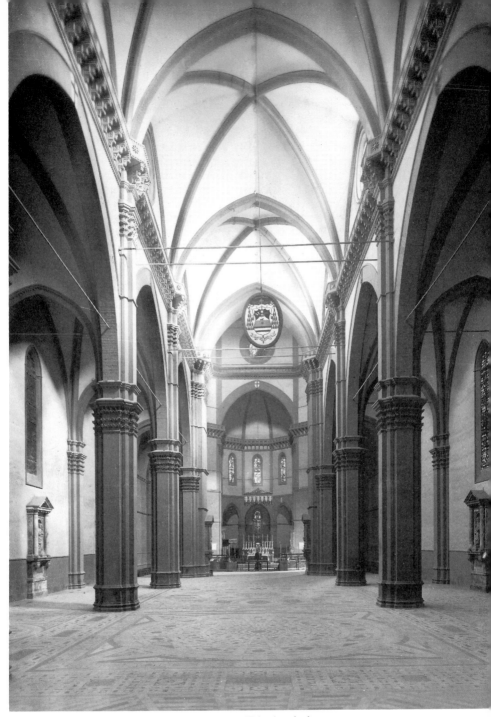

306. Arnolfo di Cambio (original plan *c.* 1294), Francesco Talenti, and others:
Florence, Duomo, nave, redesigned 1357, new plans 1366

now seem extraordinary were then common-place. When the commission's model was accepted in 1368 not a man in Italy, let alone in Florence, can have had the remotest idea of how the cupola could actually be built. No dome on such a scale had been attempted since Antiquity. Even the baptistery dome was only slightly more than half the width and a mere fraction of the height. When Brunelleschi solved the problem, half a century later, it was even then among the wonders of the age. Indeed, the later Milanese controversies only confirm the existence of the ways of thought and patterns of procedure that the Orvietan, Sienese, and Florentine documents each reveal in their own way.

Brunelleschi's completion of the building is not the only thing that underlines the gradual emergence of Renaissance architectural concepts from the preoccupations of the fourteenth-century architects. The replacement of pointed windows by oculi and the external pattern of firm horizontal cornices, unbroken by Gothic pedimental forms, accentuate the classical strain already apparent in Arnolfo's Gothic. There is severity, almost austerity, in the internal forms of piers and capitals, and the Arnolfan emphasis on the flat surfaces of walls and on the planar discipline of every detail is redolent of the same tendency [306]. Crisp angles are the rule, and there is not a single softly-rounded supporting form in the whole building. The weight and complexity of the piers create a gravity of feeling that makes S. Croce seem light-hearted, even lightweight by comparison. The heavy horizontal of the gallery, the massive capitals of the supporting pilasters, and the low springing of the main vaults all damp down the vertical thrusts of the nave. Together with the wide inter-columniation, reminiscent of earlier mendicant designs, they also encourage movement through the open spaces of the nave and aisles. Finally, they increase the contrast and the sense of vertical expansion as the space beneath the cupola is reached. It is indeed the latter which, internally and externally, ensures that the cathedral

307. Florence, Duomo, dome and choir

takes its place, not merely among the largest, but among the most remarkable of all late-fourteenth-century Italian churches.

The liturgical and distributional qualities of the Duomo represent a wholly new departure.[18] The cupolas of Romanesque and Early Gothic Latin-cross churches normally only extend the width of the nave. Even in the Duomo at Siena the full width of the aisles is not attained. At Florence the dome not only extends across the full width of the main body, but the build-up from the fifteen outer chapels through the three tribunes to the cupola itself has a coherence and compactness that is unprecedented in such buildings. It is only comparable to the volumetric hierarchies characteristic of wholly centralized structures.[19] The outcome is a building that retains all the liturgical advantages of a Latin-cross design. There is a steady crescendo as the altar is approached and a climax of unusual grandeur when it is finally reached. The setting is ideal for civic ceremonies and processional occasions. The retention of a kind of crossing and the placing of the altar at its centre, underneath the dome, allow huge concourses of the faithful to assemble in close contact with the altar. The sense of focus on a central event surpasses that in S. Vitale at Ravenna and in many other famous centralized designs. In most such buildings the high altar is either at the entrance of, or actually within, a lesser space that opens from the central core. In functional terms the centralized main area becomes a bulbous nave and the architectural and visual centre no longer coincides with liturgical and functional focus. In Florence, moreover, the system of circulation is virtually ideal. A steady stream of people can enter through one of the lateral doors of the façade and then move up the aisle and round the central altar, past the tribunes, and back along the opposite aisle to leave by the other lateral door. The lesser altars can be used without impinging on the central space, and pilgrimages

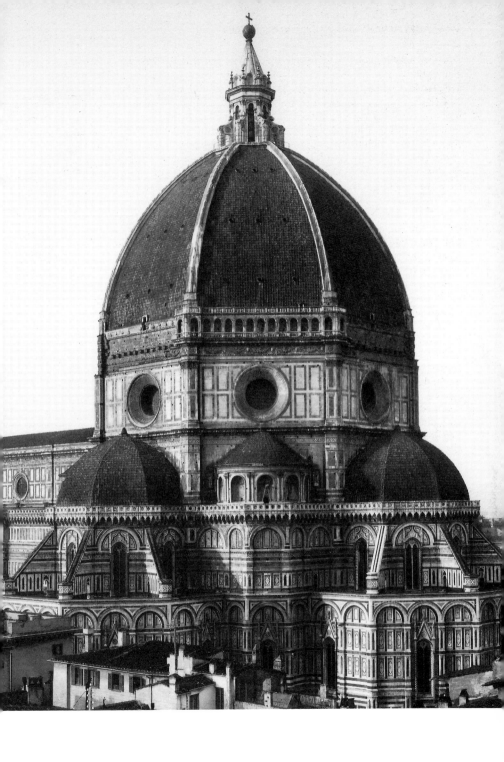

to the various shrines flow smoothly in and round and out.

Whatever the extent to which this brilliant compromise reflects Arnolfo's plan or was gradually evolved in the course of the innumerable discussions that attended the slow growth of the cathedral, the move towards Renaissance ways of thinking is remarkable. The fourteenth-century architects and citizens of Florence were, in practical terms, well on the way to realizing the advantages, while avoiding the disadvantages, of the centralized constructions that Alberti upon part-historical, part-aesthetic, part-philosophical grounds was to propose as the ideal form for a church or temple.[20] Not unexpectedly, the building also carries certain negative, as well as positive, marks of the fundamental compromise that is its most distinctive quality. The dome that Brunelleschi built upon a plan and scale already basically established in the fourteenth century is a landmark visible for miles. In visual terms its mass and grandeur, and the awkward nature of the junction at the upper levels, turn the nave into a kind of architectural tadpole's tail. Whatever its deficiencies in other respects, the very different nave-to-dome proportions in Andrea da Firenze's painting in S. Maria Novella seem specifically designed to avoid this difficulty [347]. The extent to which the Duomo has outgrown the scale of the original marble cladding and the deficiencies of the nineteenth-century completion of its outer skin are also evident.[21] In compensation, the build-up of the masses of the eastern end [307], the solid seating of each form, the interaction of repeated and contrasted shapes, the towering compactness of it all, provide one of the major architectural experiences in Europe. Nothing of such complexity and unity, such weight and sensitivity, such flexibility in the handling of architectural volumes on so grand a scale had been built for a thousand years in Italy. The incidental faults are dwarfed by the achievement. If it remained for Alberti to declare that every temple should be raised above the level of the square in which it stood, the early-four-teenth-century Florentine sense of the dramatic impact of what they were about is shown by an ordinance of 1339 declaring that the levels of surrounding streets were to be lowered to give the height of the new building maximum effect as it came into view along the narrow network of approach roads. In its still uncompleted early-fifteenth-century state the greatly enlarged church must indeed have been an awe-inspiring sight.

S. TRINITA IN FLORENCE

The years which saw the Duomo taking final shape were those in which the present S. Trinita, the fourth church on its site, was slowly being built [308 and 309]. The long controversies surrounding its chronology now seem to be settled.[22] The four shallow chapels on the left of the nave appear to be late-thirteenth- or early-fourteenth-century additions to the preceding late-twelfth- or early-thirteenth-century structure, and work on them appears to have continued in the twenty years preceding the mid century. The first three bays of the existing nave were seemingly carried out in 1360–70, and the rest of the church was substantially completed between 1383, when, following a long delay, it was still roofless and in danger of ruin, and c. 1405. The series of chapels flanking the nave connects the plan, which is otherwise loosely related to that of S. Maria Novella, with the traditions possibly reflected in Arnolfo's plans for the Duomo. The only other link with the cathedral is the absence of columnar forms of any kind. The square piers, which so greatly emphasize the effect of the flat termination of the choir, to some extent recall the little mid-fourteenth-century church of S. Maria Maggiore, also in Florence. The width of the transepts and the size of the openings of the transept chapels are such that the inner pair of chapels gives no impression of continuing the aisles. The opening of the last pair of nave chapels into the transepts as well as into the aisles allows the full extent of the transepts to be seen from half-way down the nave and further

and simple surfaces restrain the sense of line-created movement. Whereas in S. Croce space was the dominant architectural effect, here the quiet solids that enclose it tend to take the eye.

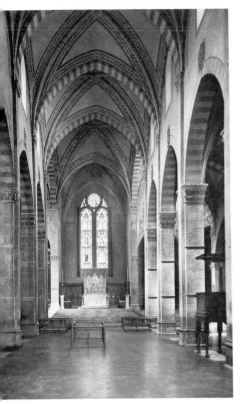

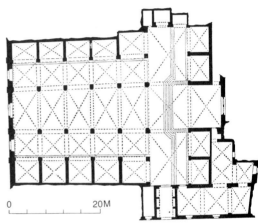

308 and 309. Florence, S. Trinita, nave, 1360–70 and 1383–*c*. 1405

stresses their importance. The resulting sense of lateral expansion accentuates the effect of the side chapels. It also counterbalances any tendency for the nave to be too sharply isolated in its progress towards the raised choir by its relatively narrow arcading and omnipresent planar surfaces. How much the unbroken sweep of the main pilasters to the springing of the vaults both lightens the general effect and contributes to the verticality of the nave is demonstrated in the aisles. There, the close succession of the emphatic lower and upper capitals effectively breaks the vertical flow. Successive horizontal mouldings likewise slow the vertical thrust of the piers supporting the arcading of the nave. Everywhere calm solids

THE LOGGIA DEL BIGALLO AND THE LOGGIA DELLA SIGNORIA IN FLORENCE

A complementary trend towards increasing decorative intricacy is to be seen in the Loggia del Bigallo, built in 1352–61 [310]. Alberto Arnoldi, who is documented between 1359 and 1364 as working on the closely related sculpture for the altar and for an external lunette, may well have been concerned in its design. The porch is so intricately carved in low relief that it almost qualifies as sculpture. If the blank pierced quatrefoils were indeed meant for paintings, like the shallow niches on the inner piers, this would be a further stage in the blend-

310. Alberto Arnoldi(?):
Florence, Loggia del Bigallo, 1352–61

the supervision of Benci di Cione and Simone Talenti from 1376 to c. 1381 [136]. The gravity of the pier forms, closely related to those of the Duomo; the severity of the upper horizontals and of a roof-line which is barely and yet adequately softened by a decorative reminiscence of the military past; the height and breadth of space beneath the cross-vaults; the contrast with the impenetrable mass of the Palazzo Vecchio, are such that realization of the spatial meaning of the whole Piazza – of the streets that open from it and of the volumes that impinge upon it – is intensified. Here the heritage of the Roman and the Romanesque grows ever more insistent. Although the forms have not yet become those of the Renaissance, the pressure of the forces soon to work that transformation is already manifestly growing.

THE DUOMO AND THE CAPPELLA DI PIAZZA IN SIENA

The abandonment of the great enlargement plan for the Duomo of Siena was accompanied by the heightening of the existing nave and by the completion of the enlarged and heightened choir. In 1377 the sculptor Giovanni di Cecco is documented as capomaestro, carrying forward work on and in the immediate neighbourhood of the main façade, and it is probably in this period that steps were taken to heighten Giovanni Pisano's original structure so as to mask the bare mass of the nave then visible above it [63]. The breaks in articulation necessitated by the framing of the new rose-window have already been discussed.[24] The qualitative limitations of the wealth of sculpture round the window, now replaced by copies, are severe. There is, however, no denying Giovanni's sensitivity in picking up such earlier architectural details as the niche forms. The richness in texture and colour is memorable, and given the intractable nature of the problem, Giovanni di Cecco's essentially sculptural conception represents no mean achievement.

A contemporary drawing in the Opera del Duomo at Siena, this time for the Cappella di

ing of pictorial, architectural, and sculptural effects attempted at Orsanmichele.[23] On the other hand, for all its decorative complexity the architectural framework of the Loggia, with its careful rectilinear enclosure of the round-arched openings, remains severe. It is, however, in the Sienese wrought-iron work of Francesco Petrucci (1358), whose father, Petruccio di Betto, had constructed the gratings of the crypt in S. Miniato al Monte in 1338 and had worked with him on those of the Duomo of Fiesole in 1349, that intricacy, grace, and discipline have been combined in a manner that, by contrast, draws attention to the heaviness of the surrounding forms.

Not heaviness but grandeur is the outcome of the height and span of the round arches of the Loggia della Signoria, constructed under

Piazza, reveals a decorative fantasy and a like profusion of essentially pictorial sculpture that makes Andrea Orcagna's closely related and similarly round-arched tabernacle in Orsanmichele in Florence seem almost restrained. The exuberance was, however, confined to parchment. Apart from the wrought-iron work by Conte di Lello Orlandi and Petruccio di Betto, the sculpture-encrusted piers of very different design were the only parts which Giovanni di Cecco, working from 1376 onwards, completed of a project started almost twenty years before as a thankoffering for delivery from the plague.[25]

THE REST OF TUSCANY;
CENTRAL AND SOUTHERN ITALY

Elsewhere in Tuscany and throughout Central and Southern Italy the surviving non-military architecture of the late fourteenth century consists, with a few notable exceptions, of often attractive continuations of earlier traditions and of sometimes strange and occasionally distinguished architectural details. The isolation of these details usually stems from the completion or re-adaptation of an existing structure or from the subsequent completion or transformation of the building in which they are embedded. One of the most attractive architectural oddities is the internal reconstruction of the Duomo at Lucca [311]. This was started in 1372 and finished in the fifteenth century.[26] The piers supporting the round-arched arcading of the nave are closely related to those in the Duomo at Florence, but the distinctive feature of the design is the system of arcading. It roughly corresponds to the triforium in northern Gothic architecture and runs without a break across the transepts. There are two wide, traceried openings to each bay, and it almost seems as if the Pisan Camposanto had been transported bodily and built in overhead. The traceries are paper-thin, and the effect, already striking in the nave, becomes extraordinary in the transepts. The latter are unusually wide, and each has been divided

311. Lucca, Duomo, interior (detail), reconstructed 1372–fifteenth century

down its centre-line by a free-standing membrane that branches off at right angles from the similar form that runs across the opening of the transept [311]. It consists of a like sequence of round-headed main arcadings, surmounted by the now sharply pointed triforium traceries and crowned by oculi. This visually strange solution to the vaulting problem also increases the slimness and apparent height of the end-forms of the transepts.

There is strangeness of a different kind in the seemingly early-fifteenth-century façade of S. Maria di Collemaggio at L'Aquila in the Abruzzi. Its rose and white marble patterning is as insistent as that upon the Palazzo Ducale

at Venice is subtle. Gothic niches burrow into a main portal which is otherwise as Romanesque in outline as the flanking doorways. Just as the Romanesque was still a living force throughout the area in the fourteenth century, so Gothic detailing of doors and windows is a major element in fifteenth-century Abruzzan architecture.

There is a similar continuity and conservatism in the south. Even in S. Caterina d'Alessandria at Galatina, dating from 1391, the fleshy, Gothic impression of the interior with its massive vaulting is achieved much more by clustering a series of simple Romanesque columnar forms than by espousing northern or acclimatized Italian Gothic details. The capitals with their interlace and their heraldic beasts are purely Romanesque. Despite the discreet inclusion of some pointed trilobes in the decorative detail, the external shell of the unusual octagonal choir chapel, expanding laterally and vertically beyond the boundaries of the nave, is also Romanesque in its essentials.[27]

A comparable continuity binds the rough stone structure, the intricate lava inlays, and the elegant tracery of the pointed windows of the Badia Vecchia at Taormina to its long line of Sicilian antecedents. In architectural terms the relativity of historic time is nowhere to be seen more clearly than in the almost geological faulting of its strata that occurs as one moves out from the restricted centres of seismic change.

THE DEVELOPMENT OF THE FORTIFIED PALACE

The military architecture of the later fourteenth century is dominated by the emergence of a new type of fortified palace or palatial fortress. It consists of an isolated, more or less compact symmetrical block, enclosing a rectangular courtyard and reinforced by corner towers. In flat country it was normally surrounded by a moat. In the hills a stepped-up platform provided a preliminary obstacle. Additional towers were often incorporated, and there were usually detailed deviations from symmetry. The military or the palatial aspects could be stressed. Nevertheless, it is this basic pattern which is then developed in innumerable fifteenth-century castles throughout North and Central Italy.

Particularly where an older castle was being rebuilt, the keep-and-curtain-wall design continues to be elaborated alongside the newer patterns. There are also innumerable inter-mediate designs, since the borderlines between the main categories are anything but clear-cut. The possible diversities are indicated by looking at only three of the many castles erected for Cardinal Albernoz in his campaign to secure the papal territories. The hill above Assisi is dominated by a stone keep-and-curtain-wall castle, rebuilt in 1367 and supported by a smaller fortress on a secondary summit. Apart from its picturesque qualities, the main complex is notable for the 300-foot-long wall and covered passage to an outriding, dodecagonal tower immediately overlooking S. Francesco. The mid-fourteenth-century castle at Narni, partly seated on a fortified platform stepped out from the hillside, is much more of a compact block, but the main buildings only form two sides of the courtyard, and external symmetry is destroyed by the keep-like dominance of the south-west angle tower. The tendency to self-containment and to symmetry is even more marked in the castle at Spoleto [312]. This major fortress, dominating the town, was substantially carried out for Cardinal Albernoz by Matteo Gattapone, who is documented as working on it intermittently from 1362 to 1370.

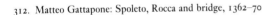

312. Matteo Gattapone: Spoleto, Rocca and bridge, 1362–70

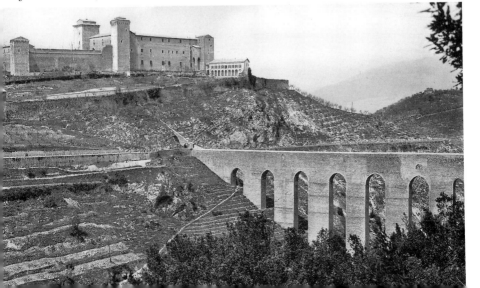

Apart from a distant outer circle of wall, again forming a step in the hillside, it constitutes a completely regular, six-towered, double rectangle. Externally the domination of the lower, south-western rectangle by the high north-eastern block and its dividing wall and angle towers exactly expresses the internal division. This consists of an outer ward for the soldiery and a main castle-palace. A spacious, two-storeyed arcade, supported by simple octagonal brick columns, extends along three sides of the courtyard. Despite the great height of the walls, particularly in the main building, the extreme length of the main sides of the double rectangle gives the external impression of a long, low silhouette, and the unrelieved severity of the design recalls a prison, which is what it has become.

Simplicity upon the grandest scale is also characteristic of the Ponte delle Torri, 750 feet long and 260 feet high, which carries water to the castle and the upper town. Its massive masonry piers may have had Roman forerunners, but as it stands its gently pointed arches are a monument to later-fourteenth-

century civil engineering. The extent of Gattapone's possible connexion with the aqueduct is as debatable as that with the superbly simple, arched and buttressed substructures that are among the most striking features of such Umbrian towns as Spoleto, Assisi, and Perugia.

The diversity of military architecture in Northern Italy and the range of military ambition are reflected in the ten-mile-long wall which the Scaligeri put up to link their castles at Nogarole, Villafranca di Verona, and Valeggio. Although most of it has vanished, an extraordinary 550-yard section between Valeggio and Borghetto is reasonably well preserved. Known as the Ponte Rotto, it was seemingly built for Gian Galeazzo Visconti by Domenico Fiorentino in 1393, a little over a decade after the fall of the della Scalas. This massive structure, which straddles the valley of the Mincio, is some 80 feet wide at the top. There are turrets, 80 feet apart, along either side, and imposing block-houses at either end and at the river crossing. It is likely that one function was indeed to act as the dam that it appears to be. By reducing or even temporarily cutting

313. Francesco Schicci(?): Montagnana, Porta Legnago, 1350/80

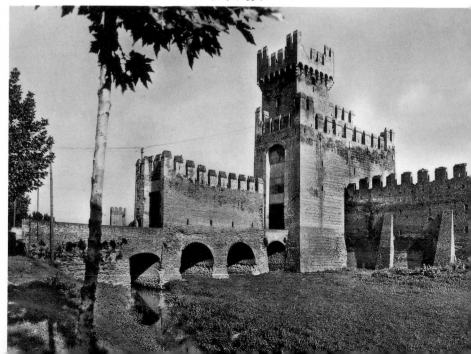

the flow of the Mincio, the lakes protecting Mantua could be drained and the city thereby stripped of its main defences.

The earlier complexities of Sirmione [155] are recalled by the Porta Legnago [313] which Francesco V da Carrara (1350–80) strengthened the perimeter of Montagnana [153]. The work was possibly carried out by Francesco Schicci. Its form re-emphasizes the constant preoccupation with defence not only against known enemies, both outside and inside the gates, but also against treachery. A gated entrance courtyard or chamber, supported by two arches over the moat, was succeeded by a drawbridge and a main gate, opening inwards. The latter led to a square chamber flanked by superimposed round-headed arches, and then to a portcullis, followed, eighteen inches farther on, by another, inward-opening gate. A second chamber, again with superimposed arches bearing passage-ways, was closed by another portcullis and gate. Since this gate opened into the chamber and away from the town, it was from the latter that its vulnerable hinges were protected. It was followed in its turn by a third

chamber with a similar gate, again protected from the town, and finally by another fortified entrance court or chamber similar to the one across the moat. The defensive sequence adds up to five chambers, two portcullises, one drawbridge, and at least six gates and possibly eight. The vertical massing, dominated by the tall, square tower that flanks and guards the central chamber, exactly expresses the rising and descending chains of command which link the hierarchy of separate units and control the horizontal sequence of defence. The gateway has itself become a little castle with two semi-independent outworks.

Another unusually interesting 'survival' is the completely but accurately reconstructed fortified bridge which links the Castelvecchio at Verona, the central fortress of the della Scala dynasty, with the far side of the river Adige [314]. In many cases medieval bridges were defended by a single tower straddling the road about midstream. Here, however, the three unequal spans are fully castellated and are guarded by two successive drawbridges. The defences at the city end include another draw-

314. Verona, Castelvecchio and bridge, c. 1354–c. 1375

◄N

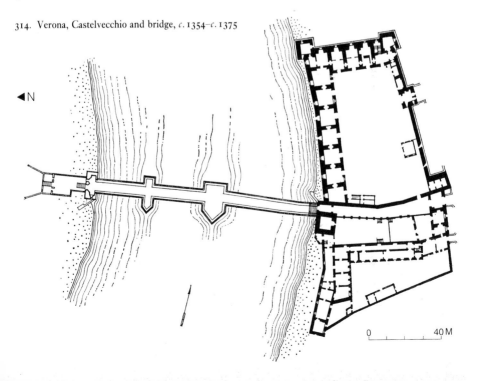

0 _____ 40 M

bridge and a tall, massive tower which flanks the road and acts as the main keep of the castle. The bridge and most of the castle were constructed for Cangrande II between c. 1354 and 1356. The completion of the castle, probably by Francesco Bevilacqua, seems to have occurred c. 1375. Built in a mixture of brick and stone and cobbled courses, the castle is characterized by its long, low profile. There is little attempt at symmetry or at maintaining any abstract geometric pattern in the plan. A partial separation of function, subsequently given definitive form in the successive courtyards at Spoleto, is here facilitated by the division of the palace into two parts by the fortified road to the bridge. To the north-east are the barracks. These form two sides of a near-rectangle completed by defensive walls. To the south-west, the more or less similarly disposed buildings of the palace proper are defended on the landward side by a more complex system of walls. The principal tower, guarding the bridge, thus controls all movement between the two main blocks of buildings. A much more radical approach to the distinction between a palace and a strong point had earlier been attempted by Castruccio Castracane at Avenza, c. 1322-4. Detailed nineteenth-century plans show that a towering, six-storeyed, round-bastioned keep of extraordinary mass and irregular plan was connected by a narrow passage to a much more lightly constructed, three-storeyed residence. The Castelvecchio at Verona is, indeed, something of a half-way house between the two main currents of fourteenth-century military architecture. A succession of pleasant rooms, with low doorways and small windows set high in the thick walls, overlooks the river. Although less markedly so than in the smaller Scaliger castles, the outcome is more fortress than palatial dwelling, and the contrast with the fortified palace of the Visconti at Pavia is extreme.

The Castello Visconteo, substantially built about 1360-5 by Galeazzo II Visconti and completed by Gian Galeazzo, fully merits Petrarch's praise as 'the most noble production of modern art'.[1] It marks the furthest point reached in the fourteenth-century metamorphosis of castle into palace. Although the most important side, containing the main buildings, was destroyed in the sixteenth century, enough remains to show how much the castle was now being influenced by the traditions of the civil, town palace on the one hand and of the monastic cloister on the other. Originally 155 yards square, its enormous scale is a foretaste not merely of fifteenth-century Italian developments but of those embodied in the European palaces and châteaux of succeeding centuries. The main defences were manpower and a wide, deep moat, and the entrance was guarded by a fortified bridge and double drawbridge [315]. The silhouette is long and low, and the squat corner-towers do little to dispel the general effect of horizontality. The latter is accentuated by the regular succession of the windows in the plain brick walls and by the unbroken line of castellations and machicolations below the roof. The external severity is relieved, but not dispelled, by the two storeys of wide, twin-lighted, pointed windows. These give promise of large, well-lit rooms within and are a symbol of good living and of the world of civil rather than of military architecture.

Internally it is only the brooding corner-towers and the Ghibelline castellations that show concern with matters of defence [316]. The surviving parts are characterized by regularity on the grandest scale. Each structural and decorative detail lies within the main tradition of Lombard civil and ecclesiastical architecture. The continuous ground-floor arcading is composed of stone arches of imposing height and breadth, supported upon sturdy columns. The gently pointed ground-floor openings are succeeded, in the loggia on the upper floor, by a correspondingly regular series of rounded forms in brick. These frame quadruple trilobate openings, surmounted by roundels with elaborately patterned openwork infillings. Since the existing regular cortile acted as a frame for the main palace building on the north side, any monotony engendered by the constant repetition of these basic elements would at once

315 and 316. Pavia, Castello Visconteo, *c*. 1360–5, south façade and courtyard

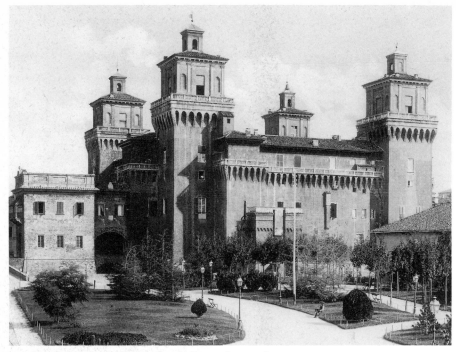

317. Bartolino da Novara: Ferrara, Castello Estense, begun 1385

have been dispelled. The strength of the desire for symmetry as an intrinsically valuable aesthetic goal is reflected in the false, and near-false, windows on the exterior. These mask the interruption of the regular room-sequence by the stairs as they trace their repeated rectangular paths up through the two main storeys. The insertion of the corner-towers, which do not break the line of the internal courtyard, causes a slight dislocation of the internal and external features. All the doors are therefore opposite the outer windows and off-centre in relation to the inner arcading. There is a succession of square vaulted rooms, one to each window, on the ground floor. Like the great continuous vaulted halls which back the upper loggia, their transverse arches again framing one bay to each window, they fulfil the expectation of internal grandeur aroused by the outward shell. The entire building is a symbol

of a power now so entrenched that military considerations, though by no means totally ignored, no longer seriously interfere with gracious living. Symmetry and appearance, spaciousness and splendour, have become more important than defensive ingenuity or even practicality.

An urge for ease and splendour much more heavily encased within a carapace of fear is evident in the castles of Ferrara and Mantua. These two castles gave the compact pattern its definitive form, and their essential features are repeated in innumerable subsequent buildings. The brick-built Castello Estense in Ferrara was begun by Nicolò II in 1385 as a result of a popular uprising, and was rapidly completed by the military architect Bartolino da Novara, whose known career stretches from 1368 to c. 1410. Despite additional upper storeys and constant internal modifications, the essence of

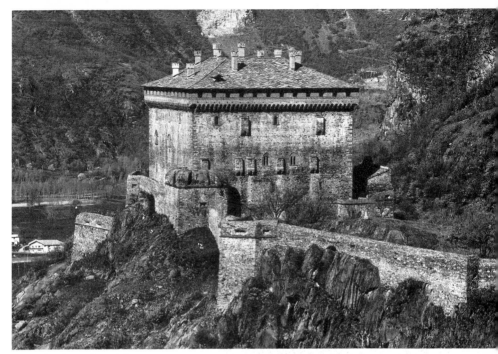

318(A). Verrès, castle, 1360–90

what Bartolino did is clear. The main buildings completely surround a square courtyard and act as curtain walls [317]. The whole is dominated by the much higher towers at the corners. Of these, the Torre dei Leoni dates from a pre-existing thirteenth-century structure and is larger than the others. The moat is spanned by entries on three sides, and the form and placing of the outworks and related structures which protect them introduce further variations within the general symmetry. Although there is probably no direct connexion, the scheme is a reworking in a new idiom, and in the light of altered military and social circumstances, of the Frederican pattern, established in such buildings as the Castel Ursino at Catania.

The Castello di S. Giorgio, which Bartolino built for the Gonzaga from c. 1395 onwards, boasts a similarly compact, square plan. The four angle towers again dominate the entire

defensive organization without the aid of intervening secondary turrets. Defensively there is the same concentration on moat and mass and machicolation. Aesthetically there is the same sharp-angled play of interpenetrating rectangular solids. Internally there is the same allowance, in the varied suites of rooms, for the multifarious functions of a building designed to be at one and the same time a fortress, a prison, a barracks, and a palace. A similar variety of purpose on a more modest scale and a similarly complete exploitation of a compact, square plan, are to be seen in the late-fourteenth- and early-fifteenth-century castle of Quattro Torri just outside Siena. A more extended square, more towering walls, and slimmer, rounded corner-towers characterize another variant which was built by Amadeo VI of Savoy in 1358 at Ivrea, at the entry to the Val d'Aosta.

318(B). Verrès, castle, 1360–90, courtyard

The Val d'Aosta itself is notable for at least one example of almost every type of Italian medieval castle. Of all of them, the one which holds least architectural promise in the uncompromising block of its exterior is the castle at Verrès [318A]. It was built for Ibleto di Challant from 1360 to 1390. Its form is so compact as to resemble a broad, square tower; no defensive subdivision into wall and turret is required. The soldiery were housed on the ground and second floors, and the first floor was devoted to the main living-rooms and their lavatories and ancillary services.[2] The thickness of the walls, the compact efficiency of the defensive arrangements, and the well-planned sequences of rooms all reflect the competence of the unknown architect. The thing which places the castle of Verrès among the masterpieces of Italian fourteenth-century architecture is, however, the treatment of the sequences of stair and balcony that surround the tiny central courtyard and complete the system of internal

circulation [318B]. The passage through the outer defences and preliminary defensive courtyard confirms the first impression of almost oppressive military severity. Then, suddenly, one stands by a square water-well within a greater well around the walls of which the massive stairs and balconies are borne up on segmental arches in a seemingly unending variety of interpenetrating curves. The climbing arch of the second flight of stairs rests at right angles upon the shoulder of the first. Another right angle, and the first length of balcony sits in its turn on the shoulder of the final climbing segment and upon that of the level segment that supports the second length of balcony. The sequence then begins again, but each relationship has been inverted. To take a single case, the arch beneath the opening section of the balcony on the second floor supports the stair arch and the neighbouring balcony arch, instead of being supported by them. Although the stair-

ways of Viterbo and the interiors of the bell towers at Assisi and Todi come to mind, there is nowhere anything that exactly matches the interpenetrating curves and planes and the sensation of freedom and confinement, mass and movement, in the well-like courtyard of Verrès. Unlike the castles of Ferrara and of Mantua, it is the prototype for no long line of subsequent development. It is simply a great work of art and a reminder that in architecture, as in sculpture and painting, the primary artistic values are independent of position in some sequence of significant events. They are not in the first place to be measured by their subsequent effects on other works of art. The latter can but act as pointers to their own intrinsic qualities. A work of art may have innumerable values: none of them transcends that of its quality as a self-sufficient statement, as unique as it is irreplaceable, as timeless as it is inseparable from its time.

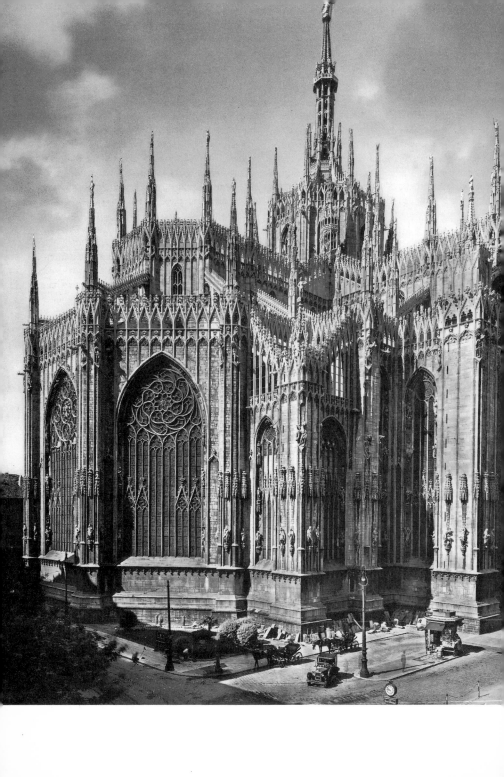

MILAN, BOLOGNA, VENICE, AND NORTHERN ITALY

The last years of the fourteenth century in Northern Italy are dominated by three buildings, each extraordinary in its own way. They are the Duomo at Milan, the church of S. Petronio in Bologna, and the Palazzo Ducale at Venice. Of these, the Duomo at Milan holds a unique position in the history of European architecture. This is due not to the strangeness of its form but to the insight into medieval European architectural theory provided by the surviving documents.

THE DUOMO IN MILAN

Externally, the sixteenth- and seventeenth-century elements in the façade of the Duomo in Milan are only the most obvious signs of the centuries-long process of completion. The spire is eighteenth-century and the lace and pincushion effect of the innumerable crocketed pinnacles and gable forms that sprout from every available surface, blurring the contours of the squat, Lombard outline, is almost entirely eighteenth- and nineteenth-century Gothic [319]. Nevertheless, however much the intended flavour of the building may have altered, a similar abundance of carved detail was certainly envisaged from the first.

The story seemingly starts in 1386 under the dual impulse of Gian Galeazzo Visconti's personal ambition and of the growing prosperity of a city which was by then the administrative centre of a political and military hegemony extending to the borders of Venice and even into Tuscany. In 1387 Simone da Orsenigo was appointed capomaestro, and in 1388 Giacomo, Marco, Zeno, and the celebrated sculptor Bonino, all from Campione,

319. Milan, Duomo, begun 1386(?), choir

and several other North Italian masters investigated a constructional irregularity in a transept wall. By 1389 the problems posed by so ambitious a project were seemingly beyond the scope of local experts, and Nicolas de Bonaventure was called in from Paris. In 1390 he was sacked, for reasons that can easily be guessed from subsequent events. By then the painter Giovanni dei Grassi had been mentioned in connexion with certain drawings and the Bolognese architect Antonio di Vicenzo had arrived to study the new project and to take notes. Luckily, two of his annotated sketches have survived, and they reveal that the main lines of the existing plan had already been established [320 and 321].[1] The decisions to have a nave and four aisles, together with aisled transepts as in the Duomo at Piacenza and subsequently at Cremona, and a polygonal choir and ambulatory, recalling North Italian Franciscan plans, had all been taken. The transepts were subsequently reduced by one bay and polygonal chapels were added at the ends. In decreasing the previously striking resemblance to the plan of the twelfth-century Duomo at Piacenza, this created a compensatory set of formal linkages between choir and transepts, again analogous to those at Piacenza. The wealth of Gothic detail in Antonio's elevation of the sacristy proves that the existing external *horror vacui* reflects late-fourteenth-century intentions. Nevertheless, surviving structural traces do appear to show that the original North Italian engineers and architects intended something far closer to the relatively simple Romanesque and Early Gothic compromises of the Lombard tradition and less reminiscent of Strasbourg and the Late Gothic North. The enlargement of the crossing piers, decided on in 1390, and also the main proportions of the elevation, reflected in Antonio's composite

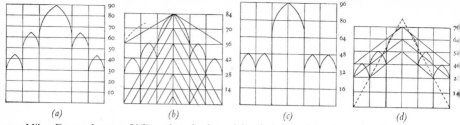

(a) (b) (c) (d)

320. Milan, Duomo, begun 1386(?), projects for determining the height of the piers and vaults in the nave and aisles on a foundation 96 braccia wide:
(a) project of 1390, after Antonio di Vicenzo – units of 10 braccia;
(b) project of 1391 by Gabriele Stornaloco;
(c) reconstruction of project of 1392 by Heinrich Parler – square, 16 braccia grid;
(d) accepted project of 1392, using Stornaloco's system to a height of 28 braccia (dotted lines), followed by units of 12 braccia in a framework of Pythagorean triangles

sketch, are probably the work of Nicolas de Bonaventure [320a]. The whole design appears to have been based on a basic unit of 10 braccia, and although the total height of the nave is not indicated, it is likely that it was to have been 90 braccia, and therefore approximately equal to the 96-braccia width of the building. The tall nave would have been beautifully supported by the regular diminution of the aisles, and the elevation as a whole could have approximately been inscribed within a square. In March 1391, however, Nicolas's German successor, Johann von Freiburg, was asked to put in writing his assertions about 'the doubts and errors in the work'.[2]

It appears from later documents that Johann not only discussed structural matters but suggested that the height of the proposed building should be considerably reduced so that the whole would fit within an equilateral triangle. By July 1391, however, when Giovanni dei Grassi was added to the list of engineers, his German namesake had been fired. By then many of the foundations had been laid and walls and piers were rising from the ground. Nevertheless, a conference was requested in August in order to determine fully 'the length of the pilasters, the height of the church, of the windows, doors, and accessories'.[3] In the following month Gabriele Stornaloco, a

mathematician from Piacenza, was summoned, presumably to solve the problem posed by the incommensurability of the apex of the equilateral triangle which was the new controlling figure for the height of the building. Stornaloco's solution was incorporated in a letter and drawing submitted after his departure [320b]. It was seemingly based on the use of two kinds of measuring rods: one of these was 8 and the other 7 braccia long. Stornaloco's drawing shows that the elevation was to be controlled by a series of six approximately equilateral triangles. Their bases and apices were to supply the coordinates for the construction of a regular rectangular grid. The 16-braccia intervals of their bases fitted exactly into the 96-braccia width of the building. A slight adjustment of their apices gave an even 14-braccia progression. This allowed the springing of the vaults of the outer and inner aisles and of the nave to occur respectively at 28, 42, and 56 braccia above ground and gave a total height of 84 braccia. All the main dimensions were thus to be related to each other within a simple and consistent mathematical framework. This in its turn would generate a complex series of harmonic relationships between the parts and the whole. Unlike the Antique and Renaissance proportional systems based upon the concept of the module, it did not control the precise

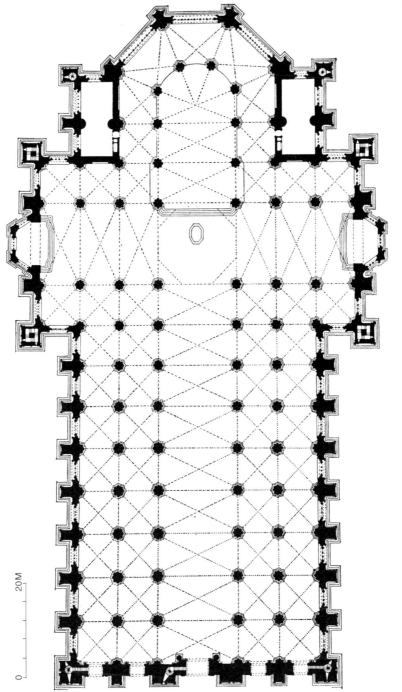

20M

0

321. Milan, Duomo, begun 1386(?)

form and proportion of each structural element. The heights of the piers are fixed in relation to the governing geometrical formulae. Their thickness or thinness is irrelevant. In this particular case the 'perfection' of the medieval system itself was compromised. The escape from the irrational numbers implicit in the controlling equilateral triangles means that the building is now no more than an approximation to the ideal geometrical figure. The way in which the drawing links the practical measuring system with the mystical numbers of a circumscribed hexagon and circles shows the importance of such matters. In discussing Nicola Pisano's first pulpit it was noted that six, as the first perfect number, is the symbol of the Old Adam and of Christ, the Saviour and second perfect man.[4] The circle, as the perfect geometric figure, with no beginning and no end, is the symbol of the godhead. This conjunction of meaning and proportion is vital to any understanding of the Italian architects' attitudes during subsequent discussions.

While the outer piers were being built according to Stornaloco's formula, the search for a foreign expert to replace Johann von Freiburg, having previously failed to coax a leading master from Cologne or Ulm, bore fruit in the arrival of Heinrich Parler of Gmund in December 1391. Unfortunately, the taste proved singularly bitter to the Italian experts. The result of his proposals was a gathering of the interested parties in May 1392. Their proceedings are reported in a series of eleven *dubia* and *responsiones*, somewhat in the manner of a scholastic disputation.[5] The preamble states that Parler himself in no way agrees to the conclusions reached. He appears to have begun by claiming that existing piers were not sufficiently strong. Secondly, he seems to have wished to return to a square figure like that originally proposed by Nicolas de Bonaventure. Thirdly, he evidently wanted to separate the 'chapels' in the outer aisles by walls in order to strengthen the building. In this alone he was supported by a single Italian, the first recorded capomaestro, Simone da

Orsenigo. Dividing walls in the foundations evidently reflect an original intention to have only two aisles flanked by rows of actual chapels in the manner seen in S. Maria del Carmine at Pavia [324] and becoming increasingly popular in Central as well as in Northern Italy.

In all his major and in his minor proposals Parler was overruled. Clearly underlying the whole controversy was a profound disagreement about buttressing. The German evidently wanted a high nave flanked by lower forms [320c] as at Cologne or Ulm or, closer home, at S. Maria del Carmine at Pavia [326]. Flying buttresses would presumably have been the final stabilizers. The Italians preferred a broad, low format in which the lateral thrusts would be absorbed by the gradual stepping up of the succeeding rows of vaults. In order to achieve their aesthetic aims they were prepared to abandon any coherent and generally applicable geometrical framework. Their detailed proposals result in the retention of Stornaloco's system up to, but only up to, the 28-braccia height of the lesser piers [320d]. Above this, a 12-braccia basic unit was to be substituted. This gave a reduced total height of 76 braccia. At the upper levels a series of relationships based on adjacent Pythagorean right-angled triangles was substituted for the equilateral triangles that controlled the lower members. In spite of many subsequent controversies, it was this hybrid scheme which survived, with only minor modifications, to control the existing structure. Parler's dismissal two months later because of the 'great damage and detriment to the fabric caused by his malfeasances' reflects the bitterness of the arguments that accompanied its gestation.[6]

The next important stage was reached in 1399, when the piers had been substantially completed and the problem of the vaults could no longer be evaded. In April the painter 'Giacomo Cova' of Flanders, who was domiciled in Paris, and his assistants, 'Johannes Campaniosus' of Normandy and 'Johannes Mignotus' of Paris, who was also a painter, were engaged. By December only Jean Mignot was

left, and he declared quite roundly that the building was in danger of collapse. On 11 January 1400 twenty-five of his fifty-four written objections were considered.[7] The assembled masters declared that to discuss the remaining insubstantial points, and any others that Mignot might present in the future, would only mean that the discussion would never end.

Mignot begins by attacking the weakness of the piers between the large windows of the main apse and declaring that two reinforcement piers are needed. This is countered by a long technical defence. It culminates in the assertion that above the capitals there were to be 'pointed arches made in the manner indicated by many other good and expert engineers, who say of this that pointed arches do not exert a pressure on the buttresses', so that the existing members are more than strong enough and nothing else is required. Taken at face value, this is technically true of steep and narrow lancet forms, but is patently false as a generalization about wide, heavily laden arches of the kind that were actually being discussed. Nevertheless, extreme care must be taken before deriding the Italian masters' ignorance. All that we now possess are often over-simplified notarial summaries of long and complex arguments. They are, moreover, written in very crude and occasionally uncomprehending Latin. The actual position taken up by the Italian masters seems to become much clearer in the light of subsequent developments.

Mignot's opening technical objection is supported by a long list of additional faults. These descend to numerous alleged discrepancies of measurement of as little as one finger's width. This does not merely prove that Mignot was a pedant. It reveals an attitude to craftsmanship and to precise measurement which is frequently obscured in medieval buildings themselves by their often large irregularities of plan; by changes in design during the long years of construction; by the inevitable faults in execution; and, not least, by the striking distortions introduced by centuries of settlement in the foundations and of lateral thrust in vaulting systems.

A late-fourteenth-century Gothic architect's willingness to comment on such minute discrepancies is, for example, very relevant to any assessment of the possibility that aesthetic reasons underlie particular variations in measurements in a building such as Orvieto Cathedral. An architectural situation rendered dangerous by the lack of a sufficiently evolved body of theory was often only restored by the extraordinary level of craftsmanship. At Milan a variety of proposals for the height and nature of the vaulting systems was being made when building was already far advanced. A wide potential range of differing and, within the theoretical framework of the day, essentially incalculable stresses on the existing, half-completed structure were necessarily involved. The need to avoid any kind of technical flaw at any stage in construction could hardly be more pressing. In the context of late medieval architecture and of an unfinished structure, in particular, in which the existing parts were not yet fully under load, not only the beauty but the safety of the building was at stake. It is an age-old truism that the basis of all craftsmanship and the test of any craftsman lies in sensitivity to detail. An assessment of the craftsmanship of the engineers in charge must certainly have been an important part of Mignot's brief. Occasionally, as in Item 19, his criticisms evidently boiled down to a difference of opinion as to the points from which the measurements should be taken. This kind of disagreement is not unknown among modern analysts of medieval architecture. The twenty-nine points which the Italians refused to answer by no means all referred to what might be considered to be individually insignificant errors of an inch or so. In so far as they were, the cumulative outcome was itself a serious reflection on the standards of craftsmanship maintained. Mignot's aim was to show that sound craftsmanship was lacking at every level. In its context this was a perfectly serious endeavour. The Italians' unwillingness to become embroiled in such matters, and their implied charge of pedantry, are also understandable enough. It would,

however, be wrong to assume that Mignot's technical arguments proved that he was merely finding fault for purposes of self-inflation and personal profit.

Interspersed with the technical objections is an imposing list of alleged shortcomings in proportion. Mignot often simply states that certain cornices are 'worthless' or that a set of arches 'non habent suam rationem'. The Italian masters then reply, with equal conviction but a similar absence of supporting argument, that they do indeed possess 'their just proportions'. Only in Item 10, where Mignot attacks the extraordinary capitals of the nave and aisles, which already appear in Antonio di Vicenzo's drawing and are a distinctive feature of the existing church [322], is there a thoroughly revealing attempt at detailed argument. Mignot declares, evidently with Early Gothic proportions in mind, that the ratio of bases to capitals should be one to one. The Milanese reply with a debating point. Seemingly acknowledging later Northern Gothic developments, they assert that by his own rules the ratio of bases to capitals should be two to one. They then announce that 'the base of the piers is also called a foot, a foot of a man, and the capital is said to be the head of the pier, thus by capital is meant the head of a man. Furthermore a foot is a fourth part of a man's head and by this natural law they [the capitals] should be eight braccia, and if they were made ten braccia, they were made so on account of the adornment of the piers for the placing of figures.'

The first point that arises from this reply is its Vitruvian flavour. The growing interest in the human body and its proportions is witnessed in the figurative arts of the preceding century. From Nicola Pisano onwards the Italians were always reluctant to use the human form as a substitute for architectural elements or to subordinate it to architectural needs. They were even less prepared to distort it consistently for decorative reasons. It is therefore significant to discover such 'Vitruvian' ideas in writing in North Italy on the threshold of the formulation of the consciously anthropocentric and often specifically Vitruvian architectural principles of the Renaissance. Their significance is not destroyed because they may to a certain extent be merely disingenuous rationalizations of proportions set by the much discussed triangulation of the building. The second important feature of the passage is that it shows the Milanese to be just as prepared to modify a set of mathematical relationships in the interests of a practical aesthetic, when considering matters of detail, as they were to mix two incompatible formulas and then to adjust the outcome by a few feet in the direction of the desired result when dealing with the general proportions of the building.

Another particularly interesting clash occurs in Point 14, when Mignot declares that the existing gargoyles on the sacristy should be placed 5 braccia higher, according to their ratio. From a later document it seems that he was not simply objecting to appearnces. He also disliked the further weakening of already inadequate buttresses necessitated by the system of internal conduits. The Italian reply is that the wind blows water against the windows, and that they would like the gargoyles to be even lower. They only regret the impossibility of leading the water down entirely within the buttresses. It is a fascinating glimpse of the continued vigour of the attitude to practical engineering exemplified at Castel del Monte and in the civic palaces of Gubbio.[8]

The technical and aesthetic elements are naturally inseparable in many of Mignot's arguments. One of the most significant is Point 16, in which he remarks that two of the piers or buttresses of the sacristy are not stepped back. The Italians reply that they match the remainder, as is only right, and that to step them back would weaken the work, 'for the weight of a buttress should follow its due order through a straight line'. Both statement and reply reveal that the architectural expertise of both sides was strictly bounded by local practice and local aesthetic preferences. The organic quality of Northern Gothic architecture has already been

contrasted with the Italian tendency to rely for the total effect upon the coordination of self-sufficient parts. The Northern Gothic is essentially focused on the achievement of an internal architectural and spiritual climax in which all physical and structural limitations are transcended. The exterior therefore tends to be dominated by an open display of the necessary constructional mechanics. The principal elements and the architectural details of both interior and exterior only become explicable in terms of each other. In Italian Gothic architecture the tendency is everywhere towards the preservation of essentially Romanesque additive principles. The exterior is a more or less complex solid. Each minor element is essentially at rest. As can be seen in S. Francesco at Assisi, this is true, as far as possible, even of buttresses [1]. The wish that buttress forms should have their own inherent stability; that their weight should be evenly distributed upon their bases; that they should not appear to lean against the building, any more than the building should seem to press outwards against them; all this is implicit in the Milanese statement. If there were stresses which the seemingly stable main shell was unable to support, the balance was to be redressed by borrowing strength from other visually and actually stable forms. The limits on the vertical expansion of Italian church interiors seem to have been set by just such attitudes as these. Even when stone vaults replace trussed wooden roofs, the interiors neither appear to call for, nor for the most part need, elaborate external shoring. Italian Gothic architecture deals as far as possible in terms of movement, not of stress, and the Early Renaissance in Tuscany is notable for a calm, swift-running architecture, void of structural tension.

A fortnight later, on 25 January 1400, Mignot launched a further three-pronged verbal assault.[9] Firstly he recalled his previous objections and reiterated 'that all the buttresses about this church are neither strong nor able to sustain the weight which rests upon them since they should in every case be three times the thickness of one pier within the church'. The Milanese

answer is superb in its directness. One braccio of their stone or marble is as strong as two of French stone, so that 'if their buttresses are, as they are, one and a half times the piers within the church the aforesaid piers are strong and proportionate [*ad rationem*], and if they were larger they would, being outstanding, darken the said church, as in the Parisian church, which has buttresses in Master Jean's manner'. Whatever their other failings, the Milanese were well aware of a salient characteristic of the internal appearance of Notre Dame in Paris. It is as clear a reminder of the unity of European culture as the strings of foreign names that occur in the Italian records. At least as far as major cultural centres were concerned, the forms of Italian fourteenth-century architecture are based on positive aesthetic preferences, not on ignorance. Finally, it is significant that Mignot merely asserts a single straightforward rule of thumb to cover the relationship between two classes of supporting members. Any detailed differences in function are disregarded. The Milanese reply is of exactly the same kind. There was simply no way of arriving at any precise or even approximate calculation of the forces involved in any particular case. Both sides were strictly bounded by local craft traditions arising from the character of local materials. The Italians only gain the better of this particular exchange because of a clearer awareness of the situation.

The record of Mignot's Second Point, and of the reply, is, if anything, even more revealing:

Furthermore, he says that four towers for the support of the crossing-tower of the said church are started, and there are no piers nor any foundation capable of sustaining the said towers. On the contrary, if the said church were completely built with the said towers in that position it would infallibly collapse. Truly concerning those things advanced undoubtedly through passion by certain ignorant people alleging that pointed vaults are stronger and less weighty than round vaults, and furthermore concerning other things the proposal is wilful rather than meritorious: and what is worse it is

objected that the science of geometry should not have a place in these matters since science is one thing and art is another. The said Master Jean declares that art without science is nothing, and that whether the vaults are pointed or whether they are round they are nothing unless they have a good foundation, and however much they are pointed they have nevertheless an extremely great weight and burden.

Furthermore, they [the masters] say they support the towers which they said they wished to make for many reasons and causes. Firstly, for the adjustment of the said church and crossing so that they correspond to the quadrangle according to the order of geometry; also in truth for the strength and beauty of the crossing-tower, for it is clear that, as if as a model for this, the Lord God sits in the centre of the throne, and around the throne are the four Evangelists according to the Apocalypse, and these are the reasons why they were begun.

They add that the two sacristy piers, although beginning at ground level, are well secured. This statement and subsequent records prove that underlying the whole discussion was the question of the lateral thrusts involved in the design. Their culminating argument is that the weight of the towers rests everywhere upon their square or base 'and what is vertical cannot fall'.

The first point that emerges is that the impossibility of proving the correctness of deeply held convictions was finally leading Mignot to insults and to open accusations of bad faith. The second is that his arguments about the relative strengths and weights of round and pointed arches were clearly understood to cover what would now be distinguished as the vertical and lateral components of their resultant thrust. These arguments must be seen in the context of earlier conflicts on this point in the opening statements of the preceding meeting. If, like the Italians' previous reported assertion of a total lack of lateral thrust in pointed arches, the report of what Mignot now says is taken at face value, it follows that in his

irritation at the Italians' nonsensical remarks he has been manoeuvred into a false position through overstatement of his case. At least as far as lateral pressures are concerned, the 'ignorant people' who were now alleging that pointed arches were 'stronger and less weighty' than round arches were perfectly right. In the outcome, everyone is at one time or another talking nonsense in the heat of the moment and no one, whether from France or Italy, has even a practical understanding of the vaults and arches that they were continually building. This is possible but improbable. These apparent confusions and the many dependent contradictions are much more likely to have resulted merely from the compression of long and complex verbal arguments into short, written minutes.

In the opening section of the previous debate, in which the Italians are reported as making a general statement that 'pointed arches exert no pressure on buttresses', the context is that of a clearly defined, particular problem. They were arguing whether two additional reinforcing piers were really needed at points of alleged weakness. It is therefore intrinsically likely that the ludicrous statement attributed to them is simply a contraction of longer arguments to the effect that the particular pointed arches which were planned would not exert so great a lateral pressure on the buttresses that the existing forms could not absorb it. The lateral thrust was therefore negligible as far as any need for additional reinforcement was concerned. This is evidently what Mignot understood the Italians to be saying, for in his subsequent counterattack he does not accuse them of saying that pointed arches exert no lateral thrust. If they had made such a remark, it would have given him a god-sent opportunity to demolish their arguments completely. What he reportedly does accuse them of saying is that pointed arches have less weight or, as has been shown in the context, lateral thrust than round arches. This again is nonsensical as it stands. On the other hand it would have been thoroughly reasonable for him to have been accusing them of underestimating the actual thrusts in particular

pointed arches involved in the existing design. His closing remark that no matter how pointed such arches are, they exert great thrusts, shows this to be precisely what he was doing. The wording of the report also indicates that he understood the practical truth that the nature of the pressures involved was altered not only by the change from round to pointed forms, but also by the degree of pointing involved. The difficulty is that like all other medieval architects he had no way of defining, let alone of measuring these forces. Again, however, he is clearly referring to a particular context in which, by implication, the stresses involved would not merely be great, but too great. His remark is embedded in a discussion of the support of the crossing tower and of its flanking turrets. Both the vertical and the lateral components of thrust were critically involved, since the more pointed the arches were made in order to reduce lateral pressure on the buttressing piers, the greater would be the weight on the supporting members.

The third and final section of Mignot's statement is a straightforward allegation that the Italians are motivated by fear, obstinacy, or greed, and he asks that four, six, or twelve of the better engineers from Germany, England, or France be summoned. Finally, he requests a personal audience with Gian Galeazzo Visconti. The Italians ignore all this and return to his assertions in Section 2 about the relationship of 'art and science'. They evidently consider these to contain the technical crux of his argument. The report runs:

Moreover they say and reply under the same heading, that in which it says that the science of geometry should not have a place in these things. The above-inscribed say that if this man is indeed offering proof through the rule of geometry, Aristotle says that the movement of man according to place which we call loco-motion, is either straight or circular or a mixture of these. Moreover, the very same says elsewhere that every body is perfected in threes and the movement of the same aforementioned

church rises to the triangle as was already made clear by other engineers, from which they say that all things are in a straight line, or in a curved, therefore it is concluded that the things which have been done, have been done according to geometry and to practice, for he himself [Mignot] has said that science without art is nothing; concerning art, however, reply has already been made under other headings.

Allowing for the limitations in the reporting, the explanation of this strange farrago lies in two things. The first is not so much the peculiar ignorance of the Italians as their appreciation of the true gravamen of Mignot's attack. The second, affecting both sides equally, is the poverty of medieval science. Ignorance of the nature of the architectural forces which were involved in their constructions means that the only recourse is to geometry. Consequently, shape, and in its train aesthetic preference, are integral to any consideration of such matters. Science and art become inseparable, since each is intermingled with the other. Aesthetic preference or traditional practice controls the choice between one geometrical system and another. Mignot is as ready as the Italians to change from one system to another in an already half-completed building, and is as unconcerned as they are with the structural consequences. What matters to him is that once a system has been chosen, its geometrical effects should be strictly applied throughout the building. The symbolism of numbers, rather than any structural considerations, provides the primary motive for this strict adherence. Mignot never attempts to give a mathematical or geometrical proof of his assertions. He merely appeals, *tout court*, to the science of geometry. Furthermore, he uses this appeal to cover both structural matters and aesthetic and symbolic considerations. Since he was questioning both the safety and the aesthetic merit of the building, it was clearly in his interest to avoid distinctions which would complicate his case. The Italians, on the other hand, had every reason to try to distinguish the differing implications in the various contexts of

such appeals to the science of geometry. They were as anxious as anyone else that the building should not collapse. They also wished to avoid being saddled with an uncongenial aesthetic canon because of this concern. Consequently, whenever, as in the case of the relative dimensions of internal piers and external buttresses or of the positioning of water spouts, they believed Mignot's appeals to the science of geometry to be related to structural safety or good building practice, they emphasized that this was a matter of traditional workshop practice or craftsmanship. Even when their answers involved a different mathematical ratio they were explicitly based on practical considerations and on craft skills. They were determined that this aspect of Mignot's geometry, as well as of their own, should be considered as the realm of 'ars' or practice. Since it was in reality based upon masonic practice, their position was entirely logical.

The Italians also fully realized the force of the Platonic appeal to the symbolism of numbers. They distinguished this aspect of geometry as properly belonging to the realm of science or theory. It had no direct bearing on the strength of a given member, although it could radically affect its appearance, and they were determined that the appeal to symbolism should not be allowed to carry weight where it had no relevance. If the documents are interpreted in this sense, their reported assertion that where the thrust of pointed vaults is under discussion 'the science of geometry should not have a place in these matters' is fully understandable. The reason for Mignot's indignation is no less clear. If the symbolism of numbers cannot be made to provide a general umbrella of authority, his attempt to replace a Milanese by a French aesthetic must inevitably be defeated. He therefore retorts that art without science, or practice without theory, is nothing.

If this view is correct, those parts of the North Italian answer to Sections 2 and 3 of Mignot's attack which now seem most peculiar are merely a straightforward attempt to find symbolic counter-authorities with which to parry what they recognized as a singularly weighty argument. Medieval numerical symbolism gained its force by uniting the underlying structure of material phenomena to the supernatural realities of the Godhead. Appeals to the Trinity as justifying the use of the number three were not simply rationalizations after the event: they were genuine motives for action. The 'meaning' of a church in these terms was as important as, and often more important than, its particular appearance. The stress which Alberti and the Renaissance theorists later placed on the Platonic significance of the circle in deciding the form of a church and on numerical symbolism of every kind as a theological and philosophical justification of formal decisions, and an essential element in the perfection of all works of art, proves that ways of thinking which were fundamental to the High Middle Ages were by no means outmoded in the Europe of 1400. The appeal to the Apocalyptic vision of God in paradise, surrounded by the four evangelists, is as serious and, to the medieval mind, as real an argument as the reference to the Trinity and to the nature of the Godhead implicit in all the earlier discussions about the triangular form of the elevation. Similarly, when the Italians ignore the structural arguments which they feel that they have already refuted successfully and return to the science of geometry, their appeal to Aristotle is not an attempt to find a mathematical proof in the modern sense: they are again looking for a mystical justification of their proposed course of action. Its power must be comparable to that of the mystical authority which they recognize to be the ultimate sanction of Mignot's proposals. The fact that Aristotle's passage on movement concerns infinite motion in no way weakens their argument. Nor is the use of Aristotle's reference to the three-dimensionality of all bodies irrelevant to the triangulation of the elevation. It is the unifying mystical connexion of these disparate facts that matters. To them this was as important in the construction of a church as they believed it to be in that of the

universe. The recurrence of the Trinity, and not the possibility of constructing any kind of logical mathematical proof, is the significant element in all these contexts.

Apart from their differing aesthetic and practical backgrounds, Mignot is not distinguished from the Italians by being logical where they are not, or by being knowledgeable where they are ignorant. It is simply that in relation to this particular controversy, and in the realm of what the Italians themselves were prepared to recognize as science or theory, he was the purist. He opposed the slightest practical departure from the theoretical relationships which were sanctified by the mystique of numbers. The Italians, on the other hand, without denying what was then the undeniable force of such arguments, wished to make practical adjustments to the ideal canons. It made no difference to them whether the canons were their own or someone else's. It has already been suggested that the purist position was exactly calculated to meet Mignot's tactical needs if he was to transform the building in conformity with northern taste. Judging by existing northern cathedrals, it seems that such perfection was very seldom attained even in his own homeland, and had the positions been reversed he might well have taken a somewhat different stand. As it was, the flaw in his position lay in the attempt to justify structural and practical decisions by means of a blanket of theory that was not directly relevant. The weakness in the Italians' stand was that, although they distinguished the two arms of Mignot's 'scientific' attack in a thoroughly logical manner, their practical dispositions did not meet the requirements of their theoretical defence.

Mignot's appeal for outside experts was only partially satisfied when in May 1400 Bernardo da Venezia and Bartolino da Novara, in reporting that the fabric should be strengthened in various ways, gave him implicit support. A year later, in May 1401, the ten architects appointed to a fourteen-man commission recorded individual replies to ten questions, seven of which concerned Mignot's work.[10] It is perhaps sig-

nificant that by then a more precise method of recording a wide range of opinions had been evolved.

To the first question, as to whether Mignot's work on the vaults and ribs was solid, two said no, three said yes, but that it could be better, and five had no reservations. The second question as to whether 'the work is beautiful and praiseworthy' contains a revealing distinction between what is beautiful, according to local taste, and what is praiseworthy, according to the rules of the architect's craft.[11] To this, one referee replied that it was beautiful but not praiseworthy, and only one declared it to be neither beautiful nor praiseworthy and commented that while there were said to be many similar arches in Paris, 'our church does not require old things but new'. The third question, asking whether the earlier work or that done by Mignot was more beautiful and solid, again brought Mignot a healthy majority. Of all the questions, number seven is, however, the most instructive, both in itself and in confirming the interpretation of the previous documents. It asks if 'following the form of the second project there would be changed through this work only the previous dispositions concerning the greatest height or width of the church, or something of its substantial form'. Antonio da Paderno replied that since, unlike those of the other engineers, Mignot's plans failed to indicate the height of any of the arches, he could give no decision. Curiously enough, there is an exactly similar gap in the measurements written in by Antonio di Vicenzo in his drawing of 1389–90, and the same complaint was made at a late stage in the Florentine controversies.[12] The very form of the question shows that even at this date Mignot was making proposals that might affect the main dimensions of the building. It also implies that changes in dimension, largely affecting the symbolic and mystical significance of the structure, must be distinguished from alterations of its substantial form. The latter were presumably changes in style or disposition or detailed treatment that were considered to be more far-reaching than simple

adjustments of proportion. Onofrio de' Serina, in estimating that the nave would be 8 braccia higher, remarks that Mignot must be performing a miracle, since 'the same Master Jean has said at other times that the whole edifice was not firm, and now being still higher it would necessarily be even less firm'. Although two of the other experts did not think that any variation in height was involved, the consensus was otherwise. If the seven masters who foresaw a change in height were correct, it would be a final confirmation of the earlier commission's belief that all that they called science, and a large part of what Mignot called science, was unconcerned with, and unaffected by, structural considerations. It owed its validity to its philosophical and theological significance. Furthermore, if de' Serina was right and Mignot intended to add exactly 8 braccia to the projected 76-braccia height, it would mean that despite the intervening alterations in the design of various members, the overall height would return to Stornaloco's 84 braccia. The semi-Pythagorean compromise would be discarded and the perfect figure of the equilateral triangle more nearly approached. Giovanni Scrosato, who had been a member of the earlier commission which had fought such a tenacious rear-guard action against Mignot, together with three others, saw the re-establishment of the triangle as a prime virtue of his modifications. Their view is put more forcefully by Guidolo della Croce's declaration that 'following the form of the second project, the false system already prepared is altered, and the correct system of the triangle respected, which cannot be abandoned without error, as formerly master Heinrich, and a certain German master Hans, before him, preached with high and faithful voice into the ears of deaf knaves'.

Despite continued evidence of the kind of support that had maintained him in the duke's favour, the proponents of the scheme of 1392 were finally triumphant, and in October 1401 Mignot was sacked. He left behind a building that was taking on a shape quite different from the one envisaged when its ground plan had been settled. French, German, and Italian architects alike had advocated radical changes in an already partially completed elevation. Northerners and southerners alike had demonstrated that even approximate calculation of the structural consequences of their decisions was not only impracticable but inconceivable. Nevertheless, they were all willing to transform the character and magnitude of the loads and stresses to be borne by the existing members. All of them had shown that symbolism and significance were still as important as appearance to medieval architects. Despite the heat of the debate, it seems that in the context of existing knowledge and modes of thought both sides were defending fundamentally reasonable positions. The fact that the cathedral is still standing and is remarkably free from structural defects or failures is itself a warning against taking the Italian masters' arguments too lightly or their ignorance too much for granted. As the stories of the cathedrals of Florence and Siena prove, only the rarity of even partial documentation makes the proceedings at Milan appear at all extraordinary.

As often happens where there are great quantities of detail, it is the general effect of the completed interior of Milan Cathedral that is striking [322]. The double-aisled space that is enclosed is vast and gives the full impression of being so. The dwarfing of the figure sculpture in the controversial capitals carries the sense of human smallness up into the spaces overhead. There is no other church in Italy, and few elsewhere, in which the legendary source of Gothic architecture in the dark, over-arching northern forests becomes an insistent actuality. The omnipresent stained glass sheds an evocative half-light over all. The lowering of the nave and heightening of the aisles means that there are few windows in the upper spaces. Lush, complex forms sweep up to an obscurity that intensifies the forest feeling. Although the broad exterior of the façade leads to an almost unexpected sense of height on entering the nave and at the crossing, the massive capitals with their niche-enfolded figures form an effective

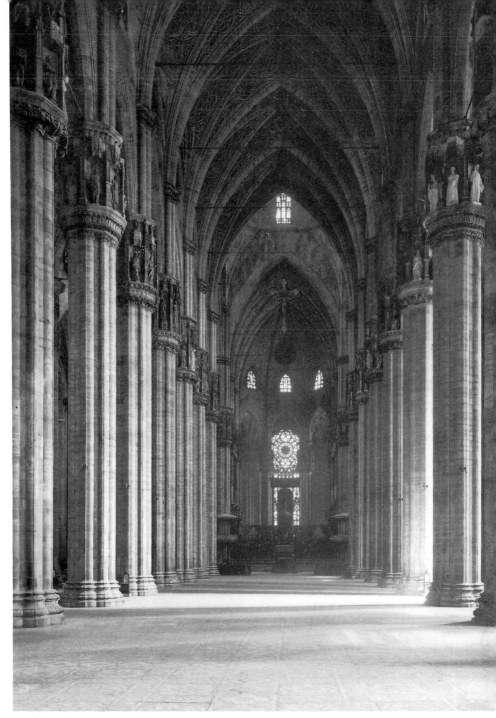

322. Milan, Duomo, begun 1386(?)

visual stop. Only in the aisles does the immediate springing of the narrow, steeply-climbing vaults result in continuity of movement through the slim, high spaces. Everywhere, diagonal views are opened up as one moves through the hall-like nave. Especially from the outer aisles the continuous kaleidoscope of rectilinear avenues, of complex clusterings, and of deep and broken vistas is impressive. The total symmetry and rippling contours of the seemingly innumerable complex piers itself encourages a sense of all-round movement. The envelopment of the shafted forms by the surrounding space takes on an almost tangible quality. There is, however, no confusion in the outcome, for the great width of the nave ensures an adequate

323. Matteo da Campione: Monza, Duomo, façade, completed 1396

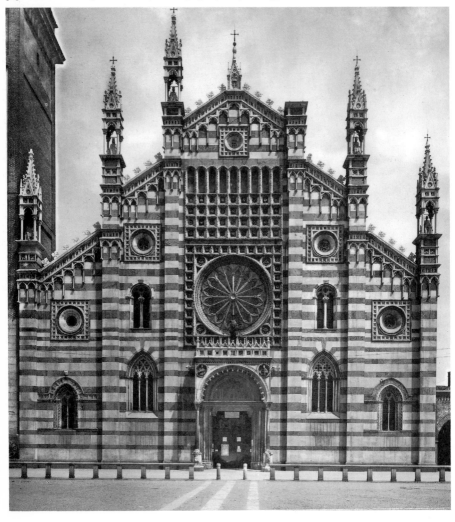

flow towards the altar. Seen from the inner aisles, the enormous windows of the ambulatory, slimmed down by their angled setting and accurately framed within the steep perspective of the arches, slant in space. The viewer is drawn on until, after the transept has been crossed, the vast expanse of glass makes its full visual impact.

THE CERTOSA AT PAVIA,
THE DUOMO AT MONZA,
AND S. MARIA DEL CARMINE AT PAVIA

The final decade of the fourteenth century, which saw the Milanese controversies approach their climax, was a period of great activity in the surrounding territories. From the ceremonial foundation of the Certosa at Pavia in 1396 to his death in 1402, Gian Galeazzo Visconti was himself as much or even more concerned with this grandiose personal project. His chosen architect was the same Bernardo da Venezia who intervened in the Milanese discussions. There was, however, a long stoppage in the work after Gian Galeazzo's death. As a result this most extraordinary architectural complex in which Romanesque, Gothic, and Renaissance styles are intermingled with a busy, gay abandon is substantially a mid- and later-fifteenth-century creation.[13] Its plan, with the aisles flanked by chapels, none the less reflects

a pattern much discussed during the quarrels at Milan, and resurrected at a late stage by Bernardo himself.[14]

Apart from the fourteenth-century additions to the flanks and east end of the once cruciform thirteenth-century Duomo at Monza with its domed crossing, the deadening restoration of the façade, originally completed by Matteo da Campione in 1396, greatly affects its flavour [323]. The flatness of the striped marble façade is barely modified by the numerous, carefully graded openings that reiterate the stepped triangulation of the upper contour, or by the heavy carving, not unlike the imprint of a waffle-iron, that surrounds the central rose-window. The internal height of the building scarcely exceeds a line from the central roundel to the lowest of the flanking windows. Finally, the flatness of the exposed screen is further emphasized by its extreme thinness. Internally the original wooden roof would have somewhat lightened the general impression of a wide, low, massive structure. Even now the drop in height from nave to aisles and aisles to chapels ensures that no hall effect is created.

The most distinguished of the group of neighbouring cruciform nave, aisle, and chapel buildings which connect both with the Duomo at Milan and with contemporary developments in Florence, is the brick-built church of S. Maria del Carmine at Pavia [324]. It appears to

324. Pavia, S. Maria del Carmine,
designed c. 1370(?)

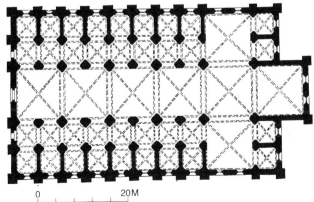

0 20M

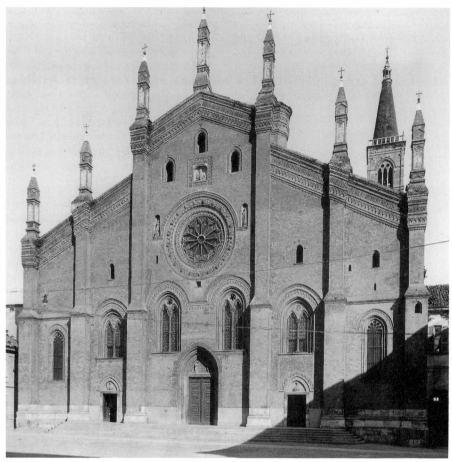

325. Pavia, S. Maria del Carmine, designed *c.* 1370(?)

have been designed *c.* 1370. The broad and typically Lombard façade, its five compartments firmly bounded by plain buttresses topped by simple pyramids, is notable for the accentuation of its rhythms by wide windows [325]. These elaborate the forms found earlier in the Castello Visconteo [315] and are linked by a continuous, overriding cornice. In the interior [326] each square nave bay opens into two lower, square aisle bays succeeded by two equally high, square chapels. There is no dome over the crossing and no break in height between

the nave and transepts. The continuity from one transept to the other is complete. The high traditions of the Lombard Romanesque live on in the mass and simplicity of the columns, of the mouldings, and of the plain, round ribbing of the vaults. Except for the main transverse arches of the nave, the simplest cushion capitals are used. The carefully maintained structural relationship of ribs and vertical supports leads to an alternating rhythm in the nave. The swelling cruciform section of the main supports is boldly contrasted with the broad, flat faces and

flanking half-columns of the intermediate piers. The eye is drawn up over the great sweep of wall, which lines each bay, by oculi set in the apex of the longitudinal arches of the vaults.

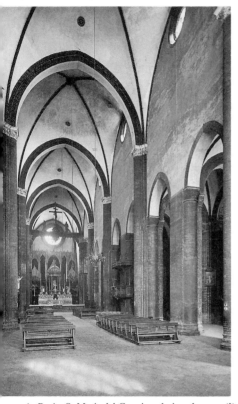

326. Pavia, S. Maria del Carmine, designed *c.* 1370(?)

The walls reveal their mass in the great thickness of the nave arcading. Within the aisles themselves there is a similar simplicity and weight in the capitals and ribs and columns. Fine colour contrast is provided by the whitewashed walls of the vaults and the deep-red supporting structures. The outcome is a feeling of the calm enclosure of great spaces by a structure notable for its solidity and its simplicity of surface. That this might seem to characterize a Romanesque construction is no surprise in Lombardy. It is also no denial of

the pressure of small changes in proportion, a more rapid rhythm, and a greater verticality in arch and vault forms. The bay shape of the nave, the lack of interruption by a raised choir or by a dome over the crossing, and the absolute dimensions all create a corresponding accent upon length, and balance the lateral extension of the plan. All in all it is a building in which great traditions are continued and, in their continuation, undergo a transformation of unusual subtlety and sensitivity.[15]

MATTEO GATTAPONE
AND THE COLLEGIO DI SPAGNA;
ANTONIO DI VICENZO AND S. PETRONIO
IN BOLOGNA

One of the more unusual structures on the road down from Pavia to Bologna is the tall, wide-mouthed atrium which was added to the transept of S. Antonino at Piacenza in 1350 by Pietro Vago. With its simple buttresses, its beehive turrets, and its cross-vaults, it recalls the even more severe form of the smooth stone tower-porch attached to S. Maria della Lizza at Alezio in Apulia. The sweep and scale of the Piacentine atrium, which is rather reminiscent of a deep-sea fish, all head and mouth, trailing a tiny body, contrasts with the busy detail and essentially small-scale conception of the much restored loggia of the Palazzo della Mercanzia in Bologna.[16] The latter's tendency to miniaturization and to elaboration of detail is the architectural reflection of one of the main strands in the contrasting pattern of late-fourteenth-century developments in all the arts of the North Italian plain. The general form continues the tradition established in the first half of the century, but the ultimate effect depends almost entirely on texture and on the colour of the terracotta mouldings and fully painted marble sculpture. The building was begun in 1382 by Lorenzo di Domenico da Bagnomarino, who was associated with Antonio di Vicenzo. Two years later the latter, together with Giovanni Dionigi, also joined Bagnomarino and Berto Cavaletto on the

modification and enlargement of the severe Palazzo dei Notai, which was begun in 1381.

Both severity and sophistication are, as might be expected, characteristic of Matteo Gattapone's work for Cardinal Albernoz in the Collegio di Spagna, also in Bologna [327]. The building was begun and substantially completed between 1365 and 1370, while Matteo was also working on the Rocca at Spoleto. The octagonal columns and two-tiered arches of the loggia at Bologna repeat the Umbrian forms, but with a difference. There is added weight

327. Matteo Gattapone:
Bologna, Collegio di Spagna, 1365–70, courtyard

and gravity in the lower arcades. More striking still, the height of the upper storey is drastically reduced. The individual forms are only minimally altered, and the reduction is mainly achieved by halving the height of the supporting columns. The parapet reaches half-way up the shortened forms and greatly accentuates the visual effect. It is almost as if the upper storey had been driven down into the lower. Finally, the unbroken horizontality of the roof-line is given positive architectural force by the abrupt, unheralded emergence of the façade and bell-screen of the aisleless, vaulted chapel of S. Clemente. The forms of the cortile give no warning of the building that erupts above and behind them. Apart from the buttresses and framing cornices, which are an earnest of solidity, it is the flatness of the façade that is emphasized. The contrast with the dark openings of the logge below is stressed by the way in which its buttressed flanks are not continued by the verticals of supporting columns. Instead, they coincide with the crowns of two round arches and so appear to sit upon the void. Finally, there is a seemingly deliberate angularity of outline. The unbroken, straight lines of the roof and balconies of the logge are contrasted with the abrupt changes of direction in the emphatic cornices of the façade. The scale and curvature of the roundel and of the bell recess appear to flout the visual rules established by those of the logge in a no less calculated manner. The precision and economy of means throughout the design argue the stature of the Umbrian architect, and any doubts about the deliberate sophistication of his scheme must be resolved on entering the chapel.[17] Nothing could be more simple, nothing on its own terms more effective, than the way in which the continuum of the lower walls, pierced only by plain lancets and otherwise without the smallest interruption, both enfolds the polygonal choir and is, in its vertical dimension, accentuated by the exactly similar windows in the upper wall which thereby link it to the articulated and contrasted spaces created by the vaults above. The corbelling of all the columns supporting the ribs of the vaults defines the boundaries of the lower wall. By these means the contrasting, interpenetrating elements of the single, simple-looking volume are divided seemingly without division. The plain grandeurs of Spoleto, the straightforward contrasts of internal and exter-

nal form that seemed to flow from function, are elaborated by means no less economical in their essence. The great late medieval engineer from Umbria was something more. He was an architect's architect.

Antonio di Vicenzo's major work, the church of S. Petronio in Bologna, represents a far more obvious claim to fame. It is the final climax to the chapter of Italian brick construction opening with S. Francesco in Bologna [6]. The power of the bonds forged by that famous church are shown by the attenuated plans of S. Giacomo Maggiore and S. Maria dei Servi in Bologna. The enlargement of the latter was promoted by the same Fra Andrea Manfredi da Faenza, the General of the Servites, whose name is associated with the construction of S. Petronio. The building of the latter started in 1390 and reached substantially its present state in 1525 [328 and 329]. By 1400 only the first two nave bays were complete, and Antonio died between 1401 and 1402. Despite the virtual

328. Antonio di Vicenzo: Bologna, S. Petronio, begun 1390

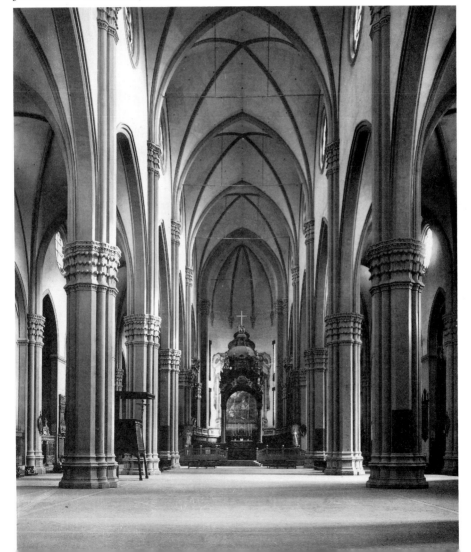

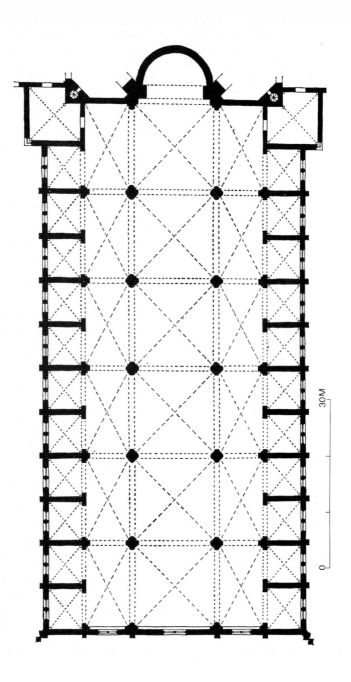

329. Antonio di Vicenzo: Bologna, S. Petronio, begun 1390

suspension of the work until 1445, the pattern was, however, firmly enough set for the design of the nave, which was all that was ever completed, to be considered an essentially fourteenth-century conception. Although the original proposal for the entire east end is uncertain, it is clear from a document of February 1390, less than a month after the original decision to build, that a Latin-cross plan of some kind was originally intended. In it Antonio di Vicenzo was ordered to produce 'a church or chapel made of stones and mortar covered over with gesso forty feet long [50 ft; 15·20 m.] and more according to the accompanying schedule, and thirty feet wide [37½ ft; 11·40 m.] and more according to the accompanying schedule as above, with whatever doors windows vaults chapels pillars towers and other appropriate things' were indicated in his drawing.[18] Since this model was to be made to a scale of one to twelve, the projected church was to have been at least 600 ft (182·40 m.) long and 450 ft (136·80 m.) across the transepts. Not only was their model to be on the grandest scale but the resulting church was to outstrip the new cathedrals of Florence and Milan by a substantial margin. The model, similar in principle to those mentioned in the Florentine documents, was, moreover, to be in accordance with the previously declared intentions of Fra Andrea, who was to stand as arbiter. In August Fra Andrea stated that the model was larger and richer than anything which he himself had laid down or the architect had proposed, but he declared in all conscience that the architect should have a hundred lire for his pains. Antonio's gratitude at this point was such that he refused to take more than eighty![19]

In the church as it now stands the use of chapels flanking the aisles can be related to the pattern established in S. Maria del Carmine at Pavia, for the surviving records of the Milanese discussions of such a scheme post-date Antonio's visit to survey the project for the Duomo. The evidence of Antonio's close acquaintance with the Duomo of Florence is also plentiful. The piers and capitals and pilaster forms of S. Petronio are clearly derived from it [306]. No less important, though perhaps less often recognized, is the possible influence of the running rhythms of S. Maria Novella on this, the airiest Gothic church in Italy [8]. Indeed, the fresh winds blowing in from Tuscany presage the gale of change which was to sweep through Northern Italy in the succeeding centuries.

The outcome of Antonio's careful observation both of rival projects and of earlier achievements is no hall of echoes but a new creation. The contrast with the crowded mystery of Milan is hardly more extreme than that which separates its sweeping verticals from the heavy horizontal cornices and cap-like vaulting of the Duomo at Florence. Large oculi, set high up in the walls, spread even light throughout the building. Simplicity of moulding; clarity of plane in wall and pier and soffit; a sensitive and carefully limited intermingling of columnar forms; the warm light red of the supporting elements, and the calm surfaces of walls and vaults, combine in such a way that space tells fully in all three dimensions. The nave bays are some 63 feet (19·20 m.) square, and the great expanse between the piers means that the lateral extension of the plan is fully realized. The height of the nave is thoroughly exploited by the soaring continuity of its supports. The eye is drawn to an unbroken and identical succession of vaults that both accentuates the length of the building and speeds the flow towards the altar that is already inherent in the bay design. The sense of space reciprocally accentuates the slimness of support forms carefully proportioned to the total scale. As often happens, what has been so well begun has been superbly if precipitously finished. However curious and incomplete the exterior of the eastern end may seem, the mass and virtually unbroken sweep of the plane-surfaced choir arch is an architecturally dramatic framework for the spiritual drama of the mass.

THE PALAZZO DUCALE IN VENICE

Apart from a number of minor palaces, and a few churches such as S. Stefano and the Madonna del Orto which in part retain their fourteenth-century character, the latter part of the century in Venice is memorable only for the single masterpiece of the Palazzo Ducale [330].

teenth-century replacements for whatever walls or other supporting structures had previously existed.[20] The existing facings of the upper walls are also likely to belong to this late date. If this somewhat controversial chronology is correct,[21] the whole campaign was probably completed by the insertion of Pierpaolo dalle Masegne's balcony of 1400–4. Finally, the

330. Venice, Palazzo Ducale, 1340 ff., late fourteenth century, and after 1424

The enlargement of the existing Sala del Maggior Consiglio on a foundation of existing rooms was decided on in 1340, and the building that contains it must have been well advanced by 1365, when Guariento was called in to decorate it. The extent of the great hall is measured by its inclusion of the first two windows on the side of the Piazzetta and of five of the seven windows facing the canal. The style of the logge beneath, and of much of their sculpture, seems to show that, although stone carvers were active as early as 1344, they are actually late-four-

further, matching section of the palace, stretching along the Piazzetta towards S. Marco, discussed in 1422, was begun under Doge Francesco Foscari after 1424.

The feat of engineering represented by the reconstruction of the double colonnade after the completion of the upper storey is only rendered less surprising by the realization that in a city built entirely upon piles and laced with waterways, the replacement of the lower levels of a building without disturbing the overlying structure was a constantly recurring problem.

The entire external construction of the Palazzo Ducale is a visible, above-ground symbol of the structural realities that underlie the solid-seeming city. The double loggia itself has ample Venetian precedents going back beyond such twelfth- and thirteenth-century palazzi as the Loredan and Farsetti to the reconstructed Fondaco dei Turchi. The placing of heavy superstructures with relatively small windows on logge which leave the building fully open at ground level, instead of merely skirted by arcading, is characteristic of many a North Italian Arengario or Palazzo del Comune from the early thirteenth century onwards. It is the subtlety with which the traditional Venetian arrangement has been elaborated and refined, and the scale on which it has been carried out, that are unprecedented. There is a fundamental contrast between the open, lace-like treatment of the lower half and the continuity of the upper wall, in which a relatively few large openings have been cut. The secret of the building lies in the harmonious resolution of such conflicts. A similar tension is inherent in the multiplicity of sculptural and colouristic detail which is disciplined both by the constant repetition of identical elements and by the unbroken, horizontally extended cube-form of the whole.

The building is ideally calculated to provide a foil for and yet not to crush the low and complex outline of S. Marco. The textural gradient created by the diminution and increasing complication of the openings as the eye moves up the logge is continued in the rose and white diagonal patterning of the upper wall. Such patterning always tends to reduce the sense of weight. Comparison with its many Umbrian and Central-Italian counterparts reveals how much this tendency is here accentuated by the context. The Italo-Islamic decoration which softens the harshness of the skyline plays a variation on the arch-forms of the upper loggia. It also completes the cycle by beginning a reverse progression from pure surface pattern to the most tenuous and least corporeal of sculptural forms. The way in which the placing of the windows that substantially repeat the forms of the lower arches has been related to the pierced roundels of the upper loggia is similarly skilful. The windows gain a curious, floating quality by being offset as regards the arches of both logge. Form and texture, void and solid, light and shade and colour, work so fine an alchemy that the outcome is a dancing calm – weightless solidity – a restfulness which has no hint of the inert. As all great works of art inevitably do, it underlines the impossibility in principle of finding any counterpart in words.

Internally there is nothing unexpected in the number and complexity of the rooms that support the enormous Sala del Gran Consiglio. There are a number of particularly fine four-teenth-century wooden ceilings, and the central row of supporting columns in the Sala del Piovego, in particular, foreshadows the treatment of the loggia that runs right through the early-fifteenth-century Foscari wing. The only essentially novel element is the increased amenity and more varied circulation allowed by the building of two storeys of continuous logge on the outer as well as on the inner face of the building. In these respects it even surpasses the Palazzo Visconteo in Pavia. There the necessities of defence restricted such constructions to the inner courtyard [316]. The only building which is both earlier and comparable as regards this feature is the Palazzo della Ragione in Padua. The double logge on either side of the latter were added in the early fourteenth century, and they may well contain the germ of the idea that was to flower in Venice.

Sculptural details comparable to those of the Palazzo Ducale can be found in the Palazzo Sagredo and in such things as the loggia of the Palazzo Ariani. Later borrowings are obvious throughout the logge and windows of such fifteenth-century Venetian private houses as the Ca d'Oro, begun in 1421, or the Palazzi Sanudo, Foscari, and Pisani. The difference is that, as in the no less evocative additions to the façade of S. Marco during the later fourteenth century, a picturesque profusion of polychrome and sculptural detail has replaced the discipline by

which the riches of the ducal palace are so subtly controlled. It is, moreover, only in these fifteenth-century palaces, as far as can be seen on the surviving evidence, that the patterns of internal organization, already settled by the early thirteenth century, when they represented an immeasurable advance beyond the comparable civil architecture of the rest of Italy, begin to loosen and develop into fresh configurations. As in the remoter regions of Central Italy, much of what appears by the time-scale of the Florentine Renaissance to be typically fourteenth-century work in fact belongs to the mid or later fifteenth century. But for its one surviving masterpiece, Venetian architecture of the later fourteenth century is a matter of innumerable minor beauties and of hints and traces long since picturesquely overgrown.

PAINTING

1350–1400

INTRODUCTION

Two great changes of emphasis mark the history of late-fourteenth-century Italian painting. Firstly, the small-scale painting of Northern Italy rivals the monumental art of Tuscany in its importance for the history of European art. The new attitude to the accurate description of natural detail which flowered in the Visconti-dominated Lombard and Emilian plain vies with early-fourteenth-century Tuscan innovations in its contribution to the art of the de Limbourg brothers and underlies the achievements of the Master of Flémalle and the Van Eycks. The second major change involves the concentration of Tuscan art on transcendental and emotional aims. The fundamental realism, the steady acquisition of new representational abilities, which had absorbed the energies of the preceding seventy-five years, are for a time, but only for a time, largely irrelevant. The new art none the less remains a vivid expression of the society that gave it birth, and is as significant in moulding contemporary modes of thought as that of the preceding or succeeding periods.

The Black Death is one element in the equation that affects the social and artistic scene in Tuscany. Artists of known achievement and great promise died. Others of quite unknown potential must undoubtedly have been cut down. Depopulation, centred in the crowded cities and followed by a riotous but short-lived period of abundance, led to massive shifts of power, to economic chaos, and to continuing

social disruption. Mercenary armies roamed the countryside and peasants swarmed into half-empty towns. The grip of the tight oligarchies of great banking houses had already been weakened by the financial crisis of the early forties, and power tended to move into the hands of the lesser merchants. In Florence in 1378 the Revolt of the Ciompi even established the ascendancy of the disenfranchised labouring masses of the wool-trade for a few short months. In Siena the oligarchy of the Nine, which had provided relatively stable government from 1287 onwards, fell in 1355, to be replaced by that of the Twelve in which the ascendancy of the smaller traders, as opposed to the greater merchants and the international bankers, was established. This in its turn was struck down in 1368 by the even more broadly based faction of the Riformatori which, after a period of extreme turbulence, incorporated a number of representatives of the factions which had dominated the previous administrations. This broadening of the base, and downward movement, of the seat of power increasingly involved such socially less privileged groups as masons, carpenters and painters, butchers, shoemakers, smiths, and tanners in affairs of state. Throughout the period the potential benefits of a broadened governmental base were, however, vitiated by the incohesiveness and inexperience of the newly influential, and by 1382, when Siena was far down the road of relative decline, Florence

was once more moving into the hands of the great merchant families.

The rise to power of different social groupings, and the economic changes which this signified and in turn encouraged, led to changes in the arts. Patronage moved for some considerable time to hands far less responsive to the sophisticated tastes of a relatively restricted elite and more responsive to the needs of social strata which were, in artistic matters, less adventurous and more conservative. In architecture and in art, the continuities which stretched across what might at first be assumed to constitute the great mid-century divide are, if anything, more obvious than the changes. The arguments which have oscillated back and forth in recent years, in connexion with a general tendency towards earlier datings, epitomized by the endless uncertainties as to whether an artist such as Barna, if he actually existed, carried out his major work before or after the Black Death, are vivid reminders that even the most cataclysmic of upheavals seldom stand in a clear, one-to-one relationship to artistic trends. Nevertheless, economic and social upheaval was undoubtedly accompanied by a radical if short-lived change in spiritual climate. The mystical tendencies of the preceding period were strengthened. Saints such as Catherine of Siena fired the popular imagination. The heirs of the Franciscan Spirituals multiplied. Popular preachers roused the multitudes to orgies of repentance and emotion only matched by the frenzied self-indulgence of the irreligious. The freeing of the individual's imagination, encouraged in the first half of the century by the artists' assumption of new freedom to interpret the religious narratives in the light of their own understanding, now posed a real threat to the established organization of the Church. This threat was met by increased insistence on orthodoxy and on the Church's institutional power and authority as the sole road to salvation: this at a time when, paradoxically, its whole administrative structure was in visible and often scandalous disarray. In 1378, on the death of Gregory XI after his return to Rome, the accumulated troubles of the papal exile in Avignon were replaced by those of the Great Schism. All the powers of Europe polarized as pope struggled with anti-pope. Out of such contradictions there arose no great new orders, no immediate and lasting organizational reorientation. There was no fundamental adaptation to real needs; no major reinterpretation of old truths. No insights deep enough to change the course of European spiritual history emerged out of the Tuscan turmoil.

The spiritual as well as economic conflicts were reflected in an art which, in as far as it did move into new channels, carried certain contradictions with it. However strongly based on an innate conservatism, the means by which it expressed the new, non-rational and transcendental urges and the new authoritarianism were, to a greater or lesser extent, conditioned by the naturalistic achievements of preceding generations. Furthermore, the needs which it was born to serve had grown less pressing long before a fundamentally new artistic language could be formed. With the return of relative economic and political stability in the final decades of the century, the fading memories of disaster made the menace of the judgement day less real. The solution of representational problems once again became exciting to the artist and his patrons. The exploration of the surface beauties and the underlying structure of this world began to move once more into the forefront of men's minds.

TUSCANY

BARNA DA SIENA

Barna is among the ghostly figures dwelling on the fringes of recorded history, their very being circumscribed by conflicting passages in Ghiberti and Vasari. Nothing factual is known of him, and the frescoes of the *Life of Christ* in the Collegiata of S. Gimignano, probably painted in the late forties or early fifties, are the core of what is generally attributed to him. These frescoes show how an extreme conservatism could, in the third quarter of the fourteenth century, form the basis of a new art and the vehicle of new emotions. Barna's interest in Duccio seems hardly to have been diminished by an overlay of influence from

Simone. Although one or two striking iconographic details seem to derive directly from Giotto's Paduan cycle, the descriptive naturalism of Ambrogio Lorenzetti might never have existed as far as Barna is concerned.

The frescoes are arranged in three tiers on the windowless outer wall of the right aisle of the Collegiata [331]. A single scene from the Early Life of Christ, predominantly carried out by an assistant, fills each of the six lunettes. In the lower registers there are two scenes to a bay as the story swiftly shuttles back and forth across the first four bays, gathering force for its climax in the *Crucifixion*. The latter takes up the entire fifth bay, and the story concludes with the four scenes in the sixth and final bay.

331. Barna da Siena: S. Gimignano, Collegiata, right aisle, scheme of decoration, early 1350s(?)

KEY

1. Annunciation
2. Adoration of the Shepherds
3. Adoration of the Magi
4. Presentation in the Temple
5. Massacre of the Innocents
6. Flight into Egypt
7. Christ among the Doctors
8. Baptism of Christ
9. Calling of St Peter
10. Miracle at Cana
11. Transfiguration
12. Raising of Lazarus
13. Entry into Jerusalem
14. Last Supper
15. Judas and the thirty Pieces
16. Agony in the Garden
17. Betrayal of Christ
18. Christ before Pilate
19. Flagellation
20. Mocking of Christ
21. Way of the Cross
22. Crucifixion
23. Entombment
24. Resurrection
25. Descent into Limbo
26. Ascension

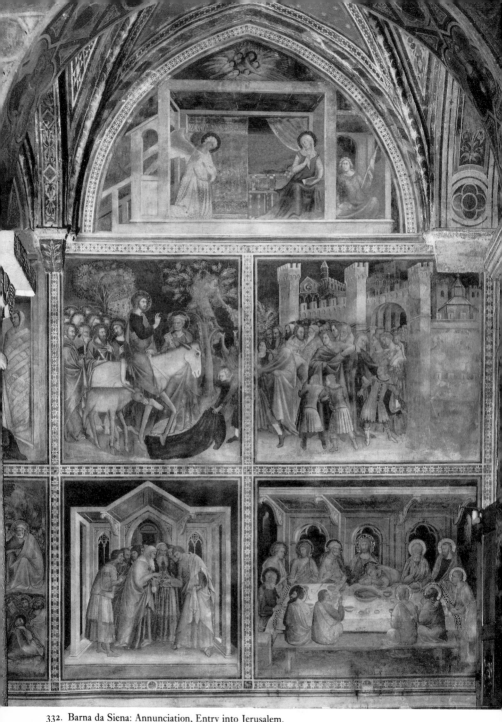

332. Barna da Siena: Annunciation, Entry into Jerusalem,
Judas and the Thirty Pieces of Silver, Last Supper, early 1350s(?).
S. Gimignano, Collegiata

This unusual arrangement permits a definitive solution of the problem that Giotto had struggled with in the Arena Chapel. Despite the multiplicity of scenes and levels, the whole narrative is welded into a dramatic unit.[1] At Padua significant coincidences were encouraged wherever possible. At S. Gimignano there are no coincidences. Each and every juxtaposition of scene with scene is meaningful and planned. Throughout the four opening bays the Early Life of Christ is allocated to the lunettes, the Ministry to the middle row, and the Passion to the lowest register. In the first bay [332] the *Annunciation* of the coming of Christ surmounts the second joyful coming of the *Entry into Jerusalem*. The latter occupies two whole compartments, and the intervening bar is bridged by the general movement from the left and by a single swift counter-movement as a youth, his figure cut in half by the vertical division, hurls his cloak on to the ground. The powerful compositional flow not only hastens the transition to the lower register but emphasizes the dramatic contrast with what follows. Welcome becomes the immediate prelude to betrayal, as the taking of the sop, the chosen moment of the *Last Supper*, gives way to *Judas and the Thirty Pieces of Silver*. Even this does not exhaust the significance of the doubling of the scene of Entry. At Assisi, two strict symmetries at the start accentuate the bay-by-bay, visual grouping of the St Francis Cycle. Here, the placing of a double scene in the first bay, immediately beneath the single episode in the lunette, stresses the vertical equivalence. It encourages the bay-by-bay scanning that adds so much to the simple serial reading of successive episodes. The coincidence of left-to-right movement, the wide spacing of the figures, and the architectural design of the *Annunciation*, which seems to pin the two halves of the lower scene together, make the artist's implicit purpose visually self-evident.

In the second lunette the swaddled, newborn infant in the *Adoration of the Shepherds*, which doubles for the missing *Nativity*, is echoed by the reborn Lazarus, swaddled in his winding sheet, and the amazement of the shepherds is succeeded by that of the apostles in the *Transfiguration*. The theme of heavenly vision, and of the contrast between the indwelling Godhead and the earthly shell of mortality, is even carried into the Passion scenes of the lower row by the vision in the *Agony in the Garden*. In the third bay the *Adoration of the Kings* is linked to the *Calling of St Peter and St Andrew* and to the festive scene of the *Marriage at Cana*. Again, the contrast with the scene of *Christ before Pilate*, the infant king of kings become the prisoner of the unjust earthly powers, gives special point to the juxtaposition with the Passion. The linkage of the *Presentation in the Temple*, in the fourth lunette, to the *Baptism*, Christ's adult recognition of the future role of the Church, and to the *Teaching in the Temple* hardly requires comment. Again, however, there is particular bite in the relationship between the Christ Child teaching the wise and the similarly designed *Mocking of Christ* in which the Saviour is reviled by fools. The *Massacre of the Innocents* then crowns the *Crucifixion* of the innocent God, and finally the physical escape of the *Flight into Egypt* surmounts the escape from spiritual as well as earthly death in the *Resurrection* and *Ascension*. Once again, at the end of the wall, the vertical connexions are compositionally and thematically emphasized by the placing of the *Entombment* and the *Descent into Limbo* in the lower registers. These linkages finally confirm the intentions governing Barna's consistently maintained principles of arrangement and complete one of the most tightly organized, many-layered narrative cycles ever painted.

Insistence on the logical and intellectual basis of Barna's cycle is especially important because of his relative disinterest in descriptive naturalism. His elongated, heavy-footed figures frequently ignore the facts of anatomical description almost as thoroughly as those which Vitale da Bologna painted a few years later at Pomposa. Spatial depth is limited and architectural realism minimal. There is frequent

tension between architectural and figural accents, and the contrast between calm and violence in the distribution of the scenes is matched by similar juxtapositions among the individual figures of the Passion scenes. The violence and evil in these latter scenes is set against the lyrical delicacy of the colour combinations and the swinging patterns of the draperies in the cycle as a whole. Apparently under the impact of unprecedented natural catastrophe and of spiritual and social turmoil, Barna uses iconographic materials primarily derived from Duccio and Simone to create an idiom as indissolubly tied to its own time as it is new. The experiments of artists such as Taddeo Gaddi are left behind, and the emotive power of Guido da Siena and Cimabue is rivalled on new levels of complexity. For the first time in Sienese, or indeed in Tuscan art, the essential challenge laid down by Giovanni Pisano and so long ignored in favour of the easier elements of his style is willingly accepted. A similar quality of strangeness, a similar compositional discipline and emotional power, a similar basis of conservatism, but a greatly increased simplicity of design, reminiscent of Simone or Bernardo Daddi, are combined with dramatic exploitation of the change of scale in such panels as the *Carrying of the Cross* in the Frick Collection in New York and the *Mystic Marriage of St Catherine* in the Museum of Fine Arts in Boston. The badly damaged Boston panel is also an interesting social document, since its symbolism seems to have been designed to record and sanctify, and thereby to confirm, a peace between two warring families.

THE MINOR SIENESE MASTERS

The message of the Old Testament scenes painted in the left aisle of the Collegiata at S. Gimignano by Bartolo di Fredi (recorded 1353–97) in 1367 is less complex and more explicit than that in Barna's cycle.[2] The impact of recurrent pestilence seems to be reflected by the stress on such unusual subjects as the *Crossing of the Red Sea*, with its tangle of floating corpses, and by the incorporation of a sequence of scenes from the *Trials of Job*. The cumulative effect of crowded, anecdotal, and often bitty compositions sets the character of the cycle. Similar qualities recur in Bartolo's mature masterpiece, the securely attributed *Adoration of the Magi* in the Pinacoteca at Siena [333]. Harshness of drawing, hardness and complexity of form and brilliance of colour are accompanied by an endless accumulation of detail. Bold and disturbing simplifications of natural appearances are married to a calculated discontinuity and compartmentalization of pictorial space. The final crowding is so extreme that, despite the large size of the panel, its borders seem to press in on the landscape, architectural, and figure content. The element of tension, even of violence, that accompanies the decorative intensity of much of the work of Bartolo di Fredi and his fellow Tuscans during the second half of the century is stressed by a comparison with the output of such northern contemporaries as the Maître aux Boquetaux. The dependent status implied by the often direct reliance on designs created by Simone or the Lorenzetti brothers is transformed by a thoroughgoing change of mood and emphasis. In a period in which genuine mysticism, often descending into religious emotionalism and hysteria of every kind, was accompanied by emphasis on orthodoxy and upon the saving power of the Church, it seems legitimate to see a parallel phenomenon in such works as Bartolo's *Presentation*, which is based on Ambrogio Lorenzetti's panel of 1342. The combination of emotive, formal tension with increasing hieratism and stress on ritual, and the diminished interest in natural description, are typical of the times.

It is only superficially a paradox that it is artists who are little interested in exploring the full range of visual appearances, and who are positively disinterested in the more serious aspects of psychological and dramatic realism, who most often indulge in elaborate feats of illusion. The surviving peaks of fourteenth-century Tuscan illusionism are to be found in

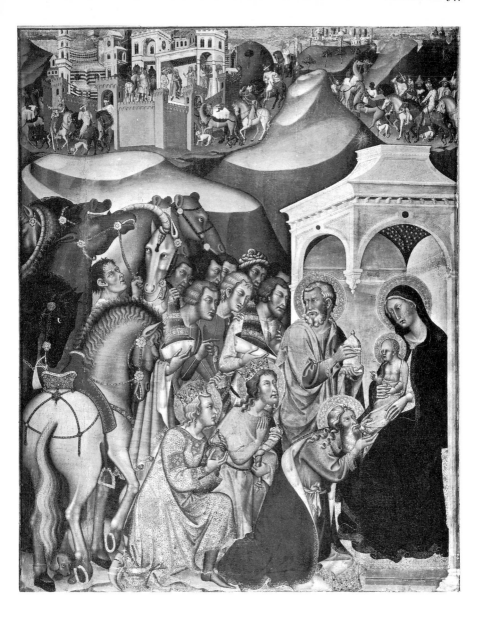

333. Bartolo di Fredi: Adoration of the Magi, 1390s(?).
Siena, Pinacoteca

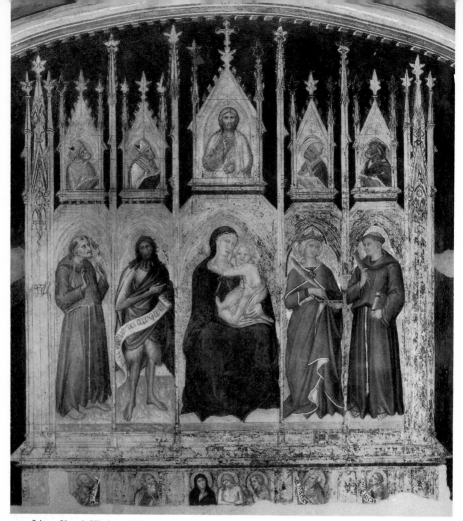

334. Lippo Vanni: Virgin and Saints, *c.* 1350–60.
Siena, Seminary

Siena, not in Florence, and in the work of
Lippo Vanni (recorded 1341–75), not in that of
Ambrogio Lorenzetti. The documented Loren-
zettian miniatures of Choral No. 4 in the
Cathedral Library at Siena, a signed triptych
of 1358 in SS. Domenico e Sisto in Rome, and
a fragmentary signed fresco of the *Annunciation*
of 1372 in S. Domenico in Siena are the stylistic
basis of his work. The latter stretches from
the documented miniatures to the vast, chaotic
battle panorama of 1363, painted in grisaille in

the Council Chamber of the Palazzo Pubblico
in Siena. His mural in the Seminary in Siena
is a thoroughgoing attempt to counterfeit a
standard, full-scale polyptych of the Virgin and
Saints, complete with every detail of its gilded
wooden frame [334]. Such representations,
taken together with the number which occur
upon the altars shown in individual narrative
scenes, provide invaluable evidence of the
overall appearance and relative disposition of
the pinnacles which have, for the most part,

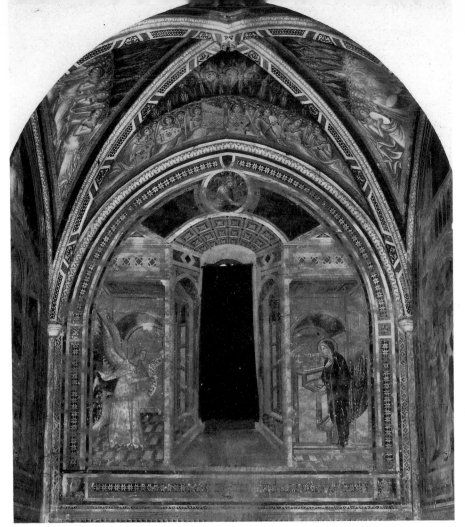

335. Lippo Vanni: Annunciation, *c.* 1350–65.
S. Leonardo al Lago

vanished even from those actual altarpieces with surviving original frames. Lippo's major surviving works are, however, the frescoes of the Life of the Virgin in S. Leonardo al Lago, near Siena.[3] Delicate colour, airy architectural complexity, and an obvious interest in breaking down the barriers between the observer and the sacred stories are everywhere apparent. Already in the frescoes at Monte Siepi, closely associated with Ambrogio Lorenzetti, painted architectural detail had been used to harmonize the three-dimensional window-embrasure with the painted architecture of the calm, majestic *Annunciation* that it cuts in half. At S. Leonardo the receding planes of a similar embrasure actually become the foreshortened sides of the aediculae in which the Annunciation takes place [335]. Three-dimensional reality is used to add the final touch of realism to a whole-hearted attempt at perspective illusion. It is typical of such intriguing visual juggling by minor masters that the actual constructions used are

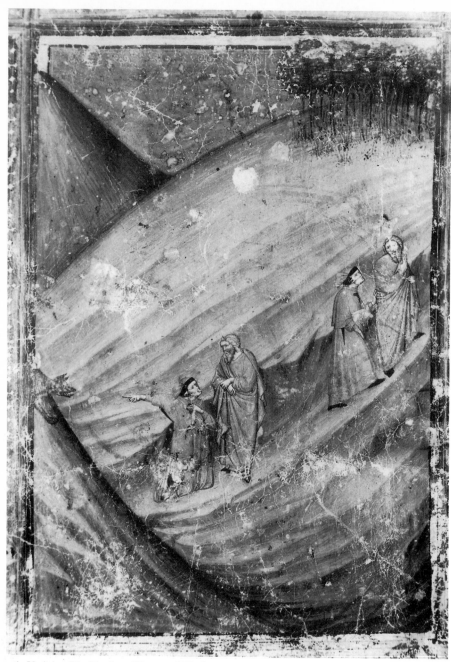

336. Umbrian: The Meeting of Dante and Virgil, MS. L.70, f. 2, mid fourteenth century.
Perugia, Biblioteca Augusta

technically incompetent and even confused. The architecture, which now dominates the subject matter, shows Vanni's complete disinterest in the theoretical advances made during the first half of the century by the Lorenzetti, the very men who, together with Simone Martini and Lippo Memmi, dominated his entire artistic life and on whose style his own was founded.

Manuscript illumination and panel painting were often combined in Siena, and in the case of Nicolo di Ser Sozzo Tegliacci illumination predominated.[4] Simone, Memmi, and the Lorenzetti are again in differing proportions the dominant influences on a career that seems to have stretched from the thirties or forties to his death in 1363. The greater inventiveness of Lippo Vanni, who succeeded him, is demonstrated by such memorable images as the figure of God looming above an O-encircled landscape in the Fogg Antiphonal. Nevertheless, the luminosity and refinement of Tegliacci's miniatures set him at the peak of mid-century Sienese achievement, and whether it belongs to Tegliacci or to Vanni or to some Umbrian associate, the rolling, heaving ocean-swell of rocky landscape in the full-page miniature of the *Meeting of Dante and Virgil* on fol. 2 of MS. L.70 in the Augusta Library at Perugia can hardly be surpassed [336].

In 1362 Tegliacci and Luca di Tommè, who is documented between 1356 and 1389, signed a polyptych now in the Pinacoteca at Siena. The close-knit quality of Sienese artistic life is illustrated by the fact that the prolific Luca is last mentioned working in cooperation with Bartolo di Fredi and his son Andrea. Similarly, the first mention of Andrea Vanni concerns the workshop that he shared with Bartolo from 1353 to 1355. Andrea Vanni's surviving masterpiece is the signed rectangular triptych of the *Agony in the Garden, Crucifixion*, and *Descent into Limbo* in the Corcoran Gallery in Washington [337]. It is as superb in execution and colour as it is conservative in terms of landscape realism and the like. The sweeping movements of the figures gain emotional and visual impact from the slashing colour contrasts. For the most part these are built up through the juxtaposition of a mere handful of brilliant, basic hues. The rhythmic continuity of the landscape and figure horizons throughout

337. Andrea Vanni: Agony in the Garden, Crucifixion, and Descent into Limbo, fourteenth century, third quarter. *Washington, Corcoran Gallery*

the three panels, the symmetry of the main masses, and the enlivening flow of figure movement over the entire surface reveal the skill and purpose with which artists such as Vanni could manipulate their carefully restricted terms of reference. His technical powers again reveal themselves in the Saints and Virtues of the slim candlestick on loan to the Metropolitan Cloisters in New York. Its diminutive figures are as finally compelling as they are initially unobtrusive.

Another link between these Sienese painters is their new political and social role. It stemmed from the steady movement of power away from the close-knit oligarchy of the Nove towards an alliance of nobles and lesser bourgeoisie subsequently known as the Dodicini. The latter held power from 1355 to 1368, only to give way, in their turn, to the most broadly based republican régime in Tuscan history. In the period 1368 to 1385 not only were the nobility and the middle classes fully represented but the lower middle classes held a political majority corresponding to their numbers. In 1363, 1368, 1369, and 1373, Andrea Vanni, who was in close contact with St Catherine of Siena, held a series of minor civic posts. He was a member of the General Council in 1370, 1372, and 1380,[5] Gonfaloniere of the Terzo of St Martin in 1371, Rector of the Opera del Duomo in 1376, and Capitano del Popolo in 1379. In 1372 he went as an Ambassador to Avignon and in 1383–5 he was Envoy to Naples. What is significant is not that one man reached such civic eminence, but that similar though less distinguished appointments punctuate the careers of Bartolo di Fredi, Lippo Vanni, Luca di Tommè, Nicolo Tegliacci, Paolo di Giovanni Fei, Taddeo di Bartolo, and many other lesser masters.

The transition from mid- and late-fourteenth-century to early-fifteenth-century painting is most richly documented in the careers of Paolo di Giovanni Fei and Taddeo di Bartolo. Fei is recorded between 1372 and 1410, and the key to his work, based on Simone and the Lorenzetti, is the signed polyptych in the Pinacoteca at Siena. His most important surviving painting is, however, the large, undocumented triptych of the Birth of the Virgin in the same gallery [338]. In it, a great elaboration of Pietro Lorenzetti's panel of 1342 [231], involving many more figures and a much deeper principal space, is accompanied by an ambiguous relationship between this main space and the adjoining garden-room. The apparent discontinuity in an actually continuous design is greatly accentuated by the sudden transition to the relatively enormous figures of the four flanking saints. That comparatively thick, painted pillars should subdivide the unified main space, while the merest sliver of frame does virtually nothing to moderate the contrast with the flanking panels, is characteristic of the period.

Taddeo di Bartolo, who is first mentioned in 1386 and died in 1422, represents a different aspect of turn-of-the-century eclecticism. Apart from the Last Judgement of 1393 in the Collegiata at S. Gimignano, the bulk of his surviving work was painted after 1400. It centres round the frescoes in the Chapel of the Virgin in the Palazzo Pubblico in Siena (1406–7) and those of the Civic Virtues and Roman Heroes in the ante-chamber of the same chapel (1413–14). The crowded completeness of the decorative scheme, the piling up of detail in agitated compositions notable for sudden, almost wild experiments in extreme foreshortening, are redolent of an almost feverish Late Gothic world already on the verge of being swept away by the events in Florence. On the other hand, the emphasis on specifically Republican Heroes in the later series echoes the humanist researches that were helping to transform a constantly resurgent classical tradition into a true Renaissance.[6]

THE DECORATION OF THE CAMPOSANTO IN PISA

Barna's frescoes in S. Gimignano are one point of entry into the changing world of later-fourteenth-century art. The opening stages of the decoration of the Camposanto, culminating in the Triumph of Death, the Last Judgement, and

338. Paolo di Giovanni Fei: Birth of the Virgin, 1390/1400.
Siena, Pinacoteca

the *Legends of the Anchorites*, are another. In the *Last Judgement* Christ and the Virgin are set side by side in separate mandorlas, and Christ concentrates upon a single condemnatory gesture. The traditional balance between the Blessed and the Damned has been maintained, but Hell has swollen to become almost a separate scene, running the full height of the wall and rivalling the whole of the rest of the *Last Judgement* in size. The change in relative proportion expresses the sense of guilt and the awareness of the just and terrifying wrath of God that follow the disasters of the forties and permeate the art of the fifties and

339. Francesco Traini(?): Triumph of Death, early 1350s(?).
Pisa, Camposanto

sixties. The sharpened realization of the eva-
nescence of earthly life is nowhere more poign-
antly expressed than in the *Triumph of Death*
[339]. The setting of Boccaccio's Decameron,
written in 1348–53, is inevitably recalled by the
seated group of maidens and young men who
make sweet music as death plunges down into
the peaceful grove. The regular pattern of the
tapestry of flowers recalls the frescoes in the
Papal Palace at Avignon and the influence of
Simone and the Lorenzetti is clear in many of
the figures. The flying putti, on the other hand,
insist that this is still the Pisa of the Pisani with
its heritage of Antique remains. The centre of
the scene is filled with piled-up corpses flanked
by cripples and aged beggars. A blinded leper
with flesh falling from his bones and both hands
eaten from his outstretched arms beseeches
death to come, and death will not, being intent
upon the lovers in the glade. There is a
maximum of contrast both with the idyllic scene
upon the right and with the cavalcade of court-
iers on the left as they encounter the three
corpses rotting in their coffins. The theme of
judgement, fully elaborated in the succeeding
fresco, is introduced by the angels and devils
battling in the sky. The vanity of life is made
explicit in the various inscriptions. Peace, and

a long-lasting freedom even from the toils of
earthly death, is illustrated by the aged Anchor-
ites clustered round their hillside church. The
theme is subsequently fully treated in the
Legends of the Anchorites and counters any tend-
ency to see the fresco as a simple outcry at the
cruel arbitrariness of death. Nevertheless, such
pagan protest is a significant undercurrent
throughout the period. Open irreligion and, in
large sections of the laity and clergy alike, an
almost feverish moral laxity and self-indulgence
were seemingly as common a reaction to the
uncertainty of life as penitence and religious
fervour. The *Trials of Job* a few yards down the
wall reiterate the orthodox view of the nature
and meaning of the lavishly distributed pain
and suffering that are part of life itself [341].
The probable influence of the Dominicans
of S. Caterina on the entire programme is
disclosed by the relationship between the
eremitical scenes and the vernacular *Vite dei
Santi Padri* written by the Pisan Fra Domenico
Cavalca (d. 1342). The increase in artistic
emphasis upon the Vita Contemplativa and the
eremitical ideal throughout the second half of
the century is one significant reaction to the
moral and spiritual as well as to the economic
and social stresses of the day.

The placing of the *Legends of the Anchorites* after the *Last Judgement* and next to the vast scene of Hell means that a series of abrupt contrasts, similar to those that underlie the opening composition of the *Triumph of Death*, embraces the entire sequence. The planar distribution of the *Last Judgement* differs from the more clearly spatial Giottesque pattern. It is matched by the piling up of the adjoining landscapes and by their tendency to a thoroughgoing compartmentalization. The spatial continuities established by the leading artists of the first half of the century are broken up into a series of individually three-dimensional compartments. The denial of the laws of diminution within the series and the absence of a consistent viewpoint create a surprisingly planar final effect. Such methods are as characteristic of many of the Northern and Central Italian artists working in the latter part of the century as is the virtual abolition of pictorial space that occurs in the work of others.

Continuous controversy surrounds the problem of whether the frescoes should be attributed to the Pisan Francesco Traini, already mentioned in the documents as active in 1321 and possibly surviving until after 1363, or to an Emilian artist from the circle of Vitale da Bologna. The Emilian elements connected with Vitale's highly emotional style are as obvious as the detailed connexions with Traini's one signed work, the altarpiece of S. Domenico, dated 1345, now in the Museo Civico at Pisa. The argument therefore boils down to whether the work is by an Emilian, influenced by Traini and the Sienese, or by Traini, strongly influenced by the Emilians during a visit to Northern Italy that is reflected in certain frescoes in the baptistery at Parma.[7] On the whole the latter hypothesis seems to be the more attractive and the frescoes are unlikely to have been painted much later than *c.* 1350.[8]

The war-time damage which reduced the frescoes in the Camposanto to ruinous shadows of their former magnificence has, in partial compensation, disclosed one of the most extensive series of fourteenth-century under-

drawings or sinopie so far known in Italy. They are a mine of information about the different hands cooperating on the various frescoes, about their compositional methods, and about the evolution of the final designs. The drawings beneath the *Triumph of Death* [340],

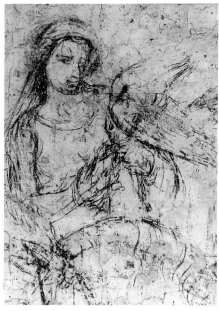

340. Francesco Traini(?):
Triumph of Death, detail of sinopia, early 1350s(?).
Pisa, Camposanto

in particular, combine boldness and freedom with a psychological depth and power of characterization that is often buried almost without trace beneath the precise stylizations, the firm contours, and the carefully built up modelling, which, together with the colour, add new decorative dimensions to the final work. In the *Legends of the Anchorites* the emotional intensity is, on the contrary, if anything increased in the final work. The picture of the evolution of the fresco is, however, enriched by the way in which a more disciplined and less evocative system of brush contours is built up into full chiaroscuro modelling in many of the figures. As artist

341. Taddeo Gaddi(?): Trials of Job (detail), early 1350s(?).
Pisa, Camposanto

succeeds artist on the decorative scheme; Francesco da Volterra and his associates (1371–2); Andrea Bonaiuti da Firenze (1377); Antonio Veneziano, with his intricate and precise architectural underdrawings (1384–6); Spinello Aretino (1391–2); Piero di Puccio, coming from the mosaics of the façade at Orvieto (1381–7) and working from 1389 to 1391; the series becomes a textbook of late-fourteenth-century working processes. Nevertheless, except in the work of Antonio Veneziano, the generally modest level of performance is transcended only in the sudden vision of a desolate seascape in the opening scene of the *Trials of Job* [341]. Whether or not the common attribution of the seascape to Taddeo Gaddi can be justified, its visual poetry rivals or surpasses that in any work by Maso or the major followers of Giotto.

ANDREA ORCAGNA, NARDO DI CIONE, AND JACOPO DI CIONE

Andrea di Cione, or Orcagna, painter, sculptor, and architect, was undoubtedly the most important Florentine artist of the third quarter of the fourteenth century. Judging from his customary signature he was primarily a painter, until 1366, when he became adviser on the construction of the cathedral of Florence, he was a frequent and evidently leading member of various commissions, including the one that evolved the definitive design. Lost works such as the frescoes in the choir of S. Maria Novella, commissioned in 1350, testify to a fame which

342. Andrea Orcagna: Christ in Majesty and Saints, 1357.
Florence, S. Maria Novella, Strozzi Chapel

customary signature he was primarily a painter, and was active from 1343 to 1368, the probable year of his death. He was capomaestro of Orsanmichele by 1356 and signed the sculptured tabernacle for that church in 1359, a year after he had become capomaestro of Orvieto Cathedral. At Orvieto he was chiefly concerned with one of the much restored mosaics of the façade and is frequently mentioned until 1362. From 1356 now rests largely on his surviving masterpiece, the signed and dated altarpiece of 1357 in the neighbouring Strozzi Chapel [342].

In theme and form alike the Strozzi altarpiece is of unique importance in establishing one of the major trends in late-fourteenth-century Florentine art.[9] The central figure of the adult Christ, suspended within a mandorla of seraphim, is unprecedented in fourteenth-

century Florentine and Sienese altarpieces. In an age marked by increasing emphasis on the non-rational and specifically supernatural elements of religious history and belief, it epitomizes a growing tendency to turn back to the hieratic and transcendental patterns of the early thirteenth century. The frame, which surviving drawings show to be a reasonably accurate reconstruction, marks a compromise between the completely unified main fields of the early-fourteenth-century Sienese altarpieces and the standard compartmental polyptych. Notional columns are incised into the golden ground, passing behind the figures and linking the pendentives of the frame to the upper edge of the ground plane. The absolute verticality of this ground plane with its regular, unforeshortened pattern asserts the non-existence of the space within which the solid-seeming figures of the attendant saints are set. Similarly, the spatial continuity and physical relationship implied by the unification of the surface and by the gestures of the supporting figures are rendered unreal by the staring, frontal pose that establishes the symbolic nature of the central figure. The brilliance of the colouring, the sculptural or metallic harshness of the modelling, and the space-annihilating emphasis on contour that accompanies the apparent plasticity of the internal forms add to the constant tension. The naturalistic and descriptive elements from the immediate past are used as the building blocks of a non-rational and non-naturalistic whole.

When handled with equivalent economy and skill, such unions of opposites are disturbingly effective. In less sophisticated but no less ambitious hands they can and do lead readily to mere confusion. The precision of Orcagna's purpose, and the school in which he learnt his subtlety of design, are underlined by the extreme economy and straightforward spatial realism of the three predella panels. The derivation from Bernardo Daddi, at its clearest in the brilliant handling of silhouette, does nothing to detract from Orcagna's personal skill in relating the compositions both to each other and to the main panel of the altarpiece above.

A similar discipline on an extended scale must once have lent distinction to his ruined frescoes of the *Triumph of Death*, the *Last Judgement*, and *Hell*, in S. Croce. The frescoes are reasonably attributed to him on stylistic grounds and probably date from the sixties. The loose, tripartite grouping so effectively built up by the successive scenes in the Camposanto in Pisa has been contracted into an actual triptych.[10] It is enclosed in a single frame and articulated by two twisted columns. The

343. Andrea Orcagna(?):
Last Judgement (detail), 1360s(?).
Florence, S. Croce

controlled conception of the whole, however crowded with detail, must once have been as striking as the volumetric discipline of the surviving individual figures. The general ascendancy of painting over sculpture, thoroughly established by this time, is reflected in Orcagna's personal career, and in these frescoes the planes and volumes of the human form are more tellingly defined than in his actual sculpture. In all the multitudinous detail of his tabernacle in Orsanmichele there is no equivalent for the swift economy of the unblended strokes with which enclosing contours and internal details are established and a pair of battling nudes [343], a hairy devil, or a sweep of flaxen tresses conjured out of the dark ground.

Andrea's brother Nardo presents a quietly distinctive artistic personality.[11] He too matriculated between 1343 and 1346 and is mentioned as living with Andrea c. 1347. He died late in 1365 or early in 1366 and his major work, the *Last Judgement, Paradise, and Hell* on the walls of the Strozzi Chapel in S. Maria Novella, was probably painted in the fifties. In the chapel itself the eye can hardly cope with the frescoed tapestry of some two hundred or so figures piling up the wall. Inevitably, all but the lowest handful assume the anonymity of a football crowd. Only in photographs or with a powerful glass can the gentle beauty of his female heads and his real talent for variety and individuality of feature be appreciated. The classic centaurs prancing round the centre of his medieval Hell are a reminder that no easy generalizations can do justice to the artists of the period or to the extreme variety of the crosscurrents of ideas that underlie their art.

Jacopo di Cione, the younger brother who matriculated in 1368–9, was active between 1362 and 1398. He completed the St Matthew altarpiece, with its almost sculptural centre figure, which Andrea had left uncompleted in 1368 and which is now in the Uffizi. He slips down much more swiftly than Nardo into the pool of minor Orcagnesques in whom the tension of Andrea's art is dissipated, to be replaced by a soft, decorative style. The tend-

ency, as in the *Coronation* in the National Gallery in London, is towards elaborate damasks; to pale roses, apple greens, and blues; to pinkish whites, light yellows, and vermilions, and to symmetries that involve the exact repetition of the most intricate textural and colouristic detail in a manner comparable, in gentler terms, to the rich Venetian decorative schemes associated with Lorenzo Veneziano.

GIOVANNI DA MILANO AND GIOVANNI DEL BIONDO

Orcagna's Lombard contemporary Giovanni da Milano was probably in Florence as early as 1350, becoming a citizen in 1366, and is last heard of in Rome in 1369. His major surviving work is the decoration of the Rinuccini Chapel in S. Croce in Florence. The contract was signed in 1365, and the lower scenes on either wall were evidently completed by an assistant. Despite close links with Nardo, the sensitivity of the colour and, still more important, the emotional intensity of the designs are much more reminiscent of Barna.

In the *Expulsion of Joachim* the power of the Church and the dire consequences of exclusion from its rites are powerfully expressed [344]. The frontality, the mass and lateral extension of the five-aisled church; the serried ranks of faithful, receding in impassive profile; the sweeping gestures of obeisance that help to concentrate attention on the towering central figure of the high priest; the fierce intensity of the exchange as Joachim looks back over his shoulder at the priest who casts him out; it is from the accumulation of such details of design that compositional and psychological tension is created. In Giovanni's only other dated work, the signed three-quarter-length panel of the *Pietà*, also of 1365, the crowding of figures and a sense almost of vertical extrusion are the visual vehicles of intense emotion. In his major surviving altarpiece, the signed polyptych in the Galleria Comunale in Prato, with its two-tier predella, the main source of tension lies, however, as much in the interaction between the

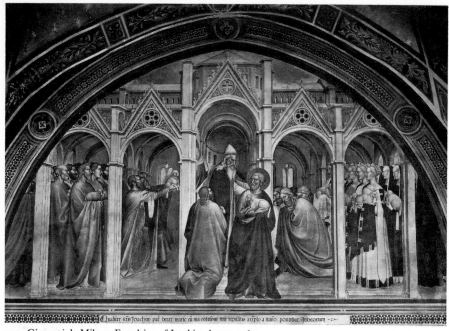

344. Giovanni da Milano: Expulsion of Joachim, begun 1365.
Florence, S. Croce, Rinuccini Chapel

individual images and the decorative richness of their frames as in the actual designs themselves.

The emotional charge in the work of Giovanni del Biondo, whose career is documented from 1356 to 1392, is carried by the wiry harshness of the drawing, the metallic hardness of the forms, the violence of the colour contrasts, and at times by the ferocity of symbolism. In the altarpiece in the Contini Collection in Florence the Baptist tramples upon Herod [345], and in the panels preserved in the Uffizi and the Duomo the enthroned figures of St John the Evangelist and St Zenobius crush the Vices under foot. The positive quality in the impassive, frontal poses and the intensity in the staring eyes distinguish such images from the passive conservatism common in the work of many minor and provincial artists. Nevertheless, the transition from such highly charged creations to the gentle, decorative theme of the Madonna

piece, exemplified in his final, signed and dated panel of 1392, is even more clearly defined than in the work of Giovanni da Milano. Even so there are surprises. The secondary theme of personal salvation that accompanies the common motif of the Virgin and Saints in the attributed Vatican panel (no. 14) is treated in a manner only possible in the wake of Traini's *Triumph of Death*. Above, the soul's reception by a heavenly, winged Virgin is accompanied by the peaceful prettiness and familiar decorative elaboration of the main scene. Below, there lies a rotting, worm-infested corpse.

The format of Giovanni's *St John the Baptist* altarpiece with a standing saint and vertical tiers of scenes from his life on either side goes back as far as Bonaventura Berlinghieri's Pescia *St Francis* of 1235, and beyond. The austere frontal poses, the arbitrary scaling, and the generally hieratic quality of his *St John the*

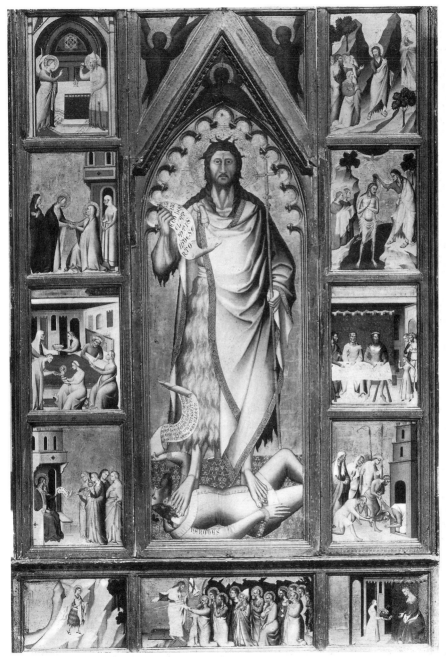

345. Giovanni del Biondo: St John the Baptist and Scenes from his Life, *c.* 1370/80.
Florence, Contini Collection

Evangelist and *St Zenobius*, and of many similar figures by Giovanni da Milano or Orcagna and his circle, immediately recall the Romanesque low-relief *Madonna del Voto* in Siena or the works of Coppo or the Bigallo Master. The dramatically stark, emotionally compelling forms, with their paradoxically equal emphasis on silhouette and volume, to be seen in the *Pentecost* [346], by a close follower of Orcagna,

None of this leads logically to the conclusion that there was an abrupt, aesthetically based return to Romanesque ideals of form in order to express the new religious attitudes.[13] The tendency to look not only at the immediate past, but back a hundred years or so, in order to invigorate the present, is endemic in Italian art. The opening quarters of the fifteenth, sixteenth, and seventeenth centuries alike each reveal, in

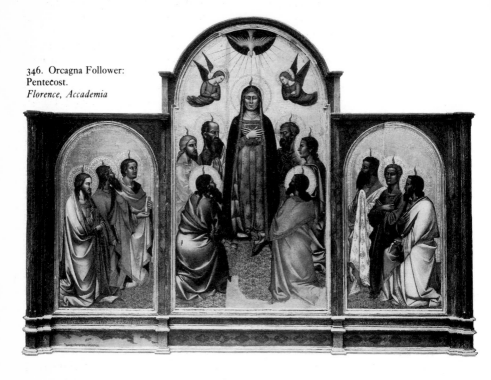

346. Orcagna Follower: Pentecost.
Florence, Accademia

are enclosed within a round-arched triptych which, if it recalls the format of triumphal arches, is even more closely allied to the cross-section of the nave and aisles of a barrel-vaulted church or to the round-arched terminations of the choir and flanking chapels of innumerable surviving Romanesque wooden-roofed constructions, large and small. Of these, the Florentine church of SS. Apostoli, in which the altarpiece once stood, is itself an example.[12]

their own way and for widely differing reasons, a closely analogous phenomenon. In the late fourteenth century, particular attention must likewise be paid to the strengthening of the broad stream of conservatism both in taste and in artistic production by the new patterns of patronage. Major examples of the originally Romanesque format of the standing saint and flanking scenes were produced in every decade of the fourteenth century. Ambrogio Loren-

zetti's *Madonna* of 1319 is closer in many ways to its Romanesque precursors than any of its later-fourteenth-century successors. The round arches of the *Pentecost* do not betray historicism of a kind which would be thoroughly anachronistic. Quite simply, they reflect their own surroundings and the fact that major buildings started in the second half of the century carried on the round-arched form which, in Florence just as in Siena, was still current during the preceding fifty years. Indeed, the actual forms of the surviving framework of the altarpiece are closely related to those of Talenti's contemporary nave piers for the Duomo. In terms of format, it is continuity reinvigorated and transformed, not revolution, which is represented in such altarpieces as the *Pentecost*, just as it is in Andrea Orcagna's round-arched Tabernacle for its round-arched setting of the 1330s in Orsanmichele [141].

ANDREA BONAIUTI DA FIRENZE

The most explicit statement of official reaction to the spiritual turmoil of the times occurs in Andrea Bonaiuti's decoration of the chapter house, or so-called Spanish Chapel, of the Dominican Friary of S. Maria Novella in Florence [347]. Even the financial provisions for these frescoes, which Andrea, in December 1365, promised to finish within two years, are typical. They stem, like the building of the chapel itself, from gifts made by a wealthy merchant, Buonamico di Lapo Guidalotti, in the wake of the Black Death. Six scenes from the Life of St Peter Martyr cover the entrance wall, and on the altar wall the *Road to Calvary*, the *Crucifixion*, and the *Descent into Limbo* are treated as a single, continuous space. The price of continuity is the absolute suspension of the laws of diminution. Particularly in the *Road to Calvary*, with its iconographic reflections of Duccio and Simone, the effect is virtually to turn the clock back forty years. The Lorenzettian crowding of the *Crucifixion*, on the other hand, would not have been possible in Florence before the sixties. Similarly, the two enormous

and iconographically original single frescoes of the *Road to Salvation* and the *Apotheosis of St Thomas*, filling either side wall, are, like the programme as a whole, an intimate reflection of important aspects of the intellectual and artistic currents of their day. The size of these two compositions, and the carrying of the landscape and figure patterns over virtually the whole available surface, connect them with Nardo di Cione's frescoes in the near-by Strozzi Chapel and with those ascribed to Traini in the Camposanto at Pisa [339]. There is an almost tapestry-like effect, and the upward movement through a wealth of detail to a point of final concentration high on either wall establishes the vertical connexion with the iconographically linked and predominantly ascending themes upon the vaults. Above St Thomas, the ultimate embodiment of Church doctrine, is the Pentecost, the moment of divine enlightenment. Above the Crucifixion is the Ascension, and in the Navicella, above the Road to Salvation with its prominent 'ecclesia', the vessel of the church sweeps by, its sails filled by the winds of heaven.

Where Ambrogio Lorenzetti ran the gamut from pure allegory to pure landscape naturalism, Andrea's realism is almost exclusively confined to details. It extends from a prophetic portrait of the then unfinished cathedral of Florence to the choir stalls of the Virtues; from gravely dancing maidens to the piebald 'domini canes' hounding the wolves of heresy. As it winds upwards from the enthroned, frontal figures, embodying the rock-founded powers of the Church, to the gates of paradise and to the remote, apocalyptic Godhead, enclosed in a mandorla and guarded by the evangelistic symbols, the Road to Salvation is still more thoroughly devoid of spatial connotations than was the compartmental yet relatively solid landscape of the Legends of the Anchorites in the Camposanto at Pisa. The landscape element involves no greater spatial penetration than do the enthroned ranks of personifications and exemplars of the Theological Sciences and Liberal Arts in the *Apotheosis of St Thomas* on the opposite wall. The superficially more

347. Andrea da Firenze: Frescoes, begun 1365.
Florence, S. Maria Novella, Spanish Chapel

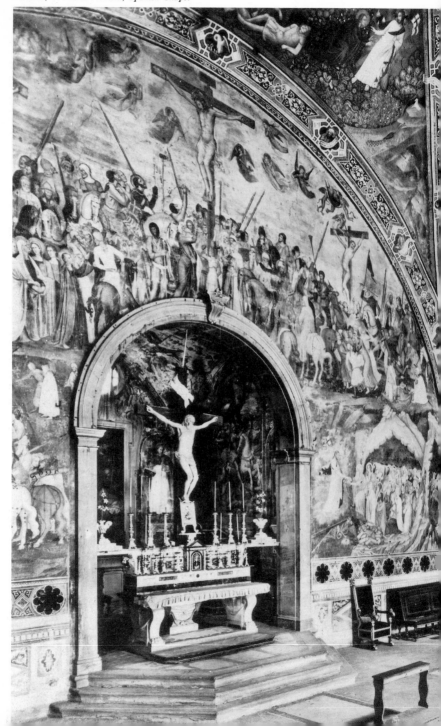

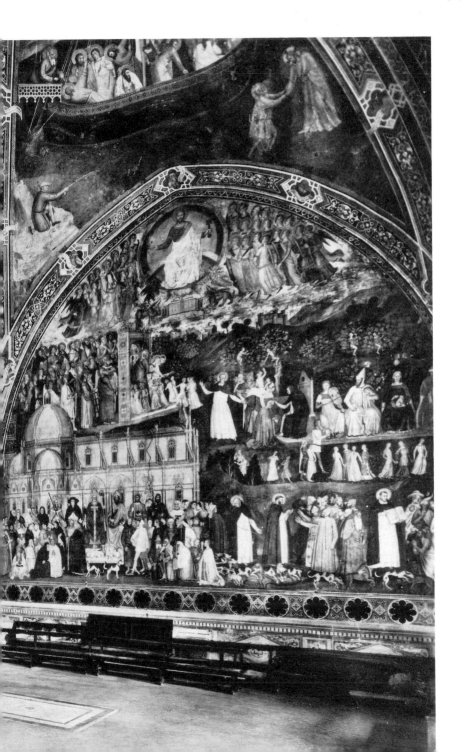

decorative aspect of the Road to Salvation does not disguise the thoroughly impersonal and intellectual basis of the whole scheme. The disciplines that underlie St Thomas's *Summa Theologiae* and the confusion of the heretics Sabellius, Averroes, and Arius are displayed on one wall. On the other the irresistible power of the Church and the rigid application of doctrinal truth lead to salvation. It is firstly with the suppression of heresy, epitomized in the person of St Peter Martyr, whose story fills the entrance wall, and only secondly with the rejection of the pleasures of the world, that the Road to Salvation is concerned. Although the Seven Virtues fly about St Thomas on the opposite wall, the individual soul's personal struggle against the Seven Deadly Sins is not the primary concern of allegories specifically intended to remind the friars of their order's special role.

Although the origins of the cycle may well lie in the personal friendship between Guidalotti and Jacopo Passavanti, the great preacher who was prior from 1354 to 1357, its themes were not directly taken from his *Specchio di Vera Penitenza*. In general the series was a reaction against the onslaught on Church institutions made by men such as Marsilio of Padua in the first half of the century. In particular it was a reassertion of the prime part in the preservation of these institutions played by the Dominician Order, despite the secular clergy's renewed attempts during the fifties to curb the mendicants' power.[14] It was a calculated blow in the continuing struggle over Averroes, who had been condemned by St Thomas himself, but whose position as a major theologian was still supported in the universities both of Padua and Bologna. It was also an implicit reminder of the threat presented by the flagellant bands and by the growing influence of the Fraticelli in Florence itself as well as in Tuscany as a whole. The following of these descendants of the thirteenth-century Franciscan Spirituals, condemned by John XXII in 1323, was such that mysticism of every kind was suspect to the authorities. St

Catherine of Siena herself was summoned in 1374 to answer to a charge of heresy at a chapter assembled in the chapel under the General of the Order, and was there assigned a spiritual adviser to ensure doctrinal purity for the future. The well-documented power of images not merely to reflect but to create new attitudes and to form the pattern of men's thoughts provides the background for such miracles as the Conversion of St Francis by the speaking Crucifix. The exact forms taken by a number of St Catherine's mystical experiences can be related to the familiar imagery of Tuscan art. The Spanish Chapel gives implicit recognition of the relevance of visual images to the intellectual concepts of the learned as well as to the intuitions of the mystic or the piety of the unlettered.

AGNOLO GADDI AND SPINELLO ARETINO

Agnolo Gaddi is the most important of the three painter sons of Taddeo Gaddi. Between them Taddeo and Agnolo span the gulf that separates the work of Giotto from that of Lorenzo Monaco and the Late Gothic painters of the first quarter of the fifteenth century. Agnolo's known career stretches from youthful activity in the Vatican in 1369 to his death in 1396, when he was working on his extant altarpiece for S. Miniato al Monte. He received a first payment for the latter in 1394, and in 1392–5 he is documented as working with a string of assistants on the frescoes in the Cappella del Sacro Cingolo in the Duomo at Prato. If the *Coronation* in the National Gallery in London, with its absolute symmetries of form and colour, is indeed an early work, it would indicate the parentage of his early style in the Baroncelli altarpiece from Giotto's workshop. The most important of the surviving works attributed to him, the frescoes of the *Legend of the Cross* in the choir of S. Croce, are usually dated *c.*1380 [348]. Taking his starting point in certain aspects of his father's style, he recomposes the objects of the natural world so radically that a world of fantasy is created. The

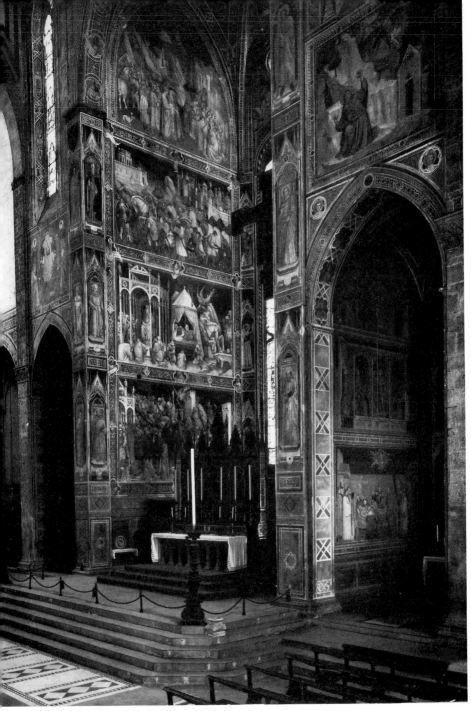

348. Agnolo Gaddi: Legend of the Cross, *c.* 1380(?).
Florence, S. Croce, choir

compositions are so crowded, the juxtaposition of succeeding episodes so rapid, the reversals of the natural laws of diminution and of relative size so violent and continuous, that formal tensions of the Orcagnesque variety do not arise. The dream-like quality, which makes the natural facts largely irrelevant, is heightened by the decorative impact of the cycle as a whole. In this the colour plays a leading part. Agnolo's delicate, light-hued palette, with its emphasis on white and yellow and its innumerable decorative colour changes, is typical of a general change of key in contemporary painting and is the crowning glory of his own art. Taddeo and his generation used a natural tonal sequence to create solidity through colour change. It allowed them, for example, to escape the limitations imposed by the very narrow range from highlight to the darkest shadow in yellow as compared with blue. Within the natural sequence, running from white to yellow and on to apple green and orange and vermilion, blue-green, deep rose-red, and finally to blue and black, the process of creating solid forms upon the walls of often ill-lit churches by using different colours for highlights and shadows already makes for great chromatic brilliance. Where Giotto or Taddeo were content to move from yellow highlight to green shadow, Agnolo, by careful manipulation of the relative saturation of his hues, often progressed from a green shadow up to a pale, rose-red highlight, in reversal of the intrinsic tonal sequence of the colours concerned. He and his generation freed themselves and their followers from the last restrictions imposed by the already highly flexible early-fourteenth-century system. The exploitation of the infinite permutations that result is only limited by the sensitivity of the individual artist's eye and by his ability to control the enormously increased complexity of the ensuing colour pattern.[15]

Agnolo's skill in orchestrating the chromatic melodies of his teeming compositions extends to the intervening windows which complete the decorative and thematic unit.[16] From the roundel in the Duomo at Siena to Andrea da Firenze's luminous *Coronation* in S. Maria Novella, the tradition of stained-glass design by leading Tuscan painters is continuous. Often, like Maso or Andrea da Firenze, the painter worked upon the glass itself. In other cases, the intervention of his workshop in design and of the glass workers in execution leads to wider stylistic variation. The normality of such collaboration is shown in the *Trattato* written towards the end of the century by Antonio da Pisa, a leading glazier who signed one of Agnolo's documented windows for the Duomo. He recommends paying close attention to the adjacent works. Where there is doubt about the appropriate dress or colour for the various saints the precedents laid down by the painters should be followed. He gives the rules for colour combinations. He describes the methods of designing and executing windows, beginning with a full-scale charcoal drawing upon paper which is later fixed in ink and finished as if it were a drawing upon panel. In view of Agnolo's glass designs and of the growing emphasis on yellows and upon plain glass, his statement that it is very good for thirty-nine parts of every hundred to be kept white is especially interesting. The bold massing of the colours and the skilful use of white are notable features of the glass which is apparently contemporary with Nardo di Cione's frescoes in the Strozzi Chapel in S. Maria Novella, and a comparable shift in taste occurs in France and England.

The survival of the craft outlook and the slow passage of evolutionary time outside the tiny circle of major innovators are still more richly documented in Cennino Cennini's *Libro dell'Arte,* which was probably written in the 1390s. Cennino proudly claims to have been trained for twelve years under Agnolo Gaddi in the tradition handed on from Giotto through Taddeo. He deals with every aspect of the painter's craft, from fresco and panel painting and their methods and materials to working upon parchment, cloth, and glass, as well as on caskets and statuary, and even concludes with a section on life-casts. He defines the 'occupation

known as painting' as one 'which calls for imagination, and skill of hand, in order to discover things not seen, hiding themselves under the shadow of natural objects, and to form them with the hand, presenting to plain sight what does not actually exist. And it justly deserves to be enthroned next to theory, and to be crowned with poetry'.[17] Great emphasis is placed on drawing and upon the proper observation of the fall of light when copying in chapels. He speaks of the importance of maintaining the original proportions in the copy, and in the light of the extreme accuracy with which stylistic information was transmitted across Europe his sections on tracing paper and its uses are particularly interesting.

Cennini underlines the dangers of reading modern meanings into old texts. There is the famous dichotomy between the splendid mixed metaphor in which he declares that 'The most perfect steersman that you can have, and the best helm, lie in the triumphal gateway of copying from nature. And this outdoes all other models ...';[18] and a second passage in which he announces that 'If you want to acquire a good style for mountains and to have them look natural, get some large stones, rugged, and not cleaned up; and copy them from nature ...'.[19] Ambrogio Lorenzetti might never have existed, and the passage exactly reflects the late-fourteenth-century Tuscan combination of intense realism in certain kinds of detail with an almost purely conventional treatment of many of the larger aspects of the natural world. Cennino's advice on linear perspective, which simply states that the upper mouldings of a building should slope downwards, those in the middle be level, and the lower ones slope up, shows a similar unawareness of the investigations of Giotto, Maso, and the Lorenzetti. It is not that he is anti-Giottesque. Quite the contrary. No one could have been more proud of his Giottesque heritage. He is simply unaware of the nature of Giotto's art. In this he reflects the conservatism which is fundamental to the overwhelming majority of artist–craftsmen even in the most progressive centres.

The conservatism of the painters was, however, as nothing to that of most of their employers. The archives of Francesco di Marco Datini of Prato deal with every aspect of the life and business of a rich merchant active in international trade. They also show just how a leading painter such as Agnolo Gaddi, working like any other craftsman for his day-wage, could be treated when it came to paying the bill. Together with Niccolo di Pietro Gerini and another painter, he was simply turned out of the house. It was only after several months' delay and recourse to arbitration that he was finally paid.[20]

Niccolo di Pietro Gerini (active 1368–1415) is one of several prolific minor masters who owe their historical importance to their influence on the painters of the first half of the fifteenth century who provide the background against which Masaccio and his fellows must be seen. The major Early Renaissance figures may themselves have been affected by the subtlety of tone and colour demonstrated by artists such as Antonio Veneziano in his Pisan frescoes. It is, however, Lorenzo Monaco who carries Agnolo Gaddi's own approach into the fifteenth century. The further possibilities of his clear, complex colour harmonies are explored. An almost Chinese fantasy and delicacy of spacing and construction add subtlety to his rather crowded dream world. Finally, an increasing sinuosity of line reflects the impact of the so-called International Gothic style upon the Florence of Ghiberti.

Foreshadowings of things to come are also implicit in the extensive output of Spinello Aretino. His documented career stretches from 1373 to his death in 1410, and his earliest dated work, the dismembered, partially surviving polyptych of 1385 from Monte Oliveto Maggiore, reveals his contact with the Sienese as well as with Nardo and Jacopo di Cione. The significance of his major surviving work, the decoration of the sacristy of S. Miniato al Monte, which was probably finished by 1387, is rather different [349]. Although the handling of paint, the colour, and the attitude to descrip-

349. Spinello Aretino: Frescoes, probably finished by 1387.
Florence, S. Miniato al Monte

tive detail all contribute to a typically late-fourteenth-century outcome, the frescoes mark the beginnings of a re-evaluation of Giotto's principles of dramatic narrative. The grey-white habits of the monks reduce the colouristic range. The figures are conceived in terms of powerful line and simple volumes. The rhythmic sinuosities of northern Europe that provide a constant background to the work of artists such as Agnolo Gaddi are nowhere to be seen. Despite erratic details of construction, variants of the Giottesque oblique setting are used in nine of the buildings shown. The number of figures is generally small, and with few exceptions they are clearly disposed within a limited and often well-defined space. Hesitant though the reinterpretation of Giotto may be by the

standards of Masaccio, and lacking any basic discoveries in terms of light or atmosphere or perspectival unity, it signifies the germination of new attitudes. The habit of looking back beyond the immediate past is a constant feature of the evolution of Italian art, and twenty-five years later a similar approach is fundamental to the revolution brought about by Masaccio and Donatello.

The lack of anchorage in any thorough reassessment of the visual world is linked in Spinello's case to an active life and a large workshop. As a result the vigour of his Pisan battle scenes of 1391–2 is accompanied by a tendency to revert to a busy confusion that lacks the qualities peculiar to Agnolo Gaddi's crowded compositions. Despite his qualitative

ups and downs, his undeniable capacity for vigorous design is constant. In the confined space of the Sala di Balia in the Palazzo Pubblico at Siena the frescoes of the *Life of Alexander III* which he executed in 1408 with the help of his son, Parri Spinelli, are almost a physical attack upon the senses. The clash between one composition and the next as they jostle for attention on the walls is hardly less fierce than the open battle for survival represented in the *Victory of the Venetians over the Imperial Fleet*. The boldness of the overall design and the exploitation of the possibilities of repetitive pattern, the sense of rushing movement and of organized confusion as the galleys grind against each other, epitomize the virtues of an art as easily buried by excessive claims as by insensitivity to its merits.

NORTHERN ITALY

The tradition established by Paolo Veneziano is so closely followed by the apparently unrelated Lorenzo Veneziano that their work has sometimes been confused. Lorenzo's eight surviving signed and dated paintings fall between 1357 and 1372 and reveal considerable variations in quality and handling. There is no slackening of the urge for brilliance of colour and complexity of decorative detail, but except in the polyptych of 1366 in the Duomo at Vicenza, Paolo's strong Byzantinism is replaced by elements seemingly derived as much from Central Italy, and even from Northern Europe, as from the immediately surrounding territories. In the finest of his signed productions, such as the *Annunciation* polyptych of 1357 in the Accademia at Venice, graceful proportions and the interplay of sinuous curves and sharply angled folds do not destroy a sense of volume that is emphasized, at the other end of his short span, by the perspective of the canopy of the Virgin and Child of 1372, now in the Louvre.[1]

The Paduan Guariento di Arpo's one signed work, the *Crucifix* in the Museo Civico at Bassano, which is almost as closely derived from Giotto as the comparable Riminese examples, is the sole stylistic anchor for the mid-fifteenth-century attribution of the vast and largely ruined *Coronation* fresco in the Palazzo Ducale in Venice [350]. According to a lost inscription the latter was painted for Doge Marco Cornaro (1365–7). It is not only in its ruination that it recalls Cimabue's fresco at Assisi. The sober brackets that connect the Assisan fresco to its architectural framework are replaced by six cusped, pointed arches, and the successor to Cimabue's already massive throne is more cathedral than cathedra. Its forms foreshadow and outstrip the complexities of the sculptured

portal of S. Maria di Collemaggio and of the fifteenth-century Gothic architecture of the Abruzzi. The mass of detail, the advancing and retreating curves, the complex niches of the two-tiered substructure inhabited by angels and evangelists and bulging forwards to the gates of paradise, foreshadow tendencies of Northern and Bohemian Gothic painting. The great size of the central figure group would have enabled it to dominate the surrounding flurry of figures and architecture. The colour that must once have been its crowning glory is still hinted at in the furnace-flames of angels' wings burning about the throne.

The quality of Guariento's borrowings from the Arena Chapel itself is seen in the marbling and in the grisaille figures of the largely destroyed decoration of the apse of the Eremitani in Padua, which he seemingly carried out with his assistants, and also in the fragmentary polyptych now in the Norton Simon Foundation, Los Angeles, which can reasonably be attributed to him.[2] Yet possibly his most significant surviving works, and also his earliest, are the twenty-nine panels from the ceiling of the Cappella del Capitano in Padua. In type and colouring, and at times in composition, the swaying, often anatomically insubstantial figures in soft-falling draperies are reminiscent, in their Romanesque and Byzantine affiliations, both of contemporary Venetian painting and of thirteenth-century Paduan art. The many panels devoted to the heavenly hierarchies, marching in all their armour upon writhing clouds or seated in the ribbed, receding tunnels formed by diminishing series of circular glories, are iconographically intriguing. The appearance of these rectangular, hexagonal, octagonal, and semicircular shapes in an area already notable for the variety of its painted wooden ceilings seems to show that at least one proto-

350. Guariento di Arpo: Coronation of the Virgin (detail), 1365/7.
Venice, Palazzo Ducale

type for the typical sixteenth-century Venetian ceiling already existed as early as the mid fourteenth century.

Guariento's seeming follower Nicoletto Semitecolo would be of little consequence on the basis of his four panels of the *Life of St Sebastian* in the Biblioteca Capitolare in Padua were it not that the architectural background and even the figure style of the *Burial*, dated 1367, provides the first hint of the nature of the resurgent Paduan School of the final quarter of the century. The leading member of the triumvirate responsible for these revolutionary developments is Altichiero. Although Altichiero is documented between 1369 and 1384, the only significant facts about this artist, who probably came from Zevio, near Verona, is that in 1379 he was paid for 'everything he had to do' in the Chapel of S. Felice in the Santo at Padua, and that in 1384 he signed a final quittance for the painting and decorative work which he had carried out in the near-by Oratory of S. Giorgio.[3]

The vaulted Chapel of S. Felice, entered through five arches crowned by niches, was begun in 1372 for Bonifacio Lupi, Marquis of Soragna, by Andriolo de'Santi and his son Giovanni. From the stone-capped wooden stalls let into the side-walls to the sarcophagi and frescoed tombs, and even to the architecture itself, with its frequent use of red Verona marble, every available inch of surface is carved or painted. The qualitative peak is reached in the soft-hued fresco of the *Crucifixion* [351] that occupies three column-separated bays in a manner reminiscent of Pietro Lorenzetti's panel of the *Birth of the Virgin*. The retention of the stylized rock construction, momentarily super

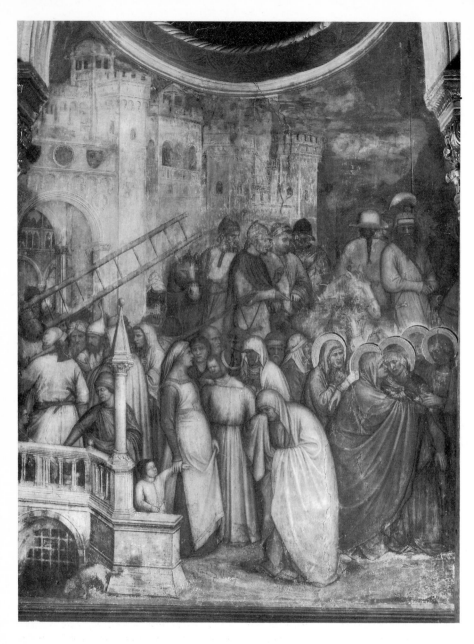

351. Altichiero: Crucifixion (detail of left bay), completed 1379.
Padua, Santo, Chapel of S. Felice

seded by Ambrogio's landscape naturalism, is the one notably conservative element in this, the first major development of the principles of Giotto's fundamental realism to take place anywhere in Italy in the second half of the fourteenth century. The portrait naturalism in the physiognomy and dress of the individual figures is accompanied by a new ease in posture and articulation and is not achieved at the expense of weight or volume or of monumental gravity of mien. The psychological variety does not diminish in the teeming crowds on either wing, but cunning compositional pauses in the middle bay ensure that what might easily have been distractions from the central theme in fact accentuate its drama. The oblique construction of the architectural detail encourages the eye to roam across the three wide bays. The horsemen that extend the figures upward over the pictorial surface also carry the design on into space and start the work completed by the unusually realistic architectural coulisses upon either wing. The culvert in the foreground counterbalances the thrust into the distance by implying the extension of the landscape forwards into the spectator's world as well as out to either side.

The lateral extensions are significant in another sense. On one side tower the walls and palaces of Jerusalem, its ceaseless commerce hardly more interrupted than the sea is interrupted by the casting of a stone [351]. The carpenters and tradesmen are already flowing back through the broad gate to their more usual tasks. Upon the other wing, the tomb, and the eternal mysteries of resurrection and salvation, wait unheeded. Here the underlying tensions of late medieval life, so vividly expressed in the accounts and diaries and letters of an individual merchant such as Francesco di Marco Datini, or in the fevered economic, social, and political history of innumerable towns and cities, are not expressed by an emotive use of line and colour, of self-contradictory visual clues and compositional conflict, but by an extension of the grave, transcendent logic first explored by Giotto.

The part played by an extension of Simone Martini's pageantry, and the parallels with late-fourteenth-century Sienese architectural backgrounds, become clearer in the somewhat weaker but extremely interesting frescoes of the *Life of St James*. It is very uncertain how much reliance should be placed on the fifteenth-century association of such changes with Avanzo, the possibly Paduan artist whose signature is rather uncertainly recorded as having accompanied the last scene of the *Legend of St Lucy* in the Oratory of S. Giorgio. The Oratory, which also contains scenes from the New Testament and from the Lives of St George and St Catherine, was built between 1377 and c. 1384 for the same family as the Chapel of S. Felice. Assuming Altichiero to have painted the *Crucifixion* in the Santo, his hand is clearly visible in the *Crucifixion*, in the *Coronation*, which has obvious connexions with Guariento, and in several scenes from the lives of St George and St Catherine, among them the deeply impressive *Decapitation of St George*. There are also figures redolent of Altichiero's gravity and mass, as well as many telling characterizations involving entire figures and not merely their portrait heads, among the scenes which have in the past been attributed to Avanzo.[4] The precise distribution of hands between Altichiero and the various co-workers who were undoubtedly involved is less important than the exuberance of their architectural imagination. This gives the chapel its unique character [352]. The eye can journey endlessly among the galleries and passages and courtyards, over towers and pinnacles and battlements, and past a multiplicity of traceries and panellings as brilliant in their yellows, reds, creams, pinks, and greys as they are varied in their forms. Nowhere in Tuscan painting is there such a wealth of imitative realism. In some designs, like the *Presentation* or the *Funeral of St Lucy*, Semitecolo's constructions are elaborated. In others, like *St George drinking the Poison*, there is a new sense both of nearness to the onlooker and of architectural continuity beyond the boundaries of the frame.

352. Altichiero and others: Frescoes, c. 1377/84.
Padua, Oratory of S. Giorgio

In terms of sheer joy in abrupt recession and deep architectural space and in the creation and control of vast crowds of figures, nothing, even in Altichiero or Avanzo, approaches the enthusiasm of Giusto de' Menabuoi. His Florentine origins are reflected in the signed *Madonna* of 1363 in the Schiff Collection in Rome and in the signed National Gallery triptych of 1367 which form the attributional basis of his work. By 1370 he was already living in Padua, and although he was still enrolled in the Florentine Guild in 1387, his fame rests on his Paduan achievements.

Despite its relatively complex form, the square, domed baptistery decorated by Giusto, seemingly in the mid seventies [353], is as thoroughly attuned to fresco as the Arena Chapel [184] or the Oratory of S. Giorgio [352]. Even so, the demands of the painter were so pressing that all but an irregularly spaced trio of the

353. Giusto de' Menabuoi: Frescoes, mid 1370s.
Padua, Baptistery

original windows in the dome were filled in. Almost all the architectural detail, including the elaborate niches of the evangelists, is fictive. The greyish stone canopy above the *Virgin Enthroned* is the only important element of real sculpture. Its interest is increased by the way in which the figures carved in moderate relief in the roundels and niches at the sides and upper centre are complemented by others painted in grisaille and lit from straight ahead, as if from the main windows on the altar wall. In the light of such confident illusionism and thoroughgoing blending of the arts, Ghiberti's talk of fourteenth-century figures that appear to 'stand out in relief' is understandable. Giusto's simulation of architectural and sculptural form even extends to the polyptych with which he completed his decorative programme. Without considering its innumerable decorative sub-divisions, the complexity of this small altar-piece, measuring only 112 inches by 73 and containing some fifty-one figured compart-ments, reflects the artist's attitude to the whole scheme. The latter begins with the Pantocrator in the centre of the dome, encircled by the saints of heaven in their hundreds. It continues through an unusually rich and varied Old Tes-tament cycle, past the evangelists on the pen-dentives, to the New Testament upon the walls. It ends in the sanctuary with an elaborate series of small apocalyptic scenes upon the walls and the extension of the story of St John upon the altarpiece.

Like Vitale da Bologna at Pomposa, Giusto establishes certain symmetries but is quite pre-pared to subdivide a wall unevenly if the scenes involved seem to demand it. At Padua sub-division of the drum, which intervenes between the symmetries of the pendentives and the dome, is wholly casual and asymmetric. The peculiar quality of Giusto's scheme derives from just such contrasts. In individual scenes he rivals Masolino and the more naïve of the Early Renaissance perspectivists. He takes inordinate pleasure in constructing block-like buildings, steeply plunging architectural recessions, and deep, echoing interiors. Lines of figures often accentuate the architectural thrust. Several of his interiors, anticipating Donatello, are extended bay on bay beyond a screen which closes in a vaulted foreground space. The bulk of certain figures almost caricatures Giottesque principles, just as the staring whiteness of the eyes exaggerates the emotional tension generated by Giovanni da Milano. The effect of individual adventures in perspective is greatly modified by the thinness of the intervening, painted framework; by close juxtaposition with scenes of either limited or contrasted spatial structure; and by the cumulative effect of the innumerable separate elements. The final impression is not of concentrated drama but of an anecdotal richness in which the realism of the incidental detail balances the architectural and sculptural illusionism that surrounds it.

For all his ebullience, Giusto is by no means lacking in certain kinds of discipline. Excited as he evidently was by the work of Altichiero and his co-workers, his own architecture is predominantly greyish or brownish-white. The figure colour is never carried over into it and the general tonal level is subdued. Ochres and earth-reds, greys and brown-greys, apple- and moss-greens, pale pinks, violets, and lilacs pre-dominate. Like them, he makes great use of shot colour, but the hues and transitions are invariably gentle and the various elements in one figure are often carefully linked to the main colour in one of its neighbours. The only unex-pected note is the bright, light blue, running to white, which is reserved for Christ and the Virgin. Colour is thus a means of singling out the most important figures.

The divergent tendencies of Giusto's art become increasingly obvious in the Belludi Chapel in the Santo, probably decorated in the early eighties. His lack of interest in naturalistic landscape is accentuated. At the very moment when his growing control of architectural space is being demonstrated in compositions unsur-passed in terms of ambition or achievement before the 1430s at the earliest, his excursions into popular imagery grow more extreme. In

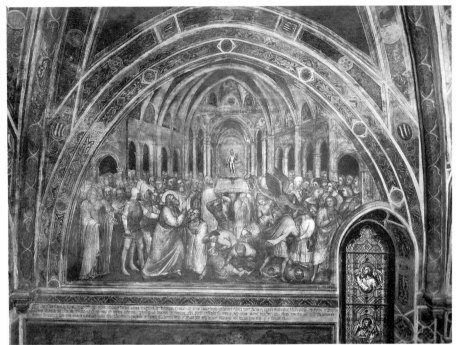

354. Giusto de' Menabuoi: St Philip exorcizing a Devil, early 1380s(?).
Padua, S. Antonio, Belludi Chapel

its feeling for a single, great hall thronged with people there is nothing in the later fourteenth century to compare with Giusto's much damaged *St Philip exorcizing a Devil* [354], and his evocation of the crowded vastness of the Piazza delle Erbe in the *Martyrdom of St James* is another remarkable monument to this short-lived Paduan pre-Renaissance.

BOLOGNA

The predominance of the Bolognese miniaturists among the painters with whom their careers are so thoroughly intertwined is confirmed in the later fourteenth century. Several relatively minor painters left for other centres and were more or less absorbed into the patterns of their adopted territories. Giovanni da Bologna went to Padua and Venice. Andrea da

Bologna practised in Umbria and the Marches in the wake of Allegretto Nuzi, who, before his death in 1373, built up a flourishing minor school on the foundations provided by Daddi and the Florentines of the mid century. Simone da Bologna, known as dei Crocefissi, is the most important and prolific of the panel painters who maintained the Bolognese tradition in Bologna, and the clear colours of his fundamentally calm art link him closely to the miniaturists.

The most significant of the series of mid-century illuminators influenced by Vitale is the so-called Pseudo-Niccolò. His work, exemplified in the Decretals in the Vatican (MS. Lat. 1389) and in the Constitutions of Clement V (Padua, Cathedral Chapter, MSS. A. 24, 25), is notable for its liveliness of iconographic invention as well as for the tumbling energy of its crowded compositions and the brilliance of its

355. Niccolò da Bologna: Page from Missal, 1374.
Munich, Staatsbibliothek

colour. It is, however, Niccolò di Giacomo (d. by 1402), from whom his name derives, who dominates the second half of the century. The influence of his school was felt not only throughout Italy but over much of Europe. His signed works include the *Crucifixion* in the *Ordo Missae* in the Pierpont Morgan Library (M. 800), a Choir Book of 1351 (MS. Lat. 1008) in the Este Library at Modena, and two historiated initials in the Fitzwilliam Museum at. Cambridge (MS. 278). The *Novelle sulle Decretali* of 1354 in the Ambrosiana (MS. B. 42 inf.), Lucan's *De Bello Pharsalico* of 1373 (Milan, Trivulzio Library, MS. 691), and the *Libro dei Creditori* of the Public Pawn Shop in Bologna of 1394–5 (State Archives), the latest dated work attributable to him, are only some of the wide range of illuminated manuscripts which poured from his own and from related workshops and which include the signed Missal of 1374 in Munich (Staatsbibl. MS. Cod. Lat. 10072) written by Bartolus de Bartolis [355]. Bold colour, reminiscent of contemporary trends in Florence; vigorous, crowded compositions; continuous iconographic inventiveness and the most fantastic adventures in extreme foreshortening of the human figure, characterize the entire series. The complexity of the architectural constructions stresses the freedom with which space is both created and negated. The text is often almost shouldered off the page. The writing seemingly becomes a mere infilling or a frame for illustrations.

Despite the multiplicity of French manuscripts in Northern Italy, Niccolò's school is in the main remarkably independent of French stylistic influence. A significant union of the two streams only occurs towards the turn of the century in Lombardy. Apart from the abstract patterns of architecture and of decorative detail in general, it is only in terms of iconography, of colour, and of certain aspects of figure style that the influence of France is powerful in Italian art during this period. Spatial construction was so integral a part of Italian design and the representational and dramatic complexity of Italian painting such that in these respects the Italians least concerned with the problems of spatial realism and of naturalism in general far outdistance the most adventurous Frenchmen.

The influence of Bolognese illumination is obvious in the most important surviving work of Tommaso da Modena, the frescoes of 1352 in the chapter house of S. Nicolò in Treviso. The decoration of this low, squarish chamber, its walls covered with some forty portraits of Dominican worthies seated in their cells and framed by substantial texts, resembles an illuminated manuscript writ large. On the other hand the reciprocal effect of such decorative schemes upon the manuscripts themselves must not be underestimated. Monotony is avoided by Tommaso's lively sense of portraiture, almost of caricature. He rings innumerable changes on the absorbing tasks – the blowing clean and sharpening of quills, the peering through pince-nez and magnifying glass, the wielding of the ruler and the scissors – which are the prop and sign, indeed, the very test of scholarship. This busy pleasure in particularities is typical of his often charming and now largely ruined works. At times his painting points to Simone Martini's continuing relevance for North Italian art. At others it raises the whole question of the nature of reciprocal exchanges with Bohemia in the very years when his fellow citizen Barnaba was carrying a personal variant of Emilian style into Liguria and Piedmont.

LOMBARDY

In Lombardy in the last years of the century, for perhaps the first and only time in the history of late medieval Italy, the manuscript illumination and the pocket-book design achieve a primacy that is neither local nor confined to their own media. They lead the visual arts of Italy and Europe alike. What in France came to be called 'ouvraige de Lombardie' marks one of the turning points in the history of European painting.[5]

The independence of the Lombard School of manuscript illumination, supported by the

356. Goffredo da Viterbo: Death of Jacob, detail of page from Pantheon, *c.* 1331.
Paris, Bibliothèque Nationale

upthrust of Visconti power, and its ability to withstand the aesthetic onslaught of the Bolognese School, were already confirmed in the first half of the century. The *Pantheon* of Goffredo da Viterbo (Paris, Bibliothèque Nationale, MS. Lat. 4895), written in 1331 by Giovanni di Nixigia for Azzo Visconti, is the peak of its achievement [356]. It is only court art in a strictly technical sense. The surviving influence of the already distant bourgeois origins of the Visconti and the popular basis of the brilliant and ferocious Azzo's power are

symbolized, if not reflected, in its decoration. Straightforward, everyday realism is one aspect of the freely interconnected scenes that spread across the page and up and down the margins, threatening to engulf the text.[6] The stone ripples of the rocky landscapes flow like lava. Stocky, well constructed figures march sedately up and down the slopes about their business. The simple, frequently straight-falling, volumetric fold-forms are accompanied by figure groupings that are often of outstanding subtlety and spatial realism. Nevertheless, minute scale and the perspectival jumble of the freely scattered buildings show that, as in dreams, the final impact of the whole depends on the imaginative force and fantasy with which acute perceptions of reality are recombined within a framework of meaningful impossibility. The technical interest of the manuscript and the part played by the vivid colouring are accentuated by a series of unfinished miniatures. Here, brush drawing is succeeded by a still free penwork in which minor changes of design can still be carried out. Then gilding and the application of flat colour washes precede the final modelling. The working sequence is as amenable to cooperative methods as that revealed by the unfinished Orvietan sculpture.[7]

The next significant development is represented by the Book of Hours which Giovanni di Benedetto da Como decorated probably towards the end of the period between 1350 and 1378 for Bianca of Savoy, the wife of Galeazzo Visconti (Munich, Staatsbibliothek, Cod. Lat. 23215), and by a closely related Bible of c. 1380 of even higher quality (Paris, Bibliothèque Nationale, MS. Lat. 757). The close connexions with the frescoes in the Oratories at Albizzate and Lentate only underline the primacy of the manuscripts. Even the frescoes in the Badia at Viboldone and the Oratory at Mocchirolo, which include a memorable St Catherine in an ermine-tasselled gown, cannot compare in importance. French connexions in both the borderings and backgrounds are accompanied by links with the work of Giovanni da Milano in figure style and composition. The structure

of the landscapes and architectural interiors, and such inventions as the *Annunciation* in the Book of Hours, map out the paths to be followed by innumerable French and Franco-Flemish illuminators until well into the mid fifteenth century.

The story of the planning and construction of Milan Cathedral has already shown the closeness of the links with France and Germany and Bohemia that were forged by the Visconti.[8] It demonstrates the central role that the Visconti played in the artistic as well as in the political and economic development of the area. The inseparability of these various aspects of Visconti policy is as clear as the way in which the macrocosm of the Duomo and the microcosm of manuscript illumination are one world in the imagination of such men as Giovanni dei Grassi.

Giovanni is first heard of in 1389, and in 1391, when he was listed among the engineers working on the cathedral, the relief of *Christ and the Woman of Samaria*, gilded and painted in 1396, was commissioned from him. In 1392 he was given materials for designs for windows. In 1395 he was painting the sacristy sculpture, and from 1396 he appears to have been associated with the illumination of the transcript of Beroldo's Treatise on the Usage of Milan Cathedral (Biblioteca Trivulziana, Cod. 2262) for which the authorities paid his son in 1398 after his own death. It is hard to say if plants or pinnacles grow more freely on these highly decorated pages. Certainly the close relationship between architectural and organic life, which is so palpable in the cathedral, becomes a virtual unity as plants sprout into canopies, and pinnacles that might have been translated bodily from the cathedral take on vegetable form. The miniatures of the Beroldo and the finest drawings of a Memorandum Book or Tacuino at Bergamo (Biblioteca Comunale, MS. Δ. VII. 14) lend each other attributional support, since one of the best pages of bird and animal drawings in the latter is signed 'Johininus de Grassis designavit' in a seemingly fourteenth-century hand.[9]

357. Giovanni dei Grassi: Vulture, Goldfinch, and Green Parrot,
from memorandum book, late fourteenth century.
Bergamo, Biblioteca Civica

358. Page with insects, from Treatise on the Virtues and Vices, late fourteenth century. *London, British Museum*

The leaves in the Bergamo sketch book devoted to graceful drawings of the human figure are significant in that the particular blending of Italian and transalpine elements heralds the development of the so-called International Gothic style that plays a dominant role both north and south of the Alps during the first quarter of the fifteenth century. The extraordinary directness and subtlety of observation in the animal drawings is, however, the most revolutionary aspect of the book's contents. Whether in terms of line or colour, there is a clarity and sensitivity that in pages like the one devoted to the *Vulture, Goldfinch, and Green Parrot* [357] lifts acuity of observation to the highest realms of art. The animal studies differ greatly from the figure drawings, in which a much greater part is played by established conventions. The explanation may partly lie in Cennino Cennini's observation that 'I will not tell you about the irrational animals, because you will never discover any system of proportion in them. Copy them and draw as much as you can from nature, and you will achieve a good style in this respect'.[10] It is the very weight of tradition in figure drawing that makes accurate observation so much more difficult. The truth of this is already demonstrated in the marvellously faithful bird studies in the thirteenth-century *De Arte Venandi cum Avibus*. This manuscript, produced for the sceptical and scientifically minded Frederick II, is the distant forerunner of the line of development that leads through Giovanni dei Grassi to Michelino da Besozzo and Pisanello. The inhibiting role which the possession of too well developed mental schemata can play is confirmed by dei Grassi's animal drawings themselves. The lion, and those animals for which there is a well-established artistic tradition, are the least alive with qualities derived from direct observation. The contrast with the vividly realistic treatment of such out-of-the-way subjects as the ostrich, which Giovanni may have seen in one of the zoos, like that of the Visconti at Pavia, that were already becoming a feature of North Italian court life, is quite extraordinary.

Even so, the new realism has its limitations. The technical and conceptual difficulties probably account for the limited quality of movement and for the tendency to profile settings.

The growing interest in observing animals is accompanied by similar developments in other directions. Some of the margins of an extraordinary late-fourteenth-century *Treatise on the Virtues and Vices* (London, British Museum, Add. MS. 28841) are also strewn with vividly realistic insects and crustacea [358]. Apart from the single page by Pol de Limbourg in the *Très Riches Heures du Duc de Berry* (f. 168v.), there is nothing comparable until the end of the fifteenth century. A like progression in herbal illustration leads from the still schematic designs seen in the early-fourteenth-century *Compendium Salernitanum* (London, British Museum, Eg. MS. 757) to the *Herbal* (British Museum, Eg. MS. 2020) written and illustrated in Padua before 1403 for Francesco Carrara. Here, for the first time it seems, whole plants or single twigs and sprays are shown as living entities [359]. Since this was the Padua of Altichiero, Avanzo, and Giusto, the comparable developments in grouping plant life in a natural spatial setting come as no surprise. Similarly, the illustrations of the Seasons, also contained in the Tacuina, are progressively transformed from allegorical illustrations connected with the Labours of the Months to true representations of natural scenes appropriate to the various times of year. Thence it is no long step to the Calendar Cycles painted between 1390 and 1407 in the Torre dell'Aquila in the castle at Trento. These are followed, with the mediation of a personal knowledge of Ambrogio Lorenzetti's Landscape of Good Government in the Palazzo Pubblico in Siena, by Pol de Limbourg's calendar scenes in the *Très Riches Heures du Duc de Berry*. The latter, which were left unfinished in 1416, open a new era in the history of landscape.

The new style associated with Giovanni dei Grassi is essentially a court art. The socially based contrast with the Tuscan scene and with the Bolognese School of illumination is clearer

maximamente quili ele se iofi. e se buoni al pieto e al polmoni.

359. Paduan: French bean, detail of page from Herbal, before 1403.
London, British Museum

than ever in an *Uffiziolo* attributable to Gio-
vanni, possibly helped by his son Salomone (ex-
Milan, Visconti di Modrone Collection, now
Florence, Biblioteca Nazionale, MS.B.R. 397).
It was illuminated for Gian Galeazzo Visconti
before his ducal coronation in 1395, and his
portrait is included on one of the pages [360].
The influence of Persian manuscripts is dis-
cernible in a number of Lombard manuscripts
such as the *Treatise on the Virtues and Vices*
already mentioned. In Gian Galeazzo's *Uffizi-*

olo a truly oriental splendour, if not oriental
influence, is accompanied by a vivid naturalism
in the abundant animal detail and by a dec-
orative *horror vacui* that makes the highly ornate
Beroldo, carried out in 1396–8 for the cathedral
authorities, seem positively restrained. In the
almost oppressively heavy decoration of the
Uffiziolo of Filippo Maria Visconti, the earlier
part of which goes back to before 1395 (Flor-
ence, Biblioteca Nazionale, Fondo Landau-
Finaly, MS. 22), Giovanni's share dwindles and

360. Giovanni (and Salomone?) dei Grassi: Page from the Uffiziolo of Gian Galeazzo Visconti, before 1395.
Florence, Biblioteca Nazionale

that presumably attributable to his son increases. There is perhaps less skill, but a no less powerful decorative urge, in the work of Anovelo da Imbonate. Soon after 1394, he completed the decoration of a Missal, already written by as early as May 1370, which contains a miniature of the *Coronation of Gian Galeazzo*, and which was given to, and is still retained by, the church of S. Ambrogio in which the event took place.[11]

The line from Giovanni di Benedetto da Como to Anovelo da Imbonate; the links with France; the combination of court style with an Italian simplicity of figure draughtsmanship; a fascination with details of dress and armour and a residual naïvety of line that recalls the hunting scenes upon so many castle walls; landscape backgrounds that connect with the new world of the Tacuinum Sanitatis; echoes of the songs and pageantry, the dreams and fables and ideals, the gaiety and gentleness, which were part and parcel of a fierce and grasping world; all these are brought together in the fragment of the *Lancelot du Lac* which once belonged to the Visconti Library in Pavia (Paris, Bibliothèque Nationale, MS. fr. 343). Like the delicately tinted Guiron le Courtois (Paris, Bibliothèque Nationale, MS. fr. 5234), which surpasses it in delicacy and subtlety of narrative and pictorial atmosphere [361], it represents innumerable similar manuscripts that graced the princely libraries, the noble palaces, and the houses of the rich in Northern Italy.

The variety of subject matter in these manuscripts is matched by that of the ivory and bone carvings on the altarpieces and caskets of all

361. Lombard: Chivalric scene, detail of page from Guiron le Courtois, end of fourteenth century.
Paris, Bibliothèque Nationale

shapes and sizes disseminated throughout Italy and France by the Venetian workshops of the Embriachi. Paris, Pyramus and Thisbe, Lancelot and Guinevere; the repertory is drawn from classical and chivalric myth or from sacred history, according to the secular or religious function of the artefact. Little is known of Baldassare degli Embriachi, the founder of a school which became increasingly active in the fifteenth century, except that the style of the workshop–factory that he headed was evidently formed in Florence. He was already in Venice when, in the years between 1400 and 1409, he was paid for the huge altar triptych, containing over sixty-five reliefs and a similar number of single figures, ordered for the Certosa at Pavia by Gian Galeazzo Visconti. Already in 1393 two large triptychs, now in the Musée de Cluny in Paris, had been given to the abbey of Champmol by the Duke of Burgundy, and Jean, Duc de Berry, the patron of the de Limbourgs, gave another to the abbey of Poissy. The frames of ebony and other woods were decorated with geometric inlays, and the reliefs were normally composed of several convex laminae of bone or hippopotamus tooth, some $1\frac{1}{4}$ inches wide and $4\frac{1}{4}$ inches high, with occasional ivory plaques where some particular design made surface unity essential. The use of these materials, necessitating something like two hundred and fifty elements in the reliefs of the Certosa altarpiece, had two main effects: it greatly intensified the impression of almost impenetrable visual complexity, and it encouraged the retention of a simple figure style derived from Florentine pictorial models and far removed from the rhythmic and linear complexities of French and German ivories. The style of the major works is essentially a simplification, a purification even, of that of Orcagna's tabernacle in Orsanmichele [141]. Its success was such as to create a truly independent Italian school of ivory carving for the first time since the century-old revival of the industry in France. It was able not only to withstand the flood of Northern European artefacts but even to make inroads into the French market. Its simple and soft drapered figures were exactly calculated to inspire the Northern artists drinking in the message of contemporary Lombard manuscripts and marvelling at first- and second-hand reports of Tuscan art.

SCULPTURE

1350–1400

INTRODUCTION

The relative importance of Italian sculpture continues to decline during the later fourteenth century. Although the death of Andrea Pisano is as incalculable in its consequences as that of Ambrogio Lorenzetti, the Black Death is only one contributory factor. The primary causes lie deeper. During the preceding fifty years the problems of dramatic narrative and its descriptive needs were uppermost and pictorial modes of vision were supreme. Three-dimensional realism and a sculptural solidity of form were, however, among the essential objectives of a number of the most important painters. When, after the Black Death, the tendency towards a hieratic, emblematic style of painting was accompanied on the one hand by the achievement of dramatic and emotional effects by non-realistic means, and on the other by increasing interest in purely decorative elaboration, the position of sculpture became doubly serious. There was no reason to challenge the dominance of a pictorial vision, since sculpture was even less fitted to meet the new, relatively non-realistic painting on its own terms than it had been to emulate the narrative realism of the preceding period. The problems involved in moving beyond the point reached by Nicola and Giovanni Pisano in their quest for descriptive realism were rendered largely irrelevant. There was therefore no attempt to break the barriers imposed by the lack of any fully developed, focused system of perspective. In terms of pictorial realism in relief there was, except in certain details, regress rather than progress. The role of sculpture in the round was still severely limited by its dependence upon architecture. Figures were nearly always set within a niche or up against a wall, and there was no purely sculptural reason for exploring the further possibilities of three-dimensional form.

Nevertheless, if later-fourteenth-century sculpture is something of a by-way in the history of Italian art, it is so only in the light of the great surge of development that had preceded it. It has its own refinement, its own charm, and its own moments of great beauty.

SCULPTURE

The boundaries of Nino Pisano's career and artistic personality are as melting as the outlines that enfold his gently smiling figures. He is first mentioned in 1349, when he was capomaestro at Orvieto in succession to his father, Andrea Pisano. He had relinquished the post by 1353. He was active as a silversmith in Pisa during 1358–9, and he was dead by 1368. Nothing connects these few scattered facts with the three signed but undated works that have survived.

The links with Andrea's small figure of Christ and with the Sibyls from his workshop may mean that the *Virgin and Child* in S. Maria Novella in Florence is the earliest of the signed works. There is greater anatomical accomplishment, a subtler smile, and a more gentle sway in the Virgin and Child from the monument to Doge Marco Cornaro in SS. Giovanni e Paolo. The group, which may or may not have been originally connected with the tomb of the doge, who died in 1367, is accompanied by two workshop saints and by two beaming angels reminiscent of the early style of Tino in their absolute simplicity of form. The remaining signature is on a relatively feeble figure of a Bishop in the Duomo at Oristano in Sardinia.

Around this island of uncertain certainties a quiet confusion reigns. In one direction lie the stocky *Madonna and Child* in the Museo dell'Opera at Orvieto, often attributed to Andrea, and two groups of carvings which may have come from either artist's workshop. These are the *Virgin and Child with St John and St Peter* in S. Maria della Spina and the complex Saltarelli monument in S. Caterina, also in Pisa. The opposite pole consists of the half-length *Madonna del Latte* in S. Maria della Spina [362] and the *Annunciation* figures in S. Caterina. These form a close-knit group in which the

facial types are as distinct from those in the signed works of Nino as they are from those in the body of Andrea's work. There are, however, strong facial links with the *Madonna* at Orvieto which, in its turn, is more vaguely related to certain figures on Andrea's bronze doors. The drapery style of the *Virgin Annunciate* [363] is somewhat closer to that of Nino's signed works, but in the end its inclusion in his output turns on the credence given to the inscriptions seen by Vasari on the lost bases. They read 'Nino son of Andrea Pisano made these figures' and 'the first day of February 1370'. Unless it refers to the placing and not to the carving of the figures, the date, two years after Nino's death, is certainly incorrect, and acceptance of the works leads to insoluble difficulties. If these are late works, then so is the Orvietan *Madonna*. This would otherwise be assigned on documentary and stylistic grounds to the borderline between Andrea and Nino during their time at Orvieto. If the *Annunciation* group is early, the development to the signed works becomes as difficult to understand as that arising from an interleaving of the two styles. Despite the example of Giotto, there is a natural reluctance to assert that, not merely one, but all three signed works are studio products and that Nino's personal hand is seen most clearly in the Orvietan *Madonna*, the *Madonna del Latte*, and the *Annunciation* group. Whether by Nino or some unknown, the latter represent the qualitative peak in terms of carving and of psychological content.

In the *Madonna del Latte* [362] Ambrogio Lorenzetti's design [223] is reinterpreted in terms of sinuous, interweaving curves. The transitions are infinitely subtle, and Ambrogio's taut line gives way to flowing freedom. The hard, schematically grasping hands take on a soft and natural grace. Blue and gold add to the

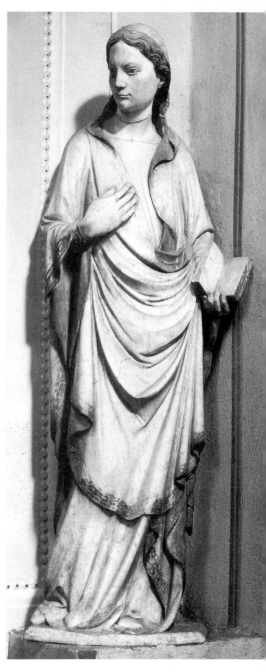

362. Nino Pisano(?):
Madonna del Latte, between *c.* 1350 and 1368.
Pisa, S. Maria della Spina

363 (*right*). Nino Pisano(?):
Virgin Annunciate, between *c.* 1350 and 1368.
Pisa, S. Caterina

rhythmic interplay of line and form. There is,
however, no descent to weakness or to super-
ficial sentiment. There is dignity, even gravity,
beneath the natural joyfulness of the relation-
ship. The complex, underlying meanings of the
image are not only preserved and reinterpreted
but enriched.

A similar sophistication in the carving and a
similar delicacy of line and colour grace the
Virgin Annunciate in S. Caterina [363]. With
the attendant Gabriel it heads a long line of

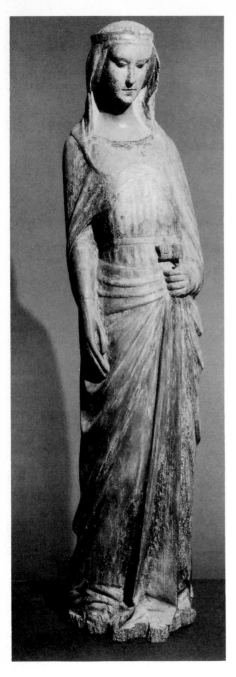

wooden Annunciation groups. The richest of these in colour and in fall of fold is that in the Museo Civico at Pisa. No less affected by French Gothic forms, and hardly less effective in their very different manner, are the more slimly graceful and less florid *Virgins Annunciate* in the Victoria and Albert Museum in London and in the Louvre in Paris. The stylistic echoes of the *Madonna of Jeanne d'Evreux* of 1339, visible in Nino's *Cornaro Madonna*, are not confined to this one figure. The varied influence of French ivories, then flooding over Europe, can never be discounted even in the most obviously Italian of the carvings of the Pisan School and its affiliates throughout Italy.

The extreme sophistication of the school is apparent as soon as its products are compared with those of the remoter areas of Italy. The late-fourteenth-century *Madonna*, with its painted shutters, in the parish church at Fossa in the Abruzzi is still Romanesque in its frontality and stiffness. Its charm lies in its colour, in the interplay of carved and painted form, and in the naïve transition from one medium to the other as the wooden Virgin sits upon her purely painted throne. The possibly late-fourteenth-century Neapolitan *Virgin of the Nativity* in the Museo di S. Martino in Naples is among the finest in a succession of such wooden figures, rendered memorable by their simplicity of form and gaiety of colour.[1] As so often happens in the work of unknown, minor craftsmen, all the accumulated skills of long tradition seem to have been concentrated in the sensitive stylizations of the head. The tension that arises from the caging of such warm humanity in a body and in limbs so stiff and clumsy, so intensely wooden, gives such works their unforgettable and distinctive flavour. Now and then, however, in carvings like the *S. Balbina* in the Museum at L'Aquila [364], there is beauty of a wholly different order. The gentle sway, the stiff and somewhat timid folds, the

364. Abruzzan:
S. Balbina, fourteenth century, second half.
L'Aquila, Museo

slim proportions, make essential contributions to a figure in which columnar grace is blended with a deep humanity. The subtlety in the stylization and disposition of the features is such as to create a deep and inward calm, a quiet spirituality that ranks this supremely unpretentious carving by an unknown fourteenth-century Abruzzan sculptor with the greatest masterpieces of Italian carving.

ANDREA ORCAGNA, ALBERTO ARNOLDI, AND GIOVANNI D'AMBROGIO

The tension in Orcagna's career is not confined to the formal qualities of his Strozzi altarpiece [342]: it embraces the dichotomy between the spare intensity of his painting and the diffuse decorative emphasis of his major surviving sculptural work, the tabernacle in Orsanmichele [141]. He entered the Stonemasons' Guild in 1352, sponsored by Neri di Fioravante, and the tabernacle is dated 1359. It was built to house Bernardo Daddi's panel of the *Virgin Enthroned* and is notable both for its extraordinary architectural form and for the covering of every available surface with sculptural detail and richly coloured marble and mosaic inlay. The curious invention of a vegetable marrow of a dome, rising behind the sharply rectilinear, equilateral triangle of a pediment flanked by pinnacles and reflecting current preoccupations with the cathedral, receives a critical commentary in the Sienese drawing for the Cappella di Piazza in Siena. There the even more ornate forms also reflect those of Orcagna's Strozzi altarpiece. Despite the relatively simple, space-enclosing form of the tabernacle, with open arches at its front and sides, it has more in common with a piece of lace than with the sculptural floridity of Giovanni Pisano's Sienese façade. It is substantially pictorial and planar. The tendency for the detailed treatment of the architectural forms to annihilate the considerable space that is actually enclosed is related to the disciplined tensions of the Strozzi altarpiece. The effect is intensified by the careful framing of Daddi's panel by the forward arch and by the great relief of the *Death and Assumption of the Virgin* that fills the whole of the rear arch.

The wide spacing that endows the figures in the *Assumption* with a free and floating quality [365]; the clear indication of their volume; the absolute denial of aerial depth by the accentuation of the limited relief of the mandorla; and finally the marbled damask of the 'sky', relate this part of the relief, and this alone, to the basic design premises of the Strozzi altarpiece. The crowded agitation of the *Dormition* and the more or less pictorial, more or less pedestrian, treatment of the other reliefs confirm that Orcagna lacked consistent means of translating his pictorial vision into stone. The one remaining relief which seems to make a major contribution to the history of Italian sculpture is the *Annunciation of the Death of the Virgin*. It only does so by completely eschewing the complexities and tensions of his pictorial style. The relatively low artistic temperature of most of the figure sculpture must, however, partly be ascribed to the efforts of a workshop notable for numbers rather than for talent.

In comparison, certain of the diamond-framed reliefs of the Sacraments carried out during the fifties on the second storey of the campanile have an almost gem-like quality. If, as seems likely, they are indeed by Alberto Arnoldi, already mentioned in relation to his work on the Loggia del Bigallo,[2] they show a minor talent stretched to the utmost of achievement and creating, in the *Eucharist* [366], one of those sudden masterpieces far beyond his normal range of expectation. There is a concentration reminiscent of Andrea Pisano and of Giotto in these economical designs. The sculptor's technical limitations become a positive virtue as the simple volumes and smoothly stylized lines become the means through which the deepest feelings are aroused.

Greater richness and technical range appear in the figures of the Virtues on the Loggia della Signoria, carried out by Giovanni d'Ambrogio (active 1384–1418), Jacopo di Piero Guidi, and others during the eighties. Historically their

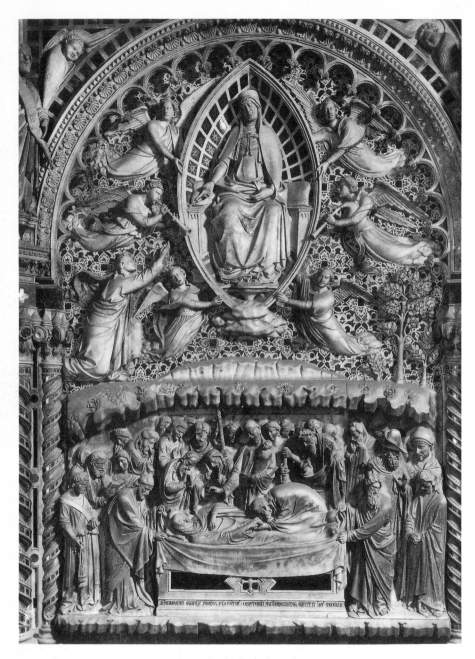

365. Andrea Orcagna: Assumption of the Virgin, detail of tabernacle, 1359.
Florence, Orsanmichele

chief interest lies in their design by Agnolo Gaddi. In this they are the Florentine counterpart of the mass of sculpture designed by painters such as Giovanni dei Grassi for Milan Cathedral. The intricately carved infillings for the arcadings of Orsanmichele, executed during the eighties under Simone Talenti, provide another parallel to North Italian trends.

The most curious expression of the pictorial tendencies in late-fourteenth-century sculpture lies in the marble altarpiece containing the Arca di S. Donato in the Duomo at Arezzo. It was carved c. 1369, but not necessarily designed, by Betto di Francesco da Firenze and Giovanni di Francesco d'Arezzo among others. Its multiplicity of framing figures and naïve pictorial gusto continue the tradition of the Tarlati monument in the same church [275]. In richness it yields nothing to North Italy and the contemporary Lombard tradition. There are abundant signs of the polychromy of every inch of surface not already decorated with a coloured marble inlay. In many of the narrative panels, curtains, similar to those held by the angels behind the relief of the Madonna or tightly stretched behind the flanking saints, become an all-inclusive backcloth. There is now no way of telling whether this is merely a kind of logical explanation for the type of background found earlier in the Pisani's pulpits and common in illuminated manuscripts, or whether it implies that the once gaily coloured scenes are painted hangings set within a marble frame.

A number of the single figures are related to the almost Romanesque stylizations of the superbly balanced gilt bronze reliquary bust of S. Donato, signed by Pietro and Paolo Aretino in 1346, in the Pieve at Arezzo [367]. In its simplicity of outline and in its clarity and repose the latter stands out from the generality of such reliquaries, in which sculptural form runs a poor second to splendour of material and intricacy of detailing and chasing. In these respects it has more in common with Bartolomeo da Teramo's reliquary of the arm of S. Biagio of 1394 in S. Flaviano at Giulianova than with many works in its own particular category.

366. Alberto Arnoldi(?): The Eucharist, 1350s. *Florence, Duomo, campanile*

These range from the silver gilt bust of S. Zenobio in the Duomo at Florence, which Andrea Arditi carried out in 1331, to the Sienese Giovanni di Bartolo's florid reliquary of S. Agata, carried out in Avignon in 1376 and now in the Duomo at Catania. The pensive bust of S. Donato which Donadino da Cividale executed for the Duomo of his home town in 1375 is, however, unrivalled in its subtlety and force of characterization [368]. Nothing comparable had been achieved since three French goldsmiths carried out the uncompromising bust of S. Gennaro in Naples in 1306.

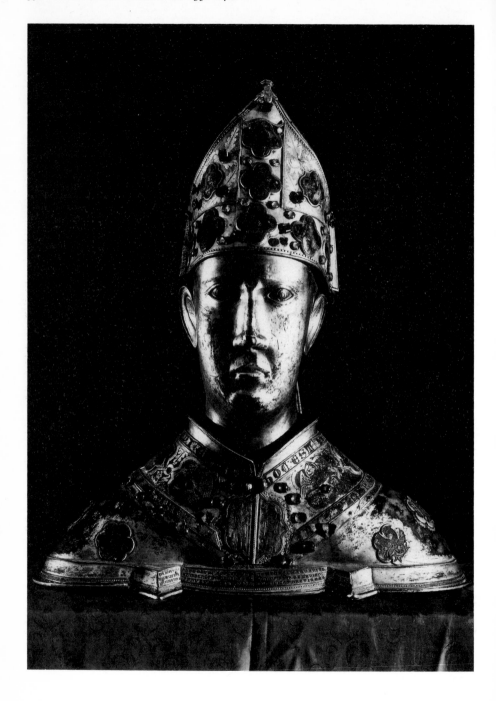

367 (*opposite*). Pietro and Paolo Aretino: Reliquary bust of S. Donato, 1346. *Arezzo, Pieve*

368 (*below*). Donadino da Cividale: Reliquary bust of S. Donato, 1375. *Cividale, Duomo*

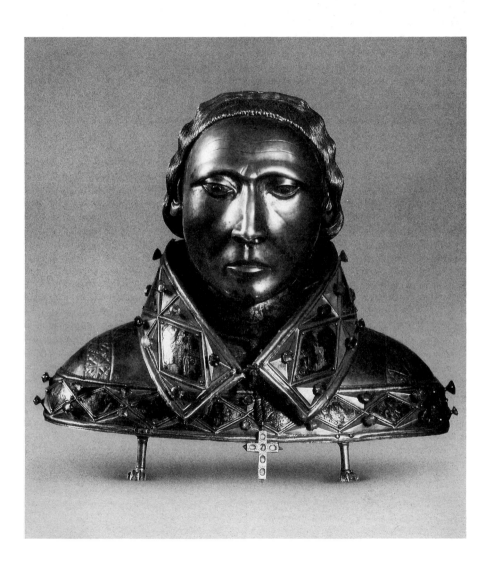

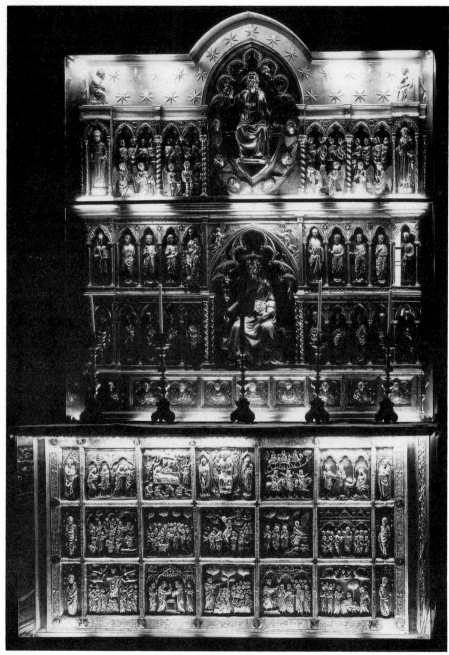

369. Altar of S. Jacopo, 1287, 1314–16, mid fourteenth–early fifteenth century.
Pistoia, Duomo

The final heights of splendour and expense were reached in two great silver altars. That of S. Jacopo in the Duomo at Pistoia had been commissioned on a small scale in 1287, looted by the notorious Vanni di Fuccio de'Lazzari in 1292, restored in 1314, and concurrently, it seems, greatly enlarged by Jacopo d'Ognabene [369].[3] The latter signed the antependium in 1316 and was probably responsible for the main series of fifteen compartments devoted to the lives of Christ and of St James. Even at this late date the influence of Bonanno's doors in Pisa can still be traced, but the main sculptural debt is to Nicola, and to a lesser extent to Giovanni, Pisano. The most striking features of the general design are the balancing of architectural and landscape scenes and the manipulation of the other details of internal composition to create a total symmetry. The radical displacement of the *Presentation* to the end of the life of Christ recalls the apparently similarly motivated displacements in the St Francis cycle at Assisi. Designs for the side panels were commissioned from Pietro di Leonardo da Firenze in 1357, and when these proved

unsatisfactory the advice of the famous Sienese goldsmith Ugolino di Vieri was obtained. Then, from 1361 to 1364, Leonardo di Ser Giovanni carried out the nine scenes from the Life of St James on the epistle side, and from 1366 to 1376, helped by Francesco di Niccolo, continued with the scenes from Genesis and the Life of the Virgin on the gospel side. Both sets of reliefs remain remarkably true to the visual tradition established on the frontal fifty years before, but a greater incisiveness in those on the epistle side prepares the way for six scenes of the Life of the Baptist on the silver altar for the baptistery in Florence [370].

This second altarpiece was commissioned in 1366 from the same Leonardo di Ser Giovanni, together with Betto di Geri, who, with Cristoforo di Paolo, Michele di Monte, and others, substantially carried it out after 1377. The scene of the Baptist before Herod is directly derived from the Pistoia altarpiece, and there are numerous similarities in drapery, landscape detail, and the like. There similarity ends. The Florentine panels are finer in detail and technically far superior to those at Pistoia. They are

370. Leonardo di Ser Giovanni, Betto di Geri, and others: Silver altar from the baptistery, after 1377. *Florence, Museo dell'Opera del Duomo*

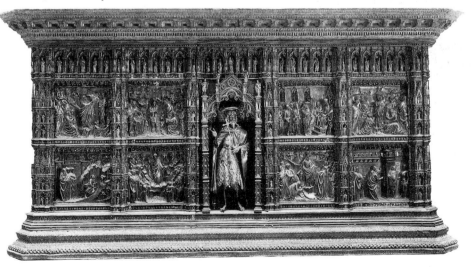

carried out in bolder relief, nearing the round at times, and are obviously indebted to the tradition established by Andrea Pisano's bronze doors. The compositions are less crowded. They are also more clearly constructed in terms of architectural perspective and landscape recession. The scenes of St John before Herod and St John in Prison are remarkable for the clarity and grandeur with which sculptural and pictorial qualities have been combined. The architectural framework of the altarpiece, which was probably begun towards the end of the century, is, like the outside of the nave of the Duomo, notable for its combination of simple structure and utmost intricacy of detail. As also in the Duomo, the ease and naturalness with which the Gothic world slips into that of the Renaissance can be seen in the completion of the work by Michelozzo, Pollaiuolo, and Verrocchio.

If the altar of S. Jacopo lacks the architectonic quality of its Florentine rival, the transition from the fourteenth to the fifteenth centuries is as smooth as that between the thirteenth and the fourteenth. Already in 1349 to 1353 a certain Gilio Pisano had carried out the central figure of S. Jacopo, whose flowing curves are redolent not of Nicola and Giovanni but of Andrea and Nino Pisano. Then, after Pietro d'Arrigo Tedesco of Pistoia and others had made several additions during the eighties, and Cristoforo di Paolo had supplied an unspecified drawing in 1394, the Pistoiese painter Giovanni di Bartolomeo Cristiani was commissioned in 1395 to design the crowning elements of the dossal. These were carried out by Nofrio di Buto da Firenze and Atto di Piero Braccini da Pistoia and include a graceful choir of angels. The latter not only recall those of French workmanship which support the reliquary in S. Domenico in Bologna, but lead directly to the new world of Ghiberti and to the figures which the youthful Brunelleschi seems to have contributed to the altar after its consecration in 1401. Indeed, from the still largely Romanesque Virgin and Child on the altar of S. Jacopo to the reliefs by Pollaiuolo

and Verrocchio, the heralds of the High Renaissance, on the altar of S. Giovanni, the sculptors, painters, goldsmiths, and their patrons have conspired, at times unwittingly, at times deliberately it seems, to demonstrate the continuities that link two hundred years of constant change.

THE ARCA DI S. AGOSTINO

The Arca di S. Agostino in S. Pietro in Ciel d'Oro at Pavia [371], dated 1362 on the cornice of the base, may not have been finished until much later. Although its frequent attribution to Giovanni di Balduccio hardly seems to be justified, the debt to the Arca di S. Pietro Martire in S. Eustorgio in Milan [300] is plain, and one of the two main executants seems to have been the sculptor of the Adoration altarpiece in that same church.[4] His hand appears most clearly in the doll-like figures of the particularly charming Funeral Procession, where the birds creep round like lizards in the cauliflower trees. Among the single figures, the caryatid Virtues of the base mark both the qualitative peak and the nearest approach to Giovanni's own style. Above this level there is an abrupt descent towards repetitive and inorganic puppetry, enlivened by one or two remarkable portrait heads. The typical late-fourteenth-century, North Italian lushness may be compared and contrasted with the forms of Orcagna's tabernacle [141] or with the ivories of the Embriachi. Wherever a ledge can be inserted, there a figure stands. Where no figures are, the surface is worked into leaf and scroll designs. Despite the tall, rectangular format, the four heavy cornices, the breaking up of all the verticals by figure sculpture, and the even upper line of pediments and figures combine to give an impression of weightiness, solidity, and horizontality. The saint's effigy, surrounded by a pigmy court of mourners, reclines within the central cavern. The pointed arch has barely penetrated to this solemn world. Although it may not have been finally erected until after 1397, when it is mentioned in Gian Galeazzo

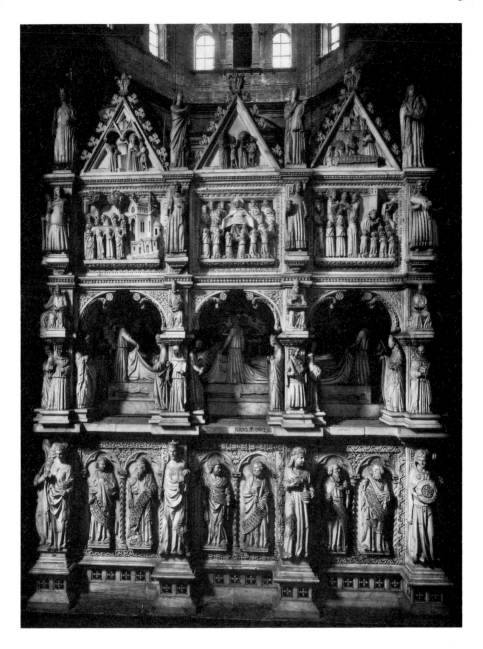

371. Arca di S. Agostino, inscribed 1362, completed later(?).
Pavia, S. Pietro in Ciel d'Oro

Visconti's will, it has as much or more in common with the Arca di S. Domenico of a hundred years before as with the new world of Milan Cathedral.

The roll-call of the creators of the hybrid sculpture of Milan in the last decade of the century is rich in French and German names. Roland de Banille, who signed the half-length S. Agata, paid for in 1398; Johann Marchestens; Peter and Walter Monich, the latter subsequently active at Orvieto, Sulmona, and L'Aquila; Pierre de France, Louis de Roy, and Pierre de Vin, are only some of those who worked with Nicola da Venezia, Alberto da Campione, and a host of North Italians. The intermingling of North French and Rhenish elements in the many figures for the sculptured capitals is so thorough that it is hard to say how much Giovanni dei Grassi may have been involved in their design. The difficulty is compounded by the tentative carving of his single documented work, the *Christ and the Woman of Samaria* (1391–6) in the north sacristy of the Duomo.[5] In 1393, however, Giovanni dei Grassi and Giacomo da Campione did succeed in modifying the architectural detail of Johann von Fernach's heavily worked relief above the door of the south sacristy. How much Giacomo was influenced by von Fernach's heavy undercutting and emotionally charged design can be seen in his own signed work over the door of the north sacristy. He moves upwards from a restrained, and in its outlines thoroughly Italianate, lunette to a relief of God the Father which is a crude if spirited attempt to beat the Northerner at his own game. His triumph is the architectural framework [372]. He follows up his open criticism of von Fernach's florid high relief with something which is virtually a page from one of Giovanni dei Grassi's books of hours. Delicate cusps and pinnacles, conceived almost exclusively in terms of line, are ghosted

372. Giacomo da Campione: Milan, Duomo, north sacristy, relief over door, 1390s

out of the smooth stonework of the wall and sink back into it like silverpoint on parchment. The sculpture of the Duomo teems with similar pictorial effects and often seems only to gain its solid form out of some alchemy of sunlight and cast shadow. The documents continually attest the power that painters such as dei Grassi wielded over every aspect of the building's growth. Indeed the 'model' of the upper parts of the cathedral which Giovanni had supplied was still being referred to in 1400 and was reinstated as a determining factor as late as 1414, the better part of twenty years after his death. A surviving drawing may well reflect a part of his highly decorated design for the crossing.[6] The present sparse and somewhat unhappy relationship between the figure sculpture and its notional niches seems to reflect the germ of his ideas impoverished by subsequent major architectural modifications to the design of the drum and the truncation of the pointed arch forms which were originally intended. Here and elsewhere, however, the extent of the painters' control and the lack of a sculptor of sufficient genius and force of character to resist them may account for much that is certainly mediocre. Nevertheless, the probably fortuitous conjunction of an unknown sculptor and a Milanese artist of whom nothing but his name, Isacco da Imbonate, has been recorded, did, in 1402, produce at least one masterpiece in their *Annunciation* [373]. It is by contrast only that an angel Gabriel, more heavily wing-loaded than a bumble-bee, prepares one for the prayerful Virgin who emerges from the shadows, slim and secret in her flowing robes, and shrouded in humility, among the traceries on the far side of the central window of the apse. Even a man of such accomplishment as Jacopino da Tradate, who heads the long list of those who worked on well into the fifteenth century, could do no more.

The finest expression of the Lombard idiom in terms of precious metal is, perhaps, the Monstrance from Voghera [374], dated 1406 and now in the Castello Sforzesco in Milan. Its graceful, many-crocketed complexity is a

373. Anon. and Isacco da Imbonate: Virgin Annunciate, 1402. *Milan, Duomo*

worthy counterpart to the sophisticated elegance of Francesco Vanni da Firenze's reliquary of S. Reparata in the Museo dell'Opera in Florence [375] or to the stylized tracery of the Sienese *Tree of the Cross*, restored and completed in the late fifteenth century and now in the Museo Civico at Lucignano Val di Chiara.

374. Voghera Monstrance, 1406.
Milan, Castello Sforzesco

375. Francesco Vanni: Reliquary of S. Reparata,
c. 1380. *Florence, Museo dell'Opera del Duomo*

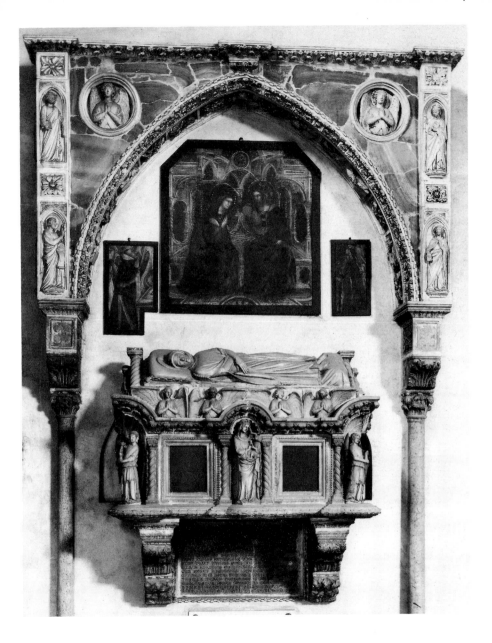

376. Andriolo de' Santi: Tomb of Jacopo da Carrara, completed 1351.
Padua, Eremitani

Similar comparisons can be made between the architectural decoration of the chalice given by Gian Galeazzo Visconti to the Duomo at Monza and the more orthodox enrichment of the enamel-encrusted chalice in the Sienese manner signed by Cataluccio da Todi and now in the Galleria Nazionale dell'Umbria at Perugia. Ignoring such ingenuous adventures in stock-broker's Gothic as the reliquary of S. Domenico in S. Domenico in Bologna, carried out in 1389 by Jacopo Roseto, the chiselled delicacy of Andreolo de'Bianchi's silver-gilt processional cross of 1392 in S. Maria Maggiore in Bergamo makes a similarly telling contrast both in time and taste with the Abruzzan cross of 1334 from Rosciolo which is now in the Palazzo Venezia in Rome. Beyond lie a host of other crosses from all over Italy which are themselves only a fragment of the surviving riches of Italian fourteenth-century goldsmiths' work.

VENICE

At the other end of Northern Italy Andriolo de' Santi was giving definitive form to a type of tomb based on a combination of two earlier patterns. The first is the Lombard type with angels set diagonally at the corners, exemplified by the tomb of Ottone Visconti in the Duomo at Milan (c. 1300). The second involves plain figures standing at the corners and is first seen in the Veneto in the alabaster and green porphyry Shrine of Beato Enrico, erected in 1315 in the Duomo at Treviso. With the tomb of Jacopo da Carrara in the Eremitani at Padua [376], for which Andriolo and three others were paid in 1351, and in the presumably slightly earlier tomb of Ubertino da Carrara (d. 1345) the new pattern is firmly established. The relief figures of the tomb of Beato Enrico have been developed almost in the round, and the greatly enriched upper cornice is bent upwards to form canopies over the central Virgin and over the angels at the angles. Finally, the whole sarcophagus, standing on brackets, is framed by a simple, pointed arch. In the monument to Doge Andrea Dandolo (d. 1354) in S. Marco the new

pattern is modified to fit the curtained Tuscan scheme which was also used for the tomb of Enrico Scrovegni in the Arena Chapel in Padua. None of the recumbent effigies or their portrait heads approach the sinuous sophistication or line or the bold stylizations of the effigy of S. Simeone which Marco Romano signed in 1318 in S. Simeone Grande in Venice, and the standard of Venetian figure sculpture is on the whole low.

Even the major figures of the last years of the century, Jacobello and Pierpaolo dalle Masegne, seldom rise to more than modest heights. They are first known from the signed fragments of the tomb of Giovanni da Legnano (d. 1383) in S. Domenico in Bologna. Their first surviving major work, the high altar of S. Francesco in Bologna [377], was carried out between 1388 and 1392.[7] It has all the complexity associated with goldsmithery or with contemporary Lombard sculpture and illumination. Yet despite the busts that balance so improbably upon the pinnacles, the severity of the basic rectangle, the mass of internal detail, and the repeated vertical strips of figures large and small – their convexities accentuated by their canopies and bases – inevitably recall the ivory altarpieces of the Embriachi. A central Coronation, much influenced by Nino Pisano, accompanies predominantly North Italianate supporting figures. The affinities with Central and Northern European sculpture are obvious. The busy, restless quality, the constant movement in and out, and the broken play of light and shade, help to create one of the few sculptural counterparts of the even more extreme pictorial architecture of Guariento.

The two brothers signed the iconostasis in S. Marco in Venice in 1394, when Jacopo di Marco Benato also signed its bronze and silver crucifix. The naturalistic tendencies and the excited play of light and shade are gone. The free-standing figures, shorn of space-defining niches, paradoxically grow more linear and less volumetric. The proportions are, however, much more secure, and the thin flow of drapery folds in the hard, highly polished, coloured

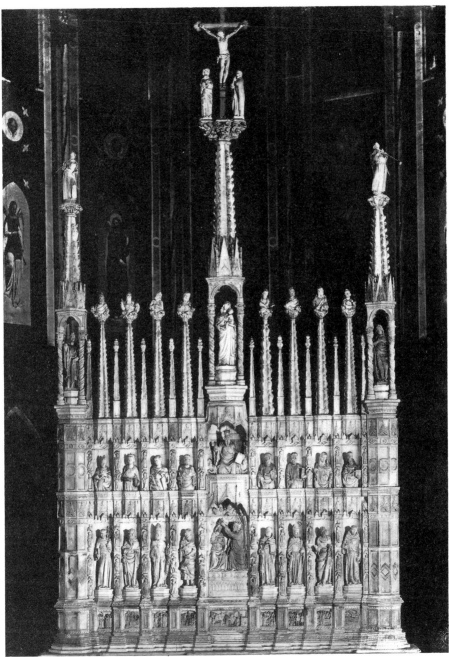

377. Jacobello and Pierpaolo dalle Masègne: High altar, 1388–92.
Bologna, S. Francesco

marble reflects the reinterpretation of such mid-thirteenth-century Venetian sculpture as the Four Prophets in the Cappella Zen. Though various hypotheses have been advanced, this sudden and extreme change of style remains unexplained, and nothing in the brothers' subsequent careers eases the problem.[8] In 1399 they moved to the Duomo at Milan and Jacobello was commissioned by Gian Galeazzo to work in the Castello Visconteo at Pavia. The almost stark simplicity of the effigy of Margareta Gonzaga in S. Andrea in Mantua, with which both brothers were associated in 1399 to 1400, is as unhelpful in solving the stylistic problem as is Pierpaolo's immediately succeeding work on the south balcony of the Palazzo Ducale at Venice.

The capitals of the lower arcading of the earlier section of the Palazzo Ducale, which probably antedate the end of the century, and the angle reliefs of the *Fall and Drunkenness of Noah*, which may or may not be contemporary with them, are surrounded by attributional problems of similar intractability. Filippo Calendario and mid-fourteenth-century Venetian sculpture; Matteo Raverti and early-fifteenth-century sculpture in Milan; South German and Austrian sculpture; the Genesis carvings on the tomb of Mastino II at Verona; the documentary fame of Giovanni Buon (active 1382 to *c.* 1443) and the subsequent activities of his son Bartolommeo, are all factors in an equation overloaded with unknowns. On the other hand, the quality of the angle reliefs and their importance for the history of fifteenth-century Venetian sculpture are as undoubted as the charm and variety of the capitals that so remarkably continue the tradition of the Romanesque reliefs on the archivolts of the central portal of S. Marco.[9] Several of the twenty-four capitals are closely related to the reliefs, and although many severely weathered ones have now been replaced by copies, their full-bodied foliage and the inventiveness and abundant powers of natural observation of the sculptors concerned are as apparent as their extraordinary iconographic range. Eight of

Love's Joys and Sorrows; eight of the Races of Mankind, with Greeks and Goths, Persians and Turks and Tartars and Hungarians; the Ages of Man; Virtues and Vices; the Liberal and Mechanical Arts; the Fruits of the Earth; the Kinds of Animals and the Seasons; the Planets and the Constellations; the Heroes of the Ancient World and Saintly Sculptors and their Pupils, are all present. Each capital, with its eight labelled aspects, seems more charming than the last, and each adds to the range of one of the most varied and compact of late medieval sculptural encyclopedias.

BONINO DA CAMPIONE AND THE SCALIGER TOMBS IN VERONA

Bonino da Campione's documented career begins with the signed tomb of Folchino de' Schizzi (d. 1357) in the Duomo at Cremona. It shows him treading the path marked out by Giovanni di Balduccio and followed earlier in the tomb of Stefano and Valentina Visconti in S. Eustorgio in Milan and in innumerable minor monuments. His studio maintains the same tradition in the sarcophagus of the signed monument to Bernabò Visconti (d. 1385), which was completed in Bernabò's lifetime and is described in Pietro Azario's *Chronicon* of 1363 [378]. In the stiff, equestrian figure he ignores the lively precedent of Cangrande's monument to follow the more recent, less sophisticated example of Giovanni da Campione in the north porch of S. Maria Maggiore in Bergamo. The anatomy of the horse is greatly improved, and what Bonino's ill-proportioned and implacable rider loses in vivacity he gains in terms of barbaric splendour. The anonymous *Lament for the Death of Bernabò Visconti* describes the figure as being covered in gold and silver and having fine golden spurs, and bearing a shield upon its arm, a pennant on its spear.[10] It must have been a strange and awe-inspiring sight, and one which throws an interesting side-light on the relationship of Church and state in the Visconti territories, when horse and rider, armed as if for battle, stood

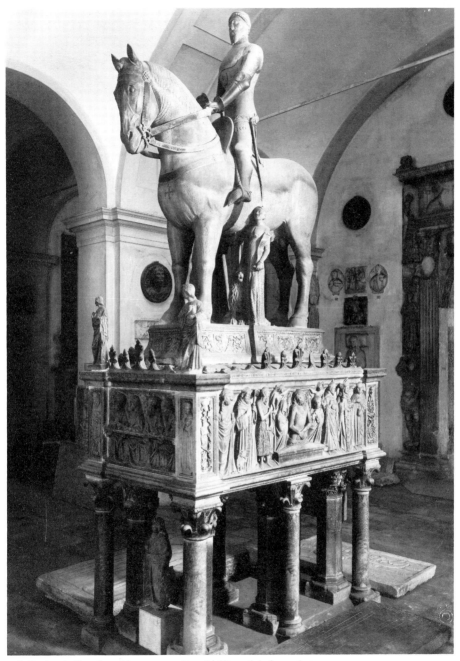

378. Bonino da Campione: Monument to Bernabò Visconti, before 1363.
Milan, Castello Sforzesco

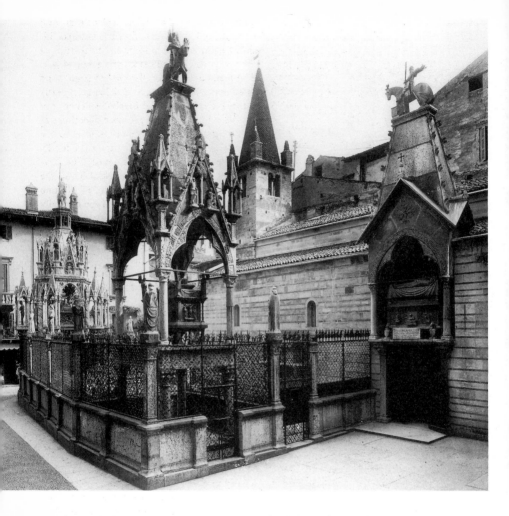

379 (*above*). The Scaliger tombs.
Verona, S. Maria Antica

380 (*opposite*). Equestrian figure,
detail of monument to Mastino II della Scala,
before 1351.
Verona, S. Maria Antica

in their original position on the high altar of
S. Giovanni in Conca in Milan.

Bonino's second important still-surviving
mission was the signed monument to
Cansignorio della Scala in Verona, reportedly
begun before the latter's death in 1375 [381].
The pattern established in the tomb of Gugli-
elmo di Castelbarco (d. 1320) [303] and in the
monument to Cangrande (d. 1329) [304] had
already been elaborated by unknown and poss-
ibly local sculptors in the monument which

Mastino II (d. 1351) apparently raised to himself in the della Scala graveyard next to S. Maria Antica in Verona [379]. The sarcophagus in the latter is raised above a rectangular podium supported by four sturdy columns. Overhead, the pyramidal canopy, with its high reliefs upon the gables and its four subsidiary tabernacles perched on pillars, rises to a climax in the equestrian figure of Mastino [380]. The fluttering draperies of Cangrande's monument are repeated, but the horse does not lean forward

quite so eagerly. The rider, armed from head to foot, his helmet and his visor lowered, his shield upon his arm and sword held stiffly at the ready, has all the tense expectancy of war. The metal wings upon the crested helmet and those that still survive on all the angels greatly enhance the courtly and heraldic splendour of a tomb originally enlivened by a liberal use of colour. Association with and contrast to the equestrian figure of Cangrande could hardly have been more brilliantly achieved. The flowing forms and decorative sophistication of the treatment of the recumbent figure of Mastino are as remarkable as the power of the normally invisible portrait head. The stylistic variations between the many sculptural elements testify to the cooperative nature of the enterprise but do not detract from the technical range of the carving. Damask designs were once painted on the drapery of the bier, and similar patterns are incised in the charger's trappings. The delicacy and complexity of the low relief on the sarcophagus resembles nothing so much as chased or repoussé metalwork. Towards the far end of the scale, among the figures in the round, there stands the naked, full-fleshed Eve of the Temptation. Her solid stance, thick waist, and heavy limbs are a preparation for and contrast to the early-fifteenth-century giants sculpted for Milan Cathedral.

If the monument to Mastino II is rich, that built for Cansignorio some twenty-five years later is still richer [381]. The wide range of sculptural style makes it hard to say how much Bonino, twice referred to as the sculptor in the inscriptions, may himself have carved. His hand is almost certainly visible in the somewhat wooden effigy of Cansignorio and is probably to be seen in the angels standing at his head and feet. Although he is unlikely to have carved it himself, the stolidly lifeless equestrian figure, based on the monument to Bernabò Visconti, certainly owes its unfortunate departure from the Veronese precedents to his inspiration, if that is the right word. Indeed, the attractiveness and technical accomplishment of the figure of Judith with the head of Holofernes on one of

the piers of the enclosure is nowhere matched upon the monument itself.

The question of to what extent, in view of the previously established Veronese tradition, the general design may have been due to the 'realtor' Gaspar, who is named in one of the inscriptions, seems to be unanswerable, but distaste for the often lifeless individual carvings should not lead to denigration of the intrinsic virtues of the general design. The latter foreshadows the filigree intricacies of such works as the Monstrance of Voghera [374], and metalwork is one of the chief glories of this small, stone garden of the dead. The grilles that form the outer fence are net-like in their flexibility. The combination of intricacy of design and rugged, boldly beaten texture in the sections which enclose the tombs of Mastino II and Cansignorio and bear the della Scala arms stands in splendid contrast to the elegance and refinement of Migliore di Nicola's more or less contemporary metal screen for the Rinuccini Chapel in S. Croce, Florence. The treatment of the enclosing grille is integral to the development that separates the tomb of Cansignorio from that of Mastino II.

In Mastino's monument there is some uncertainty in the proportions of what is locally a first experiment with a totally free-standing tomb. The forms are severely enclosed within the basic rectangle. There are no surrounding tabernacles at the lower levels, and the grille is merely a protective fence. In that of Cansignorio the pattern of the lower tabernacles, which crown the vertical supports of the grille and swell out over it, is exactly repeated in the upper tabernacles on the main structure and ensures the unity of the whole. The grille con-

tributes greatly to the textural quality of the base. Although encouraged to look swiftly up, the eye is conscious of the play of shadowy shapes within. The complex interaction between the basic hexagon, repeated at each level, and the lesser rectangles and squares is assisted by the confident and subtle handling of the proportions. An even pyramid builds up from the complexities of the main stage to culminate in the plain hexagon that repeats the simple form of the retaining wall and supports the block of the equestrian group. Such details as the twisted columns immediately above the level of the grille help to ensure the textural unity of the whole. This play of texture over, through, and round the monument is as important as the spatial interpenetration of the tomb and its surroundings. Whereas the rectangular monument to Mastino II, with its decorated upper and lower elements and simple centre section, is more effective when seen at a distance from outside the enclave, the monument to Cansignorio is best appreciated when examined from inside the enclosure, so that every detail of its structure tells to the full. The orientation of the entries and main faces confirms that these were the ways in which the tombs were intended to be seen to best advantage. On the other hand, as often happens in Italian towns and churches, the total context means as much as, if not more than, any of the individual works of art that help to shape it. This truth has been embodied in the very nature of the monument to Cansignorio. It holds the key to the enjoyment of a great part of the later architectural and sculptural achievement of Northern Italy and of late medieval Europe.

381. Bonino da Campione:
Monument to Cansignorio della Scala,
begun before 1375.
Verona, S. Maria Antica

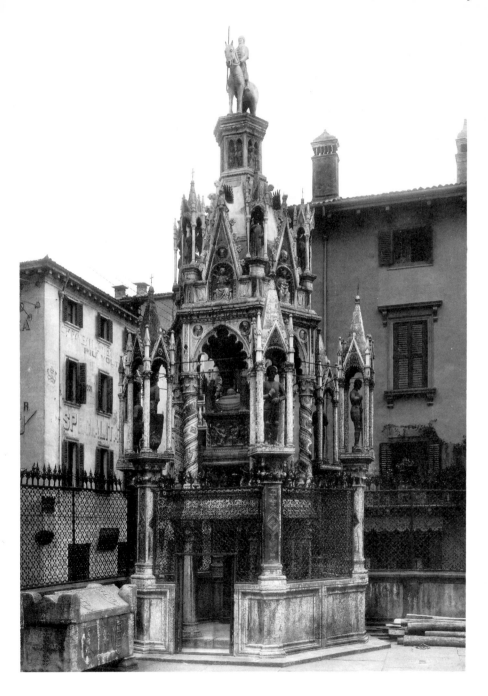

NOTES

Bold numbers indicate page references

CHAPTER 2

23. 1. The often quoted supposition (I. B. Supino, *La Basilica di San Francesco di Assisi*, Bologna, 1924) that the vaults were only completed after 1253 seems groundless. See W. Krönig, 'Hallenkirche in Mittelitalien', *Kunstgeschichtliches Jahrbuch der Bibliotheca Hertziana*, 11 (1938), 36 ff. The recent literature and the varied arguments on dating and attribution are excellently summarized in Fra Ludovico da Pietralunga, *Descrizione della Basilica di S. Francesco e di altri santuari di Assisi*, ed. P. Scarpellini (Treviso, 1982).

2. S. Chiara at Assisi; S. Francesco at Perugia, Terni, Viterbo, and Gualdo Tadino; abbey church at Montelabbate.

3. W. Krönig, *op. cit.*, 41 ff.; W. Schöne, 'Studien zur Oberkirche von Assisi', in *Festschrift Kurt Bauch* (Munich, 1957), 51 ff. P. Héliot, 'La Filiation de l'église haute à Saint-François d'Assise', *Bulletin Monumental* (1968), 126, 127-40, draws attention to similarities with the abbey church of Longues in Normandy.

24. 4. R. Branner, *Burgundian Gothic Architecture* (London, 1960), 76 ff.

25. 5. L. Fraccaro de Longhi, *L'Architettura delle chiese cisterciani* (Milan, 1958), 299 ff.

28. 6. W. and E. Paatz, *Die Kirchen von Florenz* (Frankfurt am Main, 1952-5), III, 701; I, 503.

7. In S. Maria sopra Minerva in Rome, under construction in 1280 and originally substantially completed by 1295, the elements of S. Maria Novella are repeated, with the sole addition of a polygonal main apse. Mid-fifteenth-century vaults now sit heavily on inelegant arches and frustrate the soaring promise of the supports.

8. M. B. Hall, 'The Ponte in S. Maria Novella: the Problem of the Rood Screen in Italy', *Journal of the Warburg and Courtauld Institutes*, XXVII (1974), 157 ff.

30. 9. It is over 375 feet long and 125 feet wide (115 by 38 m.), and almost 240 feet (74 m.) across the transepts.

33. 10. M. B. Hall, 'The Tramezzo in Santa Croce, Florence, Reconstructed', *Art Bulletin*, LVI (1974), 325 ff.

36. 11. Examples are a triple choir-window in S.

Domenico at Arezzo; unusual length and a façade decorated in the local manner in the Eremitani at Padua and in S. Francesco at Lucca, with its strange skew-set chapel entrances flanking the choir; external articulation and wall tombs in the Florentine manner in S. Domenico at Prato (G. Kiesow, 'Die gotische Südfassade von S. Maria Novella in Florenz', *Zeitschrift für Kunstgeschichte*, XXV (1962), 1 ff.); a campanile or a decorated door or rose; a polygonal choir, as at S. Francesco at Montefalco or S. Francesco at Lucera.

12. Apart from the vaulted S. Maria di Calena at Monte Gargano, nave-chapels were rare in Italy before the mid century, only appearing previously in Sicily, some time after 1219, in the extraordinary Cistercian church of S. Nicola at Agrigento.

13. G. Chierici, 'Il Restauro della chiesa di San Lorenzo a Napoli', *Bollettino d'Arte*, IX (1929/30), 24 ff.; R. Wagner-Rieger, 'S. Lorenzo Maggiore in Neapel und die süditalienische Architektur unter den ersten Königen aus dem Hause-Anjou', *Miscellanea Bibliothecae Hertzianae* (Munich, 1961), 130 ff.

37. 14. This plan was also seemingly adopted, *c.* 1298, for the order's enlarged central shrine of S. Domenico in Bologna.

15. The nave vaulting, dome, and complex east end of the originally very similar S. Francesco at Ascoli Piceno were only added from the fifteenth century onwards; W. Krönig, *op. cit.* (Note 1), 119 ff.

16. R. Bonelli, 'La Chiesa di San Domenico in Orvieto', *Palladio*, VII (1943), 139 ff.

40. 17. They diminish from 42 feet to 39¾ feet in width (12.75 to 12.10 m.), and lengthen from 36 feet to 44½ feet (11 to 13.50 m.) towards the choir.

41. 18. W. Krönig, *op. cit.*, 76, C. Calano, 'San Fortunato a Todi: una chiesa "a sala" gotica', *Quaderni dell'Istituto di Storia dell'Architettura*, XXIV (1977-8), 113-28, and below, Chapter 3, Note 5, and pp. 521-2.

19. See G. Lorenzoni, *L'Edificio del Santo di Padova* (Vicenza, 1981), which gives a full documentation and résumé of secondary sources. H. Dellwing, 'Der Santo in Padua, ein baugeschichtliche Untersuchung', *Mitteilungen des kunsthistorischen Institutes in Florenz*, XIX (1975, 1977), maintains that the domed design was intended from the start.

44. 20. Cistercian affiliations in plan are confirmed by

close connection with the heavier forms, Lombard Cistercian in origin, of the church of the Umiliati at Viboldone.

21. E. Arslan, *Vicenza*, I, *Le Chiese* (Rome, 1956), 118 ff. The network extends as far as S. Francesco at Vercelli, with its tall transepts and two aisle-bays to each nave-bay. For the most important Lombard structures, which include the severely simple, transeptless wooden-roofed churches of S. Francesco at Brescia and at Mantua, built respectively in stone and brick; S. Francesco at Pavia, with its massive brick columns in the local Cistercian tradition and wooden roof over the first six bays; and the fully vaulted Cistercian cruciform S. Francesco at Lodi, see A. M. Romanini, *L'Architettura gotica in Lombardia* (Milan, 1964).

CHAPTER 3

45. 1. R. Wagner-Rieger, *Die italienische Baukunst zu Beginn der Gotik* (Graz-Cologne, 1956–7), 11, 197 ff. K. van der Poele, in H. van Os, *Sienese Altarpieces 1250–1420* (Groningen, 1984), 109, is probably incorrect in thinking that the nave itself, as well as the choir and nave aisle, was vaulted from the start, since no supports for cross-ribs accompany the simple applied columns still standing against the upper walls of the nave. The documents of 1260, to which the author refers, appear to be associated with the choir and the side-aisles of the nave.

2. E. Carli, *Vetrata ducciesca* (Florence, 1946), 55 ff. and 14. K. van der Poele, *op. cit.*, 131 ff., making considerable use of Odericus's *Ordo officiarum ecclesiae senensis* of 1215 (ed. J. C. Trombelli, Bologna, 1766), considers the disposition of the original twelfth-century choir and choir-stalls in detail. It is possible that the choir was raised, but rather unlikely that the change in level was marked by four steps running straight across the entry to the choir, immediately in front of the high altar, in the manner suggested.

Certainly, no such scheme can have survived in the new building since the bases of the still extant eastern supports of the new hexagonal crossing are exactly the same as the remainder. They show no signs of reworking and were certainly not partially buried in a flight of steps. Since no other position for the proposed change of level is possible, the existing, continuous floor plane must, whatever the preceding situation, have been established from the start in the new thirteenth-century building.

Odericus (*op. cit.*, 34) refers to the archbishop's 'superius sedile' in front of the altar of the Blessed Virgin Mary or high altar. This may mean either the 'raised seat' or, in view of his usage elsewhere, the archbishop's seat or throne in the upper church as

opposed to the crypt. The four steps in front of the altar, referred to here and elsewhere (Odericus, 34, 173), seem certainly, given the context, to be those of the high altar itself, since the cantor and two of his companions next go on to sing behind the high altar, which is distinguished from the choir, which is later referred to as having entrance gates ('venerint ad cancellos in ingressu Chori', Odericus, 186). Here and elsewhere, there are allusions to 'the altar' without further qualification (notably Odericus, 180–1) which clearly refer to the high altar.

47. 3. W. Krönig, 'Toskana und Apulien', *Zeitschrift für Kunstgeschichte*, XVI (1953), 101 ff.

4. G. Vigni, 'L'Architettura del duomo di Grosseto', *Rivista d'Arte*, XX (1938), 49 ff.; A. Garzelli, *Il Duomo di Grosseto* (Florence, 1967).

51. 5. R. Bonelli, *Il Duomo di Orvieto e l'architettura italiana del duecento trecento* (Città di Castello, 1952), gives thorough plans, reconstructions, diagrams of distortions, etc. See also W. H. Goodyear, *Greek Refinements* (London, 1912).

6. C. M. Cippola, *Studi di storia della moneta*, I, *I Movimenti dei cambi in Italia dal secolo XIII al XV* (Pavia, 1948), and *Money, Prices and Civilization in the Mediterranean World* (New York, 1967).

52. 7. G. Villani, *Cronica*, lib. VIII, cap. IX.

8. The theory that Siena Cathedral ended in radiating chapels strengthened this belief. See V. Lusini, *Il Duomo di Siena* (Siena, 1911), 39 ff.

9. F. Toker, 'Florence Cathedral: The Design Stage', *Art Bulletin*, LX (1978), 212 ff., and 'Arnolfo's S. Maria del Fiore: A Working Hypothesis', *Journal of the Society of Architectural Historians*, XLII (1983), 101 ff., supersede G. Kreytenberg, *Der Dom zu Florenz* (Berlin, 1974), W. Kiesow, 'Zur Baugeschichte des Florentiner Doms', *Mitteilungen des kunsthistorischen Institutes in Florenz*, X (1961–3), 1 ff., and H. Saalman, 'Santa Maria del Fiore: 1294–1418', *Art Bulletin*, XLVI (1964), 471 ff. The documents are published in G. Guasti, *Santa Maria del Fiore: la costruzione della chiesa e del campanile* (Florence, 1887), and the main excavations of 1965–74 are reported in G. Morozzi, *Santa Reparata* (Florence, 1974).

10. This was surmounted by more elaborately recessed panelling of increased linear delicacy and culminated in the ornate marbling of the windows. Decorative and structural elements were indissolubly united, with scarcely any distinction between wall surfaces and intervening pilasters. H. Saalman, *op. cit.* (Note 9), argues that none of the incrustation above the socle of the bays nearest the façade, which W. Kiesow, *op. cit.*, analyses, antedates Francesco Talenti *c.* 1359. The relationship to the surviving lower elements of the original façade of S. Maria

Novella is discussed in G. Kiesow, *op. cit.* (Chapter 2, Note 11).

11. The dearth of further external links and ignorance of the style of Arnolfo's proposed interior mean that his documented connexion with the Duomo does not definitely confirm his generally accepted authorship of S. Croce.

53. 12. G. Villani, *op. cit.*, lib. VII, cap. XCIX.

54. 13. Similar forms recur in the basement of the east end of S. Croce.

14. E. Carli, *Sculture del duomo di Siena* (Turin, 1941), 68, note 8.

15. P. Bacci, 'Le Sculture decorative della facciata del camposanto di Pisa', *Dedalo*, I (1920), 311 ff.

CHAPTER 4

59. 1. The earlier institution of the office of Podestà had resulted in the massive palace built in the early thirteenth century and largely transformed in the sixteenth.

61. 2. The external window linkage, hinted at in the abbey, has a long history in France and Spain.

3. These arches, and the exterior above the upper cornice, are largely reconstructed.

62. 4. P. Toesca, 'Il Palazzo Papale di Viterbo', *L'Arte*, VII (1904), 510 ff.

65. 5. W. Paatz, 'Zur Baugeschichte des Palazzo del Podestà in Florenz', *Mitteilungen des kunsthistorischen Institutes in Florenz*, VI (1931), 287 ff.

68. 6. Despite the imposing mass created by such fourteenth-century additions as the angle tower, the original Palazzo dei Priori (begun 1293) seems to have been less sensitively designed.

69. 7. At Fabriano a wide roadway runs through the centre of the Palazzo del Podestà. At Volterra the three faintly pointed arches of the loggia of the Palazzo Pretorio are unusually tall. The variations are as endless as the surviving buildings are numerous.

8. C. Martini, 'Il Palazzo dei Priori a Perugia', *Palladio*, XX (1970), 39 ff.

CHAPTER 6

74. 1. R. Krautheimer, 'Introduction to an Iconography of Medieval Architecture', *Journal of the Warburg and Courtauld Institutes*, V (1941), 1 ff.

2. *Ibid.*, 29.

3. On the 13th, Giovanni is referred to as 'filius qhondam magistri Nicholo'.

76. 4. The Burgundian cusped arch occurs in various contexts at Fossanova and Castel del Monte in the first half of the century. Round arches and angle and spandrel-figures occur in the twelfth-century pulpit at Salerno, and at Split. French-derived triple columns occur at Split; as room articulation at Castel del Monte; and also in S. Chiara in Assisi and elsewhere. Luxuriant foliate capitals occur in S. Galgano and, like the now widespread, but originally Lombard, supporting lions, give no final proof of Nicola's southern origin. For analogous reasons the many architectural attributions to Nicola are logically unsatisfactory.

5. It was later replaced by Giovanni and shipped to Cagliari. The rustic structure at Groppoli, dated 1194, and the pulpits at Brancoli, in the Duomo at Volterra, and in S. Leonardo in Arcetri in Florence, are intermediate examples. The surviving reliefs in S. Bartolomeo in Pantano at Pistoia seem in fact to be the remains of two rectangular wall pulpits. The infancy scenes are now hung on the wall in the wrong order, as also are associated lengths of cornice, the remaining reliefs have been recomposed, with singularly unfortunate results, in the form of a free-standing pulpit.

6. The dependent work at Barga lacks this refinement.

7. G. Jászai, *Die Pisaner Domkanzel* (Munich, 1968), 11 ff., discusses the iconography in general, suggesting a different original order and identity for the angle figures, seeing Hercules as Samson and Faith as Gabriel. E. M. Angiola, 'Nicola Pisano, Federigo Visconti and the Classical Style in Pisa', *Art Bulletin*, LIX (1977), 1 ff., in an article which, in note 63, rather over-generously attributes to me a quotation from M. Weinberger which belongs to the previous note, agrees as to Gabriel, without however referring to Jászai, but sees Hercules as Daniel. In view of the Crucifixion symbolism, Faith is also seen as Michael by a number of earlier writers, including on pp. 358–64 of a major article, M. Seidel, 'Studien zur Antikenrezeption Nicola Pisanos', *Mitteilungen des kunsthistorischen Institutes in Florenz*, XIX (1975), 307 ff. The latter also, probably correctly, retains the attribution as Hercules (pp. 337–44), but these and all such matters are liable to remain the subject of controversy.

79. 8. G. Swarzenski, *Nicolo Pisano* (Frankfurt am Main, 1926), 16 ff., discusses in detail both the classical and French derivation of Nicola's work. M. Seidel, *op. cit.*, provides further major clarifications and precise connexions, among them a third-century sarcophagus in the Thermae Museum, Rome, in which not only the pose of the Hercules, but its proportions, like those in a number of the sarcophagi and other antiquities in the Camposanto, Pisa (P. E. Arias and S. Settis, *Camposanto monumentale di Pisa, Le Antichità*, I (Pisa, 1977), 11 (Modena, 1984), are closer to those of Nicola's Hercules, and of his figures generally, than are those of the figures in the late-

620 · NOTES

second-century Hippolytus sarcophagus, also in the Camposanto.
9. M. Seidel, *op. cit.*, 314, Abb. 4.
8o. 10. *Ibid.*, 313 ff.
11. Apart from C. A. Willemsen, *Kaiser Friedrichs II Triumphtor zu Capua* (Wiesbaden, 1953), Creswell Shearer, *The Renaissance of Architecture in Southern Italy* (Cambridge, 1935), discusses the Capuan Gate in detail.
83. 12. E. Carli, *Il Pulpito di Siena* (Bergamo, 1943), 41 ff., gives the documents; the significance of this and of other early contracts is discussed in J. White, *Duccio* (London, 1979), 34 ff.; and G. Jászai, *op. cit.*, 19 ff., gives a reconstruction of the original disposition.
13. See below, pp. 452 ff.
14. P. d'Ancona, 'Le Rappresentazioni allegoriche delle arti liberali nel medio evo e nel rinascimento', *L'Arte*, V (1902), 137 ff., 211 ff., 269 ff., 370 ff.
87. 15. M. Seidel, 'Die Verkundigungsgruppe der sieneser Domkanzel', *Münchner Jahrbuch der bildenden Kunst*, XXI (1970), 18 ff., convincingly attributes the announcing angel in the Staatliche Museen, Berlin, to Nicola Pisano as the missing Gabriel associated with the original entrance platform of the pulpit.
88. 16. He contracted to reconstruct an altar in S. Zeno, decorating it with six reliefs.
17. G. Fasola, *La Fontana di Perugia* (Rome, 1951), 71 ff. For the reconstruction of the original sequence of angle inscriptions and angle figures on the upper basin, see J. White, 'The Reconstruction of Nicola Pisano's Perugia Fountain', *Journal of the Warburg and Courtauld Institutes*, XXXIII (1970), 70 ff., in this respect correcting K. Hoffmann-Curtius, *Das Programm der Fontana Maggiore in Perugia* (Düsseldorf, 1968).
89. 18. Robertus's now dismembered Romanesque font in S. Frediano at Lucca is a geographically closer parallel. Giroldo da Como's rectangular font of 1266 in the Duomo at Massa Marittima has interesting echoes of Nicola's Pisa pulpit.
91. 19. See below, Chapter 7, Note 13.
20. For the latest discussion of the capitals and other sculptures which have been associated with Nicola Pisano in varying degrees, see A. Middeldorf-Kosegarten, *Sienesische Bildhauer am Duomo Vecchio* (Munich, 1984), 35 ff.

CHAPTER 7

93. 1. It is the restricted use of Gothic detail in comparison with the ciborium of 1285 that points to an early date.
2. K. Frey, *Le Vite ... di Vasari ... herausgegeben von Dr Karl Frey* (Munich, 1911), 558 ff., is the main proponent of the two-man theory. The precise date

of Arnolfo's death, usually given as 1302, is uncertain. See A. M. Romanini, *Arnolfo di Cambio*, 2nd ed. (Florence, 1980), 104, and J. Pope-Hennessy, *Italian Gothic Sculpture*, 2nd ed. (London and New York, 1972), 180.
96. 3. The Virgin's hand has been awkwardly cut and rotated in order to replace the original gesture of protection and make it rest on the arm of the throne, which has been moved forward, as is argued by A. M. Romanini, 'Nuove Ipotesi su Arnolfo di Cambio', *Arte Medievale*, I (1983), 157 ff. It is also suggested, because of the setting of the Virgin's feet, that the figure was originally tilted to the right, but it seems to be more likely that the rear foot rested on a step in the manner seen in so many painted versions of the theme.
97. 4. For a possible reconstruction, in which, however, it seems that the crowning gable was probably more steeply pointed and almost certainly more substantial, see A. M. Romanini, *op. cit.* (Note 2), 23 ff.
5. The reconstructed monument was originally in S. Maria in Gradi.
98. 6. H. Keller, 'Der Bildhauer Arnolfo di Cambio und sein Werkstatt', *Jahrbuch der preussischen Kunstsammlungen*, LVI (1935), 30.
99. 7. Despite some reworking, the thin, grasshopper face of the anonymous late-thirteenth-century papal bust in the Palazzo Venezia in Rome is a haunting witness to the new modes of awareness.
100. 8. J. Gardner, 'The Tomb of Cardinal Annibaldi by Arnolfo di Cambio', *Burlington Magazine*, CXIV (1972), 136 ff. French prototypes are considered in some detail by K. Bauch, 'Anfänge des figürlichen Grabmals in Italien', *Mitteilungen des kunsthistorischen Institutes in Florenz*, XV (1971), 227 ff., and A. Erlande-Brandenberg, 'Le Tombeau de Saint Louis', *Bulletin Monumental* (1968), 7 ff. A. M. Romanini, *op. cit.* (Note 3), 177 ff., suggests that the clerics were disposed in an arcading analogous to that in the tomb of St Louis and to the three-dimensional arcading of which the blind arcading now to be seen on the de Braye tomb is a remnant.
9. Comparison with the de Braye acolytes raises the question of studio intervention and complicates relative dating. If the architectural fragments in the cloister are from the tomb, their advanced Gothic detail would point to a period after the de Braye tomb. This would fit in with the recent suggestion in A. M. Romanini, *op. cit.* (Note 3), 193, that the youthful figure is not the aged Cardinal but the thirty-year-old papal notary Riccardo Annibaldi, who died in 1289.
10. N. Fasola, 'La Fontana di Arnolfo', *Commentari*, 11 (1951), 98 ff.
101. 11. J. Pope-Hennessy, *op. cit.* (Note 2), 181.

102. 12. Repeated polishing has removed all colour from the figures.

107. 13. Its quality is stressed by comparison with the tombs by Giovanni Cosmati and others in S. Maria in Aracoeli, S. Maria sopra Minerva, S. Maria Maggiore, and S. Balbina, which emphasize the closely interwoven fabric of the Roman ateliers. Stylistic considerations probably place the subsidiary figures of the *Adoration* group in S. Maria Maggiore in the orbit of Arnolfo's workshop of the eighties. (For dating and reconstruction, see A. M. Romanini, *op. cit.* (Note 2), 181 ff., and W. Messerer, 'Zur Rekonstruktion von Arnolfo di Cambios Praesepe-Gruppe', *Römisches Jahrbuch für Kunstgeschichte*, xv (1975), 25 ff.) The distinctive stylization of the neck, the general proportions, and the stiff, yet vigorous pose, distinct from anything in Arnolfo's other work, probably mean that the great bronze St Peter in St Peter's may be by a much earlier artist who slightly influenced Arnolfo. Nevertheless, M. Salmi, 'Il Problema della statua bronzea di S. Pietro nella Basilica Vaticana', and B. Bearzi, 'Esame technologico e metallurgica della statua di S. Pietro', *Commentari*, x 1 (1960), 22 f., 30 f., underline the clear distinction from Roman examples both in thickness of casting and in the mixture of metals, which is close to that in the work of Rosso or Rubeus, referred to above, p. 91.

111. 14. The startlingly life-like inset eyes recall Antique bronzes.

15. Evangelists and Doctors of the Church were seemingly intended for the upper niches. J. Pope-Hennessy, *op. cit.*, 183, mistakenly places the *Annunciation* in niches above the lunette, and an *Annunciation to the Shepherds* on its left, but this is clearly contradicted by the sixteenth-century drawing [58]. This also shows one of the figures behind the recumbent *Virgin* in the right-hand tympanum. G. Richa, *Notizie istoriche delle chiese fiorentine*, v 1 (1757), 52–3, gives the subject of the latter as 'Il transito di Maria, la quale si vedeva morta giacere, e Cristo, che l'anima di lei strettamente teneva in braccio, e tutti gli apostoli, che circondavano il corpo morto.'

16. The similar distribution, without a unified programme, in the Duomo at Lucca does not seem to justify Weinberger's attribution to Lucchese followers of Nicola Pisano.

CHAPTER 8

114. 1. P. Bacci, 'Continuazione del capitolo inedito, su Giovanni Pisano e il duomo di Siena', *Le Arti*, I V (1941/2), 268 ff. in one of four successive articles discussing the documentation of Giovanni's work. P. Cellini, 'La "Facciata Semplice" del duomo di Siena', *Proporzioni*, 11 (1948), 55 ff., argues unconvincingly that the nave was extended. This view was sub-

sequently elaborated by C. Pietramellara, *Il Duomo di Siena* (Florence, 1980), 14 ff., but only further excavation, disclosing substructures at the end of the penultimate bay, would resolve the matter in favour of an original termination at that point.

116. 2. Paatz's suggestion, in *Werden und Wesen der Trecento-Architektur in Toskana* (Burg, 1937), 11 ff., that the façade as a whole constitutes a planned system of dynamic tension seems very unconvincing.

117. 3. The extensive arguments for considering the Chronicle (L. A. Muratori, *Rerum Italicarum Scriptores*, x v, parte v I (1932), 112) to refer to the existing upper façade, given in A. Middeldorf-Kosegarten, *op. cit.* (Chapter 6, Note 20), 32 ff., and fundamental to her early dating of its sculpture, entail a radical misreading of Maitani's expertise of 1322 in order to make a *terminus ante quem* out of what is incontrovertibly a *terminus post* (see below, p. 234). It also directly contradicts the subsequent document of 1356 (below, p. 240). On the other hand, 1316–17 would be a perfectly possible completion date for the original main façade, begun by Giovanni Pisano.

4. R. Wagner-Rieger, *Die italienische Baukunst zu Beginn der Gotik* (Graz-Cologne, 1956–7), 201 ff. It may or may not be significant that less obtrusive vertical discontinuities are also present in the façade at Poitiers, and that there the piers flanking the single, central door are likewise set inside the line of the nave piers.

120. 5. In Notre Dame la Grande the general effect is similar, but the lateral arches are relatively smaller and more sharply pointed.

121. 6. E. Carli, *Sculture del duomo di Siena* (Turin, 1941), 33 ff. For the documents on Ramo, see G. Milanesi, *Documenti per la storia dell'arte senese* (Siena, 1854), I, 157, and 111, 273 ff.

122. 7. Giovanni and his workshop probably then added half- and full-length figures to the half-lengths completed by Nicola and his circle for the middle zone of the exterior of the Pisan baptistery. The few, richly evocative remains are in the Museo Civico.

128. 8. H. Keller, *Giovanni Pisano* (Vienna, 1942), 36 ff.

130. 9. It is significant of Giovanni's interest in drama, and of the siting of the two pulpits, that frontal lighting suitable for photographing Nicola's scenes at Pisa reduces the *Massacre* at Pistoia to a mere jumble. Dramatic, raking light reveals its full potential.

131. 10. R. Barsotti, 'Nuovi Studi sulla Madonna eburnea di Giovanni Pisano', *Critica d'Arte*, x I x (1957), 47 ff. The crudely joined head of Christ is not original, and his upper foot and the extended hands of both figures are joined to the main piece. See also M. Seidel, 'Die Elfenbeinmadonna im Domschatz zu Pisa', *Mitteilungen des kunsthistorichen Institutes in Florenz*, x v I (1972), 1 ff.

133. 11. P. Bacci, *La Ricostruzione del pergamo di Giovanni Pisano nel duomo di Pisa* (Milan, 1926), gives all the details of the extensive, but generally convincing, reconstruction of the pulpit and its inscriptions, modifications to which are suggested in G. Jászai, *op. cit.* (Chapter 6, Note 7).

12. J. Pope-Hennessy, *Italian Gothic Sculpture*, 2nd ed. (London, 1972), gives the inscriptions on all four Pisano pulpits in full.

136. 13. Many tell-tale details, such as the circular indentations of the knuckles, unite them to the signed Madonnas for the baptistery at Pisa and for the Arena Chapel at Padua, to the Sibyls at Pistoia, and to many other female figures.

138. 14. See below, pp. 189 f., 207 ff.

140. 15. M. Seidel, 'Ein verkanntes Meisterwerk des Giovanni Pisano', *Pantheon*, XXXIV (1976), 3 ff., and *La Scultura lignea di Giovanni Pisano* (Florence, 1971). See also M. Lisner, *Holzkrucifixe in Florenz und in der Toskana* (Munich, 1970).

141. 16. C. Marchenaro, 'Per la tomba di Margherita di Brabante', *Paragone*, XII, 133 (1961), 3 ff., publishes a Justice and, in 'La Madonna della tomba di Margherita di Brabante', *Paragone*, XIV, 167 (1963), 17 ff., a fragmentary Madonna which probably belonged to the tomb.

146. 1. John VI is written 'IHOIS SEXTUS', but this may conceivably be a copyist's error for 'IV', since, as J. Gardner, 'S. Paolo fuori le mura, Nicholas III and Pietro Cavallini', *Zeitschrift für Kunstgeschichte*, XXXIV (1971), 246, note 19, points out, only three previous abbots with this name seem to be recorded. Here, and in P. Hetherington, *Pietro Cavallini* (Isleworth, 1979), 87 ff., who like G. Matthiae, *Pietro Cavallini* (Rome, 1972), 40, doubts whether the 'Ursus sacer et monachu' of the inscription, shown in monastic garb, can really be Nicholas III as pope, the views put forward in J. White, 'Cavallini and the Lost Frescoes in S. Paolo', *Journal of the Warburg and Courtauld Institutes*, XIX (1956), 84 ff. are fully discussed. The date, however, is not affected.

2. The likelihood that Cavallini was working in collaboration is stressed in connection with the surviving roundels with papal portraits, which are clearly by an able Roman painter, in J. Gardner, *op. cit.*

147. 3. The Liber Pontificalis says that Leo I (440–61) commissioned the original decorations.

149. 4. The way in which G. B. de Rossi, *Musaici cristiani di Roma* (1872–96), concluded that a date, earlier misread as 1351 and no longer visible, was actually 1291 is fully described in Hetherington, *op. cit.*, 14–15, who argues that the mosaics succeed rather

than precede the frescoes in S. Cecilia. This view, advanced in an earlier article, which is not accepted by Gardner, *op. cit.*, 245, note 17, and which is partly based on less than convincing perspectival arguments, does not, on balance, seem likely to be correct.

152. 5. The small monastic figure in the lower zone holds compasses and a set-square, the invariable insignia of the architect or architectural supervisor, and is presumably the man responsible for the rebuilding. Although a late-thirteenth-century Paduan Chronicle of the Life of St Anthony asserts that two Franciscans were deputed to 'paint' the mosaic, Torriti is probably not represented, since there is no monastic prefix in any of his three known signatures and he refers to himself as 'pictor', a title carrying less prestige than that of 'architectus'. A second figure is clearly labelled 'Frater Jacobus de Camerino Socius Magistri Operis' and holds a mosaicist's hammer. The presence of the two figures, allied to an independent inscription in the main field, probably caused the chronicler's mistake.

6. In this case the layman accompanying the two Franciscans in the Dormition might well be Torriti himself.

154. 7. M. Alpatoff-Moskau, 'Die Entstehung des Mosaiks von Jakobus Torriti in Santa Maria Maggiore in Rom', *Jahrbuch für Kunstwissenschaft*, 11 (1924–5), 1 ff., suggests an origin in French manuscripts.

8. A similar stylistic background informs several other Roman mosaics, of which the most important is that in the vault of the Sancta Sanctorum, probably, like the architectural reconstruction under Nicholas III, the work of a 'Magister Cosmatus'. See J. T. Wollesen, 'Eine "Vor-Cavallineske" Mosaikdekoration in Sancta Sanctorum', *Römischer Jahrbuch für Kunstgeschichte*, XVIII (1979), 11 ff., and *ibid.* (1981), 37 ff., 'Die Fresken in Sancta Sanctorum'; J. Gardner, 'Nicholas III's Oratory of Sancta Sanctorum and its Decoration', *Burlington Magazine*, CXV (1973), 283 ff.

156. 9. W. Paesler, 'Die römische Weltgerichtstafel im Vatikan', *Hertziana*, 11 (1938), in analysing the relationship, reconstructs the main lines of Cavallini's design, but his thirteenth-century dating is challenged by E. B. Garrison, 'Dating the Vatican Last Judgment Panel', *La Bibliofilia*, LXXII (1970), 121–60.

165. 1. C. Brandi, 'Il Restauro della Madonna di Coppo di Marcovaldo nella chiesa dei Servi di Siena', *Bollettino d'Arte*, XXXV (1950), 160 ff.

166. 2. C. Brandi, 'The Cleaning of Pictures in Relation to Patina, Varnish, and Glazes', *Burlington Magazine*, XCI (1949), 183 ff., discussed these

matters, asking for extreme caution in cleaning such works. He was opposed by N. Maclaren and A. Werner, 'Some Factual Observations about Varnishes and Glazes', *Burlington Magazine*, XCII (1950), 189 ff., and the controversy continued in E. H. Gombrich, 'Dark Varnishes: Variations on a Theme from Pliny', O. Kurz, 'Varnishes, Tinted Varnishes, and Patina', and with particular effect and authority in S. Rees-Jones, 'Science and the Art of Picture Cleaning', *Burlington Magazine*, CIV (1962), 51 ff.

168. 3. The work of such contemporaries as the Vico l'Abate Master or the prolific, unrepentantly eclectic Magdalen Master underlines Coppo's stature.

171. 4. For detailed discussion of the place of the Master of S. Bernardino, see J. White, *Duccio* (London, 1979), 25 ff.

5. No traces of the attachment of shutters are discernible, and since certainly five and probably all of the twelve small scenes attributable to Guido and his shop come from Badia Ardenga, Montalcino, they are unlikely to derive from detached wings recorded by Tizio in the sixteenth century as being, like the main panel, in S. Domenico in Siena. An attempt to reintegrate these fragments in J. H. Stubblebine, *Guido da Siena* (Princeton, 1964), 54 ff., elaborating a proposal in a previous article, 'An Altarpiece by Guido da Siena', *Art Bulletin*, XLI (1959), 260 ff., does not seem to be convincing. The proposal in R. Oertel, *Frühe italienische Malerei in Altenburg* (Berlin, 1961), 57 ff., that the twelve scenes are a complete cycle incorporated in a lost, gabled, low dossal, which had nothing to do with the Palazzo Pubblico *Madonna*, carries greater conviction in every respect. Apart from the peculiar shape and construction of Stubblebine's reconstruction, which fails to account for the different angle of slope in the Palazzo Pubblico gable and in the shoulders of the Princeton *Annunciation* and Altenburg *Flagellation*, the argument that, by analogy with contemporary crucifixes, the main cycle must contain a Resurrection theme falls to the ground, since the six Passion scenes on the apron of the S. Gimignano Crucifix, associated with Coppo, end with the *Lamentation over the Dead Christ*. The cycle as it stands has, moreover, much in common with the concentration on the Early Life and Passion found in the Pisano pulpits. No argument of any kind can reasonably be based on such late works as the Perugia tabernacle or the Berlin altarpiece (Stubblebine, plates 90, 91), which may just as well derive from Coppo's lost altarpiece of 1275 or elsewhere.

6. C. Brandi, 'Relazione sul restauro della Madonna di Guido da Siena del 1221', *Bollettino d' Arte*, XXXVI (1951), 248 ff.

172. 7. E. Carli, 'Recent Discoveries in Sienese Painting of the Thirteenth and Fourteenth Centuries', *Connoisseur* (November 1955), 176 ff.

8. The only difference from other Guidesque patterns is that the feet are slightly wider apart than usual. They are not, however, in a position remotely related to those in the major altarpieces of Cimabue or Duccio, and the attempt to relate the clear blessing gesture to the veil-grasping motif of Duccio's London (National Gallery) triptych is even more curious (J. H. Stubblebine, *op. cit.*, 105). The altarpiece seems certainly not to precede but to be a close derivative of the Palazzo Pubblico *Madonna*. It therefore casts further doubt on the reconstruction of the latter in Stubblebine, *op. cit.*, 54 ff. The arguments against the attempt to dissociate the two works by dating the S. Gimignano panel *c.* 1300, rather than in the late seventies or early eighties, seem to be overwhelming.

9. In the group are also *Madonna*, Florence, Accademia, no. 435 (probably largely by assistants working in the early seventies); *Madonna*, Siena, Pinacoteca, no. 587 (probably shop-work of the late seventies or early eighties, following the Palazzo Pubblico *Madonna*, which is seemingly of *c.* 1275–80, since it loosens and develops the pose of the Colle Val d'Elsa *Madonna* of 127-).

10. Siena, Pinacoteca, no. 16.

11. Siena, Pinacoteca, no. 1.

173. 12. R. Offner, 'Guido da Siena and A.D. 1221', *Gazette des Beaux Arts*, XXXVII (1950), 61 ff. See also E. Sandberg Vavala, 'The Madonnas of Guido da Siena', *Burlington Magazine*, LXIV (1934), 254 ff.

13. J. Gardner, '*Guido da Siena, 1221*, and Tommaso da Modena', *Burlington Magazine*, CXXI (1979), 107 f.

14. Museo Diocesano.

15. Siena, Pinacoteca, no. 4.

16. Lindenau Museum, no. 8.

CHAPTER 12

175. 1. In November 1301 he contracted with a certain Nucolo to supply a massive carved and painted altarpiece for S. Chiara in Pisa. The documents give his name as Cenni di Pepi and his domicile as the quarter of S. Ambrogio in Florence.

181. 2. This subject, and indeed the whole topic of the painting of the choir and transepts, is considered in detail in H. Belting, *Die Oberkirche von S. Francesco in Assisi* (Berlin, 1977), in which, however, the true sequence of operations, outlined below, is reversed. For detailed discussion of the successive work stages visible in the plaster see J. White, 'Cimabue and the Decorative Sequence in the Upper Church of S. Francesco, Assisi', in *Roma Anno 1300*, ed. A. M. Romanini (Rome, 1983), 103 ff., and 'Cimabue and Assisi: Working Methods and Art Historical Consequences', *Art History*, IV (1981), 355 ff.

182. 3. There are innumerable reflections of Roman art and architecture in Cimabue's frescoes, but no

echoes of his Tuscan-Byzantine mannerisms in the copies of the Roman cycle.

4. B. Brenk, in an unpublished article, 'Das Datum der Franzlegende der Unterkirche zu Assisi', shows that the type of seraph in the *Stigmatization* and the text in the *Dream of Innocent III* specifically derive from Thomas of Celano's *Vita II* (1246–7) and not from the *Legenda Maior* of St Bonaventure (1260–3).
184. 5. The definitive publication is G. Marchini, *Le Vetrate dell' Umbria* (*Corpus Vitrearum Medii Aevi*, I, *L'Umbria*) (Rome, 1973), 17 f.
6. G. Marchini, *op. cit.*, 59 f. argues strongly for the Master of S. Francesco, and I. Hueck, 'Der Maler der Apostolszenen im Atrium von Alt-St Peter', *Mitteilungen des kunsthistorischen Institutes in Florenz*, XIV (1969), 115 f., attributes the figures of St Philip and St Simon in two of the nave windows, like the frescoed apostles on the south wall of the north transept, to the workshop responsible for the surviving heads of St Peter and St Paul from the atrium of Old St Peter's.
186. 7. W. Schöne, 'Studien zur Oberkirche von Assisi', in *Festschrift Kurt Bauch* (Munich, 1957), 68 ff.; E. Borsook, *The Mural Painters of Tuscany* (London, 1960), 127 ff.; H. Belting, *op. cit.* (Note 2), 54 ff.
189. 8. There is also a valiant attempt to equate the iconographically dissimilar scenes of *St John on Patmos* and the *Fall of Babylon* in the down-sweeping chaos of the two designs.
191. 9. Since Nicholas IV was the first Franciscan pope, and there were three Orsini senators in Rome during his reign, this has been taken (C. Brandi, *Duccio* (Florence, 1951), 127 ff.) to confirm the date 1288–92. There were, however, Orsini senators at many other times in the last quarter of the century, and the medallions in the decorative borders only contain portraits of the first protectors of the order, Gregory IX and Innocent IV. On the other hand, the representations of Asia, Judaea, and Greece, as well as Italy, in the crossing may well reflect the Franciscan missions to the east which set out in 1278 (E. Battisti, *Cimabue* (New York, 1967), 32).
10. The contract for the *Rucellai Madonna* and the question of its dating in relation to Cimabue's S. Francesco, Assisi, lower church *Madonna* and to his *S. Trinita Madonna* are discussed in J. White, *Duccio* (London, 1979), 32 ff.
194. 11. J. Pope-Hennessy, 'An Exhibition of Sienese Stained Glass', *Burlington Magazine*, LXXXVIII (1946), 306, strikes a note of caution and points to the connexions with Cimabue. E. Sindona, *Cimabue* (Milan, 1975), 117–18, sees influence from the north, as well as of Duccio and Cimabue, and attributes it to neither, while G. Marchini, *op. cit.*, 184, writes of it as 'risalente a Duccio e a Cimabue'.

12. E.g. all four Evangelists' thrones and many of the haloes at the top of the *Christ the Judge* and the *Adoration of the Lamb*.
198. 13. R. Salvini, 'Postilla a Cimabue', *Rivista d'Arte*, XXVI (1950), 43 ff.
14. E. Borsook, *op. cit.* (Note 7), 12.
15. It is usually attributed to Deodato di Orlando, a Lucchese painter who died between 1315 and 1331, and whose large output centres on signed and dated Crucifixes of 1288 and 1301 and panels of 1301 and 1308, overwhelmingly influenced by Cimabue. See E. B. Garrison, *Italian Romanesque Panel Painting* (Florence, 1949), 16 ff.; J. T. Wollesen, *Die Fresken von San Piero a Grado bei Pisa* (1977).

CHAPTER 13

202. 1. J. Garber, *Wirkungen des frühchristliche Gemäldezyklen der alten Peters- und Pauls Basiliken in Rom* (Berlin, 1918), 44 ff.
204. 2. The work of both is no less distinct from the drier, more linear, and less sensitive stroke of the ruined frescoes in S. Maria Maggiore in Rome, and from the closely related fresco in S. Maria in Aracoeli (P. Cellini, 'Di Fra Guglielmo e di Arnolfo', *Bollettino d'Arte*, XL (1955), 215 ff.).
208. 3. Any slight disparity is explained by the need to accommodate the heavy bracket of the rood-beam in the left-hand scene.
211. 4. They come from chapters VII, 12, and VIII, 9, the preceding and succeeding scenes being from chapters X, 7, and XI, 4, respectively.
5. Chapter IV, 10.
215. 6. R. Offner, *A Corpus of Florentine Painting* (Berlin, 1930–), section III, vol. I, XIX ff.
216. 7. L. Tintori and M. Meiss, *The Life of St Francis in Assisi* (New York, 1962), 43 ff., undermining the argument that the St Cecilia Master was the leading figure (A. Smart, 'The St Cecilia Master and his School at Assisi, I, II', *Burlington Magazine*, CII (1960), 405 ff., 431 ff.).
8. The main figure in the altarpiece is badly damaged, especially the head.
217. 9. A cut-down panel of the *Virgin and Child* in S. Giorgio alla Costa in Florence is a much more doubtful attribution, to which the Master of the St Francis Cycle may have better claims (Smart, *op. cit.*, 431 ff.), and the *St Peter enthroned* in SS. Simone e Giuda in Rome of 1307 would render the St Cecilia Master's artistic development incomprehensible. Both are probably better served by anonymity.
218. 10. P. Murray, 'Notes on some Early Giotto Sources', *Journal of the Warburg and Courtauld Institutes*, XVI (1953), 58 ff.
224. 11. W. Schöne, *op. cit.* (Chapter 12, Note 7), 68 ff.; H. Belting, *op. cit.* (Chapter 12, Note 2).

CHAPTER 15

227. 1. W. Braunfels, *Mittelalterliche Stadtbaukunst in der Toskana* (Berlin, 1953), 250.

228. 2. P. Hoffer, 'Siena Display', *Architectural Review*, CLXV (1979), 215–19.

229. 3. G. Chierici, *Il Palazzo italiano* (Milan, 1952–4), 20.

4. G. Milanesi, *op. cit.* (Chapter 8, Note 6), I, 232 ff., and W. Braunfels, *op. cit.*, 81, 195. The contract with its drawing are published in full and analysed in detail in F. Toker, 'Gothic Architecture by Remote Control: An Illustrated Building Contract of 1340', *Art Bulletin*, LXVII (1985), 67–95.

5. F. Toker, *op. cit.* See below, p. 294, for discussion of the root-two formula in relation to Duccio.

230. 6. The fiddling upper fortifications seem to be modern copies of the city gates or of the derivative Fonte di Pescaia, enlarged in the fourteenth century.

7. Variants of this pattern, which derives from Antiquity, occur in the Fonti at S. Gimignano, the Fonte delle Fate at Poggibonsi, the Fonte Scarnabecco (*c*. 1241) at Todi, and elsewhere in Central Italy.

231. 8. Apart from the group connected with Nicola Pisano (see above, pp. 88 ff.), the only other important surviving type is represented by the Fontana delle Novantanove Cannelle at L'Aquila, built by Tancredo di Valva in 1272 and later modified. In it, water spouts from gargoyles set into the base of a wall extended round three sides of a square.

9. The steeply sloping ground allows of a large external entrance at the north end, with eight internal steps down. There are seven bays stretching the full length of the transept, and the enlarged central bay (*c*. 41 feet or 12.6 m.) has a shallow choir to the south, its extent corresponding to the projection of the main choir above. Though relatively low and broad, with massive complex piers supporting round-arched rib-vaults, the height of the latter is such, and the bays are so spacious, that on entering from the outside one would not necessarily realize that there was anything overhead.

The upper church originally had a tall, two-bay chapel in the angle between the nave and the north transept, similar in principle to that surviving in S. Caterina, Pisa, though in the right-hand, southern angle. Its destruction was caused by the raising of the present campanile in 1490, following the disastrous fire of 1443.

234. 10. In 1260 a similar body had investigated the soundness of certain recently constructed vaults.

11. This confirms that the original plan was cruciform. The objection to formal irregularity undoubtedly gained force from the symbolic importance of the cross.

235. 12. G. Milanesi, *op. cit.*, I, 186 ff. See also Chapter 8, Note 3. The date of the heightening of the nave is especially important as it provides the *terminus post quem* for the upper part of the façade and therefore for its sculptural decoration, which A. Middeldorf-Kosegarten, *op. cit.* (Chapter 6, Note 20), argues, in the face of the documents, should be dated *c*. 1300.

13. Maitani's added buttresses are still visible, though buried in the walls of the later transept chapels [22]. Possible aesthetic value was scarcely considered, and they almost caricature Italian attitudes, being little more than permanent substitutes for temporary timber shoring. If recent engineering studies are correct, they are irrelevant to the vaulting thrusts concerned and add nothing material to the stability of the Duomo: see R. Bonelli, *op. cit.* (Chapter 3, Note 5), 80 ff., and below, p. 452.

239. 14. Jacopo di Mino del Peliciaio handed it over to the Opera del Duomo in 1382. See B. Degenhart and A. Schmitt, *Corpus der italienischen Zeichnungen 1300–1450*, I.1 (Berlin, 1968), 97–8.

240. 15. The subtlety of the ever-shifting, balanced grouping of the arches of the crossing and the choir, as one traverses the first three bays of the existing church, still reveals their sensitivity

CHAPTER 16

241. 1. G. Villani, *Cronica*, lib. IX, cap. XXVI.

2. The rhythmic liveliness underlying the Florentine severity contrasts with the absolute symmetries of the dependent late-fourteenth-century Palazzo Comunale at Montepulciano. Neatness and variety in the distribution of the openings, and a clear distinction between the rusticated lower and smoothly surfaced upper storeys, are accompanied by a fussy and confusing multiplication of cornices and a weak proportional relationship between the tower and the main mass.

243. 3. G. Villani, *op. cit.*, lib. IX, cap. CXXVII, CCLVI, CCLVII.

244. 4. C. Berti, *Palazzo Davanzati* (Florence, 1958). For even more extensive surviving decorations see P. Cole, 'The Interior Decoration of the Palazzo Datini in Prato', *Mitteilungen des kunsthistorischen Institutes in Florenz*, XIII (1967–8), 61 ff. The garden landscapes in the latter recall tapestries, as well as the frescoes in the Tour de la Garde-Robe in the Palace of the Popes, Avignon, and may even partially reflect a knowledge of Antique garden frescoes. For the Palazzo Datini, see also p. 569 below.

5. The theory that Giotto's original walls for the lower storey were far too thin to be structurally sound and had to have their thickness almost doubled by Andrea Pisano, put forward in J. Trachtenberg, *The Campanile of Florence Cathedral* (New York, 1971),

24 ff., seems to be convincingly refuted in G. Krey-
tenberg, 'Der Campanile von Giotto', *Mitteilungen
des kunsthistorischen Institutes in Florenz*, XXII (1978),
147 ff.
246. 6. H. Klotz, 'Deutsche und italienische Bau-
kunst im Trecento', *Mitteilungen des kunsthistorischen
Institutes in Florenz*, XII (1965–6), 171 ff., and J.
Trachtenberg, *op. cit.*, 44 ff.
248. 7. It was moved up from the river bank in 1871.
8. M. Seidel, 'Skulpturen am Aussenbau von S.
Maria della Spina in Pisa', *Mitteilungen des kunst-
historischen Institutes in Florenz*, XVI (1972), 269 ff.
249. 9. The external distribution of the nave and aisle
design of S. Maria della Rosa in Lucca, built in 1309
and later enlarged, is identical, but lacks comparable
architectural complexities.
250. 10. W. Paatz, *Werden und Wesen der Trecento-
Architektur in Toskana* (Burg, 1937), 116 ff., attributes
the additions to Giovanni Pisano.
11. Founded in 1294. Work was resumed in 1334
after a long interruption.

CHAPTER 17

251. 1. The inscription probably refers only to the
palace itself, and not to the substructures.
2. O. Gurrieri, *Angelo da Orvieto ... e i Palazzi ...
di Gubbio e di Città di Castello* (Perugia, 1959), 14.
3. The casual setting of the openings is not fully
explained by the disposition of the stair at one end of
the lower chamber, of the huge semicircular fireplace
in one corner, and of the balcony at one end of the
rear long wall.
4. It was probably not conceived as a buttress. It
would not affect the chief internal stresses of the main
structure.
5. The description in F. Mazzei, *Memoria sulla
condizione attuale dei Palazzi Municipale e Pretorio di
Gubbio* (Florence, 1865), 11, shows that the existing
forms, although reconstructed, are not a modern
invention, as is implied in G. Chierici, *op. cit.*
(Chapter 15, Note 3), 46.
254. 6. A more massive form supports the ground-
floor loggia of the Palazzo del Popolo at Todi, and the
forms of the Sala d'Armi in the Palazzo Vecchio in
Florence [137] are closely related. Similar ideas are
elaborated in the Palazzo Comunale at Città di
Castello [147].
256. 7. The massive, possibly earlier, ten-bay-long
and completely regular Palazzo del Governo in Città
di Castello has many almost identical features and
may also be by Angelo da Orvieto.
8. W. Krönig, *op. cit.* (Chapter 2, Note 1), 64 ff., and
R. Wagner-Rieger, *op. cit.* (Chapter 3, Note 1), 11,
125 ff., pay special attention to this feature.

258. 9. In Gubbio, S. Domenico and S. Pietro, which
were later modified, continue the tradition of the
Duomo.
10. W. Krönig, *op. cit.*, 91 ff.

CHAPTER 18

259. 1. The choir and flanking chapels were com-
pleted later. A. M. Romanini, 'Le Chiese a sala
nell'architettura "gotica" lombarda', *Arte Lombarda*,
III, 2 (1958), 48 ff., refers in passing to the building as
being of 1375–80.
262. 2. Internally, splendid restoration has revealed a
building which combines a number of the major
currents flowing through the Lombard and Emilian
plains, from the column-forms of the Duomo at
Piacenza and the Cistercian plan of Morimondo to
such closer forerunners as S. Francesco at Piacenza,
in such a way that the Romanesque past is almost as
insistent as the Gothic present. See A. M. Romanini,
op. cit. (Chapter 2, Note 21), and more particularly
A. Edallo, C. Gallini, P. M. Cambiaghi, *Il Duomo di
Crema* (Milan, 1961), 57 ff.
3. The towers in North Italy and elsewhere are
considered in relation to the campanile of the Duomo
at Florence in J. Trachtenberg, *op. cit.* (Chapter 16,
Note 5), chapter 7, 151 ff.
4. L. Fraccaro de Longhi, *L'Architettura delle chiese
cisterciani* (Milan, 1958), 70 ff.

CHAPTER 19

264. 1. W. Braunfels, *op. cit.* (Chapter 15, Note 1),
50 ff. The continuity of Italian urban history is
reflected in the number of medieval walls standing,
like those of Todi, Spoleto, and Amelia, upon pre-
historic Cyclopean stonework.
2. For the medieval search for regularity, see P.
Lavedan and J. Hugueney, *L'Urbanisme au moyen âge*
(Geneva, 1974).
266. 3. At Soave the main buildings and isolated keep
are aligned along the perimeter, forming a section of
the wall. See P. Chiolini, *I Caratteri distributivi degli
antichi edifici* (Milan, 1959), 275.
270. 4. The same is true of the charming fifteenth-
century frescoes of St George and the Dragon and of
Saints and Famous Men which decorate the stairs
and balconies.
5. P. Chiolini, *op. cit.*, 284 ff.

CHAPTER 20

277. 1. A less swiftly moving cinquefoil exists in the
basilica at Aquileia. Another is in S. Stefano in Venice.
Trilobate versions occur in S. Francesco at Treviso,

in the Eremitani at Padua, now restored, and in S. Zeno in Verona.

278. 2. The structure largely hangs on iron rods from the main beams of a normal pitched roof. A very similar roof exists at Södra Råda in Sweden; see G. Paulsson, *Scandinavian Architecture* (London, 1958), 74, plate 32.

3. H. Dellwing, 'Zur Wölbung des Paduaner "Salone",' *Mitteilungen des kunsthistorischen Institutes in Florenz*, XIV (1969), 145 ff., compares it, amongst other things, with Atlantic coast structures such as the refectory at Mont-Saint-Michel (1218), and with the granary at Cluny (1257–75).

CHAPTER 21

280. 1. His own commissions included the original Castel Nuovo in Naples, planned by Pierre d'Angicourt and built by Paumier d'Arras and Pierre de Chaulnes, and the reconstruction of Frederick II's castle at Lucera, with which Pierre d'Angicourt and Riccardo da Foggia were associated. In 1270 he gave land for S. Eligio in Naples, and he built the now ruined Cistercian foundations of S. Maria di Realvalle near Scafati (after 1266), for which he summoned Pierre de Chaulnes and the brothers Nicolas and Robert of Royaumont, and S. Maria della Vittoria near Scurcola Marsicana (1274–82).

282. 2. P. Gaudenzio dell'Aja, *Il Restauro della basilica di Santa Chiara in Napoli* (Naples, 1980), 277 ff., shows that the round arches capping the external buttresses referred to in the earlier literature were not original.

283. 3. The choir was integral to the original design, but may have been extended from three bays to four before Cavallini's followers painted the walls.

284. 4. For the delightful decoration of the splendid wooden ceilings see E. Gabrici and E. Levi, *Lo Steri di Palermo* (Milan, n.d.).

CHAPTER 23

291. 1. The reconstruction is discussed in detail in J. White, 'Measurement, Design and Carpentry in Duccio's Maestà, I, II', *Art Bulletin*, LV (1973), 332 ff., 547 ff., and *Duccio* (London, 1979), 80 ff. C. Gardner von Teuffel, 'The Buttressed Altarpiece: A Forgotten Aspect of Tuscan Fourteenth Century Altarpiece Design', *Jahrbuch der Berliner Museen*, XXI (1979), 21 ff., argues that there were substantial flanking buttresses of the kind later documented as once existing on Pietro Lorenzetti's Arezzo altarpiece, but a case against this view is put in J. White, *Duccio*, 91.

J. H. Stubblebine, *Duccio Buoninsegna and his School* (Princeton, 1979), figure 45, substantially

retains the reconstruction first advanced in 'The Angel Pinnacles on Duccio's Maestà', *Art Quarterly*, XXIX (1969), 131 ff. Although the scheme for the rear predella proposed in his 'The Back Predella of Duccio's Maestà', *Studies in Late Medieval and Renaissance Painting in Honour of Millard Meiss* (New York, 1977), 430 ff., which is criticized in J. White, *Duccio*, 122, note 44, is also retained in general, the particularly unfortunate suggestion that the sequence of the *Calling of Peter and Andrew* and the *Feast at Cana* should be reversed appears to have been abandoned. This, however, moves the latter out of its iconographically appropriate central position.

To the arguments for placing the *Raising of Lazarus* as the last scene on the face of the rear predella, put forward in J. White, *Duccio*, 122, must be added the point, which is properly stressed in F. Deuchler, *Duccio* (Milan, 1984), 66, that the vertical rock opening, which so greatly strengthens the sense of closure on the right and which is so appropriate to its proposed position, was the result of a radical change of plan from an originally horizontal sepulchre. Such a transformation is a further striking illustration of Duccio's flexibility and determination in developing his ideas.

294. 2. J. White, 'Measurement, Design and Carpentry', *loc. cit.*, and *Duccio*, 62 ff.

3. J. White, 'Carpentry and Design in Duccio's Workshop', *Journal of the Warburg and Courtauld Institutes*, XXXVI (1970), 92 ff. J. Brink, 'From Carpentry Analysis to the Discovery of Symmetry in Trecento Painting', *Atti del XXIV Congresso Internazionale di Storia dell'Arte* (Bologna, 1979), 111 (1983), 345 ff., considers the application of the $\sqrt{2}$ formula both in Duccio's *Maestà* and in related works such as polyptych no. 47 and Simone Martini's S. Caterina polyptych.

298. 4. The use of the foreshortened frontal setting is vital to the intimate connection with the succeeding scene of the *Transfiguration* which simultaneously allows the radiant figure of Christ to appear to the astonished gaze of the now sighted blind man. For a full analysis of the scene, see J. White, *Duccio*, 167 ff.

5. An attempt to do just this occurs in J. Stubblebine, 'Duccio and His Collaborators on the Cathedral Maestà', *Art Bulletin*, LV (1973), 185 ff.

300. 6. M. Kemp, 'Science, Non-science and Nonsense: The Interpretation of Brunelleschi's Perspective', *Art History*, I (1978), 150.

301. 7. D. M. Robb, 'The Iconography of the Annunciation in the Fourteenth and Fifteenth Centuries', *Art Bulletin*, XVIII (1936), 480 ff.

302. 8. The possibility of a vertical reading from the pedestal formed in the predella by the *Feast at Cana*, flanked by the *Calling of Peter and Andrew* and *Christ*

and the *Woman of Samaria*, up through the *Agony* and the *Betrayal* to the *Crucifixion*, stressed in J. White, *Duccio*, 123, is reinforced in F. Deüchler, *op. cit.*, 59 ff. In emphasizing the 'boustrophedonic' narrative sequence, with its precursors in French stained-glass window design, and summarizing earlier analyses of the succession of the narrative, he does, however, suggest a fully symmetrical pattern of narrative progression for the six scenes on the lower right of the main panel, which is not feasible, as it places St Peter's *Third Denial* before the *Second Denial*, and the scene of *Christ Accused by the Pharisees* (John 18: 28–32) after, instead of before, that of *Christ before Pilate* (John 18: 33–8), which is its direct sequel.

303. 9. L. A. Muratori, *Rerum italicarum scriptores*, xv, parte vi (Bologna, 1931–9), 90.

308. 10. The straight-nosed facial type of the Virgin and flanking angels also differs from the relatively curved-nose *Rucellai* pattern. In Duccio's work it only enters at a much later date, when the window itself could have exerted an influence.

11. As in the *Rucellai* and other panels by Duccio, colour counterpoint is used, while graduated colour chains occur in the *S. Trinita Madonna*. Nevertheless, Cavallini has counterpoint, symmetry, and possibly colour change, coexisting even in a single series of scenes, and this is fairly common. Graduated colour change would present great technical difficulties in the less flexible medium of glass at this date. The colours in the window, though naturally brilliant, are not specifically attached to Duccio's range of hues.

CHAPTER 24

309. 1. I. Hueck, 'La Matricola dei pittori fiorentini prima e dopo il 1320', *Bollettino d'Arte*, LVII (1972), 114 ff., amplifies and corrects the information in R. G. Mather, 'Nuove Informazione relative alle matricole di Giotto, Gaddo di Zenobi Gaddi, B. Daddi, A. Lorenzetti, T. Gaddi ed altri pittori nell'Arte dei Medici e Speciali di Firenze', *L'Arte*, XXXIX (1936), 33 ff.

2. See below, pp. 341–3.

311. 3. L. Tintori and M. Meiss, *The Life of St Francis in Assisi* (New York, 1962), 159 ff., provide the clinching technical evidence.

4. An early-nineteenth-century print, illustrated in C. H. Weigelt, *Giotto* (Stuttgart, 1925), xi, shows that the chapel may have been intended as one wing of a curving group of buildings reminiscent of the Campo in Siena. See also D. Gioseffi, *Giotto architetto* (Milan, 1963), 34 ff.

5. The chapel of S. Silvestro in SS. Quattro Coronati in Rome, and S. Maria ad Fossam and S. Pellegrino at Bominaco, both in the Abruzzi, are other highly painted examples.

6. U. Schlegel, 'Zum Bildprogramm der Arena Kapelle', *Zeitschrift für Kunstgeschichte*, XX (1957), 125 ff.

312. 7. M. von Nagy, *Die Wandbilder der Scrovegni-Kapelle zu Padua: Giottos Verhältnis zu sein Quellen* (Bern, 1962).

8. R. J. M. Olson, 'Giotto's Portrait of Halley's Comet', *Scientific American* (1979), 160 ff.

314. 9. U. Schlegel, *op. cit.*, 130 ff.

316. 10. J. White, 'Giotto's Use of Architecture in "The Expulsion of Joachim" and "The Entry into Jerusalem" at Padua', *Burlington Magazine*, CXV (1973), 439 ff.

11. The visual source for Giotto's striking figure of the maidservant spinning seems to be the scene of the *Annunciation* in Guido da Como's pulpit in S. Bartolomeo in Pantano, Pistoia. For discussion of the pulpit and its reconstruction, see above, Chapter 6, Note 5.

318. 12. This is the sole example of simultaneous narrative at Padua, and Giotto only returns to this tradition in S. Croce under the severest pressure of restricted space.

319. 13. T. Hetzer, *Giotto* (Frankfurt am Main, 1941), analyses these relationships in detail.

321. 14. D. Gioseffi, *Perspectiva Artificialis* (Trieste, 1957), 68 ff.

325. 15. The figures and architecture of the *Presentation* and *Betrayal*, vertically above each other at the centre of the window-wall, are, however, specifically designed to create a strong central axis continuing the band of marbling which runs over the vault from the opposite wall.

16. M. Alpatov, 'The Parallelism of Giotto's Paduan Frescoes', *Art Bulletin*, XXIX (1947), 149 ff.

331. 17. J. White, *Duccio* (London, 1979), 160 ff.

332. 18. C. Gnudi, 'Su gli inizi di Giotto e i suoi rapporti col mondo gotico', *Giotto e il suo tempo* (Rome, 1971), 3 ff.

19. The detailed documentation of its removal in 1610, re-erection elsewhere, and replacement make it clear that Francesco Beretta's facsimile of 1628 shows the original design of the central area.

20. W. Paeseler, 'Giotto's Navicella und ihr spätantikes Vorbild', *Römische Jahrbuch für Kunstgeschichte*, V (1941), 49 ff., argues, however, for a date *c.* 1310.

334. 21. J. Gy-Wilde, 'Giotto Studien', *Wiener Jahrbuch für Kunstgeschichte*, VII (1930), 46 ff., is most convincing on this still controversial point. See also L. Tintori and E. Borsook, *Giotto, The Peruzzi Chapel* (New York, 1965), 19 ff.

337. 22. H. Jantzen, 'Giotto und der gotischer Stil', in *Über das gotische Kirchenraum und andere Aufsatz* (Berlin, 1951), 30 ff.

341. 23. A fourth signature occurs on the predella

panel of the *Last Supper* in the Bearsted Collection at Upton House, near Banbury, which is particularly interesting in colour design, but which, apart from curious features in the inscription itself, does not seem to be autograph. R. Offner, *A Corpus of Florentine Painting* (Berlin, 1930–), section III, vol. VIII, 170 ff., attributes the panel to the Master of the Fabriano altarpiece and convincingly dates it after 1355 from the death date of the 'former' husband of the donor probably indicated by the inscription.

24. T. E. Mommsen, *Petrarch's Testament* (Ithaca, N.Y., 1957), 79 ff.

25. On technique, see R. Oertel, 'Wandmalerei und Zeichnung in Italien', *Mitteilungen des kunsthistorischen Institutes in Florenz*, 5 Band, Heft IV/V (1940), and L. Tintori and M. Meiss, *op. cit.* (Note 3). For a full analysis of the various fresco techniques in use from Antiquity onwards, see P. Mora, L. Mora, and P. Philippot, *Conservation of Wall Paintings* (London, Boston, etc., 1984). See also E. Borsook, *The Mural Painters of Tuscany*, 2nd ed. (London, 1980).

343. 26. See below, pp. 452 ff.

27. M. Gosebruch, 'Giottos Stefaneschi Altarwerk aus Alt-St Peter in Rom', *Miscellanea Bibliothecae Hertzianae* (Munich, 1961), 104 ff., argues for Giotto's personal authorship, as does J. Gardner, 'The Stefaneschi Altarpiece: A Reconsideration', *Journal of the Warburg and Courtauld Institutes*, XXXVII (1974), 57 ff. Gardner discusses the problem in detail and considers the earlier literature, suggesting an early date, *c*. 1300. See also J. White, *Duccio* (London, 1979), 140 ff., where an attribution to the circle of Giotto 'in the late teens at the earliest' is argued.

28. R. Offner, *op. cit.*, section III, vol. VI, 3 ff., argues against this tendency.

CHAPTER 25

344. 1. See above, p. 218. V. Hoffmann, 'Die Fassade von San Giovanni in Laterano', *Römisches Jahrbuch für Kunstgeschichte*, XVII (1978), challenges the argument in P. Murray, 'Notes on some Early Giotto Sources', *Journal of the Warburg and Courtauld Institutes*, XVI (1953), 59 ff., but seems himself to be wrong in so doing, since the twelfth-century original construction of the portico is not incompatible with the refurbishment under Nicholas IV, for which there seems to be ample evidence.

2. See above, pp. 202 ff.

3. See above, pp. 217–18.

4. M. Meiss, *Giotto and Assisi* (New York, 1960), 3 ff. The attempt by J. H. Stubblebine, in the Gardner Museum's Annual Report (Fenway Court, 1983), 44 ff., to impugn the reliability of this inscription appears to be without foundation. See J. White,

Studies in Late Medieval Italian Art (London, 1985), 343–4, and below, Chapter 29, Note 4. The same unsound arguments are repeated in J. H. Stubblebine, *Assisi and the Rise of Vernacular Art* (New York, 1985), where they are accompanied by a full-scale attempt to re-date the work of the Isaac Master to the 1320s and that of the Master of the St Francis Cycle to the 1330s on the basis of seemingly ill-founded stylistic and iconographic arguments.

5. P. Murray, *op. cit.*

6. See C. Gnudi, 'Il Passo di Riccobaldo Ferrarese relativo a Giotto e il problema della sua autenticità', *Studies in the History of Art dedicated to W. Suida* (London, 1959), 30.

345. 7. J. White, 'The Date of the "Legend of St Francis" at Assisi', *Burlington Magazine*, XCVIII (1956), 344 ff.

8. See above, p. 191. E. Battisti, *Cimabue* (Milan, 1963), 39, stresses that the representations of Greece, Palestine, and Asia in the vaults of the crossing refer to the Franciscan missions inaugurated in 1278. These, however, only establish an approximate *terminus post quem*. They do not date the frescoes.

9. See above, p. 191 ff.

346. 10. P. Murray, 'On the Date of Giotto's Birth', in *Giotto e il suo tempo* (Rome, 1971), 25 ff., shows that the information in the Codex Petrei version of the Libro di Antonio Billi, previously thought to be the source of Vasari's statements, is, in fact, an interpolated reflection of them. See also C. Gilbert, 'When did a man in the Renaissance grow old?', *Studies in the Renaissance*, XIV (1967), 7 ff., who points out that in St Thomas Aquinas and Dante respectively, youth was stated to last until the ages of forty-nine and forty-four.

347. 11. See above, pp. 321–3, 330.

12. See above, pp. 340–1.

348. 13. Rintelen is the chief proponent of this theory. R. Offner, 'Giotto, Non-Giotto, I, II', *Burlington Magazine*, LXXIV (1939), 259 ff., and LXXV (1939), 96 ff., argues convincingly against Giotto's authorship without supporting such late dating. See also A. Smart, *The Assisi Problem and the Art of Giotto* (Oxford, 1971), and H. Belting, *Die Oberkirche von San Francesco in Assisi* (Berlin, 1977), 234 ff.

14. Gnudi is among the most extreme of the supporters of all-inclusiveness. Meiss strongly opposes identification with the Master of the St Francis Cycle but stresses the connexions with the Isaac Master.

CHAPTER 26

349. 1. Simone was himself obliged to restore the central heads in 1321. See A. Cairola and E. Carli, *Il Palazzo Pubblico di Siena* (Rome, 1963), 21 ff., I. Hueck, 'Frühe Arbeiten des Simone Martini',

Münchner Jahrbuch der bildenden Kunst, XIX (1968), 33 ff., and also E. Borsook, *The Mural Painters of Tuscany*, 2nd ed. (Oxford, 1980), 19 ff., where the matter, together with literature to that date, is fully discussed and the work stages involved are illustrated.

352. 2. J. Gardner, 'Saint Louis of Toulouse, Robert of Anjou and Simone Martini', *Zeitschrift für Kunstgeschichte*, XXXIX (1976), 12 ff., considers the problems of patronage in detail.

353. 3. *Ibid.*, and J. White, *Duccio* (London, 1979), 79.

4. This is very clearly brought out in J. Cannon, 'Simone Martini, the Dominicans and the Early Sienese Polyptych', *Journal of the Warburg and Courtauld Institutes*, XLV (1982), 69 ff., and in H. van Os, *Sienese Altarpieces 1215–1460*, I (Groningen, 1984), 25 ff., who gives an excellent survey of patronage by the various religious orders in Siena.

354. 5. U. Feldges, *Landschaft als topographisches Porträt* (Bern, 1980), 30, quoting L. A. Muratori, *Rerum Italicarum Scriptores*, XV, parte VI (1933), 496.

355. 6. The controversy was begun by G. Moran, 'Novità zu Simone? An Investigation regarding the Equestrian Portrait of Guidoriccio in the Siena Palazzo Pubblico', *Paragone*, XXVIII, 333 (1977), 81 ff. In his subsequent conservation report, G. Gavazzi states that in the right-hand corner absolute certainty is compromised by an old fall of plaster at the extreme margins of the fresco and that 'solo in un punto un piccolo frammento di intonaco del Guidoriccio si sovraponeva all'intonaco dipinto del Lippo Vanni'. Certainly, as is often the case, there seems to be a very great deal of damage and replastering in the corner. L. G. Boccia, 'Note sul costume guerresco nel Guido Riccio', *Prospettiva*, XXVIII (1982), shows that the martial dress worn by Guidoriccio is consistent with the fashion of around the 1330s. Indeed, it is very hard to see how something with so many links in general and in detail with its ostensible date could have been produced in the late fourteenth century or beyond.

356. 7. The importance of judging a work of art as it stands and on its own terms, as far as aesthetic values are concerned, and the way in which repainting may create a masterpiece which could have come into existence in no other way are considered, with particular reference to Coppo di Marcovaldo's *Madonna del Bordone* [91] and Guido's Palazzo Pubblico *Madonna* [96], in J. White, *Pieter Bruegel and the Fall of the Art Historian*, Charlton Lecture, University of Newcastle upon Tyne (1980), 25 ff., in the context of the extreme case of Bruegel's *Fall of Icarus*.

8. M. Meiss, 'Notes on a Dated Diptych by Lippo Memmi', in *Scritti in onore di Ugo Procacci* (Milan, 1977), 137 ff.

357. 9. C. Paccagnini, *Simone Martini* (London, 1957), 159 ff. Memmi was concerned with a model for the cap of the Torre della Mangia in Siena in 1341 and with work in literature to that date, is fully François in Avignon in 1347.

359. 10. Allowing for fading, which has greatly affected the modelling, there seems to be no reason to doubt Petrarch's assertion. J. Brink, 'Simone Martini, Francesco Petrarca and the Humanistic Program of the *Virgil Frontispiece*', *Mediaevalia*, III (1977), 83 ff., considers the likely use of the $\sqrt{2}$ formula in setting out the composition.

11. For the probable dating of the sonnets before November 1336, and the likelihood that Simone at least visited Avignon before then, see J. Rowlands, 'The Date of Simone Martini's Arrival in Avignon', *Burlington Magazine*, CVII (1965), 25 ff.

361. 12. G. Marchini, *op. cit.* (Chapter 12, Note 5), 126–9, suggests that the glazier was Giovanni di Bonino, who is later documented at Orvieto (see below, pp. 469–70) and to whom he also attributes the rose and two left lights of the window of the Chapel of St Anthony at the end of the north transept of the lower church at Assisi. Since St Louis of Toulouse is shown without a halo, the rose may date from before 1317.

366. 13. Cardinal Gentile's bequest of 1312 seemingly financed the decoration.

14. M. S. Pearce generously demonstrated for me the extremely close network of relationships which surround the hair- and dress-styles of the fashionable mother in the *Thanksgiving Procession*.

15. A. Peter, 'Quand Simone Martini est-il venu en Avignon?', *Gazette des Beaux-Arts*, XXI (1939), 153 ff.

16. M. Meiss, 'The Madonna of Humility', *Art Bulletin*, XVIII (1936), 435 ff.

368. 17. S. Bottari, *La Pittura del quattrocento in Sicilia* (Florence, 1953), 10 ff.

18. Rome, Bibl. Vat., MS. C. 129.

CHAPTER 27

371. 1. I. Hueck, 'La Matricola dei pittori fiorentini prima e dopo il 1320', *Bollettino d'Arte*, LVII (1972), 114 ff. See also S. A. Fehm, Jr, 'Notes on the Statutes of the Sienese Painters' Guild', *Art Bulletin*, LIV (1972), 140 ff. The date of Ambrogio's death in 1348 is established by V. Wainwright, 'The Will of Ambrogio Lorenzetti', *Burlington Magazine*, CXVII (1975), 543–4, through his will of 9 June and subsequent sales of land in 1349–50.

374. 2. The commissioning document is set out in S. Borghese and L. Bianchi, *Nuovi Documenti per la storia dell'arte senese* (Siena, 1898), 10–11. See also Chapter 23, Note 1, above on the suggested derivation

of the documented flanking buttresses from Duccio's *Maestà*.

3. In colour and facial character it recalls Ambrogio's silvery-hued and evidently early Brera *Madonna*.

4. R. Simon, 'Towards a Relative Chronology of the Frescoes in the Lower Church of San Francesco at Assisi', *Burlington Magazine*, CXVIII (1976), 361 ff.

5. The sequence and pattern of the successive work stages are discussed in H. B. J. Maginnis, 'Assisi Revisited: Notes on Recent Observations', *Burlington Magazine*, CXVII (1975), 511 ff., and 'The Passion Cycle in the Lower Church of San Francesco, Assisi: The Technical Evidence', *Zeitschrift für Kunstgeschichte*, XXXIX(1976), 193 ff. E. Borsook, *The Mural Painters of Tuscany*, 2nd ed. (London, 1980), 28 ff., gives an excellent analysis of the tradition of the fictive altarpiece in Assisi, with particular reference to the *Madonna and Child with St John and St Francis*, discussed below. See also M. Seidel, 'Das Frühwerk von Pietro Lorenzetti', *Städel-Jahrbuch*, VIII (1981), 79 ff.

376. 6. H. B. J. Maginnis, 'Pietro Lorenzetti: A Chronology', *Art Bulletin*, LVI (1984), 184 ff., argues that the frescoes could not have been painted during these years.

7. R. Simon, *op. cit.*, 365–6. See also E. Borsook, *op. cit.*, 28, and H. B. J. Maginnis, 'Assisi Revisited', *op. cit.*, 516–17, in which he shows that there was an altar beneath the fresco and that the painted aumbry and bench discussed immediately below constituted a fictive chapel and its furniture.

379. 8. See above, pp. 207 ff. It is also quite likely that the solution to the problem of the intrusive arch at lower right in the *Washing of the Feet* by means of a painted wall or parapet, which is integrated into the scene by the way the figures lean on it, was the inspiration for Raphael's similar solution to the problem of the doorway on the right of the *Disputa* in the Stanza della Segnatura.

9. For a reconstruction of the altarpiece, see H. B. J. Maginnis, 'Pietro Lorenzetti's Carmelite Madonna: A Reconstruction', *Pantheon*, XXXIII (1975), 10 ff., and P. Torriti, *La Pinacoteca Nazionale di Siena*, I (Genoa, 1980), 97 ff. For a thorough discussion of its unusual iconography and its place in Carmelite propaganda, see H. Van Os, *Sienese Altarpieces 1215–1460*, I: *1215–1344* (Groningen, 1984), 91 ff.

10. L. Olschki, 'Asiatic Exoticism in Italian Art of the Early Renaissance', *Art Bulletin*, XXVI (1944), 95 ff. For the representation of the Vices in the sculptural decoration of the Sultan's loggia, see M. L. Shapiro, 'The Virtues and Vices in Ambrogio Lorenzetti's Franciscan Martyrdom', *Art Bulletin*, XLVI (1964), 367 ff. As regards the portrayal of Africans and Orientals, Giotto's depiction of specifically Moroccan

figures in the *Trial by Fire* [201] is perhaps the most notable example.

382. 11. L. Magagnato, *Le Stoffe di Cangrande* (Verona, 1983). For discussion of the relationship between textile design and painting, see B. Klesse, *Der Seidenstoffe in der italienischen Malerei des 14. Jahrhunderts* (Bern, 1967).

385. 12. A. Preiser, *Das Entstehen und die Entwicklung der Predella in der italienischen Malerei* (Hildesheim and New York, 1973), 297, gives a reconstruction of the whole, but the two panels suggested for the predella cannot belong together, since in that in the National Gallery, London, which has its original frame, the painted surface measures 30.5 by 27 cm. (12 by $10\frac{2}{3}$ in), as against the 38 by 27.5 cm (15 by $10\frac{4}{5}$ in.) of that of *Christ Before Pilate* in the Vatican.

387. 13. N. E. Muller, 'Ambrogio Lorenzetti's *Annunciation*, A Re-examination', *Mitteilungen des kunsthistorischen Institutes in Florenz*, XXI (1977), 1 ff., shows convincingly that the more decorative upper pair of wings is also original.

391. 14. C. Brandi, 'Chiarimenti sul "Buon Governo" di Ambrogio Lorenzetti', *Bollettino d'Arte*, XL (1955), 119 ff., details the evidence of early damage and restoration on the extreme left.

392. 15. J. F. Fitchen, *The Construction of Gothic Cathedrals* (Oxford, 1961), shows the extent to which this was true of all major medieval construction.

16. U. Feldges-Henning, 'The Pictorial Programme of the Sala della Pace: A New Interpretation', *Journal of the Warburg and Courtauld Institutes*, XXXV (1972), 145 ff.

394. 17. G. Rowley, *Ambrogio Lorenzetti* (Princeton, 1958), 66 ff., argues for a fifteenth- or even eighteenth-century dating on such grounds as the relative popularity of the right-to-left fold of the Virgin's cloak, which, incidentally, also occurs in Pietro's dated panel of 1340. The assertion of a mid-fifteenth-century date for the two small landscapes discussed immediately below is similarly unconvincing.

For a discussion of the significance of the *Assumption*, now in the Pinacoteca Nazionale, Siena, lately attributed to Bartolomeo Bulgarini in the third quarter of the fifteenth century, see H. van Os, 'The Black Death and Sienese Painting: A Problem of Interpretation', *Art History*, IV (1981), 237 ff., where it is stressed that the extraordinary decorative elaboration is accompanied by a thoroughly Lorenzettian emphasis on spatial realism in a subject hitherto treated in the most planar and hieratic manner.

395. 18. U. Feldges, *op. cit.* (Chapter 26, Note 5), 68 ff., decisively rejects the hypothesis of a fifteenth-century origin for the panels, but assumes what seems to be an improbably late date (*c.* 1340) in Ambrogio's career. The technical facts are well laid out in P.

Torriti, *La Pinacoteca Nazionale di Siena* (Genoa, 1977), I, 113–14. These show that the two panels, with their vertical graining, which precludes the idea that they were ever part of a predella, are substantially uncut except on the left-hand sides where *c*. $3\frac{1}{2}$ inches (8.5–9.0 cm.) are probably missing.
396. 19. The only real illogicality is the maintenance of the 'realistic', low viewpoint of the distant buildings when reversion to the Byzantine bird's-eye pattern would have been correct.

CHAPTER 28

398. 1. P. Bacci, 'Una Pittura ignorata di Segna di Bonaventura', *Le Arti*, 11 (1939–40), 12 ff.
402. 2. M. Harrsen and G. K. Boyce, *Italian Manuscripts in the Pierpont Morgan Library* (New York, 1953), no. 22 (MS. 643), 13, and R. Offner, *A Corpus of Florentine Painting* (Berlin, 1930–), section 111, vol. 11/1, 43 ff.
3. R. Offner, *op. cit.*, section 111, vol. VI, 122 ff.
4. See above, p. 344 and Note 4 thereto, and Chapter 29, Note 4, below for arguments supporting the security of the 1307 *terminus ante quem*.
405. 5. See below, pp. 460–1.
6. R. Klein, 'Pomponius Gauricus on Perspective', *Art Bulletin*, XLIII (1961), 211 ff.
406. 7. R. Offner, *op. cit.*, section 111, vol. VIII.
408. 8. *Ibid.*, section 111, vol. V, 55 ff.
9. See above, pp. 340–1.
411. 10. In the Gambier-Parry altarpiece of 1348 the static general symmetry of the crowded flanking figures is enlivened by emphatic, asymmetrical colour-pairing. All the resulting colour-combinations are then summarized in the central panel.
11. R. Offner, *op. cit.*, section 111, vol. 11, 43 ff.
413. 12. For the detachment of these frescoes from the documentation previously connected with them, see A. Ladis, *Taddeo Gaddi* (Columbia and London, 1982), 88 ff.
13. C. Sterling, *Still-Life Painting* (Paris, 1959), 20 ff. For the similar example by Pietro Lorenzetti, see above, p. 376.
415. 14. L. Tintori and M. Meiss, *The Life of St Francis in Assisi* (New York, 1962), 21 ff., argue strongly that it is indeed a preparatory study, but this has recently been challenged, not altogether convincingly, in A. Ladis, *op. cit.*, 246.
417. 15. I. Maione, 'Fra Simone Fidate e Taddeo Gaddi', *L'Arte*, XVII (1914), 107 ff., whose over-emphatic thesis triggered a lively debate, summarized in A. Ladis, *op. cit.*, 89–90.
420. 16. At the opposite end of the scale, designs, often of great complexity, were scratched into the gold leaf applied to the back of the glass panels

inserted into many reliquaries and other small works. See Cennino Cennini, cap. CLXXI. A. Ladis, *op. cit.*, 137, attributes the windows to T. Gaddi, mainly in the light of not very convincing relationships to the attributed, shopwork, Voltiggiano polyptych (*ibid.*, 196) and of bordering details which may, however, well reflect the practices of the glaziers as opposed to those of the painter responsible for the overall cartoon and the actual drawing of the heads. In so doing, he opposes the majority of earlier writers, including H. van Straelen, *Studien zur florentiner Glasmalerei des Trecento und Quattrocento* (Weltenscheid, 1938), and G. Marchini in his *Italian Stained Glass Windows* (New York, 1958) and subsequently in *Primo Rinascimento in Santa Croce* (Florence, 1968), 68.
17. The tomb mural is discussed in detail in E. Borsook, *The Mural Painters of Tuscany*, 2nd ed. (Oxford, 1980), 38 ff. For the neighbouring *Entombment* attributed to T. Gaddi, see A. Ladis, *op. cit.*, 136–7.

CHAPTER 29

423. 1. Notably by L. Coletti, *I Primitivi*, 111, *I Padani* (Novara, 1947).
2. E.g. Venice, Accademia, no. 26.
425. 3. The subtly coloured frescoes in the refectory at Pomposa reveal Cavallinesque iconographic elements alongside muddled echoes of the architectural framework of the St Francis cycle at Assisi.
4. The date as given (ANN.DNI.MILLO.CCCXL. QTO.DNI.CLEMATIS.PP ...) falls squarely in the reign of Clement VI (1342–52), and there are no valid grounds for transposing the QTO to a position following the pope's name, thus creating a reference to Clement V and therefore a wrong date and unreliable inscription, as proposed in J. H. Stubblebine, *op. cit.* (Chapter 25, Note 4).
430. 5. The contrast with most of the placidly Giottesque frescoes in the Duomo at Udine is such that, despite close links in certain figures, the attribution depends almost entirely on the documentary evidence (L. Coletti, 'Il Maestro dei Padiglioni', in *Miscellanea Supino* (Florence, 1933), 211 ff.).
433. 6. E.g. *Original Sin*, the *Offerings of Cain and Abel*, and *Cain killing Abel*, or the *Maries at the Tomb* and *Noli Me Tangere*.
7. Membership, confined to the patrician families inscribed in the Golden Book, remained much the same until the dissolution of the Republic in 1797.
8. L. Testi, *La Storia della pittura veneziana* (Bergamo, 1909), 139, and G. Monticolo, *Fonti per la storia d'Italia* (Rome, 1896–1914), 11. 1, 383.
434. 9. Paolo was apparently engaged *c*. 1335 on tapestry designs with his brother Marco, who also

worked on stained glass for the Frari. There is a slightly odd signature and date on the *Madonna* in the Aldo Crespi Collection at Merate. The date 1358, and the signature on the *Augustus and the Sibyl* at Stuttgart, have long been thought to be false additions to a later work, possibly by Jacobello del Fiore.

CHAPTER 31

438. 1. The attribution is firmly upheld in M. Seidel, 'Studien zu Giovanni di Balduccio und Tino di Camaino', *Städel-Jahrbuch*, V (1975), 37 ff., who gives a detailed analysis of the reflections of Giovanni Pisano's later works and of his Pistoia pulpit in particular.

2. The canopy over the recumbent figure is recorded in the early-fourteenth-century Codex Balbini (W. R. Valentiner, *Tino da Camaino* (Paris, 1935), 39), and the imperial figure is somewhat indebted to Arnolfo's own Charles of Anjou.

441. 3. He was succeeded by Lapo di Francesco, to whom a number of works, such as the dismembered Gherardesca tomb in the Camposanto at Pisa, have been attributed on uncertain grounds.

4. The repetition of the whole series in a drier, flatter, more pictorial and linear manner on the della Torre sarcophagus indicates the limitations of Tino's narrative invention. For full discussion and reconstructions of Tino's Florentine tombs, see G. Kreytenberg, 'Tino di Camainos Grabmäler in Florenz', *Städel-Jahrbuch*, VII (1979), 33 ff.

444. 5. The series of Tino's tombs is completed by those of Mary of Anjou in S. Maria Donna Regina, and of Philip of Taranto and John of Durazzo in S. Domenico Maggiore.

445. 6. Even the finest of the many tombs in the manner of Arnolfo or of Giovanni, scattered throughout Central Italy, such as those of Benedict XI in S. Domenico in Perugia and of Philippe de Courtenay in S. Francesco at Assisi, only emphasize his stature. The Perugian tomb is, however, noteworthy in picking up the Roman motif of the inhabited twisted column, with what were originally swarms of putti, eighteen strong were each twisted shaft, climbing up the vine tendrils and possibly representing spiritual progress or the ascent of the soul.

447. 7. The heads are stucco, the originals having been destroyed in 1341 after Arezzo had been ceded to Florence and had lost all the territories acquired under Guido.

CHAPTER 32

452. 1. L. Fumi, *Il Duomo di Orvieto e i suoi restauri* (Rome, 1891), publishes all the documents.

455. 2. The significance of the Strasbourg drawings is discussed in H. Klotz, 'Deutsche und italienische Baukunst im Trecento', *Mitteilungen des kunsthistorischen Institutes in Florenz*, XII (1965–6), 171 ff.

3. The completion of the drawing and the inclusion of the pinnacles flanking the central gable would have accentuated the vertical acceleration.

458. 4. The controlling use of the root-two formula was ascertained for me by P. Kidson. For discussion of the use of the system, with particular reference to Duccio, see above, p. 294.

5. See above, p. 235.

6. However much it may owe to Arnolfo's Florentine project, the impossibility of Giovanni Pisano's façade at Siena having this form (see above, p. 116), and the late date of the subsequent alterations (see above, pp. 234, 239 f.), means that if the façades are indeed linked, Orvieto, and not Siena, as is generally assumed, has priority.

7. See above, p. 121.

460. 8. C. Dodgson, *Vasari Society*, First Series, I (1905/6), 23–5, A. E. Popham and P. Pouncey, *Italian Drawings in the Department of Prints and Drawings in the British Museum* (London, 1950), 167 ff., and B. Degenhart and A. Schmitt, *op. cit.* (Chapter 15, Note 14), 99 ff., who note connections in figure style with the work of Giovanni d'Agostino, and with Goro di Gregorio's monument of 1333 to Guido de' Tabiati in the Duomo at Messina, although in the latter there is a very substantial divergence in the treatment of architecture in the narrative designs.

461. 9. This was pointed out to me by Bruno Zanardi.

462. 10. See above, pp. 83, 342–3, and 357–8.

464. 11. If, as is likely, he was responsible, after Maitani's death, for eight of the figures in the niches round the rose-window, this confirms the untraceability of his contribution to the infinitely more accomplished reliefs.

468. 12. Italian production in the late thirteenth and fourteenth centuries is surveyed in M.-M. Gautier, *Émaux du moyen âge occidental* (Fribourg, 1972), 203 ff. Interesting new light is thrown on Ugolino di Vieri's northern connections by the fact that when petitioning the Commune of Siena in 1372 for permission to build a twelve-bed pilgrims' hospital and chapel at his own expense, with the proviso that if it was not completed in three years all his worldly goods could be taken to pay for it, he mentions a 'figura e miracoli' of St Anthony Abbot which he had acquired in Paris. See P. A. Riedl and M. Seidel, *Die Kirchen von Siena* (Munich, 1985), I, 1, 339.

469. 13. G. Marchini, *op. cit.* (Chapter 12, Note 5), 183–7, notes the collaboration of a number of different hands and sees the personal share of Giovanni di

Bonino, who is referred to as a painter in the Orvietan documents and also worked there in mosaic (1345), as the last surviving dated output of the previously anonymous Master of Figline to whom, in discussing the Chapel of St Louis in the lower church at Assisi (p. 154, note 284), he gives some ten works or complexes in glass, panel, and fresco.

CHAPTER 33

471. 1. I. Falk and J. Lanyi, 'The Genesis of Andrea Pisano's Bronze Doors', *Art Bulletin*, XXV (1943), 134.
473. 2. The mathematical and geometrical basis of the design is analysed by D. Finiello-Zervas, 'The Trattato dell'Abbaco and Andrea Pisano's Design for the Florentine Baptistery Door', *Renaissance Quarterly*, XXVIII (1975), 483 ff.
3. A.F. Moskowitz, 'Osservazioni sulla porta del battistero di Andrea Pisano', *Antichità Viva*, XX (1981), 28 ff.
476. 4. Luke 3: 16.
478. 5. I. Falk and J. Lanyi, *op. cit.*, 147.
480. 6. G. Kreytenberg, 'Andrea Pisano's Earliest Works in Marble', *Burlington Magazine*, CXXII (1980), 3 ff., shows that these figures were probably carved for the Baptistery in Florence *c.* 1344–5.
482. 7. The Planets, Virtues, Sacraments, and Liberal Arts of the upper registers, though influenced by Andrea, were carried out by men of a later generation. The controversial, over-life-size figures of Solomon, David, the Erythrean and Tiburtine Sibyls, and four Prophets, now in the Opera del Duomo, appear to come from the niches above the reliefs, and reflect the work of various hands. Even in the two Sibyls the lowered quality and uncomfortable dislocation of upper and lower body seem, in the absence of documentation, to exclude Andrea's personal responsibility.
8. I. Toesca, *Andrea e Nino Pisano* (Florence, 1950), 58 ff., rightly argues that to attribute the superbly simple wooden *Virgin Annunciate* of 1321 to Andrea is highly dangerous in view of its signature by Stefano Accolti and Agostino di Giovanni.

CHAPTER 34

484. 1. The tomb was severely reconstructed in 1839.
2. P. Venturino Auce, 'La Tomba di S. Pietro Martire e la Cappella Portinari in S. Eustorgio di Milano', *Memorie Domenicane*, Anno 69, N.S. XXVII (1952), 3 ff., in putting forward the identification of Giovanni and Azzone Visconti and the king and queen of Cyprus, misreads St Catherine as S. Romerina. For recent discussion of Giovanni di Balduccio's

relationship with Giovanni Pisano, see M. Seidel, 'Studien zu Giovanni di Balduccio und Tino di Camaino. Die Rezeption des Spätwerks von Giovanni Pisano', *Städel-Jahrbuch*, V (1975), 37 ff.
490. 3. The original figure, shown here, has been removed to a courtyard in the Castelvecchio.

CHAPTER 36

495. 1. For recent contributions to the clarification of some of the uncertainties surrounding Arnolfo's original design and the subsequent building history of the façade see above, Chapter 3, Note 9.
2. C. Guasti, *S. Maria del Fiore, la costruzione ... secondo i documenti* (Florence, 1887), 84.
3. Jacopo's role in the construction of the vast complex of the Chiostro Verde and Chiostro Grande and their surrounding structures, which include the refectory and library with its three aisles, is undefined but probably considerable.
4. C. Guasti, *op. cit.*, 95. Since the three newly agreed nave bays of 34 braccia and a crossing of 62 braccia come to 164 braccia, it is virtually certain that these are the measurements not of Arnolfo's original plan but of the new scheme now begun.
496. 5. H. Saalman, 'Santa Maria del Fiore: 1294–1418', *Art Bulletin*, XLVI (1964), 473, argues that there probably never was an Arnolfan 'design' as such.
6. G. Kiesow, *op. cit.* (Chapter 2, Note 11), 19 ff.
7. W. and E. Paatz, *Die Kirchen von Florenz* (Frankfurt am Main, 1952–5), III, 324 ff., and F. Toker, 'Arnolfo's S. Maria del Fiore: A Working Hypothesis', *Journal of the Society of Architectural Historians*, XLII (1983), 101 ff., the excavations at the eastern end being referred to on p. 52 above.
8. C. Guasti, *op. cit.*, 102, 103–4.
9. *Ibid.*, 95 (Doc. 76).
497. 10. *Ibid.*, 140 ff.
11. See above, pp. 234 ff.
12. H. Saalman, *op. cit.*, 493 ff., considers this to be a garbled description of the finally accepted design and not a record of an earlier project.
13. C. Guasti, *op. cit.*, 159 (Doc. 120).
14. *Ibid.*, 160 (Doc. 124), 163 (Doc. 131), 166 (Doc. 138).
498. 15. In this same month cracks in the vaulting led to the initiation of the existing systems of metal bracing in the arches; C. Guasti, *op. cit.*, 168–70 (Docs. 143–5).
16. *Ibid.*, 218 (Doc. 214).
17. H. Saalman, *op. cit.*, 488 ff., believes the question of whether or not to include a drum to lie behind, and to explain, the final long series of documented controversies over the planning of the east end.

500. 18. P. Chiolini, *I Caratteri distributivi degli antichi edifici* (Milan, 1959), 239 ff.

19. In this respect even such buildings as St Mary in Capitol in Cologne or S. Fedele at Como or S. Lorenzo in Milan, whatever their relationship to Arnolfo's original design, hardly provide a precedent.

502. 20. R. Wittkower, *Architectural Principles in the Age of Humanism* (London, 1952), pt 1.

21. At an early stage the expansion of the original bay-plan led to a discrepancy between the external and internal openings of the windows at the west end of the nave.

22. H. Saalman, *The Church of Santa Trinita in Florence* (New York, 1966). Otherwise, see W. and E. Paatz, *op. cit.*, and R. Baldaccini, 'S. Trinita nel periodo romanico', *Rivista d'Arte*, XXVI (1950), 23 ff., and 'S. Trinita nel periodo gotico', *Rivista d'Arte*, XXVII (1951–2), 57 ff.

504. 23. See above, pp. 246–8. The intermingling of painting and sculpture was continued on the upper levels during the fifteenth century.

24. See above, pp. 114 ff.

505. 25. Antonio Federighi's monumental crown dates from 1463–8. The drawing is illustrated and discussed in H. Keller, 'Die Bauplastik des sieneser Doms', *Kunstgeschichtliches Jahrbuch der Bibliotheca Hertziana*, I (1937), 206 ff.

26. A. Venturi, 'San Martino di Lucca', *L'Arte*, XXV (1922), 207 ff. See also H. Klotz, 'Deutsche und italienische Baukunst im Trecento', *Mitteilungen des kunsthistorischen Institutes in Florenz*, XII (1965–6), 171 ff., for comparison with Strasbourg.

506. 27. A. Petrucci, *Cattedrali di Puglia* (Rome, 1960), 128 ff.

CHAPTER 37

510. 1. *Seniles*, V, 1, in a letter to Boccaccio seemingly of *c.* 1365–6. See J. H. Robinson and H. W. Rolfe, *Petrarch* (New York, 1914), 324, and A. Foresti, *Aneddoti della vita di F. Petrarca* (Brescia, 1928), 422 ff. The dating seemingly precludes the attribution of the design to Bernardo da Venezia, proposed in A. M. Romanini, *op. cit.* (Chapter 2, Note 21).

514. 2. P. Chiolini, *op. cit.* (Chapter 36, Note 18), 239 ff.

CHAPTER 38

517. 1. Illustrated in J. S. Ackerman, ' "Ars sine Scientia nihil est" ...', *Art Bulletin*, XXXI (1949), figures 5, 6, whose fundamental discussion of the measurements and of the significance and sequence of events are supplemented by further analyses in P. Frankl,

The Gothic, Literary Sources and Interpretations through Eight Centuries (Princeton, 1960).

The disassociation from the initiatives of Gian Galeazzo Visconti and the starting date well before 1386 argued for by A. M. Romanini, *op. cit.* (Chapter 2, Note 21) do not seem to be borne out by the surviving accounts. Receipts of 349 lire 11 soldi 2 denarii for the eight months May–December 1386 compare with receipts of 3,508. 19. 11 and outgoings of 3,436. 5. 4 for the similar period January–August 1387. The totals for 1387 as a whole rise even more steeply to 16,454. 2. 3 and 13,536. 11. 10 respectively. In 1388 income was 24,146. 4. 7, and by 1389 income was 43,639. 11. 10 and outgoings 26,858. 9. 1½, rising to new peaks of 57,287. 13. 7½ and 30,640. 11. 1½ in 1391. The impression is given that neither the fundraising process nor the constructional campaign was fully under way in late 1386 and early 1387, but that once enough time had elapsed for the necessary organizational work to be done there was no looking back. The figures, indeed, seem to support the traditional starting date of 1386.

518. 2. *Annali della fabbrica del duomo di Milano* (Milan, 1877), 45.

3. *Ibid.*, 53.

520. 4. See above, p. 74.

5. *Annali* (*op. cit.*), 68 ff.

6. *Ibid.*, 71 ff.

521. 7. *Ibid.*, 202 ff.

522. 8. See above, p. 254.

523. 9. *Annali* (*op. cit.*), 209 ff.

527. 10. *Ibid.*, 224 ff.

11. P. Frankl, *op. cit.*, 80 ff., argues persuasively on the significance of this distinction.

12. C. Guasti, *op. cit.* (Chapter 36, Note 2), 174 (Doc. 150).

531. 13. See J. S. Ackerman, 'The Certosa of Pavia and the Renaissance in Milan', *Marsyas*, V (1947–9), 23 ff. The only other church with which Bernardo is documentarily connected, and then in a very ambiguous way, is S. Maria del Carmine in Milan. Neither this building nor the Certosa seem to justify the attribution to him of S. Maria del Carmine at Pavia, as in A. M. Romanini, *op. cit.* (Chapter 2, Note 21).

14. The Milanese tendency towards a cruciform hall and cupola design is also reflected in the Duomo at Como, in which the long-drawn-out building history again leads to a hybrid outcome. There the problem of converting an earlier structure may have induced Lorenzo dei Spazii, mentioned in the Milanese documents from 1390 to 1394, to retain a standard nave and aisle pattern.

533. 15. A similar innate conservatism marks the series of wide, low hall churches, with vaulted nave

and aisles, erected in Lombardy and the neighbouring territories in the last quarter of the century and headed by S. Lorenzo at Mortara. See A. M. Romanini, *op. cit.* (Chapter 2, Note 21).

Strange metamorphoses of earlier Piedmontese traditions are notable in the needle-points and terracotta detailing of the gables over the doors of the fifteenth-century façades of S. Antonio di Ranverso and the Ospedale at Buttigliera Alta, in the Duomo at Chieri, in S. Giovanni at Ciriè, and in the Collegiata of S. Orso at Aosta. The ultimate in ornate complexity is the many-figured terracotta frontispiece of 1425, seemingly imprinted on the blank façade of the Assunta at Chivasso.

16. For its restoration, see A. Barbacci, 'I Restauri della Mercanzia di Bologna', *Bollettino d'Arte*, XXV (1950), 171 ff.

534. 17. F. Filippini, *Bollettino d'Arte*, II (1922–3), 77 ff.

537. 18. Archivio della Fabbrica di S. Petronio, *Libro delle Convenzioni e Composizioni*, fol. 3v., and A. Gatti, *La Basilica Petroniana* (Bologna, 1913), 293, doc. 2a.

19. Archivio, *op. cit.*, fol. 3v.; A. Gatti, *op. cit.*, 294, doc. 2b. When, in September 1402, the painter Jacopo di Paolo was commissioned to make a second model, it was to follow the form of the existing structure. See Archivio, *op. cit.*, 311, doc. 13. The only significant modifications in the existing structure seem to be the changes introduced by Antonio himself at an early stage.

538. 20. W. Wolters, *La Scultura veneziana gotica 1300/1460* (Venice, 1976), I, 43 ff. and 173 ff., discusses the capital sculpture in detail, with special reference to the work of Filippo Calendario.

21. P. Toesca, *Il Trecento* (Turin, 1951), 150 ff., F. J. Samuely, 'Trecento Mechanics', *Architectural Review*, CVIII (1950), 190 ff., and E. Bassi, 'Appunti per la storia del Palazzo Ducale di Venezia, 1, 2', *Critica d'Arte*, IX, 51–2 (1962), 25 ff., 41 ff.

CHAPTER 40

545. 1. E. Borsook, *The Mural Painters of Tuscany*, 2nd ed. (London, 1980), 43 ff., argues for the earlier date and refers to previous suggestions that Barna is really a no less shadowy Federico Memmi, whereas F. Delogu Ventroni, *Barna da Siena* (Pisa, 1972), proposed two campaigns, *c.* 1340–5 and 1349–54.

546. 2. S. L. Faison Jr, 'Barna and Bartolo di Fredi', *Art Bulletin*, XIV (1932), 285 ff.

549. 3. E. Borsook, 'The Frescoes at San Leonardo al Lago', *Burlington Magazine*, XCVIII (1956), 351 ff.

551. 4. C. Brandi, 'Niccolo di Ser Sozzo Tegliacci', *L'Arte*, XXXV (1932), 221 ff.

552. 5. V. Wainwright, 'Conflict and Popular Government in Fourteenth Century Siena: Il Monte dei Dodici, 1353–1368', *Atti del III Convegno di studi sulla storia dei ceti dirigenti in Toscana* (Florence, 1980), 57 ff., provides valuable information on the vertical linkages, as opposed to modern class stratifications, in the preceding regime of the Dodici.

6. N. Rubinstein, 'Political Ideas in Sienese Art ...', *Journal of the Warburg and Courtauld Institutes*, XXI (1958), 189 ff.

555. 7. The alternatives are supported by P. Sanpaolesi a.o., *Camposanto Monumentale di Pisa* (Pisa, 1960), 46 ff., and M. Meiss, 'The Problem of Francesco Traini', *Art Bulletin*, XV (1933), 97 ff. A more recent attribution to the shadowy Buffalmacco by L. Bellosi, *Buffalmacco e il Trionfo della Morte* (Turin, 1974), seems not to be wholly convincing, as is shown in a review by H. B. J. Maginnis, *Art Bulletin*, LVIII (1976), 126–8.

8. H. B. J. Maginnis, *loc. cit.*, turns the very cautious statements in M. Meiss, 'Notable Disturbances in the Classification of Tuscan Trecento Painting', *Burlington Magazine*, CXIII (1971), 178–87, into a positive dating before 1345 when there is a possible documentary reference to a *Last Judgement* in the Pellegrinaio of the Ospedale della Misericordia, Prato. The two works are virtually identical in certain details, but there is only an assumption that Pisa has the priority.

557. 9. M. Meiss, *Painting in Florence and Siena after the Black Death* (Princeton, 1951), 9 ff.

558. 10. R. Offner, *A Corpus of Florentine Painting* (Berlin, 1930–), section IV, vol. I, 43 ff.

559. 11. *Ibid.*, section VI, vol. II.

562. 12. C. Gardner von Teuffel, 'Ikonographie und Archäologie: das Pfingsttriptycon in der Florentiner Akademie an seinem ursprunglichen Aufstellungsort', *Zeitschrift für Kunstgeschichte*, XLI (1978), 16 ff.

13. The thesis that there was, put forward by M. Meiss, *op. cit.* (Note 9, above), 44 ff., has subsequently been challenged by a number of writers. H. van Os, *op. cit.* (Chapter 27, Note 17), summarizes and extends these arguments, stressing the basis in changing patterns of patronage and the new economic circumstances for the undeniable changes which take place in Sienese art in the second half of the century. For the wider effects of the Black Death, see W. M. Bowski, 'The Impact of the Black Death upon Sienese Government and Society', *Speculum*, XXXIX (1964), 1 ff., and *A Medieval Italian Commune. Siena under the Nine, 1287–1355* (Berkeley, 1981).

566. 14. M. Meiss, *op. cit.* (Note 9, above), 100 ff. For the relation to the specific activities carried out in the chapter house, notably the examination of candidates,

the daily Chapter of Faults, and numerous liturgical and ceremonial functions, see J. Gardner, 'Andrea di Bonaiuto and the Chapter House Frescoes in Santa Maria Novella', *Art History*, 11 (1979), 107 ff.

568. 15. Colour development in this period is very clearly analysed in J. Shearman, *Developments in the Use of Colour in Tuscan Paintings of the Early Sixteenth Century* (London University thesis) (London, 1957).

16. The attribution of the central lights to Agnolo in G. Marchini, *Italian Stained Glass Windows* (London, 1957), 246, and of the remainder to his school (*Primo Rinascimento in Santa Croce*, Florence, 1968), follows H. van Straelen, *Studien zur Florentiner Glasmalerei des Trecento und Quattrocento* (Wattenschied, 1938), and R. Salvini, *Agnolo Gaddi* (Florence, 1936).

569. 17. Cennini, cap. I.

18. Cennini, cap. XXVIII.

19. Cennini, cap. LXXXIII.

20. I. Origo, *The Merchant of Prato* (London, 1957), 238 ff.

CHAPTER 41

572. 1. Lorenzo's individuality is underlined by comparison with the signed altarpiece of 1372 by Donato and Marco Catarino in the Galleria Querini-Stampalia in Venice, derived from Paolo Veneziano, or with the various works, largely dependent on Lorenzo, produced by Marco Catarino alone, or by Giovanni da Bologna.

2. J. White, 'The Reconstruction of the Polyptych ascribed to Guariento in the Collection of the Norton Simon Foundation', *Burlington Magazine*, CXVII (1975), 517 ff. See also F. F. D'Arcais, *Guariento* (Venice, 1980), where, however, the preceding reconstruction is not noted.

573. 3. A. Sartori, 'Nota su Altichiero', *Il Santo*, III, 3 (1963), 291 ff., publishes the documents.

575. 4. Avanzo's independent existence and his contribution to the work in the chapel are upheld in a thesis by H.-W. Kruft, *Altichiero und Avanzo* (Bonn, 1966).

581. 5. P. Toesca's fundamental work on Lombard miniatures, *La Pittura e la miniatura nella Lombardia* (Milan, 1912), is brilliantly carried forward by O. Pächt, 'Early Italian Nature Studies and the Early Calendar Landscape', *Journal of the Warburg and Courtauld Institutes*, XIII (1950), 13 ff.

583. 6. See M. L. Gengaro and L. Cogliati Arano, *Miniature lombarde. Codici miniati dall'VIII al XIV secolo* (Milan, 1970). Among the miniatures is a splendid illustration of a cage of wooden scaffolding cantilevered out from above the first storey of a building

under construction. For the system commonly used in Tuscany, see p. 392 above.

7. See above, pp. 460–1.

8. See above, pp. 517 ff.

9. Fol. 4 v.

586. 10. Cennini, cap. LXX.

589. 11. He was paid in 1402 for another Missal now in the Biblioteca Capitolare in Milan.

CHAPTER 43

NOTE: The ground covered in this chapter to a certain extent overlaps that dealt with in another volume of *The Pelican History of Art*: Charles Seymour Jr, *Sculpture in Italy: 1400–1500* (Harmondsworth, 1966).

594. 1. E. Carli, *Scultura lignea* (Milan, 1960), 52, plate 27.

595. 2. See above, pp. 503–4.

601. 3. C. Ragghianti, 'Aenigmata Pistoriensia I, II', *Critica d'Arte*, I (1954), 423 ff., II (1955), 102 ff., E. Steingraber, 'The Pistoia Silver Altar: A Reexamination', *Connoisseur*, CXXXIII (1956), 148 ff., and M.-M. Gautier, *op. cit.* (Chapter 32, Note 12), 385 ff.

602. 4. C. Baroni, *Scultura gotica lombarda* (Milan, 1944), 97 ff.

604. 5. The high, hard finish and detailed naturalism of the crowded altarpiece in S. Eustorgio rules out his involvement in its carving. The figure style is closely related to that of manuscripts like the *Lancelot du Lac* (Paris, Bibliothèque Nationale, MS. fr. 343). See C. Baroni, *op. cit.*, 127 ff.

605. 6. M. L. Gatti-Perer, 'Appunti per l'attribuzione di un disegno della Raccolta Ferrari: Giovannino de' Grassi e il duomo di Milano', *Arte Lombarda*, X (1965), 49 ff. See also p. 583 above.

608. 7. For the works of the dalle Masegne and Venetian sculpture in general, see W. Wolters, *La Scultura veneziana gotica 1300–1460* (Venice, 1976), in which (216 ff.) the difficult problem of the restorations and existing state of conservation of the altar in Bologna are discussed in detail. A full account of the known careers of the two brothers is also given (62 ff.).

610. 8. For a detailed discussion of the iconostasis, which has lost its original polychromy, see W. Wolters, *op. cit.*, 222 ff. Only the central section is signed. The section in front of the Chapel of S. Clemente bears the date 1397, but no signature, in an inscription copying the one on the central section. That in front of the Chapel of S. Pietro is not inscribed.

9. See W. Wolters, *op. cit.*, for a full discussion.

10. C. Baroni, *op. cit.*, 110 ff.

BIBLIOGRAPHY

Further references, especially to periodical literature, occur in the Notes. Many of the works listed here contain extensive bibliographies of the specialized literature relating to the fields covered. For information on individual artists, not only the sections on artists but also those on places should be consulted where relevant, and vice versa.

The material is arranged under the following headings:

I. GENERAL

A. GENERAL WORKS

Acts of the XX International Congress of the History of Art (New York, 1961), Studies in Western Art, I, *Romanesque and Gothic Art.* Princeton, 1963.

Atti del 24° Congresso internazionale di storia dell'arte (Bologna, 1979), II, *Il Medio Oriente e l'Occidente nell'arte del 13° secolo.* Ed. H. Belting. 1982. III, *La Pittura nel 14° e 15° secolo. Il Contributo dell'analisi technica alla storia dell'arte.* Ed. H. W. van Os and R. J. Asperen de Boer. 1983.

Akten des 25. internationalen Kongresses für Kunstgeschichte (Vienna, 1983), VI, *Europäischen Kunst um 1300.* Ed. G. Schmidt.

Catalogo delle cose d'arte e di antichità d'Italia. In progress. Rome, 1911–.

DECKER, H. *Romanesque Art in Italy.* London, 1958.

EGBERT, V. W. *The Medieval Artist at Work.* Princeton, 1967.

Encyclopedia of World Art. New York, Toronto, London, 1959–68.

FRANKL, P. *The Gothic, Literary Sources and Interpretations through Eight Centuries.* Princeton, 1960.

Guida d'Italia del Touring Club Italiano. Various eds, in progress.

HAUSER, A. *The Social History of Art.* 2 vols. London, 1951.

HENDERSON, G. *Gothic.* Harmondsworth, 1967.

HYDE, J. K. *Society and Politics in Medieval Italy. The Evolution of the Civil Life.* London, 1973.

Inventario degli oggetti d'arte d'Italia. 9 vols. Rome, 1931–8.

KELLER, H. *Die Kunstlandschaften Italiens.* Munich, 1960.

LARNER, J. *Culture and Society in Italy, 1290–1420.* London, 1971.

LAVAGNINO, E. *Il Medioevo.* Turin, 1936.

MÂLE, E. *The Gothic Image.* New York, 1958.

MARTINDALE, A. *Gothic Art.* London, 1967.

PANOFSKY, E. *Renaissance and Renascences in Western Art.* Stockholm, 1960.

RAVE, P. O., and STEIN, B. *Kunstgeschichte in Festschriften.* Berlin, 1962.

Storia dell'arte italiana. In progress. Turin, 1979–.

THIEME, U., and BECKER, F. *Allgemeines Lexikon der bildenden Künstler.* Leipzig, 1907–50.

TOESCA, P. *Il Medioevo.* Turin, 1927.

TOESCA, P. *Il Trecento.* Turin, 1951.

VENTURI, A. *Storia dell'arte italiana.* 18 vols. Milan, 1901–40.

WHITE, J. *Studies in Late Medieval Italian Art.* London, 1984.

B. SPECIAL SUBJECTS

CIPPOLLA, C.M. *Money, Prices and Civilization in the Mediterranean World*. New York, 1967.

CIPPOLLA, C.M. *Studi di storia della moneta*, I, *I Movimenti dei cambi in Italia dal secolo XIII al XV*. Pavia, 1948.

GRAF, H. *Bibliographie zum Problem der Proportionen*. Speyer, 1958.

HAHNLOSER, H.R. *Villard de Honnecourt*. Vienna, 1935.

HETZER, T. 'Über das Verhältnis der Malerei zur Architectur,' *Aufsätze und Vorträge*, II (Leipzig, 1957), 171 ff.

HOPPER, V.F. *Mediaeval Number Symbolism*. New York, 1938.

MARTINI, A. *Manuale di metrologia, misure, pesi e monete*. Turin, 1883.

ORIGO, I. *The Merchant of Prato, Francesco di Marco Datini*. London, 1957.

RÉAU, L. *Iconographie de l'art chrétien*, I–III. Paris, 1955–9.

SCHLOSSER MAGNINO, J. *La Letteratura artistica*. Florence, 1956.

C. SOURCES

BALDINUCCI, F. *Notizie de' professori del disegno*. Florence, 1681–1728. Facsimile reprint, ed. F. Ranelli. Florence, 1974.

BILLI, A. *Il Libro di Antonio Billi e le sue copie nella Biblioteca Nazionale di Firenze*. Ed. C. Fabriczi. Florence, 1891.

BILLI, A. *Il Libro di Antonio Billi*. Ed. C. Frey. Berlin, 1892.

BONAVENTURE, ST. *Doctoris Seraphici S. Bonaventurae S. R. E. Episcopi Cardinalis Omnia Opera*. Ed. Quaracchi. Florence, 1882–1902.

CENNINI, CENNINO. *Il Libro dell'arte*. Ed. D.R. Thompson Jr. New Haven, 1932. Trans. New Haven, 1933.

DURANDUS, W. *Rationale Divinorum Officiorum*. Trans. J.M. Neale and B. Webb as *The Symbolism of Churches and Church Ornaments*. London, 1906.

GHIBERTI, L. *I Commentari*. Ed. O. Morisani. Naples, 1947.

GHIBERTI, L. *Lorenzo Ghibertis Denkwürdigkeiten*. Ed. J. von Schlosser. Berlin, 1912.

HENNECKE, E. *New Testament Apocrypha*. London, 1963.

HOLT, E.G. *A Documentary History of Art*, I, *The Middle Ages and the Renaissance*. New York, 1957.

Il Codice magliabechiano. Ed. K. Frey. Berlin, 1892.

L'Anonimo magliabechiano. Ed. A. Ficarra. Naples, 1968.

MURRAY, P. *An Index of Attributions made in Tuscan Sources before Vasari*. Florence, 1959.

PSEUDO-BONAVENTURA. *Meditationes Vitae Christi*. 'The Mirrour of the Blessed Lyf of Jesu Christ.' Trans. Nicholas Love – before 1410. Ed. L. F. Powell. London, 1908.

PSEUDO-BONAVENTURA. Ragusa, I., and Green, R. B. *Meditations on the Life of Christ. An Illustrated Manuscript of the Fourteenth Century*. Princeton, 1961.

VASARI, G. *Le Vite*. Eds R. Bettarini and P. Barocchi. In progress. Florence, 1966–. Ed. K. Frey. Munich, 1911. Ed. G. Milanesi. 9 vols. Florence, 1878–85.

VILLANI, G. *Cronica*. Ed. G. Antonelli. Florence, 1823. Ed. Gherardi-Dragomani. Florence, 1844–5.

VORAGINE, J. DA. *Jacobi a Voragine Legenda Aurea vulgo historia lombarda dicta*. Ed. J. G. T. Graesse. Dresden and Leipzig, 1846.

VORAGINE J. DA. *Leggenda aurea, volgarizzamento toscano del trecento*. Ed. A. Levasti. 3 vols. Florence, 1924–6.

D. REGIONS

BACCI, P. *Documenti toscani per la storia dell'arte*. 2 vols. Florence, 1910–12.

BERTAUX, É. *L'Art dans l'Italie méridionale*. Paris, 1904. *Aggiornamento*. Vols IV–VI and Index. Ed. A. Prandi. Rome, 1978.

LEHMANN-BROCKHAUS, O. *Abruzzen und Molise. Kunst und Geschichte*. Munich, 1983.

MILANESI, G. *Nuovi Documenti per la storia dell'arte toscana*. Rome, 1893.

MURRAY, P. *An Index of Attributions made in Tuscan Sources before Vasari*. Florence, 1959.

SANTI, F. *Galleria Nazionale dell'Umbria, Dipinti, sculture e oggetti d'arte di età romanica e gotica*. Rome, 1969.

Tavole di ragguaglio per la riduzione dei pesi e misure che si usano in diversi luoghi del granducato di Toscana. Florence, 1782.

VARESE, R. *Trecento ferrarese*. Milan, 1976.

E. INDIVIDUAL CITIES

1. Assisi

ZOCCA, E. *Assisi (Catalogo delle cose d'arte e di antichità d'Italia)*. Rome, 1936.

2. Florence

ALBERTINI, F. *Memoriale di molte statue et picture sono nella inclyta cipta di Florentia*. Florence, 1510. Facsimile, ed. E. Campa. Florence, 1932.

BECHERUCCI, L. *I Musei di Santa Croce e di Santo Spirito a Firenze.* Florence, 1983.
BECHERUCCI, L., and BRUNETTI, G. *Il Museo dell'Opera del Duomo a Firenze.* 2 vols. Italy, 1971.
BECKER, M. B. *Florence in Transition:* I, *The Decline of the Commune;* II, *Studies in the Rise of the Territorial State.* Baltimore, 1967, 1968.
BRUCKER, G. A. *Florentine Politics and Society 1343–1378.* Princeton, 1962.
Cronaca Fiorentina di Marchionne di Coppo Stefani (L. A. Muratori, *Rerum italicarum scriptores,* XXX, 1,2 vols). 1903.
DAVIDSOHN, R. *Geschichte von Florenz.* IV in 8. Berlin, 1896–1927. Trans. G. B. Klein. IV in 5. Florence, 1956–62.
KIEL, H. *Il Museo del Bigallo.* Florence, 1977.
MANZONI, L. *Statuti e matricole dell'arte dei pittori di Firenze, Perugia, Siena.* Rome, 1904.
MARCUCCI, L. *Gallerie Nazionali di Firenze. I Dipinti toscani del secolo XIII.* Rome, 1958.
MARCUCCI, L. *Gallerie Nazionali di Firenze. I Dipinti toscani del secolo XIV.* Rome, 1965.
NAJEMY, J. M. *Corporation and Consensus in Florentine Electoral Politics, 1280–1400.* Chapel Hill, 1982.
PAATZ, E. and W. *Die Kirchen von Florenz.* 6 vols. Frankfurt am Main, 1952–5.
RICHA, G. *Notizie istoriche delle chiese fiorentine divise ne' suoi quartieri.* 10 vols. Florence, 1754–62.

3. Genoa

GROSSI BIANCHI, L., and POLEGGI, E. *Una Città portuale del medioevo. Genova nei secoli X–XVI.* Genoa, 1980.

4. L'Aquila

MORETTI, M. *Museo Nazionale d'Abruzzo.* L'Aquila, 1968.

5. Milan

Storia di Milano. Fondazione Treccani degli Alfieri per la storia di Milano. 16 vols, especially vols IV, V, VI. Milan, 1953–62.

6. Naples

RINALDIS, A. DE. *Naples angevine.* Paris, 1927.
Storia di Napoli. Società Editrice Storia di Napoli. Especially vol. 3, *Napoli angioina.* Naples, 1969.

7. Padua

FELLARINI, C., and SARTORI, A. *Documenti per la storia dell'arte a Padova.* Vicenza, 1976.
HYDE, J. K. *Padua in the Age of Dante.* New York, 1966.

SARTORI, A. *Documenti per la storia dell'arte a Padova.* Vicenza, 1976.

8. Perugia

MANZONI, L. *Statuti e matricole dell'arte dei pittori di Firenze, Perugia, Siena.* Rome, 1904.

9. Pisa

CARLI, E. *Il Museo di Pisa.* Pisa, 1974.
TANFANI CENTOFANTI, L. *Notizie di artisti tratte dai documenti pisani.* Pisa, 1897.

10. Pistoia

Il Gotico a Pistoia nei suoi rapporti con l'arte gotica italiana (Atti del 2° Convegno Internazionale di Studi. Pistoia 24–30 Aprile 1966). Pistoia, 1972.

11. Prato

ORIGO, I. *The Merchant of Prato, Francesco di Marco Datini.* London, 1957.

12. Rome

EGIDI, F. *Necrologi e libri affini della provincia romana.* Rome, 1914.
HERMANIN, F. *Storia di Roma,* XXIII, *L'Arte in Roma dal sec. VIII al XIV.* Rome, 1945.
Roma Anno 1300. Atti della IV Settimana di storia dell'arte medievale dell'Università di Roma 'La Sapienza', 1980. Rome, 1983.

13. Siena

BACCI, P. *Fonti e commenti per la storia dell'arte senese.* Siena, 1944.
BORGHESE, S., and BIANCHI, L. *Nuovi documenti per la storia dell'arte senese.* Siena, 1898.
BOWSKY, W. M. *A Medieval Italian Commune. Siena under the Nine, 1287–1355.* Berkeley, 1981.
BOWSKY, W. M. 'The Impact of the Black Death upon Sienese Government and Society', *Speculum,* XXXIX (1964), 1 ff.
BURCKHARDT, T. *Siena – Stadt der Jungfrau.* Olten and Lausanne, 1958.
Cronache senesi (L. A. Muratori, *Rerum italicarum scriptores,* XV, 6, 4 vols). Bologna, 1931–9.
DOUGLAS, L. *A History of Siena.* London, 1902.
MANZONI, L. *Statuti e matricole dell'arte dei pittori di Firenze, Perugia, Siena.* Rome, 1904.
MILANESI, G. *Documenti per la storia dell'arte senese.* 3 vols. Siena, 1854–6.
RIEDL, P. A., and SEIDEL, M. *Die Kirchen von Siena.* Munich, 1985–.
SCHEVILL, F. *Siena: The History of a Medieval Commune.* Ed. W. M. Bowski. Reprint of 1909 ed. with Introduction. New York, 1964.

VALLE, G. DELLA. *Lettere senesi di un socio dell'Accademia di Fossano sopra le Belle Arti.* 3 vols. Venice, 1782–6.

WAINWRIGHT, V. 'Conflict and Popular Government in Fourteenth Century Siena: Il Monte dei Dodici, 1355–1368', *Atti del III Convegno di studi sulla storia dei ceti dirigenti in Toscana*, 57 ff. Florence, 1980.

14. Treviso

COLETTI, L. *Treviso (Catalogo delle cose d'arte e di antichità d'Italia).* Rome, 1935.

II. ARCHITECTURE

A. GENERAL

1. General

ARGAN, G. C. *L'Architettura italiana nel duecento e trecento.* Florence, 1937.

BRAUNFELS, W. *Abendländische Klosterbaukunst.* Cologne, 1969.

CONANT, K. J. *Carolingian and Romanesque Architecture 800–1200 (Pelican History of Art).* London, 1959.

FRANKL, P. *Gothic Architecture (Pelican History of Art).* London, 1962.

GROSS, W. *Die abendländische Architektur um 1300.* Stuttgart, 1938.

WAGNER-RIEGER, R. *Die italienische Baukunst zu Beginn der Gotik.* Graz and Cologne, 1956–7.

2. Special Subjects

AUBERT, M. *L'Architecture cistercienne en France.* Paris, 1943.

BIEBRACH, K. *Die holzgedechten Franziskaner- und Dominikanerkirchen in Umbrien und Toskana.* Berlin, 1908.

BUCHER, F. 'Medieval Architectural Design Methods', *Gesta*, XI (1972), 37 ff.

CHIERICI, G. *Il Palazzo italiano.* Milan, 1952–4.

CHIOLINI, P. *I Caratteri distributivi degli antichi edifici.* Milan, 1959.

COLOMBIER, P. DU. *Les Chantiers des cathédrales.* Paris, 1953.

DIMIER, M. A. *Recueil des plans d'églises cisterciennes.* Paris, 1949.

EBHARDT, B. *Die Burgen Italiens.* 6 vols. Berlin, 1909–27.

ENLART, C. *Les Origines françaises de l'architecture gothique en Italie.* Paris, 1894.

FITCHEN, J. *The Construction of Gothic Cathedrals.* Oxford, 1961.

FRACCARO DE LONGHI, L. *L'Architettura delle chiese cistercensi.* Milan, 1958.

GLASS, D. F. *Studies on Cosmatesque Pavements.* Oxford, 1980.

KLOTZ, H. 'Deutsche und italienische Baukunst im Trecento', *Mitteilungen des kunsthistorischen Institutes in Florenz*, XII (1965–6), 171 ff.

KRAUTHEIMER, R. 'Introduction to an Iconography of Medieval Architecture', *Journal of the Warburg and Courtauld Institutes*, V (1941), 1 ff.

KRAUTHEIMER, R. *Die Kirchen der Bettelorden in Deutschland.* Cologne, 1925.

LAVEDAN, P. *Histoire de l'urbanisme.* 5 vols. Paris, 1926–52.

O'GORMAN, J. *The Architecture of the Monastic Library in Italy 1300–1600.* New York, 1972.

PAUL, J. *Die mittelalterlichen Kommunalpaläste in Italien.* Diss., Albert-Ludwigs-Universität zu Freiburg i. Br. Cologne, 1963.

RODOLICO, F. *Le Pietre delle città d'Italia.* Florence, 1953.

3. Regions

BIEBRACH, K. *Die holzgedechten Franziskaner- und Dominikanerkirchen in Umbrien und Toskana.* Berlin, 1908.

BRANNER, R. *Burgundian Gothic Architecture.* London, 1960.

BRAUNFELS, W. *Mittelalterliche Stadtbaukunst in der Toskana.* Berlin, 1953.

DELLWING, H. *Studien zur Baukunst der Bettelorden in Veneto. Die Gotik der monumentalen Gewölbebasilik.* Munich and Berlin, 1970.

GAVINI, I. C. *Storia dell'architettura in Abruzzo.* 2 vols. Milan and Rome, 1927–8.

GIACOSA, G. *Castelli valdostani e canavesani.* Turin, n.d.

KRÖNIG, W. 'Hallenkirchen in Mittelitalien', *Kunstgeschichtliches Jahrbuch der Bibliotheca Herziana*, II (1938), 1 ff.

KRÖNIG, W. 'Toskana und Apulien', *Zeitschrift für Kunstgeschichte*, XVI (1953), 101 ff.

LAVEDAN, P. *L'Architecture gothique religieuse en Catalogne, Valence et Baléares.* Paris, 1935.

MORETTI, I. *Le 'Terre Nuove' del contado fiorentino.* Florence, 1979.

MORETTI, I., and STOPPANI, G. *Chiese gotiche nel contado fiorentino.* Florence, 1969.

PAATZ, W. *Werden und Wesen der Trecento-Architektur in Toskana.* Burg, 1937.

PETRUCCI, A. *Cattedrali di Puglia.* Rome, 1976.

RODOLICO, N., and MARCHINI, G. *I Palazzi del popolo nei comuni toscani del medio evo.* Milan, 1962.

ROMANINI, A. M. *L'Architettura gotica in Lombardia.* 2 vols. Milan, 1964.

ROMANINI, A. M. 'Le Chiese a sala nell'architettura "gotica" lombarda', *Arte Lombarda*, III, 2 (1958), 48 ff.

SHEARER, C. *The Renaissance of Architecture in Southern Italy*. Cambridge, 1935.

TARCHI, U. *L'Arte medioevale nell'Umbria e nella Sabina*. 4 vols. Milan, 1936–40.

B. INDIVIDUAL CITIES

1. Arezzo

VITA, A. DEL. *Il Duomo d'Arezzo*. Milan, n.d.

2. Assisi

HÉLIOT, P. 'La filiation de l'église haute à Saint François d'Assise', *Bulletin Monumental*, CXXVI (1968), 127 ff.

HERTLEIN, E. *Die Basilika San Francesco in Assisi*. Florence, 1964.

KLEINSCHMIDT, B. *Die Basilika San Francesco in Assisi*. 3 vols. Berlin, 1915.

PIETRALUNGA, FRA LUDOVICO DA. *Descrizione della basilica di S. Francesco e di altri santuari di Assisi*. Ed. P. Scarpellini. Treviso, 1982.

SCHÖNE, W. 'Studien zur Oberkirche von Assisi', in *Festschrift Kurt Bauch*, 50 ff. Munich, 1957.

SUPINO, I. B. *La Basilica di San Francesco di Assisi*. Bologna, 1924.

TSUJI, S., MOGI, K., and NAGATSUKA, Y. *Assisi no San Francesco seido (Basilica of St Francis at Assisi)*. Tokyo, 1978.

3. Bari

APOLLONJ GHETTI, B. M. *Bari Vecchia*. Bari, 1972.

MILANO, N. *Le Chiese della diocesi di Bari*. Bari, 1982.

4. Bologna

BARBACCI, A. 'I Restauri della Mercanzia di Bologna', *Bollettino d'Arte*, XXV (1950), 171 ff.

BELLOSI, L., and others. *La Basilica di San Petronio in Bologna*. Bologna, 1983.

BESEGHI, U. *Palazzi di Bologna*. Bologna, 1957.

FILIPPINI, F. 'Matteo Gattapone da Gubbio architetto del Collegio di Spagna in Bologna', *Bollettino d'Arte*, N.S. 11 (1922–3), 77 ff.

GATTI, A. *La Basilica petroniana*. Bologna, 1913.

SUPINO, I. B. *L'Architettura sacra in Bologna nei secoli XIII e XIV*, Bologna, 1919.

SUPINO, I. B. *L'Arte nelle chiese di Bologna. Secoli VIII–XIV*. Bologna, 1932.

VOLPE, C., ed. *Il Tempio di San Giacomo Maggiore in Bologna*. Bologna, 1967.

5. Città di Castello

GURRIERI, O. *Angelo da Orvieto, Matteo Giovanello Gattaponi e i palazzi pubblici di Gubbio e di Città di Castello*. Perugia, 1959.

6. Crema

EDALLO, A., VERGA, C., GALLINI, C., and CAMBIAGHI, P. M. *Il Duomo di Crema*. Crema, 1961.

7. Florence

BERTI, L. *Il Museo di Palazzo Davanzati*. Florence, 1972.

BERTI C. *Palazzo Davanzati*. Florence, 1958.

BUCCI, M., and BENCINI, R. *Palazzi di Firenze*. 4 vols. 1973.

BUSIGNANI, A., and BENCINI, R. *Le Chiese di Firenze*. 4 vols. In progress. 1972, 1979, 1982.

DETTI, E. *Firenze scomparsa*. Florence, 1970.

FANELLI, G. *Firenze architettura e città*. Florence, 1973.

GUASTI, C. *S. Maria del Fiore, la costruzione della chiesa e del campanile secondo i documenti*. Florence, 1887.

HALL, M. B. 'The Ponte in S. Maria Novella: the Problem of the Rood Screen in Italy', *Journal of the Warburg and Courtauld Institutes*, XXXVII (1974), 157 ff.

HALL, M. B. 'The Tramezzo in Santa Croce, Florence Reconstructed', *Art Bulletin*, LVI (1974), 325 ff.

KIESOW, G. 'Die gotische Südfassade von S. Maria Novella in Florenz', *Zeitschrift für Kunstgeschichte*, XXV (1962), 1 ff.

KIESOW, W. 'Zur Baugeschichte des Florentiner Doms', *Mitteilungen des kunsthistorischen Institutes in Florenz*, X (1961–3), 1 ff.

KREYTENBERG, G. 'Der Campanile von Giotto', *Mitteilungen des kunsthistorischen Institutes in Florenz*, XXII (1978), 147 ff.

KREYTENBERG, G. *Der Dom zu Florenz*. Berlin, 1974.

LENSI, A. *Palazzo Vecchio*. Milan, 1929.

LIMBOURGER, W. *Die Gebäude von Florenz*. Leipzig, 1910.

MOROZZI, G., TOKER, F., and HERMANN, J. *Sta Reparata: l'antica cattedrale fiorentina. I Risultati dello scavo condotto dal 1965 al 1974*. Florence, 1974.

PAATZ, E. and W. *Die Kirchen von Florenz*. 6 vols. Frankfurt am Main, 1952–5.

PAATZ, W. 'Zur Baugeschichte des Palazzo del Podestà in Florenz', *Mitteilungen des kunsthistorischen Institutes in Florenz*, VI (1931), 287 ff.

PAUL, J. *Der Palazzo Vecchio in Florenz. Ursprung und Bedeutung seiner Form*. Florence, 1969.

POGGI, G. *Il Duomo di Firenze*. Berlin, 1909.

RICHA, G. *Notizie istoriche delle chiese fiorentine divise ne' suoi quartieri.* 10 vols. Florence, 1754–62.
SAALMAN, H. *The Bigallo.* New York, 1969.
SAALMAN, H. *The Church of Santa Trinita in Florence.* New York, 1966.
SAALMAN, H. 'Santa Maria del Fiore: 1294–1418', *Art Bulletin*, XLVI (1964), 471 ff.
TOKER, F. 'Arnolfo's S. Maria del Fiore: A Working Hypothesis', *Journal of the Society of Architectural Historians*, XLII (1983), 101 ff.
TOKER, F. 'Florence Cathedral: The Design Stage', *Art Bulletin*, LX (1978), 214 ff.
TRACHTENBERG, M. *The Campanile of Florence Cathedral.* New York, 1971.
WEINBERGER, M. 'The First Façade of the Cathedral of Florence', *Journal of the Warburg and Courtauld Institutes*, IV (1940–1), 67 ff.

8. Grosseto

GARZELLI, A. *Il Duomo di Grosseto.* Florence, 1967.

9. Gubbio

GURRIERI, O. *Angelo da Orvieto, Matteo Giovanello Gattaponi e i palazzi pubblici di Gubbio e di Città di Castello.* Perugia, 1959.
MAZZEI, F. *Memoria sulla condizione attuale dei Palazzi Municipale e Pretorio di Gubbio.* Florence, 1865.
SALMI, M. 'Le Chiese gotiche di Gubbio', *L'Arte*, XXV (1922), 220 ff.
SCHULZE, R. *Gubbio und seine mittelalterliche Bauten.* Berlin, 1914.

10. Lucca

VENTURI, A. 'San Martino di Lucca', *L'Arte*, XXV (1922), 207 ff.

11. Milan

ACKERMAN, J.S. '"Ars sine Scientia Nihil Est", Gothic Theory of Architecture at the Cathedral of Milan', *Art Bulletin*, XXXI (1949), 84 ff.
CANTÙ, C. *Annali della fabbrica del duomo di Milano.* 9 vols. Milan, 1877.
GATTI PERER, M.L. *Il Duomo di Milano (Atti del congresso internazionale, 1968).* Milan, 1969.
GILLI PIRINA, C. 'Simone da Orsenigo e la fondazione del duomo di Milano', *Commentari*, XVI (1965), 204 ff.

12. Naples

BERTAUX, É. *Santa Maria di Donna Regina.* Naples, 1899.

CHIERICI, G. 'Il Restauro della chiesa di San Lorenzo a Napoli', *Bollettino d'Arte*, IX (1929–30), 24 ff.
GAUDENZIO DELL'AJA, P. *Il Restauro della basilica di Santa Chiara in Napoli.* Naples, 1980.
RINALDIS, A. DE. *Naples angevine.* Paris, 1927.
RINALDIS, A. DE. *Santa Chiara.* Naples, 1920.
WAGNER-RIEGER, R. 'S. Lorenzo Maggiore und die süditalienische Architektur unter den ersten Königen aus dem Hause-Anjou', *Miscellanea Bibliothecae Herzianae*, 130 ff. Munich, 1961.

13. Orvieto

BONELLI, R. 'La Chiesa di San Domenico in Orvieto', *Palladio*, VII (1943), 139 ff.
BONELLI, R. *Il Duomo di Orvieto e l'architettura italiana del duecento trecento.* Città di Castello, 1952.
CARLI, E. *Il Duomo di Orvieto.* Rome, 1965.
FUMI, L. *Il Duomo di Orvieto e i suoi restauri.* Rome, 1891.

14. Padua

BETTINI, S., and PUPPI, L. *La Chiesa degli Eremitani di Padova.* Vicenza, 1970.
DELLWING, H. 'Der Santo in Padua, eine baugeschichtliche Untersuchung', *Mitteilungen des kunsthistorischen Institutes in Florenz*, XIX (1975), 197 ff.
DELLWING, H. 'Zur Wölbung des paduaner "Salone"', *Mitteilungen des kunsthistorischen Institutes in Florenz*, XIV (1969–70), 145 ff.
GONZATI, B. *La Basilica di S. Antonio di Padova.* 2 vols. Padua, 1852.
HUECK, I. 'Zu Enrico Scrovegnis Veränderungen der Arenakapelle', *Mitteilungen des kunsthistorischen Institutes in Florenz*, XVII (1973), 277 ff.
LORENZONI, G. *L'Edificio del Santo di Padova.* Vicenza, 1981.
LUISETTO, P. G. *Archivio Sartori*, I, *Basilica e convento del Santo.* Padua, 1983.
MOR, C.G., ed. *Il Palazzo della Ragione di Padova.* Vicenza, 1963.

15. Palermo

GABRICI, E., and LEVI, E. *Lo Steri di Palermo.* Milan, n.d.
SPATRISANO, G. *Lo Steri di Palermo e l'architettura siciliana del trecento.* Palermo, 1972.

16. Perugia

MARTINI, C. 'Il Palazzo dei Priori a Perugia', *Palladio*, XX (1970), 39 ff.

17. Pisa

BARTALINI, A. *Architettura civile del medioevo a Pisa.* Pisa, 1937.

18. Pistoia

RAUTY, N. *L'Antico Palazzo dei Vescovi a Pistoia: storia e restauro.* Florence, 1981.

19. Prato

MARCHINI, G. *Il Duomo di Prato.* Milan, 1958.

20. Rome

GARDNER, J. 'Nicholas III's Oratory of the Sancta Sanctorum and its Decoration', *Burlington Magazine*, CXV (1973), 283 ff.

GOLZIO, V., and ZANDER, G. *Le Chiese di Roma dall'XI al XVI secolo.* Bologna, 1963.

KRAUTHEIMER, R. *Rome. Profile of a City, 312–1308.* Princeton, 1980.

21. Siena

BAGAGLI PETRUCCI, F. *Le Fonti di Siena.* Florence, 1906.

CAIROLA, A., and CARLI, E. *Il Palazzo Pubblico di Siena.* Rome, 1963.

CELLINI, P. 'La "Facciata Semplice" del duomo di Siena', *Proporzioni*, II (1948), 55 ff.

LUSINI, V. *Il Duomo di Siena.* 2 vols. Siena, 1911–39.

LUSINI, V. *Storia della basilica di S. Francesco in Siena.* Siena, 1894.

LUSINI, V. 'S. Domenico in Camporegio', *Bollettino Senese Storia Patria*, XIII (1906), 265 ff.

MIDDELDORF-KOSEGARTEN, A. 'Zur Bedeutung der sieneser Domkuppel', *Münchener Jahrbuch der bildenden Kunst*, XXI (1970), 73 ff.

PIETRAMELLARA, C. *Il Duomo di Siena.* Florence, 1980.

PRUNAI, G., PAMPALONI, G., and BEMPORAD, N. *Il Palazzo Tolomei a Siena.* Florence, 1971.

RIEDL, P. A., and SEIDEL, M. *Die Kirchen von Siena.* Munich, 1985–.

TOKER, F. 'Gothic Architecture by Remote Control: An Illustrated Building Contract of 1340', *Art Bulletin*, LXVII (1985), 67 ff.

22. Todi

CALANO, C. 'San Fortunato a Todi: una chiesa "a sala" gotica', *Quaderni dell'Istituto di Storia dell'Architettura*, XXIV (1977–8), 113 ff.

CECI, G., and BARTOLINI, U. *Piazze e palazzi comunali di Todi.* Todi, 1979.

Il Tempio di San Fortunato a Todi. Ed. G. De Angelis d'Ossat. Milan, 1982.

23. Treviso

COLETTI, L. *Treviso (Catalogo delle cose d'arte e di antichità d'Italia).* Rome, 1935.

24. Venice

ARSLAN, E. *Gothic Architecture in Venice.* London, 1971.

BASSI, E. 'Appunti per la storia del Palazzo Ducale di Venezia 1,2', *Critica d'Arte*, IX,51,52 (1962), 25 ff., 41 ff.

FOGOLARI, G. *I Frari e i SS. Giovanni e Paolo.* Milan, 1932.

RAMBALDI, P. *La Chiesa dei SS. Giovanni e Paolo.* Venice, 1913.

SAMUELY, F. J. 'Trecento Mechanics', *Architectural Review*, CVIII (1950), 190 ff.

25. Vicenza

ARSLAN, E. *Vicenza, I, Le Chiese (Catalogo delle cose d'arte e di antichità d'Italia).* Rome, 1956.

26. Viterbo

TOESCA, P. 'Il Palazzo Papale di Viterbo', *L'Arte*, VII (1904), 105 ff.

C. INDIVIDUAL ARCHITECTS

ANGELO DA ORVIETO

Gurrieri, O. *Angelo da Orvieto, Matteo Giovanelli Gattaponi e i palazzi pubblici di Gubbio e di Città di Castello.* Perugia, 1959.

ARNOLFO DI CAMBIO
See IV.C.

GATTAPONE

Filippini, F. 'Matteo Gattapone da Gubbio architetto del Collegio di Spagna in Bologna', *Bollettino d'Arte*, N.S. II (1922–3), 77 ff.
See also ANGELO DA ORVIETO

GIOTTO
See III.C.

III. PAINTING AND ASSOCIATED ARTS

A. GENERAL

1. General

BAXANDALL, M. *Giotto and the Orators.* Oxford, 1971.

BOLOGNA, F. *La Pittura italiana delle origini.* Rome and Dresden, 1962.

COLETTI, L. *I Primitivi,* II, *I senesi e i giotteschi.* Novara, 1946.

CROWE, J. A., and CAVALCASELLE, G. B. *A History of Painting in Italy.* 6 vols. London, 1903–14.

DEGENHART, B., and SCHMITT, A. *Corpus der italienischen Zeichnungen 1300–1450.* In progress. *Süd- und Mittelitalien.* 4 vols. Berlin, 1968. *Venedig. Adden. zu Süd etc.* 4 vols. Berlin, 1982.

DEMUS, O. *Romanesque Mural Painting.* London, 1970.

GARRISON, E. B. *Italian Romanesque Panel Painting. An Illustrated Index.* Florence, 1949.

GARRISON, E. B. 'Note on the Survival of Thirteenth-Century Panel Paintings in Italy', *Art Bulletin,* LIV (1972), 140.

MARLE, R. VAN. *The Development of the Italian Schools of Painting.* The Hague, 1923–38.

OERTEL, R. *Early Italian Painting to 1400.* London, 1968.

OERTEL, R. 'Wandmalerei und Zeichnung in Italien', *Mitteilungen des kunsthistorischen Institutes in Florenz,* V (1940), 217 ff.

SINIBALDI, G., and BRUNETTI, G. *Pittura italiana del duecento e trecento.* Catalogo della Mostra Giottesca. Florence, 1943.

SMART, A. *The Dawn of Italian Painting, 1250–1400.* Oxford, 1978.

STUBBLEBINE, J. H. *Dugento Painting: An Annotated Bibliography.* Boston, 1983.

WALD, E. T. DE. *Italian Painting, 1200–1600.* New York, 1961.

2. Special Subjects

BLUM, D. *Wandmalerei als Ordenspropaganda.* Worms, 1983.

BRANDI, C. 'The Cleaning of Pictures in Relation to Patina, Varnish and Glazes', *Burlington Magazine,* XCI (1949), 183 ff.

BRINK, J. 'From Carpentry Analysis to the Discovery of Symmetry in Trecento Painting', *Atti del 24° Congresso internazionale di storia dell'arte (Bologna, 1979),* III (1983), 345 ff.

BRINK, J. 'Measure and Proportion in the Monumental Gabled Altarpieces of Duccio, Cimabue and Giotto', *Canadian Art Review,* IV (1977), 69 ff.

BUNIM, M. *Space in Mediaeval Painting and the Forerunners of Perspective.* Oxford, 1947.

CÄMMERER-GEORGE, M. *Die Rahmung der toskanischen Altarbilder im Trecento.* Strasbourg, 1966.

FELDGES-HENNING, U. *Landschaft als topografisches Porträt. Der Wiederbeginn der europäischen Landschaftsmalerei in Siena.* Bern, 1980.

GARDNER VON TEUFEL, C. 'The Buttressed Altarpiece: A Forgotten Aspect of Tuscan Fourteenth Century Altarpiece Design', *Jahrbuch der Berliner Museen,* XXI (1979), 21 ff.

GAUTHIER, M.-M. *Émaux du moyen âge occidental.* Fribourg, 1972.

GIOSEFFI, D. *Perspectiva Artificialis.* Trieste, 1957.

GOFFEN, R. 'Nostra Conversatio in Caelis Est: Observations on the *Sacra Conversazione* in the Trecento', *Art Bulletin,* LXI (1979), 198 ff.

GOMBRICH, E. H. 'Dark Varnishes: Variations on a Theme from Pliny', *Burlington Magazine,* CIV (1962), 51 ff.

HAGER, H. *Die Anfänge des italienischen Altarbildes.* Munich, 1962.

HORB, F. *Das Innenraumbild des späten Mittelalters.* Zürich and Leipzig, 1938.

KLEIN, R. 'Pomponius Gauricus on Perspective', *Art Bulletin,* XLIII (1961), 211 ff.

KURZ, O. 'Varnishes, Tinted Varnishes and Patina', *Burlington Magazine,* CIV (1962), 51 ff.

MACLAREN, N., and WERNER, A. 'Some Factual Observations about Varnishes and Glazes', *Burlington Magazine,* XCII (1950), 189 ff.

MARETTE, J. *Connaissance des primitifs par l'étude du bois.* Paris, 1961.

MOMMSEN, T. E. *Petrarch's Testament.* Ithaca, New York, 1957.

MORA, P., MORA, L., and PHILIPPOT, P. *The Conservation of Wall Paintings.* London, Boston, etc., 1984.

OLSCHKI, L. 'Asiatic Exoticism in Italian Art of the Early Renaissance', *Art Bulletin,* XXVI (1944), 95 ff.

PÄCHT, O. 'Early Italian Nature Studies and the Early Calendar Landscape', *Journal of the Warburg and Courtauld Institutes,* XIII (1950), 13 ff.

PREISER, A. *Das Entstehen und die Entwicklung der Predella in der italienischen Malerei.* Hildesheim and New York, 1973.

PROCACCI, U. *La Technica degli antichi affreschi e il loro distacco e restauro.* Florence, 1958.

PROCACCI, U. *Sinopie e affreschi.* Milan, 1961.

REES-JONES, A. 'Science and the Art of Picture Cleaning', *Burlington Magazine,* CIV (1962).

ROBB, D. M. 'The Iconography of the Annunciation in the Fourteenth and Fifteenth Centuries', *Art Bulletin,* XVIII (1936), 480 ff.

SANDBERG-VAVALÀ, E. *La Croce dipinta italiana e l'iconografia della passione.* Verona, 1929.

SANDBERG-VAVALÀ, E. *L'Iconografia della Madonna col Bambino nella pittura italiana del dugento*. Siena, 1934.

SCHMITT, A. 'Zur Wiederlebung der Antike im Trecento', *Mitteilungen des kunsthistorischen Institutes in Florenz*, XVIII (1974), 167 ff.

SHORR, D. C. *The Christ Child in Devotional Images in Italy during the XIV Century*. New York, 1954.

STUBBLEBINE, J. H. 'Byzantine Influence in Thirteenth Century Italian Panel Painting', *Dumbarton Oaks Papers*, XX (1966), 87 ff.

WAETZHOLDT, S. *Die Kopien des 17. Jahrhunderts nach Mosaiken und Wandmalereien in Rom (Römische Forschungen der Bibliotheca Herziana*, XVIII). Vienna and Munich, 1964.

WHITE, J. *The Birth and Rebirth of Pictorial Space*. 2nd ed. London, 1967. Trans. R. and M. Torelli as *Nascita e rinascita dello spazio pittorico*. Milan, 1971.

3. Regions

BERENSON, B. *Italian Pictures of the Renaissance. Central Italian and North Italian Schools*. 2 vols. London, 1968.

BORSOOK, E. *The Mural Painters of Tuscany*. 2nd ed. Oxford, 1980.

CÄMMERER-GEORGE, M. *Die Rahmung der toskanischen Altarbilder im Trecento*. Strasbourg, 1966.

COLETTI, L. *I Primitivi*, III, *I Padani*. Novara, 1947.

DANEU LATTANZI, A. *Lineamenti di storia della miniatura in Sicilia*. Florence, 1966.

DEGENHART, B., and SCHMITT, A. *Corpus der italienische Zeichnungen 1300–1450. Süd- und Mittelitalien*. 4 vols. Berlin, 1968.

GARDNER VON TEUFEL, C. 'The Buttressed Altarpiece: A Forgotten Aspect of Tuscan Fourteenth Century Altarpiece Design', *Jahrbuch der Berliner Museen*, XXI (1979), 21 ff.

GENGARO, M.L., and COGLIATO-ARANO, L. *Miniature lombarde dall'VIII al XIV secolo*. Milan, 1970.

KAFTAL, G. *Iconography of the Saints in Central and South Italian Painting*. Florence, 1965.

KAFTAL, G. *Iconography of the Saints in the Painting of North East Italy*. Florence, 1978.

KAFTAL, G. *Iconography of the Saints in the Painting of North West Italy*. Florence, 1985.

KAFTAL, G. *Iconography of the Saints in Tuscan Painting*. Florence, 1952.

MATTHIAE, G. *Pittura medioevale abruzzese*. Milan, 1969.

MEISS, M. 'Notable Disturbances in the Classification of Tuscan Trecento Painting', *Burlington Magazine*, CXIII (1971), 178 ff.

PETKOVIC, V. R. *La Peinture serbe du moyen âge*. Belgrade, 1934.

STUBBLEBINE, J. H. 'The Development of the Throne in Tuscan Painting', *Marsyas*, VII (1954–7), 25 ff.

TOESCA, P. *La Pittura e la miniatura nella Lombardia*. Milan, 1912.

VOLPE, C. *La Pittura riminese del trecento*. Milan, 1965.

4. Miniatures and Manuscripts

ANCONA, M. L. D'. *Miniatura e miniatori a Firenze dal XIV al XVI secolo*. Florence, 1962.

ANCONA, P. D', and AESCHLIMANN, E. *Dictionnaire des miniaturistes du moyen âge et de la renaissance*. Milan, 1949.

AVRIL, F., and GOUSSET, M.-T. *Manuscrits enluminés d'origine italienne, Bibliothèque Nationale, Paris*, II, *XIII siècle*. Paris, 1984.

BELLINATI, C., and BETTINI, S. *L'Epistolario miniato di Giovanni da Gaibana*. 2 vols. Vicenza, 1968.

BRANDI, C. 'Niccolo di Ser Sozzo Tegliacci', *L'Arte*, XXXV (1932), 221 ff.

BUCHTAL, H. *Miniature Painting in the Latin Kingdom of Jerusalem*. Oxford, 1957.

CONTI, A. *La Miniatura bolognese. Scuole e botteghe 1270–1340*. Bologna, 1981.

DALLI REGOLI, G. *Miniatura pisana del trecento*. Vicenza, 1963.

DANEU LATTANZI, A. *Lineamenti di storia della miniatura in Sicilia*. Florence, 1966.

DIRINGER, D. *The Illuminated Book*. London, 1958.

DUPRE DAL POGGETTO, M.G.C. *Il Maestro del codice di San Giorgio e il Cardinale Jacopo Stefaneschi*. Florence, 1981.

FOLENA, G., and MELLINI, G.L. *Bibbia istoriata padovana della fine del trecento*. Vicenza, 1962.

GENGARO, M.L., and COGLIATI-ARANO, L. *Miniature lombarde dall'VIII al XIV secolo*. Milan, 1970.

HARRSEN, M., and BOYCE, G. K. *Italian Manuscripts in the Pierpont Morgan Library*. New York, 1953.

La Miniatura italiana in età romanica e gotica (Atti del I Congresso di Storia della Miniatura Italiana, Cortona, 1978). Florence, 1979.

MEISS, M., and KIRSCH, E. W. *The Visconti Hours*. London, 1972.

SALMI, M. *Italian Miniatures*. London, 1957.

TOESCA, P. *La Pittura e la miniatura nella Lombardia*. Milan, 1912.

5. Mosaics

ALPATOFF-MOSKAU, M. 'Die Entstehung des Mosaiks von Jakobus Torriti in Santa Maria Maggiore in Rom', *Jahrbuch für Kunstwissenschaft*, II (1924–5), 1 ff.

ANTHONY, E. W. *A History of Mosaics*. Boston, 1935.

CECCHELLI, C. I Mosaici della basilica di S. Maria Maggiore. Turin, 1956.

DEMUS, O. The Mosaics of S. Marco in Venice, II, The Thirteenth Century. Chicago, 1984.

HUECK, I. Das Programm der Kuppelmosaiken im florentiner Baptisterium. Mondorf/Rhein, 1962.

PONTICELLI, L. 'I Restauri ai mosaici del battistero di Firenze', Commentari, I (1950), 121 ff., 187 ff., 246 ff., and II (1951), 51 ff.

ROSSI, G. B. DE. Musaici cristiani di Roma. Rome, 1872–96.

WILPERT, J. Römische Mosaiken und Malereien. Freiburg, 1916.

WITT, A. DE. I Mosaici del battistero di Firenze. 4 vols. Florence, 1954.

WOLLESEN, J. T. 'Eine "Vor-Cavallineske" Mosaikdekoration in Sancta Sanctorum', Römische Jahrbuch für Kunstgeschichte, XVIII (1979), 11 ff.

6. Stained Glass

BRUCK, R. 'Der Tractat des Meisters Antonio da Pisa über die Glasmalerei', Repertorium für Kunstwissenschaft, XXV (1902), 240 ff.

CARLI, E. Vetrata ducciesca. Florence, 1946.

MARCHINI, G. Italian Stained Glass Windows. London, 1957.

MARCHINI, G. Le Vetrate dell' Umbria (Corpus Vitrearum Medii Aevi, Italia, I, L' Umbria). Rome, 1973.

MARCHINI, G. Primo Rinascimento in Santa Croce. Florence, 1968.

POPE-HENNESSY, J. 'An Exhibition of Sienese Stained Glass', Burlington Magazine, LXXXVIII (1946), 306.

STRAELEN, H. VAN. Studien zur florentiner Glasmalerei des Trecento und Quattrocento. Wallenschied, 1938.

WENTZEL, H. 'Die ältesten Farbfenster in der Oberkirche von San Francesco zu Assisi und die deutsche Glasmalerei des XIII. Jahrhunderts', Wallraf-Richartz Jahrbuch, XIV (1952), 45 ff.

7. Textiles

FLEMMING, E. Encyclopaedia of Textiles. London, 1958.

KLESSE, B. Die Seidenstoffe in der italienischen Malerei des 14. Jahrhunderts. Berlin, 1967.

MAGAGNATO, L. Le Stoffe di Cangrande. Verona, 1983.

SANTANGELO, A. The Development of Italian Textile Design (from the 12th to 18th Century). London, 1964.

B. INDIVIDUAL CITIES

1. Altenburg

OERTEL, R. Frühe italienische Malerei in Altenburg. Berlin, 1961.

2. Assisi

BELTING, H. Die Oberkirche von San Francesco in Assisi. Berlin, 1977.

COLETTI, L. Gli Affreschi della basilica di Assisi. Bergamo, 1949.

MAGINNIS, H. B. J. 'Assisi Revisited: Notes on Recent Observations', Burlington Magazine, CXVII (1975), 511 ff.

MAGINNIS, H. B. J. 'The Passion Cycle in the Lower Church of San Francesco, Assisi: The Technical Evidence', Zeitschrift für Kunstgeschichte, XXXIX (1976), 193 ff.

MATHER, F. J., JR. The Isaac Master. Princeton, 1932.

MEISS, M. Giotto and Assisi. New York, 1960.

SCHULTZE, J. 'Ein Dugento-Altar aus Assisi? Versuch einer Rekonstruktion', Mitteilungen des kunsthistorischen Institutes in Florenz, X (1961–3), 59 ff.

SCHULTZE, J. 'Zur Kunst des "Franziskusmeister"', Wallraf-Richartz Jahrbuch, XXV (1963), 109 ff.

SIMON, R. 'Towards a Relative Chronology of the Frescoes in the Lower Church of San Francesco at Assisi', Burlington Magazine, CXVIII (1976), 361 ff.

SMART, A. The Assisi Problem and the Art of Giotto. Oxford, 1971.

SMART, A. 'The St Cecilia Master and His School at Assisi, I, II', Burlington Magazine, CII (1960), 405 ff., 431 ff.

TANTILLO MIGNOSI, A. 'Osservazioni sul transetto della Basilica Inferiore di Assisi', Bollettino d'Arte, LX (1975), 129 ff.

TINTORI, L., and MEISS, M. The Painting of the Life of St Francis in Assisi. New York, 1962.

WENTZEL, H. 'Die ältesten Farbfenster in der Oberkirche von San Francesco zu Assisi und die deutsche Glasmalerei des XIII. Jahrhunderts', Wallraf-Richartz Jahrbuch, XIV (1952), 45 ff.

WHITE, J. 'Cimabue and Assisi: Working Methods and Art Historical Consequences', Art History, IV (1981), 355 ff.

WHITE, J., and ZANARDI, B. 'Cimabue and the Decorative Sequence in the Upper Church of S. Francesco, Assisi', in Roma Anno 1300, Atti della IV settimana di storia medievale dell' Università di Roma 'La Sapienza', 1980. Rome, 1983.

ZOCCA, E. Assisi (Catalogo delle cose d'arte e di antichità d'Italia). Rome, 1936.

3. Avignon

CASTELNUOVO, E. *Un Pittore italiano alla corte di Avignone.* Turin, 1962.
MICHEL, A. *Avignon. Les Fresques du Palais des Papes.* Paris, 1926.
PETER, A. 'Quand Simone Martini est-il venu en Avignon?', *Gazette des Beaux-Arts*, XXI (1939), 153 ff.
ROWLANDS, J. 'The Date of Simone Martini's Arrival in Avignon', *Burlington Magazine*, CVII (1965), 25 ff.

4. Bologna

CONTI, A. *La Miniatura bolognese. Scuole e botteghe 1270–1340.* Bologna, 1981.

5. Florence

ANCONA, M. L. D'. *Miniatura e miniatori a Firenze dal XIV al XVI secolo.* Florence, 1962.
ANTAL, F. *Florentine Painting and its Social Background.* London, 1948.
BERENSON, B. *Italian Pictures of the Renaissance. Florentine School.* 2 vols. London, 1963.
BOSKOVITS, M. *Pittura fiorentina alla vigilia del Rinascimento, 1370–1400.* Florence, 1975.
BRINK, J. 'Carpentry and Symmetry in Cimabue's Santa Croce Crucifix', *Burlington Magazine*, CXX (1978), 646 ff.
FINIELLO ZERVAS, D. 'The Florentine Braccio da Panna', *Architectura*, IX (1979), 6 ff.
FREMANTLE, R. *Florentine Gothic Painters from Giotto to Masaccio.* London, 1975.
GARDNER, J. 'Andrea di Bonaiuto and the Chapterhouse Frescoes in Santa Maria Novella', *Art History*, II (1979), 107 ff.
GARDNER, J. 'The Decoration of the Baroncelli Chapel', *Zeitschrift für Kunstgeschichte*, XXXIV (1971), 89 ff.
GARDNER VON TEUFEL, C. 'Ikonographie und Archäologie: das Pfingsttriptychon in der florentiner Akademie an seinem ursprünglichen Aufstellungsort', *Zeitschrift für Kunstgeschichte*, XLI (1978), 16 ff.
HUECK, I. *Das Programm der Kuppelmosaiken im florentiner Baptisterium.* Mondorf/Rhein, 1962.
HUECK, I. 'La Matricola dei pittori fiorentini prima e dopo il 1320', *Bollettino d'Arte*, LVII (1972), 114 ff.
ISERMEYER, C. A. *Rhamengleiderung und Bildfolge in der Wandmalerei bei Giotto und der florentiner Malerei des 14. Jahrhunderts.* Würzburg, 1937.
MARCHINI, G. *Primo Rinascimento in Santa Croce.* Florence, 1968.
MEISS, M. *Painting in Florence and Siena after the Black Death.* Princeton, 1951. Paperback, 1978.

OFFNER, R., and STEINWEG, K. *A Corpus of Florentine Painting.* New York, 1931–79.
OFFNER, R. *Corpus of Florentine Painting (The 14th Century Supplement). A Legacy of Attributions.* Ed. H. B. J. Maginnis. New York, 1981.
PONTICELLI, L. 'I Restauri ai mosaici del battistero di Firenze', *Commentari*, I (1950), 121 ff., 187 ff., 246 ff., and II (1951), 51 ff.
STUBBLEBINE, J. H. 'Cimabue and Duccio in Santa Maria Novella', *Pantheon*, XXXI (1973), 15 ff.
TINTORI, L., and BORSOOK, E. *Giotto: The Peruzzi Chapel.* New York, 1965.
Uffizi, Gli, Catalogo Generale. Florence, 1979.
WILKINS, D. 'Early Florentine Frescoes in Santa Maria Novella', *Art Quarterly*, N.S. I (1978), 141 ff.
WITT, A. DE. *I Mosaici del battistero di Firenze.* 4 vols. Florence, 1954.

6. Istanbul

ALPATOFF, M. 'Die Fresken der Kachrie Djami in Konstantinopel', *Münchener Jahrbuch*, N.F. VI (1929), 345 ff.
GRABAR, A. 'La Décoration des coupoles à Karye Camii — les peintures italiennes du dugento', *Jahrbuch der Österreichischen Byzantinischen Gesellschaft*, VI (1957), 111 ff.
UNDERWOOD, P. A. 'Third Preliminary Report on the Restoration of the Frescoes in the Kariye Camii at Istanbul by the Byzantine Institute', *Dumbarton Oaks Papers*, XII (1958), 237 ff.

7. Milan

GATTI-PERER, M. L. 'Appunti per l'attribuzione di un disegno della Raccolta Ferrari: Giovannino de' Grassi e il Duomo di Milano', *Arte Lombarda*, X (1965), 49 ff.

8. Naples

BERTAUX, É. *Santa Maria di Donna Regina.* Naples, 1899.
BOLOGNA, F. *I Pittori alla corte angioina di Napoli 1266–1400.* Rome, 1969.
MORISANI, O. *Pittura del trecento in Napoli.* Naples, 1947.
ROLF, S. *Geschichte der Malerei Neapels.* Leipzig, 1910.

9. Padua

ALPATOFF, M. 'The Parallelism of Giotto's Paduan Frescoes', *Art Bulletin*, XXIX (1947), 149 ff.
BETTINI, S. *Le Pitture di Giusto de' Menabuoi nel battistero del duomo di Padova.* Vicenza, 1960.
FOLENA, G., and MELLINI, G. L. *Bibbia istoriata padovana della fine del trecento.* Vicenza, 1962.

NAGY, M. VON. *Die Wandbilder der Scrovegni Kapelle zu Padua: Giottos Verhältnis zu sein Quellen.* Bern, 1962.
SCHLEGEL, U. 'Zum Bildprogramm der Arena Kapelle', *Zeitschrift für Kunstgeschichte*, XX (1957), 125 ff.
STUBBLEBINE, J. H., ed. *Giotto: The Arena Chapel Frescoes.* New York, 1969.
WHITE, J. 'Giotto's Use of Architecture in "The Expulsion of Joachim" and "The Entry into Jerusalem" at Padua', *Burlington Magazine*, CXV (1973), 439 ff.

10. Palermo

BOLOGNA, F. *Il Soffito della sala magna allo Steri di Palermo.* Palermo, 1975.

11. Pisa

ACHIARDI, P. D'. *Gli Affreschi di S. Piero a Grado presso Pisa.* Rome, 1905.
BELLOSI, L. *Buffalmacco e il Trionfo della Morte.* Turin, 1974. Reviewed, H. B. J. Maginnis, *Art Bulletin*, LVIII (1976), 126 ff.
CALECA, A., NENCINI, G., and PIANCASTELLI, G. *Pisa – Museo delle sinopie del Camposanto monumentale.* Pisa, 1979.
CARLI, E. *Pittura pisana del trecento dal Maestro di S. Torpè al Trionfo della Morte.* Milan, 1958.
CARLI, E. *Pittura pisana del trecento. La seconda metà del secolo.* Milan, 1961.
DALLI REGOLI, G. *Miniatura pisana del trecento.* Vicenza, 1963.
SANPAOLESI, P., BUCCI, M., and BERTOLINI, L. *Camposanto monumentale di Pisa.* Pisa, 1960.
WOLLESEN, J. T. *Die Fresken von San Piero a Grado bei Pisa.* Bad Oeynhausen, 1977.

12. Pomposa

SALMI, M. *L'Abbazia di Pomposa.* Rome, 1951.

13. Prato

COLE, B. 'The Interior Decoration of the Palazzo Datini in Prato', *Mitteilungen des Kunsthistorischen Institutes in Florenz*, XIII (1967–8), 61 ff.

14. Rome

ALPATOFF-MOSKAU, M. 'Die Entstehung des Mosaiks von Jacobus Torriti in Santa Maria Maggiore in Rom', *Jahrbuch für Kunstwissenschaft*, II (1924–5), 1 ff.
BUSUIOCEANU, A. 'Pietro Cavallini e la pittura romana del duecento e del trecento', *Ephemeris Dacoromana*, III (1925), 259 ff.

CECCHELLI, C. *I Mosaici della basilica di S. Maria Maggiore.* Turin, 1956.
GARBER, J. *Wirkungen des frühchristlichen Gemäldezyklen der alten Peters und Pauls Basiliken in Rom.* Berlin, 1918.
GARDNER, J. 'Pope Nicholas IV and the Decoration of Santa Maria Maggiore', *Zeitschrift für Kunstgeschichte*, XXXVI (1973), 1 ff.
GARDNER, J. 'S. Paolo fuori le mura, Nicholas III and Pietro Cavallini', *Zeitschrift für Kunstgeschichte*, XXIV (1971), 240 ff.
GARDNER, J. 'The Stefaneschi Altarpiece: A Reconstruction', *Journal of the Warburg and Courtauld Institutes*, XXXVII (1974), 57 ff.
GARRISON, E. B. 'Dating the Vatican Last Judgement Panel', *La Bibliofilia*, LXXII (1970), 121 ff.
GOSEBRUCH, M. 'Giottos Stefaneschi Altarwerk aus Alt-St Peter in Rom', *Miscellanea Bibliothecae Herzianae*, 104 ff. Munich, 1961.
PAESELER, W. 'Die römische Weltgerichtstafel im Vatikan', *Jahrbuch der Bibliotheca Herziana*, I (1938), 311 ff.
PAESELER, W. 'Giottos Navicella und ihr spätantikes Vorbild', *Römische Jahrbuch für Kunstgeschichte*, V (1941), 49 ff.
ROSSI, G. B. DE. *Musaici cristiani di Roma.* Rome, 1872–96.
WAETZHOLDT, S. *Die Kopien des 17. Jahrhunderts nach Mosaiken und Wandmalereien in Rom (Römische Forschungen der Bibliotheca Herziana, XVIII).* Vienna and Munich, 1964.
WHITE, J. 'Cavallini and the Lost Frescoes in S. Paolo', *Journal of the Warburg and Courtauld Institutes*, XIX (1956), 84 ff.
WILPERT, J. *Römische Mosaiken und Malereien.* 4 vols. Freiburg, 1916.
WOLLESEN, J. T. 'Eine "Vor-Cavallineske" Mosaikdekoration in Sancta Sanctorum', *Römische Jahrbuch für Kunstgeschichte*, XVIII (1979), 11 ff.

15. Siena

BRANDI, C. 'Chiaramenti sul "Buon Governo" di Ambrogio Lorenzetti', *Bollettino d'Arte*, XI (1955), 119 ff.
BRANDI, C. 'Il Restauro della Madonna di Coppo di Marcovaldo nella chiesa dei Servi di Siena', *Bollettino d'Arte*, XXXV (1950), 160 ff.
BRANDI, C. *Il Restauro della Maestà di Duccio.* Rome, 1959.
BRANDI, C. 'Relazione sul restauro della Madonna di Guido da Siena del 1221', *Bollettino d'Arte*, XXXVI (1951), 248 ff.
CANNON, J. 'Simone Martini, the Dominicans and the Early Sienese Polyptych', *Journal of the Warburg and Courtauld Institutes*, XLV (1982), 69 ff.

CARLI, E. *La Pittura senese*. Milan, 1955.

CARLI, E. *Le Tavolette di Biccherna e di altri uffici dello stato di Siena*. Florence, 1950.

CARLI, E. *Vetrata ducciesca*. Florence, 1946.

CECCHI, E. *Trecentisti senesi*. Milan, 1948.

COLE, B. *Sienese Painting from its Origins to the Fifteenth Century*. New York, 1980.

COLETTI, L. *I Primitivi*, II, *I senesi e i giotteschi*. Novara, 1946.

EDGELL, G. H. *A History of Sienese Painting*. New York, 1932.

FEHM, S. A., JR. 'Notes on the Statutes of the Sienese Painters' Guild 1356–89', *Art Bulletin*, LIV (1972), 198 ff.

FELDGES-HENNING, U. *Landschaft als topografisches Porträt. Der Wiederbeginn der europäischen Landschaftsmalerei in Siena*. Bern, 1980.

FELDGES-HENNING, U. 'The Pictorial Programme of the Sala della Pace', *Journal of the Warburg and Courtauld Institutes*, XXXV (1972), 145 ff.

GARDNER, J. 'Guido da Siena, 1221, and Tommaso da Modena', *Burlington Magazine*, CXXI (1979), 107 ff.

GARRISON, E. B. 'Sienese Historical Writings and the Dates 1260, 1221, and 1262 Applied to Sienese Paintings', *Studies in the History of Mediaeval Italian Painting*, IV (1960–2), 23 ff.

GARRISON, E. B. 'Toward a New History of the Siena Cathedral Madonnas', *Studies in the History of Mediaeval Italian Painting*, IV (1960–2), 5 ff.

LISINI, A. *Le Tavolette dipinte di Biccherna e di Gabella del R. Archivio di Stato*. Siena, 1901.

MAGINNIS, H. B. J. 'The Literature on Sienese Trecento Painting, 1945–75', *Zeitschrift für Kunstgeschichte*, XL (1977), 276 ff.

MEISS, M. *Painting in Florence and Siena after the Black Death*. Princeton, 1951. Paperback, 1978.

OFFNER, R. 'Guido da Siena and A.D. 1221', *Gazette des Beaux-Arts*, XXXVII (1950), 61 ff.

OS, H. VAN. *Marias Demut und Verherrlichung in der sienesischen Malerei*. s'Gravenhage, 1969.

OS, H. VAN. *Sienese Altarpieces 1215–1460*, I, *1215–1344*. Groningen, 1984.

OS, H. VAN. *Sienese Paintings in Holland*. Utrecht, 1969.

OS, H. VAN. 'The Black Death and Sienese Painting: A Problem of Interpretation', *Art History*, IV (1981), 237 ff.

POPE-HENNESSY, J. 'An Exhibition of Sienese Stained Glass', *Burlington Magazine*, LXXXVIII (1946), 306.

RUBINSTEIN, N. 'Political Ideas in Sienese Art: The Frescoes by Ambrogio Lorenzetti and Taddeo di Bartolo in the Palazzo Pubblico', *Journal of the Warburg and Courtauld Institutes*, XXI (1958), 179 ff.

SANDBERG-VAVALÀ, E. *Sienese Studies. The Development of the School of Painting of Siena*. Florence, 1953.

SHAPIRO, M. L. 'The Virtues and Vices in Ambrogio Lorenzetti's Franciscan Martyrdom', *Art Bulletin*, XLVI (1964), 367 ff.

SOUTHARD, E. C. *The Frescoes in Siena's Palazzo Pubblico, 1289–1539*. New York and London, 1979.

STUBBLEBINE, J. H. 'Byzantine Sources for the Iconography of Duccio's Maestà', *Art Bulletin*, LVII (1975), 176 ff.

STUBBLEBINE, J. H. 'Cimabue and Duccio in Santa Maria Novella', *Pantheon*, XXXI (1973), 15 ff.

STUBBLEBINE, J. H. 'Duccio and his Collaborators on the Cathedral Maestà', *Art Bulletin*, LV (1973), 185 ff.

STUBBLEBINE, J. H. 'Duccio's Maestà of 1302 for the Chapel of the Nove', *Art Quarterly*, XXXV (1972), 239 ff.

STUBBLEBINE, J. H. 'The Angel Pinnacles on Duccio's Maestà', *Art Quarterly*, XXIX (1969), 131 ff.

STUBBLEBINE, J. H. 'The Back Predella of Duccio's Maestà', in *Studies in Late Medieval and Renaissance Painting in Honour of Millard Meiss*, 430 ff. New York, 1977.

SULLIVAN, R. W. 'The Anointing in Bethany and Other Affirmations of Christ's Divinity on Duccio's Back Predella', *Art Bulletin*, LXVII (1985), 33 ff.

TORRITI, P. *La Pinacoteca Nazionale di Siena. I Dipinti dal XII al XV secolo*. Genoa, 1980.

WEIGELT, C. H. *Sienese Painting of the Trecento*. New York, 1930.

WHITE, J. 'Measurement, Design and Carpentry in Duccio's Maestà, I, II', *Art Bulletin*, LV (1973), 332 ff., 547 ff.

16. Venice

BERENSON, B. *Italian Painters of the Renaissance. Venetian School*. 2 vols. London, 1958.

DEGENHART, B., and SCHMITT, A. *Corpus der italienischen Zeichnungen 1300–1450. Venedig. Adden. zu Süd etc.* 4 vols. Berlin, 1982.

DEMUS, O. *The Mosaics of S. Marco in Venice*, II, *The Thirteenth Century*. Chicago, 1984.

PALLUCCHINI, R. *La Pittura veneziana del trecento*. Venice and Rome, 1964.

TESTI, L. *La Storia della pittura veneziana*. Bergamo, 1909.

C. INDIVIDUAL PAINTERS

ALTICHIERO

Kruft, H. W. *Altichiero und Avanzo*. Bonn, 1966.

Mellini, G. L. *Altichiero e Jacopo Avanzi*. Milan, 1965.
Sartori, A. 'Note su Altichiero', *Il Santo*, III, 3 (1963), 291 ff.

ANDREA DA FIRENZE (DI BONAIUTO)
Gardner, J. 'Andrea di Bonaiuto and the Chapterhouse Frescoes in Santa Maria Novella', *Art History*, 11 (1979), 107 ff.

BARNA DA SIENA
Faison, S. L., Jr. 'Barna and Bartolo di Fredi', *Art Bulletin*, XIV (1932), 285 ff.
Ventroni, D. *Barna da Siena*. Pisa, 1972.

BARTOLO DI FREDI
Faison, S. L., Jr. 'Barna and Bartolo di Fredi', *Art Bulletin*, XIV (1932), 285 ff.
Os, H. W. van. 'Tradition and Innovation in Some Altarpieces by Bartolo di Fredi', *Art Bulletin*, LXVII (1985), 50 ff.

BUFFALMACCO
Bellosi, L. *Buffalmacco e il Trionfo della Morte*. Turin, 1974. Reviewed, H. B. J. Maginnis, *Art Bulletin*, LVIII (1976), 126 ff.

CAVALLINI
Busuioceanu, A. 'Pietro Cavallini e la pittura romana del duecento e del trecento', *Ephemeris Dacoromana*, III (1925), 259 ff.
Gardner, J. 'S. Paolo fuori le mura, Nicholas III and Pietro Cavallini', *Zeitschrift für Kunstgeschichte*, XXIV (1971), 240 ff.
Hetherington, P. *Pietro Cavallini*. Isleworth, 1979.
Lavagnino, E. *Pietro Cavallini*. Rome, 1943.
Matthiae, G. *Pietro Cavallini*. Rome, 1972.
Sindona, E. *Pietro Cavallini*. Milan, 1958.
White, J. 'Cavallini and the Lost Frescoes in S. Paolo', *Journal of the Warburg and Courtauld Institutes*, XIX (1956), 84 ff.

CIMABUE
Battisti, E. *Cimabue*, New York, 1967.
Brink, J. 'Carpentry and Symmetry in Cimabue's Santa Croce Crucifix', *Burlington Magazine*, CXX (1978), 646 ff.
Brink, J. 'Measure and Proportion in the Monumental Gabled Altarpieces of Duccio, Cimabue and Giotto', *Canadian Art Review*, IV (1977), 69 ff.
Nicholson, A. *Cimabue*. Princeton, 1932.
Salvini, R. 'Postilla a Cimabue', *Rivista d'Arte*, XXVI (1950), 43 ff.
Sindona, E. *L'Opera completa di Cimabue*. Milan, 1975.

Stubblebine, J. H. 'Cimabue and Duccio in Santa Maria Novella', *Pantheon*, XXXI (1973), 15 ff.
White, J. 'Cimabue and Assisi: Working Methods and Art Historical Consequences', *Art History*, IV (1981), 355 ff.
White, J., and Zanardi, B. 'Cimabue and the Decorative Sequence in the Upper Church of S. Francesco, Assisi', in *Roma Anno 1300. Atti della IV settimana di storia medievale dell' Unversità di Roma 'La Sapienza', 1980*. Rome, 1983.

COPPO DI MARCOVALDO
Brandi, C. 'Il Restauro della Madonna di Coppo di Marcovaldo nella chiesa dei Servi di Siena', *Bolletino d'Arte*, XXXV (1950), 160 ff.
Coor, G. 'Coppo di Marcovaldo, His Art in Relation to the Art of His Time', *Marsyas*, V (1947–9), 1 ff.
Coor-Achenbach, G. 'A Visual Basis for the Documents Relating to Coppo di Marcovaldo and His Son Salerno', *Art Bulletin*, XXVIII (1946), 233 ff.

DUCCIO
Brandi, C. *Duccio*. Florence, 1951.
Brandi, C. *Il Restauro della Maestà di Duccio*. Rome, 1959.
Brink, J. 'Measure and Proportion in the Monumental Gabled Altarpieces of Duccio, Cimabue and Giotto', *Canadian Art Review*, IV (1977), 69 ff.
Carli, E. *Duccio di Buoninsegna*. Milan, 1961.
Carli, E. *Vetrata ducciesca*. Florence, 1946.
Cattaneo, G., and Baccheschi, E. *L'Opera completa di Duccio*. Milan, 1972.
Deuchler, F. *Duccio*. Milan, 1984.
Stoichiţă, V. I. *Ucenicia Lui Duccio di Buoninsegna*. Bucharest, 1976.
Stubblebine, J. H. 'Byzantine Sources for the Iconography of Duccio's Maestà', *Art Bulletin*, LVII (1975), 176 ff.
Stubblebine, J. H. 'Cimabue and Duccio in Santa Maria Novella', *Pantheon*, XXXI (1973), 15 ff.
Stubblebine, J. H. 'Duccio and His Collaborators on the Cathedral Maestà', *Art Bulletin*, LV (1973), 185 ff.
Stubblebine, J. H. *Duccio di Buoninsegna and His School*. Princeton, 1979.
Stubblebine, J. H. 'Duccio's Maestà of 1302 for the Chapel of the Nove', *Art Quarterly*, XXXV (1972), 239 ff.
Stubblebine, J. H. 'The Angel Pinnacles on Duccio's Maestà', *Art Quarterly*, XXIX (1969), 131 ff.
Stubblebine, J. H. 'The Back Predella of Duccio's Maestà', in *Studies in Late Medieval and Renaissance Painting in Honour of Millard Meiss*, 430 ff. New York, 1977.

Stubblebine, J. H. 'The Role of Segna di Bonaventura in the Shop of Duccio', *Pantheon*, XXX (1972), 272 ff.

Sullivan, R. W. 'The Anointing in Bethany and Other Affirmations of Christ's Divinity on Duccio's Back Predella', *Art Bulletin*, LXVII (1985), 33 ff.

Weigelt, C. H. *Duccio di Buoninsegna*, Leipzig, 1911.

White, J. 'Carpentry and Design in Duccio's Workshop', *Journal of the Warburg and Courtauld Institutes*, XXXVI (1970), 92 ff.

White, J. *Duccio*. London, 1979.

White, J. 'Measurement, Design and Carpentry in Duccio's Maestà, I, II', *Art Bulletin*, LV (1973), 332 ff., 547 ff.

GADDI, Agnolo

Cole, B. *Agnolo Gaddi*. Oxford, 1977.

Salvini, E. *L'Arte di Agnolo Gaddi*. Florence, 1936.

GADDI, Taddeo

Gardner, J. 'The Decoration of the Baroncelli Chapel', *Zeitschrift für Kunstgeschichte*, XXXIV (1971), 89 ff.

Ladis, A. *Taddeo Gaddi*. Columbia and London, 1982.

Maione, I. 'Fra Simone Fidate e Taddeo Gaddi', *L'Arte*, XVII (1914), 107 ff.

GIOTTO

Alpatoff, M. 'The Parallelism of Giotto's Paduan Frescoes', *Art Bulletin*, XXIX (1947), 149 ff.

Brink, J. 'Measure and Proportion in the Monumental Gabled Altarpieces of Duccio, Cimabue, and Giotto', *Canadian Art Review*, IV (1977), 69 ff.

Cole, B. *Giotto and Florentine Painting*. New York, etc., 1976.

Gardner, J. 'The Stefaneschi Altarpiece: A Reconsideration', *Journal of the Warburg and Courtauld Institutes*, XXXVII (1974), 57 ff.

Gioseffi, D. *Giotto architetto*. Milan, 1963.

Giotto e il suo tempo (Atti del congresso internazionale per la celebrazione del VII centenario della nascita di Giotto, 1967). Rome, 1971.

Gnudi, C. *Giotto*. Milan, 1959.

Gnudi, C. 'Il Passo di Riccobaldo Ferrarese e il problema della sua autenticità', *Studies in the History of Art dedicated to W. Suida*, 26 ff. London, 1959.

Gnudi, C. 'Su gli inizi di Giotto e i suoi rapporti col mondo gotico', in *Giotto e il suo tempo*, 3 ff. Rome, 1971.

Gosebruch, M. 'Giottos Stefaneschi Altarwerk aus Alt-St Peter in Rom', *Miscellanea Bibliothecae Herzianae*, 104 ff. Munich, 1961.

Gosebruch, M. *Giotto und die Entwicklung des neuzeitlichen Kunstbewusstseins*. Cologne, 1969.

Gy-Wilde, J. 'Giotto Studies', *Wiener Jahrbuch für Kunstgeschichte*, VII (1930), 46 ff.

Hetzer, T. *Giotto*. Frankfurt am Main, 1941.

Hueck, I. 'Das Datum des Nekrologs für Kardinal Stefaneschi in Martyrologium der vatikanischen Basilika', *Mitteilungen des kunsthistorischen Institutes in Florenz*, XXI (1977), 219 ff.

Hueck, I. 'Zu Enrico Scrovegnis Veränderungen der Arenakapelle', *Mitteilungen des kunsthistorischen Institutes in Florenz*, XVII (1973), 277 ff.

Isermeyer, C. A. *Rhamengleiderung und Bildfolge in der Wandmalerei bei Giotto und der florentiner Malerei des 14. Jahrhunderts*. Würzburg, 1937.

Jantzen, H. 'Giotto und der gotische Stil', in *Über der gotische Kirchenraum und andere Aufsatz*, 30 ff. Berlin, 1951.

Kreytenberg, G. 'Der Campanile von Giotto', *Mitteilungen des kunsthistorischen Institutes in Florenz*, XXII (1978), 147 ff.

Martindale, A., and Bacceschi, E. *The Complete Works of Giotto*. London, 1969.

Meiss, M. *Giotto and Assisi*. New York, 1960.

Murray, P. 'Notes on Some Early Giotto Sources', *Journal of the Warburg and Courtauld Institutes*, XVI (1953), 58 ff.

Murray, P. 'On the Date of Giotto's Birth', in *Giotto e il suo tempo*, 25 ff. Rome, 1971.

Nagy, M. von. *Die Wandbilder der Scrovegni Kapelle zu Padua: Giottos Verhältnis zu sein Quellen*. Bern, 1962.

Oertel, R. 'Wende der Giotto-Forschung', *Zeitschrift für Kunstgeschichte*, 11 (1943–4), 1 ff.

Offner, R. 'Giotto, Non-Giotto, I, II', *Burlington Magazine*, LXXIV (1939), 259 ff.

Olson, R. J. M. 'Giotto's Portrait of Halley's Comet', *Scientific American* (1979), 160 ff.

Paeseler, W. 'Giottos Navicella und ihr spätantikes Vorbild', *Römische Jahrbuch für Kunstgeschichte*, V (1941), 49 ff.

Pešina, J. *Tektonický Prostor a Architektura u Giotto*. Prague, 1945.

Previtali, G. *Giotto e la sua bottega*. Milan, 1974.

Rintelen, F. *Giotto und die Giotto-Apokryphen*. Basel, 1923.

Salvini, R. *Giotto. Bibliografia, I, II*. Rome, 1938/73.

Schlegel, U. 'Zum Bildprogramm der Arena Kapelle', *Zeitschrift für Kunstgeschichte*, XX (1957), 125 ff.

Schneider, L., ed. *Giotto in Perspective*. Englewood Cliffs, 1974.

Skaug, E. 'Contributions to Giotto's Workshop', *Mitteilungen des kunsthistorischen Institutes in Florenz*, XV (1971), 141 ff.

Smart, A. *The Assisi Problem and the Art of Giotto.* Oxford, 1971.

Stubblebine, J. H., ed. *Giotto: The Arena Chapel Frescoes.* New York, 1969.

Tintori, L., and Borsook, E. *Giotto: The Peruzzi Chapel.* New York, 1965.

Weigelt, C. H. *Giotto.* Stuttgart, 1925.

White, J. 'Giotto's Use of Architecture in "The Expulsion of Joachim" and "The Entry into Jerusalem" at Padua', *Burlington Magazine,* CXV (1973), 439 ff.

GIOVANETTI DA VITERBO

Castelnuovo, E. *Un Pittore italiano alla corte di Avignone.* Turin, 1962.

GIOVANNI DA MILANO

Marabottini, A. *Giovanni da Milano.* Florence, 1950.

GIUNTA PISANO

Campini, D. *Giunta Pisano e le croci dipinte romaniche.* Milan, 1966.

GIUSTO DE' MENABUOI

Bettini, S. *Giusto de' Menabuoi e l'arte del trecento.* Padua, 1944.

Bettini, S. *Le Pitture di Giusto de' Menabuoi nel battistero del duomo di Padova.* Vicenza, 1960.

Delaney, B. J. 'Giusto de' Menabuoi in Lombardy', *Art Bulletin,* LVIII (1976), 19 ff.

GUARIENTO DI ARPO

D'Arcais, F. F. *Guariento.* Venice, 1980.

Hutter, H. 'Das Polyptychon der Sammlung Czernin', *Jahrbuch der Wiener Kunstsammlungen,* LX (1964), 35 ff.

White, J. 'The Reconstruction of the Polyptych ascribed to Guariento in the Collection of the Norton Simon Foundation', *Burlington Magazine,* CXVII (1975), 517 ff.

GUIDO DA SIENA

Brandi, C. 'Relazione sul restauro della Madonna di Guido da Siena del 1221', *Bollettino d'Arte,* XXXVI (1951), 248 ff.

Gardner, J. 'Guido da Siena, 1221, and Tommaso da Modena', *Burlington Magazine,* CXXI (1979), 107 ff.

Offner, R. 'Guido da Siena and A.D. 1221', *Gazette des Beaux-Arts,* XXXVII (1950), 61 ff.

Sandberg-Vavalà, E. 'The Madonnas of Guido da Siena', *Burlington Magazine,* LXIV (1934), 254 ff.

Stubblebine, J. H. *Guido da Siena.* Princeton, 1964.

ISAAC MASTER

Mather, F. J., Jr. *The Isaac Master.* Princeton, 1932.

LORENZETTI, Ambrogio

Borsook, E. 'The Frescoes at San Leonardo al Lago', *Burlington Magazine,* XCVIII (1956), 351 ff.

Brandi, C. 'Chiaramenti sul "Buon Governo" di Ambrogio Lorenzetti', *Bollettino d'Arte,* XI (1955), 119 ff.

Feldges-Henning, U. 'The Pictorial Programme of the Sala della Pace: A New Interpretation', *Journal of the Warburg and Courtauld Institutes,* XXXV (1972), 145 ff.

Muller, N. E. 'Ambrogio Lorenzetti's Annunciation. A Re-examination', *Mitteilungen des kunsthistorischen Institutes in Florenz,* XXI (1977), 1 ff.

Rowley, G. *Ambrogio Lorenzetti.* Princeton, 1958.

Rubinstein, N. 'Political Ideas in Sienese Art: The Frescoes by Ambrogio Lorenzetti and Taddeo di Bartolo in the Palazzo Pubblico', *Journal of the Warburg and Courtauld Institutes,* XXI (1958), 179 ff.

Shapiro, M. L. 'The Virtues and Vices in Ambrogio Lorenzetti's Franciscan Martyrdom', *Art Bulletin,* XLVI (1964), 367 ff.

Sinibaldi, G. *I Lorenzetti.* Siena, 1933.

Wainwright, V. 'The Will of Ambrogio Lorenzetti', *Burlington Magazine,* XCVII (1975), 543 ff.

LORENZETTI, Pietro

Maginnis, H. B. J. 'Pietro Lorenzetti: A Chronology', *Art Bulletin,* LVI (1984), 184 ff.

Maginnis, H. B. J. 'Pietro Lorenzetti's Carmelite Madonna: A Reconstruction', *Pantheon,* XXXIII (1975), 10 ff.

Seidel, M. 'Das Frühwerk von Pietro Lorenzetti', *Städel-Jahrbuch,* VIII (1981), 79 ff.

Sinibaldi, G. *I Lorenzetti.* Siena, 1933.

Wald, E. T. de. *Pietro Lorenzetti.* Cambridge, Mass., 1930.

MARTINI, Simone

Brink, J. 'Simone Martini, Francesco Petrarca and the Humanistic Program of the *Virgil Frontispiece*', *Mediaevalia,* III (1977), 83 ff.

Cannon, J. 'Simone Martini, the Dominicans and the Early Sienese Polyptych', *Journal of the Warburg and Courtauld Institutes,* XLV (1982), 69 ff.

Contini, G., and Gozzoli, M. C. *L'Opera completa di Simone Martini.* Milan, 1970.

Degenhart, B. 'Das Marienwunder von Avignon. Simone Martinis Miniaturen für Kardinal Stefaneschi und Petrarca', *Pantheon,* XXXIII (1975), 191 ff.

Denny, D. 'Simone Martini's "The Holy Family"', *Journal of the Warburg and Courtauld Institutes*, XXX (1967), 138 ff.

Gardner, J. 'Saint Louis of Toulouse, Robert of Anjou and Simone Martini', *Zeitschrift für Kunstgeschichte*, XCIII (1976), 12 ff.

Paccagnini, G. *Simone Martini*. London, 1957.

Peter, A. 'Quand Simone Martini est-il venu en Avignon?', *Gazette des Beaux-Arts*, XXI (1939), 153 ff.

Rowlands, J. 'The Date of Simone Martini's Arrival in Avignon', *Burlington Magazine*, CVII (1965), 25 ff.

MEMMI, Lippo
Meiss, M. 'Notes on a Dated Diptych by Lippo Memmi', in *Scritti in Onore di Ugo Procacci*, 137 ff. Milan, 1977.

NARDO DI CIONE
Gronau, H. *Andrea Orcagna und Nardo di Cione: ein kunstgeschichtliche Untersuchung*. Berlin, 1937.

ORCAGNA
Steinweg, K. *Andrea Orcagna: Quellengeschichtliche und stilkritische Untersuchung*. Strassburg, 1929. *See also* NARDO DI CIONE.

PAOLO VENEZIANO
Muraro, M. *Paolo da Venezia*. Milan, 1969. London and Pennsylvania, 1970.

SPINELLO ARETINO
Fehm, S. A., Jr. 'Notes on Spinello Aretino's So-Called Monte Oliveto Altarpiece', *Mitteilungen des kunsthistorischen Institutes in Florenz*, XVII (1973), 257 ff.

Gombosi, G. *Spinello Aretino*. Budapest, 1926.

TADDEO DI BARTOLO
Rubinstein, N. *See* LORENZETTI, Ambrogio.

TOMMASO DA MODENA
Coletti, L. *Tomaso da Modena*. Venice, 1963.

Gardner, J. 'Guido da Siena, 1221, and Tommaso da Modena', *Burlington Magazine*, CXXI (1979), 107 ff.

Gibbs, R. *L'Occhio di Tomaso*. Treviso, 1981.

Menegazzi, L. *Tomaso da Modena*. Treviso, 1979. *Tomaso da Modena e il suo tempo (Atti del convegno internazionale, Treviso, 1979)*. Treviso, 1980.

TORRITI
Alpatoff-Moskau, M. 'Die Entstehung des Mosaiks von Jakobus Torriti in Santa Maria Maggiore in Rom', *Jahrbuch für Kunstwissenschaft*, 11 (1924–5), 1 ff.

Bertos, R. *Jacopo Torriti*. Munich, 1963.

TRAINI
Meiss, M. 'The Problem of Francesco Traini', *Art Bulletin*, XV (1933), 97 ff.

UGOLINO DA SIENA
Coor-Achenbach, G. 'Contributions to the Study of Ugolino di Nerio's Art', *Art Bulletin*, XXXVII (1955), 153 ff.

Davies, M. 'Ugolino: Some Observations', *Mitteilungen des kunsthistorischen Institutes in Florenz*, XVII (1973), 249 ff.

VITALE DA BOLOGNA
Gnudi, C. *Vitale da Bologna*. Bologna, 1962.

IV. SCULPTURE AND ASSOCIATED ARTS

A. GENERAL

1. General Works

CRICHTON, G. H. *Romanesque Sculpture in Italy*. Cambridge, 1938.

POPE-HENNESSY, J. *Italian Gothic Sculpture*. 2nd ed. London and New York, 1972.

SHELBY, L. R. *Gothic Design Techniques: The Fifteenth Century Design Booklets of Mathes Roriczer and Hans Schmuttermayer*. Carbondale, 1977.

2. Special Subjects

BAUCH, K. 'Anfänge des figürlichen Grabmals in Italien', *Mitteilungen des kunsthistorischen Institutes in Florenz*, XV (1971), 227 ff.

CARLI, E. *La Scultura lignea italiana*. Milan, 1960.

FRANCOVITCH, G. DE. 'L'Origine e la diffusione del crocifisso gotico doloroso', *Jahrbuch der Bibliotheca Herziana*, II (1938), 139 ff.

KELLER, H. 'Die Entstehung des Bildnisses am Ende des Hochmittelalters', *Jahrbuch des Bibliotheca Herziana*, III (1939), 227 ff.

KOECHLIN, R. *Les Ivoires gothiques français*. Paris, 1924.

ROSSI, F. *Italian Jewelled Arts*. London, 1957.

WEINBERGER, M. 'Remarks on the Role of French Models within the Evolution of Gothic Tuscan Sculpture', *Acts of the Twentieth International Congress of the History of Art (New York, 1961)*, 198 ff. Princeton, 1963.

3. Regions

BARONI, C. Scultura gotica lombarda. Milan, 1944.
GARZELLI, A. Sculture toscane nel dugento e nel trecento. Florence, 1969.
GLASS, D. 'Romanesque Sculpture in Campania and Sicilia: A Problem of Method', Art Bulletin, LVI (1974), 315 ff.
KREYTENBERG, G. Andrea Pisano und die toskanischen Skulpture des 14. Jahrhunderts. Munich, 1984.
LISNER, M. Holzkruzifixe in Florenz und in der Toskana. Munich, 1970.
WUNDRAM, M. 'Toskanische Plastik von 1250–1400', Zeitschrift für Kunstgeschichte, XXI (1958), 243 ff.

B. INDIVIDUAL CITIES

1. Bologna

GRANDI, R. I Monumenti dei dottori e la scultura a Bologna (1267–1348). Bologna, 1982.

2. Capua

WILLEMSEN, C. A. Kaiser Friedrichs II. Triumphtor zu Capua. Wiesbaden, 1953.

3. Florence

BECHERUCCI, L., and BRUNETTI, G. Il Museo dell'Opera del Duomo. 2 vols. Milan, 1969–71.
FALK, I., and LANYI, J. 'The Genesis of Andrea Pisano's Bronze Doors', Art Bulletin, XXV (1943), 132 ff.
FINIELLO-ZERVAS, D. 'The Trattato dell'Abbaco and Andrea Pisano's Design for the Florentine Baptistery Door', Renaissance Quarterly, XXVIII (1975), 483 ff.
KREYTENBERG, G. 'Tino di Camainos Grabmäler in Florenz', Städel-Jahrbuch, N.F. VII (1979), 33 ff.
KREYTENBERG, G. 'Zu Andrea Pisanos Türe am florentiner Baptisterium', Das Münster, XXVIII (1975), 220 ff.
LISNER, M. Holzkruzifixe in Florenz und in der Toskana. Munich, 1970.
MOSKOWITZ, A. F. 'Osservazioni sulla porta del battistero di Andrea Pisano', Antichità Viva, XX (1981), 28 ff.
WEINBERGER, M. 'The First Façade of the Cathedral of Florence', Journal of the Warburg and Courtauld Institutes, IV (1940–1), 67 ff.
WUNDRAM, M. 'Jacopo di Piero Guidi', Mitteilungen des kunsthistorischen Institutes in Florenz, XIII (1967–8), 195 ff.
WUNDRAM, M. 'Niccolò di Pietro Lamberti und die florentiner Plastik um 1400', Jahrbuch der Berliner Museen, IV (1962), 78 ff.

4. Lucca

POLZER, J. 'The Lucca Reliefs and Nicola Pisano', Art Bulletin, XLVI (1964), 211 ff.

5. Milan

NEBBIA, U. La Scultura nel duomo di Milano. Milan, 1905.
VENTURINO AUCE, P. 'La Tomba di S. Pietro Martire e la Cappella Portinari in S. Eustorgio di Milano', Memorie Dominicane, LXIX (1952), 3 ff.

6. Naples

MORISANI, O. Tino di Camaino a Napoli. Naples, 1945.
MORMONE, R. Sculture trecentesche in S. Lorenzo Maggiore a Napoli. Naples, 1977.

7. Orvieto

CARLI, E. Le Sculture del duomo di Orvieto. Bergamo, 1947.
FRANCOVITCH, G. DE. 'Lorenzo Maitani scultore e i bassorilievi della facciata del duomo di Orvieto', Bollettino d'Arte, VII (1927–8), 339 ff.
TAYLOR, M. D. 'The Prophetic Scenes in the Tree of Jesse at Orvieto', Art Bulletin, LIV (1972), 402 ff.
WHITE, J. 'The Reliefs on the Façade of the Duomo at Orvieto', Journal of the Warburg and Courtauld Institutes, XXII (1959), 254 ff.

8. Perugia

FASOLA, G. N. La Fontana di Perugia. Rome, 1951.
FASOLA, N. 'La Fontana di Arnolfo', Commentari, II (1951), 98 ff.
HOFFMANN-CURTIUS, K. Das Programm der Fontana Maggiore in Perugia. Düsseldorf, 1968.
WHITE, J. 'The Reconstruction of Nicola Pisano's Perugia Fountain', Journal of the Warburg and Courtauld Institutes, XXXIII (1970), 70 ff.

9. Pisa

ANGIOLA, E. M. 'Nicola Pisano, Federigo Visconti and the Classical Style in Pisa', Art Bulletin, LIX (1977), 1 ff.
ARIAS, P. E., and SETTIS, S. Camposanto monumentale di Pisa, Le Antichità, I (Pisa, 1977), II (Modena, 1984).
BACCI, P. La Ricostruzione del pergamo di Giovanni Pisano nel duomo di Pisa. Milan, 1926.
BACCI, P. 'Le Sculture decorative della facciata del Camposanto di Pisa', Dedalo, I (1920), 311 ff.
BARSOTTI, R. 'Nuovi Studi sulla Madonna eburnea di Giovanni Pisano', Critica d'Arte, XIX (1957), 47 ff.

BECHERUCCI, L. 'La Bottega pisana di Andrea da Pontadera', *Mitteilungen des kunsthistorischen Institutes in Florenz*, XI (1963–5), 227 ff.

JASZAI, G. *Die pisaner Domkanzel*. Munich, 1968.

KOSEGARTEN, A. 'Die Skulpturen der Pisani am Baptisterium von Pisa', *Jahrbuch der Berliner Museen*, X (1968), 14 ff.

SEIDEL, M. 'Die Elfenbeinmadonna im Domschatz zu Pisa', *Mitteilungen des kuntshistorischen Institutes in Florenz*, XVI (1972), 1 ff.

SEIDEL, M. 'Die Skulpturen des Giovanni di Balduccio aus S. Caterina in Pisa', *Städel-Jahrbuch*, N.F. VII (1979), 13 ff.

SEIDEL, M. 'Skulpturen am Aussenbau von S. Maria della Spina in Pisa', *Mitteilungen des kunsthistorischen Institutes in Florenz*, XVI (1972), 269 ff.

10. Pistoia

RAGGHIANTI, C. 'Aenigmata Pistoriensia, I, II', *Critica d'Arte*, I (1954), 423 ff., II (1955), 102 ff.

STEINGRABER, E. 'The Pistoia Silver Altar: A Reexamination', *Connoisseur*, CXXXIII (1956), 148 ff.

11. Rome

BEARZI, B. 'Esame technologico e metallurgico della statua di S. Pietro', *Commentari*, XI (1960), 30 ff.

GARDNER, J. 'Arnolfo di Cambio and Roman Tomb Design', *Burlington Magazine*, CXV (1973), 420 ff.

GARDNER, J. 'The Tomb of Cardinal Annibaldi by Arnolfo di Cambio', *Burlington Magazine*, CXIV (1972), 136 ff.

MESSERER, W. 'Zur Rekonstruktion von Arnolfo di Cambios Praesepe-Gruppe', *Römische Jahrbuch für Kunstgeschichte*, XV (1975), 25 ff.

SALMI, M. 'Il Problema della statua bronzea di S. Pietro nella Basilica Vaticana', *Commentari*, XI (1960), 22 ff.

12. Siena

BACCI, P. 'Continuazione del capitolo inedito su Giovanni Pisano e il duomo di Siena', *Le Arti*, IV (1941–2), 268 ff.

CARLI, E. *Il pulpito di Siena*. Bergamo, 1943.

CARLI, E. *Sculture del Duomo di Siena*. Turin, 1941.

GARZELLI, A. 'Problemi di scultura gotica senese', *Critica d'Arte*, XIII (1966); Heft 78, 17 ff.; Heft 79, 17 ff.; XIV (1967); Heft 88, 36 ff.; Heft 89, 22 ff.

KELLER, H. 'Die Bauplastik des sieneser Doms', *Jahrbuch der Bibliotheca Herziana*, I (1937), 139 ff.

MIDDELDORF-KOSEGARTEN, A. *Sienesische Bildhauer am Duomo Vecchio*. Munich, 1984.

POESCHKE, J. *Die sieneser Domkanzel des Nicola Pisano*. Berlin and New York, 1973.

SEIDEL, M. 'Der Verkundigungsgruppe der sieneser Domkanzel', *Münchener Jahrbuch der bildenden Kunst*, XXI (1970), 19 ff.

SEIDEL, M. 'Die Rankensäulen der sieneser Domfassade', *Jahrbuch der Berliner Museen*, XI (1969), 81 ff.

13. Venice

KRAUTHEIMER, R. 'Zur venezianischen Trecento-Plastik', *Marburger Jahrbuch für Kunstwissenschaft*, V (1929), 193 ff.

SCHLOSSER, J. VON. 'Die Werkstatt der Embriachi in Venedig', *Jahrbuch der kunsthistorische Sammlungen des allerhöchsten Kaiserhauses*, XX (1899), 220 ff.

VOLBACH, W. F. *Il Tesoro di San Marco*, I, *La Pala d'oro*. Florence, 1965.

WOLTERS, W. *La Scultura veneziana gotica (1300–1400)*. Venice, 1976.

14. Verona

MAFFEI, F. DE. *Le Arche scaligere di Verona*. Verona, n.d.

C. INDIVIDUAL SCULPTORS

ANDREA PISANO

Becherucci, L. 'La Bottega pisana di Andrea da Pontadera', *Mitteilungen des kunsthistorischen Institutes in Florenz*, XI (1963–5), 227 ff.

Falk, I. *Studien zu Andrea Pisano*. Hamburg, 1940.

Falk, I., and Lanyi, J. 'The Genesis of Andrea Pisano's Bronze Doors', *Art Bulletin*, XXV (1943), 132 ff.

Finiello-Zervas, D. 'The Trattato dell'Abbaco and Andrea Pisano's Design for the Florentine Baptistery Door', *Renaissance Quarterly*, XXVIII (1975), 483 ff.

Kreytenberg, G. 'Andrea Pisano's Earliest Works in Marble', *Burlington Magazine*, CXXII (1980), 3 ff.

Kreytenberg, G. *Andrea Pisano und die toskanischen Skulpture des 14. Jahrhunderts*. Munich, 1984.

Kreytenberg, G. 'Zu Andrea Pisanos Türe am florentiner Baptisterium', *Das Münster*, XXVIII (1975), 220 ff.

Moskowitz, A. F. 'Osservazioni sulla porta del battistero di Andrea Pisano', *Antichità Viva*, XX (1981), 28 ff.

Toesca, I. *Andrea e Nino Pisano*. Florence, 1950.

ARNOLFO DI CAMBIO

Bearzi, B. 'Esame technologico e metallurgico della statua di S. Pietro', *Commentari*, XI (1960), 30 ff.

Cellini, P. 'Di Fra Guglielmo e di Arnolfo', *Bollettino d'Arte*, XL (1955), 215 ff.

Fasola, N. 'La Fontana di Arnolfo', *Commentari*, 11 (1951), 98 ff.

Gardner, J. 'Arnolfo di Cambio and Roman Tomb Design', *Burlington Magazine*, CXV (1973), 420 ff.

Gardner, J. 'The Tomb of Cardinal Annibaldi by Arnolfo di Cambio', *Burlington Magazine*, CXIV (1972), 136 ff.

Gnudi, C. *Nicola, Arnolfo, Lapo*. Florence, 1948.

Keller, H. 'Die Bildhauer Arnolfo di Cambio und sein Werkstatt', *Jahrbuch der Preussischen Kunstsammlungen*, LV (1934), 204 ff., LVI (1935), 22 ff.

Mariani, V. *Arnolfo di Cambio*. Rome, 1943.

Messerer, W. 'Zur Rekonstruktion von Arnolfo di Cambios Praesepe-Gruppe', *Römische Jahrbuch für Kunstgeschichte*, XV (1975), 25 ff.

Romanini, A.M. *Arnolfo di Cambio*. 2nd ed. Florence, 1980.

Romanini, A.M. 'Nuove Ipotesi su Arnolfo di Cambio', *Arte Medievale*, I (1983), 157 ff.

Salmi, M. 'Il Problema della statua bronzea di S. Pietro nella Basilica Vaticana', *Commentari*, XI (1960), 22 ff.

COSMATI

Glass, D.F. *Studies on Cosmatesque Pavements*. Oxford, 1980.

Hutton, E. *The Cosmati*. London, 1950.

EMBRIACHI

Schlosser, J. von. 'Die Werkstatt der Embriachi in Venedig', *Jahrbuch der kunsthistorische Sammlungen des allerhöchsten Kaiserhauses*, XX (1899), 220 ff.

GIOVANNI D'AMBROGIO

Kreytenberg, G. 'Giovanni d'Ambrogio', *Jahrbuch der Berliner Museen*, XIV (1972), 5 ff.

GIOVANNI DI BALDUCCIO

Seidel, M. 'Die Skulpturen des Giovanni di Balduccio aus S. Caterina in Pisa', *Städel-Jahrbuch*, N.F. VII (1979), 13 ff.

Seidel, M. 'Studien zu Giovanni di Balduccio und Tino di Camaino', *Städel-Jahrbuch*, N.F. V (1975), 37 ff.

Venturino Auce, P. 'La Tomba di S. Pietro Martire e la Cappella Portinari in S. Eustorgio di Milano', *Memorie Dominicane*, LXIX (1952), 3 ff.

GIOVANNI PISANO

Ayrton, M. *Giovanni Pisano*. London, 1969.

Bacci, P. 'Continuazione del capitolo inedito su Giovanni Pisano e il duomo di Siena', *Le Arti*, IV (1941-2), 268 ff.

Bacci, P. *La Ricostruzione del pergamo di Giovanni Pisano nel duomo di Pisa*. Milan, 1926.

Barsotti, R. 'Nuovi Studi sulla Madonna eburnea di Giovanni Pisano', *Critica d'Arte*, XIX (1957), 47 ff.

Francovitch, G. de. 'L'Origine e la diffusione del crocifisso gotico doloroso', *Jahrbuch der Bibliotheca Herziana*, 11 (1938), 139 ff.

Keller, H. *Giovanni Pisano*. Vienna, 1942.

Kosegarten, A. 'Die Skulpturen der Pisani am Baptisterium von Pisa', *Jahrbuch der Berliner Museen*, X (1968), 14 ff.

Kreytenberg, G. 'Eine Annunziata von Giovanni Pisano?', *Pantheon*, XXV (1977), 185 ff.

Marcenaro, C. 'La "Madonna" della tomba di Margherita di Brabante', *Paragone*, XIV, 167 (1963), 17 ff.

Marcenaro, C. 'Per la tomba di Margherita di Brabante', *Paragone*, XII, 133 (1961), 3 ff.

Mellini, G.L. *Giovanni Pisano*. Milan, 1970.

Middeldorf-Kosegarten, A. 'Nicola und Giovanni Pisano 1268–1278', *Jahrbuch der Berliner Museen*, XI (1969), 36 ff.

Seidel, M. 'Das Fragment einer Statue Giovanni Pisanos im Museo Guarnacci in Volterra', *Mitteilungen des kunsthistorischen Institutes in Florenz*, XV (1971), 123 ff.

Seidel, M. 'Die Elfenbeinmadonna im Domschatz zu Pisa', *Mitteilungen des kunsthistorischen Institutes in Florenz*, XVI (1972), 1 ff.

Seidel, M. 'Die Rankensäulen der sieneser Domfassade', *Jahrbuch der Berliner Museen*, XI (1969), 81 ff.

Seidel, M. 'Ein verkanntes Meisterwerk des Giovanni Pisano', *Pantheon*, XXXIV (1976), 3 ff.

Seidel, M. *La Scultura lignea di Giovanni Pisano*. Florence, 1971.

Seidel, M. 'Studien zu Giovanni di Balduccio und Tino di Camaino. Die Rezeption des Spätwerks von Giovanni Pisano', *Städel-Jahrbuch*, N.F. V (1975), 37 ff.

GORO DI GREGORIO

Carli, E. *Goro di Gregorio*. Florence, 1946.

GUIDI

Wundram, M. 'Jacopo di Piero Guidi', *Mitteilungen des kunsthistorischen Institutes in Florenz*, XIII (1967–8), 195 ff.

LAPO

Gnudi, C. *Nicola, Arnolfo, Lapo*. Florence, 1948.

MAITANI, Lorenzo

See the four items quoted above under IV. B. *7. Orvieto*.

659

NICCOLÒ DI PIETRO LAMBERTI

Wundram, M. 'Niccolò di Pietro Lamberti und die
florentiner Plastik um 1400', *Jahrbuch der Berliner
Museen*, IV (1962), 78 ff.

NICOLA PISANO

Angiola, E. M. 'Nicola Pisano, Federigo Visconti
and the Classical Style in Pisa', *Art Bulletin*, LIX
(1977), 1 ff.
Carli, E. *Il Pulpito di Siena*. Bergamo, 1943.
Crichton, G. H. and E. R. *Nicola Pisano and the
Revival of Sculpture in Italy*. Cambridge, 1938.
Fasola, G. N. *La Fontana di Perugia*. Rome, 1951.
Fasola, G. N. *Nicola Pisano*. Rome, 1941.
Gnudi, C. *Nicola, Arnolfo, Lapo*. Florence, 1948.
Hoffmann-Curtius, K. *Das Programm der Fontana
Maggiore in Perugia*. Düsseldorf, 1968.
Kosegarten, A. 'Die Skulpturen der Pisani am Bap-
tisterium von Pisa', *Jahrbuch der Berliner Museen*,
X (1968), 14 ff.
Middeldorf-Kosegarten, A. 'Nicola and Giovanni
Pisano 1268–1278', *Jahrbuch der Berliner Museen*,
XI (1969), 36 ff.
Poeschke, J. *Die sieneser Domkanzel des Nicola
Pisano*. Berlin and New York, 1973.
Polzer, J. 'The Lucca Reliefs and Nicola Pisano',
Art Bulletin, XLVI (1964), 211 ff.
Seidel, M. 'Der Verkundigungsgruppe der sieneser
Domkanzel', *Münchener Jahrbuch der bildenden
Kunst*, XXI (1970), 19 ff.
Seidel, M. 'Studien zur Antikenrezeption Nicola
Pisanos', *Mitteilungen des kunsthistorischen Insti-
tutes in Florenz*, XIX (1975), 307 ff.

Seymour, C., Jr. 'Invention and Revival in Nicola
Pisano's "Heroic Style"', *Acts of the XX Inter-
national Congress of the History of Art (New York,
1961)*, Studies in Western Art, I, 207 ff. Princeton,
1963.
Swarzenski, G. *Nicola Pisano*. Frankfurt am Main,
1926.
White, J. 'The Reconstruction of Nicola Pisano's
Perugia Fountain', *Journal of the Warburg and
Courtauld Institutes*, XXXIII (1970), 70 ff.

NINO PISANO

Toesca, I. *Andrea e Nino Pisano*. Florence, 1950.
Weinberger, M. 'Nino Pisano', *Art Bulletin*, XIX
(1937), 58 ff.

ORCAGNA

See III.C.

PISANO

See ANDREA, GIOVANNI, NICOLA, NINO.

TINO DI CAMAINO

Carli, E. *Tino di Camaino scultore*. Florence, 1934.
Kreytenberg, G. 'Tino di Camainos Grabmäler in
Florenz', *Städel-Jahrbuch*, N.F. VII (1979), 33 ff.
Morisani, D. *Tino di Camaino a Napoli*. Naples,
1945.
Seidel, M. 'Studien zu Giovanni di Balduccio und
Tino di Camaino', *Städel-Jahrbuch*, N.F. V (1975),
37 ff.
Valentiner, W. R. *Tino di Camaino*. Paris, 1935.

LIST OF ILLUSTRATIONS

of Cardinal de Braye, d. 1282. *Orvieto, S. Domenico* (Alinari)
49. Pietro Oderisi: Tomb of Clement IV, 1271–4. *Viterbo, S. Francesco* (Gabinetto Fotografico Nazionale)
50. Pietro Oderisi: Head of Clement IV, detail of tomb, 1271–4. *Viterbo, S. Francesco* (Biblioteca Hertziana)
51. Coppo di Marcovaldo(?): Head of Christ, detail of crucifix, late 1250s(?). *S. Gimignano, Pinacoteca Civica* (Soprintendenza alle Gallerie, Florence)
52. Arnolfo di Cambio: Head of Cardinal de Braye, d. 1282, detail of tomb. *Orvieto, S. Domenico* (Courtauld Institute of Art)
53. Arnolfo di Cambio(?): Thirsting Woman, *c.* 1281. *Perugia, Galleria Nazionale dell' Umbria* (Alinari)
54. Fra Guglielmo: Pulpit, 1270. *Pistoia, S. Giovanni Fuorcivitas* (Alinari)
55. Arnolfo di Cambio: Arca di S. Domenico (detail), 1264(?)–7. *Bologna, S. Domenico* (Courtauld Institute of Art)
56. Arnolfo di Cambio: Ciborium, completed 1285. *Rome, S. Paolo fuori le Mura* (Alinari)
57. Arnolfo di Cambio: Ciborium, 1293. *Rome, S. Cecilia in Trastevere* (Anderson)
58. Drawing of the façade of the Duomo in Florence, sixteenth century. *Florence, Museo dell' Opera del Duomo* (Soprintendenza alle Gallerie, Florence)
59. Arnolfo di Cambio: S. Reparata, by 1310. *Florence, Museo dell' Opera del Duomo* (Alinari)
60. Arnolfo di Cambio: Virgin, by 1310. *Florence, Duomo, façade* (Scala)
61. Arnolfo di Cambio: Virgin and Child, by 1310. *Florence, Museo dell' Opera del Duomo* (Brogi)
62. Giovanni Pisano: Virgin and Child, *c.* 1280. *Pisa, Camposanto* (Alinari)
63. Giovanni Pisano and Giovanni di Cecco: Siena, Duomo, façade, late thirteenth–early fourteenth centuries and late 1370s (Alinari)
64. Giovanni Pisano: Maria Moise (Miriam), between *c.* 1285 and 1297, *in situ*. *Siena, Duomo (now Museo dell' Opera)* (Gabinetto Fotografico Nazionale)
65. Giovanni Pisano: Isaiah, detail of head, between *c.* 1285 and 1297. *Siena, Museo dell' Opera del Duomo* (Grassi)
66. Giovanni Pisano: Female saint, *c.* 1297–8. *Pisa, Museo Nazionale di S. Matteo* (Thames and Hudson)
67. Giovanni Pisano: Pulpit, 1301. *Pistoia, S. Andrea* (Brogi)
68. Giovanni Pisano: Sibyl, detail of pulpit, 1301. *Pistoia, S. Andrea* (Thames and Hudson)
69. Giovanni Pisano: Nativity, detail of pulpit, 1301. *Pistoia, S. Andrea* (Alinari)

70. Giovanni Pisano: Adoration of the Magi, detail of pulpit, 1301. *Pistoia, S. Andrea* (Alinari)
71. Giovanni Pisano: Massacre of the Innocents, detail of pulpit, 1301. *Pistoia, S. Andrea* (Alinari)
72. Giovanni Pisano: Madonna and Child, *c.* 1300(?). *Pisa, Museo dell'Opera del Duomo* (Alinari)
73. Giovanni Pisano: Madonna and Child, *c.* 1299(?). Ivory. *Pisa, Duomo, Treasury* (Soprintendenza ai Monumenti e Gallerie, Pisa)
74. Giovanni Pisano: Pulpit, 1302–10. *Pisa, Duomo* (Gabinetto Fotografico Nazionale)
75. Giovanni Pisano: Hercules, detail of pulpit, 1302–10. *Pisa, Duomo* (Anderson)
76. Giovanni Pisano: Fortitude and Prudence, detail of pulpit, 1302–10. *Pisa, Duomo* (Anderson)
77. Giovanni Pisano: Nativity, detail of pulpit, 1302–10. *Pisa, Duomo* (Alinari)
78. Giovanni Pisano: Crucifixion, detail of pulpit, 1302–10. *Pisa, Duomo* (Anderson)
79. Giovanni Pisano: Crucifix, *c.* 1305(?). *Siena, Museo dell'Opera del Duomo* (Alinari)
80. Giovanni Pisano: Madonna and Child, 1312/13(?). *Pisa, Museo Civico* (Brogi)
81. Pietro Cavallini: Joseph and the Wife of Potiphar, seventeenth-century copy of a destroyed fresco, *c.* 1282–97(?). *Rome, S. Paolo fuori le Mura* (Alinari)
82. Pietro Cavallini: Mosaics of the Life of the Virgin, early 1290s(?), beneath a mid-twelfth-century apsidal mosaic. *Rome, S. Maria in Trastevere* (Anderson)
83. Pietro Cavallini: Presentation, early 1290s(?). *Rome, S. Maria in Trastevere* (Gabinetto Fotografico Nazionale)
84. Jacopo Torriti: Coronation of the Virgin, 1296(?). *Rome, S. Maria Maggiore* (Alinari)
85. Pietro Cavallini: Annunciation, early 1290s(?). *Rome, S. Cecilia in Trastevere* (Anderson)
86. Pietro Cavallini: Annunciation, early 1290s(?). *Rome, S. Maria in Trastevere* (Anderson)
87. Pietro Cavallini: Last Judgement, early 1290s(?). *Rome, S. Cecilia in Trastevere* (Rotalfoto)
88. Pietro Cavallini: Head of upper right-hand Seraph, detail of Last Judgement, early 1290s(?). *Rome, S. Cecilia in Trastevere* (Alinari)
89. Pietro Cavallini: The four right-hand Apostles, detail of Last Judgement, early 1290s(?). *Rome, S. Cecilia in Trastevere* (Anderson)
90. Cavallini Circle: Head of David (detail), early fourteenth century. *Naples, S. Maria Donna Regina* (Alinari)
91. Coppo di Marcovaldo: Madonna del Bordone, 1261. *Siena, S. Maria dei Servi* (Anderson)
92. Coppo di Marcovaldo(?): Crucifix, late 1250s(?). *S. Gimignano, Pinacoteca Civica* (Soprintendenza alle Gallerie, Florence)

135. Drawing for the façade of the Baptistery at Siena, *c.* 1339(?). *Siena, Museo dell'Opera del Duomo* (Alinari)

136. Florence, Palazzo Vecchio, founded 1299, and Loggia della Signoria, construction supervised by Benci di Cione and Simone Talenti, 1376–*c.* 1381 (Alinari)

137. Florence, Palazzo Vecchio, founded 1299, Sala d'Armi (Alinari)

138. Florence, Palazzo Davanzati, mid fourteenth century(?) (Alinari)

139. Giotto: Florence, Duomo, campanile, founded 1334 (Alinari)

140. Drawing for the campanile of the Duomo at Florence, early 1330s(?). *Siena, Museo dell'Opera del Duomo* (Anderson)

141. Florence, Orsanmichele, founded 1337 (Alinari)

142. Pisa, S. Maria della Spina, enlarged after 1323 (Anderson)

143. Angelo da Orvieto(?): Gubbio, Palazzo dei Consoli, begun after 1322 (Anderson)

144. (A) Gubbio, Palazzo dei Consoli, begun after 1322, and Palazzo Pretorio, begun 1349, with intervening substructures (R. Schulze, *Gubbio*, Abb. 14); (B) Gubbio, Piazza della Signoria (*ibid.*, Abb. 11, 12, and 13)

145. Angelo da Orvieto(?): Gubbio, Palazzo dei Consoli, begun after 1322, detail of steps (Angeli)

146. Angelo da Orvieto: Città di Castello, Palazzo Comunale, mid fourteenth century(?) (Alinari)

147. Angelo da Orvieto: Città di Castello, Palazzo Comunale, mid fourteenth century(?) (Gabinetto Fotografico Nazionale)

148. Gubbio, Duomo, consecrated 1366 (Angeli)

149. Asti, Duomo, begun after 1323 (Courtauld Institute of Art)

150. Crema, Duomo, façade, *c.* 1341 (Alinari)

151. Milan, S. Gottardo, campanile, inscribed in 1336 (Gabinetto Fotografico Nazionale)

152. Chiaravalle di Milano, abbey church, crossing tower, mid fourteenth century (Alinari)

153. Montagnana, town walls, between 1242 and 1259 (Fotocelere)

154. Gradara, castle, *c.* 1307–25 (Alterocca)

155. Sirmione, castle, late thirteenth and early fourteenth centuries (Fotocielo)

156. Fenis, castle, *c.* 1340 (Regione Autonoma della Valle d'Aosta)

157. Fenis, castle, *c.* 1340 (Istituto Geografico De Agostini, Novara)

158. Venice, SS. Giovanni e Paolo, begun *c.* 1333 (G. Dehio and G. von Bezold, *Die kirchliche Baukunst des Abendlandes*, V, Taf. 533/3)

159. Venice, SS. Giovanni e Paolo, begun *c.* 1333 (Anderson)

160. Venice, S. Maria Gloriosa dei Frari, begun early 1330s (G. Fogolari, *I Frari e i SS. Giovanni e Paolo*, xxxii)

161. Venice, S. Maria Gloriosa dei Frari, begun early 1330s, choir and transepts (Alinari)

162. Treviso, S. Nicolò, begun *c.* 1303 (Dehio and von Bezold, *op. cit.*, V, Taf. 533/8)

163. Treviso, S. Nicolò, begun *c.* 1303 (Alinari)

164. Verona, S. Fermo Maggiore, ceiling *c.* 1320 (Courtauld Institute of Art)

165. Padua, Palazzo della Ragione, ceiling *c.* 1306 (Alinari)

166. Venzone, Duomo, inscribed in 1308

167. Naples, S. Pietro a Maiella, founded early fourteenth century (G. Parisio)

168. Gagliardo Primario(?): Naples, S. Chiara, begun 1310 (G. Parisio)

169. Naples, S. Maria Donna Regina, 1307–*c.* 1320. Plans at upper and ground levels (É. Bertaux, *Santa Maria di Donna Regina*, plans before p. 27)

170. Naples, S. Maria Donna Regina, 1307–*c.* 1320

171. Palermo, S. Francesco, doorway, after 1302 (Anderson)

172. Duccio: Maestà, main front panel, 1308–11. *Siena, Museo dell'Opera del Duomo* (Gabinetto Fotografico Nazionale)

173. Duccio: Maestà, 1308–11, reconstruction of front (Author's photograph)

174. Duccio: Maestà, 1308–11, reconstruction of rear (Author's photograph)

175. Duccio: Maestà, main rear panel, 1308–11. *Siena, Museo dell'Opera del Duomo* (Photo museum, courtesy Professor Enzo Carli)

176. Duccio: Entry into Jerusalem, detail of the Maestà, 1308–11. *Siena, Museo dell'Opera del Duomo* (Anderson)

177. Reliquary of S. Galgano, late thirteenth or early fourteenth century. *Siena, Museo dell'Opera del Duomo* (Anderson)

178. Duccio: Christ and the Woman of Samaria, detail of the Maestà, 1308–11. *Lugano, Thyssen-Bornemisza Collection*

179. Duccio: Temptation on the Temple, detail of the Maestà, 1308–11. *Siena, Museo dell'Opera del Duomo* (Grassi)

180. Duccio: Rucellai Madonna, commissioned 1285. *Florence, Uffizi* (Alinari)

181. Duccio: Madonna of the Franciscans, *c.* 1290–5(?). *Siena, Pinacoteca* (Anderson)

182. Duccio: Triptych, *c.* 1300. *London, National Gallery* (Photo gallery)

183. Duccio: Polyptych no. 47, *c.* 1305–8. *Siena, Pinacoteca* (Alinari)

184. Giotto: Padua, Arena Chapel, painted between 1304 and 1313, looking east (Anderson)

The plans and elevations were redrawn by Donald Bell-Scott. The diagrams of fresco cycles were drawn by Stephen Bradbery and the map by Sheila Waters

INDEX

```